special effects

the history and technique

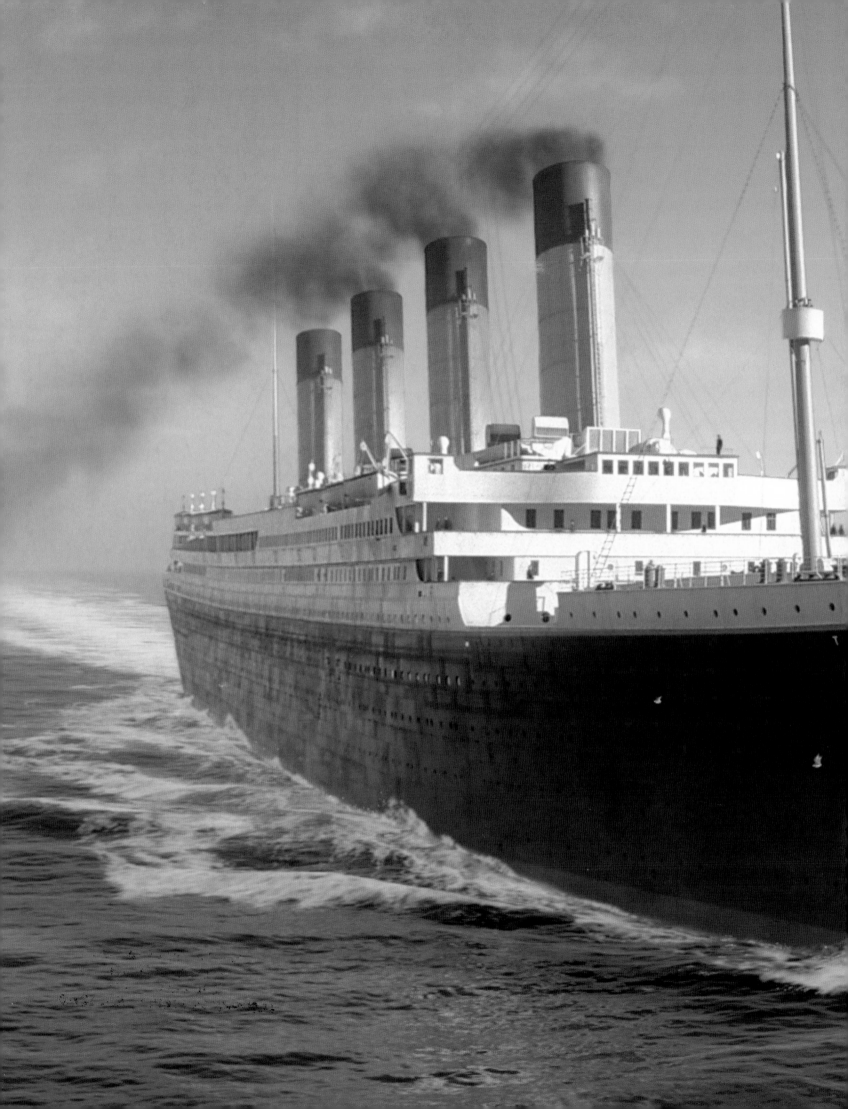

special effects
the history and technique

richard rickitt

**BILLBOARD
BOOKS**

ACKNOWLEDGMENTS

THE AUTHOR AND PUBLISHERS GRATEFULLY ACKNOWLEDGE THE GENEROUS ASSISTANCE AND PARTICIPATION OF THE FOLLOWING INDIVIDUALS AND COMPANIES WITHOUT WHOM THIS BOOK WOULD NOT HAVE BEEN POSSIBLE.

AMALGAMATED DYNAMICS INCORPORATED
Alec Gillis
Tom Woodruff

CINESITE (Europe)
Helen Arnold
Hayden Jones
Simon Minshall
Charlie Tait
Pete Williams
Aviv Yaron

THE COMPUTER FILM COMPANY (London)
Mike Boudry
Tom Debenham
Paddy Eason
Dan Class
Ruth Greenberg
Dominic Parker

DIGITAL DOMAIN
Bob Hoffman
Robert Legato

DREAMWORKS ANIMATION
Jennifer Cohen
Wendy Elwell
Jane Gotz
Al Holter
Harold Kraut
David Moorhead
Don Paul
Dan Phillips
Patrick Witting

FANTASY II FILM EFFECTS
Leslie Huntley
Gene Warren

JIM HENSON'S CREATURE SHOP
Hal Bertram
Auelio Campa
Sandra Copi
Jamie Courtier
Marie Fraser
Karen Halliwell
Mary Victoria
Kenny Wilson

INDUSTRIAL LIGHT AND MAGIC/LUCASFILM
Ben Burtt
Ellen Pasternack

THE MAGIC CAMERA COMPANY
Steve Begg
Gary Coulter
Jose Grannel
John Grant
Rick Mietkowski
Nigel Stone
Angie Willis

MATTE WORLD DIGITAL
Craig Barron
Krystyna Demkowicz
Chris Evans
Brett Northcutt

PACIFIC DATA IMAGES
Ken Biellenberg
Sheigh Crabtree
Conrad Dunton
Rex Grignon
Craig Ring
Carl Rosendahl
Simon J. Smith

4

RHYTHM AND HUES

Suzanne Datz

John Hues

Nancy Klimley

Bill Kroyer

Tom Leeser

Douglas Smith

Bert Terreri

SONY PICTURES IMAGEWORKS

Clint Hanson

Gary Hecker

Don Levy

Tom McCarthy

John Radulovic

Ken Ralston

Jay K. Redd

Barry Walton

Barry Weiss

STAN WINSTON STUDIO

Sean Dickson

Crash McCreery

Stiles White

Stan Winston

TIPPETT STUDIO

Lisa Cooke

Doug Epps

Craig Hayes

Julie Newdoll

Jules Roman

Tom Schelesny

Phil Tippett

SHOWSCAN

Ernest M. Bakenie

Bill Hole

Russel H. Chesley

Nick Alder

Grahame Andrew (**Mill Film**)

Tim Burke (**Mill Film**)

Phil Attfield (**Men in White Coats**)

Becky Elliot (**Men in White Coats**)

Jon Brook

Kevin Brownlow

Craig Chandler (**General Screen Enterprises**)

Dale Clarke (**Bapty & Co**)

Chris Corbould

Neal Corbould

David Crownshaw (**Snowbusiness**)

Cliff Culley

Nick Dudman

Richard Edlund (**Richard Edlund Films Inc**)

Kim Doyle (**Richard Edlund Films Inc**)

Harrison Ellenshaw

Peter Elliot

Roy Field (**Field Films**)

George Gibbs

Michael Gratzner (**Hunter Gratzner Industries**)

Ray Harryhausen

Graham V. Hartstone (**Pinewood Studios**)

Guy Hauldren (**Cyber-Site Europe**)

Stephen Hines (**HinesLab, Inc**)

Max Hoskins (**ReelSound**)

Conrad Kiel (**Photo-Sonics, Inc**)

Mike Kelt (**Artem Visual Effects**)

John Spring (**Artem Visual Effects**)

Stefan Lange

Michael Lantieri

Brendon Lonergan

Tim McMillan (**Time Slice Films**)

Mitch Mitchell

Chris Knowles (**Ronald Grant Archive**)

Bob Pank (**Quantel**)

Roger Thornton (**Quantel**)

John Richardson

Mark Roberts (**Mark Roberts Motion Control**)

Bob Skotak (**4Ward Productions**)

Angus Taggart (**Arete Image Software**)

Leigh Took (**Mattes and Miniatures**)

Tom Tolls (**House of Moves**)

Douglas Trumbull (**Entertainment Design Workshop**)

Joe Viskocil

Sean Ward (**Breakaway Effects**)

C O N T E N T S

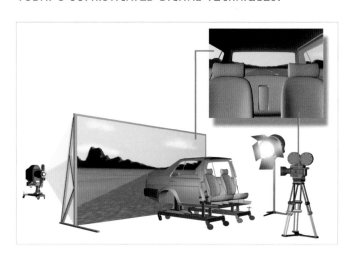

OUT OF THE SHADOWS

CINEMA IS NOW OVER A HUNDRED YEARS OLD. THE INVENTION OF PHOTOGRAPHY IN THE NINETEENTH CENTURY MAY HAVE PROVIDED THE VICTORIANS WITH A REMARKABLE MEANS OF RECORDING REAL-LIFE IMAGES, BUT IT WASN'T LONG BEFORE THEIR CURIOSITY CREATED THE FIRST MOVING PICTURES.

At first, the wonder of moving pictures, no matter how dull the deeds they showed, was enough to entertain and amaze. But the ordinary subjects of these early 'flickers' could not satisfy imaginative audiences, eager for the drama of the stage or the fantasy of the page. This led to the development of 'trick photography', which was used to astound viewers with visions of trips to the moon and journeys in flying cars.

As the moving pictures developed, 'special effects' grew increasingly sophisticated to match changing audience expectations. What thrilled in one decade seemed quaint and creaky in the next. The animated dinosaurs of *The Lost World* (1925) would have made audiences of the 1950s laugh, just as the monsters of the 50s held no terror for viewers in the 80s.

This chapter provides an overview of the development of special effects in the cinema's first century, decade by decade. Later chapters examine specific special effects techniques in depth, showing how they have helped to make cinema the most popular and influential form of entertainment.

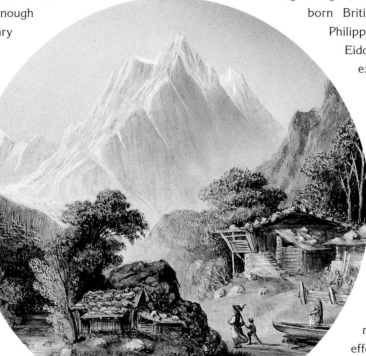

A hand-painted magic lantern slide dating from the 1800s.

THE PREHISTORY OF CINEMA

Cinema has many ancestors. In Europe, the period from the Renaissance to the eighteenth century saw a revival of interest in the visual arts, architecture and the theatre. Painting and theatre were married in the ancient art of shadow puppetry, ombres chinoises ('Chinese shadows'), which came to Europe from the Far East in the late seventeenth century. Its popularity led to the emergence of light shows of all kinds. The panorama, for example, devised and patented by the Scottish artist Robert Barker in 1787, told a story by allowing the audience to view different parts of a painting in stages. At about the same time, the German-born British painter and stage designer Philippe de Loutherbourg developed the Eidophusikon, a sequence of paintings exhibited in a theatre, complete with lighting and sound effects to enhance the drama of the scene. Louis Daguerre, one of the fathers of photography, developed another idea with his Dioramas, which were popular in Paris in the 1820s. These were paintings made on several layers of transparent gauze, each of which was hung and lit separately, one in front of the other. By dimming the light on one gauze layer and raising it on another, primitive yet effective dissolves could be made from scene to scene.

A popular attraction during the Renaissance was the camera obscura (meaning 'dark room'). For centuries it had been noted that a small hole in the wall of a darkened room would permit an inversed image of the outside world to appear on the opposite wall. (This process would later be adapted to produce the pinhole camera.) In the mid-1500s, patrons would crowd into a darkened room to see moving images of

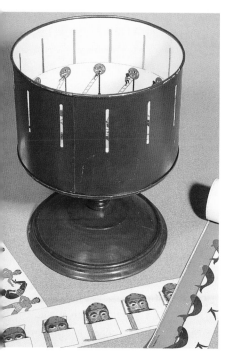

The Zoetrope, popular in Victorian times, showed animated sequences through slits in a rotating drum.

the outside world that had been focused and turned the right way up with the use of crude lenses.

By the seventeenth century, the camera obscura's principles had been adapted to produce the magic lantern. A light source (the 'lantern') was used inside the darkened room to project images through a lens onto the wall, in the manner of a slide projector. Scenes were painted on glass 'sliders' (strips of glass that slid between lens and light source just like modern slides) and were manufactured on a large scale. In the nineteenth century the magic lantern reached a peak of refinement. Dissolves could be achieved by using dual lanterns to project images on to the same spot. One image would slowly be replaced by another by controlling the amount of light in each of the lanterns. Slides were manufactured with images on several layers, and by moving them illusions such as beheadings and beatings could be achieved. From such optical tricks came the next step in the development of the moving pictures that were to dim the lantern and put its static magic in the shade.

The new magic of movement would not have been possible without a peculiarity of human sight. The human retina registers an image for a fraction of a second after it has gone from view. Called 'persistence of vision', this is the principle that makes a rapid sequence of slightly differing images seem real and continuous. The principle was first noted by the ancient Greeks, and in the nineteenth century it inspired the development of a succession of 'scopes' and 'tropes' – visual toys with names derived from Greek roots. The most famous of these was the Zoetrope. A popular parlour toy from the late 1860s, the Zoetrope consists of a drum with a sequence of drawings around the inside, which can be viewed from the outside through equidistant slits. The drum is spun, and persistence of vision causes the slits to merge into one, while the drawings coming into view create the impression of a moving image: a man turning a somersault, for example, or a bird flapping its wings.

There were many other optical toys at the time that worked on the same principle of revealing and obscuring images at a rate that made them appear to have motion. Developed by Reynaud and patented in 1892, the Théâtre Optique used a light source to project sequences of varying images, each of which had been painstakingly hand-painted on to a strip of translucent material. The system

produced what we would now call a cartoon, but did not involve any form of photographic process.

The first fledgling photographic processes, developed at the beginning of the nineteenth century, involved light-sensitive emulsions requiring long exposure times to capture any permanent image, and so were not suitable for shots of moving images. It was not until the 1870s that emulsions sensitive enough to take a photograph in a fraction of a second became practically available, although the creation of moving pictures was still hampered by the fact that a single photographic plate was needed for each picture.

An Englishman working in San Francisco under the unusual name of Eadward Muybridge (originally Edward Muggeridge) developed a system of individual stills cameras set alongside a track to record the normal movement of men, horses and other animals. His photographs, and the pioneering studies of the Frenchman Etienne Jules Marey (who invented a kind of photographic machine gun), were a major advance in the development of motion picture apparatus. They projected their pictures by slotting photographic plates into large revolving discs, in a device similar to a magic lantern called the Zoopraxiscope. If celluloid had been available in 1879, the birth of cinema might have been quicker and calmer.

The development of a sensitized strip of celluloid film by Kodak founder George Eastman in 1888 marked an end to calm. From then on inventors in Europe and America vied with one another to patent cinematic devices, and studied each others' patents with equal frenzy. Friese-Green, Edison and Dickson, the Lumières, Le Prince – who would be first? Cinema was finally born in 1895, when the first successful method for filming and projecting moving pictures, the Cinématographe, was publicly exhibited in Paris by the Lumière brothers. However, like all new arrivals, it owed its existence to many forebears.

Eastern shadow puppets were one of the precursors of cinema. This example is from Java in Indonesia.

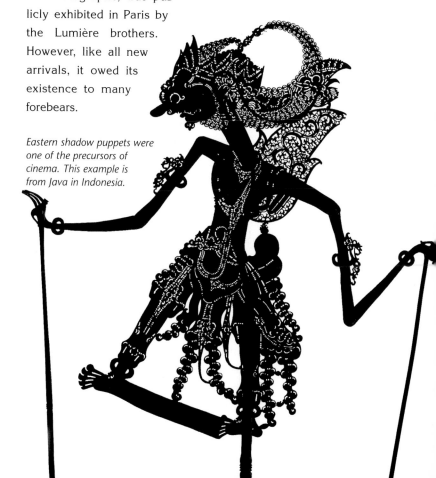

WHAT THE NINETIES SAW

By the end of the 1880s, all the elements required to make moving pictures had fallen into place. In the United States, Thomas

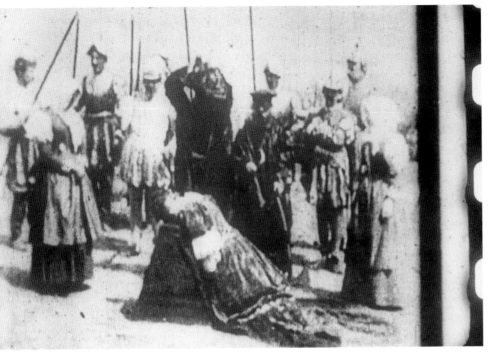

In what is considered to be the world's first special effects shot, stop-action was used to create an on-screen beheading for The Execution of Mary, Queen of Scots *(1895).*

Alva Edison (1847–1931), having already recorded sound with his invention the Phonograph (1877), took up the challenge to develop an apparatus for recording moving images. In 1888 he entrusted his assistant, the Englishman W. K. L. Dickson (1860–1935), with the task of inventing something on his behalf.

By late 1890, Dickson had developed the Kinetograph, which could take rapid sequential images. These were then shown using loops of 35mm film held in a Kinetoscope (patented in 1891), a slot machine that provided a brief display of moving images for an audience of one, who had to bend down as if looking through a keyhole – hence the nickname 'What-the-Butler-Saw'. Such films were 'single shot' dramas, where there was no editing and the position of the camera was not moved. It was for one of these films that the world's first known special effect was created. On 28 August 1895, camera operator Alfred Clarke filmed a re-creation of the execution of Mary, Queen of Scots at the Edison studio in New Jersey. To create the illusion of a royal beheading, Clarke first

Edison's 1894 Kinetophone improved on the Kinetoscope, combining moving images with a soundtrack provided by the Phonograph.

filmed the Queen as she knelt before the executioner. After the axe was raised, the camera was stopped so that the actress could leave the scene and be replaced with a dummy. When filming resumed, the axe was dropped and the Queen's head appeared to be separated from its shoulders. Such stop-action techniques would remain at the heart of special effects production for the next century.

It was quickly recognized that if the moving images could be projected on to a screen, a paying audience would gather for each display. The answer was sought in the magic lantern, and was found by two French brothers – whose surname, appropriately, means 'lamplighter' – Auguste (1862–1954) and Louis Lumière (1864–1948). The Lumières devised the Cinématographe, which served as camera, film printer and projector. The cinema had come, albeit silently, into the world.

The Lumières initially felt that their invention would be part of a passing craze and decided to exploit it for short-term financial gain. The brothers gave the first public exhibition of their small repertoire of short films at the Grand Café on the Boulevard de Capucines, Paris, on 28 December 1895. Early films included *A Lesson in Vaulting, Feeding a Baby, Fireman Extinguishing a Fire*, and most famously, *Train Arriving at a Station*. The latter is reputed to have caused alarm when the locomotive seemed about to steam out of the screen into the audience. The journalist G. R. Baker wrote: 'The train is seen approaching, and gradually gets nearer and larger until the engine passes where we are apparently standing, and the train stops, the guard comes along, passengers get out and in, and all is real!'

Louis and Auguste realized the power of their invention immediately, and they quickly engaged two hundred agents to travel to almost every part of the world, exhibiting their films and shooting new ones to add to their library. The first Cinématographe display in Britain took place in London's Regent Street on 20 February 1896. The show soon transferred to Leicester Square, still the centre of film-going in London. The immense popularity of the moving pictures was described in the press at the time as the 'Living Picture Craze'.

The invention of moving pictures was a collective process. To single out Edison, Dickson or the Lumières as the inventor of movies is unjust to the many others who were also at work on moving picture systems at that time. The efforts of men such as Louis Le Prince (1842–1896),

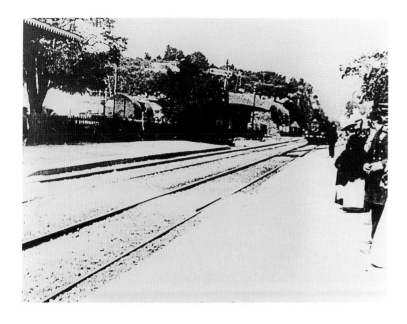

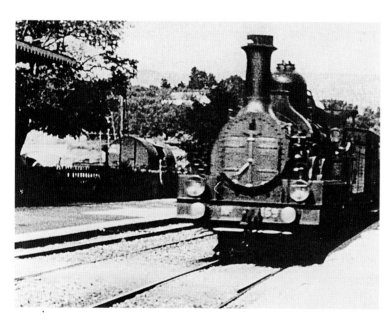

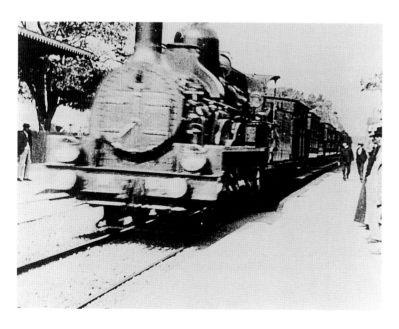

The Lumières' Train Arriving at a Station *(1896) alarmed viewers who thought the train would burst through the screen.*

who experimented with paper rolls of film, or William Friese-Greene (1855–1921), who helped develop a system for projecting still images at four or five frames per second, should not be forgotten.

Similarly, the creation of a cinema industry did not happen because of the business acumen of any one man or company. The Lumières captured the public imagination, but they could not hold a monopoly on the production and exhibition of films. Their invention was copied and exploited in countries where their patents did not apply. In the United States, Edison initially dominated the market, but soon had competition from other moving picture systems.

It became clear to all concerned that, because no particular system had a unique selling point, the only way to make a success in the business would be to produce films that told a story, rather than show the one-shot wonder of a man combing his hair or a woman dancing.

The fundamentals of film spectacle as we know it today – sound, colour, widescreen – were all being striven for within a few years of that first Lumière show. In 1900, at the Paris Exposition, the latest in cinema technology was on display. This included Cineorama, a primitive sound system relying on a separate synchronized sound disc, and hand-tinted films giving a gaudy illusion of colour.

Audience reactions to these cinematic 'effects' can be judged from these observations on 'Living Pictures' that appeared in a general family reference work, *The Sunlight Year-Book*, in 1898: 'This ingenious and pleasing exhibition has become very popular. The method ... though at first incomprehensible, yet becomes fairly clear on examination ... a French gentleman named Cordy is said to have taken a set of photographs of growing flowers at different stages of development, and flashing them thus quickly on the screen, shows you a plant growing and budding and flowering in a moment or so. This living picture, though no doubt interesting, must, however, be likely to have an unnatural effect, for in nature we do not see plants budding and flowering in a minute.'

A poster advertisement for the Lumières' Cinématographe showing viewers watching a film.

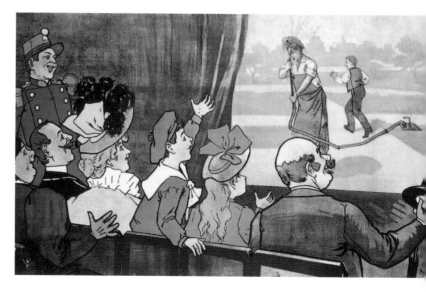

GEORGES MÉLIÈS

Perhaps the most important innovator in the early history of cinema was Georges Méliès (1861–1938), who within ten years of discovering film, made hundreds of short films and pioneered many of the methods that would remain at the heart of special effects production for much of the next century.

The father of special effects was the youngest son of a French boot-making tycoon and was expected to follow his father and two brothers into the trade. His destiny, however, did not lie in filling the family shoes, and when his father retired Georges Méliès sold his share in the family business. With the considerable proceeds he purchased the Théâtre Robert-Houdin in Paris, one of the most famous magic venues in the world.

In addition to being manager, Méliès took to the sulphur and sodium life of the theatre magician with a flourish and conjured up an array of innovative stage illusions – all of which he designed, built, painted and performed in famously comic style. Magic lantern shows were another attraction on his bill of wonders, with fantastical presentations of hand-coloured glass slides.

So Méliès was aware of both the science and the popularity of theatrical projection when, on 28 December 1895, he sat among the first audience in the world to witness a performance of the Lumière brothers' Cinématographe. He immediately saw the potential of the new device. After the historic screening, Méliès entered into a bidding war with other Parisian impresarios, only to be told that the amazing box of tricks was not for sale at any price. Méliès was undeterred. Within three months he had bought a device built by Robert W.

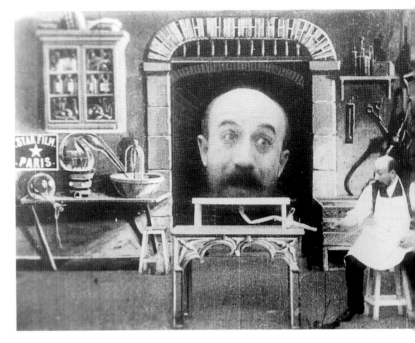

The fantastical result of Méliès's use of double exposure in Indian Rubber Head *(1902).*

Paul of London, designed for use with Edison's Kinetoscope films. Méliès then worked with two engineers in his theatre workshop to build an enormous and unwieldy prototype camera of his own. Early warning of a growing obsession came when he took the camera with him on a seaside vacation in July 1896. The frustrations of a family holiday accompanied by a 35kg (77lb) camera can only be imagined. Luckily for family harmony, Méliès patented a lighter version in September 1896.

Méliès began making simple one-shot films, usually sixty-second scenic views – moving versions of the magic lantern shows that had preceded them. When he was filming one such scene in the Place de l'Opéra in Paris, however, a chance incident occurred that appealed to both the innovator and the showman in Méliès, and which helped him to become one of the most important figures in the history of special effects.

As he turned the camera's hand-crank, the device jammed. 'It took a minute to release the film and get the camera going again,' Méliès later wrote. 'During this minute the people, buses, vehicles, had of course moved. Projecting the film, having joined the break, I suddenly saw an omnibus changed into a hearse and men into women. The trick of substitution, called the trick of stop-action, was discovered.'

In fact, stop-action photography had already been used by the Edison camera operator Alfred Clarke for the beheading sequence in *The Execution of Mary, Queen of Scots* (1895). There is no doubt, however,

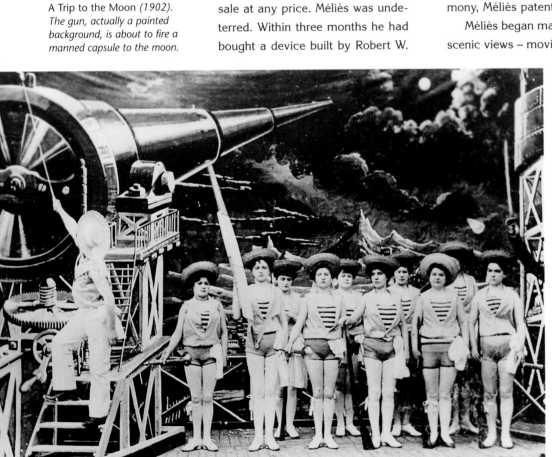

A Trip to the Moon (1902). The gun, actually a painted background, is about to fire a manned capsule to the moon.

that Méliès discovered the trick for himself, and that his application of what had been a cinematic accident would make him the world's foremost producer of 'trick films'. Méliès was soon using stop-action, double exposure, fast and slow motion (achieved by varying the speed at which film runs through the camera while recording), dissolves and perspective tricks in his films, which became increasingly elaborate. His love of storytelling, his feel for illusion and his new-found photographic abilities led him to devise spectacles that would have been impossible on stage. To realize his ideas, Méliès built an impressive glass studio in the garden of his family home near Paris. The studio, perhaps the most sophisticated of its age, could claim to be the world's first special effects facility. It was equipped like a magic theatre, with trap doors, winches, pulleys, mirrors and flying rigs, as well as a number of workshops and scenery stores.

The convention of the age was to film the world as it was in front of the camera. Méliès created more complex films, weaving his unique spell in what he termed 'artificially arranged scenes'. Each film comprised a number of distinct scenes, filmed from a single viewpoint, as if the camera were in the front row of a theatre. The action took place within this single setting, with characters and their props entering and exiting from stage left or right.

Though Méliès produced war scenes, historical scenes, news reconstructions, operas, publicity films, dramas, comedies and even erotic 'stag' films, his most popular and famous films were those based on fairy tales and fantasies. In *Cinderella* (1899), stop-action turns a pumpkin into a glittering coach, and Cinderella's rags into a luxuriant gown. Slow motion allowed elfin dancers to glide in the air. Some scenes were even painstakingly hand-coloured.

In *Indian Rubber Head* (1902) Méliès used a split-screen process, which involved masking off areas of the film so that they did not receive an image in the first exposure, and then adjusting the masking so that only these areas were exposed in the second take. The viewer sees Méliès in the role of a scientist, placing a duplicate of his own head on a table and beginning to inflate it using a bellows. An assistant takes over and enthusiastically pumps air into the head, which grows enormous, pulling distended faces until finally exploding. The disembodied head was added in the second exposure, and enlarged by wheeling Méliès closer to the camera in a specially constructed carriage.

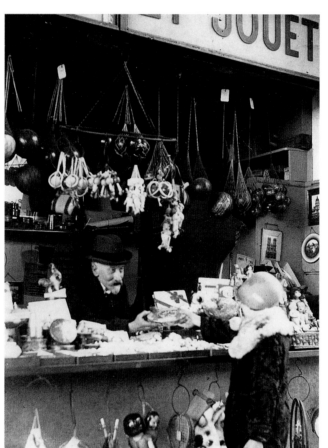

Cinema's best-known early magician spent his last years, perhaps fittingly, supplying toys to the children of Paris.

Of the 500 films that Méliès produced between 1896 and 1912, perhaps his most impressive is *A Trip to the Moon* (1902), which was based on the writings of Jules Verne and H. G. Wells. The 21-minute film – a sprawling epic in an age when films rarely lasted more than two minutes – uses every available artifice to tell the story of a group of Victorian explorers who visit the moon. The sets and props were typical of the Méliès style, simply consisting of *trompe l'oeil* paintings designed and painted by Méliès himself to give the illusion of three-dimensional depth. The presentation was pure pantomime, with a dash of moonshine. Groups of leggy chorus girls help to launch the spaceship shell from its cannon. Flying through space, the ship passes stars with beaming feminine faces at their centres, while the Moon's grumpy crater-face becomes even more cheesed off when the enormous spacecraft lands in his eye. On the lunar surface, the explorers are confronted by impish self-destructing aliens, and Méliès exhibits one of his most imaginative effects when the various two-dimensional moonscape elements move in relation to one another to suggest a camera perspective shift.

For more than ten years Méliès was the most popular film maker in the world and could justifiably lay claim to being the cinema's first star. The simple storylines and visual enchantment of his films meant that they could be enjoyed around the world without subtitling, and they were frequently pirated by foreign producers. However, Méliès's visual style did not evolve, and his narratives were little more than linkage for fantastic special effects. From around 1910 audiences in Europe and the United States began to see the innovative work of American film makers such as D. W. Griffith – films with realistic locations, stories and fast-paced editing. By comparison, the films of the Parisian master magician seemed outdated. Despite conjuring up greater spectacles than ever, Méliès could not hold on to his audience.

The Théâtre Robert-Houdin was closed by the outbreak of World War I in 1914, and Méliès was bankrupted. He spent the last years of his life running a toy kiosk at the Gare Montparnasse. He enjoyed a minor comeback in the late 1920s, courtesy of the surrealists, who admired the dreamlike sense of adventure and the whimsical treatment of science and logic in his work – and his films continue to beguile appreciative audiences today.

OTHER INNOVATORS

The reputation of Georges Méliès as the father of special effects is undisputed, yet he was not working in a vacuum. Film was still a young medium, so the simple process of solving everyday film-making problems often led to the discovery or invention of new techniques – making it almost impossible to pinpoint who invented what. The many film pioneers working in Britain, in particular,

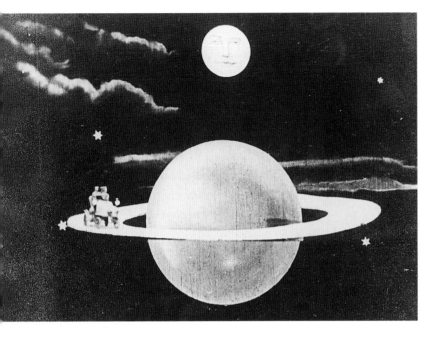

R. W. Paul's The ? Motorist (1906) entertained audiences with its visions of an interstellar car journey.

were especially innovative in the art of special effects.

Méliès bought his first projector from Robert W. Paul, a scientific instrument maker from London. Paul entered the film business when he was asked to make six duplicates of an Edison Kinetoscope for two Greek showmen. Although Paul copied the machines legally – Edison having been unable to patent his device in Europe – the American inventor refused to supply films to run in the machines. Not to be defeated, Paul built his own camera and projection device and went into production himself.

Like other early film makers, Paul's first efforts were single-shot views, but he quickly realized the value of offering audiences the unusual and fantastic. In 1897 he sent a cameraman to Egypt to capture scenes such as *An Arab Knife Grinder at Work*. He was also the producer of 'trick films' in a specially built studio in north London. One of the earliest gives an idea of the effects that could be achieved in films of the day, using methods such as stop-action and by combining elements filmed in different exposures. In *The Haunted Curiosity Shop* (1901, directed by W. R. Booth), the top half of a woman enters a shop, closely followed by her bottom half. When the elderly storekeeper attempts to embrace the woman, she suddenly changes into a mummy, and then again into a skeleton. Three pixies arrive on the scene and launch into frenzied capering, before merging into a single pixie, which the old man captures in a jar. A giant head then emerges from a puff of smoke and frightens the old man away.

Of the few surviving Paul films, the curiously titled *The ? Motorist* (1906) is the most remarkable. Equalling anything produced by Méliès in technique and ambition, the film uses every available method to tell the story of a couple who exceed the speed limit in their car and fly off the face of the Earth into outer space. Motoring through the solar system, the model car touches down on the Sun and circumnavigates its surface before taking off for a spin around Saturn's rings. Paul did not look upon himself as a film maker, however, and only produced films to support the sales of his company's equipment. In 1910 he abandoned film making, sold his studio and tragically burned many of his films.

Paul was not the only trick film pioneer in England. In 1897 photographer G. A. Smith constructed his own movie camera and began the production of a series of imaginative trick films. In the same year he took out an English patent on the process of double exposure, and used the method to create an eerie semi-transparent ghost in *The Corsican Brothers* (1909). Smith later joined forces with Charles Urban, a business manager whom Edison had sent to England in an attempt to prevent the piracy of his machines and films. Their company produced several notable films, including *Airship Destroyer* (1919, directed by W. R. Booth), in which the city of London is attacked by a fleet of mysterious airships. A large and remarkably realistic model of

G. A. Smith's Santa Claus *(1898), a charming trick film using, among other effects, his patented process of double exposure.*

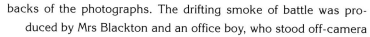

London was bombed and destroyed before the film's hero was able to defeat the zeppelins with radio-controlled missiles.

Among other notable film makers working in Britain was Cecil Hepworth, whose trick films included the evocatively titled *Explosion of a Motor Car* (1900), *How it Feels to be Run Over* (1900) and *Alice in Wonderland* (1903).

After the dramatic early coup of the beheading in Alfred Clarke's *The Execution of Mary, Queen of Scots* (1895), American film makers remained surprisingly slow to use tricks in their fiction films. There was innovation, however; where Europeans favoured spectacular films in which tricks were the stars, American producers preferred a more subtle approach. A popular form of entertainment was the news film – a short film that claimed to portray real events as they had happened. In fact, many such 'events' were faked for the cameras.

In 1898, Englishmen Albert E. Smith and J. Stuart Blackton, who together formed the Vitagraph Company, filmed *The Battle of Santiago Bay*. The bay was created by laying one of Blackton's paintings face-down and filling the canvas-covered frame with water to produce a small pond. The warring ships were cut-out photographs, pinned to floating wooden bases and pulled along on strings. Explosions were created using gunpowder attached to the

Edwin S. Porter, one of early cinema's great visionaries.

backs of the photographs. The drifting smoke of battle was produced by Mrs Blackton and an office boy, who stood off-camera blowing cigar smoke into the scene. The result was surprisingly convincing. Vitagraph's next reconstruction was of *The Windsor Hotel Fire* (1899), in which miniature figures fell from burning cardboard buildings, and water squirted from toy guns suggested the gallant efforts of the fire department to quench the flames.

Vitagraph was not alone in its techniques; other early studios, such as Biograph, Lubin, Selig and Edison, regularly counterfeited current events. Several companies produced films that showed both the real aftermath of the 1906 San Francisco earthquake and reconstructions of the disaster itself. Biograph produced a particularly spectacular model of the city, which was filmed as it burned and fell apart. It may seem extraordinary today that the viewers of such scenes rarely questioned their authenticity, but this was a time when moving pictures themselves seemed a miracle to most, and few paused to consider that what they saw might be deceptive.

The most significant American pioneer of this time was Edwin S. Porter. Joining Edison as a projectionist in 1900, he quickly assumed the rank of director. Porter produced several important films in which he challenged the conventions of editing, but his major contribution to the history of special effects came with *The Great Train Robbery* in 1903. This early 'Western' used shifting camera viewpoints and naturalistic settings, and startled audiences with one of the first known close-up shots. But the film's most significant breakthrough probably passed audiences by at the time – literally.

While the robbery takes place in the railroad telegraph office, a train can be seen steaming past the window. Later, in a mail car, a real moving landscape is seen going past an open doorway. To create these moving backgrounds, Porter adopted the double-exposure technique Méliès had used to make himself appear twice in the same shot in *Indian Rubber Head*. In another scene, Porter tinted three frames red to simulate the firing of a gun – a technique that would be used again by Alfred Hitchcock in *Spellbound* (1945).

Porter advanced the use of special effects to increase the naturalism of scenes and to further the plot of a dramatic film. Whereas Méliès, Paul and other early film makers had used trick photography for its own sake, Porter exploited special effects as unobtrusive storytelling tools.

For The Great Train Robbery *(1903), Porter filmed the live action in the telegraph office in one exposure and the train passing the window in another.*

THE 1910s

By 1910 film making and exhibition was becoming a major business, and was beginning to assume the structure that would characterize the industry for much of the ensuing century. What was once a cottage industry gave way to film factories – nickelodeons became goldmines.

Many small production companies emerged in the period, including Rex, run by Edwin Porter, who had left Edison in 1909. A considerable number of these companies disappeared almost before they arrived, while a few survived to dominate world film production for more than three-quarters of a century. Porter's company was among the early casualties. Moving out of production into technical research and manufacture, he was wiped out in the 1929 stock market crash.

As the industry found its feet, artistic pioneers continued to develop the art of film making. Foremost was David Wark Griffith. Griffith joined Biograph in 1907 and quickly began to revolutionize film grammar through his command of editing, camera movement, shot composition and lighting. Not an effects pioneer like Georges Méliès, D. W. Griffith standardized a number of photographic effects for storytelling.

He used shot transitions, such as the fade-in and fade-out, to indicate the lapse of time between scenes. Such effects were achieved during photography by opening and closing the camera aperture diaphragm to control the amount of light reaching the film. If a fade was required after photography, the camera negative was lowered slowly into bleach until the start point of the fade was reached. The negative was then slowly withdrawn, producing a linear fading of the image on the negative.

Around 1913, Griffith also began to make frequent use of the iris-in and iris-out for dramatic effect. There is some dispute as to whether the device was pioneered by Griffith or by Thomas Ince, though it was undoubtedly Griffith who developed the art of the technique. The iris was a simple device that fitted in front of the lens and could be opened and closed to progressively reveal or conceal areas of the frame. Griffith used the device to draw the eye to the centre of the drama or to reveal previously hidden elements of a scene. In *The Birth of a Nation* (1915), a mother and her children are shown huddling

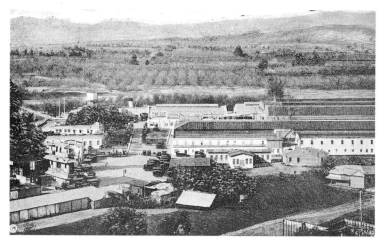

Many film companies settled in Southern California in the 1910s. Universal Studios was built among the orange groves of the San Fernando Valley.

D. W. Griffith (right) and his cameraman Billy Bitzer (left) pioneered standards of motion picture photography and editing.

in the upper left-hand corner of an otherwise black screen. The object of their concern is revealed as the iris opens to show the Northern armies marching through the family's devastated town.

By 1914 the American industry was well established in Southern California, where the fine weather and extreme distance from New York's Motion Picture Patents Company (which prosecuted anyone caught using its film equipment without authorization) made for ideal working conditions. Though Europe had developed its own thriving film industry, the outbreak of war effectively ended all commercial production. With its European competition crippled by war, Hollywood was set to dominate the hearts, minds and screens of the world.

Typical Hollywood film units consisted of a small all-purpose (and all-male) crew. At the head was the director, and under him the cameraman. Any good cameraman was capable of producing a number of 'live' tricks during the hand-cranked filming process, including the basic fading and iris effects. Cameramen could also produce dissolves, by which one image merges seamlessly into another. The effect was achieved by reducing the camera's aperture at the end of a sequence to produce a fade to black, rewinding the film, starting a second exposure and opening the aperture as the new scene was shot. By varying the speed at which they cranked the camera, cameramen could also produce fast or slow motion. The average cranking speed for cameras and projectors at this time was sixteen frames per second. Under-cranking the camera would appear to speed up the action in the film when it was projected, and became a favourite trick of helter-skelter slapstick comedies.

Methods that required running the film through the camera twice, such as split screens and double exposures, became much more practical after the introduction of a new Bell and Howell camera in 1912. The new camera was unique in the way it moved film and held it steady in front of the aperture on fixed registration pins during exposure. The ability to produce steady images, combined with an accurate frame counter, made the Bell and Howell ideal for producing in–camera special effects, which required the exact placing of images on film.

16

The creation of any unusual effect had generally been the responsibility of whoever came up with a workable on-the-spot solution to a problem. Some people gradually began to specialize in particular techniques and gained a reputation for those skills. One such individual was Norman O. Dawn, Hollywood's first effects man.

Dawn pioneered the glass shot, whereby scenery could be altered or extended on film by the use of highly detailed paintings. The technique was typically used to add height to studio sets that were only built one or two storeys high; the upper levels were added by painting them on a sheet of glass positioned in front of the camera. He later developed the in-camera matte shot, a technique that enabled filmed scenery to be combined with paintings (189>).

The 1910s also saw the emergence and exploitation of the film 'star'. At first, film actors were happy to appear anonymously. But audiences grew attached to their favourite performers, and came to know them by their nicknames – Mary Pickford was known to millions simply as 'Little Mary' and 'The Girl with the Curls'. Producers and exhibitors quickly grasped the potential drawing power of these audience favourites, and the 'star' was born. By the end of the decade, performers such as Pickford, Douglas Fairbanks and Charlie Chaplin were among the most famous and best-loved personalities in the world, often commanding huge salaries.

Among the decade's other developments was the introduction of the feature film format. Exhibitors had generally nursed the belief that audiences could only concentrate for the length of one reel: ten or fifteen minutes. When D.W. Griffith found himself unable to tell the story of *Enoch and Arden* (1911) in less than two reels, exhibitors insisted on releasing it in two halves. Films several reels in length emerged from Europe at the beginning of the decade, and in 1912 the French four-reeler *Queen Elizabeth*, featuring the distinguished classical actress Sarah Bernhardt, was an international hit. In the United States, film producer Adolph Zukor took the lead when he began making feature-length productions of 'Famous Players in Famous Plays'. By the end of the decade, the feature film – usually around ninety minutes in length – was on every cinema bill.

D. W. Griffith masked the sides of the frame to emphasize the length of this fall from the walls of Babylon in Intolerance *(1916).*

Buying their tickets, the majority of moviegoers expected to be entertained. Weepies were fine, but weeping with laughter was even better. Visual comedy was loved the world over, and no one developed the art of screen slapstick more than Mack Sennett – the 'King of Comedy'.

In 1912, after a stint working as actor, gagman and comedy director at Biograph, Canadian-born Sennett persuaded two ex-bookmakers to lay money on his sure-fire idea for movies about a blundering troupe of policemen. He called his studio Keystone, and its Komical, Kar-chasing Kops were to arrest audiences for much of the next decade.

Keystone was a laughter factory where two-reel comedies were churned out like custard pies from a bakery. At the peak of production, several films a day emerged from the strictly run studio. Teams of writers, performers and prop builders manufactured gags that formed the keystone of all Keystone comedy: the fall from dignity.

Keystone performers underwent all manner of punishing pratfalls to make gags work. Helping them raise their laughs were a stable of effects men, perhaps the most skilled of their time. Any day might find them making rubber bricks, rigging telegraph poles to collapse on cue or building fake houses for cars to smash through. Central to the Kop films was the patrol wagon. Designed by Del Lord, the vehicle's heavy chassis and specially designed brakes allowed it, loaded with lunatic lawmen, to perform some astonishing stunts.

Sennett was notoriously tightfisted, refusing to pay his performers their worth – names such as Charlie Chaplin, Harold Lloyd, Fatty Arbuckle, Gloria Swanson and even Frank Capra passed through the studio on their way up the ladder. The studio flourished in the 1910s, but by the 20s its comedy was seriously challenged by the likes of Hal Roach Studios, whose stars included Harold Lloyd, Harry Langdon and Laurel and Hardy. Though Sennett had made a fortune from investing in oil and real estate, he had scraped the bottom of his barrel of laughs by 1933, when the Wall Street crash bankrupted him with debts of over $5 million.

MACK SENNETT: THE 'KING OF COMEDY'

THE 1920s

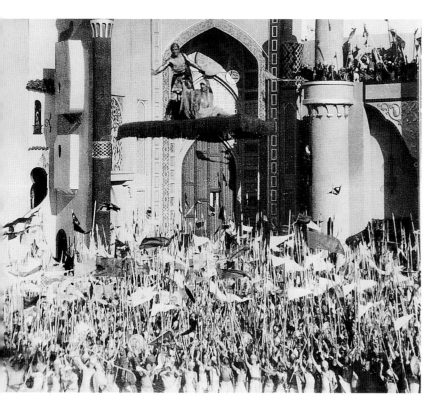

Douglas Fairbanks on a flying carpet suspended by wires above hundreds of extras on the set of The Thief of Bagdad (1924).

American film making flowered in the 1920s. Film makers began to branch out beyond the artistic and technical boundaries established by the pioneers of the previous decade, and relied increasingly on special effects to tell their increasingly elaborate stories. The Hollywood studio system was up to speed, and film making was an efficient and rationalized business.

Under the fledgling movie moguls, specific departments were created to deal with each aspect of movie production, from scripts and costumes to props and editing. There is uncertainty over the question of which studio was the first to establish a department dedicated to the creation of special effects – some claim that it was Fox, while others are convinced that it was MGM. Either way, the term 'special effects' received its first screen credit in the 1926 Fox picture What Price Glory? The term referred in this case to the film's physical and mechanical effects.

New techniques were developed to help film makers present the lavish or historical settings that their films demanded. The first travelling matte processes, which allowed actors filmed in the studio to be isolated from their surroundings and placed within settings from a different time and place, were crude but enabled a degree of realism (44>). These processes were helped by the development of much-improved camera and lighting equipment and faster, finer film stocks (22>).

Since the earliest days of the industry, film makers had built small models of any object or location that was too big, expensive or impractical to be filmed in any other way. In the 1920s, as production budgets quickly soared along with film makers' ambitions, studios became increasingly dependent on the use of money-saving

models. As a result, effects technicians became highly skilled in the building and shooting of accurately scaled-down landscapes, buildings and vehicles, and in the amalgamation of such footage with live-action full-scale photography for films such as The Crowd (1928) and Just Imagine (1930).

German films were a major influence on American film makers of the 1920s. Douglas Fairbanks' (1883–1939) spectacular The Thief of Bagdad (1924) used opulent sets and the best effects Hollywood could buy in an attempt to compete with the German films of the time. Some of the scenes were effective, such as the flying carpet sequences (when the wires didn't show), but Thief mainly served to show that while American technicians could build enormous sets, they still had a lot of ground to cover in the field of special effects.

Epics on the scale of The Thief of Bagdad were popular, demanding sets of biblical proportions. Ben Hur (1925) required the creation of a

The science-fiction musical Just Imagine (1930) was enlivened by shots of a magnificent model city inspired by the German film Metropolis (1926).

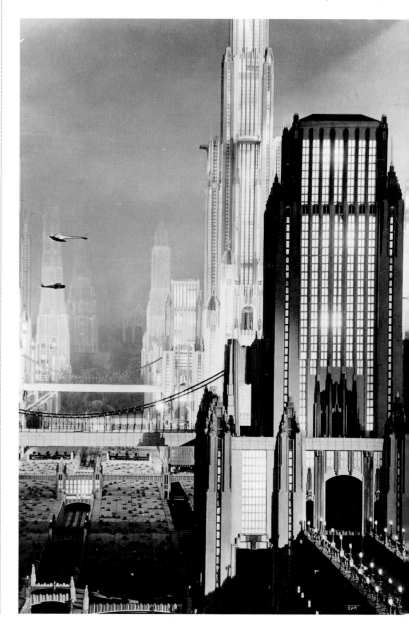

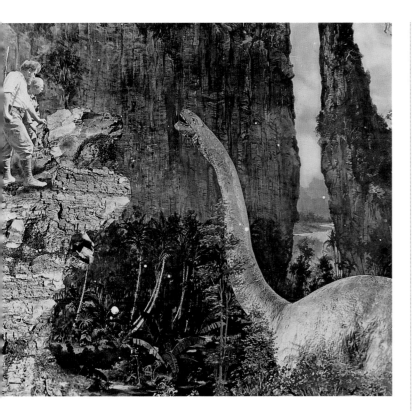

Professor Challenger (Wallace Beery) confronts one of Willis O'Brien's animated dinosaurs in the classic effects film The Lost World *(1925).*

full-scale Circus Maximus and a fleet of seven huge Roman galleys on location in Italy. But a number of incidents – including the burning of the galleys (in which some extras are reputed to have drowned when they jumped from the burning ships) – combined with bad weather and Italian labour disputes, brought the production back to California. The film was completed in rebuilt sets with significant use of miniatures.

Meanwhile films using animation grew in sophistication and popularity. Some cartoon characters even began to rival the popularity of live-action movie stars. By the mid-1920s the fame of Felix the Cat, first introduced by animator Pat Sullivan in 1914, was second only to that of Charlie Chaplin. In 1923 Walt Disney (1901–66) began production of his technically ambitious *Alice* comedies, in which a live-action Alice was combined with two-dimensional cartoon figures. The combination of live action and animation went even further in *The Lost World* (1925). This ambitious version of Conan Doyle's novel used startling stop-motion animated dinosaurs created by Willis O'Brien (1886–1962).

The greatest technical development of the period came towards the end of the decade. The coming of sound was no surprise – sound systems of varying effectiveness had been around for much of the decade. By the time Al Jolson broke into song on film on 6 October 1927, many audiences had experienced Fox Movietone newsreels that used the sound-on-film methods pioneered by Lee De Forest (1873–1961). However, Warner Brothers' release of *The Jazz Singer* (1927) – in a last-ditch effort to stave off bankruptcy – fired the public imagination and signalled that the 'talkie' was here to stay.

GERMAN SPECIAL EFFECTS

Hollywood was the world's leading film factory of the 1920s, but the special effects of German film makers, with their mechanical expertise and love of fairy tales, was technically far superior.

Actor and director Paul Wegener was a great advocate of special effects. In a 1916 speech, which was more prophetic than probably even he imagined, he envisaged the development of a 'synthetic cinema' in which totally artificial scenes would be created by the abilities of the camera. Wegener made significant use of special effects, notably in his religious meditation *Living Buddhas* (1923). For one dramatic sequence, a double-exposure matte technique was used to create the impression of a Buddha in the sky directing a ship lost at sea to safety.

UFA, Germany's largest studio, made the country's most spectacular film productions, with Fritz Lang (1890–1976) as their major director. Lang's two-part epic *Die Niebelungen* (1924) was filmed entirely on enormous studio sets and featured an awesome 18m (60ft) mechanical dragon – a far cry from the awkward reptile of Douglas Fairbanks' *The Thief of Bagdad*, which was made in the same year. The production also exploited the Shuftan process (90>), which used mirrors to combine full-sized sets with miniatures – a technique for which German cinema would become famous.

Lang's effects masterpiece was *Metropolis* (1926), a visionary science-fiction fable that made stunning use of models (90>), animation (134>), matte painting (188>), early rear projection (66>) and full-scale mechanical effects (246>). Parts of the futuristic city of Metropolis were built as full-scale sets and populated by thousands of extras. Although a financial failure, *Metropolis* had a huge impact on contemporary American film makers, and it continues to be one of the most influential films ever made. Futuristic artistry and technical excellence have secured its place in popular culture.

Ironically, by 1930 many of Germany's leading directors and technicians had left for Hollywood. Lang was one of the last to take flight, lingering in Germany to produce *Frau Im Mond* (1929; released as *Woman In The Moon* in the UK and *By Rocket To The Moon* in the US). Though it was science fiction, Lang strove to make the film as accurate as possible, hiring professor Herman Oberth (who later designed the V-1 rocket) and Willy Ley (who went on to design rockets for the United States) to work as consultants. The resulting scenes of rocket construction were so revealing that prints of the film, and model rockets used during filming, were later confiscated by the Gestapo.

JAMES WHALE

English director James Whale (1896–1957) came to Hollywood to direct the film of *Journey's End* (1930), a play tracking the horrors of war. Under contract at Universal, Whale then created *Frankenstein* (1931), the success of which would both bless and damn his career. An enigmatic man, his best films smiled darkly at the terrors of the imagination. Growing dissatisfied with the limiting label of horror director, however, he faded into a solitary lifestyle in the 1940s and 50s, drowning himself in his Beverly Hills Pool in 1957.

The laboratory scenes and lightning in *Frankenstein* were created by Kenneth Strickfaden, whose 'Electrical Properties' (251>) boosted the fading current of many horror movies of the 1930s. Modelwork by John P. Fulton (47>) was used for the laboratory and the blazing mill at the end of the film. These techniques, combined with Jack Pierce's iconic monster design (213>) and the expressionistic lighting, produced a science fantasy unlike anything Universal had made before.

Whale made three more horror films for Universal. *The Bride of Frankenstein* (1935) embellished the achievements of its forerunner with technically superior effects, supervised again by Fulton. The two men also worked together on *The Invisible Man* (1933), in which Fulton used the Williams process (45>) to ensure that when Claude Rains shed his bandages, he revealed nothing. *The Old Dark House* (1932) employed modelwork to create a realistic landslide.

Whale also directed *Showboat* (1936), a musical that re-created a Mississippi riverboat with models; and *The Man in the Iron Mask* (1939), where double-exposure techniques allowed Louis Hayward to speak to himself; his other lines were spoken to him by a stand-in (Peter Cushing), who was then edited from the composite image.

Whale became increasingly frustrated by the limits of the horror genre. Like Frankenstein, he had unlocked the mysteries of creation, but all that the studio gods expected him to create was horror.

Despite the success of *The Jazz Singer* (1927), the new phenomenon of the 'talkie' was largely ignored in most Hollywood studios. For Warner Brothers, however, the gamble had paid off. Audiences couldn't get enough of the talkies. Using their Vitaphone sound-on-disc process, the studio hastily added snippets of music and dialogue to the silent films already in production, and began planning all-talking future projects. Fox also added sound to their films, using their rival technique Movietone – a sound-on-film process that would later become the industry standard. The rest of Hollywood remained silent, resisting sound as no more than a fad.

A young Hitchcock (centre) listens to actress Anny Ondra during the filming of Blackmail *(1929). The camera stands within a soundproof chamber.*

But the public appetite for talkies was not to be starved, and by the mid-1930s, the big studios were producing all their major films in sound. Others, such as the Chaplin Studio, remained to be convinced, and it was another ten years before Charlie Chaplin was first heard in *The Great Dictator* (1940).

The coming of sound brought massive changes to an industry that was still settling into departmentalized production routines. New studio departments were tasked with sound recording, mixing and dubbing, as well as the scoring and performance of musical soundtracks. Stages needed to be soundproofed and movie theatres equipped for sound.

By the late 1920s, silent films had achieved extraordinary finesse. Directors knew how to position and move their cameras to heighten dramatic impact, and when to use intertitles – the written titles between scenes – to represent dialogue and express plot

points. But the arrival of sound hijacked everything. Early sound recording was a delicate and demanding process, and the needs of the soundmen began to dictate every aspect of shooting. Cameras were noisy and drowned out dialogue, so they were housed in soundproof sheds, cameraman and lens peering through a glass window. Action had to be performed before this fixed camera, becoming almost as confined and stagey as it was in Méliès's day.

Early microphones were weak, and actors often suffered the indignity of delivering emotional dialogue into a microphone disguised as a telephone or a vase of flowers. Many actors didn't progress that far; numerous stars of the silver screen found that their voice was unsuitable for the talkies, or that their voice didn't fit their image. They were replaced by a constellation of newcomers, often from the stage, whose richer diction had the approval of the sound department.

From about 1933, sound recording restricted filming on location, and for the next twenty years the great Hollywood outdoors would be filmed almost entirely within studio walls. The coming of sound is often held responsible for this wholesale move into the studios. In truth, the move probably had as much to do with increasing control by studio bosses who, after location nightmares such as those on *Ben Hur* (1925), preferred to keep wayward productions and problematic directors well within view.

For special effects departments, sound brought some new challenges. With films being made exclusively on the studio lot, effects technicians had to find ways to bring exotic and even everyday locations to the set. The technology that was developed enabled the first practical use of rear projection, a process enabling background scenery to be projected on to a screen behind actors while filming in the studio (66>). Over the next twenty years the technique would be perfected for use in almost every Hollywood production – providing backdrops for ocean-going romances, tropical adventures and journeys in trains and cars.

Although rear projection often replaced the uses of travelling mattes (44>), effects technicians continued to perfect travelling matte photography. The development of advanced optical printers, which enabled the separately filmed elements involved in travelling matte photography to be combined on film with greater control than had previously been possible, resulted in much-improved image quality. The optical printer also found favour in the production of many 1930s musicals whose spectacular dance sequences needed flamboyant scene transitions, such as the star-wipe (57>) and the now iconic spinning newspaper effect.

By the middle of the decade, special effects had advanced so much that a single department under the umbrella title of 'special effects' was not enough, and each studio's effects department found itself with a number of subdivisions. At MGM, for example, the special effects department was responsible for rear projection, miniatures, and physical and mechanical effects, while the optical department dealt with matte paintings and optical printing.

Special effects became an integral aspect of movie making during the decade – often for their time- and money-saving power more than their ability to create the fantastic or the seemingly impossible. There was good investment in technology and leeway for innovation. In 1932 Carl Laemmle (1867–1939) ordered the construction of Universal's first dedicated special effects stage, inaugurated with the filming of the miniature aeroplanes for John Ford's *Air Mail* (1932). Special effects technicians themselves began to earn considerable respect within the studios, although they rarely received any notice from the outside world; studio bosses believed audiences would feel cheated if they knew the realities of reel life.

The studios of Hollywood began to develop distinct personalities in the 1930s. A film's studio parentage was often clearly recognizable without reading its titles. The type of pictures a studio produced depended largely on its roster of contract stars. The Warner's house style, for instance, was built around a string of crime dramas and gangster movies featuring James Cagney; earnest biopics starring Paul Muni; Errol Flynn swashbucklers; and a series of 'women's pictures', starring Bette Davis. Each studio established output patterns related to its stars, market position and resources.

The kind of film a studio produced affected the resources dedicated to its special effects department. Universal maintained a substantial department to provide optical, physical and make-up effects for its famous stream of horror movies, begun with Tod Browning's *Dracula* in 1931 and established by James Whale's *Frankenstein* later the same year. The series, comprising some twenty-four films, centred around the characters of Dracula, Frankenstein's Monster, the Invisible Man, the Mummy and the Wolf Man, later combining two or more of these characters. At RKO, a particularly good optical department provided prominent effects for its series of Astaire and Rogers musicals, and contributed astonishing effects to the landmark smash-hit *King Kong* (1933). Despite the success of *Kong* and some of Universal's horror movies, special effects films did not flourish in their own right in this decade. Effects people spent most of their time perfecting the type of unglamorous methods that allowed Hollywood's stars to drive convincingly in front of rear-projected traffic.

The craze for talkies had shielded the major studios from the world's financial crisis in the 1930s, and at the end of the decade Hollywood remained in good financial shape – unchallenged as the supplier of the world's filmed entertainment. The end of the 1930s also witnessed one of the greatest periods in Hollywood production history, with the release of now classic films including *The Wizard of Oz*, *Mr Smith Goes to Washington*, *Stagecoach*, *Goodbye Mr Chips*, *Wuthering Heights* and *Gone with the Wind* (all 1939).

THE 1940s

The 1940s began auspiciously with the production of Orson Welles' *Citizen Kane* (1941). The film, now ranked as one of the greatest ever made, was a *tour de force* of matte paintings, miniatures (91>) and ingenious optical printing techniques (56>). Perhaps it is a tribute to their invisibility that the film was not even nominated in the special effects category of that year's Academy Awards.

Most of Hollywood's leading effects people now had well over a decade's worth of experience in studio production behind them and were masters of the various techniques available to them. Rear projection, optical printing, matte painting, and to a lesser degree, travelling matte photography, played a key role in the majority of studio productions, and were considered as much a part of the normal film production process as they were special effects techniques in their own right.

The rise of colour photography, however, brought significant changes to the industry – although it did not cause a revolution on the scale that the arrival of sound had provoked in the previous decade. Colour film processes had been around since the early days of film, but few systems had been either practical or pleasing to the eye. The first popular system, introduced in the late 1920s, was Technicolor's two-strip process. But with very slow film speeds requiring blinding amounts of light – often resulting in false colours and a grainy image – the two-strip technique did not enjoy widespread use. The early 1930s saw the introduction of a three-strip Technicolor process, whose colour reproduction was superb. Three-strip Technicolor was first used commercially for Disney's cartoon short *Flowers and Trees* (1932), and RKO's *Becky Sharp* became the first live-action feature to use the process in 1935.

Filming with early three-strip Technicolor still required three to four times as much light as black-and-white photography, so it was largely impractical for interiors. In a break from the studio-bound regime of the 1930s, a number of prestigious productions were shot on location in three-strip Technicolor, a move also facilitated by improved sound technology. The first film shot entirely outdoors

The filming of Trail of the Lonesome Pine *(1936) was dominated by the enormous Technicolor camera.*

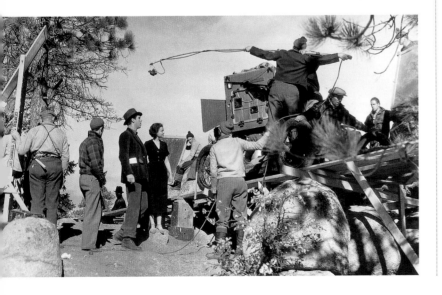

Child actor Sabu sitting in the hand of the giant djinn in The Thief of Bagdad *(1940).*

was Henry Hathaway's *Trail of the Lonesome Pine* (1936). However, the introduction in 1939 of much faster film stock – requiring far less light – made three-strip Technicolor a viable option for studio production in the 1940s.

For effects technicians, colour was a challenge. Rear projection in colour was at first a vivid but unattainable dream. The background images projected on to a screen behind actors in the studio were not bright enough to be re-filmed in colour. However, the faster film stocks of 1939 and a powerful new projection system devised at Paramount helped to overcome this problem in the early 1940s.

Travelling matte techniques (44>) also needed modification to accommodate colour. The first new method was pioneered in the UK and used in the 1940 version of *The Thief of Bagdad* (49>).

The technique that was most affected by the arrival of colour was matte painting (188>). In black-and-white the painter and subsequent photographer only had to worry about matching the greyscale tones of painting and live action. In Technicolor, however, every colour and shade of the painting had to match exactly those of the original footage *after* both had been combined under different lighting conditions *and* after the original exposure had been stored undeveloped for some time. The first major display of Technicolor matte painting was the epic and eagerly anticipated *Gone with the Wind* (1939) – a successful blend of painting and live action born out of months of patient experimentation.

Despite the success of Technicolor, however, it was both an intensive and expensive system, and so was generally reserved for prestige productions. The majority of films in the 1940s continued to be shot in black-and-white.

The involvement of Europe and the United States in World War II meant that a large proportion of Hollywood's 40s output was devoted to boosting the morale of those in the armed services and their families back home. The number of films made by Hollywood studios fell from an average of fifty pictures a year to thirty. But with fewer films being made, more resources were available for the on-screen version of a world at war.

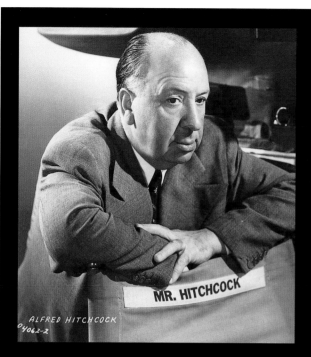

ALFRED HITCHCOCK

MR. HITCHCOCK

ALFRED HITCHCOCK
04062-2

Alfred Hitchcock (1899–1980) is celebrated as the undisputed master of the thriller genre, but he is less often credited as an important special effects director. He entered the film industry as a title card illustrator in 1919, but soon graduated, via scenario writing, to directing – making his first feature, *The Pleasure Garden*, in 1925. Hitchcock directed Britain's first sound film, *Blackmail* (1929). Not content with merely capturing sound, he put the untried medium to adventurous use – with startling effects. Employing the Shuftan process (90>) – which he had noted during a visit to Germany's UFA studios – he combined models and live action for a large-scale finale that British International Pictures could not otherwise have afforded.

Hitchcock's technical virtuosity continued to grow in the 1930s, with films such as *The 39 Steps* (1935) and *The Lady Vanishes* (1938) demonstrating the director's ability to combine witty scripts and characters with deft camerawork and subtle special effects. Quickly latching on to the potential of the new process of rear projection, Hitchcock devised some of the most imaginative uses ever of the technique for films such as *Foreign Correspondent* (1940, 68>).

Hitchcock moved to Hollywood in 1940. With *Rebecca* (1940), his first American production, he started to explore the increased potential for special effects that higher budgets allowed, making particular use of miniatures and rear projection. Later experiments included *Lifeboat* (1944), a film set entirely within the confines of a drifting boat, and *Rope* (1948), a film engineered to appear as one continuous shot. Hitchcock's position as the most creative and influential director of the period was assured. His bold and imaginative use of special effects could not be matched.

The re-creation of battlefields, destroyer-prowled oceans and fighter-filled skies fell to the effects technicians. Full-scale armaments were out of the question, so war films relied heavily on models and miniature photography – often on an epic scale. The demand for realistic sea battles led to advances in marine model-making and shooting in studio tanks – huge outdoor pools in which naval confrontations were staged. The tank at MGM was 92m (300ft) square, but the 15m (50ft) vessels that it often contained – such as those for *Thirty Seconds over Tokyo* (1944) – were so cramped that special devices had to be engineered to give the impression that they were full-steaming ahead. Filming water to scale will always be a problem – it being difficult to make a pond look like an ocean – but the experience gained in the 1940s brought the art as close to perfection as it would ever be.

Aerial combat was re-created using squadrons of miniature aircraft, held aloft and manoeuvred by complex systems of wires. One of the most remarkable uses of the technique saw two dozen model aircraft take off in convincingly precise formation for *Mrs Miniver* (1942). War films also meant the frequent use of explosives, and Hollywood powdermen were kept busy supplying carefully devised miniature explosions for the destruction of models, in addition to convincing (but safe) mortars and bullet hits for full-scale live-action combat sequences.

Wartime box-office takings soared in the US and the UK, more than compensating for the loss of important revenues from much of war-torn Europe and Asia. But after the end of hostilities box-office revenues began to slump, partly because of the growth of suburban housing developments away from city centre cinemas, and increasingly because of the arrival of a mighty challenge to the dominance of the big screen: television.

Films such as Ships with Wings *(1942) relied on model ships, planes and miniature pyrotechnics for their portrayal of war.*

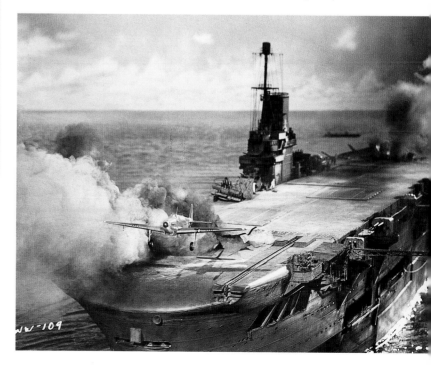

NW-109

In the 1950s television caused cinema attendances to plummet to an all-time low.

small independent production company. Hollywood had lost the guaranteed outlet for its films – good or bad.

In response to the competition from television, Hollywood decided it could still bank on the fundamental differences between movies and television, and win back audiences with innovation and technology. It began with the quality of the image. The small television screen provided a fuzzy black-and-white picture of variable quality. The big movie screen could dazzle, with enhanced images – huge, sharp and colourful.

The availability of good, economical colour systems, such as Eastman Kodak's single-strip Eastmancolor process, effectively ended Technicolor's market monopoly in the early 50s. In their attempt to outshine television, the studios splashed colour into the majority of their films, although many directors and stars objected to its use for artistic reasons. Later, it became evident that colour made little difference to the commercial success of most films, and after the initial surge, the proportion of films made in colour declined to around fifty per cent from the middle of the decade. Ironically, the number of colour films did not increase significantly again until the mid-1960s, when the TV networks switched to colour broadcasting, and films made in colour became worth more when sold for broadcast.

Efforts were also made to improve the size and quality of the image. In 1952, Cinerama was introduced: a widescreen projection method using three synchronized projectors to produce an exceptionally wide image and multi-track stereo sound. Spectacular though it was, Cinerama nevertheless caused more problems than it solved, since it required theatres,

Television took hold quickly. For the many families who moved away from city centres into post-war America's mushrooming suburbs, TV provided a cheap and accessible form of entertainment in their new homes.

The massive rise in American television ownership terrified the Hollywood film studios. With free viewing available in their living rooms, families didn't need to face the inconvenience and expense of travelling to city centre theatres for their entertainment. For the first time in its history, Hollywood's position as the foremost provider of the nation's entertainment was seriously challenged; average weekly attendances at movie theatres plummeted from around 90 million in 1948 to just 51 million in 1952.

But Hollywood's troubles did not end there. In the 1930s the trading practices of the studios had been placed under the scrutiny of a Federal anti-trust investigation. In 1948 the Supreme Court ruled that ownership of both the means of film production (the studio) and the means of distribution (the film theatre) was monopolistic. The studios were forced to separate their production and exhibition activities by selling off their theatre chains. As a result, the newly independent theatre chains could now show films made by any producer – be it major Hollywood studio or

A poster for The Robe (1953), the first film made in CinemaScope.

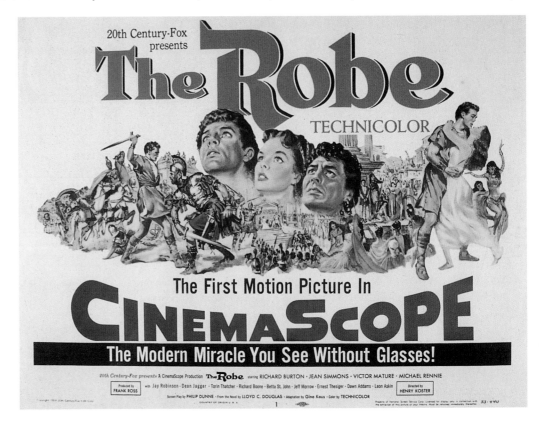

which were already desperate to cut costs, to invest in additional screens, projectors and projection staff.

CinemaScope was a more successful widescreen process, which used an anamorphic lens that squeezed wide images on to film during photography and unsqueezed them during projection. The only investment required by theatres was the new lenses, which could be fitted to their existing projectors. Fox pioneered the process and unveiled it spectacularly with *The Robe* in 1953. Within a year, every major studio – except for Paramount (which used its own VistaVision process) and RKO (which used SuperScope) – had adopted CinemaScope. By 1957, eighty-five per cent of the movie theatres in the USA were equipped to show films in 'Scope'.

The other major attraction of the 1950s was pure gimmickry. Persuading itself that 3-D films might be the industry's saviour, Hollywood forced its new perspective on all kinds of film, from musicals (*Kiss Me Kate*, 1953) to thrillers (*Dial M for Murder*, 1954),

3-D films such as The House of Wax *(1953) were initially popular, but audiences soon tired of the gimmick.*

and from horror films (*House of Wax*, 1953) to Westerns (*Hondo*, 1953). However, despite early successes, audiences disliked wearing

Science-fiction movies such as George Pal's The War of the Worlds *(1953) did much to encourage younger audiences back to the cinema.*

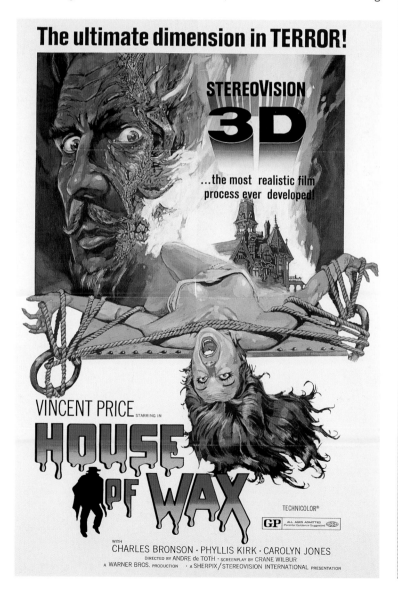

The ultimate dimension in TERROR!

STEREOVISION
3D
...the most realistic film process ever developed!

VINCENT PRICE STARRING IN
HOUSE OF WAX

TECHNICOLOR®

GP ALL AGES ADMITTED
Parental Guidance Suggested

WITH
CHARLES BRONSON · PHYLLIS KIRK · CAROLYN JONES
DIRECTED BY ANDRE de TOTH · SCREENPLAY BY CRANE WILBUR
A WARNER BROS. PRODUCTION · A SHERPIX/STEREOVISION INTERNATIONAL PRESENTATION

the special glasses that the process required, and quickly tired of it. Within eighteen months of its much-touted launch, the craze had sunk almost without trace.

Studios tinkered with more than image quality. As families sat at home watching Lucille Ball and Jackie Gleason on television, movie audience demographics changed. The movie theatre was now the darkened haunt of teenagers and young couples, glad to slip away from their parents. Drive-in theatres sprang up in response to the post-war boom in car sales and the rise of suburbanization. By 1956 the United States had over four thousand of these out-of-town sites, and at their height, more people sat in cars to watch a movie than in the traditional theatres. Despite their popularity, however, the drive-ins did little to stop the overall decline in film-going.

Pulp science fiction and comics had become hugely popular since the 1940s, but the Hollywood majors had hardly explored the sci-fi genre, considering it the fodder of cheap serials and B-movies produced by the Poverty Row studios. But the popularity of sci-fi literature and movie serials among young people – now the front row of film audiences – made it appear a safe bet for greater investment.

Destination Moon (1950) was the first major sci-fi film of the decade. Produced by George Pal, who was to create several of the decade's most significant science-fiction films, *Destination Moon* was a critical and commercial success, and sparked a meteor shower of similar movies. The fears of the 50s – atomic annihilation and Communist invasion – were echoed in tales of aliens visiting Earth intent on domination and destruction.

From the middle of the decade, a rash of films offered variations on sci-fi themes, and all kinds of aliens were seen to be populating

the planet. These included beasts forgotten by time (*The Creature from the Black Lagoon*, 1954), angry monsters stirred from the deep by atomic explosions (*The Beast from 20,000 Fathoms*, 1953), creatures mutated by atomic experiments (*Them!*, 1954), people whose bodies had been invaded by aliens (*Invasion of the Body Snatchers*, 1956) and people harmed by modern science (*The Fly*, 1958).

All of this meant plenty of work for Hollywood's special effects departments. Modelmakers were kept busy fashioning spacecraft, often in the now classic flying saucer design – though there were notable exceptions, such as the sleek manta-like ships of the decade's most memorable science-fiction film, *The War of the Worlds* (1953). Many science-fiction movies of the 1950s were produced on tiny budgets by independent producers, such as the cinematically challenged director Edward D. Wood, whose weird, wired and wobbly efforts in films such as *Plan 9 from Outer Space* (1959) and *Night of the Ghouls* (1960) have become classics in their own right.

Aliens and monsters of the 50s were generally men in rubber suits, with little subtlety of movement or performance. Perhaps the most famous was that which emerged from the infamous Black Lagoon – a wholly typical creation that required stuntman Ricou Browning to flail around in a rubber suit of half monkey and half lizard design. A number of entirely mechanical creatures also appeared, however, including a crude but effective ant in *Them!*, the popular Robby the Robot in *Forbidden Planet* (1956), and most spectacularly of all, the mechanical giant squid that surfaced in Disney's *20,000 Leagues Under the Sea* (1954).

There were some important effects innovations during the decade. In Britain, the Rank Organisation pioneered a superior new travelling matte system using sodium vapour lighting (50>), which would later be adopted and developed by Disney. There were also mechanical inventions, such as a crude but effective motion-control system (118>) called a 'repeater', developed at Paramount. This device recorded camera motion so that shots of separate elements, such as models and live action, could be taken with the same camera movements, enabling them to be combined effectively.

The decade also saw the rise of the only effects artist ever to become a household name. Gaining attention with the stop-motion ape in *Mighty Joe Young* (1949), Ray Harryhausen (153>) continued to produce spectacular animated creatures for a series of 'monster on the rampage' films, including *It Came from Beneath the Sea* (1955) and *Twenty Million Miles to Earth* (1957). Harryhausen ended the decade with the first of a series of spectacular mythical fantasies: *The 7th Voyage of Sinbad* (1959). To produce the Arabian Nights adventure, Harryhausen used perspective tricks (92>), split screens (54>), over- and undersized props, mattes (44>) and stop-motion animation (150>) of a complexity not seen before.

Hollywood ended the 50s in a beleaguered and somewhat bewildered state, unsure of how to prevent its previously unchallenged dominance from slipping further from its grasp. The good times were a fast-fading memory as Tinseltown dug in to prepare for whatever the 1960s might bring.

GEORGE PAL

Actor Russ Tamblyn sits on producer George Pal's shoulders in this publicity still from Tom Thumb *(1958).*

Although many film makers ventured into the realms of science fiction during the 1950s, few of them produced so consistent and successful a body of work as George Pal (1908–1980). After training as an architect at the Budapest Academy of Arts, Hungarian-born Pal began his film career as an animator in Budapest before working as a set designer for Germany's renowned UFA Studios in Berlin. The rise of Hitler prompted Pal to move to Paris, where he established a successful animation business, until forced to move once more by the spectre of German invasion.

In the United States Pal secured a contract to produce a series of animated puppet films called 'Pal's Puppetoons'. Following their success, Pal secured finance for his first feature film, *Destination Moon* (1950). This most notably simulated the launch of man's first flight to the moon with the clever intercutting of a model spaceship and a full-size version 150 feet in height. Pal gave his first film the high production values that would come to distinguish all of his features – in this case, hiring German rocket scientist Hermann Oberth to ensure the film would be scientifically accurate. As producer – and in later films director – Pal's use of special effects was typically restrained; he recognized when it was best to allow character and dialogue to tell a story, and when to rely on special effects and action.

Pal's later productions contained less science and more fantasy, but his commitment to detail, high production values and judicious use of special effects ensured that his films – particularly the spectacular science-fiction romps, such as *When Worlds Collide* (1951) and *The War of the Worlds* (1953) – were among the most popular and critically acclaimed of the period.

THE 1960s

Rear-projected cars chase secret agent '007' (Sean Connery) in Dr No (1962), the first of the James Bond films.

decade included *Planet of the Apes* (1968) – an impressive film, pointing towards the maturity of science-fiction cinema. The superbly expressive ape make-up allowed for subtle and believable performances that no 50s creature could have achieved.

Continuing the theme of excess, movies in general became increasingly fast-paced, action-packed and violent. The beginning of the decade saw audiences shocked by the graphic horror of *Psycho* (1960). The 1962 release of the first James Bond film, *Dr No*, delighted large audiences with a new style of flamboyant machismo action. Soon the limits of on-screen violence were being extended, as audiences responded positively to faster chases, fiercer fights and bigger explosions in films such as *A Fistful of Dollars* (1964) and *Bonnie and Clyde* (1967). The 'bigger is better' ethos continued with war films such as *The Great Escape* (1963), whose makers crashed real planes instead of models. *The Hellfighters* (1968), an oil-fire drama, capitalized on audiences' love of explosions by setting the entire film against a backdrop of blazing oil rigs. Even comedy had to be of epic proportions – *It's a Mad Mad Mad Mad World* (1963) combined an all-star cast with over three hours of increasingly slapstick comedy, frenetic chases and big explosions.

Fantastic Voyage (1966) captured the public's imagination with its action set inside the human body.

Hollywood entered the 1960s with trepidation. Film audiences around the world had dwindled by millions, and once-profitable theatres were closing by the thousand. Still struggling to win back audiences from television, studios continued to produce a broad range of mainstream genre films. With the persistent conviction that size was the one attribute they could offer that television could not, the studios embarked on the production of a number of spectacular historical epics, where scale was everything. Films such as *Spartacus* (1960), *Exodus* (1960), *El Cid* (1961), *Mutiny on the Bounty* (1963) and *The Greatest Story Ever Told* (1965) hyped their casts of thousands and enormous sets.

Perhaps the most excessive example was Twentieth Century Fox's production of *Cleopatra* (1963), which reputedly spent $6,500 on a crown of real gold and employed ten thousand extras in period costume. Cleopatra's capital, Alexandria, was rebuilt as a twenty-acre set of huge palaces and temples; the twelve-acre reconstruction of Rome's forum was bigger than the original; and Cleopatra's barge was a full-scale floating vessel built at the cost of $250,000. The finished film cost an unprecedented $37 million, and its dramatic failure at the box office almost bankrupted Fox.

However, Fox got rich again with their version of Rodgers and Hammerstein's *The Sound of Music* (1965), which became the most successful film in history and helped to underwrite the continuing policy of lavishly adapting successful stage musicals, plays and classic stories. Fox also profited from *Fantastic Voyage* (1966), a tremendously entertaining science-fiction adventure, which reconstructed the organs of the human body as enormous sets in which wire-suspended actors floated around. Other sci-fi successes of the

ROGER CORMAN

When the studios were at their most vulnerable, one director found a way to make a profit, becoming one of the most prolific and commercially successful film makers in Hollywood history. Roger Corman (1926–) began working in the movie industry as a messenger boy at Twentieth Century Fox, before finding work as a story analyst and scriptwriter. Frustrated by studio interference during the shooting of his first script, *Highway Dragnet* (1954), Corman decided to form his own company to shoot his next script, *The Monster from the Ocean Floor* (1954).

By the time he directed his own first feature, *Apache Woman* (1955), the Corman formula was in place. His productions were invariably characterized by offbeat plots and quirky characters. They were made at lightning speed (sometimes in under a week) on minuscule budgets, and employed largely untried performers and young crews.

Although Corman's science-fiction films and creature features cried out for lavish special effects, budgets dictated otherwise. Effects were generally limited to the simplest physical or mechanical methods – avoiding the use of costly post-production processes. Occasionally budgets stretched to elaborate monsters, such as the 4.5m (15ft) crustacean that sidled into *The Attack of the Crab Monsters* (1957) to snap up $1200 of the $70,000 budget. More often, budgetary constraints meant that alien invaders would be no more than actors wearing special contact lenses, as in *Not of this Earth* (1957).

The 50s fare of monsters and aliens gave way to slightly more sophisticated horror in the following decade. Corman's Edgar Allan Poe adaptations had time and money 'lavished' on them – they could be in production for as long as three weeks. Despite their almost crippling constraints, however, some have become classics of film horror.

Corman has made over two hundred films to date, and has prospered in one of the toughest industries in the world. He has earned great respect in Hollywood – not only for his ability to produce profitable films for less than the catering bill of the average blockbuster, but also for the start he has given to many ambitious youngsters, including Martin Scorsese, Francis Ford Coppola, James Cameron, Joe Dante, Jonathan Demme, Penelope Spheris, Robert De Niro and Jack Nicholson.

A full-sized racing car is fired into Monaco harbour for Grand Prix (1966).

The 60s hunger for the spectacular had little use for the traditional skills of Hollywood's special effects departments. Where biblical cities might once have been rendered by the matte artist or the modelmaker, 60s epics had to have reality. Planes crashing into trees were full-scale aircraft flown by living pilots, and real racing cars were fired from pneumatic cannons to create spectacular crashes (*Grand Prix*, 1966). The predominance of such extravagant physical effects and the increasing reliance on location shooting – diminishing the need for rear projection or travelling matte effects – reduced many special effects departments to workshops for producing mundane optical effects and titles.

Hollywood had started to streamline operations in the late 1940s. The severe financial difficulties faced in the 60s, combined with the new policy of distributing more independent films (by the early 60s two-thirds of films distributed by the majors were independently

2001: A Space Odyssey, with its balletic space stations soaring to the music of Strauss, challenged everyone's concept of space travel, and made the real moon landing of the following year seem something of an anti-climax. For Kubrick, realism was the key, and his quest to make the film the most visually arresting portrayal of man in space led to an obsession with the quality of his special effects. The production of *2001* was also responsible for the only major effects technology developments of the decade. Rear projection was not effective enough for Kubrick's vision, and so the relatively untried process of front projection, which offered the potential of much bigger, brighter and clearer background images behind actors, was developed and used for the first time in a feature film (69>). A new process of mechanically repeatable camera control, the forerunner of modern motion control (118>), was also developed for the photography of the film's enormous model spacecraft. The most visually striking of the film's innovations was the now legendary 'Stargate' sequence, produced using an inventive animation method dubbed 'slit scan' (145>).

Audiences had never seen anything like it, and it seemed as if the success of *2001* might make the studios regret the closure of their special effects departments.

2001: A Space Odyssey *(1968) established a new benchmark in special effects photography.*

produced), increased the drive to downsize facilities and reduce overheads. In the climate of the 1960s, the effects departments became a costly burden that studios no longer wanted to bear.

By the end of the decade, only Disney maintained a full-time effects department to service its range of fantasy-based family entertainment films, such as *The Nutty Professor* (1963) and *Mary Poppins* (1964). Elsewhere, a generation of artists left their departments. Some discovered a life outside the studios and set up their own small companies to service independent productions. Many, reaching the end of their working lives, chose to retire for good. The accumulated skills of more than a quarter of a century were discarded in order to save a few dollars, and like silent stars faded by the blare of the talkies, special effects were reduced to bit-parts.

But in 1968, a film of unprecedented visual impact, drawing on the most astonishing special effects yet seen, was released to critical bewilderment and impressive box-office business. Stanley Kubrick's

Studying film at the University of Southern California, George Lucas (1944–) made a twenty-minute dystopic vision of the future, which – with the backing of his friend Francis Ford Coppola (1939–) – he later developed into a feature film. *THX 1138* (1971) was a stark, intelligent science-fiction film that gained cult status and earned Lucas the mantle of an 'intellectual' film maker. He surprised everyone with *American Graffiti* (1973), a semi-autobiographical film crystallizing teenage life on one night in 1962. Made for a pittance, it took a fortune at the box office, becoming one of the most profitable films of the decade. The success of Lucas's next project, *Star Wars* (1977), is legendary, and – together with Spielberg's *Close Encounters of the Third Kind* (1977) – resurrected the big-budget sci-fi/fantasy movie and ushered in the age of special effects on the grand scale.

To furnish the effects for *Star Wars*, Lucas created his own facility, Industrial Light and Magic (ILM) – a company that would become an industry byword for innovation and quality. ILM has since contributed many of the most memorable special effects to modern films, and earned dozens of Academy Awards for its extraordinary work. Lucas himself, with his Lucasfilm organization, has played a key role in the development of digital visual effects (185>), editing and sound technology (278>).

Making *Star Wars* was such an ordeal for Lucas that on future projects he gave up the director's chair for the role of creative producer, becoming the architect of massive commercial success with the *Star Wars* sequels (1980, 1983) and the *Indiana Jones* trilogy (1981, 1984, 1989). Indiana Jones was revived in the popular *Young Indiana Jones Chronicles* TV series (1991), which pioneered the use of digital visual effects in television production. Despite immense successes, there have been occasional failures for Lucas, including *Willow* (1988), *Tucker: The Man and His Dream* (1988) and *Howard the Duck* (1986).

Unlike George Lucas, Steven Spielberg (1946–) had no formal training, learning his craft and polishing a natural talent for film making with a series of childhood home movies. His college film *Amblin'* (1969) won critical praise and, more importantly, a contract to direct at Universal. After a number of television assignments, including episodes of *Night Gallery* (1969, 1971) and *Columbo* (1971), the apprentice film maker moved up the ladder

George Lucas (left) and Steven Spielberg (right) on the set of Indiana Jones and the Temple of Doom (1984).

to TV movies. The popularity of *Duel* (1971), in which a lone driver is pursued relentlessly by a mysterious, menacing truck, earned Spielberg the opportunity to direct his first theatrical film, *The Sugarland Express* (1974). Though it was not a commercial success, his future was assured. By the time it was released, he was already directing *Jaws* (1975).

The worldwide popularity of *Jaws*, and then *Close Encounters*, was not matched by Spielberg's rip-roaring misfire *1941* (1979), though what the film lacked in dramatic subtlety it compensated for in exquisite miniature work. However, the first collaboration between Spielberg and Lucas, *Raiders of the Lost Ark* (1981), was a barnstorming success that demonstrated the value of fantasy combined with dazzling special effects in the creation of earthbound historical adventures.

The 80s were a golden time for Spielberg. In addition to his own directorial projects, he mined an endless seam of popular movies produced by his company Amblin Entertainment. *Gremlins* (1984), *The Goonies* (1985), *Back to the Future* (1985), *Innerspace* (1987) and *Who Framed Roger Rabbit* (1988) were just some of the films that emerged. All were immense hits, and all were heavily reliant on the visual treats created by ILM.

More than any others, George Lucas and Steven Spielberg were responsible for the rejuvenation – some would say juvenilization – of cinema in the 1980s. They made films with an emphasis on throwaway stories and visual spectacle. The special effects in their films demanded groundbreaking technical developments that would benefit the entire industry.

THE 1990s

By the centenary of its birth in 1995, the American film industry had developed into an efficient money-making machine – and the country's most profitable export. The cost of making movies continued to mushroom, and by the middle of the decade, the average studio film cost $50 million to produce, and the big seasonal blockbusters considerably more. By their very nature, blockbusters must surpass whatever has gone before if they are to attract a large audience; the concepts must be more outrageous and the special effects more stunning. In an attempt to limit the risks involved in investing so much money in a single movie, studios came to rely heavily on sequels. In a notoriously unpredictable business, the sequel's potential for success seemed marginally more predictable.

The 1990s also witnessed the resurgence of the feature-length animation movie. Disney followed its smash-hit *The Little Mermaid* (1989) with *Beauty and the Beast* (1991), which was an even greater box-office success and became the first animated feature film to be nominated for a Best Picture Academy Award. Other major studios, including Twentieth Century Fox, Warner Brothers and the newly created DreamWorks

Terminator 2: Judgment Day (1991) extended the possibilities of digital effects.

SKG, developed their own feature animation programmes, banking on a share of Disney's box-office magic.

The profits from animated features can be enormous, even though the majority of tickets sold are for low-priced children's seats. Box-office success is just one part of the money-making equation, however, and Disney – more than any other studio – became supremely accomplished at extending the commercial value of its films by licensing its animated characters for use in every imaginable consumer product, from toys and books to clothing and computer games.

In the realm of special effects, the early 1990s saw a monumental breakthrough in digital imaging. Although generating original imagery with a computer had become faster and easier by this time, such images still had to be manipulated and incorporated into film footage using traditional optical techniques. However, the development of fast and reliable scanning and recording technology (74>) at the beginning of the decade allowed film images to be converted to the digital medium, manipulated within a computer and recorded back on to film for exhibition. The ability to get film in and out of the digital realm with no loss of quality opened the floodgates for Hollywood's digital revolution.

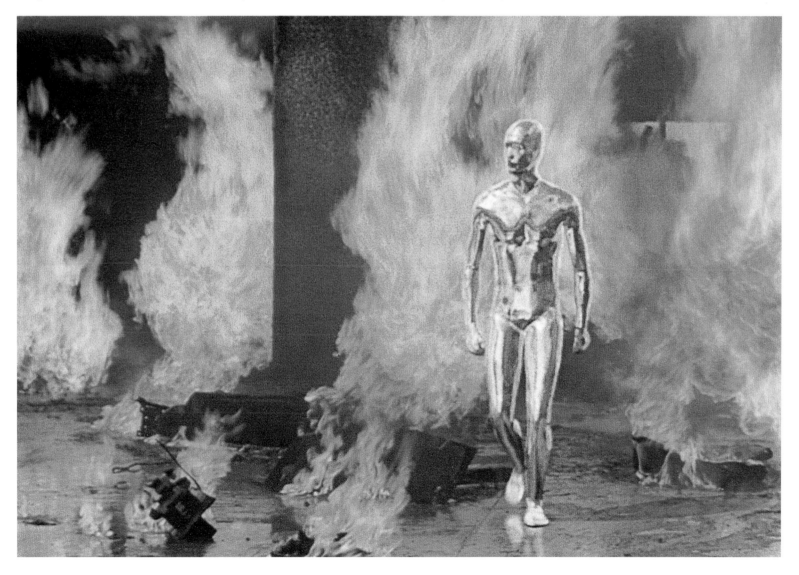

James Cameron (1954–) began his film career working for Roger Corman (<28) as art director, miniature set builder and rear-screen photography supervisor for *Battle Beyond the Stars* (1980).

Cameron made his directorial debut in 1981 with *Piranha II: The Flying Killers*, which he co-wrote. The film barely betrayed the talent of its director, but did signal Cameron's interest in science fiction and special effects, which materialized three years later in *The Terminator* (1984), an exciting and inventive science-fiction thriller that was the first of several collaborations with action star Arnold Schwarzenegger.

Aliens (1986) saw Cameron using striking visuals and Oscar-winning special effects to create a landmark in science-fiction action films. *The Abyss* (1989) was a critical and commercial disappointment, but featured some groundbreaking computer-generated effects that helped to assure the future of digital imagery in film making and won Industrial Light and Magic an Oscar for its work on the film.

Terminator 2: Judgment Day (1991) relied on the computer-generated wonders of ILM to provide one of its key characters – a shape-shifting cyborg that could assume any form or texture that it wished. The stories that Cameron wanted to tell had become so reliant on cutting-edge special effects technology that, after making *Terminator 2*, he established his own special effects facility, Digital Domain.

True Lies (1994) saw the director's first foray into real-world action adventure, and the use of digital effects to create naturalistic environments and events – perhaps a rehearsal for his epic *Titanic* (1997), which became the first film to pass the $1 billion figure at the box office. With *Titanic*, Cameron showed that digital effects could be equally effective at conjuring historical eras as they were at creating futuristic ones. Cameron directed *Terminator 2 3-D* in 1999, a theme park attraction based on the movie.

Perhaps more than any other film maker of the 1990s, Cameron had the imagination and ambition to harness the potential of both traditional and cutting-edge special effects techniques.

The hugely successful Jurassic Park *(1993) awed audiences with its magnificently realistic computer-generated dinosaurs.*

James Cameron's *Terminator 2: Judgment Day* (1991) offered stunning, digitally created characters that performed feats impossible to achieve in the physical world. Audiences were amazed by a liquid-metal character that could turn into any other object. *Jurassic Park* (1993), which used computers to produce amazingly lifelike images of extinct dinosaurs, took digital imaging to a new level of sophistication and became the highest grossing film in history.

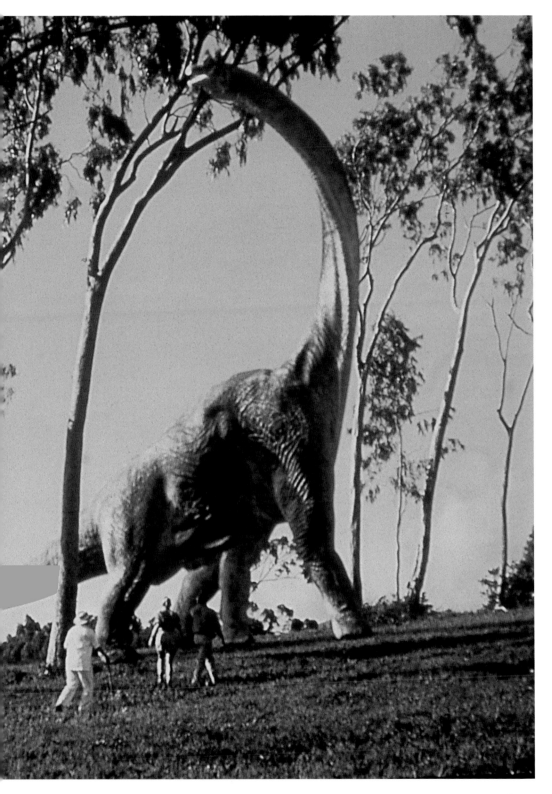

Toy Story (1995) became the first entirely computer-generated feature film. Its stunning images, appealing characters and compelling storyline ensured that it was a huge hit. Several wholly computer-generated films followed, including Disney's *A Bug's Life* (1998) and Dream-Works' *Antz* (1998). The all-digital film is now set to become a regular offering of the future.

As the decade progressed, digital technology, once the preserve of big-budget movies, quickly became affordable and available to even the most modest productions. Crowds could be replicated, removing the need for hundreds of extras in expensive costumes. Physical effects were made practical and safe because safety wires used to protect actors during filming could easily be digitally removed. Futuristic or historical locations could be conjured up with the minimal use of sets and locations. Directors could make grass greener and skies bluer at the touch of a button. The most glaring on-set errors could be corrected during post-production, to the extent that effects artists commonly complained that careless filming methods were causing unnecessary digital work at a later stage of production.

At the end of the century, George Lucas released *Star Wars Episode One: The Phantom Menace* (1999), the long-awaited addition to the *Star Wars* saga, which had sparked a big bang in special effects twenty years before. Taking advantage of the progress in digital effects technologies that had developed largely as a result of his earlier successes, Lucas produced a landmark movie in which otherworldly locations and fully interactive characters were created almost entirely within the com-

The film confirmed that digital effects were the way of the future. Almost overnight, machinery and skills that had been in use in the movie effects industry for over half a century became outmoded. Special effects facilities scrambled to recruit people who had never touched a frame of film in their life, but who could operate computers and write programming code. Producers were impressed by the capabilities of the new technology, and scripts whose impossible scenarios had made them unfeasible in the past were quickly dusted off and put into production.

puter. For the first time in the one-hundred-year history of the cinema, a film maker was able to put literally anything that they could imagine on screen.

Whether or not digital technology has enhanced the art of film making is open to question, but there can be no doubt that, with access to such tools, directors now have the means, more than ever before, to produce the film that they have conceived in their mind's eye. Given a computer and some powerful software, one can only imagine what wonders George Méliès might have produced.

OPTICAL ILLUSIONS

MOVING PICTURES HAD BARELY BEEN INVENTED WHEN ENTERPRISING FILM MAKERS BEGAN TO EXPERIMENT WITH THE UNIQUE PROPERTIES OF MOTION PICTURE PHOTOGRAPHY TO CONJURE NEW AND SOMETIMES FANTASTIC IMAGES. AT THE HEART OF MOST CINEMATIC EXPERIMENTS WAS THE SELECTIVE COMBINATION, ON A SINGLE PIECE OF FILM, OF SEVERAL IMAGES FILMED AT DIFFERENT TIMES AND PLACES. THE EARLIEST METHOD OF COMBINING IMAGES IN THIS WAY WAS THE SIMPLE DOUBLE EXPOSURE, IN WHICH ONE PART OF THE IMAGE WAS FILMED IN ONE TAKE AND THE REST CAPTURED IN A SECOND. FILM MAKERS HAD SEVERAL REASONS FOR WISHING TO TRANSFORM REALITY. THE MOTIVATION WAS PARTLY PRACTICAL — AN IMAGE OF ACTORS FILMED IN THE STUDIO COMBINED WITH ONE OF THE PYRAMIDS ALLEVIATED THE NEED FOR A TIME-CONSUMING TRIP TO EGYPT. COST FACTORS ALSO PLAYED THEIR PART; IF MODELS COULD BE FILMED AND COMBINED WITH LIVE ACTION THEN THE COST OF BUILDING LARGE AND EXPENSIVE SETS COULD BE AVOIDED. AND THERE WERE ARTISTIC REASONS, TOO — THE ILLUSION OF FANTASTIC AND OTHERWISE IMPOSSIBLE EVENTS COULD BE ACHIEVED THROUGH THE MANIPULATION OF SEVERAL REALISTIC ELEMENTS.

The Panavision Millennium camera, one of the most sophisticated 35mm cameras in the world.

EARLY METHODS OF IMAGE COMBINATION WERE CRUDE BUT, AS THE CENTURY PROGRESSED, FILM MAKERS BEGAN TO DEVELOP MORE SOPHISTICATED TECHNIQUES THAT TOOK ADVANTAGE OF THE OPTICAL AND PHOTOCHEMICAL PRINCIPLES OF FILM ITSELF. LIGHT, LENSES, FILTERS AND FILM WERE ALL INVESTIGATED TO ENABLE NEW FORMS OF PHOTOGRAPHIC ALCHEMY.

THIS CHAPTER EXPLORES THE BASIC PRINCIPLES OF MOTION PICTURE PHOTOGRAPHY BEFORE EXAMINING IN DEPTH THE IMAGE MANIPULATION PROCESSES THAT HAVE BEEN USED OVER THE LAST HUNDRED YEARS, FROM THE EARLIEST OPTICAL METHODS TO TODAY'S DIGITAL TECHNIQUES.

THE CAMERA

Despite its complex engineering and precision mechanisms, the movie camera is, in principle, a relatively simple device. The camera holds a detachable magazine (fig. 1 (a)) that contains two lightproof chambers. During photography, unexposed film leaves the first chamber, travels through the camera for exposure and is fed into the second chamber, where it is stored until being removed for processing.

Film travels through the camera at a continuous rate – in the case of normal sound photography, at twenty-four frames per second. As the film approaches the gate where it will be exposed to light (b), a claw mechanism (c) engages the film's sprocket holes. The mechanism holds each frame motionless in the gate for exposure before pulling the next frame into place.

during exposure. Without such a device, images exposed on the film would move slightly from frame to frame, causing 'image weave' when projected on to a screen. While a small degree of image weave is acceptable when watching a film, it cannot be tolerated in any shot that is to become part of a special effects sequence. Effects procedures require the precise placing of images on film so that multiple elements can be combined effectively to achieve the desired result. To register film in the gate, cameras used in special effects production feature a system of 'pilot pins' that slot into the sprocket holes of each frame of film and hold the film absolutely steady during exposure. Cameras with this feature are known as process cameras.

Once developed, film is displayed on a screen using a projector – essentially a camera in reverse. Rather than outside light entering the device through the lens, light is generated within the machine and channelled out through the lens. The light first passes through the film, where it picks up an image, and is then focused by the lens on a distant screen.

Like cameras, projectors also have a rotating shutter. Although pictures recorded at twenty-four frames per second are sufficient to establish the illusion of smooth movement, they have a noticeable 'flickering' effect when projected. It is a feature of human vision that the faster the flickers occur, the less we perceive them. To present apparently flicker-free pictures, the shutter actually closes once during the projection of each frame of film so that we are presented with forty-eight images a second.

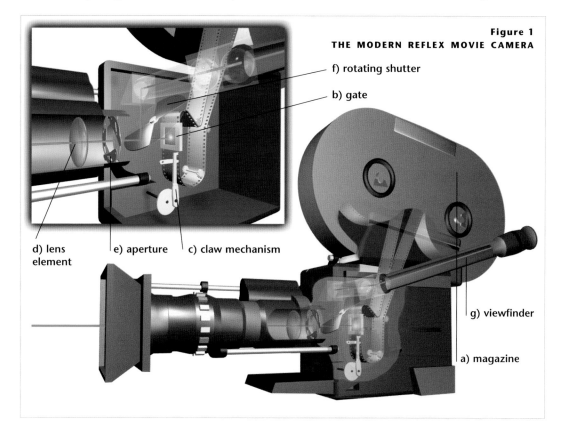

Figure 1
THE MODERN REFLEX MOVIE CAMERA

f) rotating shutter

b) gate

d) lens element

e) aperture

c) claw mechanism

g) viewfinder

a) magazine

The lens

The most important component of any camera is its lens. The purpose of the lens is to collect all the lightwaves emanating from a single point on the subject matter and to make them converge on to a single point on the film. Different coloured lightwaves do not focus at the same point if channelled through a single lens element, however, so several lens elements with different properties are combined to ensure that the image is focused correctly on the film. These glass elements are arranged in a lens barrel, which, when turned, moves the elements towards or away from the film, allowing the image to be focused correctly. The lens barrel also contains an adjustable diaphragm, or aperture, that can be opened and closed to control the amount of light reaching the film.

Film is exposed to light that has been gathered and focused by a lens (d), which is attached to the front of the camera. An adjustable diaphragm, or aperture (e), can be opened or closed to admit varying amounts of light through to the gate. The camera's shutter (f) is a continually revolving disc with gaps in it that can be made larger or smaller. The width of the gaps determines the length of time that the film is exposed to light coming through the aperture. While the film is held in the gate, the revolving shutter opens to let light on to the film. As the shutter closes, the film is moved on. While the next unexposed frame is being moved into the gate, the closed shutter's mirrored surface reflects light into the camera's viewfinder (g), enabling the camera operator to see the image being photographed.

All cameras employ mechanical methods to ensure that each frame of film is correctly positioned, or 'registered', in the gate

Lenses are generally classified according to their focal length – that is, the distance between the optical centre of the lens, where all incoming light converges, and the film plane (fig. 2). A wide-angle

THE TROMBONE SHOT

Alfred Hitchcock (<23) made startling use of the optical principles of lenses during the

James Stewart in the bell tower shot from Vertigo (1958).

making of his psychological thriller *Vertigo* (1958). The film maker wanted to give visual expression to the psychological feeling of vertigo when actor James Stewart peered down the stairwell of a high bell tower.

Knowing that depth perception changes with the focal length of a lens (see main text), Hitchcock set up a track with a camera and zoom lens at one end, and a large model of the stairwell laid on its side at the other end. Looking towards the distant stairwell, the camera's lens was zoomed in so that the model filled the whole frame. During filming, the camera was rapidly tracked towards the model and the lens zoomed out correspondingly. Although the camera got nearer to the model, zooming out meant that the stairwell actually appeared to stay the same size.

The resulting footage showed a stairwell that remained the same size in the frame while its depth perception appeared to radically increase. The shot is astonishingly effective in simulating the psychological point of view of a vertigo sufferer. Much to Hitchcock's annoyance, this technique, subsequently dubbed the 'trombone shot' (fig. 3), was later stylishly borrowed by Steven Spielberg for a shot of Roy Scheider during a shark attack in *Jaws* (1975) and has since become a cliché of horror films and television commercials.

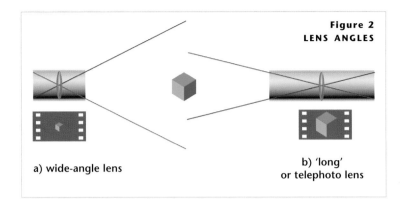

Figure 2
LENS ANGLES

a) wide-angle lens

b) 'long' or telephoto lens

lens with a focal length of 28mm has its optical centre very near to the film plane, and is able to photograph objects from a wide area around the camera, making it ideal for photography in confined spaces. A long, or telephoto, lens with a focal length of 125mm has its optical centre further from the film plane. It has a narrow field of view and will make objects that are in fact a great distance from the camera appear closer to it, making the telephoto lens suitable for filming distant wildlife, for example. In 35mm photography, a lens with a focal length of 50mm is considered normal, since the field of view in pictures taken with this lens approximates what can be seen by the human eye.

Focal length also affects the ability of a lens to keep subjects in focus. With a wide-angle lens, objects both close to and far from the camera remain in focus. With a long lens, only objects a small distance apart from each other remain in focus. The distance within which objects remain in sharp focus is known as depth of field, a phenomenon that is also influenced by the amount of light in a scene, the aperture of the diaphragm and the sensitivity of the film being used (91>).

The focal length of a lens also affects the depth perception of a shot. Where two objects are placed at varying distances from the camera, for instance, a wide-angle lens will exaggerate the space between them, while a long lens will make them appear to be closer to one another.

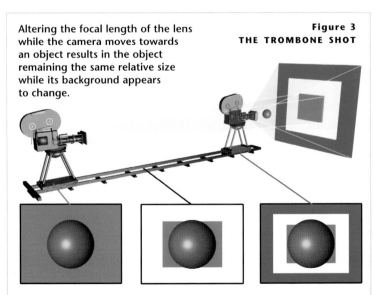

Altering the focal length of the lens while the camera moves towards an object results in the object remaining the same relative size while its background appears to change.

Figure 3
THE TROMBONE SHOT

Though most lenses used in motion picture photography are of a fixed focal length (known as 'prime' lenses), zoom lenses can also be used. The zoom lens has a variable focal length that can be altered during photography to make subjects that are a fixed distance from the camera appear to move nearer or further away. The distance between subject and camera does not have to change during a zoom, so it is not necessary to re-focus the lens during the movement, which would be the case were camera and subject to change their relative positions.

THE FILM

Film is the medium traditionally used to capture, store, manipulate and deliver motion picture images. It is a flexible strip of transparent cellulose acetate that is coated with a light-sensitive emulsion in which tiny crystals of silver halide are suspended in gelatin. Black-and-white film consists of one layer of light-sensitive emulsion; colour film consists of three layers, each one sensitive to a different colour – red, green or blue. When exposed to light, the silver halide crystals undergo a chemical change which makes them turn dark when the film is processed in the laboratory. Crystals not affected by light are washed away during processing to leave clear areas on the film. The result is a 'negative' image of the original scene.

In the case of black-and-white film, the negative is purely tonal – that is, a mixture of dark and clear areas, with light from a bright area of the subject affecting more silver halide crystals than light from a dark area. Colour negatives, on the other hand, record both tone and colour – red light affects the silver halide crystals in the red-sensitive layer of the film, green light affects the green-sensitive layer and blue light the blue-sensitive layer. During processing, a coloured dye forms where the silver halide crystals have been affected in each layer of the film, and the crystals are then bleached away. The dyes that form in each layer of the negative are in that layer's 'complementary' colour (44>) – that is, cyan dye forms in the red-sensitive layer, magenta dye in the green-sensitive layer and yellow dye in the blue-sensitive layer. When negatives are copied on to film or photographic paper to produce a 'positive' image, the dark areas on a black-and-white negative become light again, and light areas dark, and the dyes in the colour negative are reversed to their original colours.

The speed of film – that is, how much light it needs to record an image – is determined by the size of the silver halide crystals held in the emulsion. Slow films have small silver crystals, needing a large quantity of light to produce an image. The small crystals, however, produce a high-quality, fine-grained image. Fast films, on the other hand, will produce a picture in low light conditions, but the large silver crystals needed result in a much grainier image.

Duplication

At the heart of all optical special effects is the ability to copy images from one film to another. During the copying process, images can be manipulated in various ways – for example, to extract selected

Figure 4 FILM GENERATIONS

When films are copied from negatives or positives, they are named according to their place in the production chain. Each copy is known as a generation, and each generation can be given a number of names.

1 *Original camera negative*. The film that is held in the camera during photography and subsequently developed into a negative. Also called the *master negative*.

2 *Master positive*. First-generation copy of original negative. Such copies are used in the production of special effects where a positive image of the highest quality is required – for rear projection, for example. Also called the *interpositive*.

3 *Internegative*. Made from copying the master negative on to reversal film to produce another negative, or by copying the master positive on to negative film. Many additional positives can be struck from this film – edited release prints, for example. Also called an *interdupe* or *colour reversal intermediate*.

4 *Release print*. Thousands of release prints may be made of a film to be sent to cinemas around the world.

Figure 11 THE WILLIAMS PROCESS

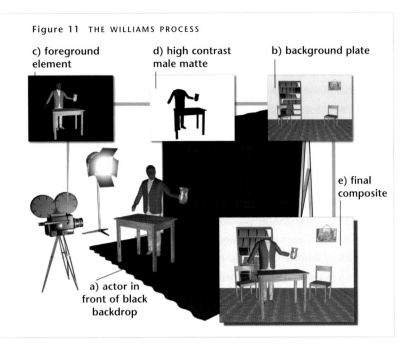

c) foreground element

d) high contrast male matte

b) background plate

e) final composite

a) actor in front of black backdrop

foreground action was to be combined was usually filmed in advance (b), so that directors and performers could refer to it in order to choreograph movement.

Once a shot of the foreground element against its black backdrop had been filmed (c), this was copied a number of times using high-contrast film, which turns variations of tone into either black or white. This produces a clear background with the black silhouette of the foreground element (d).

The film containing no image other than a black silhouette was then sandwiched, or 'bi-packed', with the film containing the desired background element, and contact-printed on to a new piece of film, thus producing an image of the correctly exposed background with an unexposed area at its centre. This piece of film, still undeveloped, was then bi-packed with the developed strip of film containing the correctly exposed image of the foreground element with an opaque

The Williams Process was used to combine foreground car with background train in Cecil B. De Mille's Manslaughter (1922). A black matte line can be seen around the woman's scarf.

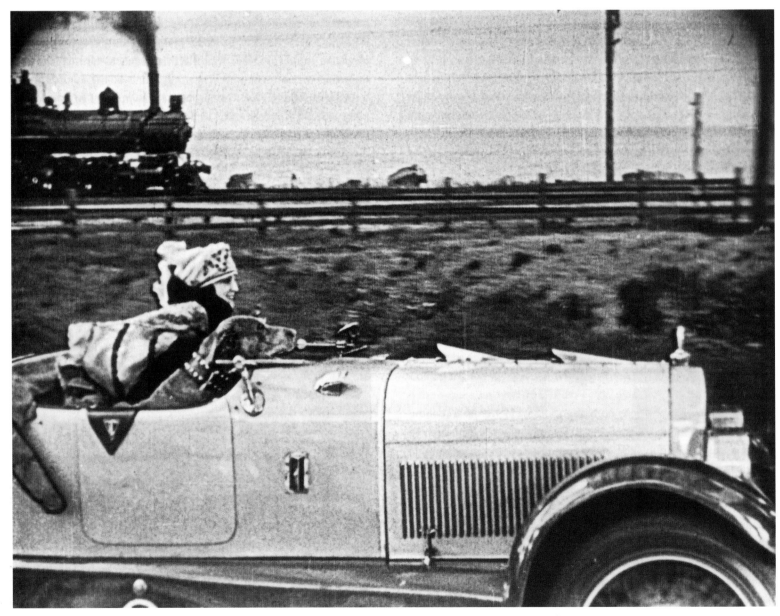

background. These two elements were run through the printer and re-exposed to light, thus printing the foreground element into its prepared hole (e). The developed piece of film combined foreground and background elements relatively satisfactorily – although it was not uncommon to see a telltale black outline (known as a 'minus' or 'matte line').

The Williams process was used in a number of films of the 1920s, becoming especially popular after it helped Rudolph Valentino to rescue Gloria Swanson from a perilous mountain-top situation in Famous Players Lasky's *Beyond the Rocks* (1922). It was also used to great effect in *The Lost World* (1925) and *Ben Hur* (1925).

Perhaps the most creative use of the technique was for James Whale's *The Invisible Man* (1933), for which John P. Fulton (see panel), head of Universal's special effects department, produced some extraordinary 'invisible' moments. Scenes in which the film's star is totally imperceptible were relatively simple to produce – his presence was indicated by using fine wires to manipulate scenery and objects as he apparently interacted with them. The problematic scenes were those in which the invisible man is seen to fill his otherwise empty clothes. To create the image of an empty set of apparel wandering about, Fulton and his team prepared a studio draped entirely with black velvet – a fabric often used in the film industry because it is the most light-absorbent of materials and reflects no highlights. The team then dressed a performer in the clothes worn by the invisible man, having first covered all areas of his body from head to toe in black velvet, including his head, where he had a suffocating headpiece, with no holes for eyes or mouth. Air was supplied to the actor through tubes fed up his trouser leg, further impeding his movement. Fulton and the actor rehearsed each shot for hours in order to find ways in which the character could move naturally without allowing a black-gloved hand to pass in front of any clothed area; any black areas would become see-through after going through the Williams process.

Producing these scenes was painfully slow. The actor could not see where he was going and could barely hear the directions bellowed by Fulton, who stood just yards away with a megaphone. If a shot was completed in twenty takes, Fulton considered it a triumph. But the finished result *was* a triumph. The foreground element of the actor in the suit was copied on to high-contrast film, enabling the removal of his black velvet-covered head, hands and neck. This allowed the foreground element of the mobile set of clothes to be combined with the desired location element. The technique was so successful that a number of sequels to the film were produced in which Fulton used increasingly elaborate 'invisible' effects. Even after the development of more satisfactory travelling matte techniques, the Williams process continued to be used in a number of 'invisibility' films, including *Topper* (1937) and its various sequels.

THE DUNNING–POMEROY SELF-MATTING PROCESS

The colour-matting method that first became widely used in Hollywood was the process pioneered by C. Dodge Dunning and

JOHN P. FULTON

John P. Fulton (1902–1965), son of scenic artist Fitch Fulton, who painted backdrops for movies such as *Gone with the Wind* (1939), became hooked on film making when, as a teenager, he watched D. W. Griffith (<16) directing. In the mid-20s, Fulton secured a job as an assistant cameraman, later graduating to cinematographer. After shooting *Hell's Harbour* (1929) and *Eyes of the World* (1930) for director Henry King (1888–1982), Fulton took a job in Frank Williams' optical laboratory, where he learned the art of 'trick' photography.

In 1930 Fulton became the head of Universal's special effects department, where he oversaw effects for the studio's series of classic horror movies – for which he is best remembered. A keen aviator, Fulton filmed all the aerial footage for *Air Mail* (1932) in his own plane before managing special effects production for the film, which made extensive use of model aircraft.

In 1945, Samuel Goldwyn (1882–1974) borrowed Fulton from Universal to produce the effects for the Danny Kaye film *Wonder Man* (1945). Kaye was so impressed with the effects enabling him to appear twice in one frame that he called Fulton the 'real star of the film'. Equally impressed was Goldwyn, who offered Fulton a contract with the promise of directing. Fulton never got his chance to direct a feature, although he did direct second-unit footage on several films, including *The Secret Life of Walter Mitty* (1947).

Fulton became the head of special effects at Paramount following the death of the previous head, Gordon Jennings, in 1953. Fulton's greatest achievement at Paramount was the effects for *The Ten Commandments* (1956), including the famous parting of the Red Sea sequence.

Fulton supervised some of the most important special effects photography in Hollywood history, and won Oscars for his work in *Wonder Man*, *The Bridges at Toko-Ri* (1954) and *The Ten Commandments*. He died in London in 1966 while preparing to film *The Battle of Britain* (1969).

later refined by Roy J. Pomeroy. The Dunning–Pomeroy process allowed actors to be filmed in the studio while their image was combined simultaneously with a previously filmed background plate without any additional photographic processes. The production of the necessary mattes and their combination to produce a final composite image was done entirely in-camera during studio photography.

The background scene was filmed and developed in the normal way, and then printed to produce a positive black-and-white image. This strip of film was then bleached in the silver areas (the exposed part of the image) and then submersed in a dye that turned the bleached areas a deep orange. The result was not a black-and-white image but an orange-and-white image (fig. 12 (a)).

The orange-and-white positive was bi-packed with ordinary unexposed black-and-white negative film in a camera capable of running two films

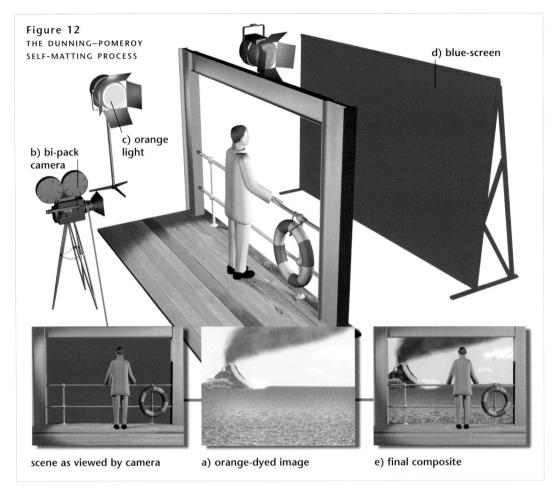

Figure 12
THE DUNNING–POMEROY SELF-MATTING PROCESS

b) bi-pack camera

c) orange light

d) blue-screen

scene as viewed by camera

a) orange-dyed image

e) final composite

together (b). When exposed, light would pass through the orange-and-white film before reaching the unexposed negative film behind it.

In the studio, the foreground was set up and its various elements – actors and props – were illuminated by orange light (c). Behind these bright orange foreground elements was placed a flat screen, which was evenly illuminated with blue light (d). During photography, light from the orange foreground elements entered the camera and travelled equally through both the orange and the clear portions of the orange-dyed positive film – thus forming a normally exposed negative image of the foreground elements on the undeveloped film behind. However, the light from the blue-screen that surrounded the foreground elements hit the orange-dyed film and was absorbed where it hit orange areas and transmitted where it hit the clear areas – thus copying a negative image of the desired background on to the undeveloped film behind. When developed and printed, the black-and-white film produced a composite of the desired foreground and background elements (e); by blocking the blue light, the performer served as a 'living' travelling matte.

Ingenious though the theory was, the Dunning–Pomeroy process was unfortunately a lot less practical than it sounds. The density of the orange-dyed background plate and the balance of the orange-and-blue lit elements were all critical, and any imbalance led to incorrect exposure or 'ghosting' of the foreground elements. The preparation and dyeing of the orange component was a tortuous process, and once the film was bi-packed in the camera, there was

no way of judging whether an actor's performance married with the action of the background element until the footage was developed.

Despite its drawbacks, the Dunning–Pomeroy process was the only truly practical and effective method of combining separately filmed foreground and background elements in its day. The technique was widely employed in Hollywood from the late 20s and early 30s, and can be seen in films such as *Trader Horn* (1931) and *Tarzan the Ape Man* (1932). Though the development of effective rear-projection soon made the process obsolete (66>), it remains of interest because it was the first technique to use the properties of coloured light to produce a matte – a method that would become integral to all future travelling matte developments.

BLUE-SCREEN COLOUR SEPARATION PROCESS

In the early 1930s, rear projection (66>) replaced the Dunning–Pomeroy process as the dominant means of combining separately filmed images. The introduction of colour photography in the 40s and 50s presented problems for rear projection, however, and a new method of combining foreground and background elements was sought.

The Dunning–Pomeroy process had used the properties of coloured light to produce travelling mattes, but its use of orange and blue light, which remained unnoticed in black-and-white photography, would create problems if filming in colour was required. A new process, using similar principles but capable of rendering the

colours of the final image realistically, was therefore sought.

In the late 1930s, the Technicolor laboratory in London experimented with methods of creating travelling mattes using the three colour separations produced in the three-strip Technicolor process. They discovered that by filming foreground elements in front of a blue background screen, the blue and red colour separations of the scene could be used to generate high-contrast male and female mattes. The first feature film to employ this process was Alexander Korda's *The Thief of Bagdad* (1940), which used it to produce scenes with a flying horse and a giant genie. In the 1950s, the Technicolor three-strip blue-screen process was developed and improved for use with single-strip colour film stocks such as Eastmancolor. Known as the blue-screen colour separation process, the new method was the basis for modern blue-screen techniques.

As in all travelling matte photography, the process requires two basic elements: a background plate and a foreground element that can be used to produce a male and female matte.

The foreground element is filmed in front of a bright blue background screen (fig. 13 (a)). Great care must be taken that the screen, which is effectively a large blue reflector, does not cast blue light on to the foreground subject. Such blue 'spill' can make the production of clean mattes extremely difficult to achieve. To help separate the foreground element from the blue-screen behind it, a weak yellow filter is sometimes added to the foreground lighting in order to prevent the emission of blue light. The foreground element is then filmed on colour film stock and developed into a negative in the usual way.

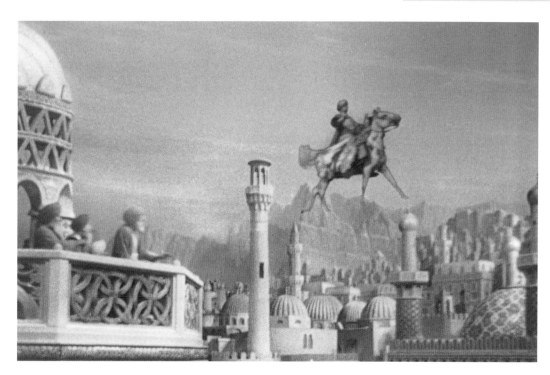

The Caliph (Miles Malleson) enjoys an airborne horse ride over his city in one of the first-ever Technicolor blue-screen shots for The Thief of Bagdad *(1940).*

The developed camera negative is then printed to produce a colour master positive (b). This is in turn printed on to black-and-white film through a blue filter to produce a colour separation negative that is a black-and-white record of the blue component of the scene. In this negative, the background screen area is now black (c).

Another copy of the master positive is made on to black-and-white film. This time a red filter is used. This produces a separation negative of the red component of the scene (d). In this negative, the background area is clear. This is then printed on to high-contrast

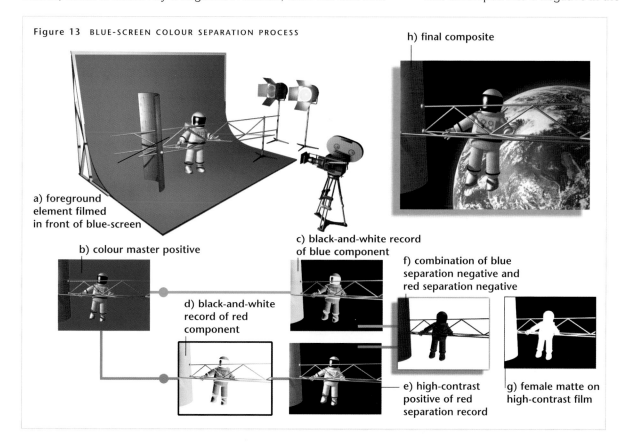

Figure 13 BLUE-SCREEN COLOUR SEPARATION PROCESS

a) foreground element filmed in front of blue-screen

b) colour master positive

c) black-and-white record of blue component

d) black-and-white record of red component

e) high-contrast positive of red separation record

f) combination of blue separation negative and red separation negative

g) female matte on high-contrast film

h) final composite

Water spray causes blue fringe problems for Humphrey Bogart and Katharine Hepburn in this blue-screen composite shot from The African Queen *(1951).*

black-and-white stock to produce a positive image in which the background screen area is black (e).

As a result of these processes, the blue separation negative and the red separation positive both have black backgrounds. The two pieces of film are then printed on to the same strip of high-contrast black-and-white film stock. The black backgrounds on both separation strips prevent any light from reaching the background area on the new strip of film, while the combination of negative and positive images of the foreground element ensure that the whole of the foreground area is exposed to light (f). The resulting negative is clear in the background area and solid black in the foreground area – this is the male matte (also known as the hold-out matte). A positive copy of this forms the female matte, which is clear in the foreground area and solid black in the background area. These elements are then combined with the master positive of the foreground and the master positive of the desired background element in an optical printer to produce the final composite image of foreground and background objects (h).

While the blue-screen colour separation technique was an effective method of producing travelling matte shots in colour, it did have its pitfalls. Any transparent foreground element through which the blue-screen was visible – for instance, a glass of water – became invisible in the final image. Semi-transparent objects – for example, smoke, fine hair or soft-edged items such as out-of-focus or fast-moving objects – often inherited a hazy blue fringe. Examples of this effect can be seen in the rapid scenes of *The African Queen* (1951) and the closing of the Red Sea in *The Ten Commandments* (1956). In both cases, the edges of water spray have a dramatic blue halo. Despite its disadvantages, however, the technique was at the

time the only way to successfully combine large-scale foreground and background elements in colour.

SODIUM VAPOUR

In the mid-1950s an alternative method of colour travelling matte photography was devised in France and developed for practical use by the J. Arthur Rank Organisation in England. The sodium vapour process resembled the Dunning–Pomeroy method in being a 'dual-film' system that produced the travelling matte while the action was being photographed. While the older method combined background and foreground elements in-camera, the sodium vapour technique involved the in-camera production of a live-action foreground negative and a separate travelling matte element on two different pieces of film that could be combined with a background image at a later stage.

The process required the use of a camera that could hold two separate films which could be exposed to the same image simultaneously. The system developed in England employed specially built cameras, whereas in America, obsolete three-strip Technicolor cameras were modified to take two rather than three strips of film (fig. 14 (a)). The films loaded into the camera were a standard colour stock (to record the foreground image) and a black-and-white stock (to record the travelling matte image).

As in other processes, the foreground action was staged in front of a coloured backdrop. In this case, the backing was a brilliant yellow, further illuminated with yellow light

The sodium vapour process can be used to combine live action with animated characters and backgrounds, as in this final composite from Mary Poppins.

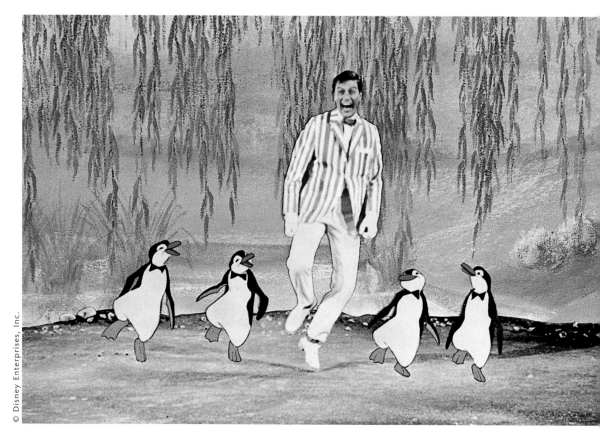

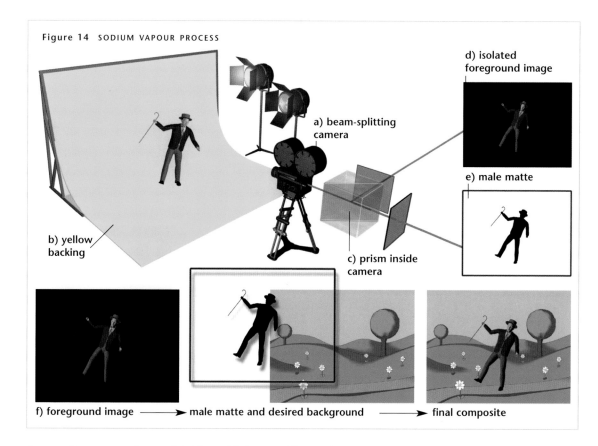

Figure 14 SODIUM VAPOUR PROCESS

d) isolated foreground image

a) beam-splitting camera

e) male matte

b) yellow backing

c) prism inside camera

f) foreground image ⟶ male matte and desired background ⟶ final composite

from sodium vapour lamps (b). Normal lights used for the foreground action were equipped with a filter coated with didymium (a material that absorbs yellow light) to subtract monochromatic yellow from the foreground lighting.

During filming, light entered the camera through the lens and hit a beam-splitting prism (c). This prism divided the light, sending identical images of the scene towards the two separate films contained in the camera. Light heading for the colour-negative stock was passed through a didymium filter, which blocked the yellow light from the background, resulting in an image which when developed showed the foreground action surrounded by black (d). The light directed towards the black-and-white film passed through a filter that transmitted only the yellow light of the background, thus producing a black area around a clear foreground (a female matte). This could be copied to produce a male matte (e). The developed elements were then combined (f) to produce exceptionally fine results.

As well as producing accurate mattes, the process allowed for the photography of transparent objects; an actor could now enjoy a drink during photography, and in the final composite image the matted-in background would be visible through the glass and liquid.

The sodium vapour process was first used by Rank during its production of *Plain Sailing* (1958) and was then adopted by the Walt Disney Studio, which developed the system under the guidance of its head of research and development, Ub Iwerks (1901–71). The technique was used to enliven many Disney productions in the 1960s and 70s, an early and spectacular example being the combination of the live-action antics of Julie Andrews and Dick Van Dyke with animated cartoon elements in *Mary Poppins* (1964). Alfred

Hitchcock also used the method to produce many of his travelling mattes for *The Birds* (1963).

The sodium vapour process was the most successful of a number of similar methods that were developed at around the same time. Alternative systems differed in their use of background light; rather than using sodium vapour light, some employed either infrared or ultraviolet light to produce mattes. These systems required additional processing after initial photography and so were less accurate, practical and popular.

BLUE-SCREEN COLOUR DIFFERENCE PROCESS

Dual-film travelling matte techniques such as the sodium vapour process produced high-quality travelling mattes that were far more versatile and effective than those produced using the blue-screen colour separation process. However, dual-film methods required the use of specialist cameras that were unwieldy, expensive to hire and which could not be used with the anamorphic CinemaScope lenses that were popular from the mid-1950s onwards. A system of producing travelling mattes was sought that combined the quality of the dual-film sodium vapour technique with the convenience of the blue-screen colour separation process, which derived its mattes from a single negative shot in a standard production camera.

A number of methods were devised in response to this need, most of which worked on principles similar to that of a system first developed and patented by Petro Vlahos of the Motion Picture Research Council. His system, which he called the blue-screen colour difference process, became the basis for the most widely used method of producing travelling mattes from the mid-1960s until the advent of digital alternatives in the late 1980s.

In its photography and subsequent optical processes, the blue-screen colour difference system resembles the colour separation process. However, the newer method differed from its older cousin in several important ways, one of which was a reduction in the number of duplication generations needed to produce the final composite of background and foreground action. The system is a complicated one, but its basic principles are as follows (fig. 15).

The live-action element of a scene is filmed in front of a carefully illuminated blue-screen. While early blue-screens could be a wall or any other surface that had been painted blue and illuminated with blue light, the colour difference process requires such pure blue that

Figure 15 BLUE-SCREEN COLOUR DIFFERENCE PROCESS

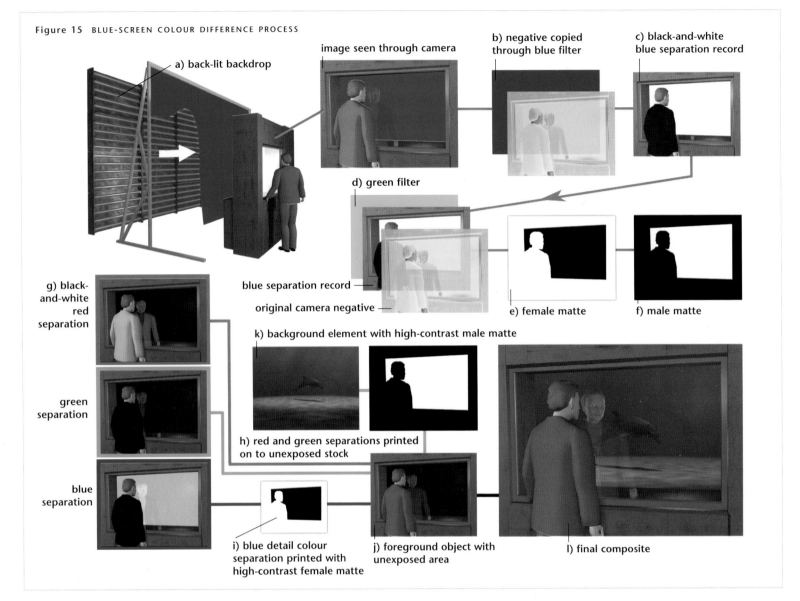

a) back-lit backdrop

image seen through camera

b) negative copied through blue filter

c) black-and-white blue separation record

d) green filter

blue separation record

original camera negative

e) female matte

f) male matte

g) black-and-white red separation

green separation

blue separation

k) background element with high-contrast male matte

h) red and green separations printed on to unexposed stock

i) blue detail colour separation printed with high-contrast female matte

j) foreground object with unexposed area

l) final composite

new screens had to be developed for the purpose. Such screens are made from a translucent blue material and are lit from behind with banks of flicker-free fluorescent tubes (a).

After processing, the negative of the foreground action is copied on to high-contrast black-and-white film stock through a blue filter, whose colour exactly matches the blue-screen (b). The filter absorbs the blue light from the scene but allows red and green to pass through, resulting in a black-and-white separation record in which the blue-screen area is transparent (c). However, in most cases the foreground element is likely to contain some traces of blue – perhaps in an actor's costume or make-up. These traces of blue appear partially transparent in the separation record.

To remedy this, the black-and-white separation record is bi-packed with the original negative and printed again on to high-contrast stock, this time through a specially balanced green filter (d). This produces a high-contrast female matte that is transparent in the foreground area and black in the blue-screen area (e). A negative is taken from this to produce a high-contrast male matte, in which the blue-screen area is clear and the foreground is black (f).

Once the mattes have been produced, red, green and blue colour separations are made from the original camera negative on to normal-contrast black-and-white film (g). These contain all of the essential colour information from the scene. The red and green colour separations are then printed on to a single piece of unexposed colour film stock through their corresponding colour filters, to produce an image in which the background area remains clear, while the foreground details are recorded (h).

Next, the blue colour separation is printed on to the colour film stock, through both its corresponding colour filter and the high-contrast female matte. The transparent area of the female matte ensures that the blue details in the foreground image are exposed, while the black area of the matte stops the background blue-screen image from transferring to the colour film stock (i). The result of combining the colour separations in this way is a foreground object surrounded by an unexposed area of film (j).

This film is then combined with the high-contrast male matte in order to record the desired background element. The male matte prevents any unwanted light from reaching the already exposed

The advantage of using this system is that, because each separation is taken directly from the original negative, fine details such as hair or grass are not lost through 'image spread', which occurs whenever film images are repeatedly duplicated. Since reflections from semi-transparent objects are also represented in each colour separation, their detail is present in the final composite. This makes the process suitable for filming transparent objects such as windows and water, which would become invisible or suffer from blue-fringing if the colour separation process were used.

'The colour difference process was a major development in the production of travelling mattes,' explains British effects supervisor Roy Field. 'We had been trying all sorts of systems with varying degrees of success for years, but the colour difference process was the basis of a system that really enabled us to produce travelling mattes of pretty much anything we wanted.' Field stresses that the system was still extremely difficult to use. 'Because it is based around the physics of light and uses man-made materials and equipment, there are many subtle ways in which things can go wrong – and you only need one part of the chain to be wrong to mess

The crew of the Enterprise *perform in front of a blue-screen for* Star Trek: The Motion Picture *(1979).*

foreground elements, but allows light to fall on to the unexposed areas of the undeveloped film – that is, the background area (k). The required background is then printed into the previously unexposed area of the film, thereby completing the illusion that the foreground and background elements were filmed simultaneously (l).

The blue-screen colour difference process enabled Superman to soar over Metropolis, despite his blue clothing.

everything else up. The best way to get over this is to develop your own system in which you continuously test every variable and know how to calibrate everything accordingly. Nevertheless,' he says, 'once you had mastered the basic principles of the process, there were all sorts of variations that you could use to produce a good matte according to the subject being filmed.'

Field put his knowledge to the test during the production of *Superman* (1978), which required the hero in a blue costume to appear in many blue-screen shots. 'On *Superman* I was slightly perturbed to find that the main character's costume was going to be blue – which wasn't ideal,' laughs Field. 'I tried to persuade the producers to change the colour – but it had to be blue. I then spent six months testing all sorts of different blues and turquoises to find which we could use in conjunction with a blue-screen. Eventually I found an extremely narrow band of blue that could be filmed in front of a blue-screen and which could be utilized to produce mattes using a variation of the colour difference method. After persuading DC Comics to allow us to use this particular shade of blue – which was different to that used in the comics – we had to find a way to get costume material made to this exact colour. Eventually we found a company in France that could get it just right.' Though Field won an Oscar for his work on the film, he was never entirely happy with all of the work. 'There's one shot in particular that we never got right,' he says. 'It's where Superman is flying around the dam – his costume is far too green-looking. Unfortunately, we had a tough schedule, but with a little bit more time we could have got that one right.'

HAND-DRAWN MATTES

For those occasions when filming with specialized cameras or backdrops is impossible or impractical, travelling mattes and split screens can still be produced without reverting to complicated photochemical techniques. In such cases, effects artists draw their mattes by hand.

The equipment used to draw mattes is based on that invented and patented by animator Max Fleischer (1889–1972) in 1917. Fleischer developed the process known as rotoscoping as an aid to

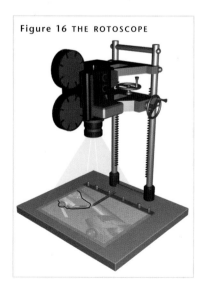

Figure 16 THE ROTOSCOPE

drawing cartoon animation (141>), but a variation of the technique is used for many aspects of effects production. The rotoscope (fig. 16) – often called the 'downshooter' – is simply a large, sturdy frame on to which a downward-pointing camera is mounted. The camera is adapted to operate as both a camera and, with the addition of a lamp, a projector.

To produce a travelling split screen, various aspects

of the same shot are filmed in different takes (fig. 17). If, for example, a shot of an actor running across the road in front of a car accident is required, the actor might be filmed crossing the road in one

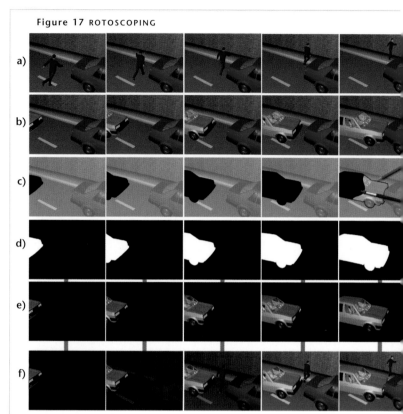

Figure 17 ROTOSCOPING

a)

b)

c)

d)

e)

f)

The best aspects of two similar shots ((a) and (b)) can be combined using hand-drawn mattes ((c), (d), (e)) to create a new shot (f).

take (a), and the accident in the next (b). The two takes would then be combined. To achieve the desired result, one of the films is loaded into the camera-projector. In this example, it might be the film of colliding vehicles. The first frame of film in the sequence is projected downwards and focused on the animation table, on which specially punched paper is held in precise registration by a peg-bar. The first 'split' is then traced on the paper in pencil. The split forms the dividing line where the separate takes will be joined together – the image on one side of the line will come from one take, the action on the other side of the line will come from the other. Splits are usually drawn around well-defined lines that already exist within the image – in this case, as can be seen, it is where the front of the vehicle enters the frame (c). When the first split has been drawn, the film in the camera projector is advanced by one frame and the next split drawn on a new piece of paper. This continues through the sequence to produce a series of pencil drawings that represent a moving line progressing across the screen.

The pencil lines are then carefully inked in and the area on one side of the line is painted black – the part of the screen that will be occupied by the oncoming vehicle, in this instance. The projector – still locked in exactly the same position – is then converted back into a camera and loaded with high-contrast black-and-white film, which is used to photograph the painted artwork one frame at a time

in the correct order. This produces a strip of film on which the blacked-out areas form a travelling matte. This film is then copied to produce a counter-matte element (d), in which the film on the opposite side of the line is black – that is, the area where the actor will be seen running.

In an optical printer, the footage of the crashing car is printed along with its female matte to produce a strip of film that is exposed only in the area occupied by the car (e). This film, still undeveloped, is then rewound and exposed to the footage of the running actor, using the counter-matte to protect the area of the frame already exposed to the footage of the car. The actor will now appear to be running across the road to avoid the car accident (f).

Rotoscoping can also be used to enhance the impression that the various elements matted into a shot are not simply placed *on top* of the scene, but are actually *within it*. In *Return of the Jedi* (1983), animated walking vehicles were matted into real forest scenes. By creating hand-drawn split screens, the vehicles were 'sandwiched' between live-action elements and appeared to walk in between trees and bushes as if actually interacting with the environment. To achieve the effect, the forest environment was rotoscoped to produce mattes that split the image into its 'foreground' and 'background' planes (fig. 18). Travelling mattes of the vehicle were then produced using a blue-screen. To assemble the final composite, the background forest area was first printed on to unexposed film using the male mattes from the

The animated walking vehicle in this scene from Return of the Jedi *(1983) was added using hand-drawn split screens.*

foreground forest area and the vehicle to prevent exposure in these areas. The vehicle was then printed into the new composite by using mattes to cover the already exposed background and the area reserved for the foreground. Finally the foreground was then added by covering the already exposed background and vehicle areas with their mattes to prevent additional exposure.

It is also possible to achieve intricate travelling mattes using a rotoscope. Objects that need to be placed into a scene, but which have not been filmed in front of a blue-screen, can be traced frame by frame, inked in and the resulting mattes and counter-mattes used to place them into their new background. Drawing such mattes is an intricate and time-consuming process. For Alfred Hitchcock's *The Birds* (1963), a shot required that hundreds of seagulls be seen descending towards a town from a bird's-eye point of view. The nature and scale of the shot meant that filming birds in

Figure 18 ROTOSCOPING

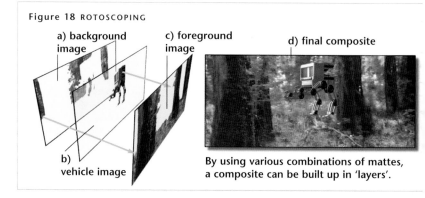

a) background image
b) vehicle image
c) foreground image
d) final composite

By using various combinations of mattes, a composite can be built up in 'layers'.

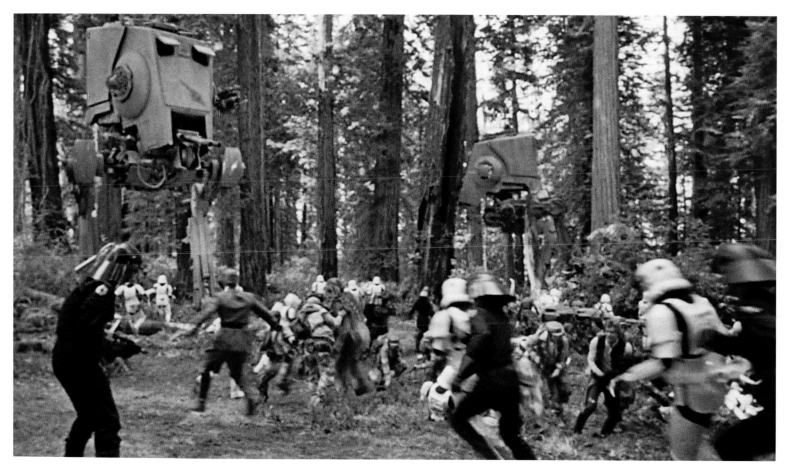

Figure 19 HAND-DRAWN MATTES IN *THE BIRDS*

a) hand-drawn mattes

b) mattes and backdrop combined

c) final composite

front of a blue-screen was impossible. Instead, the gulls were filmed from a cliff-top as they swooped towards the shore where food had been placed. The resulting footage was then rotoscoped – every gull painstakingly hand-traced to produce a matte that would separate it from its background of sea and sand, and allow it to be placed into an aerial view of the town – which was itself a combination of a matte painting by Albert Whitlock (194>) and live-action footage shot from a hill at Universal Studios (fig. 19). Rotoscoping the five hundred frames in this one shot took two artists three months to complete.

The rotoscope is also useful for removing any unwanted items from a shot or for cleaning up images before compositing. When models or puppets are filmed in front of blue-screens, they are usually attached to various pylons, rods and wires that support them, control their performance or supply them with power. Rods and wires are sometimes painted blue to enable them to be 'automatically' removed during the generation of blue-screen mattes. If this is not possible, the shots are rotoscoped instead. If the rods are moving, they are individually hand-traced to produce a separate matte for each frame of film.

Furthermore, since large blue-screens can be difficult to light, performers, puppets or miniatures are often placed in front of a screen that is just large enough to isolate their edges – foreground objects need only have a small area of blue around them to produce a travelling matte using the blue-screen method. However, if a small blue-screen is used, the clutter of studio surroundings (lights, camera tracks, technicians and so on) will also be photographed. To clean up the shot, the rotoscope is used to create 'garbage mattes' that obscure all the unwanted elements at the edges of the shot. Garbage mattes are sometimes hand-painted for each frame but, since they do not have to follow the edge detail of an object accurately, are more commonly generated by arranging and photographing sheets of black paper that cover up all of the detail outside the

blue-screen area. If the camera moves during the shot, the paper is reconfigured every few frames to keep the unwanted areas covered.

Sometimes garbage mattes show up as grey boxes around flying superheroes or spacecraft when seen on television. They are usually invisible in the cinema because film records a huge range of subtleties. Television, however, is a relatively coarse medium and is unable to reproduce as many variations of colour and contrast, especially when an image has been brightened for home viewing, with the result that garbage mattes do not always blend in with their surroundings (fig. 20).

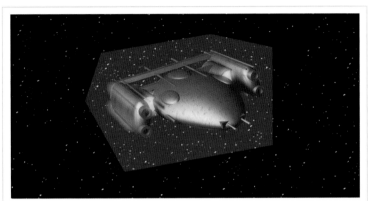

Figure 20 GARBAGE MATTES
These often show up as low-contrast boxes around flying objects when shown on television.

OPTICAL PRINTING

When all the elements of a special effects shot have been produced – models, animation, live action, travelling mattes – the separate pieces must be reassembled to form a single, completed image for inclusion in the final version of the film. The process of fitting all the pieces together is known as compositing. Until the arrival of digital techniques, almost all compositing was done using a machine called an optical printer, which, of all the equipment available to the effects technician, has been the most versatile, creative and consistently employed.

The early copying of moving images was done by contact printing – the film to be copied was sandwiched in contact with unexposed film, and light shone through the two pieces to produce a copy. However, some early film makers wished to do more than simply copy their images – they wanted to *alter* them in the process.

Around the turn of the century, British film pioneer Cecil Hepworth devised a system by which he pointed the lens of a projector into that of a camera and, by projecting and photographing one frame at a time, could re-photograph an image. Hepworth used his technique of 'projection printing' to produce *The Frustrated Elopement* (1902), in which the forward-moving action occasionally reversed, mid-scene, to make characters and action move backwards. This was achieved simply by changing the direction that the film moved through the projector during re-photography.

The copying of moving images in this way was generally avoided until the mid-20s, since re-photographing early film stocks led to a significant deterioration in image quality. The emergence of a film

Figure 21
A SINGLE-HEADED OPTICAL PRINTER, as shown below, would be used for basic copying of film and adding simple fades or wipes.

stock specifically designed for duplication in 1926, followed by greater improvements in the early 1930s, meant that the potential of optical printing could be explored by the fledgling special effects departments of the studios.

Early optical printers were hand-built to cater to the individual needs of the department in question, and were designed to incorporate whatever equipment was available to them. Such printers typically consisted of a process projector (called the printer head), which faced an adapted production camera (fig. 21). Both camera and projector featured fixed-pin registration, so that the film was held absolutely steady during the copying process. The camera and projector were mounted on a heavy base, typically a cast-iron lathe bed, to prevent any form of vibration during operation.

Scene transitions

The ability to copy images efficiently and effectively meant that optical tricks, which were previously achieved in-camera, could be left until post-production. While the skilled camera operator had once been responsible for the 'live' production of fades and dissolves during original photography, the optical printer could now be used to produce these effects with more control at a later stage, with no danger of spoiling the original negative. Optical printers are still used for scene transitions by some film makers today.

To produce a fade-out, the master positive of a scene is loaded into the printer head, and re-photographed one frame at a time by the camera. The fade-out is produced by incrementally closing the camera's shutter in order to reduce the amount of light that reaches the copied film.

To create a dissolve from one shot to another, the editor studies the film and marks the points at which a dissolve should start and end. The first scene is loaded into the printer head, and the camera's shutter is gradually closed during re-photography to produce a conventional fade-out. The second shot is then loaded into the printer head, the film in the

camera back-wound and a second exposure made. This time the camera's shutter is gradually opened over the same period that it was previously closed. The second image therefore fades in as the first fades out, the two appearing to dissolve into one another.

As well as basic dissolves and fades, a plethora of elaborate scene transitions can be achieved. A simple wipe from one shot to another is produced by fitting the camera with a set of 'blades' that are moved mechanically. During the copying of the first shot, the blade is moved horizontally, vertically or diagonally across the frame, progressively obscuring the image and leaving a portion of the frame unexposed. The camera film is then back-wound and the second shot run through the printer while the wipe blade repeats its movements in reverse – thus printing the second shot on to the unexposed portion of film. The result is a transition in which one shot is replaced by a second as it wipes across the screen. By sliding the projector head sideways at the same rate as a wipe blade, the wipe can be turned into a 'push-off' – one image pushing the other off the screen.

An optically printed star-wipe from Flying Down to Rio *(1933).*

A major pioneer of transition effects was Linwood G. Dunn (59>) of the RKO optical department. Dunn experimented with scene transitions in the short film *This Is Harris* (1933), and achieved such good results that he added several to the studio's next musical feature film, *Melody Cruise* (1933). The enthusiastic reaction to his optical transitions persuaded Dunn to add even more elaborate ones to the studio's next production, *Flying Down to Rio* (1933), the first pairing of Ginger Rogers and Fred Astaire. Dunn merged shots with kaleidoscopic starbursts, rotating swirls, circular 'clock' wipes and zig-zag 'saw' wipes.

David Lean's naval drama, *In Which We Serve* (1942), employed more subtle techniques. Watery dissolves between shipwreck scenes were created by moving a piece of rippled glass between camera and projector during printing. Similar methods were used to achieve the wavering transitions to flashback scenes and dream sequences for decades to come.

Optical tricks

The optical printer, at first used for simple copying jobs and scene transitions, soon became a major tool for the creative manipulation of film footage and, although now largely replaced by digital techniques, is still used by some film makers today.

If a chase sequence needs a little more impact, every third or fourth frame can be skipped during printing in order to speed up the appearance of the action. A scene that seems a little too fast, on the other hand, can have some frames double-printed to slow the action down. By projecting and copying a single frame, a freeze-frame can be produced – a technique employed with dramatic effect by L. B. Abbott for the final shot of *Butch Cassidy and the Sundance Kid* (1969). By moving the camera closer to the projector, the original image can be re-framed – perhaps to crop out an unwanted object such as a microphone, or to turn a long shot into a close-up.

A shot originally filmed without any camera movement can be brought to life by adding a small pan or zoom during the copying process. Tilting the camera from side to side during printing adds the sway of the seas to elements shot in land-locked

This optical printer was built for the production of Superman *(1978) and is still used to create titles and optical effects at Pinewood Studios.*

A multiple-image shot from Grand Prix *(1966).*

studios. To help solve a difficult cutting problem, editors may request that a shot be 'flopped' to produce a mirror image. Adding filters to the camera can turn scenes filmed by day into night, make a clear day foggy, or add a glowing sunset to an overcast sky. Simple cut-out masks can produce 'through the keyhole' shots or views through binoculars and periscopes.

Similar processes can be used to salvage footage that might otherwise be unusable. During the editing of *Flaming Gold* (1933), it was noticed that a passing truck had an objectionable phrase written on its side. The footage was sent to the optical department, where a glass slide was placed in front of the camera and the offending words blotted out with a fine grease pencil. The glass was moved, frame by frame, to follow the truck as it passed through the shot and the words in question were blurred unnoticeably.

By masking different areas of the camera negative, several exposures can be made on a single frame of film to produce complex multiple-image shots. To produce a shot containing four different images, for example, a matte device is slotted in front of the camera to obscure three-quarters of the frame. One image is then projected on to the unmasked area of film. The camera film is then back-wound and a new mask inserted, this time revealing a different quarter of the frame of film. The next image is then printed on to that area and so on, until each quarter of the frame has been exposed to a different image. This method was used in *Grand Prix* (1966), in which multiple images informed the viewer of different events that were taking place simultaneously during the course of a motor race.

Sophisticated moving split-screen shots can be achieved entirely within the printer using a variation of the moving-blade system employed to produce wipe transitions. Shots that require the interaction of two elements that cannot be filmed together for reasons of practicality or safety can instead be filmed in two takes and then selectively printed together to produce a convincing composite. For some scenes in *Wonder Man* (1945), Danny Kaye was required to play identical twins. Under the supervision of John P. Fulton, each

shot was filmed twice (once for each twin), and in each the actor's movements were carefully planned to correspond to those of his twin. During filming, the camera remained locked in one position, and care was taken that the actor did not enter or cross the part of the shot that his twin would later occupy.

In the optical department, the images from one of the films was projected into the camera. As the first twin moved around the frame, a split-screen matte was moved with him to ensure that only the area occupied by the actor during that frame was exposed to the camera film. The camera film was then back-wound and the second film printed on to it, using a moving counter-matte to expose footage of the second brother on to the areas of unexposed film. Ensuring that the two moving mattes complemented each other frame by frame was an exacting business, but the results allowed two Danny Kayes to perform together convincingly, walking from side to side of the frame, in a way that fixed-position, in-camera split screens never could.

Even films that require no special effects normally rely on optical printing for the addition of titles and credits. Wording is produced as black-and-white artwork and photographed on to high-contrast black-and-white film. The resulting negative and positive are used as a matte and counter-matte to superimpose the wording on to live-action footage. By using an optical printer with two printer heads, this can be achieved in one simple operation (fig. 22) and, by adding filters to the process, title sequences can be produced in colour.

Optical compositing

While optical printers have been used to create many visual tricks, perhaps their most important function has been to combine the multiple elements of travelling matte shots in order to create a final composite image. (Digital compositing techniques have now largely superseded optical compositing methods, though the latter are still in use.)

Figure 22 A TWO-HEADED OPTICAL PRINTER
This can combine two images in each pass, making it ideal for creating titles. In the example shown, the black-and-white title card acts as its own matte.

Linwood G. Dunn (1904–1998) began his working life in the movie business as an assistant cameraman for Pathé in 1925. After moving from New York to Hollywood, Dunn worked at a number of different studios until, in 1929, he was asked to do two days' work in the photographic effects department of the newly established RKO Radio Pictures in Hollywood.

Dunn stayed at RKO for the next 28 years, producing effects for hundreds of films and eventually becoming head of the studio's photographic effects department. He became known as the first master of the optical printer.

Optical printers had been individual, custom-made machines until Dunn was asked to design and build a device for manufacture on a large scale for film units of the US armed forces during World War II. After the war, the device, which Dunn designed and built with associate Cecil Love, was manufactured as the Acme-Dunn Optical Printer – the first commercially produced off-the-shelf printer. Dunn and Love won an Academy Technical Award for their design in 1944. Dunn pioneered many groundbreaking ways of using the printer to combine images, working on classic films such as *King Kong* (1933), *Flying Down to Rio* (1933), *The Last Days of Pompeii* (1935), *Bringing Up Baby* (1938), *The Hunchback of Notre Dame* (1939) and *Citizen Kane* (1941).

When RKO ceased production in 1957, Dunn leased the studio effects facilities for use by his own company, Film Effects of Hollywood, an independent organization that he had founded in 1946. The company continued to produce sophisticated visual effects for films such as *West Side Story* (1961), *It's a Mad Mad Mad Mad World* (1963), *My Fair Lady* (1964), *Airport* (1970) and television productions, including the original *Star Trek* TV series (1966–69). Dunn received an Academy Award for his contributions to *Mighty Joe Young* (1949), a Special Academy Award for lifetime achievement in 1979, and another in 1981 for having designed the Acme-Dunn Special Effects Optical Printer.

Dunn sold his company in 1985, though he continued to work in the field through his involvement in many industry societies and committees. His technical activities moved with the digital age, and he was busy working on a digital projection system at the time of his death in 1998.

The Thief of Bagdad (1940) was the first film to use an optical printer to combine travelling matte elements produced using the Technicolor blue-screen process.

red or green light), male and female mattes, and the background plate. Six separate pieces of film, therefore, have to be carefully combined to produce the seventh, final, image. When a composite shot includes more than a single travelling matte element – such as a space battle involving many spacecraft – dozens or even hundreds of individual film elements may need to be printed on to the final composite.

The number and complexity of elements that sometimes need to be combined mean that, in addition to the technical expertise required to operate the printer, first-class administration skills are necessary. During the production of Star Wars (1977), Bert Terreri was hired to keep track of all of the optical elements being used. 'When I came on board the film, fifty per cent of the special effects photography was already done,' recalls Terreri, now a visual effects supervisor at Rhythm and Hues animation studio. 'They had created thousands of bits of film and no one knew where they all were. I spent six months tracking down all those different pieces of celluloid and preparing them so that the optical printer could put them together.'

As well as identifying and labelling the various elements, an optical administrator oversees the preparation of those elements and the printing instructions that need to be given to the printer operator – a task called optical line-up. 'The line-up people would plan the actual compositing process,' explains Terreri. 'They would look at all the

Optical compositing involves copying the master positive of the background plate, along with the male 'hold-out' matte of the foreground element. These two elements are threaded into the printer head and projected into the camera. The result is a copy of the background scene with an unexposed area that is the shape and size of the foreground element. The film in the camera is then back-wound to the starting position and re-exposed to the foreground plate, along with the female 'hold-out' matte. The female matte obscures the background, allowing the foreground element to fit into the unexposed area of the film. Providing all the elements have been correctly prepared, aligned and exposed, the developed result will be a satisfactory composite of separately filmed background and foreground elements.

Though the principle of compositing travelling matte shots is a simple one, in practice the task is a laborious and exacting art that requires the work of highly skilled operators to achieve successful results. Elements that are incorrectly exposed or misaligned by mere thousandths of an inch may result in matte-lines – thin, black outlines around the matted elements that make them look as if they have been stuck on top of their environment.

One of the complicating factors of optical printing is the number of elements sometimes required to produce a composite image. Travelling matte composites produced using the blue-screen colour difference process can comprise three individual colour separations (each of which needs to be printed with the correct amount of blue,

A line-up sheet. This is used to plot the way in which every element of a composite shot is combined in an optical printer.

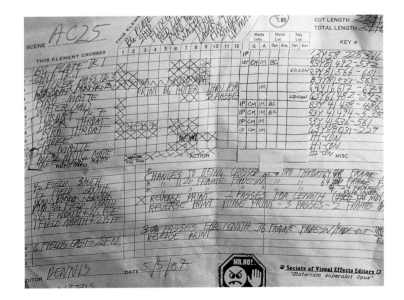

shots to be combined and line them up so that they knew what went with what, and which order it should be assembled in. They would check that all the mattes matched and that no elements overlapped. All the bits of film would then be cleaned and given to the printer operators with a line-up sheet that plotted exactly how every piece of film was to be combined, what type of filters were to be used and so on. A single shot could involve hundreds of bits of film – it was a logistical nightmare and the tiniest mistake could ruin hundreds of hours of work.'

For a composited shot to be successful, its separate elements, all filmed at different times and places, must appear to fit together as a unified whole. One of the keys to the success of such a shot is the relative movement of its individual elements. For example, if an element such as a miniature castle is composited into a background plate of a real landscape, the slightest movement of the castle element will make it appear to slide against its environment, shattering the illusion. Elements to be composited are therefore usually filmed with a 'locked-off' camera to prevent any movement or with a motion-control camera (118>) to replicate identical camera moves when filming each separate element. However, printer operators are sometimes presented with two pieces of film containing images whose movements bear no relation to one another and which must be locked together to produce a convincing composite. In such cases, the exact movements of one image must be 'tracked', so that the other element can be moved frame by frame to match it during optical printing.

Fantasy II Film Effects, one of the few Hollywood effects houses still regularly using optical printers in addition to their digital facilities, has dealt with some particularly tricky tracking shots. 'One of the hardest tracking shots we have done was for Bram Stoker's *Dracula* [1992],' says Fantasy II owner Gene Warren. 'There was a sequence in which a coach carrying Keanu Reeves approached Dracula's castle and Keanu had to look from the coach window to see some big blue flames in the distance. Unfortunately, the camera used to film this shot was mounted on the coach itself, so the image was bouncing all over the place. We somehow had to composite a nice steady shot of some blue flames

This optical printer is still in regular use at Fantasy II Film Effects of Hollywood.

into a shot that was moving about quite dramatically.'

Warren began by studying the film of the background to find an element that could be used as a tracking marker. 'The shot was taken at night and was very dark, but I found a little white pebble in the distance that just caught the light. That was the point that I used to judge the movement of the shot.' Warren then measured the position of the pebble every five frames throughout the 55-frame shot to identify the gross movements of the camera. Those movements were translated into north, south, east and west co-ordinates, and the flame element was moved accordingly every five frames during the first optical printing test. Test composites were printed on to black-and-white film, which could be developed quickly and studied on a moviola. 'I carefully studied each test, and for every frame I noted whether the flames should go a little more to the north, south, east or west in relation to that pebble. I repeated this task over and over, each time refining the movements a little more. Eventually you need to see the film projected on a big screen, because looking at the film in a small moviola you might not spot a very small movement, but on a big screen the flame might

The optical line-up room at Boss Film Studios.

CITIZEN KANE

Orson Welles (1915–1985) had an auspicious early career. His 1938 radio broadcast of H. G. Wells' *War of the Worlds* sent shockwaves across the United States, causing panic on the streets with its tale of alien invasion. An impressed RKO offered the 23-year-old Welles a contract. The terms: carte blanche. The result: perhaps the greatest film of all time.

Welles arrived in Hollywood in 1939, admitting he knew nothing about film production. An RKO researcher was asked to tutor him in basic film terms, and patiently explained the difference between a close-up and a long-shot. The young Welles watched John Ford's *Stagecoach* (1939) every night for a month before he felt ready to make his own film.

Vital in creating the astounding look of *Citizen Kane* (1941) was cinematographer Gregg Toland (1904–1948). Toland had asked to photograph Welles' first film, because he realized that the young man's great vision and scant experience meant that he would know no bounds. As Welles himself later admitted, 'I thought that you could do anything with a camera that the eye could do, or the imagination –

I didn't know that there were things you couldn't do, so anything I came up with, I tried to photograph.' The combination of Toland's skill and Welles' vision resulted in cinematic magic.

Also responsible for much of the film's imagery was Linwood Dunn of RKO's photographic effects department. The master of the optical printer carefully explained the potential of the device to the young director – a kindness that he would regret. 'Telling Orson about the optical printer was the kiss of death,' Dunn later recalled. 'He used it like a paint brush, which was fine – except that he asked for things that I'd never done before. However, he had enough power at the studio to OK the time and money it would take – I learned a lot from it.'

The optical printer was used to combine elements in many pre-planned shots – for example, extending the production's relatively small sets into seemingly huge constructions. During the editing process, Welles began to feel that many scenes lacked the dramatic impact that he sought. Dunn was asked to improve a number of shots. Typical of these was the scene in the Thatcher Memorial Library, which started with a camera pull-out from the chiselled

inscription on a huge plinth to reveal a female guard sitting at a desk. Only the base of the statue had been built and filmed, but Welles decided he would like to see the non-existent statue and asked Dunn to provide it. 'I had a statue made – about two feet high,' explained Dunn, '… and I made a straight shot of it, and on the optical printer I made a motorized pan down from it. Then I made a pan from the scene with the girl and I matched [the two] with a travelling split screen.' The finished shot looks, for all the world, as if a monumental statue had presided over the filming.

The entire film is littered with subtle optical effects by Dunn and fine matte paintings by Mario Larrinaga. Dunn later estimated that over fifty per cent of *Citizen Kane* was optically improved or tinkered with, and that only he and editor Robert Wise (1914–) might ever be able to identify all the changes made.

Citizen Kane has been hailed by many as one of the greatest films ever made. Its narrative structure, acting, editing and cinematography have provoked volumes of praise. It also demonstrates the most impressive and fascinating array of special effects of its time – assembled for an impudent young film maker who didn't know enough of the conventions to be aware when he was breaking them, but who learned as he went along.

This shot from Return of the Jedi *(1983) is an optical composite assembled from over one hundred separate elements.*

flying machines and full-scale, live-action shots of real people fighting. Both the full-scale and miniature elements had fires, explosions and laser bursts going off. Our task was to match the elements so that as a big fireball went off in one element, the quality of light in another element of the shot changed in response – as if the fire were casting its light on to that part of the scene.'

Since every element being combined usually exists as three black-and-white colour separations, each one can have different amounts of coloured light added to it during printing, thus changing the characteristics of the final image. 'Every frame of those shots had to be fiddled with to make the light in the live action match the model, or the model match the live action,' says Warren. 'Sometimes we changed the focus on elements slightly, or cut out little filters to affect the light reaching one small area of the film. Sometimes the colour of an element had to be tweaked so minutely that even the most subtle filter was too much and we'd have to print a shot at half exposure with the filter in, back-wind the film and re-expose it with no filter. The amount of work that goes into making shots like that is immense, and when the director sees it and asks for one corner to be just a little bit greener, you have to go back and do it all again!'

still look as if it's moving three feet from left to right!' Warren eventually did thirty-five black-and-white test shots before the flame elements looked as if they were actually sitting in the background plate. The shot was then composited in colour, and over two weeks of work resulted in two seconds of convincingly blended images.

Once tests have been carried out to ensure that the elements being printed actually fit together, the final look of the composite must be refined. This involves making sure that the colour of the various composited elements matches perfectly. Again, Gene Warren has had plenty of experience in making very different elements match. 'We optically composited the shots in the opening battle sequence of *Terminator 2* [1991],' says Warren. 'These shots were combinations of miniature landscapes with model tanks and

Optical printers traditionally consisted of one or sometimes two projectors, but to cope with the increasing demands of modern special effects shots, optical departments began to build machines with additional projectors. Optical printers with three and even four heads were ultimately built (fig. 23).

For Industrial Light and Magic's work on *The Empire Strikes Back* (1980), effects supervisor Richard Edlund (65>) designed an Academy Award-winning four-headed optical printer that became

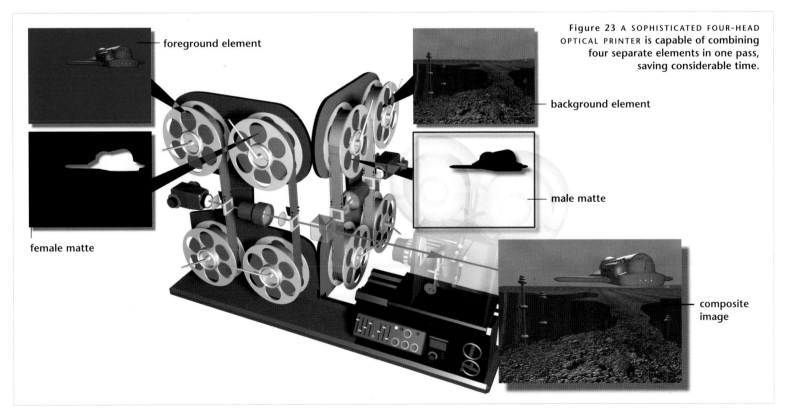

foreground element

female matte

Figure 23 A SOPHISTICATED FOUR-HEAD OPTICAL PRINTER is capable of combining four separate elements in one pass, saving considerable time.

background element

male matte

composite image

Gene Warren optically composited this combination of miniature background, full-size foreground and animated laser beams for Terminator 2: Judgment Day *(1991).*

known as the 'Quad'. 'The Quad was a great time-saver when we were compositing on *Empire*,' recalls Edlund. 'The Quad had two projectors mounted at a right angle to another two projectors. The projectors, which could handle both standard 35mm and VistaVision film, would throw their images into a beam-splitting prism that combined them and redirected them into the camera. By using the Quad, a simple travelling matte shot could be produced in one pass, while complicated shots that contained several hundred elements, like those from the asteroid chase in *Empire*, could be achieved in a fraction of the time that it would take on a traditional printer.'

Edlund's Quad printer was the first to use specially built telecentric lenses, which helped to create highly accurate matte shots. 'When normal lenses emit light, it travels outwards in a cone shape,' explains Edlund. 'When you change the focus of something, it not only blurs, it also changes in size. But telecentric lenses emit totally parallel bundles of light, which meant we could alter the focus of the matte, but it would not change size, as would normally be the case. The bottom line was that we could have a hold-out matte in the rear projector of the printer and the colour separation element in the front projector. We could then change the focus of the matte slightly to

blur its edges and make it fit the element better. This allowed us to produce some extremely subtle travelling matte shots.'

Edlund started his own effects facility, Boss Films, in 1983, where he continued to design and build state-of-the-art optical printers. By the mid-80s, computers had begun to affect all areas of film production, and they were incorporated into new optical printers to allow precise and repeatable control of focusing, camera and projector movement, and exposure levels. 'At Boss we built two of the finest optical printers ever constructed,' states Edlund. 'The ZAP [zoom aerial printer] and the Super Printer were utterly reliable 70mm printers. We could control the accuracy of matte-fits to within a thousandth of an inch. But the photochemical process of optical printing is ultimately flawed,' states Edlund. 'We spent hundreds of thousands of dollars building precision equipment and controlled every stage of the process as much as we could. But optical processes are affected by variables such as temperature, the quality of the chemical bath being used by the lab to develop film that day, voltage changes, weakening lamps, fading filters, and on and on and on. There are just so many variables that even with the best equipment in the world, a good optical composite relied partly on science and skill, and a little bit on good luck.'

Though he had been responsible for some of the finest optical equipment ever built, when optical compositing began to be

replaced by digital alternatives in the early 1990s Edlund was relieved. 'I have no love lost for the optical printer,' he claims. 'In terms of optical printing and photochemical technology, we got about as far as we could go. I had started to realize that we still had all the same limitations that we did back on *Star Wars*. The improvements that we could make to the process were so subtle that, frankly, they just didn't matter.'

Today, the rhythmic click of optical printers has been replaced by the hum of computers in almost every effects facility around the world. Optical printing is still used to produce fades and dissolves and by companies such as Fantasy II, whose skilled artists produce stunning composites for a fraction of the price of the digital equivalent, but Fantasy II owner Gene Warren admits that the days of the optical printer are numbered. 'Optical printing is going to be around in its basic forms for a few years yet,' he believes. 'At the moment, the cost of getting film in and out of the computer is expensive. But that will come down drastically, and then Kodak will stop making the film stocks that optical printing needs. Then everything will be digital, and the people who know how to make a shot work just by sensing that an element needs nudging a fraction here, or that something almost imperceptible about a shot has to be finessed there, will retire. Then there will be no more optical work and a skill – an art – will be lost forever.'

Despite its state-of-the art technology, the Super Printer was still constrained by the limitations of the optical photochemical process.

Fascinated by photography from an early age, Richard Edlund (1940–) was trained in high-speed photography and camera maintenance while serving in the US Navy. Edlund then spent two years studying at the USC School of Cinema, before going on to learn about special effects production while working at the Joe Westheimer special effects studio in Hollywood.

In 1975 he joined Industrial Light and Magic, the team George Lucas had assembled to produce the effects for *Star Wars*. Edlund helped to design the pioneering motion-control camera system (118>) used to produce the film's space battles, a technique which has since become a cornerstone of effects production. He also developed the use of blue-screen travelling matte photography for the film, and resurrected the VistaVision film format – both of which also became standards in the effects revolution following the film's success.

While at ILM, Edlund supervised groundbreaking effects for a number of smash-hit films which have now become classics. Among his most memorable achievements were the thrilling asteroid chase in *The Empire Strikes Back* (1980), the supernatural finale to *Raiders of the Lost Ark* (1981) and the extraordinary imploding house seen at the end of *Poltergeist* (1982). In 1983 he formed his own effects production company, Boss Films, where he continued to oversee the development of new equipment and effects techniques for films such as *2010* (1984), *Die Hard* (1988) and *Cliffhanger* (1993).

Though Boss worked on the cutting edge of technology – contributing early digital effects to *Ghost* (1990) and *Batman Returns* (1992) – Edlund felt unable to continue making the massive investment in time and money that was required to sustain a large independent effects company in the digital age. In 1997 he closed Boss Films and has worked as an independent visual effects supervisor since then.

He received Oscars for his contributions to *Star Wars*, *The Empire Strikes Back*, *Raiders of the Lost Ark*, and *Return of the Jedi* (1983), and technical Oscars for the development of the Quad optical printer and the Empire Motion Picture Camera system, a sophisticated means of motion control.

REAR PROJECTION

The shift to studio production with the coming of sound in the late 20s brought the need to simulate realistic outdoor scenes inside the studio. Early methods of travelling matte photography were never wholly successful, failing to produce the quality or quantity of shots necessary to replace location shooting. The solution came with the development of rear projection, whereby previously shot footage of an outdoor scene is projected on to a screen behind actors in the studio and the two are re-photographed together.

Special effects pioneer Norman O. Dawn (190>) experimented with rear projection (sometimes known as 'back projection'; see fig. 24 for basic rear-projection set-up) for *The Drifter* (1913). Dawn projected photographic stills on to a small frosted glass screen to produce the background for two close-up shots. Finding the results discouraging, however, he abandoned the process to devote time to the more successful development of other effects techniques.

Dawn had experimented with the projection of still images. However, what studio-bound film makers really needed was the ability to project and photograph moving images behind their actors. Though the concept is a simple one, the projection and subsequent re-photography of moving images relies on several crucial technical factors. Film cameras and projectors let in or throw out images when their continuously opening and closing shutters are open. Therefore, to photograph a projected moving image, the shutter of a camera has to be exactly synchronized with that of a projector – if the camera shutter is open at the instant the projector shutter is closed, no background image will be photographed. Furthermore, in order to be thrown on to a large screen and photographed clearly, a projected image has to be very bright, demanding the use of a projector of unusually high power. The effective photography of such an image also depends on the utilization of highly sensitive film stocks.

Some success was achieved in the early 1920s when a system was devised for the production of *Sahara* (1923). The shutters of

projector and camera were synchronized mechanically by connecting them with a 24m (80ft) drive shaft between a specially woven silk projection screen. The system worked, but it was impractical. A similar method was used to create the images seen on futuristic television in *Metropolis* (1926); in this case, the images were projected on to a ground-glass television screen by projectors concealed at the back of the set.

By happy coincidence, the sound technology that imprisoned film makers in the studios, making rear projection so desirable, also enabled the effective electronic synchronization of cameras and projectors. Simultaneously, big-screen projection developments meant the creation of particularly powerful projectors, and much faster film stocks were produced. With all these developments, rear projection evolved into a highly practical production method just when it was needed most. From the early 1930s it was used to combine fantastic and unlikely images in films such as *King Kong* (1933). It was also employed in the most pedestrian of circumstances – dialogues on street corners. The method became so routine in film production that rear-projection shots came to be known nondescriptly as 'process shots'. In 1930, Paramount used 146 process shots. By 1932, the figure had risen to over 600.

A method so essential to production attracted investment and quickly became highly sophisticated. The first screens used for rear projection were small, fragile, frosted-glass sheets – unsuitable for anything much bigger than a close-up of a foreground actor. As the process gained popularity, other screen materials were developed, the standard becoming a form of translucent celluloid. Early celluloid screens could be up to 3.5m (12ft) in width, but as directors' rear-projection needs expanded, so did the screens. By the 1940s, screens 14.5m (48ft) wide were being used.

Throwing images on to such screens was a trial for any projector. Projectors used for process shots were not merely high-performance versions of regular cinema apparatus, which sometimes allow the image to twitch up and down or from side to side without the viewer's pleasure being too badly affected. Rear-projected images must be held solidly in register with absolute accuracy, since with fixed scenery objects in the foreground, the smallest imperfections in projection will cause supposedly immovable mountains or cityscapes to appear to wander across the screen, shattering the illusion of reality. To avoid this, process projectors use pilot-pin registration: each frame of film is lifted on to fixed pins and held tight before being projected. Large screens were sometimes serviced by several projectors, each of which threw a segment of the background image on to a portion of the screen – the joins being concealed by judiciously placed foreground trees or lamp posts. Large single images could be thrown on to a screen by powerful projectors placed over 45m (150ft) behind it. Such projectors used water-cooling devices to prevent the intense heat of their massive lamps from melting the celluloid film.

As with all composite photography, producing a good union of images depended greatly on the ability of a director of photography to

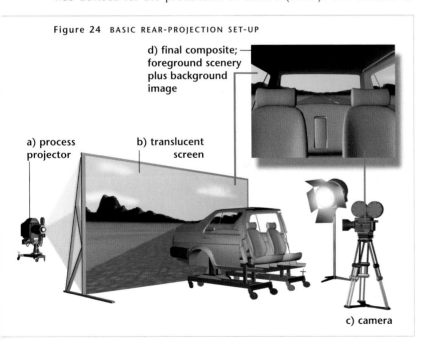

Figure 24 BASIC REAR-PROJECTION SET-UP

d) final composite; foreground scenery plus background image

a) process projector

b) translucent screen

c) camera

reproduce the qualities of the pre-filmed background plate in the foreground action. The focal length of the lens used to film the background must be replicated on the studio camera. The lighting conditions in the background plate must be matched exactly – the human eye can spot the smallest lighting inconsistencies. Matching studio conditions with those of the background was a complex task. When the background images were re-photographed, their qualities would alter somewhat. Re-photographed images tend to gain contrast, so footage for rear projection was printed at a lower contrast than normal.

Done properly, rear projection can produce an almost seamless blend of foreground and background images. Done badly, it can be obvious to even the least sophisticated moviegoer; we have all seen unconvincing driving scenes in which the retreating background scenery appears to bear no relationship to the foreground car and its passengers.

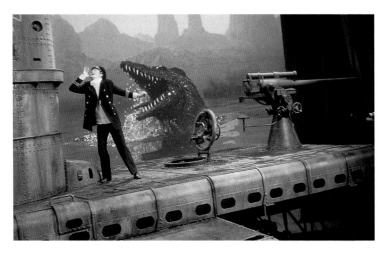

Pre-filmed dinosaur footage was projected behind a studio mock-up of a submarine for The Lost Continent *(1968).*

James Stewart and Kim Novak meet on a rear-projected San Francisco street in Hitchcock's Vertigo *(1958).*

Some of the most successful applications of the technique have been those using it as an integral part of the storytelling process. Alfred Hitchcock was a keen exponent of the method and employed it to great effect in many of his films.

A particularly ingenious application can be found in Hitchcock's

blue-screen had significant advantages over a traditional blue-screen. Normally, the water and wet submarine decks in such a scene would have reflected the blue of the screen and caused blue-spill problems during the compositing process. But in this case, because most of the front-projected blue light was reflected directly back into the camera by the Scotchlite screen, there was not a gleam left to reflect off the water. The principles of Abbott's experiment were later developed into a system called 'The Blue Max', which was successfully used to achieve large-scale composite photography in films such as *2010* (1984).

Scotchlite has been used in a number of films for purposes other than front projection. Much of the Krypton set in *Superman* (1978) was covered in the material to lend it a glowing, ethereal look. The radiant white costumes of the actors in these scenes were also made from Scotchlite. The material has also been adopted by modelmakers, who have employed it to produce glaring spacecraft lights or vehicle headlamps where the use of miniature electric lighting would be impractical or uneconomical.

ZOPTICS

Superman (1978) was also the first film to use an imaginative variation of front projection. The plausibility of the film depended on convincing audiences that Superman was actually flying – like a bird or a plane. Among other means used to get actor Christopher Reeve off the ground was a method developed by optical expert Zoran Perisic, dubbed 'Zoptics' (fig. 26).

Scenes where Superman was required to fly towards or away from the camera could have been achieved by suspending Reeve from wires and physically propelling him over considerable distances. Not only would this have been uncomfortable and dangerous for the actor, however, it was also about as feasible as location filming on the planet Krypton. A large and complex flying rig would have been needed, built over a long distance, with massive lighting set-ups to light the actor through the flight – and a superhero of a camera operator to keep focus on the hurtling man of steel.

The Zoptic system allowed Superman's long flights to be achieved in a small studio without any of these problems. To achieve the effect, both the camera and projector of a front-projection set-up were fitted with matching zoom

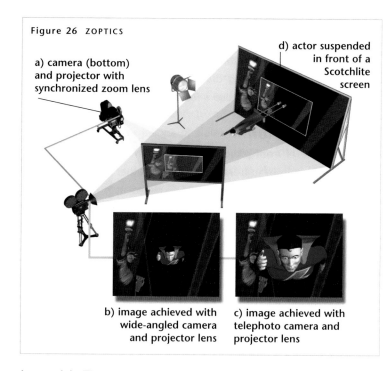

Figure 26 ZOPTICS

a) camera (bottom) and projector with synchronized zoom lens

d) actor suspended in front of a Scotchlite screen

b) image achieved with wide-angled camera and projector lens

c) image achieved with telephoto camera and projector lens

lenses (a). The lenses were both set at the same focal length and electronically linked to zoom in and out in unison. This meant that if the projector lens was used at a short focal length – throwing a large image on to the screen – the camera lens would also be at a wide angle in

Superman (Christopher Reeve) speeds towards another disaster in a Zoptic shot from Superman (1978).

order to photograph the whole picture (b). If the projector lens was altered – so that the image on the screen grew smaller – the camera lens would also change, zooming in to keep the projected image exactly the same apparent size when photographed (c).

With the size of the projected image growing and shrinking on the screen, and the camera lens changing to keep the photographed image the same size, any object placed in a fixed position between camera and screen would appear to be moving, rather than the other way around (d). In this case, Superman was suspended in front of the screen, and as the projected image behind him shrank and the camera's zoom lens followed it, he appeared to fly towards the camera.

INTROVISION

A variation on front projection can be used to place actors *within* pre-filmed backgrounds. In a complex process perfected by the Introvision Corporation, a 2-D projected background can be divided into a number of apparent 'layers', with performers seeming to act 'within' these layers – thus transforming a 2-D image into a convincing 3-D view.

Like all front-projection processes, Introvision (fig. 27) uses a camera (a) and a projector (b) set at 90° to one another with a half-silvered beam-splitting mirror placed at 45° between them (c). This mirror reflects half of the light from the projector on to a Scotchlite backdrop (d), which reflects the light back into the camera. The other half of the light from the projector passes directly through the half-silvered mirror. In other front-projection processes, this light is 'wasted' and is simply absorbed by a piece of black velvet. Introvision, however, makes use of this light by replacing the black velvet with another Scotchlite screen (e), in order to reflect the second portion of the image back to the camera. The camera

therefore receives two identical images, both of which have come from the same source, but have taken different routes back to the camera.

Harrison Ford in an Introvision shot of a crashing model train in The Fugitive (1993).

The technique uses a system of carefully placed male and female mattes (f) such that the images to be returned to the camera from the Scotchlite screens are split into the background (g) and foreground (h) parts of the original projected image. In the final composite (i) the foreground is in effect superimposed on the background so that an actor placed in front of a background (j) can be made to appear as if they are moving about between the background and foreground elements, creating a 3-D effect.

The Introvision process was employed extensively in *Outland* (1981) to combine actors with models of the mining colony of Con-Am 27 and has also been used in films such as *Under Siege* (1992) and *Army of Darkness* (1993). The same

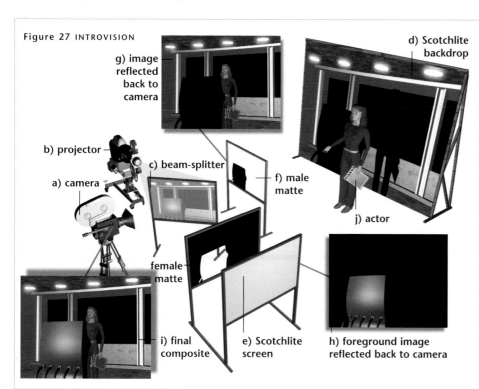

Figure 27 INTROVISION

g) image reflected back to camera

d) Scotchlite backdrop

b) projector

c) beam-splitter

a) camera

f) male matte

j) actor

female matte

i) final composite

e) Scotchlite screen

h) foreground image reflected back to camera

Based on a short story by Arthur C. Clarke, Stanley Kubrick's *2001: A Space Odyssey* (1968) has stood the test of time, remaining one of the most admired and influential science-fiction films ever created. Released to a mixture of critical hostility and frank bewilderment, *2001* acquired an instant cult following and became a considerable box-office success.

Kubrick recognized that the minimalist dialogue and esoteric drama of his film might confuse audiences, and that the power of its visual effects would have to redeem the lack of a conventional narrative. To Kubrick, the Hollywood fantasy of earlier space-travel films was anathema – he was determined that his film would be scientifically accurate and the closest encounter with space travel that audiences might ever experience. To help achieve this vision, the director assembled an effects team that was a unique combination of old-time experience and gifted young talent. For over two years, the team occupied London's Borehamwood Studios and produced the most astonishing special effects that had ever reached the screen.

In the 'dawn of man' sequence, mankind's ape-like ancestors inhabit an arid rocky landscape. The apes themselves used a revolutionary new type of facial mask (223>) designed by Stuart Freeborn who, many thought, deserved an Oscar for his make-up creations (it went instead, ironically, to John Chambers for *Planet of the Apes*). To provide the prehistoric landscape, Kubrick turned to veteran effects supervisor Tom Howard, Oscar winner for special effects on *The Thief of Bagdad* (1940) and *Blithe Spirit* (1945).

Howard persuaded Kubrick to attempt the relatively untried process of front projection, and built an apparatus to project 20 x 25cm (8 x 10in) transparencies of African landscapes on to an enormous 12 x 27m (40 x 90ft) Scotchlite screen. Production designer Ernie Archer constructed a rocky landscape set on a

One of mankind's ancient ancestors in a front-projected landscape in the influential 2001: A Space Odyssey.

revolving platform, which allowed it to be filmed from different angles against the fixed background screen. The composite images are extraordinarily convincing; their fakery can only be spotted in a leopard's eyes, which – acting like Scotchlite – glow eerily as they reflect projected light back into the camera.

To produce the space sequences, an early motion-control system was built to move the camera past fixed spaceship models. Dismissing blue-screen and other travelling matte processes, Kubrick insisted that as much compositing work as possible be done in camera. Producing shots of the model spacecraft with live action inside their cockpits involved filming each model twice. A first pass of the camera filmed the model with its windows blacked out; a second pass then filmed the spacecraft draped in black velvet with only the windows showing. Fitted with a miniature Scotchlite screen, these windows had pre-filmed cockpit footage front-projected into them.

To place the ships in a star-field environment, thousands of hand-drawn mattes were traced and inked by teams of art students before being printed together with photographed star artwork and then combined with the first-generation spaceship footage to produce composites of the highest quality.

Perhaps the film's most startlingly original special effect was the climactic psychedelic light sequence known as the 'Stargate'. Kubrick didn't know exactly what he wanted for this sequence, asking only for his camera to 'go through something'. The task fell to the youngest member of the effects team, Douglas Trumbull (295>). Trumbull devised a system that he called 'slit scan', and spent nine months photographing backlit artwork one frame at a time to produce a streaking rush of colour and light the like of which had never been seen before.

In the thirty years since *2001*'s release there have been many outstanding special effects achievements – often influenced by the innovations of *2001*. However, it is testimony to the vision of its makers that when viewed today, the film remains as convincing as it was then. In the words of the film's own publicity, *2001: A Space Odyssey* remains 'the ultimate trip'.

process thrust Harrison Ford into a shot of a train smashing into an overturned bus in *The Fugitive* (1993). This composite shot would normally have needed complex post-production, but Introvision enabled Ford to defy death 'live' in the studio.

ELECTRONIC ADVANCES

Optically combining separately filmed elements – either by a system of travelling mattes or by front or rear projection – is a time-consuming and ultimately inexact process. Even using highly skilled operators and the most sophisticated equipment, merging images in this way always involves some degree of image degradation and places limitations on creative possibilities.

In the mid-1970s, new developments in computer processing power and digital technology ushered in a new era, since it became possible to combine and manipulate the relatively low-resolution video images used in television production in ways that were previously impossible. In 1973 the UK company Quantel developed a practical system for converting analogue TV signals into digital ones, thereby enabling them to be altered in the digital realm. Audiences around the world saw the TV coverage of the 1976 Montreal Olympic games transformed by early digital processes, which enabled the use of small on-screen inserts. These showed audiences the events from multiple camera angles simultaneously – a dramatic new experience.

In 1978 Quantel introduced the first practical machines that could alter digital television images to produce an array of visual effects. Having watched flat television images for thirty years, audiences began to see their TV pictures turned like the pages of a book, or rolled up like a newspaper. In the 1980s, Quantel continued to create revolutionary tools for manipulating

An example of the 'page turn' effect achieved with a Quantel Mirage system in the 80s.

A shot from the television coverage of the 1976 Montreal Olympics. Multiple angles were achieved courtesy of Quantel's digital technology.

television images and effectively created the market for television graphics. The introduction of their 'Harry' system in 1986 allowed the live multi-layering of video images and the creation of a host of other spectacular visual effects.

Digital technology is an immensely powerful tool for film and television production because it offers complete control over image quality. Film is an analogue medium: it records and stores a representation of the images to which it is exposed through a process of transcription. As light hits the film emulsion, a likeness in one medium is transferred, or transcribed, into another medium. In other words, the physical qualities of the photo-sensitive emulsion on a piece of film are directly altered by the qualities of the light that hits it. Similarly, when an image is recorded on to analogue videotape, light (measured in lux) enters the camera and is transcribed into an electrical signal (measured in volts), which is recorded by physically altering the magnetic field on the tape.

In all analogue systems, transcribing one quality into another quality with a direct physical relationship means that some attributes of the original subject are lost, and degradation of both master and copy is inevitable when further copies are made.

Digital systems, on the other hand, deal purely in abstract numbers. When an image or sound is recorded digitally, its qualities are measured and converted into a series of binary numbers. Binary numbers have only two states: 1 and 0. These can represent on and off, high and low, or black and white, for example, and are the basis of the mathematics used in digital systems and computing.

In digital image recording, light is converted into an abstract string of numbers that have no intrinsic physical relationship to the original image. The resulting digital file, simply a huge string of zeros and ones, can be manipulated by a computer according to mathematical formulae in order to change, filter and refine the information contained in the file. The information can then be copied or transferred repeatedly without any loss of quality because a computer cannot misinterpret a zero or a one and accidentally convert, warp or dilute it.

With the startling progress of digital television technology in the early 1980s, those involved in film production began to seek ways to apply digital techniques to the world of celluloid-based imagery. If a way could be found to process film in much the way that TV images were being manipulated, then the optical printer, with its associated problems and constraints, would be a thing of the past.

Two major problems faced those who wished to use digital technology for the manipulation of filmed images. Motion picture images are of a significantly higher resolution than television images, and an immense amount of processing power and memory is therefore needed to store and manipulate them. Computers in the early 1980s were neither powerful nor cost-effective enough to process and store more than a few frames of film-resolution images. Even if the massive amounts of data involved could be handled, no one had yet devised an economical and efficient way of converting analogue film images into digital information and, after alteration, converting the finished work back into film.

A practical means of getting film images in and out of the digital realm would be the key to unlocking the potential of the computer in the production of film special effects.

THE DIGITAL GATEWAY

Finding an effective way of getting filmed images in and out of the digital realm became the prime goal of a number of people in the mid-1980s. Among them was Dr Mike Boudry, co-founder of The Computer Film Company (CFC). 'In 1984 we realized that there was the potential for using the computer to combine the sort of image manipulation that was emerging in TV production with the tasks that had traditionally been done optically on film,' says Boudry. 'We thought that this could radically change the type of effects that could be achieved for feature films.'

This early multi-shot video image was digitally composited from a number of separately shot images.

However, Boudry and his colleagues quickly discovered that their goal was still beyond the power of the computers of the day.

An operator manipulating and compositing television quality images at a computer console using a graphics tablet and pen.

'We did a few early calculations and realized that the type of computer needed to achieve what we were looking for would have to be much faster than anything available in 1984,' he explains. 'However, computers were evolving so fast that we thought it would only be a matter of time before machines that were affordable and fast enough would become available, so we continued to develop the system that we had in mind.'

'Our goal was to start with filmed images, get them into a computer, manipulate them and then put them back on to film with no loss of quality,' explains Boudry. 'We looked around for anything on the market that could do anything vaguely like what we wanted,' he remembers. 'We found a fairly primitive camera that was designed to scan and digitize printed documents. It turned out to be completely useless for our purposes but we butchered it, found out how it worked, and re-used its useful components in our own film scanner.'

Boudry and his team built one of the first practical film scanners. Their machine, completed in mid-1987, was the computer-age equivalent of the optical printer. Instead of copying images from one film to another, their device converted analogue film images into digital files. 'Our scanner was loaded with the film to be digitized,' explains Boudry. 'A very bright light source then illuminated the whole frame of film, which was focused through a lens on to a CCD [Charge Coupled Device] array. The CCD converted light from the film into electrical signals that were then converted into digital information. The scanner produced digital information at a rate of two megabytes per second – which doesn't sound like much now, but back in 1987 that was pretty awesome.'

The next task was to create a method of recording the digital images held in the computer back on to film. 'We didn't have time to build a proper recorder by the time we started doing commercial work,' admits Boudry, 'so we got a really high-resolution Sony monitor and stuck it at one end of a cupboard and put a film camera at the other end. We basically filmed the finished images directly off

the screen – and the results were surprisingly good. We used to talk in awe-struck tones about our "recorder" whenever we met our

clients, but we never let them anywhere near it in case they noticed it was just a camera and a monitor in a cupboard!' Within a year, the CFC team had built a much more professional device that replaced the monitor with a high-resolution cathode ray tube, which presented digital images to a camera with specially designed lenses.

'By the time we had our scanner and recorder ready, we had developed the hardware and software to manipulate the images,' says Boudry. 'We did our first feature film work for a movie called *The Fruit Machine* [1988].' The low-budget British film featured a character obsessed by dolphins, who in one scene imagines himself turning into one. 'We had footage of the character diving into the water and got some footage of a dolphin in roughly the same position,' remembers Boudry. 'After scanning the two pieces of film into the computer, we used our new software to change the man into the dolphin by producing a sort of mix of the two elements. It wasn't a "morph" [86>] – we called it an "artistic transition". It's quite embarrassing to look at now, but at the time it knocked everybody's socks off.' Boudry is careful to point out that their dolphin shot certainly was not the first digital work to go into a feature film. 'By that time Disney had used digital effects in *TRON* (1982), and ILM had done the digital effects for *Young Sherlock Holmes* (1985). But those films had used digital elements that were produced within the computer and then output to film, before being composited in the old-fashioned optical way. As far as I'm aware, our dolphin shot was the first full-frame digital composite to go into a feature film.'

The experience of Mike Boudry and his colleagues was not unique. In the late 80s a number of companies wishing to work in digital effects independently developed their own scanning and recording equipment. In 1995, the Academy of Motion Picture Arts and Sciences awarded technical Oscars to Mike Boudry and a number of other individuals and companies who had been instrumental in the development of the technology. Today, scanning and recording equipment is commercially produced by a number of manufacturers and can be purchased by any company that can afford the huge sums that such systems cost.

Modern film scanners work on the same principles as the original machine built by Mike Boudry and his team. There are several types on the market, but the Kodak Cineon lightning scanner operated by Cinesite Europe is of typical design. 'Scanning is a very expensive operation,' says Simon Minshall, imaging systems engineer at Cinesite. 'When the first edit of a film has been completed, we get instructions from the editor about which footage will be needed for some sort of digital manipulation. We scan only the footage that is needed – with a "handle" of a few frames either side.'

Once selected, the length of original camera negative is loaded into the scanner, an impressive device that stands inside an atmosphere controlled room. The scanner itself is kept at a positive atmospheric

Figure 32 CRT FILM RECORDER

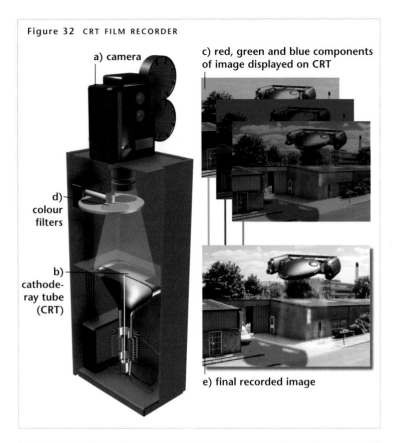

a) camera

c) red, green and blue components of image displayed on CRT

d) colour filters

b) cathode-ray tube (CRT)

e) final recorded image

A red-screen being used while filming a model plane for a shot in Air Force One *(1997).*

A CRT film recorder.

tube (b). Each digital image is displayed on the CRT screen three times – once for each of its three colour components (c). The camera has a set of three coloured filters that mechanically swing in front of the lens during the recording of each image (d). Each frame of film takes approximately twenty seconds to record (e).

Until now CRT recorders have been the most commonly used, but the recent development of less expensive and more reliable lasers seems likely to make the faster and more accurate laser recorders the standard of the future.

It is the cost and time involved in converting filmed images into digital information that at the time of writing prevents many productions from fully utilizing digital technology. When cheaper and faster scanners become available, or if film itself is replaced by digital video as the dominant means of image acquisition, all film makers will be able to exploit the full potential of the computer for image creation and manipulation.

DIGITAL COMPOSITING

A huge range of 2-D processes can be used to manipulate digitized images, but digital technology is also widely used to composite live-action images shot at different times and places with additional elements such as models, matte paintings and computer-generated animation and effects.

Many of the basic principles and processes of optical compositing apply within the digital realm. Elements to be composited still need to be photographed in a manner that allows them to be isolated and re-combined using a system of mattes and counter-mattes. In the optical world, producing mattes is a skilled job in which photochemical processes are carefully balanced to produce an acceptable result. In the digital world, producing mattes is a more automated process, in which operators rely on the versatility of powerful, pre-programmed image-processing software.

Digital mattes

The process of producing mattes digitally is called 'keying', though operators often refer to the process as 'pulling a matte'. As with the production of optical mattes, there are a number of ways to pull a matte on a digital image, depending on the image content and the way in which it has been filmed.

Actors, puppets and models are still filmed in front of blue- or green-screens in order to produce an image that can be easily divided into foreground and background elements after it has been scanned into the computer. Black, red or any other colour can be used as the backdrop for a digital shot, but green or blue is favoured. Green backdrops require less light than other colours to be illuminated sufficiently, so the cost of hiring lighting equipment and operators may be reduced. Blue is still the most popular colour when actors are to appear in a shot, since its extraction during the matting process does not greatly affect a performer's appearance.

To produce a matte from an image with a coloured backdrop *Digital composites now hide any trace of manipulation – even when they contain glass and hair – as in this shot from* The Saint *(1997).* such as blue or green, the operator simply identifies the colour to be removed from the image and the computer software automatically produces a matte. If the foreground element contains blue or green, the software can be instructed to ignore that particular area of the image. Unlike in optical processes, the exact shade and balance of the blue or green backing colour is not critical when setting up and taking a shot. By sampling a few pixels of background colour, the computer can be calibrated to remove only those exact shades. It is therefore quite possible – though not by any means ideal – to photograph a blue object against a blue background, as long as the two blues are measurably different.

As well as background colour, a number of other image characteristics can be used to produce a matte when keying. Among the

most commonly used keying processes is Luma-key – a method that derives its mattes from luminance, a measure of the brightness of a colour. Luminance might be employed to produce a matte of an explosion, for example, where the use of colour might prove difficult, since explosions are likely to contain a wide range of different colours. An explosion is so bright that luminance can be used to separate the explosion from its background.

There are, in fact, a variety of ways to measure the visual information in a scene, and often a number of different keying techniques are combined to produce the perfect matte. For example, it is not always possible or practical to place a coloured screen behind an object that is to be removed from a shot. In such cases, a technique called 'difference matting' may be used. Difference matting requires that two versions of a scene be shot – one with the element that needs to be isolated, and one without. The two shots are then compared with one other by computer software, which can automatically detect the differences between the two images and produce a matte based on the changes. This technique might be used when a large crowd of people filmed in a busy location needs to be removed from its background and placed in another environment. It might also be employed to turn a shot of a busy city centre into a deserted one – as people and vehicles move about the scene, the computer detects the changes in each frame and builds up a shot that contains only those elements that remain the same from frame to frame, such as buildings and roads.

When 'automatic' methods of producing a matte are inappropriate or ineffective, mattes can be produced using the digital equivalent of the traditional technique of rotoscoping. The image from which a matte is to be pulled is displayed on a computer monitor, and an operator using a graphics tablet and a pen manually draws around the objects that are to be isolated

A typical digital workstation at CFC in London. Operators can access digitized film images and choose from an array of image manipulation software.

A modern film compositing suite.

from the scene. By significantly enlarging the image on the screen, pixel-accurate matte lines can be drawn. This task can be semi-automated by hand-drawing the matte lines only every few frames and instructing the software to calculate the matte for the frames in between. Automation usually only works for simple shapes that move in a relatively linear fashion, however, so, more often than not, every matte in a sequence has to be hand-drawn. Such techniques may be used when a complex live-action background plate is to have new elements placed within it. In *Jurassic Park* (1993), computer-generated dinosaurs were inserted into real jungle environments. To place the dinosaurs behind trees and foliage, every single leaf and blade of grass in the foreground of each frame in a sequence was hand-traced to produce a split screen that would give the impression of dinosaurs roaming the jungle.

Compositing the image

Once mattes for each of the elements in a shot have been extracted, the scene can be composited. Starting with a blank 'canvas' on the computer monitor, the operator introduces the elements of a shot, one by one, to build up a new image.

In optical printing, an operator only finds out if a composite has been successful when the final film is developed and returned from the processing laboratory. The smallest mistake means performing the entire compositing process again. Digital compositing, on the other hand, is a non-linear process. If an element needs to be added, changed or removed, the layer in question can be accessed at any stage of the process. Just as with computer word-processing, if the operator wants to try something different, one version of the shot can be saved while a new version is tried. A digital composite will only be recorded to film when the visual effects supervisor and the

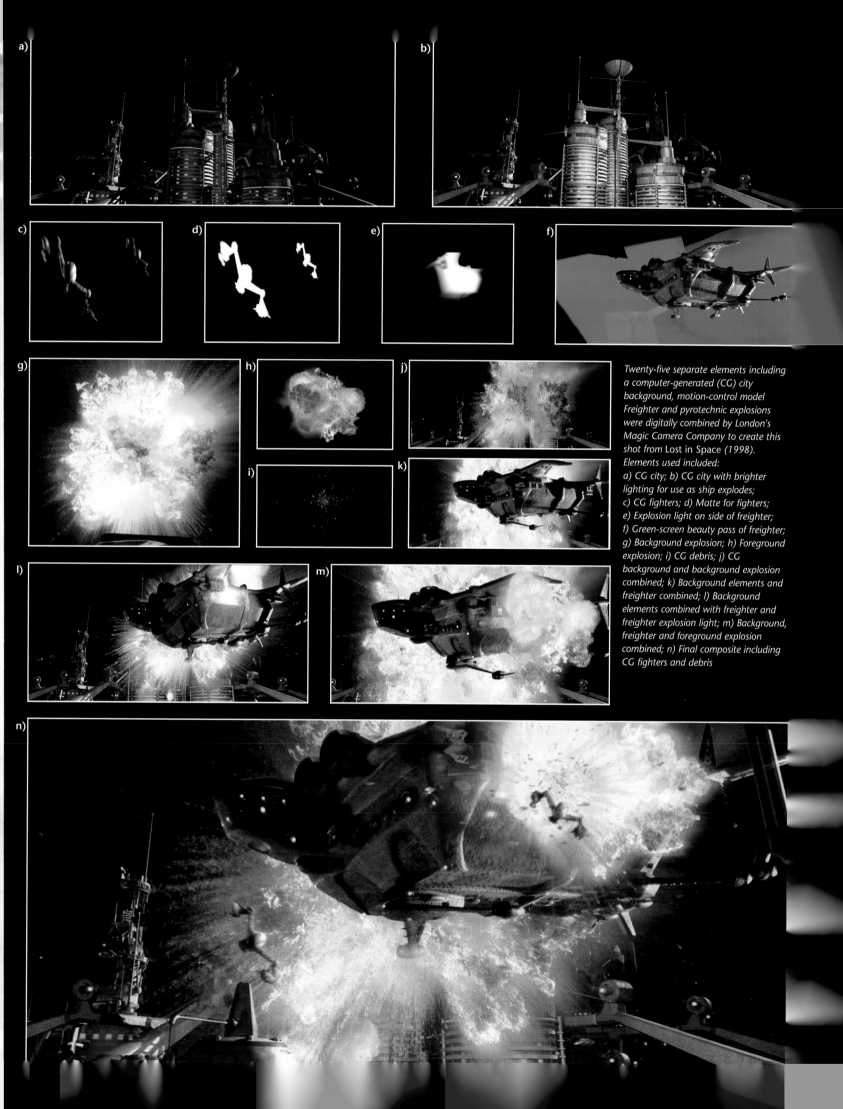

Twenty-five separate elements including a computer-generated (CG) city background, motion-control model Freighter and pyrotechnic explosions were digitally combined by London's Magic Camera Company to create this shot from Lost in Space *(1998).* Elements used included:
a) CG city; b) CG city with brighter lighting for use as ship explodes; c) CG fighters; d) Matte for fighters; e) Explosion light on side of freighter; f) Green-screen beauty pass of freighter; g) Background explosion; h) Foreground explosion; i) CG debris; j) CG background and background explosion combined; k) Background elements and freighter combined; l) Background elements combined with freighter and freighter explosion light; m) Background, freighter and foreground explosion combined; n) Final composite including CG fighters and debris

Most of the images on the television screens in this scene from Crocodile Eyes (1998) *were 'tracked' into the shot during post-production, using the white crosses on the blue-screens as tracking markers.*

The background plate that is to have other 2-D images composited into it is studied for a number of discrete reference points – usually corners of architecture, distinct landscape details or intentionally placed luminous 'tracking markers'. These points, just a few pixels in size, are registered by special tracking software. By automatically recording the movement of these groups of pixels as the shot progresses, their relative motion within the scene can be used to form a 'map' of their movement or of the camera's changing position. A single point is sufficient to keep track of the subject's vertical and horizontal movement, and two points are enough to measure its rotation and spatial arrangement. More points can be used to gather in-depth detail of a complicated camera move so that computer-generated three-

dimensional elements can be added using a process called 'match-moving' (182>).

Once the tracking information of a shot has been obtained, the exact motion can be applied to any element that is to be added into the shot in order to 'tie' the two elements together. This method is commonly used in scenes of spaceship interiors or mission controls, where the camera needs to roam freely while a number of television screens and computer monitors display images. Filming televisions so that their screen images are both visible and synchronized with the main action of a scene is extremely complicated. Instead, such scenes are filmed with blank television screens. As the camera roves around the room, the corners of each television monitor are tracked and the appropriate images are later composited on to each screen.

Removing unwanted objects

Removing unwanted objects from a scene is relatively easy in the digital domain. If it is known during filming that an object will need to be removed from a shot, two versions will usually be filmed – one plate with the object, and one clean plate without it, whatever

The wires used to suspend performers during filming were digitally removed by CFC from this shot from Event Horizon (1997).

change this involves. By layering one image on top of another within the computer, the objects that need to be removed can simply be 'erased' from the top layer to reveal the clean layer below. This makes the rods, stands and wires used to hold up models or suspend stunt performers extremely easy to remove.

If a clean plate is not supplied, wires and rods can be removed in a number of other ways. Moving objects can be removed by tracking their movement as they cross the frame, and then placing clean background information – extracted from the preceding frame in which the object was in another position – into the relevant areas. Thin, stationary objects can be removed by measuring the colour of the pixels on either side to produce new pixels that are of a colour that will 'bridge' the gap. This can be useful for removing electricity pylons and telephone cables from landscapes that are supposed to be historical settings.

Crowd replication

Film makers who wish to film a crowd scene without over-extending their budget (extras have to be hired, transported, fed and costumed, and this can quickly strain budgets) can use a computer to turn an unimpressive collection of extras into an epic cast of thousands. To produce a throng from a small gathering, a shot will be filmed a number of times. In each take, the crowd moves to a different part of the screen, and in order to escape recognition, individuals may swap costumes. During filming, a portable blue-screen may be placed around the edge of the crowd to enable a matte of their edges to be pulled. More commonly, a difference matte will be extracted by comparing the shot with the extras to one without them. Each take can then be combined, allowing groups of people to be layered on top of one another to form a dense crowd.

Warping

Digital images can be distorted in countless ways by using software filters that stretch, displace or combine pixels. This is useful for a number of compositing tasks. To help tie a model spacecraft to a landscape into which it is being composited, for example, the background plate can be reversed, distorted and tracked on to the spacecraft windscreen to create convincing reflections. Similarly, any water contained in the real scenery can have a warped reflection image of a spacecraft tracked on to its surface as the model passes overhead.

If a fire is to be composited into the foreground of a scene, the image on the background plate can be distorted to look as if it is

For this shot in Elizabeth *(1998), flames and smoke were added after filming, and the image was digitally distorted as if filmed through a heatwave.*

being seen through the heat of the flames. A matte of the fire ele-
ments will be used to isolate the area of the background plate that
is behind the flames. This part of the background plate is then
slightly enlarged, blurred and warped, before being placed back into
the composite image to simulate heat distortion.

Morphing

Morphing is one of the few modern special effects techniques to have
become a household word. The technique's striking ability to
metamorphose one image into another was first brought to the
public attention when it was used by Industrial Light and Magic for
the film *Willow* (1988). George Lucas's mythical story required a
character to change seamlessly into a number of different animals
in a single shot. To achieve the groundbreaking effect, a selection of
real creatures and performing model animals were filmed normally
in similar positions; the models were built to mechanically perform
the more extreme alterations that were needed. The animal images
were scanned, and software specially written by Doug Smyth was
used to distort each image into the next and create an extraordinary
blend (Smyth, along with Tom Brigham of MIT, received a technical
Oscar for the development of morphing techniques in 1992).

Morphing is a mathematical process, in which the computer cal-
culates the changes that need to be made to turn one image into
another. To achieve this, the original images in a sequence are ana-
lyzed by the operator to find areas of shared similarity – in the case of
a human head, eyes will be matched with eyes, ears with ears and so
on. A series of curves are created to surround the boundaries of each
of these key areas on the first image in the sequence (fig. 34 (a)).
These boundary curves are then transferred to the second image,
where they are manually distorted to conform to the characteristics of
the new object (b). Having been instructed which areas of one image
are to be merged with the corresponding areas of another, the com-
puter software calculates the necessary changes in colour and shape
that will turn one image into the other over a set number of frames (c).

The sensation caused in the entertainment business by the mor-
phing in *Willow* proved that computer graphics had become a pow-
erful tool in the production and manipulation of images. Morphing
one character into another became an overused trick in films, tele-
vision commercials and music videos in the early 1990s, but has
since become a powerful and subtle tool in the creation and com-
positing of visual effects.

Morphs can be used to change a shot of a movie star into one
of a stunt performer just before a dangerous stunt is performed.
A model spacecraft composited into a sequence can come to land
and be morphed seamlessly into a full-sized prop spacecraft that
has been built on the live-action set. In Kenneth Branagh's *Much
Ado About Nothing* (1993), some
scenes were apparently filmed in
extremely long takes, as the cam-
era swooped over hedges and trees
to follow characters moving around

*ILM morphed the image of
actress Iman into that of
William Shatner to create this
shot in* Star Trek VI: The
Undiscovered Country *(1991).*

Figure 34 MORPHING

a) first subject has boundary lines identified

b) the second subject has the same boundary curves applied and distorted to match new features

c) The first image is converted into the second over a set number of frames

the garden of a Tuscan villa. The aim was to produce the effect of the camera following the characters' every step, so a number of separately filmed shots were subtly morphed into one another, creating the illusion of continual camera movement (167>).

Temporal interpolation

The computer's ability to analyze and interpret images has advanced so much that software is now able to create completely artificial images. If there is a frame missing in the middle of a sequence of images, the software is able to study the frames on either side and create a new replacement. It does this by studying small groups of pixels over a period of several frames. The computer detects the tendencies of those pixels and calculates their changes for the frame to be added. An image made in this way is not simply an 'average' of the frame on either side, it is a completely new and artifical creation.

This technique has been used to restore classic films in cases where frames have been irretrievably damaged or lost. It has also been useful for replacing frames of film damaged by airport X-ray machines. The ability to create new 'in between' frames means that shots can be made to last longer without actually slowing them down. This technique

was used by Cinesite Europe to lengthen a shot in *The Avengers* (1998). The shot of Ralph Fiennes hooking his umbrella on to a tree in order to swing over a puddle was thought to be a little too short, so additional new 'in-between' frames were created and inserted into the sequence to lengthen it.

The opening sequence of The English Patient *(1996) was slowed down and lengthened by using interpolation to create new images to appear between existing ones. This is one of the synthetic images of a brush painting on stone created by CFC.*

To produce a shot of a coronation for Elizabeth (1998) a small crowd of extras dressed in period costumes was filmed in several positions inside a cathedral (top and bottom left).
The group was also filmed from a number of angles on a dressed platform in front of a blue-screen (top right).

London-based effects facility Men In White Coats then digitally composited the elements to create a cathedral full of people. Before the image was complete, the cathedral's modern organ was removed from the shot and the area behind it repaired with pieces of stone and window that were cloned from elsewhere in the image. Stained-glass windows behind the left-hand balconies were also removed. Finally, the setting was made more atmospheric with the addition of a stream of hazy sunlight.

appeared in films such as *Lost in Space* (1998) and *Entrapment* (1999). 'It's easy to ruin good models with bad photography,' claims Stone, 'but good photography can often save the day if the models themselves are not quite as detailed as they could be.'

One of the first considerations when photographing a miniature is depth of field – the distance over which objects within a scene are in focus. Normal motion picture photography usually has a relatively deep depth of field – objects that are in the extreme background or foreground tend to look slightly out of focus or 'soft', but the majority of the action in the middle distance is perfectly sharp.

To help models look full-size, it is necessary to reproduce a similar depth of field in miniature photography to that normally achieved in full-scale photography. 'To photograph models so that they look like full-sized objects, the camera must often get very close to them,' explains Stone. 'If we filmed a full-sized car with a camera 3m [10ft] away from it, we would probably get a shot in which the car and most of the background is in focus. To reproduce this look with a model car that is built at 1:10 scale, our camera would have to be nine-tenths nearer the car – only about 30cm [1ft] away. Then our problem is making sure that we have enough depth of field to ensure that the car is in perfect focus as well as the rest of the miniature set behind it.' Ensuring that both car and miniature background are perfectly focused can prove difficult, since most lenses, when focused on objects extremely close to the camera, will make anything in the background look out of focus – in other words, the shot will have a very shallow depth of field.

Depth of field can be controlled in a number of ways. Lenses with a short focal length (wide-angle lenses, <39) usually produce images that have greater depth of field than lenses with a long focal length. This is convenient for model photography since when cameras have to be close to models, wide-angle lenses are generally used to replicate the look that would be produced by a longer lens on a full-scale set. Depth of field is also affected by the size of the lens aperture. Opening or closing the aperture not only alters the amount of light that reaches the film, it also affects the depth of field. A small aperture allows a small amount of light into the lens but results in a deep depth of field (deep focus). A large aperture lets in a lot of light, but results in a shallow depth of field. To produce correctly exposed deep-focus miniature shots with a small aperture, a model can be lit with extremely bright lights or filmed using a fast film stock, which needs less light to record images than slow stock.

'When shooting miniatures you're constantly juggling the amount of light you use with the speed of the film, the focal length of the lens and the aperture you're shooting at,' says Stone.

© Disney Enterprises, Inc.

WALT DISNEY
presents
"DARBY O'GILL AND
THE LITTLE PEOPLE" (U)
starring
ALBERT SHARPE · JIMMY O'DEA
JANET MUNRO · SEAN CONNERY
KIERON MOORE
Distributed by
WALT DISNEY PRODUCTIONS LTD.

In Darby O'Gill and the Little People *(1959), deep-focus photography made actors in the distance look tiny compared to those nearer to the camera.*

'It becomes quite a complicated equation, but it can make all the difference to the success of a shot. On top of all these factors you also have to consider the camera speed at which you shoot the models. Ordinary films are shot at twenty-four frames per second. If you film a moving full-sized car at twenty-four frames it will look normal, but if you film a model car

CALCULATING CAMERA SPEED

The following mathematical formula can be used to calculate the correct camera speed when filming miniatures:

$$\sqrt{\frac{D}{d}} \times 24 = fps$$

D = dimensions of full-scale object (in feet) d = dimensions of model object (in feet)

FPS = correct speed for filming (frames per second)

$$\sqrt{\frac{30}{3}} \times 24 \cong 76 \ fps$$

For example, to film a scene in which a full-scale truck measuring 30ft in length (D = 30) is represented by a model truck that is 3ft in length (d = 3), the equation would produce a filming speed of seventy-six frames per second:

Therefore a 1:10 scale miniature needs to be filmed at seventy-six frames per second. When the finished film is projected at the standard rate of twenty-four frames per second, an event that took just one second to film will be stretched to a little over three seconds.

at twenty-four frames it will look like a toy car. That's because of the difference between the scale of its size and the scale of its weight.' A full-sized car might be 3m (10ft) in length and weigh around 1360kg (3000lb). A model built at 1:10 scale will therefore be 30cm (1ft) in length, but its weight is likely to be disproportionately small. As a result, models tend to look unconvincingly light-weight when filmed at the usual twenty-four frames per second – a real car will sway steadily as it turns a corner, while a miniature car will wobble and jolt in response to every small bump in the road, just like a toy. To lend miniatures the sense of weight that they lack, they are filmed at higher than usual frame rates (see panel opposite). When the film is projected at normal speed, the small, irregular movements that reveal a model's true weight are slowed down and smoothed out to give a sense of bulk.

To calculate the frame rate at which a model should be filmed, cinematographers use an equation that takes into account the comparative scale of the full-sized object and its model. However, this formula is just a starting point when deciding the speed at which to film a miniature. 'Although working out camera speeds mathematically is helpful to a degree,' says Stone, 'there are lots of other factors

The five-foot mothership in Close Encounters of the Third Kind *(top) seemed enormous as a result of filming in a smoke-filled atmosphere* (bottom).

to consider, such as the lens you're using, what the model is doing, how it's going to be used in the film and so on. You usually end up guessing the best speed based on a mixture of science and gut feeling. When we shot the Jupiter 2 spaceship crash for *Lost in Space* [1998], we had five cameras shooting the 3.7m [12ft] model at between 72 and 250 frames per second. This gave us a selection of

A foreground miniature was used for the bridge and everything below it in this shot from The Living Daylights *(1987). The top of the real bridge in the background is just visible.*

6m [20ft] high. So we built a model bridge over a miniature ravine with a cellophane river at the bottom. The miniature bridge, which was about 6m [20ft] long and 1.2m [4ft] high, was placed about 6m [20ft] in front of the camera with the real bridge about 300m [1000ft] behind it. With everything positioned correctly, real horse riders and tanks moving across the full-scale bridge in the background looked just as if they were actually using the miniature.' Richardson loves to use traditional methods when filming. 'Despite all the amazing things you can do with a computer,' he says, 'simple tricks like these have always worked – and will always work – and they can be cheaper, faster and a lot more fun to create.'

CITYSCAPES AND LANDSCAPES

Since Fritz Lang's *Metropolis* (1926; 101>), models have been used to create the futuristic cityscapes of our dreams and nightmares. Increasingly, however, film makers rely on architectural models to replicate the ordinary world. 'More and more these days we are asked to build models that represent not mythical or alien cities, but the modern cities that audiences know so well, like London, New York and Paris,' says Matthew Gratzner, a partner in Hunter Gratzner Industries, one of Hollywood's leading modelmaking companies.

According to Gratzner, replicating modern cities in miniature is a greater challenge than constructing the cities of alien civilizations or of our own future. 'Modelling contemporary cities is so hard because everybody is an expert on what these places look like,' believes Gratzner. 'We all have a little mechanism in our brain that screams "fake!" when we see something that isn't totally convincing. Often the audience doesn't know *why* a shot looks fake – it just senses that there's something not quite right about it. Building realistic models of everyday environments is therefore about the hardest thing that can be done, and it takes the skill and knowledge of the best artists and technicians.'

For Gratzner, planning the way in which models will be filmed is the first step to take in the creation of successful miniatures. 'We like to approach the filming of models like ordinary first-unit production,' he explains. 'With models it is possible to do incredibly fancy shots with the camera flying around on a crane, but that rarely has any story-telling purpose – it's just showing off. The audience will then instantly realize that there's some sort of trickery going on and it's the effect that becomes the focus of attention and not the story. So we always try to restrain model photography to the normal type of shots that a live-action unit, with all its physical constraints, might produce.'

Once it is known what is required of a model, plans are drawn up for its construction. If the model is of a city or a building that already exists, hundreds of photographs and measurements are taken to

In this shot from Batman Returns *(1992), a full-size actress is suspended above a miniature of Gotham City Plaza.*

help the modelmakers reproduce every detail. 'Once we know the design of a building, we begin to break it down into easily constructed sections. We do this for several reasons,' explains Gratzner. 'Firstly, the models may be filmed many miles from where we manufacture them, so they often have to be made in sections and then transported to the studio for assembly. At the studio, each section of building is affixed to a custom-built steel frame designed to make the model structurally sound. Secondly, we always study a building for any repeated patterns. Once we've identified parts of a building that are the same – usually brickwork or sections of façade – we can model them, then create a mould and cast as many copies as are

Many scenes of Gotham City were reproduced in miniature. For long-shots, minute models of people were moved with wires from below the set.

needed to make up the whole building. When you only have eight weeks to produce a block of buildings, finding techniques like this becomes really important.'

Wood, metal, foam and plastic can all be shaped and sculpted to produce the repeatable parts of a building. Most materials, other than metal, can be cut using a computer-controlled laser to create the precise design required. Once completed, the cut-out design is covered with liquid rubber, which sets to form a mould that can be peeled off. The completed mould can then be filled with the type of material needed to produce an exact copy of the required design.

'We fill the moulds with different types of plaster, fibreglass, resin or foam, according to what is required of the final buildings,' explains Gratzner. 'Fibreglass and resins will produce a lightweight and strong shell that is suitable for many types of building. However, the models we make often have to be destroyed in the film, so we use materials that, when exploded, will produce many tiny chunks that are the correct scale for a building of that particular size.' To produce a building that will blow up realistically, its façade is moulded from specially mixed plaster. 'Destructive plaster is made up with baking soda, sawdust and any other materials that make it light, brittle and crumbly when set,' explains Gratzner. 'This mixture ensures that the models will blow up perfectly, but they can become so fragile that they are a real pain to work with.'

This miniature building from X-Files: The Movie *(1998) was constructed pre-destroyed. Each room was filled with miniature office furniture and even scaled-down pieces of paper.*

Models to be destroyed also have to have some sort of interior that will be revealed during the explosion. 'We often build one layer of rooms around the inside of a building and fill them with miniature furniture, fittings and carpets,' explains Gratzner. 'Then, at the edge of the floors and ceilings, we fit twisted miniature I-beams, joists, air-conditioning ducts and so on, as if the front of the building had been blown off and all this stuff has been left exposed. Once this pre-destroyed interior has been arranged and filled with dust and debris, we carefully place the façade of the building over the front and prepare it for destruction with compressed air or miniature pyrotechnics [102>].'

Once built, the exterior of the building is painted. 'Painting is one of the most vital parts of model construction,' stresses Gratzner. 'It makes a building the correct colour, but also gives it authenticity and character. Woods, metals and other materials may have been reproduced in plaster, so they need to be painted to look like the correct material. Then, once all the colours are correct, we begin the vital process of ageing and weathering.'

A model of New York's famous Flatiron building is positioned for use in Godzilla *(1998).*

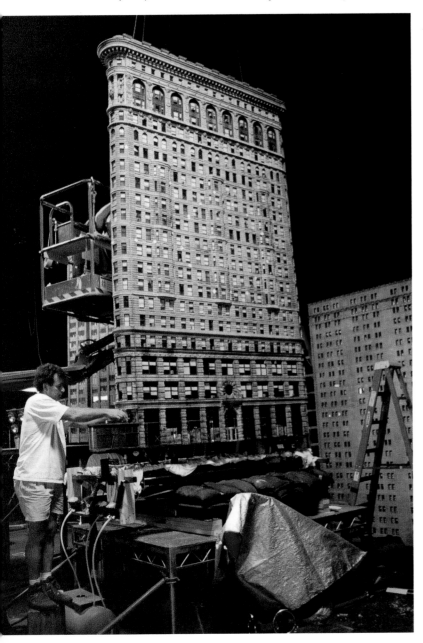

Nothing in the real world is perfectly clean. From the moment an object comes off the production line, it becomes dirty, greasy and imperfect. For Gratzner, these imperfections are vital in persuading the audience that what appears on the screen is the real thing. 'In the real world most objects are pretty dirty,' says Gratzner. 'Absolutely everything is affected by environmental elements such as rain, wind, dirt, smog, smoke or the sun – and we paint all of that into our models. Whenever I look at buildings I see the way that rain-water has stained the brickwork, or how the corners of the windows have been missed by the window cleaner. Most people may never notice this kind of detail, but if it's not in a model, that little voice in their head will shout "fake!"'

Gratzner's obsession with the limitations of the real world is observed throughout the modelmaking process. 'Straight lines are another thing that rarely occur in real life,' he claims. 'We all think that skyscrapers are about the most regular, perfectly angular buildings that it's possible to find, but if you stand at the foot of one of those buildings and look up at them, you'll see that the lines that should go vertically upwards actually wobble all over the place. We try to replicate that in our models. What's more,' Gratzner adds, 'if you stand at the right angle to the light, you'll notice that what you would assume are perfectly flat sheets of glass are actually rippled. Each sheet of glass used on these buildings is so huge that it bulges under its own weight, so we try to reproduce that by using sheet acetate that has similar kinds of ripples in it.'

The scale to which miniature cityscapes are built depends on a number of factors. 'There are mathematical ways of working out what scale buildings should best be built in,' says Gratzner, 'but the biggest factor in deciding a scale is practicality. If you're building a vast city, you could build the whole environment with every building at the same very small scale, which might make good photography difficult,' explains Gratzner. 'Or, you could build the whole city from very large models and then hire the world's biggest stage to house it all. Alternatively, you could work out which angles you were going to shoot from and build the models in that area a good size and have them get gradually smaller from then on.'

'Forced perspective' models were used in theatre set design long before cinema was invented, and the method still proves a useful way of fitting an apparently enormous city on to a small stage, while saving time and money in construction costs. 'In a forced perspective shot we diminish the scale of buildings the further they get from the camera,' explains Gratzner. 'We might have 1:8 scale buildings in the foreground with every little detail perfect, then a couple of blocks further down we might go to 1:10 scale and the buildings will have a little less detail. The buildings will carry on getting smaller, and with each step down in scale, we will take a step down with the detail. Nothing makes a model look less convincing than too much detail on distant objects,' believes Gratzner. 'If you look into the distance in a real city, you can see buildings but you can't make out actual

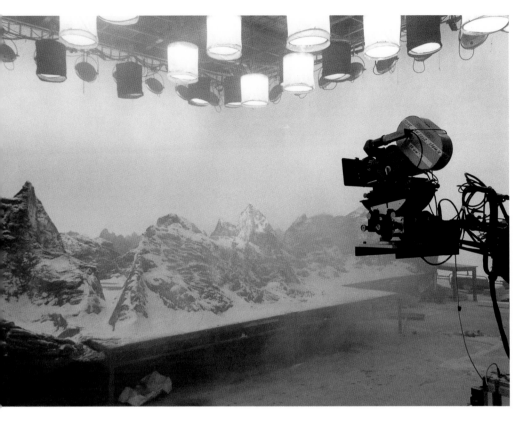

to manufacture sections of architecture are of limited use when building models of landscapes. A pattern can only be reproduced a small number of times before the repetition is spotted by the viewer.

'Making miniature versions of anything that Mother Nature makes is hard, so we often look to the real world as a source for our materials,' explains Granell. 'It's surprising how many real objects nature already reproduces in miniature. Many full-size trees can be represented by using immature or dwarf varieties – especially fir trees. Some houseplants even make good tree stand-ins. We sometimes buy varieties of real grass and these can be laid into the foregrounds of landscape models before filming,' says Granell. 'If the grass grows too long during filming, it can be trimmed or replanted with a younger batch. For smaller scale grass in the middle and far areas of a landscape, there are a number of types of moss that look surprisingly grass-like.' Borrowing from nature does

A mountainous miniature landscape created by the Magic Camera Company for Hamlet *(1996).*

details, just suggestions of detail. Colours also get less defined the further away objects are. We might build a city with exquisite models in the foreground and end up arranging grey and lavender coloured shoe boxes in the distance. For the most distant buildings, we will often just use black-and-white photos of the foreground buildings stuck on mounting board and cut out to produce 2-D silhouettes.'

LANDSCAPES

Rebuilding the cities we see every day is difficult, but reproducing natural landscapes can be equally challenging. In many respects, imitating nature in miniature is more complicated than producing scaled down versions of man-made objects. 'Copying nature can be extremely hard,' says José Granell, joint director of The Magic Camera Company and one of the UK's leading modelmakers. 'Unlike buildings that are man-made, scenes of nature are totally random,' points out Granell, 'and modelling randomness is a surprisingly tricky thing to do.' Since nature is so random, the production-line techniques that can be employed

not stop at foliage; soil and rocks can also be used. 'Pebbles are basically boulders in miniature,' says Granell, 'and there are all sorts of gravels and sands that can be used for boulders as well.'

English effects master Derek Meddings, whose work included the British television series Thunderbirds *as well as many James Bond films, sits in a miniature landscape created for* GoldenEye *(1995).*

In this dam-bursting scene from Earthquake (1974), the scale of the model is given away by the unconvincing look of the water and the oversized grass.

Often nature just isn't enough, however, and a miniature natural world has to be created using artificial materials. 'For *The Avengers* [1998], we had to model a number of miniature landscapes such as the Serpentine lake in London's Hyde Park,' explains Granell. 'The park features a range of fully grown classic English trees such as oaks and chestnuts – and there's nothing else that looks like that.' The trees for this sequence were made by painstakingly sculpting each trunk and branch in clay, making moulds, and using the moulds to produce foam rubber castings. Each tree was constructed with a flexible wire frame inside the foam rubber body so that, during filming, the smaller branches would sway realistically in the wind. After being painted, the trees were given plastic or paper leaves. Once planted, the fake trees were supplemented with an undergrowth of real dwarf trees, shrubs and artificial grass, which comes in an amazing variety of types and sizes.

Producing geological features such as rocks and mountains is a case of being creative with plaster. 'We used to carve mountains out of blocks of polystyrene,' says Granell, 'which made transporting sets very easy, but it wasn't very environmentally friendly. Now we use plaster for most things. Plaster can be moulded over basic wood

and chicken-wire frameworks while wet, then carved and shaped when dry. We have people who are very good at reproducing the look of various types of stone at all different scales. The plaster is then painted and, of course, aged and weathered – the most important part in making a model look genuine.'

Whenever possible, Granell likes to film models of natural environments in the open air. 'The sun really is the best light to use when filming anything that's meant to be outside. There are so many things about the real sun that are hard to replicate artificially, but relying on the sun can be inconvenient because it limits shooting to daylight hours and means depending on weather conditions. By shooting outside, models also benefit from genuine skies with moving clouds, though the back of a miniature set often has to be raised on ramps to obscure a horizon that is littered by trees, buildings and power lines. There is also the danger of the unwelcome intrusion of birds and aircraft when filming outdoors.

Like many others involved in special effects, it is the challenge of deceiving the viewer that attracts Granell to the world of model-making. 'With high-quality model construction and good photography, an audience today may never know if they're looking at a shot of a Russian mountainside taken from a helicopter or a shot of a model filmed in a field outside London,' he says with satisfaction, 'and I find that a great challenge.'

Despite the struggling economy of mid-1920s Germany, the country's giant film studio UFA (Universum Film Atkien Gesellschaft) embarked on a series of ambitious and expensive productions directed by the expressionist film maker Fritz Lang (1890–1976). After the success of *Dr Mabuse* (1922), a brooding thriller in which an arch-criminal leads a gang of murderers in a series of crimes, and *Die Niebelungen* (1924), the tale of legendary German hero Siegfried, Lang took a trip to the United States to learn about American production techniques. While sailing through New York harbour, Lang gazed at the Manhattan skyline and conceived the idea for his next film, *Metropolis* (1926).

Metropolis was the first great science-fiction feature, a futuristic *tour de force* that established many of the themes and motifs that we expect in the sci-fi movies of today. The film contrasts the lives of the ruling classes, who frolic in the luxury of their utopian skyscrapers, with the underclasses who toil below ground to keep the massive machines of industry in production. The story of *Metropolis*, with its simplistic themes and sentimental romance, today seems rather weak, but its images of a great city whose citizens are divided by their status remain powerful.

It is the image of the great futuristic city of Metropolis itself – towering, gleaming and optimistic – that remains most striking and influential. Endless streams of smoothly flowing traffic fill the wide streets, sky-bridge railways swiftly transport people from block to block, while bi-planes glide through the man-made canyons of buildings. The city is more fiction than science, however, and Lang, who trained as an architect, must have known that the updraught around such huge buildings would make it impossible for light aircraft to fly around them. The film's prediction of television and videophones (achieved through rear projection; <66) was more prophetic, however.

Part of the underground city, the machine room and the Cathedral Square were built full-size and populated by some 30,000 extras. These full-scale sets were built on UFA's giant stages, and special watertight walls were built around them to contain the thousands of gallons of water that were unleashed by dump-tanks for the climactic flood scenes. However, most of the city was conjured using matte paintings and models (200>), cleverly combined with live action by cinematographer Eugene Shuftan (<90).

The film's other major contribution to the science-fiction movie genre was Maria. Built by mad scientist Rotwang, Maria (like many of her descendants, created by an actor wearing a very uncomfortable suit) was the first memorable robot to appear on screen.

After eighteen months in the making, *Metropolis* was a financial disaster and almost bankrupted the studio that produced it. It was, nevertheless, the greatest effects achievement of its age, and set a trend for futuristic cities that has reverberated through the decades since its creation. Several years later the American musical *Just Imagine* (1930) produced a direct (though inferior) copy of the city of Metropolis, and its classic design has influenced the cityscapes featured in films such as *Blade Runner* (1982), the *Star Wars* series (1977, 1980, 1983) and *The Fifth Element* (1997) – among many others.

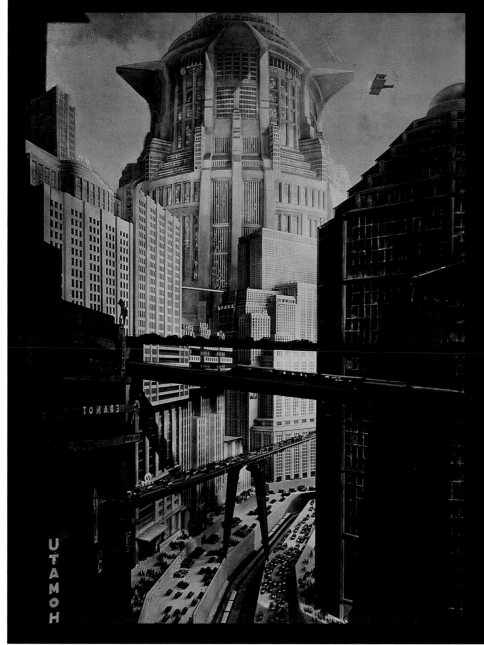

MINIATURE PYROTECHNICS

For many people, high-octane action is what going to the cinema is all about. Big explosions are one of the most important ingredients in any modern action-adventure movie but, ironically, the biggest explosions to engulf our screens are usually created in miniature. Miniature pyrotechnics are used in film making for many of the same reasons that models are used – blowing up real buildings and vehicles would be time-consuming, expensive and, most of all, dangerous.

'Every kid wants to blow things up,' says Academy Award winner Joseph Viskocil, one of Hollywood's leading miniature pyrotechnicians. 'For me, the inspiration was the Saturday morning serials made by the Lydecker brothers [117>], and the Gerry Anderson puppet shows like *Thunderbirds*, which had a different explosion every week. As a kid I didn't know these things were done in miniature; I thought they were out there blowing up a new warehouse every week. When I discovered it was all models, I decided that was what I wanted to do.'

Viskocil's work on a project begins by discussing what type of explosion is required with the film's director and visual effects supervisor. 'What the explosion must do, and what it must look like, will affect a number of factors,' explains the pyrotechnician. 'It can influence the way a model is built, the way it is filmed, and what type of explosives and chemicals I will use for the job.'

Filming explosions on the Death Star surface for Star Wars. *The camera is sliding down a wire (far right) to produce a pilot's-eye view of the havoc.*

Once plans for a shot have been confirmed, Viskocil works with the film's modelmakers to make sure that the miniature to be destroyed is built to the correct specifications. 'A model for destruction is quite different to one that is used for normal shooting,' he explains. 'Most models are built to look good and perform, but destruction models must look good *and* blow up convincingly – it's a very different thing.' While most models are built to survive the rigours of filming, destruction models must be designed to come apart in all the right places when detonated. The way that a building comes apart is largely dependent on the materials used for its construction. 'The material a model is made of is very important,' states Viskocil. 'Plastics may be no good because they may just melt; on the other hand, metals might not break apart so well. When it comes to buildings, plaster is the best material; it blows up in nice chunks that can be controlled by the consistency of the plaster that is used. It can look totally convincing.'

Once a model is built, Viskocil takes it apart again. 'Models that explode have to be *told* how to explode,' states Viskocil. 'If you just rig a model with explosives, there's no telling what it might do, so we weaken them first.' Simply obliterating a model can be visually uninteresting, so by scoring and pre-weakening it, the model's destruction can be engineered so that particular parts break away or remain intact.

Viskocil also considers the way in which an explosion should be filmed. 'The speed we choose to film at will depend on the size of the model and what it will be doing,' he says. 'Most model explosions are

made to appear orange, red, blue or green. 'For the tie-fighter explosions in *Star Wars* [1977], I produced green explosions using gasoline and powdered zinc,' remembers Viskocil. 'George Lucas had specifically asked for green because he said it represented all the money that was being blown on the film!'

Surprisingly small quantities of gas are needed to blow up miniatures effectively. Blowing up the 2m (7ft) model gas tanker in *The Terminator* (1984) involved just 7 litres (1½ gallons) of gas to create the apparently huge ball of fire seen in the film. Additional ingredients can be mixed with the gas to produce other effects. Adding titanium powder results in a shower of silver-blue sparks; gold sparks are produced using iron filings. 'I produced a really nice sparky explosion when we were shooting some test explosions for *Star Wars*,' recalls Viskocil. 'When we watched the results the next day, someone saw this explosion and said, "That's the one we'll use for the Death Star!" I'd never even heard of the Death Star by this point so I didn't know what they meant, but that explosion was the one that they used at the end of the film.'

Gasoline explosions are frequently achieved using a mortar – a

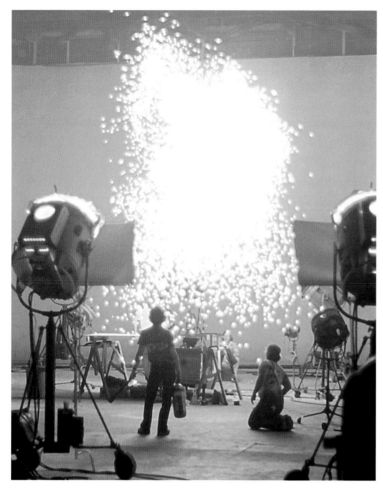

Joe Viskocil's Death Star explosion for Star Wars.

done at about 96 or 120 frames per second, which will normally make an explosion look pretty good. Generally speaking, the smaller the model, the faster we will film it.' Camera position must also be considered. Most explosions are filmed with two cameras, though more are used for shots that can only be filmed in one take. 'You have to make sure you've got all the angles covered,' explains Viskocil. 'It's not so important with things like aeroplanes, because the modellers usually make a number of copies, but with a big building like the White House that I destroyed for *Independence Day* [1996], you're talking about blowing up models that cost tens of thousands of dollars each – sometimes hundreds of thousands. You don't want to have to ask them to go build you another if you get it wrong!'

As the shoot approaches, Viskocil prepares the explosives themselves. 'The first thing I will consider is safety. The work I do could easily kill, and no one should try anything like this without an awful lot of experience and technical know-how,' explains Viskocil. 'After considering the safety aspects of a shot, I will work out what the explosion needs to look like and which explosives will achieve that look. There are basically two types of explosion that I use,' he explains. 'One is largely cosmetic; it produces lots of fire and sparks. The other type of explosion is purely destructive and is used to rip things apart physically.'

Gasoline is the basic ingredient used to produce billowing clouds of fire. By adding other chemicals to the gasoline, explosions can be

Joe Viskocil prepares a miniature version of the White House for destruction in Independence Day. *The yellow and black rope is explosive Prima-Cord.*

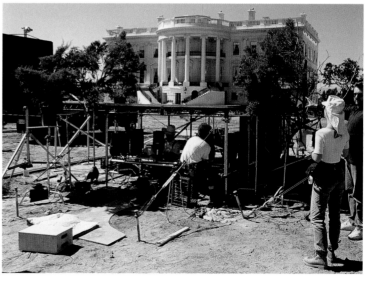

103

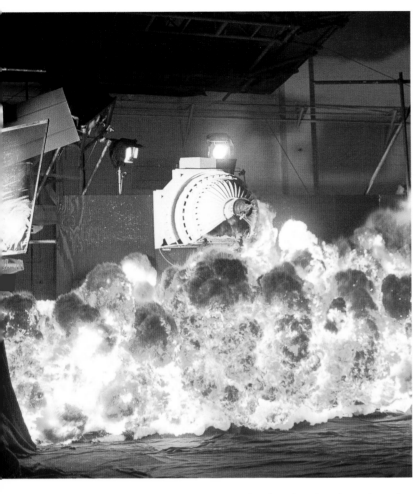

Filming the destruction of Capitol Hill for Independence Day. *The film camera is looking down from above, as the dome is engulfed in fire.*

over from the modelling process – is the last thing placed in the mortar, so that it will be projected outwards to produce chunks of wreckage that are silhouetted by the ball of fire behind it.

For gas explosions in the zero gravity of space, pyrotechnics are filmed in a high-ceilinged building. The camera is placed on the floor pointing up at the explosive device that hangs from the ceiling; and after detonation the cloud of combusting gas and sparks propelled towards the camera seems as if it is travelling outwards in the vacuum of space, while the unwanted smoke rises to the ceiling, concealed by the explosion in the foreground.

To physically destroy objects, an explosive rope called Prima-Cord, also known as Det-Cord, is used. Prima-Cord can be wrapped around, or threaded through, objects, and when detonated by an electrical charge, explodes at a speed of 6,700m (22,000ft) per second. 'It's a strange substance,' remarks Viskocil. 'You can carry it around in rolls like normal rope and even throw it into a fire and it won't explode, but if you hit it with a hammer, you can say goodbye to your hand.'

Detonating explosives is a job that requires considerable planning. 'Normally we may have a dozen or more explosions in one shot,' Viskocil explains. 'Usually we film at around 120 frames per second, and the average explosive shot may need to be on screen for two, maybe four seconds. At 120 frames, a four-second shot will actually take about three-quarters of a second to film, so we may have dozens of explosions going off in less than a second – it gets pretty complicated!' The exact order in which a sequence of explosions should be detonated is calculated carefully, taking into account the varying speeds at which different charges will explode and the position of each camera. If an explosion near the camera were to go off before those in the distance, the foreground explosion would obscure the background action. Once a shot has been planned and wired, a test is conducted using flash bulbs in place of explosives. The sequence of flash

metal tube that is planted at the point where the explosion has to appear. 'A mortar is used to shape an explosion,' explains Viskocil. 'Ultimately all fire will always go upwards, but using a mortar you can bully an explosion and force it in the direction you want it to go.' A detonator is placed at the bottom of the mortar, and on top of this goes a polythene bag containing the gas and other chemicals. Debris – usually bits of material left

Joe Viskocil (below left) preparing a model gas tanker for destruction in one of the climactic sequences from The Terminator *(1984). Below: the explosion itself.*

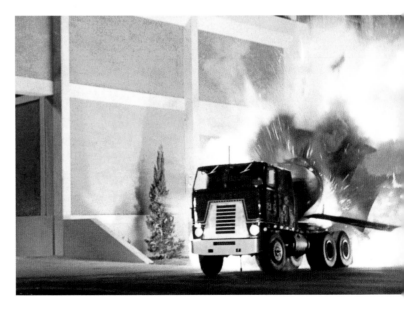

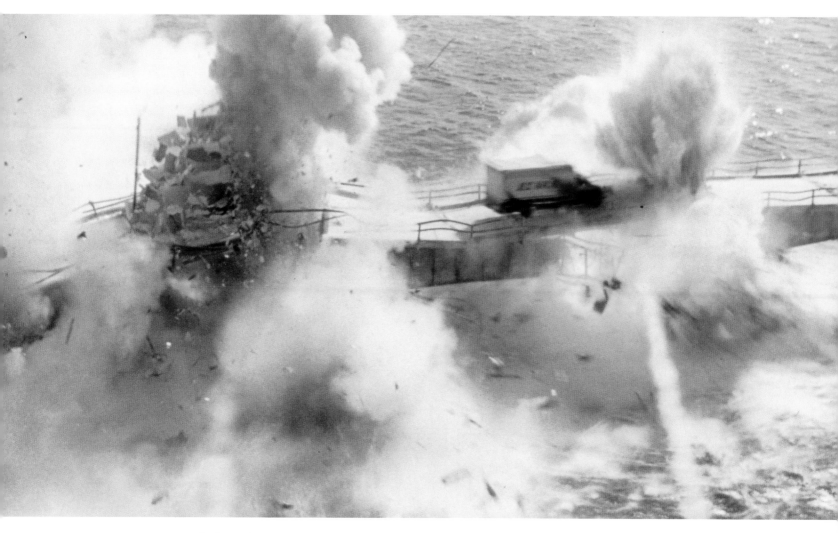

bulbs is filmed at the correct camera speed and the result studied to make sure that each 'explosion' is in the right place at the right time.

Once tests have been approved, the shot can be filmed. All of the wiring and mortars are already in place, so setting up the shot is a matter of installing the pre-prepared charges. Each charge is linked to an electronic firing box that can detonate the explosives at intervals of anything from one hour to one thousandth of a second. 'We do a lot of checks and rehearsals before setting off an explosion,' says Viskocil. 'Everyone has to know the exact running order. We deal with potentially lethal events, so if, at any point during a shot, I have the slightest doubt about anything, the whole thing will be shut down – even if there are tens of thousands of dollars at risk. Safety is number one on the set – there's no two ways about it.'

When asked about his favourite shot in his thirty-year career, Viskocil is quick to respond. 'I received an Oscar for *Independence Day*, and the shots of waves of fire sweeping through New York were pretty innovative, but the shot I like best is from *True Lies* [1994],' he admits. 'It's where a truck is travelling across a bridge and the bridge is blown up by missiles. The shot was filmed down in the Florida Keys using a model bridge in shallow water. Everything

Top: *A miniature bridge explodes in* True Lies. *The computer-generated missile trails were added in post-production.* Right: *Joe Viskocil prepares the miniature bridge in the shallow water of the Florida Keys.*

about that shot worked so well that most people are convinced that it's a real bridge being destroyed. When I look at shots like that one, I realize what a great job I have – people actually pay me to blow stuff up. What school kid wouldn't want a job like that?'

105

HIGH-SPEED PHOTOGRAPHY

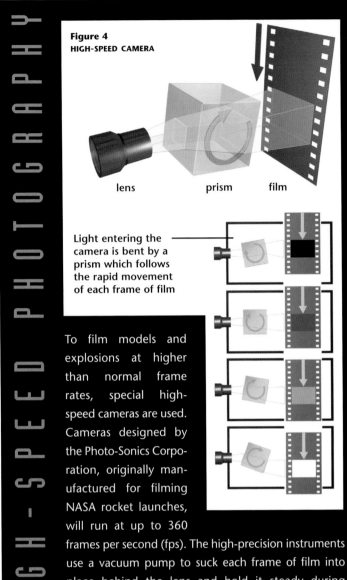

Figure 4
HIGH-SPEED CAMERA

lens prism film

Light entering the camera is bent by a prism which follows the rapid movement of each frame of film

To film models and explosions at higher than normal frame rates, special high-speed cameras are used. Cameras designed by the Photo-Sonics Corporation, originally manufactured for filming NASA rocket launches, will run at up to 360 frames per second (fps). The high-precision instruments use a vacuum pump to suck each frame of film into place behind the lens and hold it steady during exposure. The cameras have to be operated by specialist engineers who lubricate the moving parts between each shot.

An even faster Photosonics camera can film at an incredible 2,500 frames per second, making a one-second event last over 100 seconds when projected at the normal 24fps. At this speed, it is impossible to hold each frame still for exposure, so a spinning prism is used to bend the light from the lens and project it on to each frame of film as it passes.

High-speed cameras take a few seconds to attain the right speed, and so could waste hundreds of feet of film before anything useful is filmed. To avoid this the camera is brought up to speed before the film is released through the camera at a rate of 5m (16½ft) per second. Jams sometimes occur when filming at this speed and the cameras have even been known to explode. Such high speeds are normally reserved for filming small but intense explosions, which look massive and slow moving when projected at normal speed.

PHOTO CUT-OUTS

2-D images have been used to simulate 3-D reality in movies ever since George Méliès (<12) painted *trompe l'oeil* spacecraft and settings for films like *A Trip to the Moon* (1902). The method of using 2-D photo cut-outs to create apparently 3-D sets has proved a useful and labour-saving one ever since.

Responsible for the effects in many of the low-budget Hammer horror films of the 50s and 60s, British effects artist Les Bowie (1913–1979) spent much of his career achieving convincing effects at rock-bottom prices. For the production of films like the Bulldog Drummond adventure *Deadlier Than the Male* (1966), and the classic thriller *The Face of Fu Manchu* (1965), Bowie did not have the budget to construct and destroy the miniature buildings that were called for in the scripts. To solve his problem, Bowie photographed real buildings and produced large prints that were cut out and arranged to look 3-D. Bowie then attached small explosive charges to the back of the photographs and filmed them as they detonated. Judicious editing prevented these shots lingering on screen long enough for the deception to become too apparent.

More recently Robert and Dennis Skotak have used photo cut-outs to great effect. 'While filming *Aliens* [1986] we had a pretty tiny budget to produce over 150 effects shots, so we were always looking for ways to do shots effectively but cheaply,' explains Robert Skotak. 'For shots of the spaceship cargo lock we built only the walls nearest to the camera as 1:12 scale miniatures. Then we went over to the sound stages and photographed the full-size sets and various props like the power-loader, and used those 2-D photos to produce the background for our miniature.'

For *No Escape* (1994) the Skotaks used photo cut-outs to produce shots of far more down-to-earth flying objects. 'We needed to produce a shot looking up at the underside of a helicopter as it flew over a facility,' explains Robert Skotak, 'but we didn't have the time or budget to use a real helicopter. Instead, we took a photograph of the underside of a model helicopter that we were using for some other shots. We then stuck that photo on to a sheet of glass and glued a few 3-D model parts on to it to give the picture more depth. On the other side of the glass we attached a disc of perspex on which we drew grease-pencil blurred streaks to represent the moving rotor-blades. The disc was attached so that an out-of-shot airline would blow on to it and cause it to spin. Then we set up our camera to look up at the futuristic buildings of the real life facility and simply moved the sheet of glass across the front of the lens. The finished shot looks just like a real helicopter is passing overhead, and because it's such an ordinary type of shot, no one would ever imagine that it's a special effect.'

Simple photo cut-outs have even been used in the most cutting-edge digital productions. For *Titanic* (1997), the Skotaks were asked to produce a view of the doomed liner as seen from the window of a dockside pub. 'We took several photographs of the 13.5m [44ft] model that was being used for many of the effects sequences, and glued them together to produce one huge 5m [17ft] photo of the

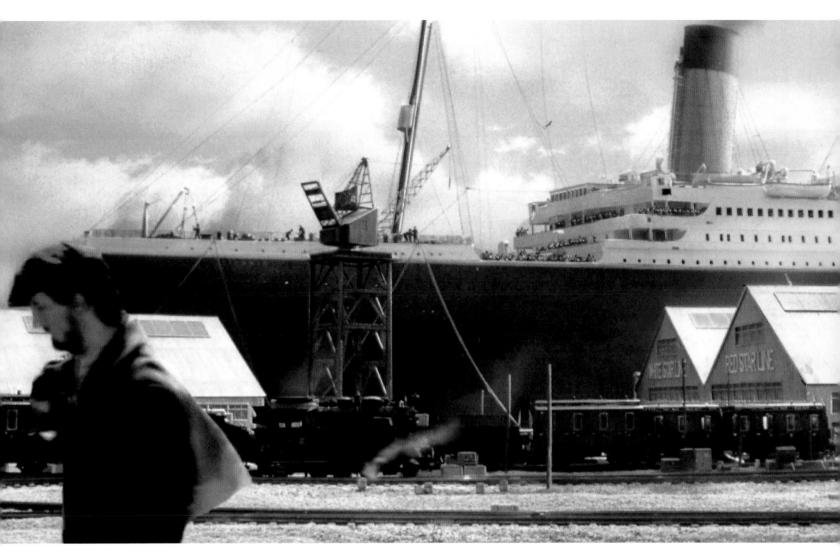

ship,' explains Robert Skotak. 'That giant photo had to be touched up a bit since the model used for filming was in several sections and a bit worse-for-wear by the time we photographed it. The main body of the photo cut-out ship looked quite convincing, but the rounded funnels looked a bit fake from the oblique angle that we were filming from, so we cut them out separately and angled them so that they looked more convincingly 3-D from the position of the camera. Then we dressed the photo with real model masts and rigging to give a better sense of depth.'

As well as the Titanic itself, the surrounding dockside area was also partly re-created using photo cut-outs. 'We built detailed miniature warehouses and needed to put some railway carriages in front of them,' says Skotak. 'We purchased some large European hobbyist trains, but these were very expensive – even for the budget of *Titanic* – so we photographed the models, then scanned them into the computer where we retouched the pictures to produce a number of variables such as wagons with open doors and windows and so on. We then printed out these photos and mounted them on cards which we added to the model to produce a much more impressive-looking railway yard.'

To finish the shot, the Skotaks resorted to digital technology. 'We now find that the computer is a really useful tool for helping us to achieve the last ten per cent of an image that used to take us a disproportionate amount of time to get right during actual filming,' comments Skotak. 'Now we can spend more time making sure that we get the lighting right on the model and it doesn't matter too much if any bits of equipment stray into a shot because they can be removed digitally later on. In the *Titanic* dockside shot we digitally tweaked the ship's tonal values to make it look more realistic, and we added a plume of steam coming out of one of the funnels.' The Skotaks then digitally composited the photo cut-out shot into the live-action pub sequence in which Leonardo DiCaprio wins tickets for his trip on *Titanic*.

A photo cut-out ship sits behind model buildings and photo cut-out railway carriages in Titanic (1997).

BATTLESHIPS AND SEASCAPES

The maritime history of the movies is a long one. As early as 1898, J. Stuart Blackton and Albert E. Smith of the Vitagraph Company were sailing cardboard cut-out ships on improvised ponds to re-create the *Battle of Santiago Bay* (1898). Their later depiction of the Battle of Manila is said to have been so convincing that even naval officers present at the real conflict mistook the film for documentary footage.

DENNIS AND ROBERT SKOTAK

Growing up in Detroit, Dennis Skotak (1943–) and his brother Robert (1948–) were influenced at an early age by a Saturday matinee screening of George Pal's (<26) classic film *Destination Moon* (1950). The boys became obsessed by space travel and sci-fi movies. To re-live their favourite movies, the two took photographs of scenes featuring home-made model spaceships. Taking photographs soon turned into making movies. In 1958 the pair made an ambitious thirty-minute version of H. G. Wells' *The Time Machine* (1895). The effects-laden epic was the first 8mm film shot in Cinemascope and won them awards in a Kodak competition for young film makers.

Dedicated to a career in the movies, the Skotaks moved to Los Angeles in 1976 and found work producing imaginative low-budget effects for Roger Corman's (<28) company New World Pictures, where they befriended another aspiring young film maker, James Cameron (<36).

The Skotaks became known for their ability to create dazzling in-camera special effects for films like *Battle Beyond the Stars* (1980) and *Escape from New York* (1980). For James Cameron's *Aliens* (1986), the two made extensive use of foreground miniatures, mirrors, photo cut-outs and a host of other traditional techniques to produce extraordinary effects on a limited budget. It was the start of a working relationship that would include most of the director's future output.

Although the Skotaks have gained great respect within the industry for producing amazing effects using a minimum of resources, the two brothers embrace the digital medium. They now pioneer the production of stunning visual effects that are a clever hybrid of sophisticated in-camera techniques and modern digital technologies. The best of both disciplines have been combined for the benefit of films such as *House on Haunted Hill* (1999).

The Skotaks have won Academy Awards in recognition of their work on *Aliens* (1986), *The Abyss* (1989) and *Terminator 2: Judgement Day* (1991).

Sea-going dramas have always been in great demand, and by the 1940s, special effects departments were well equipped to provide miniature pirate galleons or battle cruisers. Techniques were greatly refined during World War II. With limited access to naval resources and the coast during wartime, special effects artists relied on the studio 'tank' – a large pond with a painted backdrop – to provide the setting for sea battles and any other scenes that involved water. Today, model ships are used as much as ever, and special effects artists continue to rely on the methods that were developed in the 40s and 50s.

Effects supervisor Martin Gutteridge, based at London's Pinewood Studios, specializes in miniature maritime sequences. 'Miniature ships are still the most effective way of achieving any sort of action at sea,' says Gutteridge. 'Real ships are cumbersome, they take a long time to manoeuvre, they rely on the right sort of weather conditions, and they need a large crew to operate. It's also quite hard to find anyone who will let you blow up their boat and sink it!'

The greatest problem when filming miniature ships has always been the difficulty in making water look to scale – while it is easy to make small boats, it is impossible to make 'small water'. Whatever is done to it, water always remains the same scale. 'There are few things you can do about water,' says Gutteridge, sighing. 'It is physically impossible to scale down. There are a few tricks that we use to make things a little better, but on the whole you need to design model shots so that water appears for the shortest time possible.'

One of the most important areas of water in a model shot is that immediately in front of the camera. When filming miniature ships, the camera is kept as close as possible to the water level, and is sometimes even partially submerged so that its lens remains just above the surface. This low angle helps to make model ships look larger and also ensures that the sky detail painted on the tank's backdrop is seen as a reflection in the water. Such a low angle does, however, mean that the water may be just inches in front of the lens and a very large depth of field must be used to keep both foreground water and distant ship in acceptable focus. Out-of-focus foreground water is an instant giveaway to the presence of model shots and can be seen in many wartime films, shot without the advantage of modern fast film stocks.

Much of the art of filming miniature sea battles lies in the way that water is persuaded to perform for the camera. 'Getting waves right is essential,' says Gutteridge. 'In fact, we spend as much time on the performance of the water as we do on almost everything else.' Small waves are produced by placing huge fans around the edge of the tank to blow winds across the water and create the desired wave pattern. Some people add a little detergent to the water to encourage slightly foamy wave tips, though just a few drops too much can turn an ocean into a bubble bath. By positioning wedge-shaped paddles that move up and down at the edge of the tank, larger waves and rougher sea conditions can be created. Storms and tidal waves are produced using 'tipper-tanks', which can release thousands of gallons of water into the tank to crash into

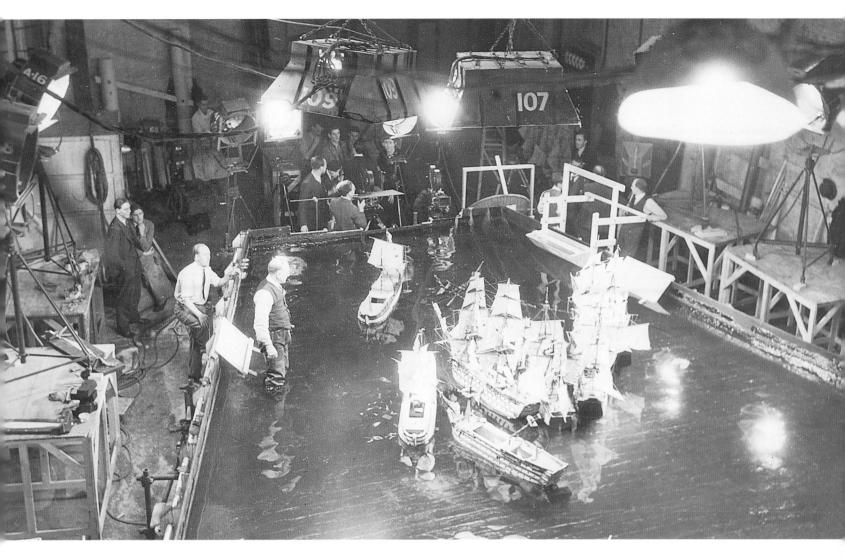

Technicians stage an indoor sea battle for Jack Ahoy *(1934).*

boats and simulate treacherous seas. Successful wave patterns can often only be sustained for a few seconds before they reach the opposite wall of the tank and rebound to cause new and unrealistic ripples. Wave patterns are therefore set up and tested before shooting commences. Once ships and cameras are in position, the desired pattern is created just moments before the action begins.

The camera speed used to film model ships is influenced more by the need to create realistic water conditions than by the scale of the models. Small waves can be made to look larger by filming at faster frame rates. This has the effect of slowing down their movement when the film is projected at the normal speed. However, rather than looking larger, waves can look thick and oily if they are filmed too fast. 'Depending on the scale of model that we use, we tend to film most of our water sequences at somewhere between 75 and 125 frames per second,' says Gutteridge. 'This will usually give quite acceptable scaled water. One way to get water to look totally convincing, though, is to film at night – the dark is very good at hiding scale problems in a water shot.'

To help with problems of scale in water shots, all models are built as large as possible. 'When working out at what scale to build a ship,

we tend to do it in reverse,' explains Gutteridge. 'We like working with ships that are around 7.5m [25ft] in length. A ship that size is relatively easy to move, it's not a bad size in terms of water scale, and we can climb on board to make adjustments during filming. We can also comfortably float a small fleet of ships of that size on the Pinewood tank at the same time. Therefore we tend to look at the measurements of the full-size ship and derive a scale to produce a ship that is about the size we need.'

Model ships are built from a variety of materials, depending on

Miniature maritime masterpieces under construction in the workshops of Martin Gutteridge's well-known facility Effects Associates.

The problems of making water look to scale are apparent in this model shot from The Poseidon Adventure *(1972).*

filming. 'Moving ships around in a tank is quite a complicated business and we use a number of different methods,' explains Gutteridge. 'We can actually sail a boat by using huge fans to fill the sails and blow it along. But it's hard to get a ship to sail exactly where you want it to go and the fans can cause problems with the wave pattern. We can also build motors into the ships and sail them by radio control. More commonly, however, we use a system of underwater cables to push and pull the boats.'

Each vessel is built with a series of rings along the bottom of its keel. The rings are threaded on to an underwater guide cable that is arranged along the path that the ship needs to follow. A second underwater cable is then run through an on-shore winch and attached to the bow and stern of the boat. When this cable is moved backwards or forwards the boat moves along the guide cable at the desired speed and in the correct direction. 'With six or eight ships being operated at once, which isn't uncommon in sea battles, there can be a real maze of wires under the water and it can become quite complex,' says Gutteridge.

the type of vessel being replicated. Modern naval vessels are often constructed using a fibreglass hull with wood and metal fittings. Traditional galleons, on the other hand, are crafted entirely from wood. 'Old-fashioned ships are our favourite to re-create,' says Gutteridge. 'We construct our models just like a real ship, using traditional methods to produce a scaled-down hull on to which we attach miniature planks of wood. We find that ships that are constructed in the correct way will move in all the right ways when floating in the water.' After the hull is complete, it is given decking and every external detail, from capstan to crow's nest, is carved in wood, painted and placed on board. Masts as high as 4.6m (15ft) are fitted with historically accurate, hand-tied rigging and hung with lightweight sails designed to undulate like heavy canvas when filmed at high speed. Several sets of rigging are normally made for each boat, since they tend to be the first part of a ship to suffer from battle damage.

The finished masterpieces, often weighing over a tonne, are lifted into the tank by crane, ready for

Filming a shot for Interview with a Vampire *(1994) in Pinewood's huge tank.*

The staging of sea battles is something of a military operation in itself. 'The thing about models is that we spend months building them only for editors to spend their time trying to show them as little as possible,' explains Gutteridge. 'That's because even the best models shouldn't be on screen for too long, otherwise the audience has the chance to scrutinize the image and see that it is actually just a miniature – especially where water is involved.' As a result, Gutteridge and his team often spend their time producing shots that will be on screen for perhaps four seconds or less. 'A lot can happen in four seconds,' says Gutteridge. 'Our problem, however, is that in a typical miniature ship sequence we will be filming at about 100 frames per second – four times normal speed. That means that in reality we have to perform a four-second shot in just one second. In one second we may have to manoeuvre six ships, fire a dozen cannon and blow up a mast. We have to plan things like explosions to hundredths of a second,' he explains. 'We can make a small

Not all model ships are miniatures. At forty feet long, the model built for Titanic *was bigger than many private yachts.*

The destruction of a 25-foot ship for the pirate adventure Cutthroat Island *(1995).*

explosion filmed at high speed look totally convincing, but when you're dealing with explosions in or around water, they will only look real during the explosion itself. Water and debris looks fine while it's on the way up, but as soon as it comes back down and hits the water, the patterns and ripples that it produces are totally unconvincing. So we always plan explosions to happen at the end of a shot so that the editor can cut away before things start to look wrong.'

Filming at four times normal speed means that ships need to be manoeuvred around the tank at a surprisingly fast rate of knots. However, these speeds are rarely enough to simulate the look of a real ship ploughing through the oceans. 'To give the impression that our small ships are actually cutting through the waves, we have to cheat a little,' admits Gutteridge. 'A normal ship travelling at speed will have waves and spray around its bow. We can't achieve that at the speeds our models move, so we fit the front of each ship with a pipe that pumps a stream of water up in front of the bow to give the impression that the ship is slicing through the waves. A similar device may be used to create a ship's wake.'

A watery grave is the fate of many model ships, and sinking them is another complex operation. Most studio tanks are just 1–1.2m (3–4ft) in depth but include a much deeper 'sinking hole' at their centre. This central well will allow 6m (20ft) ships to up-end and go down. 'To sink ships, we sometimes divide their hulls into a number of ballast tanks. These are fitted with remote-controlled valves and can be filled with air or water to control the way in which a ship lists,' says Gutteridge. 'For dramatic sinkings, however, we attach ships to a submerged hydraulic rig that will twist the vessel in any direction we want as it goes down below the surface.'

ARNOLD GILLESPIE

Contributing to over six hundred films spanning fifty years, Arnold 'Buddy' Gillespie (1899–1978) was perhaps the longest serving special effects man in Hollywood history.

Beginning as an art director at MGM in 1924, Gillespie worked under Cedric Gibbons, who would later design the 'Oscar' statuette for the Academy Awards. In the days before heavy unionization, Gillespie's early career included work in various roles on hundreds of films. In 1924 he spent nine months filming the original *Ben Hur* in Italy and was dressed in soldier's uniform on board a Roman galley during the infamous sinking in which extras are reputed to have drowned. With Gibbons, Gillespie built the hanging miniature that was used to add additional stories to the film's Circus Maximus set. Gillespie's career was so lengthy that he had the rare honour of working on the originals and remakes of both *Ben Hur* (1925 and 1959) and *Mutiny on the Bounty* (1935 and 1962).

In 1936 Gillespie became the head of MGM's special effects department where he oversaw the effects for hundreds of feature films including classics such as *The Wizard of Oz* (1939), *Forbidden Planet* (1956) and *North by Northwest* (1959). Gillespie is most renowned for his work in MGM's 300-foot square tank. During World War II Gillespie spent much of his working life up to his waist in water over-seeing the filming of increasingly sophisticated model ships, including the 54-foot hydraulically operated aircraft carrier built for *Thirty Seconds over Tokyo* (1944). Gillespie didn't always resort to the use of such dramatic techniques, however; for *Mrs Miniver* (1942), he re-created the flotilla of Dunkirk rescue ships from hundreds of cardboard cut-outs pulled along the water on strings. The result was surprisingly effective, if a little jerky.

Gillespie won Academy Awards for his work in *Thirty Seconds over Tokyo* (1944), *Green Dolphin Street* (1946), *Plymouth Adventure* (1949) and *Ben Hur* (1959).

CLOUD TANKS

For *The Beginning or the End* (1947), director Arnold Gillespie (see panel) was asked to re-create the explosion of an atom bomb. Gillespie's first problem was discovering what such an event looked like, since the only existing footage of real atomic explosions was classified at the time. To create the mushroom cloud eventually seen in the film, Gillespie remembered the way in which he had seen fake blood form billowing clouds in water when filming Tarzan movies years earlier. The effects man built a large glass tank, and after experimenting with various dyes, filmed an underwater mushroom cloud. When superimposed over background footage, it created an impression of an explosion so convincing that the shot was used in air force training films for years afterwards.

Similar methods have been used to provide brooding cloud formations in films such as *Close Encounters of the Third Kind* (1977) and *Ghostbusters* (1984). To create the effect of clouds billowing towards the camera, a large glass tank is half filled with a heavy saline solution. A layer of plastic sheeting is then floated on top of the saline liquid and fresh water gently poured over it. After the

and fired when engulfed by the paint mixture. For the threatening cloud cover that cloaks moving spaceships in *Independence Day* (1996), a horse-shoe arrangement of coloured lights was pushed through the water while attached nozzles squirted paint, to create clouds that moved in front of the travelling rig.

To produce a convincing World War II bombing raid in *Memphis Belle* (1990), effects supervisor Richard Conway produced the aerial view of bombs hitting the ground by covering the bottom of a large water tank with an aerial photograph. The targets on the picture had valves placed beneath them. As the camera passed overhead, puffs of paint were squirted out of the valves to give the impression of bombs hitting their targets.

Any material that is required to fly, float in the air or blow with the wind can be suspended in water for photography. In *Poltergeist* (1982), the hair-raising phantom that threatens the mother was actually a puppet filmed in a tank of water. Underwater, the ghoul's long hairs floated eerily around its body. For *The Good Earth* (1937), Arnold Gillespie filmed a tank of water to which an assistant added handfuls of coffee grounds. The image of thousands of drifting particles was superimposed over footage of rice fields, to create a convincing plague of locusts. A very British approach was taken by effects supervisor Cliff Richardson when filming *The African Queen* (1951). Where Americans had used coffee to portray a plague of locusts, Richardson used tea leaves to create a swarm of mosquitoes.

Dark clouds – actually grey paint suspended in water – roll ominously across the sky in Independence Day *(1996).*

A cloud tank being used by Gary Platek and Gary Waller at ILM to create a tornado effect for Poltergeist *(1982).*

water settles, the plastic sheeting is carefully removed, causing as little disturbance as possible. Salt and fresh water have different densities, and this causes an invisible barrier called an inversion layer to form where the two liquids meet.

Various liquids can be employed to create the clouds themselves, though the most commonly used is a mixture of thinned grey emulsion paint. The paint is injected into the tank and, since it is heavier than fresh water, it sinks until it reaches the dense salt water, where it starts to spread out, creating the effect of rolling clouds. The process is normally filmed at high speed through the glass sides of the tank, and when projected at the normal rate of twenty-four frames per second, gives the impression of vast, heavy cloud movement. A blue backing screen may be placed behind the tank to help produce a travelling matte for use when compositing (<56) the clouds into a background plate.

To create the effect of lightning within the cloud formations, waterproofed photography flashguns are suspended in the water

AIRCRAFT AND SPACESHIPS

Aeroplanes and spacecraft are among the most called-for model effects in film making. Model aircraft need to be particularly strong, since they often undergo considerable stress during filming. They must be able to withstand the heat of intense studio lights, occasional collisions with camera equipment, rough handling by technicians and even falls from great heights when support cables fail.

The strength of such craft comes from within. Model builders usually construct aircraft from a honeycombed framework of wooden or aluminium cross-sections. This skeleton must be light enough to allow the model to be handled easily, but strong enough to support the whole model when it is suspended on a pylon at a single point. Aircraft are normally built with a number of mounting points, so that a support pylon can be hidden behind the body of the model regardless of the angle from which it is being filmed.

Models are usually clad with an exterior of lightweight plastic or fibreglass panels. These can be removed easily to allow access to interior mechanisms, and quickly replaced for shooting any retakes after the filming of explosions or collisions. Modelmakers often save time and money by decorating the exterior of their creations with ready-made items. A favourite resource is commercial model kits, whose moulded plastic components can provide instant detail for a film miniature. For *Silent Running* (1971), parts scavenged from

over 650 German tank kits were used to embellish the exterior of the 8m (26ft) model spaceship, *Valley Forge*.

Model aircraft and spaceships often have a number of mechanical features, such as hinged wing-flaps, spinning propeller blades or intricate puppet pilots whose heads can be turned during flight. The models must also accommodate the motors and gears that control their movement and the batteries that power them. The mechanisms themselves may be operated by radio control or via a bundle of electric cables that trail behind the model during filming.

Planes, and especially spacecraft, often need some form of internal lighting. This can be provided by drilling tiny holes in the body of the model to allow a bright interior light source to shine through. For *The Empire Strikes Back* (1980), the 1.8m (6ft) model of Darth Vader's Star Destroyer was drilled with over 250,000 tiny holes that twinkled with light from interior neon tubes. Occasionally, a bundle of fibre-optic cables is placed inside a model and the luminous end of each cable laboriously threaded into each porthole. The 3.7m (12ft) mothership model for *Independence Day* (1996) was illuminated by over 10,000 individually fitted fibre-optic cables – 45km (28 miles) worth in all. This cargo of lights and motors can become extremely hot during the

A selection of model spaceships do battle in The Empire Strikes Back. *Tiny shipboard lights were created by drilling thousands of holes in the models.*

The Skotaks and their crew prepare to film the drop ship scenes for Aliens *(1986).*

long hours that it usually takes to photograph each shot, so some models are fitted with extractor fans to prevent a meltdown of plastic components.

Once model aircraft have been constructed, they are ready to take to the skies. The simplest and perhaps easiest approach is to hang them on wires – a method favoured since the earliest days of movie making and perfected by legendary effects artists Howard and Theodore Lydecker (117>).

Wire techniques have been used more recently by modern effects legends Robert and Dennis Skotak. 'We built quite a sophisticated flying rig to move some of the spacecraft for *Aliens* (1986),' remembers Robert Skotak. 'One of the most complex shots that we achieved was where a drop ship had to land at the deserted colony of Acheron,' he states. 'The ship had to arc across the shot and then land in exactly the right spot on the miniature colony set. The doors of the craft then had to open up so that a remote-controlled personnel carrier could drive out. The 1:12 scale fibreglass spacecraft, approximately 1.8m [6ft] in length and weighing some 27kg [60lb], was suspended from four wires, one at each corner. The wires went up to a T-shaped support rig that was itself attached to a 3.7m [12ft] boom arm mounted on a platform that ran on rails.'

'Two or three people pushed the platform to give the ship forward and backward movement,' explains Skotak. 'Another person sat on the platform and operated a steering wheel mechanism that

was attached to the wires to control the roll of the model. Another person controlled the pitch of the model, and another its rise. A further person operated the swing of the boom arm. All of these people had to co-ordinate their actions perfectly so that the ship would fly on the desired flight path, pass within a few inches of the camera – which also had to follow the action – then land at the correct place. The director, Jim Cameron, had asked that the craft have a hard

Joe Viskocil about to fly a model aircraft using the Lydecker technique on the set of Independence Day.

An effects engineer prepares a Martian craft for The War of the Worlds *(1953). Wires were used both to suspend the models and supply power for their various functions.*

The impression of flying aircraft in this shot from The Sky's No Limit *(1984) was created by suspending model planes in a tank of water, behind which fibrecill wool was slowly moved.*

landing, but the model's landing gear was quite delicate, so we found a way to give the model a rough-looking touchdown without putting too much weight on its legs. Once the ship had landed, a door opened and the radio-controlled personnel carrier had to drive out without hitting the door or getting snagged on any of the rocks on the set. We were filming at sixty frames per second, so the whole sequence of events had to be done at two and a half times the speed that it appears on screen. To make things worse, the shot was filmed in rain and we had a fan blowing to break up the falling water to make it look more to scale. Getting all the variables right was almost impossible. Every time one part of it worked, something else went wrong. We eventually got the shot but it took about fifty takes.'

Working with wires requires a number of performance skills on the part of special effects technicians. 'One of the hardest things to get right is the velocity of the model that you are flying,' states Robert Skotak. 'The biggest rule is to make sure that an aircraft that is taking off or flying is always in a state of acceleration. If there is any uncontrolled deceleration, it causes slack in the wires, and the model will start to wander and shake. Sometimes we might attach additional wires to the tail or nose of a model, and someone standing some way in front of or behind the model will try to judge the speed at which it is travelling and manually keep some tension in the wires. However, if they pull the wires too much, it will just swing the model in the wrong direction.'

Hiding wires is another factor that must be considered when using them to suspend models. 'Today we can remove wires digitally without any difficulty,' says Skotak, 'but even without computer assistance, there are all sorts of tricks that we can use to try to disguise wires. A little Vaseline smeared on a lens filter in the area above a ship can help to soften the image and conceal wires. A little extra smoke in that area of the image will do the same thing. Or, if a craft is flying in a linear sort of fashion, the sky above the ship could be painted on a sheet of glass and placed near to the camera and in front of the wires. It also helps if there is rain in the scene – a little backlit rain will hide wires very well.'

Another method used to hide wires is to vibrate them by attaching small motors. Wires that shake at a high frequency become blurred and unnoticeable. Providing the model is relatively heavy and the motor relatively small, the shaking wires will not affect the flight performance of the model itself.

The swinging and shaking that can occur when a model is hung on wires is one of the biggest drawbacks of the method. Again, the Skotaks have devised techniques to overcome such difficulties. For *The Sky's No Limit* (1984), director David Lowell Rich wanted to place shots of model aircraft into shots of the sky without using travelling mattes (<44), which he felt had been unsuccessful in his earlier film, *The Concorde* (1979). 'To avoid travelling mattes, we decided that we would film the planes on wires,' explains Robert Skotak. 'Then we started to think about the normal giveaways of using wires – like the juddering that you can get when a model isn't perfectly controlled. We decided that these problems could be reduced if the models were suspended in heavier than normal air – in other words, water.'

The Skotaks invested in a large aquarium and constructed a rig that suspended the film's model aircraft on almost invisible tungsten wires. The model planes were then lowered

into the water, where their movements could be puppeteered quite smoothly from above. However, although the models could turn and bank convincingly, they could not move forward very far in the confines of the aquarium. 'Since we couldn't move the planes through the "sky", we decided to move the sky past the planes,' explains Skotak. 'We got a strip of clear Perspex about 3m [10ft] in length and just a few inches high and sand-blasted parts of it so that they went misty. This strip was mounted right in front of the camera and was pulled past the lens during filming to look like passing foreground cloud. Behind the tank of water we had two large banks of clouds made from fibrecill, a material similar to cotton wool. These banks of clouds were right next to each other, but during filming the front layer of clouds was moved faster than the back one. In the distant background we had a painted sky backing that also moved – but very incrementally. With these differential cloud speeds, we created a great feeling of depth within the scene.'

Occasionally, model aircraft must perform manoeuvres that are too complex to achieve with small models in a studio environment. In such cases, radio-controlled model aeroplanes may be the answer. For *Empire of the Sun* (1987), a fleet of 1:3 scale radio-controlled aircraft were constructed. With wingspans ranging from 2–5.5m (7–18ft), the Japanese Zeros, American Mustangs and a single B-29 bomber were some of the largest operational model aircraft ever assembled for a film. Motorcycle engines powered the huge models, which looked like full-sized planes when flown in the sky behind actors. The models could even drop miniature bombs on to areas of ground pre-rigged to erupt into flames upon impact.

Radio-controlled aircraft powered by motorcycle engines fly over a Japanese prisoner-of-war camp in Empire of the Sun.

HOWARD AND THEODORE LYDECKER

The Lydecker brothers, Theodore (1908–1990) and Howard (1911–1969), worked for Republic Pictures, a small independent studio that churned out B-movies and adventure serials featuring heroes such as Captain America and Dick Tracy. As joint heads of the studio effects department, it was the Lydeckers who oversaw the production of the flying superheroes, rocket ships and underwater cities that kept thousands of children on the edge of their seats during their Saturday morning visits to the movie theatre in the 1940s and 50s.

The brothers excelled at producing spectacular effects on shoestring budgets that any other studio department would have laughed at. In particular, they perfected a method of flying model aircraft and even full-scale papier-mâché superhero models. Their technique involved fitting aircraft or model people with two thin, parallel copper tubes. In the case of a human dummy, the tubes – one placed on each side of the body – entered the figure's shoulders, travelled the length of the body and exited at the heels. Piano wire was threaded through the copper tubing, with talcum powder for lubrication. One end of each piano wire (strong, thin wire used in many special effects applications) was firmly secured, while the other was attached to handles that were operated by the Lydeckers or an assistant. Keeping the wires taut, the operator could twist them to make a flying model bank and turn. By slackening the wires or pulling them tight, the model could be encouraged to take off and land. A third central cable could also be added to pull the model forwards and backwards.

In 1959 Republic went out of business and the brothers sought work elsewhere. Howard found employment at Universal Studios providing effects for features such as *Voyage to the Bottom of the Sea* (1961) and the 1960s TV series *Lost in Space*. After an unhappy stint at Disney, Theodore also joined Universal where, among other projects, he produced the mechanical birds for Hitchcock's *The Birds* (1963).

Since the success of *Star Wars* (1977), the method employed to film model spaceships and aircraft in flight has centred around the use of travelling matte techniques. In such cases, static models are suspended in front of a blue-screen (<48) and held aloft on some form of arm or pylon. Rather than the models moving past the camera, it is the camera that moves past the models – which are themselves often manipulated to produce additional movements such as banking and rolling. The resulting blue-screen shots are used to place the models into environments such as skies and star fields. The technology utilized to move cameras around models in this way is known as motion control.

MOTION CONTROL

The successful combination of separately filmed elements has traditionally depended on ensuring that there is no movement in any of the cameras used to film the various components. If a model castle was filmed in one shot, and a full-scale set in another, the two images could only be combined successfully if there was absolutely no camera movement in either shot. The slightest movement of one element in a composite causes it to 'slide' against its neighbouring image, shattering the illusion of a unified whole. Film makers traditionally avoided this problem by using a static camera to shoot all of the elements that were to be combined in the final sequence, although this proved very limiting.

The only way to have camera movement in a composite shot is to use a camera that can precisely repeat the same movements while filming each of the shots that are to be combined. This is the basic principle of motion control – using mechanical or electronic means to record the movement of a

Early motion-control photography was used for this composite of full-scale live action and models in Samson and Delilah *(1949).*

camera and reproduce that movement wherever and whenever different elements of a composite shot are filmed.

Though motion-control photography has only flowered in the past two decades, the idea is not a new one. As early as 1914, one of Thomas Edison's (<10) camera operators, James Brautigam, built a mechanical system that allowed a camera to repeat its movements over and over again. For *The Flying Duchess* (1914), Brautigam wanted to double-expose a shot so that an actor introduced during the second exposure would appear as a transparent, ghostly figure. The basic approach was not unusual, but Brautigam realized that creating a double exposure while moving the camera would be a unique and logic-defying special effect.

Brautigam's camera was mounted on a 21m (70ft) track and moved manually using a block-and-tackle winch rig. By carefully marking the winch drum and the winch cable with distance indicators, and with some careful timing, Brautigam was able to manually match a second camera movement to the first. The system was hardly efficient or precise, but it worked. The effort and technology involved in mechanically repeating camera movements, however, meant that it was rarely attempted over the next twenty years, and it was not until the 1940s that any practical systems of motion-controlled photography were developed.

In the late 1940s an MGM sound engineer called O. L. Dupy developed a machine known as the Dupy duplicator. Dupy's system was incredibly sophisticated for its time. The camera's pan and tilt motions were recorded directly on to a phonographic record, which repeated the camera's movements when played back in subsequent takes. The system was used with great success during the filming of *An American in Paris* (1951) to combine studio live action with reconstructed views of the French capital.

At about the same time, Gordon Jennings (119>) was working on a similar motion repeater at Paramount. Jennings' device recorded camera motion on a strip of film, but the motion itself was plotted mathematically before any sets or miniatures were built. Jennings studied construction blueprints and calculated the necessary camera moves by using stand-ins on an empty stage. Once the motion track was recorded, the camera ran automatically while filming each shot of live action, matte painting or miniature. The system was most spectacularly used to combine live action and model elements in the temple destruction scene of Cecil B. De Mille's *Samson and Delilah* (1949). Dupy and Jennings were awarded technical Academy Awards for their systems in 1951. Though sophisticated, the rather cumbersome and unreliable machinery that they designed did not enjoy widespread use.

The work of experimental film maker John Whitney is perhaps the next link in the development

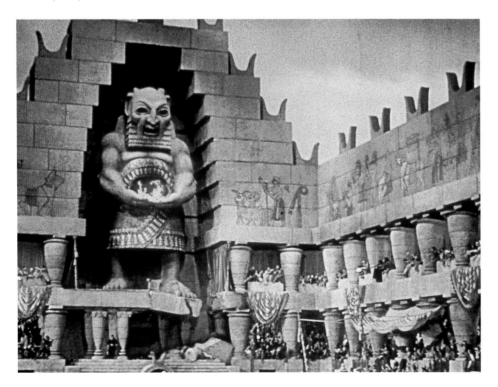

The huge model spacecraft in 2001: A Space Odyssey was fixed motionless in the studio, but filming with motion-control photography gave the impression of the spacecraft moving past the camera.

of motion control. In 1957 Whitney acquired an army-surplus mechanical analogue computer – previously used as part of an anti-aircraft gun system – and rebuilt it to control the movements of a camera and lights so that he could film streaks of coloured light for an abstract film called *Catalog 61* (1961). His goal was to give visual representation to the pattern, colour and dynamics of a piece of music. Whitney did not employ the technology that he pioneered to produce special effects as we know them, but the method was adopted for the production of the streak-photography graphics that became widely used in television advertising and films. The technique was further developed for the production of the Stargate sequence in *2001: A Space Odyssey* (1968), whereupon it was dubbed 'slit scan' (145>).

The method of repeating camera movement for the Stargate sequence of *2001* was also used for the photography of the film's giant spaceship models. The 16.5m (54ft) model spacecraft Discovery was too large to hang on wires or be physically moved past the camera. It was decided, therefore, that the camera should move past the model. Next to the huge model spacecraft, which was anchored on steel supports, a 45m (150ft) camera track was constructed on which a camera platform was moved back and forth by worm gearing. The camera was moved incrementally past the model and, in each new position, the shutter opened to expose the new image of the ship on to film. The fact that the movement of the camera could be repeated meant that additional identical 'passes' could be made to film the different elements of the same shot.

Douglas Trumbull (295>) was part of the team responsible for the effects on *2001*, and he continued to develop the technology of motion control after the film's release, producing the visual effects for *The Andromeda Strain* (1971), which employed a new electronic system that recorded repeatable camera movements using an ordinary stereo tape recorder. However, it was the release of *Star Wars* (1977) that really brought the potential of motion control to the

Gordon Jennings entered the film industry as an assistant cameraman in 1919, and quickly established a reputation for innovation by inventing the first moving titles – he painted credits on glass and slid them over painted backdrops.

In 1933 Jennings became head of special effects at Paramount where, over the next twenty years, he oversaw the effects for hundreds of classic movies. For *Cleopatra* (1934), Jennings stretched a meagre budget by using mirrors and double exposure to turn just two model galleys into a fleet of thirty. For *When Worlds Collide* (1951), he oversaw the construction of a huge 'miniature' of eight blocks of New York before destroying it in a massive tidal wave. The film's miniature rocket sequences are some of the most memorable of the time.

Jennings is perhaps best remembered for his work on George Pal's special effects *tour de force The War of the Worlds* (1953). The film's pulsating manta ray-like spacecraft were 1m (3ft) flexible rubber models that were inflated by hidden air pumps. Internal coloured light bulbs glowed eerily through the plastic bodies.

The Martian crafts' famous death rays were created by melting welding wire with a blowtorch to create a stream of sparks. The craft are now a design classic. Soon after the completion of *The War of the Worlds* Jennings died, and his department was taken over by John Fulton (<47).

Jennings, whom Cecil B. De Mille called 'the best special effects man I have ever been privileged to

work with', won Oscars for his contributions to *Spawn of the North* (1938), *I Wanted Wings* (1941), *When Worlds Collide* and *The War of the Worlds*. He also received technical Oscars for the design of a nodal-head tripod in 1944 (<95), and a motion-control device in 1951 (see main text).

GORDON JENNINGS

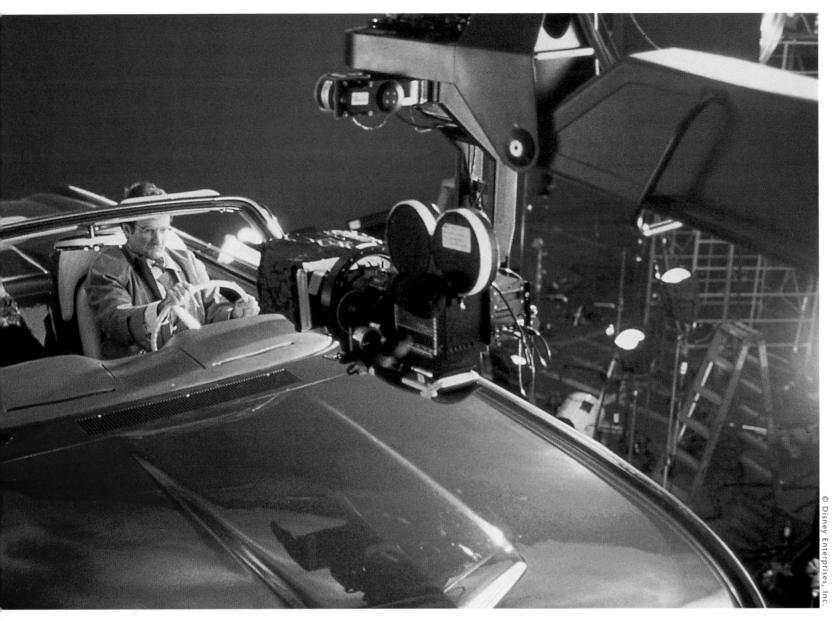

A motion-control camera tracks past Robin Williams during the filming of effects plates for Flubber (1997).

world's attention. Using the latest in microchip technology, Industrial Light and Magic, headed by John Dykstra (122>), built the first computer-controlled motion-control rig, which was capable of memorizing and repeating sophisticated camera movements with absolute precision (121>). Motion control became an essential part of production for the many special effects driven movies that appeared in response to the success of *Star Wars*, and many companies devised their own motion-control systems based on the one built at ILM.

Today, motion-control rigs (fig. 5) can be purchased from a number of companies that manufacture the equipment using the latest motor and computer technology. One of the world's leading manufacturers is Mark Roberts Motion Control. 'We make two types of motion-control rig,' explains the company's founder, Mark Roberts. 'Our Cyclops rig is a large rig for studio-based shooting, our smaller and more popular rig is the Milo. Milo grew out of the need to make motion control much more of a first-unit filming

device. Early motion control like that used during the filming of *Star Wars* was a comparatively

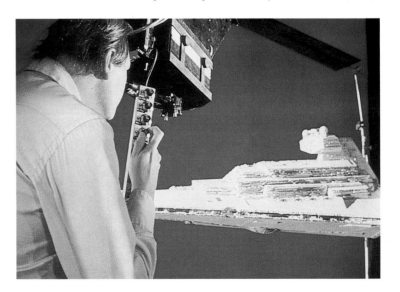

Dennis Muren programs ILM's Dykstraflex motion-control camera for a shot in The Empire Strikes Back *(1980).*

120

Figure 5 MOTION-CONTROL RIG SET-UP

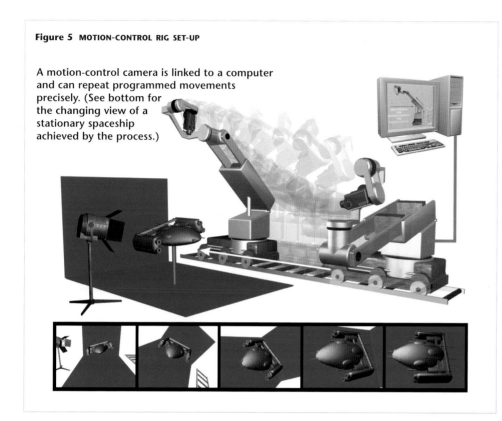

A motion-control camera is linked to a computer and can repeat programmed movements precisely. (See bottom for the changing view of a stationary spaceship achieved by the process.)

operator can measure the distance from that object to the lens in the first and last position of the sequence. The computer software will then automatically track the target object in all its camera movement calculations to ensure that the item remains in the same part of the frame throughout a complicated camera move.

Increasingly, motion-control rigs act as the link between the real world environment of the film studio and the digital world of the computer. A typical special effects shot today might contain live-action footage, miniatures and computer-generated animation (146>). The shot may first be designed in the computer using a digital model of the motion-control rig, which simulates the movement constraints that exist in the physical world. Once the shot is planned, the movement data from the digital motion-control rig can be

Motion control can also be used to precisely control the movements of models. Here, a huge model-mover rig is being prepared to fly a model for Starship Troopers (1997) at Sony Pictures Imageworks.

cumbersome, studio-based technology that was highly specialized and incredibly time-consuming to program and shoot with. Our Milo rig responds to modern production needs in which motion control is used for a lot more than just a few select effects shots. The rig can be taken anywhere in a few flight cases and be set up and operational in forty-five minutes.'

The rig offers thirteen axes of movement and, as well as physically moving the camera, can control its focus, zoom, aperture and other mechanisms. The device sits on a 1m (3ft) wide length of track, along which it can travel at 2m (7ft) per second.

The system is controlled by a powerful software program called Flair. To program a camera movement, the operator instructs the software how many frames there will be in a sequence. The operator then uses a hand-held remote-control device to move the camera to its starting position. The axis and camera information for this point is logged by the computer. The operator then moves the camera to a second position, changing the camera's angle and focus as necessary, and instructs the software to log all of the key information once again. Depending on the complexity of the move, the operator may log from two to ten key-frame positions. The software then calculates an arc based on the key-frames to determine the exact position of the motion-control rig and camera for all the frames in the sequence between the key-frames. Once a move has been programmed, the motion-control unit can repeat the movement in real time – or at one frame at a time – to within thousandths of an inch wherever and whenever asked.

The software contains a number of automatic functions that help the operator to achieve perfect results. If the device is being used to film a shot in which one item is to remain central in the frame, the

JOHN DYKSTRA

Interested in mechanics and photography from an early age, John Dykstra (1947–) studied industrial design at Long Beach State College, California. After leaving college, he combined the two disciplines when he became involved in the production of the special effects for Douglas Trumbull's classic effects movie *Silent Running* (1971; <114).

After *Silent Running*, Dykstra worked for Berkeley's Institute of Urban Development, where future urban developments were simulated by building small-scale city models and filming them using innovative miniature photography techniques.

In 1975 Dykstra was appointed special effects supervisor on *Star Wars* (1977). Of the many technical innovations that Dykstra oversaw during production of the film, the most significant was the computer-controlled motion-control system that was called Dykstraflex in his honour. Dykstra won an Oscar for his effects supervision on *Star Wars*, and a Scientific and Technical Oscar for the development of the Industrial Light and Magic facility.

After the success of *Star Wars*, Dykstra was chosen to create the special effects for the high-budget television series *Battlestar Galactica* (1978–80). As a result, Dykstra and a group of colleagues established Apogee, a facility that became a leader in special effects innovation for its work on films like *Star Trek: The Motion Picture* (1979) and *Firefox* (1982).

Apogee closed its doors in 1993, but Dykstra has continued to supervise the production of cutting-edge special effects in films such as *Batman Forever* (1995) and *Stuart Little* (1999).

downloaded to the real motion-control rig, which then repeats the movement when shooting the live-action element of the shot. The same camera movement is then used to film any miniatures that are to appear in the shot. However, because models are smaller than the live-action elements, the movements of the camera must be scaled down accordingly. Scaling movements was once a mathematical problem for operators, but today the comparative scale of a model is simply entered into the motion-control software, which automatically calculates the camera move required.

A model shot may be filmed a number of times using identical camera movements but with different lighting conditions in each pass. A 'beauty pass' films the model in its most perfectly lit state; a 'shadow pass' captures the shadow elements of a model; and a 'matte pass' records the blue- or green-screen under optimal lighting conditions. Additional passes may be employed to capture any lights that are part of the model's construction – these are normally too weak to be visible under normal exposure conditions. Each pass is captured on a separate piece of film and is later selectively combined in the digital compositing process. Finally, the movement data may be applied to the virtual camera that is used to 'film' any elements that are generated within the computer (179>).

In today's increasingly international production environment, it is quite possible for a motion-control move to take place in one part of the world and for that data to be e-mailed to another facility, on another continent, for the generation of additional elements with an identical camera move.

Modern motion control is so fast, accurate and user-friendly that it is increasingly being used for work that is not necessarily visual effects oriented, but which does require specific camera movements. Although the equipment is expensive to hire, motion control can save money for productions such as commercials where shooting time is limited. By programming a camera move just once, art directors can spend more time arranging and lighting shots of products, and when everything is ready, perfect camera movements are assured at the touch of a button.

COMPUTER GRAPHICS

Star Wars (1977) may have been the first feature film to use a computer to control its camera, but computers had already started to replace the camera altogether for the creation of wholly synthetic 3-D images.

Synthetic electronic imagery became a goal in the 1950s when scientists at the Massachusetts Institute of Technology (MIT) produced the first numerically controlled industrial production tools – drills and milling machines that could be programmed to perform simple and repetitive tasks during the manufacturing process. The technique became known as CAM (computer-aided manufacture), and once it had become a viable technology, the MIT scientists began to engineer a complementary technology that could be used as part of the design process, a technique that became known as CAD (computer-aided design).

'A long time ago in a galaxy far, far away ...' When these legendary words first scrolled across our screens over two decades ago, science-fiction movies and special effects changed forever.

Everyone knew that the special effects in *Star Wars* (1977) were truly special, but few were aware of just why those thrilling space battles felt so realistic, or why the imperial star destroyer looked so awesome as it passed overhead. The exhilarating realism of these moments was due to the development of a new computer-controlled method of moving the camera.

Richard Edlund (<65) was a member of the first Industrial Light and Magic team, and was part of the film's pre-production planning process. 'Our work on the *Star Wars* space battle sequences began when George Lucas showed us a reel of black-and-white film that he had edited together from footage of World War II aerial dog fights,' remembers Edlund. 'That was when we realized that this was going to be no kids' sci-fi movie with spaceships flying around on wires. We realized that we were going to need an electronically controlled camera that would be capable of motion in a number of axes, and which could be programmed to perform and repeat moves to film models whenever we required them.'

Edlund was part of a team headed by John Dykstra (<122), who spearheaded the design and construction of the microchip-controlled motion-control system dubbed Dykstraflex. 'Each category of camera movement would be stored as an individual channel in a microchip,' explains Edlund. 'I always thought it was pretty ironic that we were using technology developed as a result of the NASA space programme to make our own space movie! The chip could store twelve channels of movement, which we programmed individually by adjusting a potenti-ometer to control the motors that would operate the various parts of the system. I would begin by programming the required forward movement of the camera. Then I would do the pan movement, then the tilt and then the roll, slowly building up the overall movement of the camera,

axis by axis. We didn't have any sort of video feedback at the time, so while the camera was moving forwards or up into the air, I would be up and down a ladder twisting my neck to look through the viewfinder to see what we had.'

'Once we had programmed a move, we could repeat it whenever we wanted,' says Edlund. 'This meant that we could program a move and then use it for a number of different takes to film model spacecraft that were situated in different parts of the picture. I could then quickly develop black-and-white tests of these shots and lay them on top of one another to make sure that none of the ships would cross over any of the others when they had been filmed and composited.'

The Dykstraflex was essential in producing the film's fast-paced space battles because, once programmed, the intricate camera moves could be performed one frame at a time while the shutter was actually open. Moving the camera past models while exposing the film meant that the resulting images were actually blurred, in the way that they might be if real fast-moving objects were filmed. This motion blur was essential in making the space battles look convincing and unique for their time, and was one of the groundbreaking techniques that helped *Star Wars* smash box-office records around the world.

TRON

TRON (1982) was the first major feature film to include fully realized sequences of computer-generated animation. The film was the brainchild of animator Steven Lisberger, who believed that the fledgling technology of computer graphics could be combined with more traditional hand-drawn animation to tell a story set mainly within the body

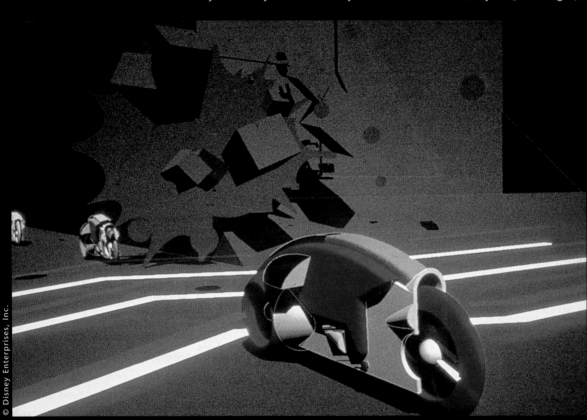

© Disney Enterprises, Inc.

of a computerized arcade game. Lisberger initially tried to finance the movie independently, but when the resources involved in producing such an ambitious film became apparent, the Disney organization was persuaded to become involved.

To produce the characters who inhabit the computer world, actors were dressed in costumes that were covered with black-and-white computer circuitry designs. Each frame of this live action was then blown up on to large black-and-white transparencies, which were placed on a backlit animation stand and re-photographed through coloured filters. With coloured light shining through the white areas of their costumes, the resulting characters appeared to glow as if lit from within.

While optical processes were used to create all of the film's computerized characters, real computers were used to generate much of the world that they inhabited. From the tiny selection of American companies then capable of producing film-resolution computer images, Disney chose four outside groups to produce the computer graphics for TRON. At this time, off-the-shelf graphics hardware and software packages were not available, so most computer graphics companies differed greatly from each other in

the techniques and technology they used and the images they could produce. Each of the four companies was therefore given work that most suited its production capabilities.

Robert Abel and Associates used vector graphics (<124) to produce the film's title sequence as well as a scene in which the main character, Flynn (Jeff Bridges), first enters the world of the computer. Digital Effects Inc produced a character called The Bit, and a short sequence of graphics at the beginning of the film. Triple-I and MAGI contributed sixteen minutes of raster imagery (<124), including the memorable light-cycle sequence.

To produce the 3-D models needed for its portion of the film, MAGI first built a series of uniform geometric shapes called 'primitives'. The light-cycle models that the company produced were made entirely by intersecting these primitives to build up the body of the object – rather like building a model using children's toy bricks.

Triple-I, however, used a more sophisticated method to build the models for its share of the animation. After preparing detailed blueprints of the objects to be modelled, Triple-I mounted the plans on a digital encoding table – the early equivalent of today's graphics tablets – and recorded the position of each vertex (see main text) by using an early mouse device with a cross-hair viewfinder. With this encoded information the computer was able to construct the models in three dimensions.

The system used by MAGI was favoured for the production of mechanical objects like the police Recognizer robots, while Triple-I worked on the more organic images such as the 'solar sailor' and the 'sea of simulation'.

As the first film to make extensive and widely publicized use of digital graphics, much of the film industry treated TRON as a test for the viability of computer-generated imagery. Although its computer animation was stunning, the film's failure at the box office was proof to many that the future for CGI was limited. The fact that computers had been used to re-create the world within a computer did nothing to alter people's opinion that computer graphics could only represent the artificial.

modelled. Once those parts are made, they will be combined to produce the final model. If we were going to build a wooden chair, for example, we would break it down into legs, seat, arms and back. Within those chunks we will look for what we call primitive shapes – spheres, cubes and so on. These are our basic building blocks, and it's surprising how many complex items can be made from these simple shapes. We also look for any symmetry in an object,' says Coulter. 'As soon as we've spotted any symmetry or repetition, our job is halved because we only need to make one object and then multiply it, or instruct the computer to make a mirror image of it.'

All modern modelling packages come with a range of ready-made 'primitives' – shapes such as spheres, cubes, cones and cylinders. These objects can be summoned on to the screen at the touch of a button. The designer can define the exact number of vertices and segments that the primitives contain, depending on the amount of detail needed in a model or the way in which the object is going to be manipulated.

'Once we have a wire-mesh primitive, there are all kinds of ways that it can be bullied into the shape that we want,' says Coulter. 'It's a bit like having a big ball of clay and being able to mould it to shape, and the more polygons a mesh has, the more we can refine its detail.'

Primitives can be 'deformed' to resemble the various parts of the model that they are to represent – a cube can be stretched to produce a long rectangle or squeezed to make a thin tile, for example. A polygon's wire mesh can also be 'edited' to amend its shape. For instance, by selecting a single vertex and pulling it away from the surface of the object, a spike can be produced (fig. 9).

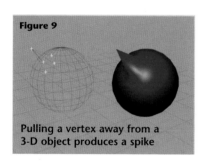

Figure 9

Pulling a vertex away from a 3-D object produces a spike

'Sometimes an object is just too complicated to be made from a primitive. In these cases, there are a number of other methods we can use,' says Coulter. 'If something is an odd shape, we may study it to see if it has a cross-section – that is, a constant shape that runs right through it. Once we identify such a shape, we re-create its cross-section by arranging and connecting vertices to form that shape in 2-D. That shape can be stretched and squeezed and refined until it matches the outline of the cross-section perfectly. Sometimes we scan a plan or a blueprint into the computer and use that as a template to get the shape perfect. Once we have the outline that we want, it can be "extruded" – that is, pulled outwards to form a 3-D object of any length [fig. 10]. It's a bit like pushing children's modelling clay through a hole to produce one long sausage of the same shape.'

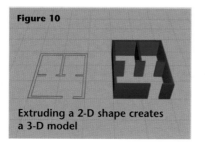

Figure 10

Extruding a 2-D shape creates a 3-D model

A number of different shapes can be arranged in a line and linked to create a single object whose cross-section alters from one end to the other. This process, called 'lofting' (fig. 11), requires each of the shapes along the path to contain the same number of vertices, so that each vertex in one shape can be linked to a corresponding vertex in its adjoining shape.

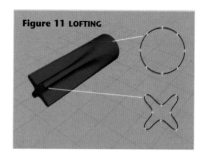

Figure 11 LOFTING

Any circular object can be created through a process called 'lathing' (fig. 12). To produce a model of an ornate table leg, for example, a profile of one half of the vertical leg is made. This template is then rotated around its central vertical axis to create a perfectly circular object that has the same profile all the way around. The shape can be swept through different axes to create a number of different objects if required.

Figure 12 Rotating a 2-D shape around a central axis is known as lathing

Once objects have been made, it is possible to punch holes through them. A model that is the shape of the desired hole is created, then 'intersected' with the main object at the place and depth that the hole is to occur. In an operation called a 'boolean' (fig. 13), the first object is subtracted from the second, leaving a hole in its place. Boolean operations can also be used to merge, split, carve and join objects in various ways.

'Once we have created our basic model parts, we start to put them all together,' explains Coulter. 'It's a bit like making a model kit of an aeroplane

Figure 13 b) c) a)

Model (a) is intersected with model (b) and subtracted to form model (c)

where you have to make all the little pieces first, and make sure that they're all going to fit before you actually glue them together. Sometimes the bits don't fit very well, but it doesn't matter too much because, unlike a plastic modelling kit, our objects can be stretched and shrunk and warped until they do.'

Since the models created in a computer are not actually solid, they can be assembled by simply pushing one object through another. If one model part needs to be affixed to the side of another object, it can simply be dragged to the object and 'placed' against the object's side. If part of it protrudes a little too far, it can be pushed a little further into the main object. Once the position is satisfactory, the two parts are 'attached' to each other so that, wherever the main object goes, the smaller part follows. Should the two elements need

readjusting at any time, they can be separated and addressed individually. If the union is completely satisfactory, however, the two parts can be merged to form a single, inseparable object.

Small details can be added to the main body of the model to decorate its exterior. 'There are often times when we need to add extra detail to a model, but don't want to spend a long time modelling every small part,' says Coulter. 'In such cases we use what we call "nernies". These are just meaningless exterior details that we arrange to give the feel of some kind of complicated mechanical workings. Most of the time nernies are just made from primitive shapes. It's similar to the method used in traditional modelmaking, where they borrow random parts from commercial modelling kits.'

The final process in making a polygonal model is to 'clean' it. 'We sometimes use more vertices or segments than we really need when making a model,' explains Coulter. 'The more vertices and segments a model has, the more polygons there are in its surface. While more polygons means a more refined surface, it also means that the computer will take a lot more time to process the model during the lighting and animation stages.' One of the biggest costs in digital effects production is machine time – the time that it takes for computers to prepare images so that they are ready to be transferred on to film. This is a process called 'rendering', whereby the computer uses all the information it has been given about models, lighting and the camera to produce a film quality 2-D image (182>). The more polygons a model contains, the more calculations a computer has to make during rendering. Rendering time can be reduced by many hours per shot by removing a model's unnecessary polygons.

'It's surprising how much detail can be removed from a model before it starts to look bad,' says Coulter. 'Much depends on how big a model will be on the screen in the final shot. If a model will be very close to the camera, it should have more detail; if it will be further away, we will use a lot less. If the model starts near the camera and moves away during the shot, we may change the model to a less detailed "proxy" model as it moves into the distance – there's no point having an incredibly detailed model in a shot if it only looks like a distant moving shape.'

To reduce the number of polygons in a model, the designer studies the surfaces to decide which vertices and polygons can be removed without adversely affecting the quality of the model. During modelling, many individual parts may have been constructed and joined together. Part of one object's detail will be hidden 'within' the other object where they intersect. Any polygons hidden inside a model will not be visible when rendered and can therefore be removed. Large flat surfaces also need very few polygons to be represented successfully.

TEXTURING

Once the structure of a computer model has been completed, a designer begins work on its outer appearance. Basic computer models are usually grey and dull in appearance – in fact, they look remarkably similar to an unfinished plastic kit model. Like

SPLINE-BASED MODELLING

Polygonal modelling is the most popular method of producing digital models, but there are other ways to construct objects within the computer. The most commonly used alternative is spline-based modelling. A spline is a path or shape that is created by linking a number of vertices or control points (<125). This path can be straight or curved.

The most frequently used spline-based modelling system is known as 'nurbs' (which stands for Non-Uniform-Rational Bezier-spline). The system is based on the use of 'nurbs patches'. A nurbs patch is a 2-D shape whose surface is formed using a number of splines.

Figure 14

Control points positioned on or above a nurbs patch can be used to manipulate its shape

By changing the position of control points along the path of a spline, the surface of a nurbs patch can be distorted to create the desired shape.

It is easiest to envisage a nurbs patch by imagining a square of flexible rubber that is pinned to a surface at its corners. By attaching a number of strings to this rubber, its surface can be pulled and stretched into different shapes. Using just a few control points, a single nurbs patch can produce a complex shape that would otherwise require a mesh of hundreds of thousands of polygons. Because of its low number of shape-defining vertices, the modelling, animation and rendering of a complete nurbs model requires less processing power than would be needed for a similar model created using polygons. To produce a complete model, many individual patches may be 'stitched' together like a patchwork quilt.

In a polygonal model one vertice can be moved in order to reshape one particular aspect of its shape. In a nurbs model, however, changing one aspect of one spline will alter the shape of the whole nurbs patch. For this reason, some systems allow small areas of a nurbs patch to be converted to polygons which can then be more carefully refined.

modelling kits, computer models must be finished with a coat of 'paint' and additional exterior details. It is this part of the design process that can truly define a model's characteristics and bring it to life. Simply by applying different colours, textures and surface properties to the model's exterior, a basic sphere can be turned into a planet, a golf ball or an orange.

Surface materials are applied to basic models in a process called 'texture mapping'. Texture mapping resembles the process of wrapping a gift. First, the wrapping paper is chosen; if nothing suitable can be found, something is specially made. The paper is then wrapped around the item in the best way possible. When gifts are oddly shaped, getting the paper on neatly may involve using various approaches. Putting a surface on a computer model works in much the same way. All textures begin like printed paper that has to be wrapped around the model, or each of its separate parts, in order to make it look real.

Texture maps contain all the information about the exterior details of a model – its colour, material, texture, translucency and so on. Any number of texture maps, each describing a different aspect of a surface quality, can be attached to a single model using a number of techniques.

The simplest form of mapping is 'planar mapping'. Planar mapping is similar to the process of applying wallpaper to a flat wall. The designer decides what the pattern of the wallpaper should be, what size it should be, where it should be applied on the wall, and how many times the pattern should repeat along the wall's length and width (fig. 15). As with wallpapering, planar mapping only works well if the model's surface is relatively flat and featureless.

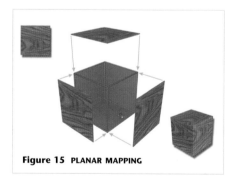

Figure 15 PLANAR MAPPING

'Cylindrical mapping' is used for surfaces that have a little more curve to them – like wrapping a label around the body of a bottle. The texture map can be arranged so that its height fits the cylinder's height, and its width fits the cylinder's circumference (fig. 16).

'Spherical mapping' is similar to cylindrical mapping in that a linear measurement, such as image width, is converted into a circumference measurement. However, while cylindrical mapping takes only the curve of the object's circumference into account (as a cylinder's sides are straight over its entire height), spherical mapping takes into

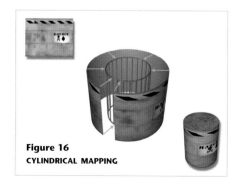

Figure 16 CYLINDRICAL MAPPING

account both the curve of an object's circumference and the curve of its height (a sphere's 'sides' are curved over its height) (fig. 17).

Texture mapping can be applied automatically by the computer program, which can predict the most likely co-ordinate system for any given object, or it can be applied manually, with the designer pulling the texture one way or another until it sits on the model in a satisfactory way.

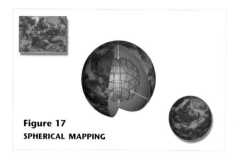

Figure 17 SPHERICAL MAPPING

'Wrapping' may be a useful analogy to use when describing texture mapping, but the term is actually somewhat misleading. Texture maps that are applied to a digital model are not 'physically' wrapped around an object at all. The texture map is distorted by the computer according to the mapping co-ordinates, then projected on to the surface of the digital model (much like the image from a slide being projected on to a wall from a distance), with the computer calculating the appropriate amount of distortion that is required to make projected images on the sides of curved objects look convincing.

Before texture mapping can take place, the textures themselves must be created. Simple textures are produced using a 'material editor', a part of every modelling software package in which the basic structure of a material's surface is designed. The designer can begin by choosing from the range of ready-made materials that most programs contain. These textures are then refined by varying a number of surface parameters. These include variables such as colour, shine, transparency and self-illumination, and the way that light interacts with each of those surface values under certain conditions. Unique or highly detailed materials, such as a specific type of leaf, or liquids, may have their surface properties specially written by a software expert. These programs are called 'shaders'.

In addition to these materials, there is another group called 'procedural textures'. Procedural textures are applied to an object's surface in the same way as normal textures, but the actual texture is generated by a mathematical algorithm. The result is not a material that needs to be wrapped around an object, but one that uses the geometry of the object to generate its own appearance. Examples of procedural textures are marble and wood, where no texture mapping option is uniquely suited to the object.

If the texture required for a model cannot be made from one found in a library of ready-made materials, a material can be imported from elsewhere. Designers often photograph materials and scan them into the computer for use as textures. During location filming, a special effects supervisor might take photographs of buildings so that subsequent computer models can be built from the correct type of local stone. Even greasy fingerprints may be scanned and added to digitally created windows or paintwork. Texture maps can also be painted by hand or created using a

digital paint package. Using such tools, a texture map can be weathered – a building may have water stains painted on to its brickwork, or an aircraft be given exhaust stains and grease marks.

The process of painting 2-D texture maps that look good and fit properly around a complex 3-D model can be a frustrating one. Just like wallpapering, if a flat image is pasted on to a particularly curved or bumpy surface, there will be a lot of stretching and creasing. To avoid this, it is possible to use a graphics pen to 'paint' directly on to the surface of the 3-D model. Using the digital equivalent of an airbrush, designers can decorate the skin of the model once it is in place. Often a designer uses this process to mark the areas that need to be painted before 'unwrapping' the texture map to work on it in greater detail as a flattened image. The map is then reapplied to the model when finished. Industrial Light and Magic created such a system, called Viewpaint, to achieve accurately mapped fine skin detail on the dinosaurs in *Jurassic Park* (1993).

Texture maps do not have to be still images. An animated texture map, such as a piece of video footage, can also be mapped on to an object – this is useful for putting moving images on to a television set, for example, or creating the appearance of a moving reflection in a window.

To create reflections on digital objects, a 'reflection map' can be used. If a digital car with shiny paintwork and chrome is to be composited into live-action footage, reflections from the live-action surroundings can be added to the digital car. After assigning shiny, reflective surfaces to the computer model car, a cube or dome can be placed around it. Moving footage of the location in question is then mapped on to the cube or dome, which is itself made invisible to the virtual camera so that only the moving images that it holds are reflected in the paintwork of the car. The finished image will be a digital car with real location reflections, so that, when the car is composited into the live action, it will look as if it is physically within the real environment.

To bring more life to the surface of a model, a special texture map called a 'bump map' may be used (fig. 18). Bump maps are greyscale pictures – that is, images composed of varying shades of grey – of the surface of an object. They are usually painted in the computer by artists using a digital paint program such as Photoshop. Although a bump map is 'flat', when it is added to a model, the computer renders light grey areas to look as if they are raised from the surface, and dark grey areas to look as if they are sunk below the surface. The actual surface of the model remains 'physically' unaffected, but the bump map produces an impression of depth. A bump map may be used to save modelling time when building a complex model like a ship, for example. The hull of the ship may be modelled as a perfectly smooth object. A separate bump map containing the detail of the thousands of rivets on the hull can then be hand-drawn or made from photographs of a real ship. When applied to the model hull, the bump map will give the impression of a much more complex and believable model without the modeller having to make and apply each rivet.

In addition to bump maps, modellers can use 'displacement maps' (fig. 18). Displacement maps are similar to bump maps in that they use light and dark areas to represent areas of surface detail that are raised or sunk. However, when a displacement map is attached to a model, it 'physically' alters it, pulling areas of highlight outwards and pushing areas of shade inwards, to create a much more complex and realistic model.

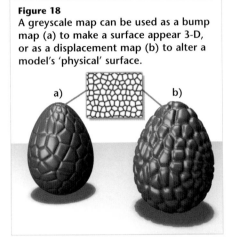

Figure 18
A greyscale map can be used as a bump map (a) to make a surface appear 3-D, or as a displacement map (b) to alter a model's 'physical' surface.

a) b)

Another variety of map, called an 'opacity map', can control the solidity or transparency of a surface (fig. 19). Opacity maps are greyscale maps that range from black to white – the darker areas resulting in see-through sections of surface and the lighter parts creating areas of solidity. These maps are useful for placing holes in

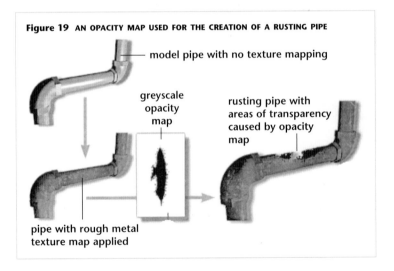

Figure 19 AN OPACITY MAP USED FOR THE CREATION OF A RUSTING PIPE

model pipe with no texture mapping

greyscale opacity map

rusting pipe with areas of transparency caused by opacity map

pipe with rough metal texture map applied

complicated models, allowing the artist first to build a perfect model and attach various texture maps to it before making alterations. As with any texture map, opacity maps can be animated so that an object appears to turn transparent – bullet holes appearing in the side of a computer-generated car, for example. Opacity maps were used by ILM during the making of *The Mummy* (1999). The computer-generated Mummy, Imhotep, was first built with many layers of skin, flesh, muscle and bone, before opacity maps were applied to create the holes and fissures that revealed the Mummy's underlying flesh and bone.

LIGHTING

Just like real models, digital objects must be properly lit before filming takes place. 'A model built in the computer exists within a totally dark environment,' explains Craig Ring, lighting director at

the California-based Pacific Data Images (PDI), the animation company that produced *Antz* (1998). 'During the modelling process, a very flat type of light is used to view the object that a designer is working on. Without placing additional lights within the scene, the model would be in total darkness when finally rendered.'

Much like cinematographers on location, digital lighting designers have a full range of lighting tools at their disposal. However, the computer environment is very different from the real world, in which light is affected by how shiny a surface is or by how much dust is in the atmosphere.

'In a real environment, you can shine a light at an object and the whole scene will be affected,' explains Ring. 'Light hitting an object will change colour and become more diffused when it is reflected off again. Then that reflected light will hit another object, where its colours and characteristics are changed even more. Digital lights don't usually work quite like that, so we have to study nature and then mimic it.'

To help mimic nature, the computer contains a number of types of light, which go some way towards creating the effects that can be achieved by natural light and the electric lights that are used during filming. The designer can choose from spotlights, which provide focused cones of light that cast shadows; radial lights, which cast light outwards in all directions like a real light bulb; ambient lights, non-directional diffuse lighting that illuminates a scene uniformly; and global lights, which cover the whole scene with parallel rays of light from a distant spot. Digital lights are totally invisible, so they can point directly into the virtual camera and nothing will be seen, but any objects in the path of their light will be illuminated.

'To help us along, the lights we use at PDI are designed to look like real lights,' explains Ring. 'We have little icons of fluorescent tube lights, or spotlights with little movable barn doors on the front. These lights don't behave exactly like the real thing, but they are our nearest equivalent. When we want a light, we can pick up one of these icons and drag it to the place in the digital environment where we want to use it – just as a stage technician would pick up a light and place it where they want before plugging it in.' Once a light has been positioned within the virtual environment, the designer adjusts variables such as focus, colour and so on.

'The easiest part of lighting a shot is placing the key light,' explains Ring. 'The key light is the main source of illumination in any scene. Outdoors, the key light would be the sun. Indoors, the key light would be the brightest light in a room – probably a window. Once we've placed the key light, we spend a lot of time artificially creating the side effects of that light. Most of the time digital lights don't work in the same way that real lights work, so we have to re-create all the side effects that would occur if we did have a big light pointing at something in the real world. If we point a bright white key light at a red box in our digital environment, we might then place a smaller light inside the box to cast some red "reflected" light away from it [fig. 20]. Building up the light in this way may mean that each main light may have many smaller lights working

as its "slaves".' In order to create realistic lighting effects inside an artificial environment, digital lighting designers must have a thorough understanding of how light works in the real world, along with the eye of an artist to re-create those conditions convincingly in the digital world.

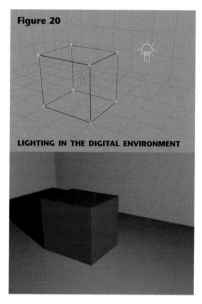

Figure 20

LIGHTING IN THE DIGITAL ENVIRONMENT

According to Ring, one of the hardest things to light in the computer is natural exteriors. 'Lighting an interior scene is fairly easy to get right because the inside of every room is different,' says Ring. Nobody watching a film has ever been in the room that they see up there on the screen – so as far as they're concerned, it could be lit almost any way and still look convincing. However, everybody is an expert on what things look like outside,' claims Ring. 'Everybody sees ordinary exterior light every day, and because we all know what bright sunlight or cold wintry light looks like, they are quite a challenge for us to re-create perfectly. The sun is relatively easy to get right – it's just a great big hard light in the sky,' continues Ring. 'The difficult bit is getting the fill light right – that is, the soft light that comes from the blue sky or that is bounced off the ground and surrounding areas.'

'We don't actually have a "soft" light in the computer,' explains Ring, 'so we have to re-create it artificially. There was a scene in *Antz* where the character called Barbados dies. The scene was supposed to be overcast with very soft light and gentle shadows. To create the effect, I placed about twelve lights in an arc around Barbados' head. Each light cast a hard shadow, but by arranging each light so that its shadow overlapped the shadow caused by the light next to it, the shadows added up to feel like a very soft light.'

Shadows are an area of detail to which digital lighting designers pay a great deal of attention. 'Shadows are very useful for giving the impression that a character is travelling through space,' believes Ring. 'By having the lighting get slightly darker or lighter as a character walks forwards, it really gives the impression that they are walking past several light sources or perhaps under the shadow of trees.' Shadows such as these can be created in exactly the same way that they are in the real world. A computer model of a filter is made and placed in front of the virtual lights to cast areas of light and shade.

'We also spend a lot of time on the shadows cast by our characters,' says Ring. 'If you look at the shadow that your body casts on a sunny day, you will notice that the shadow is quite sharp where it joins your feet, but up near your head it's quite fuzzy and out of focus. We find that little subtleties like that make all the difference,

Dozens of digital lights were used to simulate the effect of just two real lights in this scene from Antz.

but they aren't always possible to achieve with our normal lighting set-ups. We often render shadows as a separate element in which we can concentrate just on getting them looking right – perhaps by manipulating them with a 2-D image-processing procedure. Sometimes we even draw the shadow by hand if it proves really complicated. When the shadow is looking right, we reintroduce it to its body during compositing.'

Like cinematographers in the real world, digital lighting designers need to make the stars of the film look as good as possible. 'When lighting characters, there are certain small things that are important to get right,' explains Ring. 'Real cinematographers are always careful to get a bright highlight in the actors' eyes – a little sparkle that helps to bring them to life. With the characters in *Antz*, we spent a lot of effort trying to do the same thing. Though their

eyes look as if they are round, the model ants' eyes were actually flat, which meant that they didn't easily pick up the reflection from a light. To get over this, we filled our environments with lots and lots of small lights and programmed them so that they didn't actually cast light on to anything except the eyes of our ants.'

Being able to tell a light exactly which objects to illuminate is one of the great advantages of digital lighting. In the real world, cinematographers may spend hours arranging lights so that particular actors or areas of a set have just the right quality of illumination. In the digital world, a light can be told to light just one object and nothing else. 'The flexibility of digital lights is something that film and stage lighting people get really jealous of,' exclaims Ring. 'We can animate the position of a light so that it follows a character around wherever they go, or I could ask a light to illuminate the tip of a nose and nothing else, or I can drastically change the quality of the light at any time. It's very liberating!'

Lighting digital models for completely computer-generated scenes is a complex task, but lighting a computer-generated model that is going to be added into a real environment requires considerable skill. In such cases, the lighting on the digital model must perfectly match the natural light in the real environment. During the filming of the live-action plate into which a computer-generated model is to be added, effects supervisors carefully record the position and strength of each of the lights being used. Often, a highly reflective chrome lighting reference ball is placed in the scene and filmed to record a reflected map of the position of the lights. In addition, a plain white ball is used to record the direction and shape of light and shadow in the scene. Sometimes a real model or sculpture of the object to be created in the computer is filmed so that the way light falls on surfaces can be judged. Once the live-action plate has been filmed, lighting on the computer models must be designed to match.

'We spend a lot of time trying to match our lights to the real lights used on location,' says Clint Hanson of Sony Pictures Imageworks. 'For *Stuart Little* [1999], we created an incredibly lifelike computer-generated model of the mouse, Stuart Little. Once completed, Stuart was placed into environments in which everything else was real. All the hard work that went into producing that mouse could easily have been wasted if we didn't get the lighting on our computer-generated rodent to match the live action perfectly.'

The effects team at Sony were provided with highly detailed descriptions of the position, colour and intensity of the lighting used to film the live-action sequences. They then replicated this lighting within the computer environment in order to produce a computer-generated mouse that perfectly matched the environment into which it was to be composited. 'In fact,' admits Hanson, 'taking great care to copy the real lighting on a film set is just the start of the process. Once we have digital lights that match the real lighting in a scene, we often end up altering them slightly because what is scientifically correct is not always what is aesthetically pleasing. Using the live-action lighting information is about eighty per cent of the task. The last twenty per cent is done by eye, and that's the art of digital lighting.'

For this scene from The Lost World *(1997), the natural lighting in the location footage was carefully replicated within the computer so that the digital dinosaurs matched their environment perfectly.*

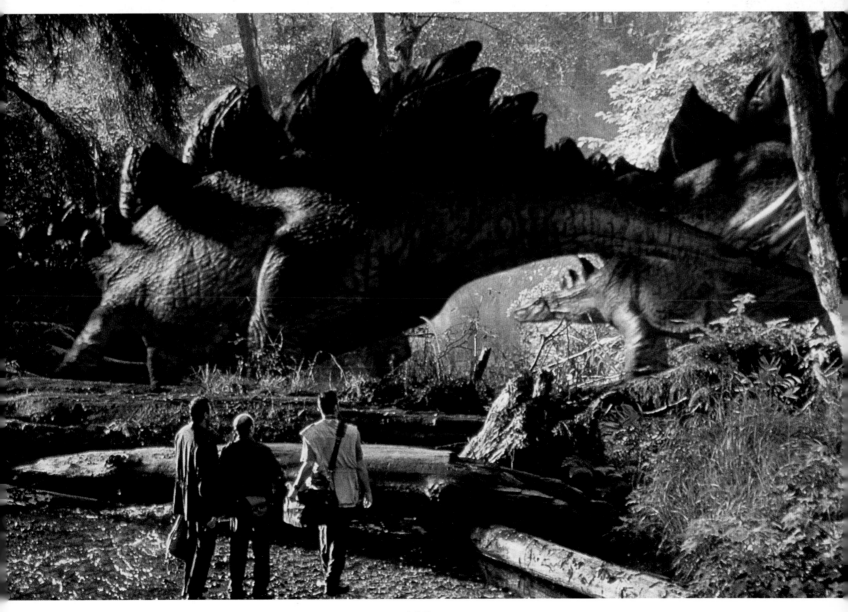

A) Screen grab from computer monitor during modelling. Shows a wire frame preview of whole model.

B) During modelling, the model can be viewed from a number of separate angles at once.

C) Close up of wheel showing the individually modelled components from various angles.

D) A simple rendering converts the wire mesh model into a solid object for preview purposes.

E) This colour map is projected onto the model to give it it's exterior markings. Notice the basic helicopter outline of the highlights.

F) Fully rendered images of the final helicopter.

G) A wire frame render of final model showing each of its components in a different colour.

H) A render of final model with colour map applied to it.

I) Final model with texture and shadow maps applied.

J) A render of final model with bump map and opacity map applied to it (notice transparency of windows).

K) Final fully rendered version of helicopter as it would appear on film.

L) Final version of helicopter showing underlying wire frame structure.

ANIMATION

THE PRINCIPLE AT THE HEART OF MOVING PICTURES IS THE ABILITY TO PROJECT STILL IMAGES AT THE SPEED OF TWENTY-FOUR FRAMES PER SECOND, THUS CREATING THE ILLUSION OF CONTINUOUS MOVEMENT. ANIMATORS TAKE ADVANTAGE OF THE FACT THAT THE FILMING OF SUCH IMAGES NEED NOT BE CONTINUOUS, AND THAT EACH FRAME IN A SEQUENCE CAN BE PHOTOGRAPHED INDIVIDUALLY WITH A LENGTHY TIME BETWEEN EXPOSURES. BY MANIPULATING OBJECTS INCREMENTALLY FROM FRAME TO FRAME, ANIMATORS ARE ABLE TO CREATE THE IMPRESSION OF MOVEMENT AND LIFE WHERE THERE IS NONE.

THERE ARE TWO BROAD CATEGORIES OF ANIMATION. 2-D ANIMATION MAINLY INVOLVES THE PHOTOGRAPHY OF FLAT ARTWORK SUCH AS DRAWINGS OR PAINTINGS TO PRODUCE WHAT WE MIGHT CALL A CARTOON. SUCH METHODS ARE USED TO PRODUCE SHORT FILMS FEATURING POPULAR CHARACTERS SUCH AS TOM AND JERRY OR, IN THEIR MOST COMPLEX FORM, ANIMATED FEATURE FILMS SUCH AS *PINOCCHIO* (1940) OR *BEAUTY AND THE BEAST* (1991). LESS WELL KNOWN IS THE PRACTICE OF ANIMATING 2-D ARTWORK TO CREATE VISUAL EFFECTS FOR LIVE-ACTION FILMS. ELEMENTS SUCH AS SPARKS,

LIGHTNING AND LASER BOLTS CAN ALL BE DRAWN BY HAND AND PHOTOGRAPHED ONE FRAME AT A TIME BEFORE BEING ADDED TO LIVE-ACTION IMAGES. THESE TRADITIONALLY PAINSTAKING AND LABORIOUS PROCESSES HAVE BEEN GREATLY AFFECTED BY THE EMERGENCE OF THE COMPUTER, BUT THE PRINCIPLE OF ANIMATING 2-D IMAGES REMAINS ESSENTIALLY UNCHANGED.

3-D ANIMATION PROCESSES, ON THE OTHER HAND, INVOLVE MANIPULATING THE POSITION OF DIMENSIONAL OBJECTS, SUCH AS PUPPETS, AND ENVIRONMENTS FROM FRAME TO FRAME. SUCH TECHNIQUES ARE BEST KNOWN FOR CREATING THE PERFORMANCE OF MYTHICAL CREATURES IN FILMS SUCH AS *KING KONG* (1933) OR *THE SEVENTH VOYAGE OF SINBAD* (1958). 3-D ANIMATION HAS ALSO BEEN GREATLY AFFECTED BY THE DIGITAL REVOLUTION, AND MANY STUNNINGLY REALISTIC MODELS, FROM DINOSAURS TO SPACESHIPS – AND EVEN CLOUDS OF DUST, ARE NOW CREATED AND ANIMATED ENTIRELY WITHIN THE COMPUTER.

ANIMATION IS PERHAPS THE MOST IMPORTANT AND WIDELY USED OF ALL SPECIAL EFFECTS TECHNIQUES, AND IT HAS PRODUCED SOME OF THE MOST MEMORABLE AND TRULY BREATHTAKING MOMENTS IN THE HISTORY OF THE MOVIES.

2-D animation

It was a decade after the emergence of moving pictures before 2-D animation, the ancestor of the modern cartoon, became a recognizable mode of production. J. Stuart Blackton (1875–1941)

produced a film called *Humorous Phases of Funny Faces* (1906), in which an artist's hand sketched faces in white chalk on a black background. Once drawn, the caricatures assumed a life of their own and performed exaggerated facial expressions. The film was

made by a process of exposing a frame or two of the drawn face, then re-drawing it in a new position and exposing it for another frame or two.

In 1908 French caricaturist and comic-strip artist Émile Cohl (1857–1938) made *Fantasmagorie*, a two-minute film of hand-drawn, moving stick figures. Between 1908 and 1910, Cohl contributed animation to over seventy-five films for the Gaumont company, and invented many of the tools that became standards of the trade, including the vertically mounted camera animation stand and charts for plotting character and camera movement. Cohl's surreal animations, in which fantastic drawings metamorphosed into one another with no apparent logic, were very popular, and in 1912 he moved to the United States to produce a series of animations based on a newspaper comic strip called *The Newlyweds and Their Baby*.

A number of American newspaper cartoonists were encouraged by the success of Cohl's films and began to make moving adaptations of their own work. Among them was Winsor McCay (1886–1934), who drew the *Little Nemo* cartoon for the New York *Herald*. In 1911 McCay produced a short untitled film based on his *Little Nemo* comic strip. Before the animation itself, McCay appeared on screen to demonstrate the way in which thousands of individual drawings had been photographed to create the impression of movement. McCay actually painted the black-and-white celluloid images, to produce the first colour animated film.

After a year's work, McCay produced *Gertie the Dinosaur* (1914) – not, as is often claimed, the world's first cartoon, but certainly the first to feature a character with a

Drawings of simple stick figures were animated in Émile Cohl's Fantasmagorie *(1908)*

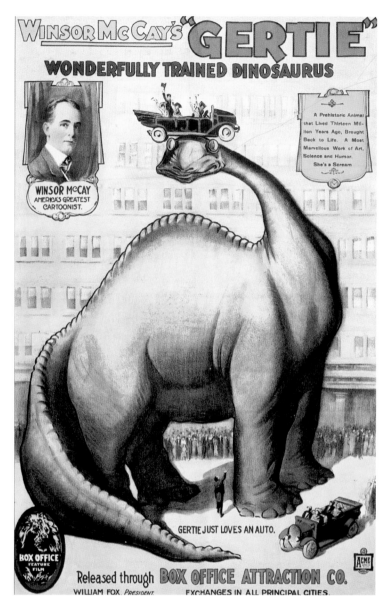

An advertising poster for Gertie the Dinosaur *(1914), one of the cinema's first cartoon stars.*

personality. Gertie appeared to move with a feeling of ponderous weight, was shy but liked to show off, and even shed tears when admonished by McCay (who appeared as an animated character in the film). McCay drew every detail of every frame line by line, each picture replicating the last except for minute differences, which produced the impression of movement when the pictures were photographed and shown in rapid succession.

In 1914 the cartoonist and producer John Bray (1879–1978) pioneered a method of painting the background scenery of a shot on a clear cellulose acetate sheet, leaving the area where the moving characters were to appear unpainted. The acetate sheet was then placed on top of the characters, still drawn individually on paper, and filmed. The system made production much quicker since only the moving characters and not the static background scenery had to be re-drawn for each shot. Bray's system was improved later in the same year by Earl Hurd, who reversed the process, using a single elaborate background painting over which cellulose sheets, or 'cels', containing the changing characters were laid. The system of

Disney's multiplane camera (invented in 1937) brought a new sense of realism to cartoon animation.

of the multiplane camera at the heart of the animation production process remained unchanged until the arrival of computer-aided techniques in the 1980s.

SPECIAL EFFECTS ANIMATION

Although creating the illusion of life with a few strokes of a pencil could be considered a special effect in itself, traditional 2-D animators distinguish between character animation and special effects animation. Anything that moves and which is not a character is usually animated by the

effects department. This can include rain, snow, water, falling leaves, fire, smoke, shadows – anything that brings the scene to life.

As with so many aspects of animation, Walt Disney was an early innovator in the field of special effects. Character animators were traditionally responsible for drawing their own special effects, and as a result, such elements often remained crude and ineffective compared to the advances that were made in stylistic character animation. Disney was aware that his first feature film, *Snow White and the Seven Dwarfs* (1937), would rely just as much on the credibility of its environments as it would on its characters. To create the film he envisaged, Disney established the first special effects department and staffed it with animators whose talents lay in the portrayal of the natural world. These animators spent months studying the way in which different types of rain fell, rivers flowed and flames danced. With nothing to animate but special effects, the skills of the effects department staff developed so greatly that, as *Snow White* neared completion, the

Special effects animation brings drama to this scene from Walt Disney's Pinocchio *(1940).*

effects animation created at the beginning of production had to be redesigned to match the sophistication of the later work.

One of the major innovations made by Disney during the production of *Snow White* was a method of creating complex shadows. Traditionally, characters looked rather flat because there were no shadows on their bodies. The shadows that characters cast on the ground and the objects around them, which are important in 'tying' a character to its environment, were usually limited to amorphous dark patches that followed the characters around. For *Snow White*, Disney artists completed the character animation and painting before the effects team placed another cel on top of each character on which they drew the outline of a shadow area. The shadow area was then painted solid black. During photography, the shadow cel was laid on top of the character cel and the two were photographed for around seventy per cent of the time required for a good exposure. The shadow element was then removed and the character was photographed on its own for the remaining thirty per cent of exposure time. The result was an image that contained a character with a transparent shadow – that is, the character detail could be seen beneath the shadow. Varying the proportion of exposure time given to the shadow element made it darker or lighter.

'Shadows continue to be a large part of an effects animator's job,' says Jon Brook, an animation effects supervisor who has worked on modern animated classics such as *An American Tale 2* and *Who Framed Roger Rabbit*. 'You might think that creating a shadow down the side of a character is simply a case of drawing an area of darkness over the body, but in fact, shadow style varies greatly from scene to scene and film to film, depending on the overall production design. Shadows can be hard-edged and bold, or soft-edged and subtle so that they wrap themselves gently around the body. Shadows also have to be animated according to the content of the scene; as a character moves past a light source, the direction and quality of a shadow will change. If there's a fire in the scene, a shadow will shudder and move in response to the mood of the fire.'

Perhaps the greatest challenge for an effects animator is water. Water is transparent, elastic, constantly moving, sometimes heavy, sometimes light and frothy. Re-creating water with a few hand-drawn pencil lines is an extraordinary skill. A wave is not simply a crest that can be drawn with a single line – a wave has shadows, currents and smaller waves that grow and die within it as it moves. 'A simple little splash has so much thought put into it,' says Brook. 'It has to grow and die in probably less than a second, yet in that twenty-four frames we must draw a series of droplets that separate out and rise up to a crest before falling back down convincingly, all within the specific style of the production. We don't simply draw a standard splash when one is needed; we spend a great deal of time designing the feeling of the splashes in any production so that they fit in with the overall art direction – they might be hard, spiky splashes or delicate, soft ones.'

An effects animator is often called upon to draw objects as they move around and change position. A classic example is leaves

blowing in the wind. Each leaf must change its shape, colour and shadow as it is twisted and carried along by the breeze. Some of the most extraordinary examples of this artistic skill can be seen in Disney's *Fantasia* (1940). For the Nutcracker suite sequence, animator Cy Young created a beautiful moment when a delicate white blossom drifts down to land on the surface of a pond before being reborn as a graceful ballerina swirling up into the sky. This moment is one of hundreds of sublime animated effects in the film and, despite being over half a century old, *Fantasia* remains one of the finest examples of the art that has ever been produced.

Unusual movements such as water splashes are painstakingly planned and drawn by special effects animators. These production designs were created by effects supervisor Jon Brook.

ROTOSCOPING

The use of effects animation is not confined to films featuring cartoon characters. Many live-action feature films make extensive use of hand-drawn 2-D animated special effects.

In 1917 animator Max Fleischer (1889–1972) patented the rotoscope, a device that projected pre-filmed footage of a performing actor on to a sheet of glass. The movements of the actor were then traced on to sheets of paper one frame at a time, and these tracings were then used as templates to draw cartoon characters that, when animated, had incredibly lifelike movements. Max Fleischer and his brother Dave (1894–1979) used the rotoscope to produce the popular *Koko the Clown* cartoons of the 1920s and the *Betty Boop* and

WHO FRAMED ROGER RABBIT

Film makers have always been fascinated by the potential of combining live-action performers with animated characters. Max Fleischer's (<141) *Out of the Inkwell* series of cartoons (1919–28) featured animated characters that left their artificial environment for a jaunt in the live-action world. Walt Disney (<138) reversed the conceit with his *Alice* comedies (1923–27), in which a live-action actor was placed within an animated environment populated by cartoon co-stars. Later feature films such as *Bedknobs and Broomsticks* (1971) and *Pete's Dragon* (1977) combined human and cartoon characters, but the blend was never particularly subtle.

When director Robert Zemeckis (1952–) and executive producer Steven Spielberg (<34) decided to make *Who Framed Roger Rabbit* (1988), they knew that modern audiences would only watch the film if the human characters and the 'Toons' (the film's shorthand for cartoon characters) co-existed with a level of realistic interaction that had never been seen before. After two years in production, the film that was finally released blurred the lines between animation and live- action until they were almost unrecognizable. Audiences were thrilled by a world that included such inconceivable marvels as a cartoon car with a human passenger inside being chased by a real car driven by cartoon weasels.

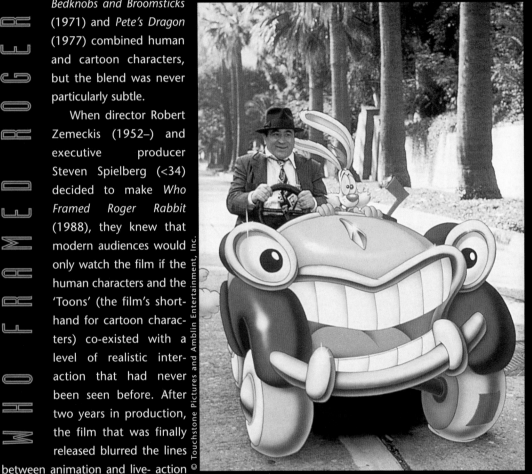

© Touchstone Pictures and Amblin Entertainment, Inc.

The first stage of production involved filming the live-action scenes into which animation would eventually be inserted. The film had to go through so many optical processes before completion that the whole movie was shot in the large VistaVision format (<42), which helped to retain good picture quality. It was the first film shot entirely in the format since the 1950s.

Star Bob Hoskins endured months of reacting to non-existent characters. To help Hoskins, voice artist Charles Fleischer dressed in a Roger Rabbit costume and read Roger's lines from the wings. Hoskins was also surrounded by dozens of technicians operating a host of wire and radio-controlled props that had been cleverly designed to indicate the presence of an unseen co-star. Coats bulged with the contortions of an invisible rabbit, chair seats depressed and puffed out dust as nothing sat down on them, and guns floated around in the hands of a transparent pack of weasels – Zemeckis referred to the proceedings as 'the most elaborate invisible man film ever made'.

Once live-action photography was completed, the film was edited into a semblance of its ultimate form. Scenes awaiting Toon performances were then enlarged into a series of photographs. These blow-ups were used as a guide by the 375 animators working under the supervision of master animator Richard Williams at his London studio. Williams produced rough pencil-line performances and combined them with the live-action backgrounds for the director's approval. Animation was particularly taxing because Zemeckis had filmed many scenes with a moving camera. To create cartoon characters that fitted into these scenes, animators had to draw Toons whose perspective altered as if filmed by the same camera.

Once approved by the director, animation was re-drawn, inked and painted. To help bring a sense of 3-D life to 2-D characters, a new method of producing shadows was devised. Since the 1930s shadows had been painted in black and double-exposed into a shot (<141), which gave all the shadows the same grey, sometimes muddy tone. To help the Toons blend more realistically with their surroundings, all shadow detail was painted in coloured tones; Jessica Rabbit's red dress was fringed with dark burgundy shadows and scarlet highlights, for example. Additional layers of animated effects – sparkling sequins in the case of Jessica's dress – were also created. Extensive rotoscoping (<141) was used to produce hand-drawn travelling mattes (<54) so that Toons, humans and real-life props could be composited together as if actually interacting.

The 82,000 frames of hand-drawn animation were then optically composited (<59) at Industrial Light and Magic to produce over a thousand special effects shots – visual effects supervisor Ken Ralston compared this to creating the effects for all three *Star Wars* films. *Who Framed Roger Rabbit* became a huge hit upon its release and picked up an Academy Award for its special effects.

Popeye cartoons of the 1930s. However, the rotoscope did not revolutionize the production of cartoons in the way that Fleischer had hoped. Many animators, including Walt Disney, preferred to use a stylized hand-drawn form of human movement.

Although rotoscoping was rarely used in the production of animated cartoons, its basic principles have found other important uses in the field of film special effects. By projecting pre-filmed images on to a flat surface, they can be traced to produce hand-drawn travelling mattes (<54). The process can also be used to hand-draw a variety of 2-D animated elements, such as lightning, lasers, gun blasts and shadows.

Steve Begg is one of Britain's leading special effects artists and is recognized for his skill in hand-drawing animated special effects elements. 'One of the most commonly required animation effects is lightning and electrical charges,' says Begg. 'To produce such effects optically, we first load a registration print [a developed print of the sequence that needs an animation effect added to it] into the rotoscope projector. Each frame of the sequence is projected down on to a piece of paper. Using the projected image for reference, we hand-draw a rough version of the actual animation itself, or trace reference points from the scene that we can use as a guide for our animation later.' The artist then sketches the animation in pencil before going over it with black ink or paint.

'There are a number of different ways of getting lightning to look like the real thing,' says Begg. 'Some people like to draw just the tip of the bolt of lightning as it emerges from a cloud and then extend it down towards the ground over the course of three or four frames. In actual fact, lightning is so fast that it's instantaneous – it's not there and then suddenly it is. It's the same with laser guns in sci-fi films; the beams of light are usually animated to look as if they leave the guns and travel across space until they hit something. If those were real lasers,

Hand-drawn lightning effects illuminate the skies in Dragonslayer (1981).

Effects supervisor Steve Begg photographs flat artwork using the rotoscope at The Magic Camera Company.

the beams would travel far too fast for you to see them moving across the screen – they would simply be a beam of light that was on or off. For natural lightning, I think it looks best if it snaps down to the ground instantly. If it's some sort of fantasy film and you want the lightning to appear to have a life of its own, however, you can draw it so that it twists and curls in an organic-looking way before recoiling back into

Actors fought with wooden sticks during the making of The Empire Strikes Back. *The glowing light sabres were then hand-drawn and added to the footage during compositing.*

itself. It's important to try to give the lightning that life.'

Once the animation of lightning or lasers has been drawn and painted, it is photographed. Each sheet of animation is laid back on the rotoscope stand and photographed sequentially on to high-contrast black-and-white film. When developed, the result is a series of black negatives with white (transparent) animation on them; in other words, the black-painted lightning becomes a clear area on the negative. This film is then loaded into an optical printer (<56) and combined with the film of the original scene. 'We will often print animation in several passes,' explains Begg. 'Drawn animation is usually quite sharp-edged. This is fine for sharp electrical sparks and lighting, but lasers and other effects often look better if they have a soft glow. To achieve this, we first print the animation in what we call a "core pass". This gives a bright, sharp centre to the effect. Then we rewind the animation and print it a second time using a diffusion filter that blurs the image. This produces a soft glow around an intense, "burnt-out" centre. By placing a coloured filter in front of

the animation during printing, the lightning or laser bolts can be made any colour that you want.'

As well as creating areas of light, effects animation can be used to create areas of darkness. When real aircraft fly over a real landscape, they cast shadows beneath them as they travel. When model aircraft are optically composited into real or model landscapes, the two elements have no physical relationship and no corresponding shadows. By using the rotoscope to plot the path of a flying object, shadows can be drawn by hand that trace the shape of the aircraft on the contours of the ground below. By adding the shadow of one object on to another, the separate elements of a scene are effectively 'tied' together, as if filmed at the same time. Fine examples of this method can be seen in *The Empire Strikes Back* (1980). When the Millennium Falcon is pursued across the surface of an asteroid by Imperial TIE-fighters, the spaceship's shadow can be seen rippling over the rocky surface below.

Rotoscoped effects animation can also be used to create more down-to-earth effects. 'Over the years there has been one simple effect that we have been asked to do probably more than any other,' explains Gene Warren (<61). 'Lots of films contain shooting, and

getting a gun to look as if it's firing can be a hit-or-miss thing. Firstly, the person using the gun has to remember to pull the trigger – in all the excitement of an action scene, they sometimes forget to do this. Secondly, even if the gun does go off, the flash of the gun lasts for just a fraction of a second and it is quite possible for it to occur between frames when the shutter of the camera is closed. We often end up having to rotoscope the muzzle blast on guns into a scene; we've done this hundreds of times over the years.'

'We do muzzle blasts just like normal rotoscoped animation,' explains Warren. 'The shot is projected down on to paper and the position of the necessary flash is traced and then shaded in pencil. Pencil shading is great because it gives you a random, grainy look that is perfect for muzzle blast and it only takes about five minutes to draw. The drawing is then photographed

Part of the psychedelic light show from the Stargate sequence of 2001: A Space Odyssey *(1968).*

and printed into the shot in the optical printer. The last little touch is to place a filter in front of the image during optical printing and put a dab of petroleum jelly on to the filter. With a fine brush, we just draw the grease out along the path of the bullet – this gives an almost imperceptible blur as if a bullet really is coming out of the gun. One of the biggest jobs we did this for was *Point Break* [1991]. We did nearly all the gun blasts in the bank robbery scenes. A few of those muzzle blasts are real and lots of them are fake, but it's totally impossible to tell which is which – I'd have to go and check our records to find out which ones we did because even I can't see the difference!'

Slit scan

For the tunnel of light known as the 'Stargate sequence' in *2001: A Space Odyssey* (1968), director Stanley Kubrick simply told his effects crew that the camera should appear to 'go through something'. Several options were considered, but it was a proposal from Douglas Trumbull (<295) that caught Kubrick's imagination.

Experiments in abstract streak photography had been made as early as the 1940s by brothers James and John Whitney. In the 1950s John Whitney acquired an army-surplus analogue computer and rebuilt it to photograph patterns of light for an abstract film called *Catalog 61* (1961; <119).

In the system Trumbull built for *2001* (fig. 2), an animation camera (a) was placed on a 4.6m (15ft) track, on which it could be moved slowly and smoothly backwards and forwards using worm

gearing (b). Two large sheets of glass were placed at the far end of the track, each sheet about 1.5m (5ft) high and 3m (10ft) wide. These sheets could be moved vertically and horizontally. The sheet of glass farthest from the camera held transparent, back-lit artwork (c). The sheet of glass nearest to the camera was masked in black material, apart from a small vertical or horizontal slit (d), from which the system derived its name, slit scan. The slit allowed only a small area of the back-lit artwork to be visible to the camera at any one time.

To produce the streaking effect seen in the film, the camera began with its lens close to the slit so that the artwork behind it reached the edges of the frame, either vertically or horizontally. The shutter on the camera was then opened to expose a single frame of film to the image. Still exposing the same frame of film, the camera was moved away from the slit until it reached the end of the track. As the camera moved backwards, gears ensured that its lens kept the shrinking artwork in focus. At the same time, the artwork itself was moved horizontally or vertically across the slit to provide distortion. When the camera reached the point farthest from the artwork, the shutter was closed after having exposed, on one frame of film, a distorted

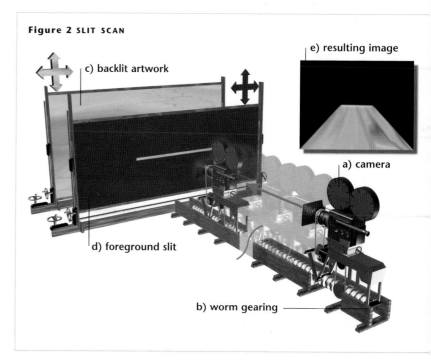

Figure 2 SLIT SCAN

c) backlit artwork

e) resulting image

a) camera

d) foreground slit

b) worm gearing

streak of coloured light. Douglas Trumbull has compared this process to photographs of roads at night, where long exposures register passing vehicles simply as the blurred streaks of headlights.

Next, the film was rewound and the process repeated with the blur of light travelling from the opposite side of the frame towards the centre. The process was carefully programmed so that for each subsequent frame filmed, the movements of the camera and the artwork were repeated with minute, sequential differences. The result was the effect of travelling through a tunnel of light.

No hard-and-fast rules were followed when producing the sequence. Each filming session was set up with different variations of artwork, movement and exposure, and after many hours of laborious work, the result might be, according to Kubrick, 'like carpet going by' or one of the most dazzling, kaleidoscopic lightshows ever to have been captured on film. After slit scan's spectacular debut in *2001*, it was used to create streaking title effects for films such as *Superman* (1978) and the worm hole sequence in *Star Trek* (1979).

2-D COMPUTER ANIMATION

Everything about traditional hand-drawn animation is laborious and painstakingly slow, so when computers began to affect other areas of movie production, animation studios wasted no time in looking for ways to streamline their own production methods using digital technology. An early innovator in

In FernGully ... The Last Rainforest *(1992), hand-drawn animated scenes were complemented with computer-generated animation.*

computer-aided animation techniques was the biggest and oldest animation studio of all, Disney. In 1986, Disney, in association with Pixar, began to develop CAPS (computer animation production system). CAPS was designed to perform many of the tasks of the traditional animator within the computer. First, the black-and-white artwork was drawn by hand and scanned into the computer. Each drawing was then coloured in on screen using a digital paint system. The rows of artists who had once worked amid pots of freshly mixed paint were replaced by a few computer monitors. While one artist could hand-paint perhaps twenty cels a day, a single computer operator could now complete around 200. As well as painting images, CAPS could also be used to generate certain special effects and to assemble multi-layer scenes without the use of a multiplane camera (<137). The first feature film entirely painted and assembled using CAPS was *The Rescuers Down Under* (1990).

2-D animators also wanted to take advantage of the computer's ability to create 3-D images. While traditional animators could draw images resulting from a complex camera move, the process was complicated and not always successful. In the computer, however, objects created in 3-D (<125) could have any movement or change in camera angle accurately applied to them at the touch of a few buttons. Bill Kroyer, who first became involved in computer animation when he supervised some of the effects for Disney's *TRON* (1982), was among the first to seek a way of fusing traditional 2-D animation style with the convenience of 3-D computer animation methods. 'I liked traditional cartoons, and I also really liked working with computer animation, so I began to look for a way to combine the elegance and style of hand-drawn animation with the dynamics of 3-D computer animation,' remembers Kroyer, who now supervises computer animation for Rhythm and Hues Animation Studios.

'I had this friend, Tim Heidmann, who knew a lot about software and computer plotters, and together we devised a special system that would print out a 3-D computer image as a 2-D picture on a piece of paper. Our software was quite sophisticated, because 3-D objects don't have black lines around their edges like cartoon drawings do; they are solid objects whose boundaries change whichever angle you look at

them. So we wrote some special "edge-detection" software so that the computer would draw a black line around the outside edge of each object and its details, and then print out a perfect black-and-white line drawing of it.' Using this software, Kroyer could animate a digital 3-D object and then print it out as a 2-D image, ready for painting and combining with traditional 2-D backgrounds and other elements.

'It was a really amazing system,' exclaims Kroyer. 'The computer was like an artist that could draw moving objects and get all the angles perfectly correct. A traditional animator drawing a motorbike coming towards the camera would spend weeks working out all the angles. We could just build a digital model bike in a day or so and animate it in five minutes. Then we could print out a series of 2-D images of the bike but leave the face of the rider blank. Animation artists could then fill in intricate facial details and other subtleties by hand.'

After using the system for the title sequences in a number of feature films such as *National Lampoon's Christmas Vacation* (1989) and *Honey, I Shrunk the Kids* (1989), Kroyer put it to use in the production of *FernGully ... The Last Rainforest* (1992). 'We used 40,000 frames of computer animation in *FernGully*,' claims Kroyer. 'We used it to produce shots of flocking birds, running animals, all

sorts of things that would have been very time-consuming to produce traditionally. We managed to finish the entire movie in about half the time that animated films normally took to produce.'

3-D computer-generated settings and chariots were combined with traditional backgrounds and character animation for the exciting chariot race in The Prince of Egypt *(1998).*

Computers are now an essential part of the production process of 2-D animated feature films. At the forefront of modern animated feature production is DreamWorks Animation, whose ambitious first movie *The Prince of Egypt* (1998) was a landmark in feature animation. '*The Prince of Egypt* was an epic story told on an epic scale,' comments 3-D layout artist Harald Kraut. 'We felt that traditional 2-D multiplane camerawork – or at least today's computerized equivalent – wasn't up to the scope of the story. We didn't want all of the wonderful Egyptian architecture to look like pieces of flat artwork sliding past each other; we wanted to create a real sense of environment.' To help create this environment, DreamWorks collaborated with computer company Silicon Graphics to develop a new animation system called 'Exposure'.

'Exposure helped us to integrate traditional and computer animation, but in a totally new way,' explains Kraut. 'We wanted to

147

create a movie with all of the advantages of 3-D digital animation, but what bothered me was the idea of using noticeably 3-D elements in an otherwise 2-D movie. Whenever this had been done before, the computer-generated elements always had a different look to the painted effects around them, which was very unsatisfactory.'

The Exposure system is based on the principles of normal 3-D animation production, in which a 3-D environment that has been built, textured and lit in the computer has a virtual camera (177>) placed within it. The camera is then animated to move around and 'film' objects from any angle. Using Exposure, DreamWorks artists construct digital 3-D buildings and objects in the usual way, but the exterior of the objects is left flat and without details.

'The models built in the computer are basically dummy objects that are simply the right shape and nothing else. Sometimes we only need to see buildings from one angle so they are built as flat objects, rather like the scenery flats used in stage theatre,' says Kraut. 'We position the virtual camera to look at each object from an angle that shows the largest amount of surface area on that model. We then print the shot out on a sheet of paper, which artists use as a template to paint the detail of the object. All of the exterior detail and definition on the object is added at the painting stage – all the cracks, weathering, water stains and so on. We didn't want to use computer-generated lighting – which often looks too perfect – so all of the shadow and light information was added as 2-D detail in these paintings. When finished, they were scanned into the computer and then projected on to the model from the position that they were originally filmed from. Two or more projectors may have been used for each object to cover the detail of all of its sides.'

'What we ended up with was the computer equivalent of the sound stage,' says Kraut. 'To build a street within the computer, we would position two rows of buildings, place another object underneath for the road, position a background painting in the distance and place a large dome with a sky painting mapped on it over the

The use of tens of thousands of 3-D digitally animated characters gave a huge sense of scale to the Exodus sequence in The Prince of Egypt.

whole thing. The buildings with their projected surfaces looked like 2-D pictures, but we could animate our virtual camera to move past them, look around and do all the normal things that a live-action camera could. We wrote lots of software that would do things like blur the edges of the objects, so that they looked more than ever like 2-D paintings rather than hard-edged 3-D objects. For the first time ever, animation directors could actually create dynamic cinematography just like a live-action director, but their final images looked as if a camera was moving through a traditionally painted scenic environment. If they didn't like a camera angle, the directors could just move the camera.'

Exposure was used to magnificent effect in an early sequence of *The Prince of Egypt* in which Moses and his brother Rameses race their chariots through the city. 'In the chariot race, most of the buildings and other objects were 3-D digital models,' states Kraut. 'The chariots themselves were also 3-D models, but the people inside them were 2-D character animation. Rameses and Moses were animated by hand and scanned into the computer. They were

then placed inside the chariots – a bit like standing cardboard cut-outs inside real-life models. We then animated the chariot chase, altering the movement of the chariots and the camera to produce the most dynamic shots. Once the movements of the camera and 3-D chariots were decided, the 2-D characters standing inside the chariots were moved so that they always faced the camera – otherwise you would see that they were "flat" 2-D objects. We found that we had a surprising amount of latitude to swivel the characters before they looked as if they were standing in their chariot at the wrong angle.'

Though the main characters in *The Prince of Egypt* were hand-drawn and animated in the traditional way, much of the film's additional cast of thousands was generated by computer. 'Descriptions of the Exodus in the Bible actually mention 600,000 Hebrews. We didn't have quite as many as that, but we still had scenes with many thousands of people that could never have been achieved using traditional techniques,' says crowd animator Wendy Elwell.

Elwell and her colleagues used two methods to create the crowd sequences in the film. 'The first big crowd scenes are right at the beginning of the film, when we see hundreds of male slaves building a new temple complex,' explains Elwell. 'For these scenes we built a single 3-D digital character that matched the drawn characters. He was then reshaped to create a total of twenty different characters. These were then dressed with different hair, beards and clothing so that each person in the crowd looked more unique. We then animated walk cycles – sequences of movement that can be repeated as required – so that characters could walk for as long as was needed in any scene. Four separate cycles were used to give more variety of movement. The characters were then placed into scenes as 3-D objects, but they were rendered [180>] with flat colours and black outlines to make them look like hand-drawn 2-D characters. They were originally intended only to be in the background, but as the directors got used to using them, they put them nearer and nearer to the camera until their detail didn't hold up any longer. When the 3-D digital characters got too near the camera, they were swapped with 2-D hand-drawn ones – though I defy anyone to spot where they change.'

The second major use of computer-generated characters was in the Exodus sequence itself. 'For this sequence we made more 3-D digital models of men, women and children, as well as oxen pulling carts,' says Elwell. 'When we got the background artwork that these characters had to appear in, we matched our virtual camera to it so that we could film the 3-D characters from the correct angle. We then rendered the characters as 2-D animation moving "on the spot" in a walk cycle. Each of these 2-D animated characters was then individually mapped on to an invisible card called a "sprite".' Sprites are a way of animating large numbers of objects. The objects themselves are pre-animated and then mapped on to a flat, invisible surface – rather like sticking a cut-out photo on to a piece of glass. These sprites are then animated and programmed to behave in certain ways.

'We placed our sprites into a scene and animated them so that they moved at the same rate as the walk cycle of the characters that were mapped on to them,' continues Elwell. 'Using this method it was a simple case of moving the cards with the character that they contained. We could program groups of cards to move at faster or slower rates, or to avoid bumping into other groups if they were moving too slowly. To get a sense of movement in long-shots of the crowd, they actually had to move really fast. In some cases we had people walking at 65kmph [40mph], but it looks right on the screen. The largest crowd scene in the film was in the epilogue where Moses returns with the Ten Commandments. In this shot the crowd contains 146,392 characters – not including the oxen.'

By combining the finest traditions of classical animation with groundbreaking computer technology, *The Prince of Egypt* was a visionary retelling of one of the greatest stories ever told, and will influence the way that all animated feature films are created in the future.

KING KONG

During the Depression of the early 1930s, RKO hired Paramount producer David O. Selznick (1902–65) to help the company stave off bankruptcy. Selznick's assistant in this task was Merian C. Cooper (1893–1973), who, with Ernest Schoedsack (1893–1979), had made a series of successful adventure films including *The Four Feathers* (1928). One of the first decisions made by Selznick and Cooper was to cancel Willis O'Brien's *Creation* project, which had already cost the studio $100,000 and showed no sign of nearing completion.

However, Cooper believed that O'Brien might be the only person who could bring life to a story that had been gestating in his mind for some time. After O'Brien produced some successful test footage, the project was green-lighted under the working title of *Production 601*, later becoming known as *The Beast* and then as *The Eighth Wonder*. Eventually, on its release, the film became known to the world as *King Kong* (1933).

For *The Lost World* (1925), O'Brien had built a large set that could be photographed from all angles. For *King Kong*, he created another exotic world for the film's star to inhabit. Before starting the film, O'Brien had discovered the engravings of French artist Gustave Doré (1832–83), whose illustrations of forest settings with shadowy fringes and scattered pools of sunlight had a feeling of impenetrable depth. O'Brien decided to re-create this distinctive look in Kong by building a number of small sets, each designed to look like a Doré engraving come to life.

A model dinosaur lumbers through O'Brien's atmospheric forest settings. The bottom of the image has been matted out to receive a live-action element.

The miniature jungle sets were filled with gnarled trees made from modelling clay and palm fronds made from sheet metal. Each tabletop set was arranged in a number of planes one behind the other to create, for instance, the foreground, middle distance and background. Each plane was separated by a sheet of glass on which Doré-style scenery had been painted by production artists Mario Larringa and Bryon Crabbe. Once properly aligned and lit, each forest scene had an impression of great depth. O'Brien's multiplane model system was in fact the precursor of the system used to bring depth to the flat animation of Disney a few years later (<139).

Marcel Delgado was called upon to produce the marvellous model creatures. The mighty Kong was portrayed by six 46cm (18in) puppets made using the same build-up technique that had given the creatures of *The Lost World* their convincing muscle and flesh. For Kong, Delgado even stretched rubber tendons between joints to give the ape a realistic sinewy appearance. Covering the ape's complex body was a patchwork of trimmed black rabbit fur. The steel armatures in Kong and his prehistoric co-stars were built with keyholes in the base of their feet, allowing them to be secured firmly to the floor between moves using 'tie-down' pins screwed up through a patchwork of holes in the tabletop set.

Again, O'Brien needed to mix real-life actors with his animated wonders, but he wanted to avoid the process of double-exposed split-screen mattes that he had used in *The Lost World*, which was slow and carried with it the associated risk of losing the original footage. The process of rear projection was being perfected in the early 1930s and RKO was an early leader in the field, pioneering the use of a new type of background screen invented by paint department head Sidney Saunders. The first scenes to use the new Saunders screen were those of Fay Wray perched in a treetop while pre-animated footage of Kong fighting a tyrannosaurus is seen in the background. The new process took some time to perfect, due to the difficulties in preventing foreground lighting spilling on to the background screen – one shot of Wray in the tree was achieved only after an exhausting 22-hour session.

Cooper asked O'Brien if the process could be reversed in order to place rear-projected actors in the miniature tabletop scenery. After much experimentation, O'Brien and his team perfected a method of miniature rear projection (fig. 3). The model jungle settings were built with small areas where images could be rear-projected on to miniature screens made from stretched surgical rubber. Before each shot was filmed, many tests were made in order to match the lighting of the miniature set with the exposure of the rear-projected images. During animation, the model creatures were manipulated fractionally, the rear-projected image was advanced by one frame, and a frame of the composite image photographed before the process was repeated.

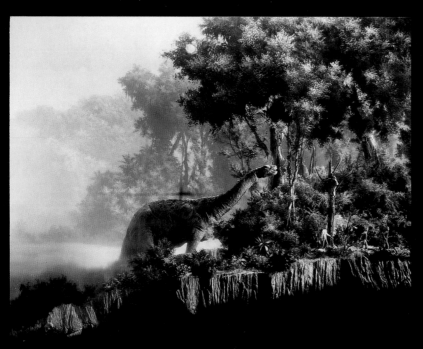

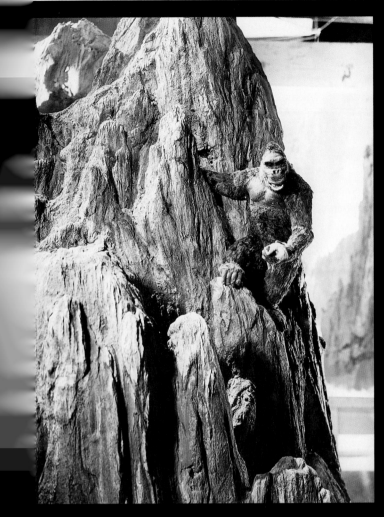

The stop-motion puppet of King Kong clings to a model cliff face.

bottom of the frame. Not wanting to start the sequence afresh, the animator slowly animated the out-of-focus grey shape out of the shot, hoping that it would look like a passing jungle creature. In another scene, a primrose planted as part of the jungle foliage chose the day of animation to come into bloom. No one noticed the flower's cautious emergence during animation, but when the finished shot was viewed, the scene's prehistoric star was upstaged by the herbaceous border, wasting hours of work.

While a team of animators achieved much of the animation of Kong in long-shot, O'Brien animated particularly emotional scenes and close-ups himself. As a result, Kong remains perhaps the most emotive creature to have been created for the screen. Even Kong's often criticized, bristling fur coat – caused by disturbance of the stiff rabbit fur during animation – seems to add to the great ape's personality.

King Kong was a sensational hit on its release and again when re-released in 1952. The public flocked to see the film, thrilled by both the story and the wonders of a lifelike giant ape. *Kong* was undoubtedly the most extraordinary technical achievement of its time and a catalogue of modern special effects techniques, including animation, rear projection, miniature rear projection, travelling mattes and matte paintings, as well as clever optical work by Linwood Dunn (<59).

For once, brilliant special effects achieved only reflected glory, for it was Kong himself that the public responded to, taking to their hearts the tragic performance of the character that Willis O'Brien had delivered, one frame at a time, from a 46cm (18in) assemblage of metal, rubber and fur.

One of the first scenes to use the miniature rear-projection process was that in which Bruce Cabot (John Driscoll) hides from Kong in a cave. A miniature cliff was built with a small cave in its wall, and a rear-projection screen was set just inside the cave. Footage of the actor in a large-scale cave set was projected on to the screen one frame at a time, while the model of Kong was animated on the cliff above. This shot was later cut together with a close-up of the performer interacting with a giant mechanical arm that reached into the cave.

The animation of *Kong* took over a year to complete. Its key actors were called back to the studio every few weeks to film scenes in which they had to react to recently completed animation, or provide the performances needed for the next miniature rear-projection shots. Some animation sessions turned into marathon events; the animation team quickly learned that shots begun one working day and completed the next often took on awkward changes of style or pace mid-scene; once started, the animation of a shot therefore continued until it was finished.

There were other unexpected hitches in the animation process. On one occasion an animator was halfway through a shot when he noticed that a pair of pliers left on the set was just visible in the

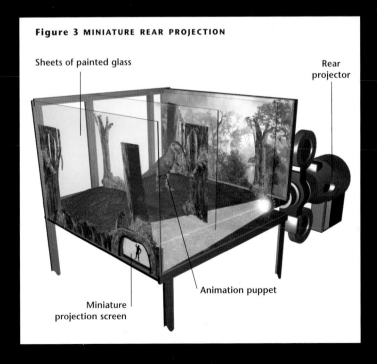

Figure 3 MINIATURE REAR PROJECTION

Sheets of painted glass

Rear projector

Animation puppet

Miniature projection screen

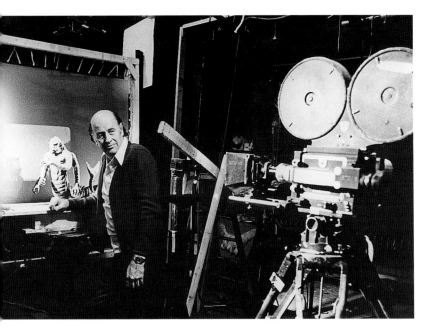

Ray Harryhausen poses in front of his animation camera while making Clash of the Titans *(1981). Behind him is an animation model and a rear-projection screen.*

the studio and took along some of the dinosaurs I'd been making. He looked at my stegosaurus, which had won second prize in a competition at the local museum, and he said: "Its legs look like sausages. You need to learn about anatomy and how muscles work." So then I began to study anatomy, life drawing, sculpture and photography.'

Harryhausen's animation skills quickly developed, and in 1940 he gained employment as an animator on George Pal's *Puppetoon* series (159>). After spending the war as an assistant cameraman and animator in Frank Capra's special-services division film unit, Harryhausen began to make his own series of animated fairy tales. Then, in 1947, having kept in touch with his mentor, Harryhausen was offered a job as O'Brien's assistant on *Mighty Joe Young* (1949). 'Working with O'Bie was a dream come true,' says Harryhausen. 'I helped during the whole pre-production phase, and when we got the go-ahead from RKO, I began work on the animation. I eventually did about eighty per cent of the character animation on *Joe Young*. O'Bie spent much of his time supervising all the other elements.'

The production of *Mighty Joe Young* used many of the techniques developed for *Kong*. One small but significant advance was the use of rubberized fur for the gorilla puppets. Kong had been covered with rabbit fur, but for Joe, unborn calf hide was considered more to scale for the smaller, 30cm (12in) puppet. In a process invented by taxidermist George Lofgren, the fur was embedded in paraffin, leaving only the skin exposed. The skin was then removed with acid and replaced with liquid latex. The finished fur, with its roots in latex, sprang back into place when touched during animation. Kong's bristling fur, which had annoyed some but endeared him to so many more, was not a feature of Joe's character.

After the release of *Mighty Joe Young*, Harryhausen was offered a job as chief animator on the low-budget *The Beast from 20,000*

Fathoms (1953). '*Beast* had a ridiculous budget considering its subject matter,' remembers Harryhausen. 'Doing things the O'Bie way was out of the question. He used big, painted sheets of glass in several planes that created a wonderful atmosphere but took a team of expensive artists to paint and restricted the camera to a single view. Also, the glass could crack in the heat of the lights. For *Beast* I devised a way of combining live-action actors with animated creatures and miniature backgrounds. It was the basis of the system that I used for the rest of my working life.'

The system that Harryhausen devised, which became known as 'Dynamation' for publicity purposes, was in many ways the opposite of that favoured by O'Brien. Rather than placing rear-projected actors into a miniature environment, Harryhausen used rear projection to place his animated characters into real environments containing real people. During live-action photography, performers reacted to the invisible creatures, sometimes looking at a cardboard head on a long stick as a guide. Harryhausen then studied the developed footage to figure out the movements that the animated creature should make in relation to the actors and their environment.

In his studio, Harryhausen then prepared an animation table (fig. 4)

Harryhausen was expert at achieving the apparent interaction of animated creatures and live-action characters. Here a real lance appears to penetrate a dinosaur in Valley of Gwangi *(1969).*

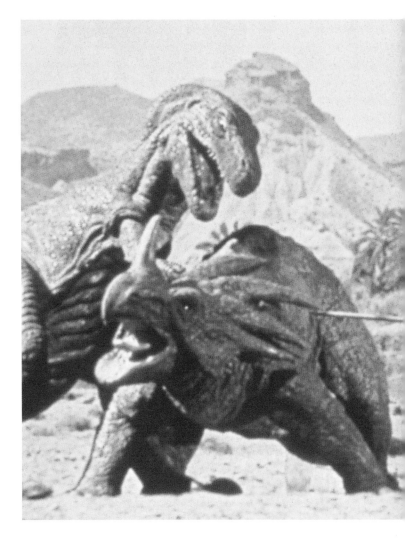

with a floor contoured to match the one that the creature was to traverse in the live action. A static split-screen matte (194>) that matched this contour was fitted to the bolted-down animation camera and used to mask out the bottom half of the frame of film, which contained the animation table and other paraphernalia. The image exposed to the camera showed the puppet down to foot level, with the top portion of the rear-projected, live-action background plate behind it.

Animation then proceeded as usual. Surface gauges were placed at important points around the puppet's body to mark its last position. The puppet's new pose was then created, in relation to the action in the rear-projected frame of film and the old position marked by the gauges. When the new position was satisfactory, the gauges were removed, the animation lights switched on and a frame exposed. The surface gauges were then brought back in, the rear-projected footage was advanced one frame and the next pose was created.

When the whole sequence had been animated, the puppet and animation table were removed from in front of the rear-projection screen. The camera negative and rear-projection footage were rewound to the start frame, and a counter-matte was applied to the camera to mask out the top section of the frame that had already been exposed. The camera negative was then exposed to the lower section of the background plate, so the two halves were married

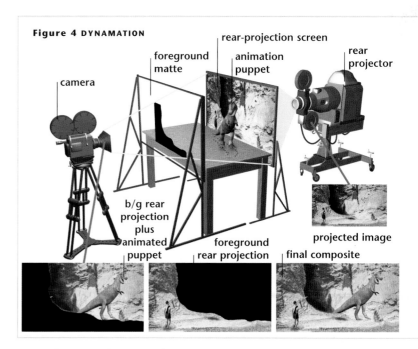

Figure 4 DYNAMATION

camera — foreground matte — rear-projection screen — animation puppet — rear projector

b/g rear projection plus animated puppet — foreground rear projection — projected image final composite

along the matte line. The final developed negative was a pleasing composite of live-action footage and animated creature.

Harryhausen also made changes to the type of puppet he used for animation. 'Delgado's build-up method was terrific,' says Harryhausen, 'but it was time-consuming, and if a breakdown occurred during filming, the whole puppet might have to be stripped down and rebuilt.' Instead, Harryhausen sculpted his creatures in clay. These clay shapes were covered in plaster to create a mould. The creature's ball-and-socket armature was placed inside the mould, which was then filled with liquid foam rubber. When baked, the rubber set. The rubber creature was then painted and dressed with eyes, clothing and props. If a mishap occurred during filming, the puppet could be stripped off and an identical rubber model quickly made. Harryhausen did not rely on this method to produce all of his creatures, however. For *Mysterious Island* (1961), a giant crustacean was made by fitting an armature inside a real crab shell.

After a series of 'monster on the rampage' films in the 1950s, Harryhausen turned to the subject matter for which he became best-known. 'Charles Schneer [Harryhausen's long-term producer] and I decided that we wanted to move on,' he explains.

The 7th Voyage of Sinbad (1958) became the first in a series of films based on the *Arabian Nights* tales and Greek myths. Harryhausen considers this work to be his best, partly because of the suitability of stop-motion animation for the subject matter. 'I think that mythological stories are best served by stop-motion because the process produces a sort of dreamlike quality. It's true that the animation is not very realistic, but we never tried to mimic reality. We played on the melodramatic aspects of film, and Greek mythology is very melodramatic.'

Harryhausen's work in these mythological films was technically and artistically stunning, with the animator paying more attention than ever to the subtleties of characterization in his creations. 'I always tried to give my characters little habits that made them

seem more believable,' he explains. 'It doesn't take much, just small habits such as taking a quick look at the ground before they step forward. I would also consider a creature's physique when planning their movement. In *The Golden Voyage of Sinbad* [1973], Kali moves in an unwieldy way because she is so top-heavy, and Talos in *Jason and the Argonauts* [1963] was actually criticized by one journalist for being jerkily animated – he was designed to move that way because he's a giant, rusting statue!'

In the early 1960s, Harryhausen and Schneer moved their head-quarters to England, which was closer to the European locations that they often used and allowed them access to the sodium vapour trav-elling matte process (<50), which only Disney was licensed to use in the United States. During this period Harryhausen developed many techniques for combining live action and animation more realisti-cally. 'I tried all sorts of methods to make the two separately filmed elements look as if they were filmed together,' he says. One of the animator's cleverest tricks involved using objects that appeared to cross the boundaries between live action and animation.

Typically, a live-action character might throw a spear through the air and it would appear to stick in the side of an animated crea-ture. Such shots were achieved by animating the creature in front of rear-projected live action in the usual manner. As the rear-projected actor threw the spear, the weapon did, of course, disappear *behind* the model creature rather than stick into it. As the rear-projected, live-action spear began to disappear behind the model, Harryhausen placed a miniature spear inside the miniature set so that, from the camera's viewpoint, the miniature spear covered the image of the rear-projected spear. As the live-action spear disap-peared behind the creature, Harryhausen animated its miniature replacement so that it impaled the rubber model, producing the illu-sion that both live-action and animated elements were actually sharing the same space.

Harryhausen used a different method to create the illusion that live-action characters with swords

A clever composite of stop-motion animation and live action from Ray Harryhausen's Clash of the Titans (1981).

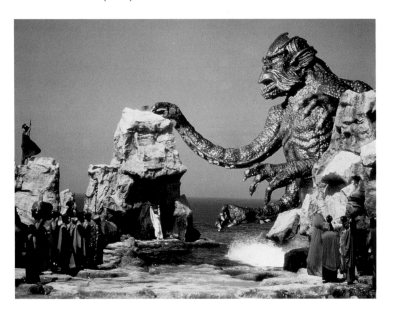

were interacting with animated creatures. He mounted a sheet of glass in front of the puppet so that, as a character thrust a sword at the creature, the tip (which in reality disappeared behind the model) could be painted on to the foreground glass frame by frame.

The edge of the animation table is visible in this production shot from Harryhausen's masterpiece Jason and the Argonauts *(1963).*

One of Harryhausen's most memorable and technically exacting achievements is the famous skeleton fight in *Jason and the Argonauts*. 'For that sequence I had to plan the movements in every single frame meticulously in order to animate seven skeletons simultaneously. Each skeleton had five appendages, so this meant I had to animate thirty-five separate movements for each frame, and each movement had to synchronize perfectly with the movements of the three live-action men.' It is hardly surprising that Harryhausen averaged just thirteen frames a day during the four and a half months that the sequence took to complete. Such dedication could be physically and mentally punishing, especially since, with the exception of *Clash of the Titans* (1981), Harryhausen was person-ally responsible for every frame of animation in all of his films.

To this day, the methods used to create some of Harryhausen's best shots remain a secret. 'I never give everything away,' he muses. 'When a magician gives away all of his secrets, no one is interested any more!' Whether the technique behind his art remains a secret or not, the films of Ray Harryhausen continue to beguile.

Replacement animation

The majority of stop-motion animation is produced using a method called displacement animation, in which flexible models of the animated characters are moved fractionally between exposures. An alternative method involves substituting the entire model, or just parts of it, between exposures. This rarely used technique is called replacement animation.

George Pal is often credited with pioneering replacement animation. Whenever the Puppetoon characters that he animated were required to walk, the entire bottom half of the puppet was replaced with one of a sequential set of carved wooden legs. Each step of a Puppetoon character was made using about thirteen leg models.

George Pal sits among some of the many replacement figures used for his Puppetoon *series in the 1940s.*

One of Pal's first employees was the young Ray Harryhausen (<153). 'Working for George Pal was my first professional job,' recalls the animator. 'The Puppetoons were basically just animated wooden puppets. Each one was minutely different from the last, which took many hours of construction and necessitated that they be very stylized, almost cubist in design. The job taught me patience and discipline, but also that it wasn't the type of animation I wanted to do. For every move we referred to a pre-prepared cue sheet that dictated the movement of the figures. It didn't allow for much creativity during filming.'

The replacement method has also been used in various television commercials. Before computer morphing (<86) made it possible to make objects appear to transform seamlessly into one another, objects could be shape-shifted using a sequence of replacement models. To produce a commercial for a brand of menthol vapour rub, British special effects supervisor George Gibbs (271>) created a sequence of forty-eight model pots of the product. Each pot, including the label and its writing, was a little more distorted than the last. When the pots were filmed, replacing each model with the next in the sequence in successive frames, the pot appeared to breathe in and out with a life of its own.

One of the most groundbreaking modern uses of the replacement technique was in the 1993 stop-motion animated feature, Tim Burton's *The Nightmare Before Christmas*, which was directed by Henry Selick. The film used traditional ball-and-socket displacement armatures for the bodies of its main characters, which necessitated some 230 puppets in all.

Computer-aided replacement animation was used for the characters in Tim Burton's The Nightmare Before Christmas *(1993).*

However, because the characters were required to talk, sing and express emotions beyond the range normally expected of stop-motion puppets, each of the major characters was given a supply of replacement heads. A dialogue animator was employed to draw every conceivable combination of mouth and facial expression. The resulting four hundred designs were then sculpted in modelling clay, moulded in rubber and cast in polyurethane plastic resin. Each head was then airbrushed to give it the correct colouring. One character, Jack Skellington, eventually had a collection of around eight hundred heads, allowing the expression of every possible emotion.

Each of Jack's heads was photographed, digitized and placed in a computer database. The dialogue of each character was then studied and broken down into frame-by-frame increments. The database was used to select which face was needed for each frame of animation. Once selected, a rough test sequence was assembled to show what the speaking characters would look like when finally animated. When the test was approved, the computer performance was output on a breakdown sheet, telling the animators which heads to use in which order. During photography, animators had to manipulate the ball-and-socket puppet body to produce the performance they wanted before fixing the necessary replacement head on for each shot.

Motion blur

Successful stop-motion animation can breathe the illusion of life into inanimate objects, but the method has a serious flaw that can prevent even the greatest animators from producing completely lifelike images.

When a real moving object is filmed at the standard speed of twenty-four frames per second, the shutter of the movie camera is actually open *during* the movement of the object. Since the object being filmed is in motion while its image is being exposed on to photographic film, the result is a photograph that contains 'motion blur' – a visible blur that follows the most extreme movements of the object. Motion blur helps to impart the illusion of smooth, realistic movement when the still images are later projected on to a screen at rapid speed.

However, stop-motion animation creates the illusion of movement by projecting images of *still* objects in rapid succession. An animated object is moved *before* it is photographed, so its movements have no motion blur. The object's incremental yet distinct movements appear to jump from one position to the next during projection instead of flowing like real live-action photography. This jerky movement,

called 'strobing', is most pronounced in fast-moving animated objects that change position substantially from frame to frame. It is also particularly noticeable when animated objects without motion blur are combined with live-action actors with motion blur.

Many people believe that it is the very absence of motion blur that gives stop-motion animation its unique, almost magical quality. Without motion blur, the mythical monsters animated by Ray Harryhausen certainly possess an ethereal presence that makes them particularly effective in the fantasy films in which they appear. However, for many productions realism is the goal, and without motion blur, stop-motion animation can rarely be mistaken for live action.

Master animator Jim Danforth used a time-consuming method to create artificial motion blur when animating a number of dinosaur sequences for *When Dinosaurs Ruled the Earth* (1970). The method he used involves exposing each frame of stop-motion animation three times. The puppet is moved into position and photographed at one third of the exposure normally needed to capture a good image. After moving the subject again, the animator exposes a second image on to the same frame of film, again at one third of the correct exposure. After repeating this operation a third time, the result is a single correctly exposed frame of film in which the animated object appears in three positions. The fast-moving parts of the subject – such as its legs – look partially transparent, because in these areas the three exposures record images of background scenery either before or after the object was moved in front of it.

Though effective, this method requires the artist to animate three poses per frame of film, each pose covering one third of the movement normally needed for each frame of animation. Rather than twenty-four

Phil Tippett admires the complex Go-Motion device built by ILM for the production of Dragonslayer (1981).

separate movements per second of finished film, the process requires seventy-two moves and is therefore extremely time-consuming and impractical.

Another method of creating an artificial area of blur around an object is to smear petroleum jelly on to a sheet of glass placed between the camera and the animation subject. This process is also fairly time-consuming, because the grease has to be cleaned from the glass and reapplied for each new movement of the subject. Though not true motion blur, the unfocused edge around objects that this method produces can be quite convincing. The technique was used to bring life to the Terminator robot in the animated sequences of *The Terminator* (1984).

Motion blur can also be produced in stop-motion animation by physically moving a puppet during exposure. This method was used by Phil Tippett (see panel) while animating the ED209 robot for *RoboCop* (1987). After moving the robot puppet to each new position, a single frame was filmed in the usual manner. However, while the camera shutter was open and the film exposed, the model was physically 'wobbled' very slightly. Moving the model during exposure added a small amount of motion blur to the image, resulting in a very convincing animation.

Before Phil Tippett worked on *RoboCop*, he had already been part of an experiment that had culminated in some of the most effective model animation ever produced. During the making of *Star Wars* (1977), Industrial Light and Magic had pioneered the use of computer-operated motion-control cameras (<120) to film spaceship models one frame at a time while the camera moved past them. Since the camera moved while its shutter was open, the result was fast-moving spacecraft with realistic motion blur.

For *The Empire Strikes Back* (1980), the ILM team tried to apply this technology to the stop-motion animation of the woolly ice-lizards called 'tauntauns'. The tauntaun puppets were fixed to a motion-control mechanism that could move them backwards and forwards and up and down. The finer actions of the running tauntaun, such as its head and leg movements, were animated by Tippett in the usual fashion, but during photography, a motion-control mechanism moved the model vertically and/or horizontally while the shutter of the camera was open. The result was a form of selective motion blur that helped to eliminate some of the problems of traditional stop-motion.

Soon after working on *The Empire Strikes Back*, the ILM team were given a chance to develop their animation techniques for the production of *Dragonslayer* (1981). The motion-control technique that had been used with the puppet tauntauns was developed into a system that could control every joint of the film's flying dragon. This system involved computer-controlled gears and motors that moved six rods. These rods were attached to the key joints on the puppet dragon. The rods themselves were attached to a motion-control unit that could travel backwards and forwards on a 2.4m (8ft) track. The whole contraption was connected to a computer that could record and play back nineteen channels of movement.

PHIL TIPPETT

After seeing *The 7th Voyage of Sinbad* (1958) as a child, Phil Tippett (1951–) became obsessed with animation. At the age of thirteen, he bought an 8mm cine camera with the money he had earned from mowing lawns, and began to teach himself the art of stop-motion animation.

While studying art at the University of California, Tippett began to work on commercial animation projects, gaining experience at a number of studios animating popular characters such as the Pillsbury Doughboy and the Jolly Green Giant. Tippett's big break came when he joined the production team of *Star Wars* (1977), where he contributed to the design of the aliens in the famous cantina sequence and animated the miniature holographic chess game between Chewbacca and R2-D2.

Tippett became a regular contributor to Industrial Light and Magic projects, and was part of the team that animated the Imperial snow walkers for *The Empire Strikes Back* (1980). Tippett also animated the renowned tauntaun

sequences for the film and developed a new method of producing stop-motion animation with motion blur (see main text). Tippett helped to refine the process, named Go-Motion, with breathtaking effect for *Dragonslayer* (1981). By 1983 Tippett was the head of ILM's creature shop, where he designed and built models for *Return of the Jedi* (1983). Tippett won an Oscar for his work on the film.

In 1983 the animator established his own company, Tippett Studio, to provide sophisticated stop-motion animation for films such as *Robocop* (1987) and *Honey, I Shrunk the Kids* (1989). Tippett has continued to work in association with ILM on a number of productions, and it was his association with *Jurassic Park* (1993) that forced the animator to enter the fledgling world of computer character animation.

Despite the burden of running a large studio, Tippett has still managed to oversee work that combines the traditional performance skills of the stop-motion animator with digital technology. His studio has produced some of the most stunning examples of computer-generated character animation yet seen, for films such as *Starship Troopers* (1997), *Virus* (1998) and *The Haunting of Hill House* (1999).

replaced by computers,' admits Hauldren. 'I don't think this is a serious threat. At the moment a cyberscan is only useful for putting a star's face on to the body of a stunt performer in fairly distant shots. It will be a while before technology is advanced enough to take that information and create a convincing artificial performance. In fact, performers now have a chance to earn more money from their image because cyberscans can be used to create the characters in computer games. When you buy a game based on a film, you will actually be able to have a little Sylvester Stallone or Harrison Ford running around on your screen. The information can also be used by toy manufacturers to create action figures that actually look like the people they are meant to be. A well-known star now has the potential to continue earning from their image long after they have retired.'

Top: Event Horizon *(1997). Original plate showing a burning stunt man wearing a protective mask. Bottom:* Final image with replacement head, additional flame elements and reconstructed background detail.

Like many areas of information technology, laws that directly cover the use of an actor's electronic likeness have yet to be established, but some stars have already registered their cyberscans under copyright laws. Despite the ethical and legal questions that it would raise, it now seems a distinct possibility that a popular star could eventually appear in films long after death.

Digital face replacement

To show a film star in perilous situations, film makers once relied on the traditional technique of cutting away to a lookalike stunt performer for the dangerous parts of a scene. However, the ability to create a convincing digital model of an actor's face now means that stars can be shown apparently enduring the entire stunt.

For *Event Horizon* (1997), the Computer Film Company (CFC) used a cyberscan to graft the face of actor Lawrence Fishburne on to the body of a burning stunt performer. 'We had a shot of a stuntman on fire with a fireproof sock over his face,' explains Tom Debenham, a digital artist at CFC. 'We also had a cyberscanned

a) b) c)

moved in
dragged a
processing
the object
When the
tory, the a
animator 1
position. V
animator s

The an
sequence,
object nee
the object
fashion, a
every twe
positions
interpolate
'in-betwee
incrementa
in the inte
characters
to the next

Every
framed at (
in a straigh
frames – c
However, t
ing its fligh
movement
ment of the
do this, the
tion of one
detail and

The fac
and refine
ing a perf(
using tradi
mation is p
it's still all
dilemma c
movement
translate th

'In som
with the cc
like a mou
object that
ulating a s
also have r
have any s
find it usef
are animat

model of Fishburne's head. Using the live-action footage as reference, we moved the 3-D model head so that it matched the size and position of the stuntman's head in each frame. Once the movement of Fishburne's digital head was satisfactory, it was animated to look as if it were screaming.'

'The head image was then rendered [182>], so that the cyberscanned detail of Fishburne's face was mapped on to the wire-frame model. The resulting image showed a realistic shot of a dismembered head rolling about. The stuntman's head was removed from the original plate using replacement background detail from adjacent frames to create a shot of a headless body. The model head was then composited into the plate so that it took the place of the stuntman's head. Special attention was paid to the point at which the head joined the body, so that the neck always disappeared behind the collar of the shirt. Flames were then sampled from other parts of the sequence and composited on to the digital Fishburne head.' The result was a realistic shot in which the actor appears to writhe in pain as his body and face are engulfed in flames.

Skeletons

When the digital model of a character has been constructed, the result is a complicated mesh of polygons or nurbs patches (<128) that form the character's outer shape – basically, an empty skin. To make this skin suitable for animation, it must be filled with the digital equivalent of flesh and bones.

Taking into account the physique of the model and the subtlety of the performance that it is required to give, the computer modeller constructs a skeleton to fit inside the skin. This skeleton, usually built from simple primitive shapes, is rather like the ball-and-socket

To create the character of Blawp for Lost in Space (1998), Henson's Creature Shop built a basic digital skeleton (a). This was then 'padded' with flesh and muscle (b) before being surrounded by a cyberscanned outer skin (c). Additional features such as eyes were added (d) before a range of texture maps (e) were applied to the surface of the model.

d)

e)

armature that forms the framework of a traditional stop-motion puppet. The bones in the skeleton are linked by joints or pivot points. These points can be programmed to rotate, twist or simply 'translate' (that is, move in any direction to another position). The skeleton can also have a number of constraints applied to it, which determine the way in which the model is animated and the way it reacts when moved.

Skeletal models can be programmed to act in a hierarchical fashion, whereby each object in the skeleton forms part of a chain that is linked in a one-way relationship. A hierarchy begins with a parent object. Branching from a parent can be any number of child objects. Each of these 'children' can also act as 'parents' to further child objects. When a

JURASSIC PARK

Early plans for Steven Spielberg's (1947–; <34) adaptation of Michael Crichton's novel *Jurassic Park* (published 1990) involved a combination of full-scale animatronic dinosaurs and traditional stop-motion animation techniques (<150 and 230>). However, in the wake of their success with digital characters in *Terminator 2* (1991), the artists at Industrial Light and Magic were able to convince Spielberg that digital dinosaurs were a viable alternative to stop-motion.

To create their digital dinosaurs, the artists at ILM, under the guidance of special effects guru Dennis Muren, employed a number of groundbreaking new computer techniques. The dinosaurs themselves were first created as clay models and then cyberscanned (<162) to produce digital models. The digital models were then given a skeleton so that they could be animated using inverse kinematics (<166). ILM software engineers developed a program called 'Enveloper', which allowed the skin of the model to move freely over internal muscles in order to create the look of a real animal.

ILM also created a program called 'Viewpaint', which allowed artists to paint the surface details of a dinosaur's skin directly on to the digital model. These are known as texture maps (<129) and are normally painted as a flat design that is then wrapped around the 3-D digital model, but this can cause stretching and distortion of the design. Viewpaint allowed designs to be painted in their correct place on the model itself. Several layers of texture map were applied to each dinosaur model, including bump maps to describe the contours of the skin and additional maps to describe skin colour and pattern, mud and dirt. For the sequence in which the T-Rex attacks Jurassic Park's jeeps in the rain, a special shader was written to create the effect of water running down the creature's back.

Computer animators created the dinosaur performances by referring to simple animatics – low-resolution tests that were created and refined using traditional stop-motion puppets or basic computer models. The dinosaurs were then animated using a combination of key-frame techniques (<166) and a 'dinosaur input device' (<168), which allowed traditional stop-motion animators to transfer their animated performances directly into the computer.

Once dinosaurs had been animated and rendered (182>), they were composited (<78) into live-action background plates. The compositing process was vital to the credibility of the dinosaurs – even convincing digital dinosaurs will look fake if they do not interact with their environment. As the T-Rex ran, small clouds of dust and dirt were added beneath its feet, and splashes of water were placed where it stepped in puddles. For shots in which dinosaurs emerged from behind objects, each frame of the plate was rotoscoped by hand (<54) so that the digital creatures could be sandwiched within the scene.

As production progressed, ILM became more confident in its ability to deliver photo-realistic dinosaurs, and the creatures were given a greater on-screen presence. A late addition to the schedule was a scene in which the actor Martin Ferrero is eaten by the T-Rex. According to the original plan, the character would be seen disappearing out of frame when snatched from his seat on a toilet. The revised version showed the actor being picked up, tossed around and then eaten by the dinosaur in a single shot. During compositing, the real performer was swapped for a digital character just as the dinosaur's mouth closed over his body. Though a last-minute decision, the shot became a show-stopper.

During the planning stages, digital dinosaurs had only been intended for use in long-shots. However, as ILM's digital work became increasingly convincing, the creatures were brought closer to the camera. For the last sequence featuring the tyrannosaurus rex, the dinosaur's texture maps were repainted with extra detail and the creature was animated as if moving just a few metres or feet in front of the camera as it rampaged through the Jurassic Park visitor centre.

On its release the public flocked to see *Jurassic Park*. The film smashed box-office records worldwide to become the highest grossing film in history and later won Academy Awards for its special effects and sound effects. Perhaps the film's greatest legacy was to prove that, finally, the computer could help special effects artists create almost anything the scriptwriter could conceive. Film making was changed forever.

To extract useful information, the computer to which this data is fed compares the position of each dot from several camera angles and calculates its exact position in 3-D space. 'The computer needs to cross-reference continually between a number of camera angles,' states Tolls. 'Looking at a performer from just one or two angles isn't enough, because each moving marker is continually being hidden behind various parts of the body.' Although the system is designed to calculate the position of each marker automatically, the technology is not foolproof and the resulting data has to be 'cleaned up' manually.

'Motion capture data has to be organized before it can be used,' explains Tolls. 'The markers are continually moving about. Sometimes one can pass another, and then the computer can get confused and swap them. The result could be an arm movement getting mixed with a hip movement, which would result in a pretty weird-looking performance!'

'This system produces a huge amount of data,' notes Tolls. 'Each CCD captures images at least sixty times a second, and with thirty markers on a body, that's 1,800 measurements per second per camera. However, it is because the system is so sensitive that it can capture recognizable performances. We do a lot of capture for the games industry, which hires famous sports stars to come and have their basketball or boxing

A stunt performer covered with tracking markers slides down a tilted deck, providing information for the creation of a computer-generated victim in Titanic *(1997).*

containing a number of moving white dots – a 2-D representation of movement from a single position. Seeing this cloud of floating points is a strange experience. Although nothing connects the markers, their movement fools the mind into connecting dots to form a sense of human movement.

Computer-generated performers stroll on the decks of the Titanic. *The ship is actually a 45-foot model, while the water, seagulls and even the flag on the ship's stern are digital.*

The flood sequence in Antz *was created in stages. From top to bottom: model of ant colony; rough effects using simple particles for water; final environment and basic water effects incorporating rough lighting; the final scene.*

flat object in order to create the wave pattern during rendering. A common approach is to use a hybrid of displacement map and bump map – the displacement map to 'physically' produce the large waves on a model, and the bump map to add the appearance of finer surface details such as ripples.

To create compelling imagery of ocean surfaces, the optical interaction of the water's surface with ambient light sources has to be correctly reproduced. Important factors include the colour of the sky, the position of the sun, and objects above and below the surface of the ocean that can reflect or refract light. Areté Image Software employs a physics-based, fully 3-D digital model of the earth's atmosphere that can provide any sky condition needed. The 3-D atmosphere can include haze and rainbows and will depend on the position of the sun and the location and direction of the virtual camera among other factors.

When all the parameters are set, the water is ready for rendering. 'The system uses ray tracing [184>] to calculate the visual properties of the water during rendering,' explains Taggart. 'The rays [representing sunlight] are used to calculate how the surface should look, which depends on the way that light is reflected and refracted by water, and also on what we call "upwelling colour" – light that penetrates water, bounces around and then comes back up towards the surface. The final result is very convincing water imagery.'

To produce shots that show a ship moving through water, such as those in *Titanic* (1997), a basic digital model of the ship in question is built and animated moving through the water. Using fluid dynamics (see below), the computer is able to calculate accurate waves that emanate from the bow and stern of the ship. 'Unfortunately, the system can't yet produce convincing foam and spray where the water interacts with objects,' says Taggart, 'so those elements are normally filmed on real ships out at sea and then mapped [<128] on top of the digital water.'

Flowing water can be achieved through the use of particle systems (<167) to represent millions of individual drops of water moving as a mass. This method was successfully used during the production of *Antz* (1998). 'We created natural looking water based upon a physics discipline called "fluid dynamics", which calculates mathematical explanations for the way liquids flow,' says Ken Bielenberg, the film's effects supervisor. 'First, we created 3-D sets of an ant colony with obstacles for particles to hit and flow around. We could then select the places where the particles were emitted from, and how many of them there should be. Using fluid dynamics equations, the computer calculated the movement of the particles as they flowed through the scene. We could "direct" the flow by placing rocks where we wanted more splashing, and even use the digital equivalent of depth charges, which would blow-up to produce bigger splashes. Once the flow of the particles was satisfactory, we replaced them with spheres with a shader to make them resemble

water. We programmed these spheres to change their characteristics at certain times so, for example, they would turn into foam particles for a few moments when they hit a rock.'

The virtual camera

There are many analogies between the creation of images within the computer and live-action film making. In live action, scenery and props have to be constructed and painted; in the computer environment, they are modelled and texture-mapped. Real actors perform under the guidance of a director; computer characters are given life by animators under the guidance of an effects supervisor or animation director. Film stars, sets and locations have to be lit appropriately; animated digital characters and models receive the same careful consideration. The same analogy applies to filming itself – much like the shooting of a live-action feature film, everything that is created, modelled and animated within the computer also has to be 'filmed' before it can be seen by audiences.

The 'virtual camera' is the object used to 'film' the world inside the computer. The digital domain does not, of course, actually exist as a physical location that can be photographed in any traditional sense. However, the virtual camera is the device used to describe the viewpoint that the computer will use when deriving information about the digital world during the process of rendering.

Motion picture cameras used to shoot live action are large and unwieldy devices. Despite sophisticated modern methods of controlling their movement, such as the steadicam (a gyroscopically mounted camera) and motion control, what can be achieved with real cameras is still constrained by the physical size and weight of the camera itself and the manual methods used to adjust its aperture, focal length, focus and other parameters. These constraints have created a particular style of film making with which audiences have become familiar and which they accept as the 'norm'.

The virtual camera suffers from none of the constraints of its real-world equivalent. The virtual camera does not actually exist as an object, so it has no size – it could fit through a pinhole if asked. The camera also has no weight and therefore does not rely on carefully engineered equipment to hold it steady or transport it during complicated manoeuvres – it can go anywhere, at any speed. Finally, the virtual camera has no optical lenses, so there is no need

to worry about the amount of light in a scene and how the light affects aperture, film speed or depth of field.

However, because audiences are so familiar with the look produced by the traditional film camera, the virtual camera has had many of the characteristics of a real camera imposed upon it. 'The camera that we use to film our computer environments has been designed to replicate real cameras,' explains Simon J. Smith, a digital cinematographer at Pacific Data Images (PDI). 'We can give our camera any focal length lens and the camera will replicate the look that the lens would produce on a real camera exactly. We can zoom, pan, tilt, dolly – all the moves that a normal camera can do. We can also do a lot of things that a normal camera can't do.'

Since the virtual camera has no physical constraints attached to it, it can be used to produce breathtaking rollercoaster rides through the artificial environment of the computer. This type of movement is fine for television commercials and theme-park rides, but it is not particularly suitable for most feature film applications. 'You can do almost anything with the virtual camera, so people have a tendency to go over the top and create very complicated moves,' says Smith. 'When we filmed Antz [1998], we didn't want to draw attention to the camerawork because the film wasn't about showing off what wonderfully clever things we could do with the computer, it was all about telling a story and getting the audience involved with the characters. The way to do that is to use the same techniques that a real director of photography would employ for highlighting certain emotions or making a moment memorable.'

Real-world camera techniques were applied to the virtual camera used to film Antz.

'We limited our camera moves to the type that you would expect to see in a live-action film,' says Smith. 'In real films a camera is often mounted on a boom arm that moves it in an arc shape, so we set up our virtual camera so that it would move the same way in large scenes. We also moved the camera just as if it were mounted on a dolly track that could only be pushed at a certain speed by technicians. When a character walked and our camera panned to follow them, we delayed the start of the camera movement very slightly as if there were a real camera operator reacting to the movement of an actor.'

Virtual cameras are animated much like any other object within a computer scene (fig. 7). The digital artist begins by defining the size of the lens and the number of frames that the shot in question will last. The camera is then placed within the 3-D environment. When the artist is happy with the view from the camera's start position, they will set the first key-frame. The artist then moves the camera to its second position and, if using a zoom lens, may adjust the focal length of the lens. In this way, the digital artist builds up the movement of the camera one key-frame at a time, continually running the camera backwards and forwards, studying its motion and making refinements where necessary.

In the real world the camera operator must concentrate on moving the camera to follow the important action within a scene. In the world of the computer, the camera can use 'target tracking' to keep the subject automatically in the centre of the frame, however extreme the movement of the camera is. The precision of target tracking tends to produce artificially perfect shots, but the device can be used as a starting point when animating a sequence.

Designing camera movements for completely digital scenes, such as those in a film like *Antz*, gives the digital artist all the freedom that a real-world camera operator has to move a camera and produce the best composition for the scene. However, many digital animation effects are eventually composited into footage of a real environment that has already been filmed, so the movements of the virtual camera must exactly match those of the camera used to film the live-action footage.

Traditionally, whenever a special effects element, such as a model or animated creature, was combined with live-action footage, the camera used to film both elements was kept 'locked off' (completely still) so that the two images could be combined without appearing to 'slide' against one another. When combining 2-D shots with an optical printer, it was possible for images with some vertical

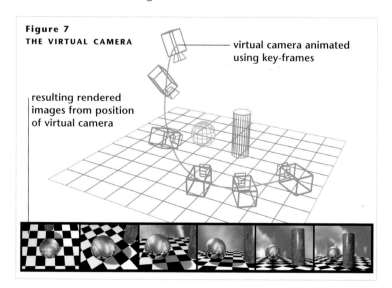

Figure 7
THE VIRTUAL CAMERA

virtual camera animated using key-frames

resulting rendered images from position of virtual camera

or horizontal camera movement to be 'tracked' so that the same movement could be added to the other elements (<83). A similar method can be used when digitally compositing 2-D elements. However, with the development of sophisticated camera cranes and devices such as the steadicam, most modern film directors have developed a taste for taking their camera anywhere – for it to run with characters, crane over buildings or plunge through windows. Audiences, too, have come to expect this frenetic camera style in big-budget productions. With all this movement on the screen, it

For this scene in The Lost World: Jurassic Park *(1997) the camera used to film the fast-moving vehicle was match-moved so that computer-generated dinosaurs could be added to the shot.*

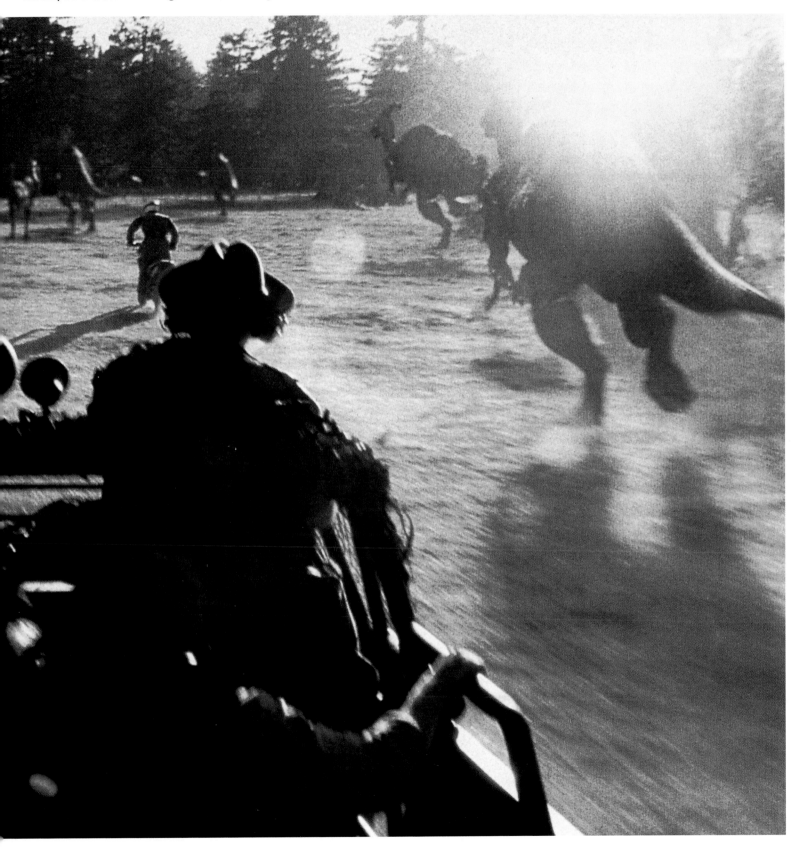

would be too much to expect everything to grind to a halt whenever a special effect is added to a scene.

In order to place a digital creature such as the star of *Godzilla* (1998) into moving shots of New York City, or have a stampeding herd of gallimimus chase human characters across a rolling landscape in *Jurassic Park* (1993), the exact three-dimensional movements of the live-action camera must be applied to the virtual camera. When the computer camera films its subject with movements that match the real-world camera, the two elements can be combined effectively.

To replicate the movement of the real-world camera, a process known as '3-D camera match-moving' is used. During photography of the live-action plate, a special effects supervisor takes accurate measurements of the position of each significant object in a scene, including specially placed markers. These measurements are sometimes recorded using the highly accurate laser measuring equipment that is used by cartographers and architects. The starting position of the camera is also measured and details of its lens type are noted.

The information collected on location is used to construct an accurate 3-D model of the real location within the computer. This digital reconstruction of the real environment is essential because any CGI objects that will eventually need to appear to interact with this environment, for instance digital vehicles, must be animated to move on an accurate representation of the real surface. The digital model of the surface will later be removed from the animation and replaced with the footage of the real location.

To create a camera match-move, the developed film of the live-action background plate is scanned into a computer and displayed on a monitor. The digital model of the environment is then superimposed over the image of the background plate, and the virtual camera is manipulated until its view of the model is perfectly aligned with the position of the camera used to film the live action. When the first frame of the live-action plate and the digital environment have been matched, the operator moves through the scene a few frames at a time and alters the position of the virtual camera so that its perspective remains identical to that of the live-action camera. By working through the whole scene in this way, the virtual camera is programmed to produce a perfect copy of the location camera's movements. The virtual camera can then be used to 'film' the computer-generated element – be it rampaging beast or distant city – and the resulting image will sit in the live-action background plate perfectly when the two are composited.

It is difficult to overestimate the importance of match-moving to modern special effects production. The ability to synchronize the performance of virtual and real-world cameras is the key to the invisible integration of live action and digital effects. With this technology, film makers are becoming increasingly reliant on the computer to provide not only the expected animated monsters and spaceships, but also ordinary set-dressings and location details such as period buildings, trees and replica historic vehicles.

Rendering

The last process in the production of computer-generated imagery is 'rendering'. Rendering is the highly complex mathematical operation that conjures a completed, high-quality, 2-D image from the huge mass of instructional data that is generated during the production process. It is one of the most important, and probably least understood, parts of the digital production process.

When a digital shot has been finished by an artist, it is launched into a render. Nothing immediate happens; the computer operator does not participate in the process – they can only wait while the computer creates a final image. During this process, the computer studies every piece of information that it has been given about a scene. As it processes this data, the final image is constructed one pixel at a time. Examining a tiny part of the scene, the computer calculates the geometry of the object that the virtual camera is looking at; what animation, texture maps and shaders have been assigned to that object; and the quality and quantity of lights that surround it. When every influence has been considered and calculated, the computer produces a number that represents a colour. The colour is assigned to one pixel, and the computer then begins to calculate the colour for the next pixel along. After the process has been repeated several million times, a single frame of computer animation will be complete.

Rendering is the most time-consuming and processor intensive task in the production of digital images. Most large special effects facilities have powerful render 'farms' with many hundreds, sometimes thousands, of processors dedicated to rendering. The individual work stations used by operators are also networked to the render farm so that, as soon as a processor is out of use, it can be put to work rendering. Most rendering is done at night; digital artists usually aim to finish a shot before they leave work. Their shot is then distributed throughout the organization's processors and, providing it is not a particularly complicated sequence, it may be ready for them to view upon their return the next day.

Rendering is often the deciding factor in the quality of the digital visual effects that appear in a film. Using modern modelling and animation software, digital artists have the potential to create almost any conceivable image. However, it is the time that such images may take to render that affects how much can be achieved on the budget of a feature film. A frame of complex computer animation may typically take five hours to render. With 120 frames in a five-second sequence, such a shot would take one processor 600 hours – twenty-five days – to render. Using a few hundred processors, however, the shot could be completed overnight.

The amount of information contained in a scene directly affects the time that it takes to render. Some of the shots of invading bugs in *Starship Troopers* (1997) took the machines at the Tippett Studio over sixty hours per frame to render. Since rendering can take so long, there are a number of fast, low-resolution render options that allow a shot to be rendered and examined before the final process is attempted.

To make rendering faster, the final version of a shot is sometimes rendered in several different pieces. A scene that involves aliens in a spaceship might have the spaceship background, the aliens, the aliens' shadows, black-and-white mattes of each element and a host of other details rendered in separate passes. Some elements, such as those that will appear in the far distance of a shot, can be rendered at a lower resolution in order to save time. The result will be a number of elements that can be composited together to produce the final scene at a later stage. By breaking a shot into its constituent parts, greater versatility is possible during compositing.

There are many rendering packages available and effects facilities tend to use several types, depending upon their specific requirements. By far the most popular rendering package is Photorealistic RenderMan. RenderMan was one of the first effective pieces of rendering software and was developed at Lucasfilm in the mid-1980s by Dr Edwin Catmull, now the executive vice-president of Pixar. It was this software that allowed breakthroughs in computer-generated imagery in films such as *The Abyss* (1989) and *Jurassic Park* (1993).

Many of the distinct visual qualities of a scene are programmed at the modelling or animation stage of production, but they are not actually visualized until the rendering process. These include motion blur, anti-aliasing, ray tracing and radiosity.

Motion blur

All fast-moving real-life objects that are filmed with a movie camera feature motion blur, a streaked effect that results from the subject's movement during exposure. Like ordinary stop-motion puppets, computer models do not actually move while they are being photographed (or rather, rendered). However, fast-moving objects can have motion blur added to them during the rendering process (fig. 8). The computer, knowing an object's position in previous key-frames and in-between frames, is able to calculate how much blur should emanate behind an object, according to the speed at which it is travelling. Since this task requires a relatively large amount of processing power, it is sometimes

Early computer-generated animation lacked realistic touches such as motion blur, which is missing from this scene from The Last Starfighter *(1984).*

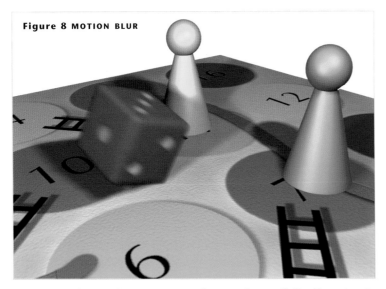

Figure 8 MOTION BLUR

omitted at the rendering stage and created as a 2-D effect that is added during compositing.

Anti-aliasing

A digital image is made up of many thousands of discrete square pixels, each of which can only represent a single colour. In some situations, the picture definition created by these tiny pixels is not good enough to create a smooth representation of the edges of an object. If a black object is placed in front of a white object, the edge of the darker object may fall, mathematically, in the centre of a pixel. The pixel, however, can only be white or black, so the computer must decide one way or the other using a weighting system. The result may be spatial 'aliasing', also known as 'jaggies' – rather than a completely straight line, the supposedly smooth edge of an object may appear as a wavering stepped line. During the rendering process, the computer can be instructed to study the edges of objects and set the characteristics of pixels on boundary edges as a mixture of the background and foreground qualities. The result is a much smoother edge (fig. 9).

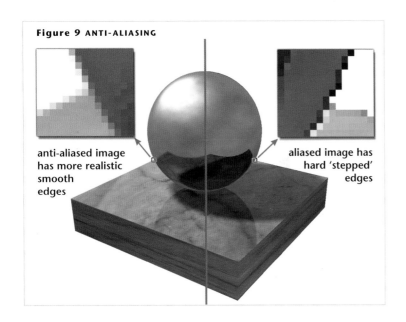

Figure 9 ANTI-ALIASING

anti-aliased image has more realistic smooth edges

aliased image has hard 'stepped' edges

Ray tracing

One method of producing realistic-looking images that include accurate reflections is to use a rendering method called 'ray tracing'. Ray tracing involves simulating the paths taken by rays of light within a scene in accordance with precise details about the surface qualities of objects and the types of light used to illuminate them. To determine the colour of a pixel, a ray is traced from the virtual camera to the spot of the scene that is being studied (fig. 10). According to the quality of the surface that the ray hits, as described by an object's geometry and the texture maps and shaders that have been assigned to it, the ray will be reflected towards another part of the scene.

The ray will continue bouncing off each object until it either exits the scene or reaches a light source. When the ray has finished its journey, the colour of the single pixel that it represents is adjusted according to the way that the intensity and colour of the light has

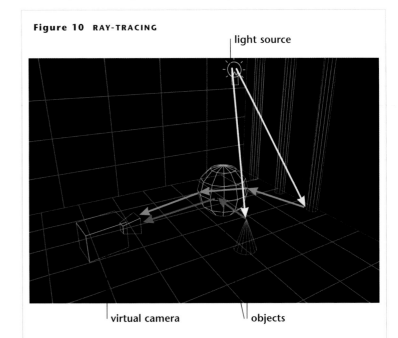

Figure 10 RAY-TRACING

light source

virtual camera

objects

(below) rendered ray-traced image from position of virtual camera

been affected during the ray's journey. This process has to be repeated for each of the millions of pixels in a typical frame of computer animation. The process is therefore extremely slow and processor intensive, but the results can be spectacular.

Radiosity

A more precise yet even slower method of calculating the effect of lighting in a scene is called 'radiosity'. Radiosity was developed to help architects produce highly realistic computer renderings of proposed buildings and interiors, but can also be used to create startlingly lifelike images for motion pictures. The process works by assuming that the light energy that strikes a surface must equal the sum of the energy that is reflected, transmitted and absorbed by that surface. Extensive processing calculates the effect of every object as a source of light on every other object in a scene. The colour quality of a yellow wall will be affected by a nearby green carpet, for example.

Unlike ray tracing, radiosity calculations are independent of viewer position, so providing that nothing within the scene changes, only one calculation is necessary per scene. Calculating radiosity is an extremely intensive process, and at present is impractical for the majority of animation purposes. It is, however, used by some facilities for the production of digital matte paintings (203>).

When a shot has been rendered, its frames are assembled in the correct order and the sequence can be viewed on a computer monitor or transferred on to videotape. Once the work has been approved by the film's effects supervisor and director, it can be combined with other elements during compositing, or recorded on to celluloid ready to be edited into the final version of the movie.

Time slice photography

A striking visual effect that merges the techniques of animation and motion-control has become popular in recent years. 'Time slice' photography produces shots in which the camera roams freely around a scene in which the action appears to have been frozen at one moment in time.

The technique, first exploited by British film maker Tim McMillan in the early 1980s, requires an array of individual 35mm stills cameras to be positioned around the subject. Each of these cameras is programmed to take a single photograph simultaneously. The resulting still photographs are then edited together to form a succession of images on a single strip of film. When this film is projected at the normal speed of twenty-four frames per second, the result is a sequence in which it appears that a single movie camera is moving around a subject whose movements have been captured during one moment. If the shutters of the still cameras are released with a fractional time delay, rather than remaining frozen, the subject will appear to move in extreme slow motion as the shots progress.

Perhaps the most remarkable use of time slice photography can be seen in *The Matrix* (1999), in which actor Keanu Reeves appears to dodge bullets in extreme slow motion while the camera circles

DENNIS MUREN

Fascinated with the creation of moving images from an early age, Dennis Muren (1946–) began making films when he acquired a simple 8mm cine camera at the age of ten. However, it was not long before Muren was using more sophisticated equipment and experimenting with techniques such as stop-motion and rear projection.

Muren studied business at California State University but invested his spare time and money in the production of an ambitious science-fiction film, *The Equinox*. The film was picked up by a distributor and, with the addition of extra footage, released as a feature in 1970.

After graduation, Muren spent several years shooting TV commercials before finding work at the fledgling effects company Industrial Light and Magic as second cameraman on *Star Wars* (1977), specializing in stop-motion and miniature photography. After working with Doug Trumbull to film the mothership sequences for *Close Encounters of the Third Kind* (1977) and a stint creating effects for the TV series *Battlestar Galactica*, Muren returned to ILM as director of effects photography for *The Empire Strikes Back* (1980).

Muren is currently senior visual effects supervisor at ILM, having overseen the creation of groundbreaking work on many important special effects films. Though a devotee of the traditional optical effects crafts, in 1989 Muren took a one-year sabbatical to learn about computers and digital technology. Since then he has been responsible for some of the most significant advances in digital visual effects, including those for *Star Wars Episode One – The Phantom Menace* (1999).

Muren has won Oscars for his work on *The Empire Strikes Back* (1980), *E.T. – the Extraterrestrial* (1982), *Return of the Jedi* (1983), *Indiana Jones and the Temple of Doom* (1984),

Innerspace (1987), *The Abyss* (1989), *Terminator 2: Judgement Day* (1991) and *Jurassic Park* (1993). He was also awarded a technical Academy Award for his contribution to the development of Go-Motion animation for the film *Dragonslayer* (1981). In 1999 he became the first effects artist to gain a star on the Hollywood Walk of Fame.

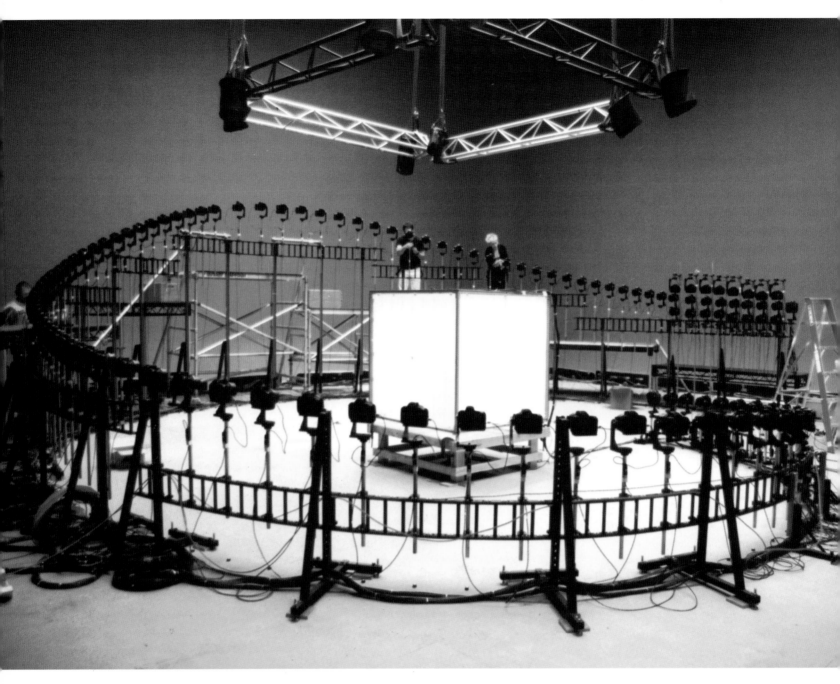

around him. To achieve this spectacular effect, American company Manex Visual Effects developed the basic concept of time slice photography to produce what they called 'bullet-time'. Each shot was first pre-visualized in the computer. This resulted in a computer model that told the film makers exactly where to place their still cameras and at what intervals the photographs should be taken. An array of 120 stills cameras was then arranged in a pattern around the subject, using laser positioning to ensure that they were accurately placed and aimed. The stills cameras were concealed behind a circular green-screen so that the resulting images of the actor could later be isolated and composited into new computer-generated backgrounds.

As Reeves and his fellow actors performed, each camera took its single photograph – sometimes with as much as one second of real time lapsing between photography of the first and last picture in the sequence. When the 120 frames were then projected at twenty-four frames per second, the result was a sequence that stretched one second of action into a five-second moving camera shot. Using frame interpolation techniques (<87), these images could then be used to create additional synthetic in-between frames of action, turning the five-second sequence into a ten-second one. When completed, the time slice footage of the actor was composited into computer-generated 3-D cityscape backgrounds. Information from the original computer pre-visualization of the sequence was used to create the same virtual camera movement on the 3D backgrounds so that they matched the time slice foreground material exactly.

To create the 'bullet-time' shots in The Matrix (1999), 120 cameras were arranged in a predetermined path before being concealed behind a green-screen. Actors suspended on wires then performed complex aerial moves while being photographed by the cameras.

The sequels to George Lucas's *Star Wars* (1977) – *The Empire Strikes Back* (1980) and *Return of the Jedi* (1983) – were as popular as the original and continued to push the art and technology of special effects to the limit. *Star Wars* fans knew that these three films were only the middle chapters of a planned nine-part saga and waited eagerly for the next instalment. When asked about the new films, Lucas maintained that technology was not yet capable of creating the worlds he had in mind.

When ILM created dazzling computer-generated dinosaurs for

Jurassic Park (1993), Lucas realized that effects technology had finally caught up with his imagination, and he began work on the first chapter of the story, *Star Wars Episode One: The Phantom Menace* (1999). In terms of scale and ambition, *The Phantom Menace* was to be the greatest visual effects film yet made. Of the 2000 shots in the film, some 1900 would be digitally generated or enhanced (a major effects film might normally involve perhaps 200 effects shots).

Where previous *Star Wars* films had always been heavily populated by a mixture of loveable and loathsome creatures – usually produced using prosthetic make-up, animatronics (221>) or stop-motion animation – many of the main stars of *The Phantom Menace* were entirely digital, walking, talking and interacting with all the freedom of human actors. The most complex digital character was clumsy sidekick Jar Jar Binks. With a face that comprised over four hundred expressions, Jar Jar was the most emotive and expressive digital character yet created for a film.

More than any other film, *The Phantom Menace* explored the potential of the 'digital backlot' (206>), by which actors are filmed with minimal sets and props while the majority of the scenery is created and added digitally. Most of the film's live action was photographed with minimal pieces of full-scale set in front of blue- or green-screens. Locations such as the city of Coruscant were created almost entirely within the computer and then composited with live action. Other locations, such as the ornate city of Theed, were traditional models filmed with motion-control cameras and combined with digital extensions. Some methods of bringing locations to life were reassuringly old-fashioned, however. The magnificent waterfalls that surround Theed were created by filming fine dry salt as it was poured over a model cliff – a traditional effects trick.

Some of the film's most interesting effects were invisible. During editing, Lucas was able to alter images and even create entirely new ones with remarkable freedom. Many original scenes were digitally altered, allowing actors facing one way during filming to be turned around or repositioned. Digital split-screen effects allowed shots to be assembled by selecting an actor's best performance from various takes. Some dialogue was rewritten after filming, so actor's mouths were filmed speaking new lines and then composited over mouths in the original footage. Entirely new scenes were created by selecting and manipulating images of performers taken from various scenes and combining them with new backgrounds.

With *The Phantom Menace*, George Lucas achieved what he had always dreamt of – total creative freedom without any of the physical and optical constraints that have hampered film makers and effects artists for over a century. This was perhaps the first glimpse of the way that all films will be made in the cinema's second century.

EPISODE ONE: THE PHANTOM MENACE

ALBERT WHITLOCK

London-born Albert Whitlock (1915–2000) began his movie career at the age of fourteen as an errand boy at London's Gaumont British Studio. Whitlock graduated from errands to painting signs and scenery and was employed by Alfred Hitchcock (1899–1980; <23) to paint a news-stand sign for *The Lady Vanishes* (1938). Whitlock's work as a scenic artist led him to matte painting, and he was taught by pioneering British matte painter W. Percy Day, whose own paintings appeared in films such as *The Thief of Bagdad* (1940) and *Black Narcissus* (1947).

In 1954 Whitlock moved to the United States, working first at Disney before becoming the head of the matte department at Universal Studios in 1963. Whitlock earned recognition for his highly realistic matte paintings; he was particularly skilled at capturing the essence of natural lighting and atmosphere. Whitlock was also known for his speed as a painter. For *Earthquake* (1974), he produced and composited twenty-two paintings for forty shots in under twelve weeks. He painted the impressive Tibetan fortress in *The Man Who Would Be King* (1975) in just six hours.

Most of Whitlock's paintings were achieved using the original negative technique (see main text) and he frequently used complex multiple exposures to insert additional details – a risky practice that can destroy the entire image if one mistake is made. One shot for *Catch-22* (1970) would have cost $350,000 to re-film had Whitlock's calculations failed.

During his career, Whitlock became most associated with the work of Alfred Hitchcock, a director who believed in the potential of matte paintings. Whitlock painted mattes for all of Hitchcock's productions after 1961, including *The Birds* (1963), *Marnie* (1964) and *Frenzy* (1972). He won Oscars for his work on *Earthquake* (1974) and *The Hindenburg* (1975).

any piece of footage, whether or not it was originally planned as a matte shot. Another advantage to the technique comes from the fact that the live-action plate can be divided into three colour separations (<47). The unexposed camera negative can therefore be variably exposed to each of these separations to produce a highly controlled colour balance between live action and painting.

The biggest disadvantage to the method is that the live-action portion of the composite image (e) is in fact a second-generation image and therefore of an inferior quality to the painting with which it is combined (the same is also true when using rear- and front-projection methods; see below). The difference between the first-generation footage of the painting and the second-generation footage of the live action often becomes apparent when matte shots are viewed on television. Since television has a lower resolution than film, it is a medium less capable of conveying subtleties of colour and contrast, and the live-action portion of a matte shot sometimes appears to stand out from the painting around it.

Rear projection

Rear projection (<66) is probably the simplest and most popular method of combining moving images and paintings. Once filmed and developed, the live-action footage is threaded into a projector and projected on to a sheet of glass from behind (back-to-front so it appears the right way when viewed from the front of the matte painting (fig. 4)). Working on the other side of the glass, the matte artist delineates, sketches and then paints the required image in the appropriate areas. When the painting is complete, a frosted glass screen is attached to the back of the unpainted areas of the glass.

Figure 4 REAR PROJECTION FOR MATTE PAINTING

previously filmed live-action element of scene

camera

matte painting on glass

projector

final composite

The frosted glass allows the rear-projected live action to be seen on the surface of the glass, whereas without it, the glass would allow the projected image to pass through unseen. A camera looking at the front of the painting then films the combination of painting and rear-projected live action. It is difficult to achieve a balanced combination of painting and rear-projected image with one exposure, so the live action and painted elements of each shot are often filmed separately. The painting is first filmed by illuminating it appropriately and replacing the frosted glass used for rear projection with black velvet. The rear-projected image is then added in a second exposure, in which the lighting on the painting is removed to ensure that the film is exposed to only the live action.

Rear projection is particularly useful for matte paintings that need many small areas of live action added to them. By using several projectors, live-action elements can be projected on to a number of different areas of the glass at the same time. Depending on the number of elements required, the projectors can be

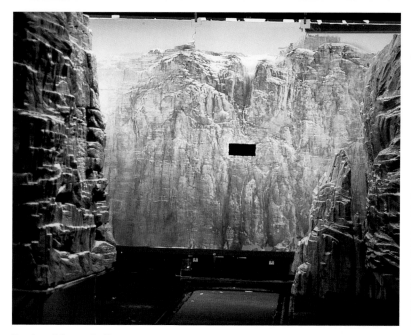

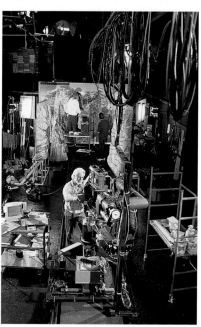

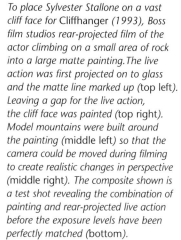

To place Sylvester Stallone on a vast cliff face for Cliffhanger *(1993), Boss film studios rear-projected film of the actor climbing on a small area of rock into a large matte painting. The live action was first projected on to glass and the matte line marked up (top left). Leaving a gap for the live action, the cliff face was painted (top right). Model mountains were built around the painting (middle left) so that the camera could be moved during filming to create realistic changes in perspective (middle right). The composite shown is a test shot revealing the combination of painting and rear-projected live action before the exposure levels have been perfectly matched (bottom).*

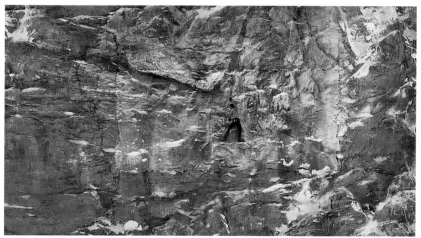

moved to new positions and more live action projected into other areas of the painting for filming in any number of additional exposures. This technique was used by Industrial Light and Magic during the making of *Return of the Jedi* (1983) to project twelve live-action shots of the furry Ewoks as they danced around bonfires in their painted tree-top village.

Front projection

A less frequently used method of combining live action and matte paintings is front projection (<69). Front-projected matte shots are created in a similar way to rear-projected ones, the main difference being that the live action is projected into the image from the front rather than from behind.

The windows for live action in a matte painting are backed with Scotchlite, which reflects light directly back to its source. Just like the front-projection system used to combine actors with live action (<69), camera and projector are mounted at 90° to one another in front of the matte painting. The projector throws the image of the live-action plate on to a half-silvered (two-way) mirror that is placed at an angle of 45° to both camera and projector. The projected live-action footage passes through the mirror and hits the painting, where most of its light is absorbed. The footage that hits the Scotchlite areas is reflected directly back to the mirror, through which it passes into the camera. The camera therefore films both live action and matte painting.

Front projection is a more complicated process than rear projection, but the reflected live-action images are generally brighter and sharper than those achieved with rear projection. Most of the scenes that included matte painting elements in *The Empire Strikes Back* (1980) were achieved using front projection.

Optical printing

Probably the least common method of combining matte paintings with live action involves producing mattes and counter-mattes of each of the elements that are to be combined. These are then assembled in an optical printer (<56), much as in any other form of optical compositing (<59). This method allows maximum control over the image characteristics (such as focus, colour and size) of each of the elements being combined, but a little less control over subtleties like the way that the matte lines between painting and live action can be varied. Matte paintings often have blue-screen travelling matte elements (<51), such as characters or spaceships, printed on top of them using the optical printer.

THE ART OF MATTE PAINTING

The first stage in producing an image that will fool an audience into accepting a painting as real is careful planning. Matte shots are not simply high-quality paintings, they are illusions cleverly designed to deceive the eye.

'Matte shots tend to be held on screen for longer than the average special effects shot,' explains Craig Barron, once a matte cameraman at Industrial Light and Magic and now a co-founder of matte painting specialists Matte World Digital, based in Marin County, California. 'Matte shots are normally used for establishing shots that are quite contemplative – they tell a story or establish a scene and people look at these images for a relatively long time. That means that the quality really has to be there, otherwise people will notice that something is wrong. The whole idea of an establishing shot is

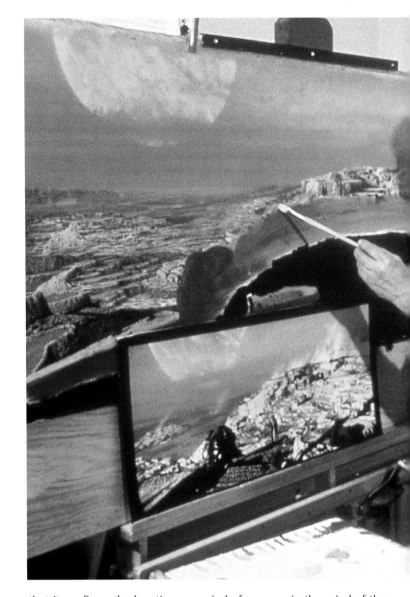

that it confirms the location or period of a scene in the mind of the audience. If this first image is not convincing, the realism of the whole scene will be destroyed, no matter how good the other elements.'

'Good matte paintings are as much about design and planning as anything else,' states Barron. 'Long before anything is filmed, a matte shot will be carefully planned by us and the film's production designer. This usually entails producing a number of small test paintings in which we figure out composition, colour schemes, lighting effects and how live action will integrate with painting.'

The key to planning a successful matte shot is devising a composition that will quickly impart an authentic sense of location. 'There are a number of basic rules about how to compose a matte shot,' says Chris Evans, a senior artist at Matte World Digital. 'These help us to create images that tell a story effectively and efficiently and allow us to disguise the fact that what an audience is looking at is not reality, but an artificially created environment.'

The artist begins by deciding which parts of an image should be live action and which should be painted. The human eye tends to scan images in a uniform way – most of us read an image from left to right. Some people believe that our eyes also move up towards

196

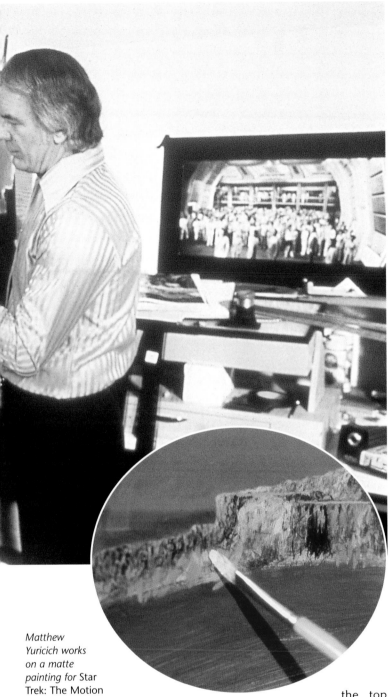

Matthew Yuricich works on a matte painting for Star Trek: The Motion Picture *(1979). Inset: the impressionistic style of painting often used to create photo-realistic images.*

white or grey base paint is applied to the surface, over which the coloured paint is added. There is some difference of opinion about whether oil paints or acrylics are the better material for matte painting. Oil paints dry slowly, which allows the artist to push them around and alter them for some time after they have been applied. The rich colours of oil paints do not alter when they dry, which is useful when a painting has to match live-action footage. Acrylics, on the other hand, dry in a matter of minutes and can be painted over almost immediately. However, acrylics do tend to dry a slightly different colour. Some artists like to combine the two mediums, developing and perfecting a design in acrylic and then laying oil paints over the top to create the final image.

Matte paintings can sometimes be a combination of original artwork and other materials. 'The purpose of a matte painting is to tell a story without the deception being discovered,' says Harrison Ellenshaw, who oversaw the matte paintings for *Star Wars* (1977) and *The Empire Strikes Back* (1980) before becoming the head of Disney's matte painting department, where he supervised paintings for films such as *Dick Tracy* (1990). 'The method you use to create that image is really not important. If you are trying to create an image of something that already exists, then you might as well make use of that object or location by photographing it and adding the photo to your painting. I used this method for matte paintings of the Jawa's Sandcrawler in *Star Wars* and Boba Fett's spaceship in *The Empire Strikes Back*. We had models of these machines, so I lit them appropriately and photographed them from the correct angle. I then stuck the photographs on to glass, painted on top of them and added the correct environment around them.'

The matte artist must create the illusion of a spatial environment that may be many kilometres or miles in width and depth, merely by applying a few thin layers of paint to a flat surface that is perhaps 1.2m (4ft) wide and 1m (3ft) high. 'When a director of photography films a real landscape, they don't have to worry too much about the atmosphere and sense of distance in their image, because the sun does all of that for them,' explains Chris Evans. 'However, a matte artist has to make decisions about every single visual aspect of an image. What is the quality of the atmosphere? How does the sun penetrate that atmosphere? How does the quality of light affect the relationship between every object between the camera and the horizon? Composition and planning are very important, but in the end the success of a painting comes down to lighting. Natural light is very consistent; it reacts in certain ways according to the weather and the location, and it has a consistent transition of tonality and colour over distance. We are all used to those relationships; we see them every day without being aware of it. The physics of light and optics and atmosphere are locked into everyone's brains and we have to get those relationships right in our paintings. If something is not quite perfect in a painting, an audience will know it immediately. They will rarely think "That's a bad matte shot", but they will sense that there's something not quite right about what they are seeing. That can pull them out of the narrative very quickly.'

the top of an image in a triangular motion during this left-to-right scan. 'This is what I call the "pyramid of believability",' says Evans. 'If a viewer's eye scans these three broad areas of an image and reads them as real, then he or she will probably accept the whole image as genuine. These are the parts of an image that we tend to reserve for the live-action portion of a shot. We also consider the fact that the eye is always drawn to the lightest areas of an image. The live action therefore tends to be situated in the brightest regions of a composition, while the painted areas tend to be darker and more shadowy.'

Once an image has been planned, the matte artist begins to produce the painting. If a painting is to be done on glass, a wash of

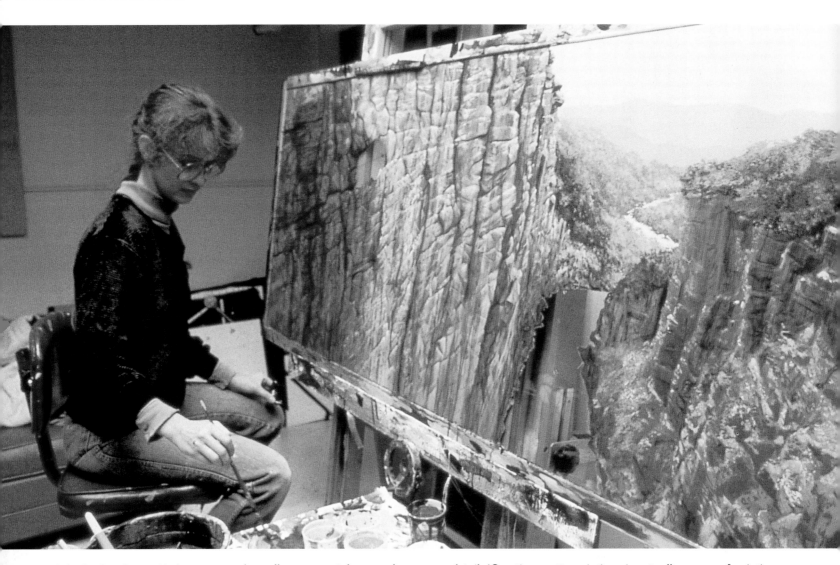

Artist Caroleen Green adds the finishing touches to a matte painting by Chris Evans for Indiana Jones and the Temple of Doom *(1984). Footage of the hero emerging from a tunnel was rear-projected into the hole on the left of the painting and a real river added at the bottom of the ravine. The composite was filmed with a moving camera to look as if it was shot from a helicopter.*

As well as accurately reproducing the qualities of light, the matte artist must also be able to reproduce a realistic sense of scale and perspective. Matte painter Chesley Bonestell, who created paintings for classic films such as *Citizen Kane* (1941) and *Destination Moon* (1950), believed that it was his training as an architect that enabled him to produce convincing images. In an examination he was once asked to produce a painting of a mirror that was tipped at an angle of 10° from a wall, and its reflection of a chair that was tipped at 10° from the mirror. Only those with an eye for such visual relationships are likely to produce convincing matte paintings.

The effectiveness of a matte painting also stems from the way in which paint is applied to its surface. For paintings to combine seamlessly with photographed images, a style of painting is required that is photo-realistic when filmed. From around 2m (6ft) away, most good matte paintings do look like photographs. Closer inspection usually reveals an impressionistic style of painting in which the artist has stabbed rough areas of colour with surprisingly little intricate detail. 'Creating matte paintings is actually a case of painting something that mimics the way our eyes perceive a scene,' explains Harrison Ellenshaw. 'If we look into the distance, we don't actually see very much detail at all. A window on a far-off building looks just like a small grey smudge, a tree looks like a dull green blob, perhaps with a bit of brown in it. What makes these distant objects look like windows or trees is the fact that our brains see them in context and tell us what they are – our brains fill in the fine details that our eyes don't actually perceive. If you were to create a matte painting in which every little detail was visible, you might think that it would look incredibly realistic. In fact, it would look like the most fake image that you have ever seen. Matte paintings are therefore impressionistic in style. They are made up of lots of little blobs and lines of colour that look pretty nondescript up close, but when you step back they look very natural.'

Matte painter Matthew Yuricich, whose paintings have appeared in films such as *Ben Hur* (1959) and *Star Trek: The Motion Picture* (1979), tells the story of a film director who came to see his painting of a pirate ship for a particular production. The director was insistent that Yuricich paint every one of the ship's many cannons in extreme detail. The painter tried to show the director that a single stroke of black paint would suffice for each gun, but the director

ordered him to paint each barrel in minute detail. On seeing the finished shot, the director thanked him for taking the effort to include the detail he had asked for. Yuricich had, of course, used only a single streak of black paint for each gun – the director's imagination had supplied the rest of the detail.

'When creating a matte painting, I use all sorts of painting techniques,' notes Chris Evans. 'If you look at a real building or a mountain, there are layers of history and weathering and decay. All those nuances of surface texture need to be suggested in a painting. I often lay on colours in broad strokes and then push them around and stipple them with a rag or a piece of newspaper. However, an important aspect of matte painting is destroying any sense of there being a painted surface,' he cautions. 'Modern artists like Jackson Pollock and impressionists like Claude Monet draw attention to the surface of the canvas through their painting techniques. We have to make sure that there is absolutely no sense of surface on matte paintings – they need to be more like windows opening out on to a view. No part of the painting should catch the light in a way that indicates a surface. Some matte painters have even been known to sand down each layer of paint so that it is totally smooth before applying the next layer, as if making a lacquer box.'

No matter how well crafted, a matte painting can only ever be a still image – a moment in time that has been captured like a photograph. Even on a windless day, a real scene is never static – grass and trees always sway, clouds drift, heatwaves distort the distant view. Matte paintings can look artificial without these almost imperceptible

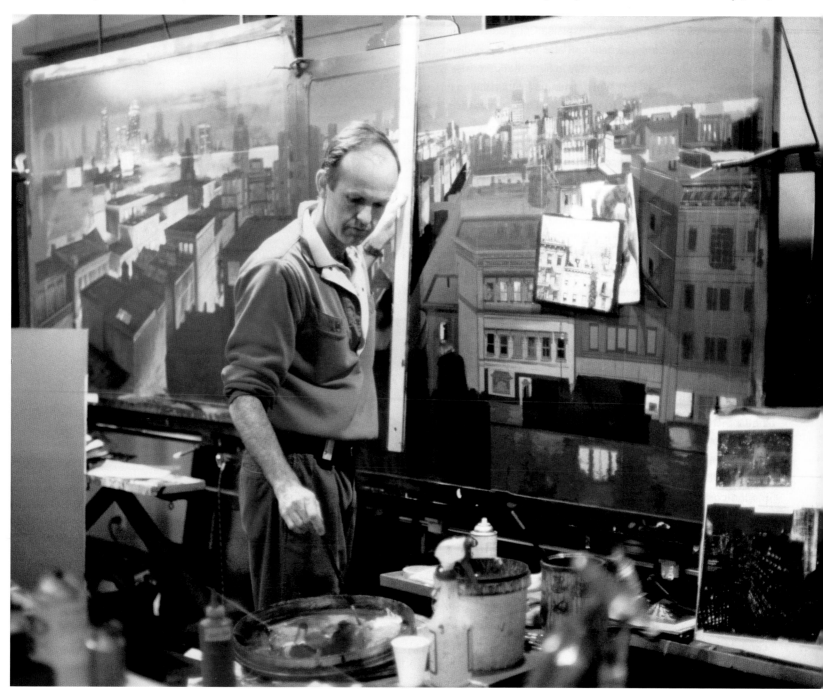

Second-generation matte painter Harrison Ellenshaw works on one of the many paintings used for Dick Tracy (1990).

The famous closing shot from Raiders of the Lost Ark (1981). The warehouse is a matte painting by Michael Pangrazio, and only a small area of the central aisle is occupied with the live-action plate of an old man pushing a trolley.

the painting combined with the live action. We then go through every one of those different iterations to decide which particular match is the nearest. Sometimes the artist will go back and make a few changes to the painting just to get the match absolutely perfect. Before we do the final exposure of a front- or rear-projected matte painting, we may take a scalpel blade and scrape small flakes of paint away from the glass all around the edges of the live-action areas of the painting – this will help the

painting to merge with the live action in a more gradual way, without any hard lines.'

Despite the matte artist's best efforts, there are some matte lines that cannot be blended to perfection. 'One of the hardest paintings we did while I was at ILM was the final shot of *Raiders of the Lost Ark* [1981],' comments Barron. 'The shot was of a man pushing a trolley along a concrete floor in a warehouse. Only a small part of the floor was live action and everything else was painted by matte artist Mike Pangrazio. Because the floor was grey – which is made up of every colour in the spectrum – it took us endless tests to get a good enough colour match, and even then we were never able to make it

202

The difference between a matte shot being a success or a failure can literally be a few frames.' Chris Evans agrees, believing that directors can fall in love with a good matte painting and spoil it by showing it off. 'Any longer than a few seconds and an audience will begin to notice the conceit – even the best matte paintings will be spotted if they are on screen for too long. Even I can sit in a movie theatre and miss half of the matte paintings in a film if they are used well. A director who keeps a matte painting on screen for too long is like a magician who can't resist repeating his best tricks. When you keep showing them the trick, the audience soon works out how it is done.'

DIGITAL MATTE PAINTING

Like every aspect of special effects production, matte painting has been dramatically revolutionized by the arrival of the computer. 'Probably one of the earliest examples of the computer encroaching on to the territory of the matte painter was during the production of *Star Trek II: The Wrath of Khan* [1982],' states Chris Evans.

The film features a sequence in which a barren moon evolves into a lush planet after being treated with

The Genesis sequence from Star Trek II: The Wrath of Khan *(1982) was created entirely within the computer using digitally painted texture maps.*

completely perfect.' Despite Barron's reservations, the shot is perhaps one of the most successful matte paintings ever used and remains convincing even though it is on screen for over thirty seconds. Even the best matte paintings can normally only be shown for three to five seconds before an audience begins to spot their flaws.

Once the matte artist's work is completed, the final success of a matte shot may depend on the decisions made by the film's director and editor. 'How and where a matte painting is used in a film is crucial to its success,' says Harrison Ellenshaw. 'A matte painting needs to be on screen just long enough for the audience to read what it says, but not so long that they will start to scrutinize it and notice problems.

the so-called 'Genesis device'. Once the device hits the moon, a firestorm spreads across its surface, transforming the rocky moonscape into green forests and blue oceans. The scene was created at Industrial Light and Magic, and is considered to be the first entirely computer-generated sequence in any feature film.

'The Genesis sequence was created totally within the computer,' says Evans, formerly of ILM. 'The planet surface was made up of digital texture maps [<129] that I "painted" directly into the computer using ILM's then primitive computer paint system. The digitally painted surfaces were applied to a computer-generated planet. Everything about the project was new. The graphics pen that I painted with would get really hot, which made my hand sweat and the pen slip. As an artist there were all sorts of basic commands that I needed but that weren't yet written. At that time the computer couldn't paint "soft" things like clouds; it was only good at heavy, solid colours. I would make suggestions about how the system could be improved from an artist's point of view, and the software guys would go off and write some new piece of code to help me.'⟩

In the early days of computer paint systems, matte artists took advantage of the computer to manipulate and composite traditionally produced artwork. 'For a while we continued creating matte paintings in oils and acrylics,' comments Evans. 'When a painting was complete, we would photograph it and scan it into the computer. Once digitized (<203), we could do all sorts of things that just weren't possible with the old optical techniques.'

One of the first uses of the computer to manipulate traditional matte paintings at ILM was during the production of Young Sherlock Holmes (1985). 'For Young Sherlock I did a number of paintings in the traditional way and we scanned them into the computer and combined them digitally,' explains Evans. 'For a sequence in which a computer-animated knight leapt out from a stained glass church window, I painted the window in watercolours and then created the surrounding church environment as a separate oil painting. These elements were scanned into the computer where they were joined together. Where we had once spent all our time trying to blend matte lines – the edges where elements join together – the computer actually allowed us to select colours from either painting and seamlessly blend the two elements across the matte line. It was a very exciting time because it was just beginning to dawn on us how much computers were going to allow us to do in the future.'

The key to creating convincing matte paintings within the computer has been the development of sophisticated computer paint software allowing images to be 'painted' directly within the computer. There are a number of computer paint packages available, but the software most commonly used for this purpose is Adobe Photoshop. Photoshop was developed in the late 1980s by ILM effects supervisor John Knoll and his brother Thomas Knoll as a method of manipulating digitized images for use in the print and publishing trade. However, the software's powerful ability to manipulate and even create original digital images within the computer has also made it a favourite in the film special effects industry for removing scratches and imperfections in filmed images that have been scanned into a computer, creating texture maps for digital models (<125) and producing digital matte paintings.

For some artists, putting down the brush and palette and learning to use a graphics pen has been a difficult process, but for others it has been liberating. 'I learned to paint in oils,' says Evans. 'When I first started working at ILM, I had to get used to working with acrylics, which is what they used for their matte paintings. Learning to paint within the computer was really just the same process. We still have to create the same balance of tone and colour and light and shade – the only things that have changed are the tools and materials. Probably the biggest difference between traditional painting and digital painting is the "brush" that you use. When using paints, you choose a brush that is the right size and shape for what you want to achieve. You can dip that brush into two or three paints, collecting a little more of one particular colour on one part of the brush. Then when you're painting you can jam that brush into

Below: *Matte artist Chris Evans creates a watercolour painting of a stained-glass window for* Young Sherlock Holmes *(1985).* Right: *Once completed, several paintings were scanned into the computer and digitally manipulated and combined.*

really a work of art in itself – its sole purpose is to serve the film.'

There are many similarities between the production of a digital matte painting and a traditional matte painting. The matte painter or a supervisor normally travels to the location to oversee photography of the live-action plate. While on location, the artist takes photographs of the surrounding environment and close-ups of interesting textures such as the brickwork of buildings or the surface of rocks. These photographs not only serve as reference material for the artist during the creation of the matte painting, but may also be scanned and cloned to provide textures for the digital image itself. 'A large part of digital matte painting is manipulating photographic elements that have been collected on location,' explains Craig Barron. 'There isn't much point spending time painting something new if you can use a photograph of a real object. Digital matte paintings are often a collage of photographic elements woven together with digitally painted original elements. That may make creating a digital matte painting sound easy, but it's no easier than producing a convincing image by gluing together lots of photos that have been cut out of a magazine.'

the surface and twist it around to achieve hundreds of variations of colour and texture, all from that single loading of paint. Painting with a graphics pen is more like airbrushing – you can only use one colour at a time and the tool doesn't actually make contact with the surface of the artwork; it's more like spraying paint from a distance. I do miss the physically interactive process of using a brush and paint. It would be nice if someone could create a digital brush and colour palette that worked in a more tangible, physical way.'

Despite the artist's lack of physical interaction with the work, digital matte painting does have some compensations. 'There are lots of really amazing things that you can do with a digital brush that you can't do with a real one,' says Evans. 'Probably the most useful thing is the ability to paint with textures. If you're creating a painting of some rocks, instead of painting every detail of every rock, software like Photoshop allows you to sample an area of real stone from the live-action plate or a reference photograph and then "paint" with that texture. After spending years meticulously painting every subtle detail, it's amazing just to be able to say "I'll have some of this grass over here, and some of this brickwork over there", and then see it just appearing on the screen.'

This ability to create images 'automatically' through cloning and copying has made some traditional matte painters question the artistic value of digital matte painting. 'There was – and probably still is – some reluctance on the part of traditional matte painters to use digital painting techniques. It's as if there is something not "proper" about creating a piece of art with a computer,' says Evans. 'However, the end result of matte painting is judged by what it looks like up on the screen in a theatre, not by whether it started life on a canvas or as a digital file in a computer. A matte painting is not

Once the live-action plate has been scanned into the computer, the matte artist can begin painting directly on top of the image. 'We used to spend a lot of time matting off the image while on location, and trying to get the best matte lines for original negative matte paintings,' says Barron. 'Thankfully, we don't have to do anything like that now. The whole shot can be filmed without any masking, and once it's on our computer monitors, we can decide at which points the digital matte painting is going to start. If the live action is the wrong size or in the wrong part of the frame, we can simply reposition the image on the monitor and create a new environment around the edges. The other major difference about the way live action is filmed for digital matte painting is that we don't need to worry too much about where the matte line is eventually going to be. We used to place actors and props very carefully so that no moving object would pass over the point where the painting began – otherwise an actor's head might disappear behind the painting. Today, moving objects can be digitally rotoscoped [<54], effectively cutting out an object from its real background so that painted areas can be brought right down behind characters and objects in a scene.'

With the live-action image displayed on the computer monitor, the matte artist begins to produce a digital matte painting in much the same way as a traditional matte painting. First, the artist looks for perspective lines in the live action and extends them out into the area that is to be artificially created. The artist then 'sketches' the

composition of major elements on the screen before starting to paint. As well as having a digital palette with which to mix any colour of paint, with a package like Photoshop the artist can also select colours and textures from the live-action plate itself.

The artist then begins to build up the painting. 'A digital matte painting can be created in layers,' explains Evans. 'With traditional painting, you physically layered coats of paint on top of one another to create an effect. If you painted something undesirable on top of a good bit of work, you had pretty much lost the work beneath it. In the digital realm, we can paint one layer, then tell the computer we want to paint on top of that in a separate layer. This way every object or area in a scene can be stored as a different piece of art. If we decide we want to change any aspect of an image at any stage of the process, we can simply access the layer in question and change it without affecting anything else. For example, if the image does not appear to have enough atmospheric depth to it, we could go back to some of the more distant layers and tone down some of the colours or cast a haze over the image. A digital matte painting might be made up of fifty or more layers. We will render [the final process of producing a high-quality, 2-D image from the computer's instructional data (<182)] each of these layers separately and give them to the compositor as individual elements, which allows maximum flexibility for refining the image when it is combined with the live action in the final composite.'

Like traditional matte paintings, many digital matte paintings are used to create a 2-D extension to locked-off (that is, filmed with the camera in a fixed position) live-action establishing shots, but the potential of the computer is now being harnessed to produce far more dynamic environments. 'During Hollywood's Golden Years the studios used to have extensive backlots where they would build a Western street and a European street and so on,' says Craig Barron. 'These days studios don't have the space or the money to keep a selection of permanently standing sets, and modern audiences want to see new and original environments instead of redecorated sets that they've already seen in a dozen films. Building entire sets for every new film is prohibitively expensive and time-consuming, so increasingly the answer is to create what we call the "digital backlot".'

Traditionally, a production might build only those sections of sets which actors are to interact with – in the case of buildings, usually only the first storey. These would then be extended using matte

paintings or miniatures. However, the limitations of these techniques meant that the camera normally had to remain in a fixed position for the duration of a shot. Moving it could result in a change of perspective causing 3-D set and 2-D painting to become misaligned. Today, computer technology allows real physical environments to be supplemented with 3-D digital set extensions, allowing the camera to move around freely within a scene.

'The key to digital set extensions is camera match-moving [<182], which gives us an accurate record of the movements of the live-action camera,' explains Barron. 'The ability to recover a camera move from a live-action plate means that instead of being limited to expanding a locked-off shot with a 2-D matte painting, we can create 3-D digital set extensions and then 'film' them in the computer with the same camera moves. When rendered, these computer-generated images can be composited into the footage of the partially built live-action environments. With a dimensional model instead of a flat painting, the camera can change perspective and the artificial additions to a scene will alter accordingly.'

A fine example of a digital backlot created by Matte World Digital is the small town of Seahaven, home of Truman Burbank, the unwitting star of *The Truman Show* (1998). 'The exteriors for *The Truman Show* were filmed in a small Florida town called Seaside,' recalls Barron. 'The whole town had been designed by the same architect so it had a too-perfect, almost surreal feel to it, which was ideal for the story of a man who unknowingly exists within the world's biggest film set. The real town only consisted of small residential buildings, but some scenes of the film required an equally perfect-looking downtown area of larger office buildings. No suitable location could be found, so the production team decided to build its own. The production designer planned the downtown area using a CAD [computer-aided design] programme, and divided the actual creation of the buildings between partially built, full-scale sets on location and 3-D digital extensions created at Matte World.'

Once approved by the director, the digital wire-frame (<206), CAD-designed models created by the production designer were used by the construction crews as blueprints for building the full-size sets of the

Far left: Sets for The Truman Show *(1998) were only constructed as high as the first storey. Matte World Digital then match-moved wire-frame models of the desired set extensions to the original footage.*
Below: After rendering, the digital models were composited into the live-action plate.

downtown area up to the first storey. Matte World Digital also received copies of the digital wire-frame buildings, which they used to create 3-D digital models of the top half of the buildings that exactly matched the real-life construction work.

'Once we had the live-action location footage, we tracked the camera movements and applied those movements to the virtual camera [<179] that was used to film the digital models within the computer,' says Barron. 'We then combined these models with the bottom halves of the location sets [<206]. The result was shots in which the camera moved around real buildings that had computer-generated extensions.'

With the digital models attached to their live-action foundations, Chris Evans and Brett Northcutt, colleagues at Matte World Digital, created texture maps to make the digital models match the real buildings in appearance. 'To make the top half of the buildings look like the bottom, we used close-up photographs that Craig Barron had taken of the location sets,' explains Northcutt. 'We scanned the pictures into the computer and sampled areas of wood and items like windows and used them to make digital matte paintings, which were then applied to each side of the wire-frame digital models. We used Photoshop to make the digital models blend really well with the bottom half of the constructions. It was quite a strange project because we normally add lots of weathering and ageing to a building to make it look real, but the buildings in *The Truman Show* were meant to look a bit fake – though still real. We found that even though the bottom sections of the buildings were brand new and "perfect", they still had slight blemishes as a result of the construction process and we replicated this look on our digital models.'

To help the digital models match the real sets, Evans and Northcutt painted lighting effects such as highlights and shadows

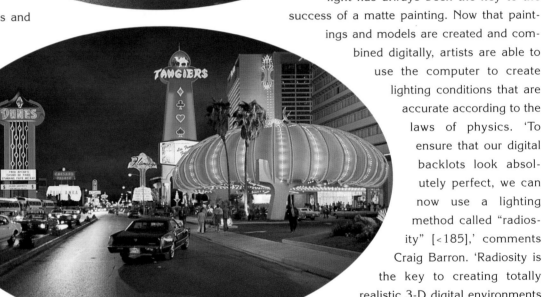

To re-create 1970s Las Vegas for Martin Scorsese's Casino (1995), live-action scenes were filmed outside an old Las Vegas hotel. Digital set extensions were then added to re-create the period hotels and casinos.

directly on to the digital matte paintings. 'Normally when you build digital models, you then have to light them digitally with the computer equivalent of the lights used on a real film set,' explains Northcutt. 'In this case, the lighting in the live-action scenes remained constant, so we actually painted the lighting effects directly on to our texture maps. The texture maps were therefore self-illuminating – that is, they needed no additional lighting for their look. However, we added a few small lights to the edges of the digital models, just to change the quality of their edges slightly and help them blend perfectly with the real sets.'

Capturing the natural quality of light has always been the key to the success of a matte painting. Now that paintings and models are created and combined digitally, artists are able to use the computer to create lighting conditions that are accurate according to the laws of physics. 'To ensure that our digital backlots look absolutely perfect, we can now use a lighting method called "radiosity" [<185],' comments Craig Barron. 'Radiosity is the key to creating totally realistic 3-D digital environments because it accurately calculates the way that diffuse light reflects between inter-related objects within a scene. If you set up a light on location and shine it on to the side of a building, the light would bounce off the surface and spill on to the surrounding objects. Every object in the scene affects the lighting quality of every other object in some way. That quality remains consistent until either the light changes or the objects move. In a digital scene, the computer can calculate the radiosity of each object according to the information it is given about the spatial relationship of objects, the characteristics of each surface, and the position and quality of various light sources. The computer spends a very long time calculating all these influences before producing a map

which describes the lighting quality of each surface within the scene. Radiosity maps are viewer independent – the quality of light that they emit is the same whatever angle you look at them from. This differs from the ray tracing [<184] lighting method, which has to recalculate lighting every time the camera moves fractionally. Once the lengthy initial radiosity calculation has been done, the information is applied to each surface and the virtual camera can move around within the environment without additional light calculations having to be made.'

Matte World Digital was the first company to use radiosity in a feature film when it produced stunning re-creations of 1970s Las Vegas for Martin Scorsese's *Casino* (1995). 'We had to re-create some of the lost icons that represented Las Vegas in the 1970s, like the famous onion-topped Dunes sign, as well as the Tangiers, which is the mythical casino at the centre of the film's drama,' says Barron. 'These build-ings were covered with neon and flashing lights, so the lighting of our environments was absolutely essential. We built digital models of the buildings and signs that were needed and animated their flashing lights. We then cal-culated the radiosity infor-mation for each model so that it would look correct whatever angle we looked at it from.' With the models built, Matte World match-moved them into live-action shots filmed in and around modern-day Las Vegas. 'It was the first time we had used the technique, so we were a little nervous,' admits Barron. 'However, when we attended a screening to see the projected images for the first time, we just couldn't believe how good they looked. We've all been doing matte paintings for years, so we are used to seeing effective combinations of the real and the artificial, but this time we were really impressed. We kept asking the projectionist to show the shots over and over again – we were so amazed by how good it looked.'

Now that computers help artists to create completely convinc-ing environments, do they find that they miss the old-fashioned methods? 'Creating digital matte paintings today is an amazing process enabling us to produce completely realistic environments,' says Barron. 'However, I think most of us kind of miss the old – if often frustrating – process of creating matte paintings, and secretly look for ways of reviving some of the old techniques.' Chris Evans agrees – he jumped at the opportunity of combining old and new technology for a shot in *Titanic* (1997). 'James Cameron wanted a

shot of the rescue ship *Carpathia* on the morning after the disaster,' recalls Evans. 'We were going to build a digital model of the ship and add it to the live-action plate of sea and rowing boats. However, I realized that since the vessel didn't have to move, it needn't be built in 3-D, so I did a traditional oil painting, which we pho-tographed and scanned. We then added some digital rigging to the ship and some particle-generated [<169] funnel smoke that was provided by Digital Domain, the company that provided most of the film's effects. The ship was digitally composited [<78] into the live-action plate and we used the painting to create a reflection of the ship in the water. In this case, the lighting and choppy water meant that there shouldn't really have been any reflection, but we all felt that it looked better with it. It's one of the paradoxes of matte paint-ing that reality often needs to be cheated slightly to make a paint-ing look more real. Referring to a watercolouring actually done by

an artist on board the *Carpathia* that morning, we then manipu-lated the overall image to make the light look more like it was early morning.'

'Using a combination of old and new methods was really interesting because it reminded us that software does not replace all the knowledge that has been acquired over the years about light, colour and composition,' com-ments Evans. 'The computer can take many hours to calculate a realistic lighting effect that a good artist can achieve with a single dab of paint.'

'There is the tendency to think the computer can fix anything – that anything can be achieved digitally,' says Craig Barron, 'but in our experience it still takes an accomplished artist to know if and why an image is working. I know that part will never change.'

For this scene from Titanic *(1997), lifeboats were filmed in the Atlantic Ocean at dawn. The footage was then combined with a digitally painted sky, a traditional painting of the rescue ship* Carpathia, *miniature icebergs and a CG smoke element.*

SPECIAL EFFECTS MAKE-UP

LONG BEFORE THE ADVENT OF THE MOVIES, THEATRE PERFORMERS USED MAKE-UP TO STRENGTHEN THEIR APPEARANCE WHEN SEEN FROM A DISTANCE, MAKING THEMSELVES MORE ATTRACTIVE, DRAMATIC OR LOATHSOME AS REQUIRED. THEIR FEATURES HAD TO BE VISIBLE TO THE WHOLE AUDIENCE, EVEN TO THEATRE-GOERS IN THE MOST DISTANT, LOW-PRICED SEATS.

ACTORS APPEARING IN FILMS QUICKLY FOUND THAT THEY NEEDED A DIFFERENT KIND OF MAKE-UP TO THAT USED BY STAGE PERFORMERS. APPEARING IN CLOSE-UP ON THE LARGER-THAN-LIFE SILVER SCREEN, THERE WAS LITTLE CHANCE OF THEIR FEATURES BEING MISSED. A MORE SUBTLE, TONAL MAKE-UP WAS THEREFORE REQUIRED.

The first great make-up artist, Lon Chaney, as he appeared in The Phantom of the Opera *(1925).*

Appearing on film also presented actors with a new set of problems. Early black-and-white film was not capable of capturing every skin tone. Many actors, such as romantic idols Ramon Novaro and Rudolph Valentino, ringed their eyes with a wide rim of dark make-up to prevent the whites of their eyes from blending with the light tone that the rest of their faces became when photographed.

The sensational subject matter that quickly became the staple of the movies often called for more than simple tonal make-up – monsters and madmen were the order of the day. Actors such as Lon Chaney (211>) began to specialize in fantastic three-dimensional makeovers, using a range of primitive materials to transform the actual shape of the face. Mortician's wax or putty was smeared on and built up in thick layers, then sculpted to create false noses, scars and other horrific appendages. Perhaps the most unpleasant of these early materials was collodion, a syrupy liquid plastic normally used in the production of photographic plates. It was highly flammable and often irritating to the skin. Collodion, combined with cotton, was built up layer by layer to give Boris Karloff his freakishly high forehead in *Frankenstein* (1931; 213>).

The mechanical and optical principles of cinematography provided film actors with opportunities not available to stage actors. The frame-by-frame nature of film meant that radical changes could be made to a performer's appearance between takes. This technique was used in *The Wolf Man* (1941) to show Lon Chaney Jr (1906–73) changing from gentleman to werewolf. To effect the

Wearing his Mr Hyde make-up for Dr Jekyll and Mr Hyde *(1931), actor Frederick March enjoys afternoon tea with director Rouben Mamoulian and co-star Miriam Hopkins.*

transformation, Chaney was positioned against a set of curtains that were starched to prevent any movement. The camera was also heavily weighted to hold it in place. When the actor had taken up a suitable stance, tiny nails were hammered into his costume to pin him to the wall and a few frames of film were shot. Make-up maestro Jack Pierce (212>) then applied make-up to begin Chaney's transformation from man to wolf. When the make-up was ready, a few more frames were filmed and the process repeated. It took twenty-one make-up changes and twenty-two hours to film the scene, which still looks remarkably eerie today.

The optical characteristics of film were cleverly utilized during the filming of *Dr Jekyll and Mr Hyde* (1931). Actor Frederick March, who played the dual roles of Jekyll and Hyde, had two types of make-up applied to his face. His Mr Jekyll character was created using green make-up while the Mr Hyde make-up was created in red. During filming, a green filter was placed over the camera lens, which caused the red Mr Hyde make-up to show up on the final black-and-white film but left the green Mr Jekyll make-up almost invisible (<44). Replacing the green filter with a red one made the red make-up vanish and the green make-up appear – converting the pleasant Mr Jekyll into the horrible Hyde before the audience's eyes.

A significant breakthrough in make-up came in the late 1930s with the development of foam latex technology, which was used to make false noses, chins and other parts that could be stuck directly on to the actors' faces and bodies. The first major film to use foam latex appliances on a large scale was *The Wizard of Oz* (1939). Make-up artist Jack Dawn, among others, created the magical make-up for the film's much loved characters. The pre-prepared foam latex pieces could be glued to the actors' faces at the start of each day, removing the need to build up fresh make-up each morning and guaranteeing consistent results. Foam latex appliances and costumes still form the basis of most modern special effects make-up.

The changing style and subject matter of the movies has been the cause of many revolutions and evolutions in the work of the

LON CHANEY

The son of deaf-mute parents, Lon Chaney (originally Alonso; 1883–1930) learned to communicate through mime and facial expression at an early age. As an aspiring actor, Chaney toured in musical comedies for several years before arriving in Hollywood in 1912. Over the next five years, Chaney directed a number of films for Universal and appeared as a bit-player in around seventy-five films, gradually gaining a reputation as an actor who could create almost any character through the use of make-up.

Chaney's big break came in *The Miracle Man* (1919), in which he played the part of a con man who pretends to be contorted by paralysis. The film was the biggest hit of the year and established Chaney as a star. For his subsequent roles, Chaney created increasingly complicated and physically painful make-up designs. In *The Penalty* (1920), the actor tied his legs behind him and walked and jumped on wooden pegs strapped to his knees.

Chaney is best remembered for his monstrous but sympathetic characters in two epic films, *The Hunchback of Notre Dame* (1923) and *The Phantom of the Opera* (1925). To create Quasimodo in *Notre Dame*, Chaney wore a 18kg (40lb) rubber hump that was strapped to a leather harness weighing a further 13.5kg (30lb). The actor filled his mouth with wax and covered one eye with putty. For the Phantom, Chaney gave himself painfully stretched features by inserting wires beneath his lower eyelids and inside his mouth and nostrils.

Chaney was secretive about his techniques, working on his own make-up behind locked doors until he was ready to appear before the camera. As a result, many of his methods remain a mystery. Chaney enjoyed hiding behind his make-up, and despite being one of Hollywood's greatest stars, was rarely recognized in public. A popular saying of the 20s was 'don't step on that spider – it might be Lon Chaney'.

Chaney died of bronchial cancer in 1930, just after the release of his first sound film, *The Unholy Three* (1930), directed by Tod Browning, for whom he had produced much of his best work. His life story was told in the film *The Man of a Thousand Faces* (1957), which starred James Cagney.

JACK PIERCE

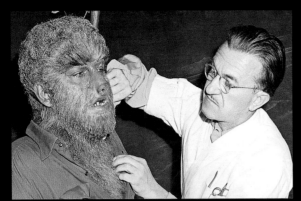

The son of a Greek goat-herd, Jack Pierce (1889–1968) tried his hand as a

Jack Pierce working on his design for The Wolf Man *(1941).*

stage actor, stunt man, projectionist, assistant director and cameraman before settling for the grease-paint-and-powder life of a make-up artist. He became one of Hollywood's most celebrated and influential make-up men.

One of Pierce's earliest monster make-ups was for the Fox production *The Monkey Talks* (1927). Pierce used chamois leather, putty and spirit gum to build the features of a monkey on to the face of actor Jacques Lerner. Pierce then moved to the make-up department at Universal, where, over the course of the next fifteen years, he created some of Hollywood's most memorable monsters.

Universal launched its celebrated cycle of horror films with *Dracula* (1931). The Count, played by Bela Lugosi, needed little physical alteration, but Pierce created a special green make-up that, when photographed with black-and-white film, gave the Prince of Darkness his porcelain glower.

Later the same year Universal firmly established its horror cycle, and Pierce his place in make-up history, with the production of *Frankenstein* (1931). Pierce's designs, applied to actor Boris Karloff, gave us the towering creature now recognized as the definitive Frankenstein's monster.

Pierce followed Frankenstein with *The Mummy* (1933), wrapping Karloff in bandages and thereby creating the prototype for the many movie mummies that have stumbled through horror films, and comedies, ever since. Pierce's other creations included the stars of *The Bride of Frankenstein* (1935) and *The Wolf Man* (1941).

Pierce became the head of Universal's make-up department in 1936, where he stayed until the mid-1940s, when new management, keen to use new materials and faster methods, clashed with Pierce and his methodical use of traditional techniques. Pierce left Universal to become a freelance make-up artist, working on various television series throughout the 50s, but never again having the chance to startle and amaze the world with his glorious big-screen monsters.

For The Exorcist *(1973), young actress Linda Blair was hideously transformed into a demonically possessed child by make-up maestro Dick Smith.*

make-up artist. The 1950s saw a rash of colourful science-fiction films that required a range of aliens and atomically mutated creatures. This was the age of the rubber suit – a generation of stunt performers dressed in latex to flail about in front of the cameras. The prime couturier was Paul Blaisdell, whose monstrosities added colour to films such as *It! The Terror from Beyond Space* (1956) and *Invasion of the Saucer Men* (1957).

Starting in the 1960s, movies became increasingly violent, and film makers dared to show their audiences gruesome details of murders and mutations. Make-up artists became as adept at re-creating the appearance of the insides of the body as its exterior details. *The Exorcist* (1973) brought new levels of horror to the screen and encouraged a generation of make-up effects artists specializing in fantasy and horror creations. Artists such as Bob Keen (*Hellraiser*, 1987, *Nightbreed*, 1990) and Tom Savini (*Friday the 13th*, 1980, *Day of the Dead*, 1985) populated our screens with increasingly realistic, if outrageously fantastic, characters.

Whether a film requires an actor to age by a decade or decompose before our eyes, to be subtly altered with a new nose or transformed into an astonishing character who could otherwise only populate our worst nightmares, special effects make-up artists the world over now use the same basic materials and methods.

Following the enormous success of *Dracula* (1931), Universal embarked on the production of a series of horror films, starting with an adaptation of a recent stage version of Mary Shelley's classic of gothic science fiction, *Frankenstein* (published 1818). They would soon move on to film The Mummy *(1932)*, The Wolfman *(1941)* and others, stretching the skills of their team of make-up artists to the full.

After false starts in pre-production under the writer and aspiring horror director Robert Florey, the task of bringing Frankenstein to the screen was assigned to an English director relatively new to Hollywood, James Whale (<20). Whale chose to cast a virtually unknown English actor, Boris Karloff (born William Henry Pratt), as the monster – having spotted him lunching quietly in the studio canteen. The 44-year-old Karloff had until then scratched a living playing bit parts in films as diverse as an Edward G. Robinson gangster film, *Five Star Final* (1931), and the French language version of Laurel and Hardy's prison comedy *Pardon Us* (1931). Karloff was offered the part of the monster only after it had been turned down by Bela Lugosi, who considered that the almost entire concealment behind make-up the role demanded would do nothing for his career as a serious actor. Karloff had no such misgivings, and ironically his subtle and sympathetic portrayal of the monster made him one of the best-known and best-loved stars of the 1930s.

Turning the slight, mild-mannered Karloff into Frankenstein's monster was a make-up artist's dream come true. James Whale was an accomplished artist himself, and produced detailed sketches of his own conception of Karloff as the monster. He recalled, 'I made drawings of his head, and added sharp bony ridges where I imagined the skull might have been joined. His physique was weaker than I could wish, but that queer, penetrating personality of his I felt was more important than his shape, which could easily be altered. ' Universal's resident make-up genius, Jack Pierce (212>), took Whale's sketches and threw himself into the project, reading the original novel as well as books on human anatomy, medicine and surgery. With his new-found knowledge, and in close consultation with the director, Pierce designed a monster that he believed would be the most likely outcome of the processes described by Shelley, given that the book itself gives few practical clues to the monster's physical appearance.

Pierce began with the monster's head. 'I discovered that there are six ways that a surgeon can cut the skull,' he explained after the release of the film. 'I figured that Dr Frankenstein, who was not a practising surgeon, would take the easiest. That is, he would cut the top of the skull straight across like a pot lid, hinge it, pop the brain in and clamp it tight.' The result of Pierce's reasoning was the tall, square head with clamps and scars that is perhaps the most recognizable feature of Karloff's monster.

Pierce built up the monster's head on top of Karloff's own

features using many layers of cheesecloth soaked in collodion (a viscous liquid made from gun cotton dissolved in ether and alcohol). It took six hours to apply the finished make-up and another one-and-a-half to remove it. Karloff could not even relax with a cigarette during these lengthy and tedious sessions, since the flammable nature of the make-up materials risked sending the actor up in flames. Facial make-up also included a pair of heavy wax eyelids which, when attached to Karloff's own features, caused them to droop halfway over his eyes. Small wires were used to pull the corners of the actor's mouth out and downwards. Grey-green greasepaint helped to give the monster's face its dead pallor on the screen. His other famous feature – the conductive bolts in his neck – were so tightly fixed to Karloff's skin that he was left with small scars for years to come.

Karloff's height was increased to 2.3m (7½ft) with heavy platform boots and his legs were strapped to steel struts that prevented him from bending his knees, producing the awkward, shuffling walk for which the creature became well-known. Having read that the blood in a decomposing body flows to the extremities, Pierce added a final grim touch by blackening the monster's fingertips. Sensing the visual power of Pierce's creation, Universal shrouded the production of the film in mystery, keeping the appearance of the monster a heavily guarded secret.

Frankenstein was a sensation on its release. The primitve methods of early sound film mean that the film has lost a great deal of its power to shock, and it can seem as stiff and slow as the monster himself. However, filmgoers of the day were genuinely involved by the sheer strangeness of the whole production, scared by Karloff's appearance and touched by his performance as the tormented and vulnerable monster. Contemporary accounts report that some women passed out on their first sight of the monster (one unsuspecting studio secretary had fainted when catching a glimpse of Karloff taking tea with the rest of the case between takes).

The stark image of Pierce's monster is now so deeply embedded in our consciousness, and has been so frequently imitated, that it is difficult to imagine that Pierce was the first person to conceive such a design.

The film made a star of Karloff, secured the reputation of Pierce as one of Hollywood's foremost make-up artists and made enormous profits for Universal. The success of the film led to inevitable sequels and imitations, with Karloff returning as the monster in *The Bride of Frankenstein* (1935) and *Son of Frankenstein* (1939) before he handed the role on to other actors including Lon Chaney Jr and the man who had refused the role in the first place – Bela Lugosi.

FRANKENSTEIN

With a protective plastic cape taped around their body, the subject first has a bald cap glued over their head to cover the hair

Make-up artist Brendan Lonergan uses plaster bandages to build a ridge across the top of the head

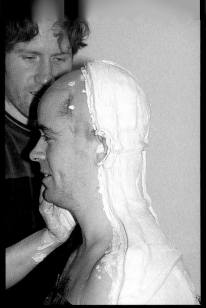

The back of the head and shoulders are completely covered in plaster bandages

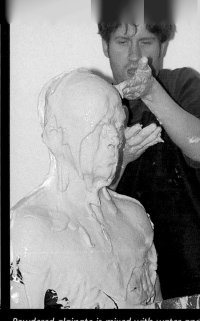

Powdered alginate is mixed with water and poured over the face

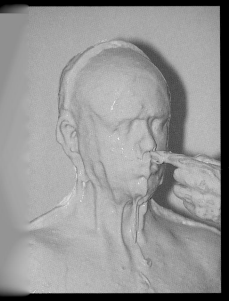

Keeping the nostrils clear, the mixture is gently worked into all areas of the subjects face to ensure an accurate cast

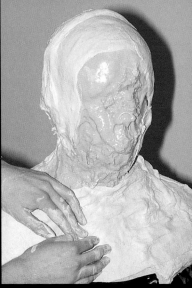

When the alginate has set into solid rubber, the front of the head is bandaged to the plaster backpiece

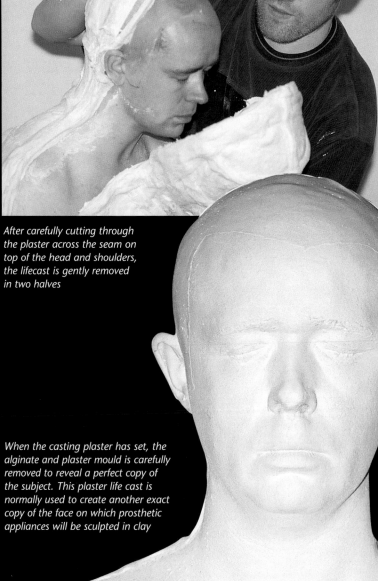

After carefully cutting through the plaster across the seam on top of the head and shoulders, the lifecast is gently removed in two halves

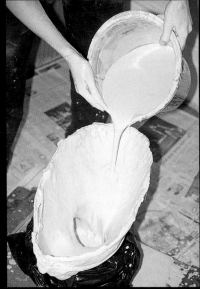

The two halves of the mould are glued and then bound together with another layer of plaster bandages

The empty mould is then turned upside down and filled with liquid casting plaster

When the casting plaster has set, the alginate and plaster mould is carefully removed to reveal a perfect copy of the subject. This plaster life cast is normally used to create another exact copy of the face on which prosthetic appliances will be sculpted in clay

Prosthetics

Prosthetics – the art of creating three-dimensional make-up – depends on producing artificial appliances that can be accurately, and invisibly, attached to the performer. To create appliances able to transform the regular features of actor John Hurt into the hideously disfigured subject of *The Elephant Man* (1980), or turn Danny DeVito into the beak-nosed Penguin for *Batman Returns* (1992), the make-up artist must first acquire an accurate template of the face, or other body part, on which he or she will be working. These templates are created by taking a 'life cast' directly from the body of the performer.

Life casts

'Life casts are the first part of the process of creating prosthetic make-up,' explains Tom Woodruff, who, with his partner Alec Gillis, runs the Los Angeles-based special effects make-up company Amalgamated Dynamics Incorporated (ADI). 'Whatever we need to create – be it a simple wart or a major facial mask – must be designed so that it perfectly fits the face or body of the actor beneath. To do that, we need a completely accurate representation of that performer.'

'The most common type of life cast is probably a face cast,' says Woodruff. 'This is used to create things like masks, scars, false noses, bags under the eyes, double chins and so on.' To create a face cast, the performer is first fitted with a skullcap to prevent their hair from becoming entangled in the casting material. The back of the head is then covered with strips of plaster-covered bandage. The bandages are applied as far as a straight line running over the top of the head from ear to ear. The plaster back-piece takes around ten minutes to set, after which work can begin on the face.

'The face is the important part,' comments Woodruff. 'We have to capture the exact shape of a performer's face with a neutral expression. In this way, the finished prosthetic appliance can be effectively glued to the actor's face and will easily conform to whatever expression they create when performing. For the front of the face, we use dental alginate – the waxy material that dentists use to take a cast of your teeth if you're having any major dental work done.' Dental alginate is a seaweed-based powder that, when mixed with water, creates a paste that normally sets hard in less than ten minutes. 'We carefully spoon it on to the performer's face, making sure that it gets into all the wrinkles and corners,' he explains. 'Too much will pull the lips and cheeks downwards, resulting in a misshapen cast. This is the point where people always expect to have straws stuck in their nose so that they can breathe. Actually, we don't do that because nostrils are never perfectly round, so straws don't fit them very well. A straw will also tend to distort the nose shape and produce a bad cast. Instead, we leave the nostrils uncovered and carefully paint the alginate around them, which leaves the nasal cavities open.'

Once the layer of alginate has set and the performer's features are captured, the whole cast is reinforced with strips of plaster bandage that are wrapped over both the front and back of the head (still leaving the nasal holes unblocked). When this layer has set, after about twenty minutes, the cast is carefully cut in half from ear to ear across the top of the head, so that it separates into a plaster-and-bandage back-piece and an alginate-and-plaster front-piece.

Sitting completely still for half an hour, unable to talk, see or even hear properly, can be an intimidating experience, and the procedure affects different people in different ways. 'Some people are fine having their cast done,' says Woodruff. 'Others are very nervous. These people cannot communicate with us – other than by moving their hands to let us know that they are still conscious under the plaster – so we just have to keep talking to them, reassuring them that everything is okay. Some people find the whole experience quite pleasant – it's dark and warm, and according to some, a womb-like experience. Some people fall asleep, some pass out and some totally freak out and rip the plaster from their faces. We once had a navy diver who was used to being in deep water and mud. However, when we got the alginate on his face, he just panicked and pulled it all off! You can never tell how it will affect someone, so you have to monitor each person constantly.'

Casts of body parts, or even the entire body, are produced in much the same way as facial casts. The performer stands upright and is often strapped to a frame to ensure that the same stance is maintained throughout the process. 'We normally cast bodies in neutral positions, with arms and legs open, so that the final shape allows access to all areas of the body,' says Woodruff. 'However, for *Demolition Man* [1993] we had to produce models of Wesley Snipes, Sylvester Stallone and about twenty other characters frozen in agonized positions. We didn't actually use the stars' bodies; we used body doubles and later grafted the stars' facial casts on to them. The body doubles had to be taped to metal poles in very uncomfortable positions in order to create the life casts.'

When the cast of a face or body feature has been produced, the result is a fragile two-part shell that is a perfect 'negative' of the performer. This shell is fitted back together and filled with a very fine gypsum plaster mix. When the plaster has set, the mould is opened and the result is a 'positive' copy of the performer that replicates their appearance in every way.

'The live performer who we cover in plaster is the original positive, then we make a cast of that person and end up with a negative mould,' says Woodruff. 'We fill this mould with plaster and end up with another positive – a perfect copy of the performer made in plaster. The rest of the process of producing prosthetic make-up operates on exactly the same principles – we continue making positive and negative copies of our original life cast together with the changes we make to it.'

Sculpting

Having obtained a positive copy of a face or body part, the make-up artist can begin to design the prosthetic appliances. 'If we are producing a false nose, we take some clay and sculpt it directly on top of the plaster cast head,' explains Woodruff. 'What we are doing

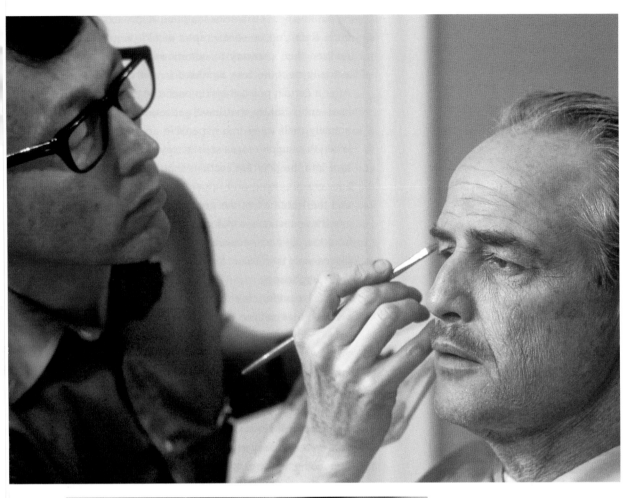

melted their rubber surface. Once the array of prosthetic appliances was attached, Smith applied make-up on top, accentuating wrinkles where necessary and adding liver spots, one of the sure signs of old age.

The following year, Smith was asked to age Marlon Brando by around twenty years for *The Godfather* (1972). For this altogether more subtle make-up, Smith was prevented from using prosthetic appliances because the star did not relish the time and trouble involved in using such techniques. He devised a simpler make-up that did not entail making life casts or quite so many hours in the make-up chair.

The 47-year-old Brando's hair was already grey, but Smith actually died much of the actor's hair black. Brando's remaining grey hair, and some that was dyed white, was then combed back through the black hair to look more like hair that was in the process of ageing. Brando's eyebrows were also greyed.

Top: Dick Smith carefully applies old-age stipple to wrinkle Marlon Brando's skin for The Godfather *(1972). Left: Brando, who was forty-seven at the time, as he appeared in the film.*

Since Brando did not want the shape of his face changed by prosthetics, Smith used a 'dental plumper' – a wire that runs around the lower teeth to give the appearance of pronounced gums. Attached to the sides of this wire were pieces of moulded dental plastic, which pushed out the lower cheeks to give the appearance of jowls. The actor's teeth were also painted a shade of brown to represent nicotine stains.

To give Brando's skin the appearance of old age, Smith applied several layers of old-age stipple – a mixture of liquid latex, gelatin, talcum powder and other ingredients that is dabbed on to the skin with a sponge. After application, the actor's skin is stretched and the latex dried with a hair dryer. When the latex has set, the skin is released. The skin is prevented from going back to its original shape by its coat of latex, so it wrinkles much like old skin.

One of Smith's most successful old-age make-ups was the addition of thirty years to the face of actor Max von Sydow as Father Merrin in *The Exorcist* (1973). Von Sydow was not required to age during the course of the film, but was chosen by director William Friedkin for his ability to play the role despite the fact that he was some thirty years younger than his character. Smith's make-up

Dick Smith won an Oscar for the old-age make-up that transformed F. Murray Abraham into the composer Antonio Salieri for Amadeus (1984).

was particularly challenging since the narrative of the film continually moves back and forth using flashbacks. Both young and old Salieri characters are seen in quick succession, which could have made the use of make-up all the more obvious to the audience. Smith's job was particularly demanding because Abraham has pockmarked skin, and his old-age prosthetics had to be sculpted to represent the same skin in later life.

Animatronics

The term 'animatronic' was first coined in the early 1960s when Walt Disney attempted to bring three-dimensional mechanical figures to life for his revolutionary theme park, Disneyland. Among the Magic Kingdom's attractions when it opened in July 1955 were a cruise through jungle waters populated by simplistic mechanical beasts, and a mechanical barbershop quartet whose members moved and sang by virtue of a series of metal spindles or cams.

As part of the ongoing improvements to his park, Disney planned a restaurant called the Enchanted Tiki Room, where mechanical birds would perform and sing to diners at the end of their meal. With help from the studio's electrical and sound departments, Disneyland's engineers created a system that employed the magnetic audio recording used for the birdsong to send electrical signals to the motors that controlled the mechanical creatures. The Enchanted Tiki Room opened in 1963, and the success of its two hundred performing birds led Disney to build a more elaborate exhibit called the Hall of Presidents, which used the same electromechanical system to make a moving, talking re-creation of Abraham Lincoln. Since the system combined sound, animation and electronics, Disney christened the method 'audio-animatronics'.

scheme involved the use of prosthetic appliances on the cheeks, upper lip and chin, and a wrinkled wattle for his neck. These were supplemented by coats of old-age stipple on the forehead, neck, hands and around the eyes.

An unusual requirement of Smith's make-up for von Sydow was that it be heat-resistant. Some scenes were to be filmed in the deserts of Iraq, and Smith knew from experience that the latex stipple could melt in warm conditions. As a result, Smith used a particularly stubborn stipple formula that he had accidentally discovered while working in television many years before. Later scenes were filmed in a bedroom set that was built within a giant refrigerator so that the actor's breath would be visible. Different make-up formulations were used to prevent the stipple from becoming too brittle in the cold. Smith's make-up on Max von Sydow was so convincing that many people have seen *The Exorcist* without realizing that the old priest is played by a young actor with heavy and elaborate make-up.

In 1985 Smith won an Oscar for his remarkable old-age make-up work for *Amadeus* (1984). The old-age make-up that Smith designed for F. Murray Abraham, who played the composer Antonio Salieri,

Although the practice of bringing life to mechanical creations was not given a name until the 1960s, film makers had relied on such techniques since the earliest days of film. Edwin S. Porter's (<15) *The Eagle's Nest* (1907) featured a crude model of a giant eagle. The bird, which had hinged wings, was suspended on piano wire and filmed 'flying' in front of a moving scenic background with a snatched baby clutched in its talons. In a climactic clifftop scene, the eagle lurched and juddered in battle with future director D.W. Griffith (<16), then an aspiring young actor.

In 1911, George Méliès (<12) created the 7.5m (25ft) bust of a giant ice monster for *The Conquest of the Pole* (1911). The creature

had rolling eyes and a gaping mouth, and its unwieldy 6m (20ft) arms were raised and lowered by two men pulling on cables from an overhead gantry.

A landmark mechanical monster was created at Germany's technologically advanced UFA studios (<101), where a huge model of the legendary dragon Fafner was constructed for *Die Niebelungen* (1924). The 18m (60ft) dragon had an articulated skeleton, which allowed its body and limbs to flex naturalistically. It also had a scaly outer skin made of vulcanized rubber, and could drink water, breathe fire and bleed when stabbed. Seventeen technicians laboured to create the dragon's performance – four were concealed within the creature itself, while others worked under it in a trench that contained the rails on which the whole contraption moved back and forth.

Early animatronic creatures were necessarily large, because the mechanical systems used to produce their movement relied on bulky, low-tech cables, levers, gears and hinges. Subtle expression was not an option – creatures were brought to life through the large-scale movements of major limbs, with perhaps the roll of an eye and gape of the mouth to suggest higher consciousness.

These mechanical monsters, simplistic by today's standards, proved popular characters in adventure and fantasy films of all varieties. The star of *King Kong* (1933) was a stop-motion (<150) animated gorilla just 46cm (18in) high, but for scenes in which the creature was seen in extreme close-up, a 4.6m (15ft) 'life-sized' bust of the great ape was constructed. This was built using a wood and metal frame interwoven with cloth to create what looked like a wickerwork ape. This frame was covered with an estimated thirty bearskins. The beast's plaster eyes were 30cm (12in) in diameter, he had a 60cm (2ft) nose and 120cm (4ft) eyebrows, and his wooden incisor teeth were 25cm (10in) long. Three men squeezed inside Kong's head to operate the cables, levers and compressed-air mechanisms that controlled the eyes, eyebrows, nose, mouth and lips. Kong's facial performance,

A dragon called Fafner was one of the earliest mechanical film stars. Seventeen technicians worked to create his performance in Die Niebelungen *(1924).*

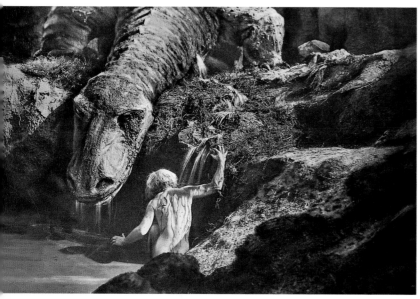

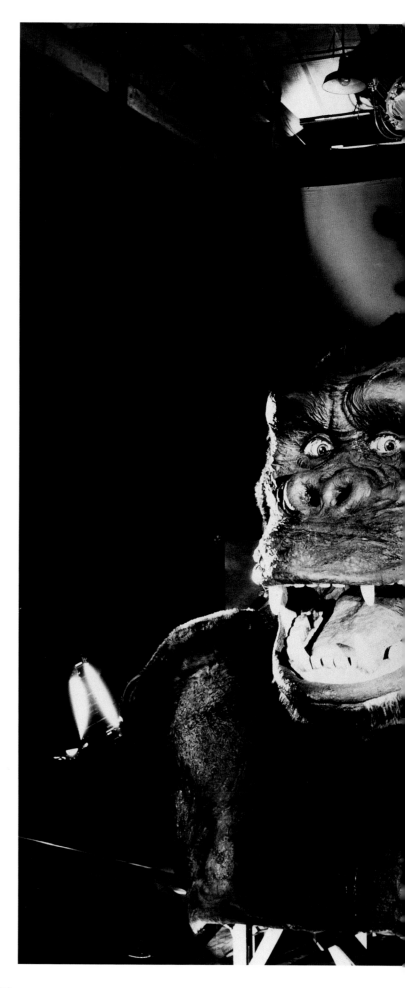

Though an animated miniature was used for most shots of the giant star of King Kong (1933), close-ups were achieved using a fifteen-foot mechanical bust.

particularly in his scenes with Fay Wray, is surprisingly expressive. Other full-size props included an articulated hand that could close around Fay Wray, and a huge foot and lower leg that was used to film people being stepped on.

The alternative to building entirely mechanical creatures was to build them around existing life forms – usually human performers. Dressing people in creature costumes had, of course, been done in the theatre for hundreds of years. The technique was first used on film by Georges Méliès, who created a troupe of stylish lunar-nymphs with papier-mâché heads for *A Trip to the Moon* (1902). The technique flourished with the rash of science-fiction movies that were made in the 1950s – the skimpy budgets of many could not stretch to anything more sophisticated than a man in a rubber suit. Perhaps the most popular rubber-suit creation of the era was *The Creature from the Black Lagoon* (1954). The film's monster star, Gill Man, was played by several performers, including swimmer Ricou Browning, who swam underwater in a heavy rubber suit while holding his breath for several minutes. Gill Man was so popular that he appeared in two sequels. In Japan, Toho Studios used 'suitmation' methods to create the enduring star of *Godzilla* (1954) and its many sequels (239>).

The birth of the sophisticated modern rubber suit, which allows a performer to control the gross (overall) body and limb movements while an external puppeteer operates subtle facial expressions, can be traced to the work of British make-up artist Stuart Freeborn. Freeborn designed and built the prehistoric apes that appear in the opening sequence of *2001: A Space Odyssey* (1968). Unhappy with the level of facial expression that he was able to achieve with a performer wearing layers of prosthetic appliances or a cover-all rubber mask, Freeborn devised an ape make-up with facial movement that could be controlled by the wearer. To make the rubber lips of an ape curl, Freeborn fitted a plate to the underside of the performer's chin. The plate was attached to cables that operated a lip-control mechanism attached to the ape's mouth. When the performer opened his or her mouth, the plate would move and the ape would snarl. For occasions when the snarl was needed while the mouth remained closed, Freeborn devised a toggle that fitted into the mouth of the performer. By using his or her tongue to pull the toggle, the performer could curl the lips of the face mask.

Freeborn built the Chewbacca costume for *Star Wars* (1977) using a similar internally controlled face mask and was asked to produce creatures for the film's sequel, *The Empire Strikes Back* (1980). Among the follow-up's menagerie was the Jedi master Yoda, an ancient green wizard who was in fact a sophisticated glove puppet, operated and given its voice by Muppet performer Frank Oz (1944–). Director George Lucas was worried about relying on an artificial performance for one of the film's most important characters, and asked fellow fantasy film maker Jim Henson (225>) for help and advice. Freeborn received a great deal of valuable guidance from Jim

With a little help from Muppet performer Frank Oz, the wizened Jedi master Yoda was able to give a convincing performance alongside luminaries such as Alec Guinness in The Empire Strikes Back *(1980).*

Henson's Creature Shop, which at the time was developing revolutionary creature performance techniques for *The Dark Crystal*.

Freeborn's Yoda, and Henson's creations for *The Dark Crystal*, were the first steps in an animatronic revolution that used increasingly sophisticated technology to create subtle and naturalistic creature performances. Other early animatronic work was seen in the low-budget but no less influential films *The Howling* (1981) and *An American Werewolf in London* (1981), both of which combined make-up and mechanics to turn humans into werewolves. In the mid-1990s, the art of animatronics was fused with computer-control technology to produce the frighteningly convincing dinosaurs that roamed *Jurassic Park* (1993) and farm animals so lifelike that they could be intercut with the real thing for *Babe* (1995).

Today, animatronic work fits into two broad categories. The simpler method is the person-in-a-suit approach. Such creatures usually have their major limbs operated by a performer encased within a sculpted rubber suit, but have a mechanical head and other moving appendages operated by remote control. The alternative is an entirely mechanical creature – with an interior packed with motors, gears and wires – that is operated by external puppeteers. Whichever method is used, the goal of such creations is to produce convincing, lifelike characters whose existence will not be questioned by the audience.

Character design

Building an artificial creature – even a down-to-earth domestic animal – always begins with a period of intensive design work. The design of a character not only determines its physical appearance, but also has a considerable influence on the way in which it will be built, performed and filmed.

'All character design starts with the script,' comments Mark 'Crash' McCreery, conceptual designer at Stan Winston Studio, for whom he designed the inhabitants of *Jurassic Park* and the beastly star of *The Relic* (1997), among others. 'Some scripts have elaborate descriptions of a character that tell us exactly what it should look like, but sometimes all we have to go on is what we are told about its physical actions. Occasionally you'll get a director like Tim Burton or James Cameron, who already has a very strong idea about what something should look like and may already have some sketches of their own. Then it's a case of reinterpreting their ideas to produce a practical character. For *Edward Scissorhands* [1990], Tim Burton had already drawn some lovely concepts – they really conveyed the fragile nature of the Edward character. However, his designs didn't really relate to reality. I had to find a way of turning the drawings into practical designs that could be manufactured and fitted to a performer, while keeping the original spirit.'

'There are a number of things to consider other than the actual look of a character,' explains McCreery. 'I need to know what the budget constraints are – is this going to be a fully animatronic creature, or a guy in a suit? If it is a guy in a suit, anything I create will have to be fitted around the human anatomy, which can be very limiting. It also helps to know what kind of schedule we're dealing with. It's no good designing the most fantastic and elaborate character if we only have one month to build it. All

Crash McCreery at work on creature designs at Stan Winston Studio.

From the beginning of his career in the mid-1950s, Jim Henson (1936–90) strove to create sophisticated puppets that could produce ever more intricate and convincing performances. Most of Henson's work centred around the Muppets, the gang of zany animal-inspired puppets that appeared in their own long-running television show (1976–81) as well as feature films, beginning with *The Muppet Movie* (1979).

However, the Muppets, for all their loveable, madcap antics, could never be anything more than colourful glove puppets. Henson longed to use the talented artists, technicians and performers he worked with to create a new form of storytelling.

Henson dreamed of creating a magical world, populated entirely by extraordinary creatures, but did not have a screenplay or even a particular story in mind – more of a sense of time and place from which he would ultimately extract a tale. Henson asked British fantasy illustrator Brian Froud to begin designing a new world and its inhabitants. Froud produced thousands of intricately detailed sketches, and even small

A malevolent Skeksis from The Dark Crystal.

sculptures, of the imaginary inhabitants of a fantastical planet. It was Froud's characters and locations that eventually inspired the *The Dark Crystal* (1982).

Henson's idea was a bold one. He wanted to create a film in which no humans appeared, only imaginary characters created from foam latex and cloth. In 1979 Henson set up a workshop in London to begin designing and building the creatures that would populate the world of *The Dark Crystal*. It was the first time that such complex puppet characters had been created for a film. Many

of the techniques commonly in use today were first developed for *The Dark Crystal*, bringing life to characters such as the evil vulture-beaked Skeksis, the wise and melancholy Mystics and the film's most human-like characters, the Gelfling.

Large creatures such as the Skeksis were designed to fit around human performers. The body of each Skeksis was built on to a lightweight metal harness that was cantilevered from the performer's hips. As a result, the character appeared to 'float' above the performer in a peculiarly non-human form of motion. The performer hidden beneath each Skeksis's swathe of robes provided the creature's gross body movements, while up to four additional puppeteers manipulated rods and cables to control the movement of other bodily features.

Performers also crouched inside the 31.5kg (70lb) shells of the crab-like Garthim foot soldiers. These costumes were so heavy that between takes the shells were hung on racks while the performers, still strapped to their underside, relaxed below. Perhaps the most extraordinary performer-based characters were the Land Striders, bat-like creatures perched on top of a set of spindly 4.6m (15ft) legs. Carbon-fibre stilts were attached to the arms and legs of the performer, who strode forwards on the stilts in a crouched position.

By modern standards, the creature-control mechanisms were primitive. The wooden keys of an organ-like contraption were 'played' to create the movement of a character's hand. Breathing movements were achieved by inflating and deflating balloons inside a character's cheeks. Radio control was at first used only sparingly to operate the eye movements of some characters, but during production more sophisticated methods were developed and the two lead Gelfling characters were given all of their most subtle facial movements via radio control – a considerable breakthrough then, but now a common practice.

The Dark Crystal was not a box-office success, perhaps because its fantastic special effects were not matched by an equally compelling story. However, the film proved that convincing, naturalistic performances could be coaxed from a collection of foam rubber contraptions. The Henson organization today remains a pioneer in the field of animatronics (see main text).

THE DARK CRYSTAL

these mundane but very important practical aspects have to be considered before I can begin to get creative.'

The design process may involve weeks of research and many dozens of development sketches. 'I look at a lot of books, watch wildlife documentaries, sometimes visit the zoo – whatever it takes to be inspired before I start drawing,' comments McCreery. 'Sometimes it can take a lot of scrappy little sketches before something starts to look right. Other times you can think about it for a while before getting it right in just one or two drawings.'

However well conceived, McCreery's initial designs are unlikely to end up on the screen. 'Once I have a design, it goes out to the director or the producer or the studio. Very often these people have no preconceived idea of what the character should look like, but as soon as they see a design, they start to tell you what they don't want and how it should change. I often get quite attached to a character that I have developed over a period of time, and it's frustrating having to change all the things that you think are neat about it. At the end of the day, though, this is a business and we have to do what the client wants, not what satisfies us personally.'

According to McCreery, the design of a creature can involve much more than its physical appearance. 'If there's time, I try to do what I call "attitude" drawings. Most design work involves simply planning the physique of a character – its dimensions and form – but by drawing the creature in action, in its own environment, we can really impart a sense of what or who this character is – how it thinks and moves.' The way a creature will eventually move is an important part of the design equation for McCreery. 'Sometimes you see creatures in a film whose movements just don't seem to match the way they look. That's because they haven't really been designed with their performance in mind. It's very important to know what animatronic or puppetry method will be used, because that will affect the way creatures move and how they should be designed.'

McCreery spent over a year producing concepts for the cast of *Jurassic Park* (1993). McCreery's designs not only dictated the appearance of the beasts, but also influenced their eventual behaviour. 'I spent a couple of weeks on a sketch of the T-Rex coming out of some trees,' remembers McCreery. 'The current thinking was that dinosaurs had evolved into modern-day birds, so I gave the T-Rex very birdlike talons and eaglelike eyes. It was kind of pouncing out of the jungle rather than lumbering in the way that dinosaurs had traditionally been depicted. The ultimate design changed somewhat,

but that drawing really affected the way the dinosaurs were approached in the whole film – as warm-blooded, fast-moving animals, not slow, old reptiles.'

When the design of a character has been approved on paper, a small clay sculpture called a macquette is produced.

Although McCreery's original concept for the T-Rex in Jurassic Park *(1993) was not used for the final design, the creature's pose and attitude influenced the approach to every creature that appeared in the film.*

Crash McCreery's colour design for the T-Rex in Jurassic Park.

'Even though you have been working on a paper design for weeks, you never really know how it's going to look until you get this little sculpted clay model. Then you can see if there's something a bit funny about the legs or the neck, and maybe it doesn't work as well from some angles as it does from others,' says McCreery. Macquettes are also a really useful way of checking a design with the mechanical guys. They will be able to tell if a limb is going to be too small to get a hydraulic mechanism into it, or if some other aspect isn't going to work for them.'

As well as helping to decide the final shape of a character, macquettes are used to plan its colour and texture. 'When we have nailed the shape of the character, we'll spend time on the fine details. In the case of a dinosaur, this might involve working on the exact pattern of its scales,' says McCreery. 'We also think about colour design, which is the icing on the cake. The colouring of a creature can make a big difference to its success on screen, but you really can't tell how well a colour scheme will work until you see it on the model.'

Sculpting

Once an animatronic character's appearance has been approved, the design must be translated into a full-sized operational creature. 'We begin by converting the macquette of a character into a full-sized sculpture,' explains Alec Gillis of Amalgamated Dynamics Incorporated. 'Depending on the shape and size of a character, this may be done in one of several ways. If the creature is going to be completely mechanical, we build a metal frame that roughly complies with

the anatomy of the character. This is like a skeleton on top of which we will build the clay sculpture. The frame is usually modular, so that we can later carve up the finished sculpture and remove the various limbs to be moulded and cast as individual pieces. For some large characters, like the Brain Bug we made for *Starship Troopers* [1997], we take a copy of a macquette and cut it into slices. These cross-section profiles are then enlarged and reproduced in wood or foam before being reassembled to create an accurately shaped, full-size framework over which we can sculpt in

clay. In the case of a character that is eventually going to have a performer inside it, we simply start with a life cast and then sculpt clay directly over the top of that.'

A sculpture is created using various types of clay, depending on the subject matter and the material in which the character will later be produced. 'If the creature is going to be made from silicone, we have to use a special clay that has no sulphur in it – sulphur residue in a mould will react badly with silicone,' explains Gillis. 'If we are doing a really big sculpture, we might use a water-based clay that we can keep damp and soft by wrapping it in wet towels. We have to be especially careful that parts of a sculpture where the clay is particularly thin don't dry out and crack. We normally create the gross shape of the character using wet clay – which is easy to push into shape – then we'll let it dry a little so we can sculpt the finer details into a harder surface. If a sculpture is going to be worked on for a very long time, we might use an oil-based clay that doesn't dry out at all.'

Sculpting is perhaps the most crucial stage of bringing an animatronic character to life. 'Every little detail, each skin blemish or hairline wrinkle that is created during the sculpt will be transferred to the final piece,' continues Gillis. 'A good sculpture can make so much difference. This is where a character is really created.'

As with the creation of prosthetic appliances, making animatronic creatures from foam latex is a matter of producing a series of negative and positive copies of a sculpted clay shape. When the clay sculpture of a character has been completed and finessed in every minute detail, it is used to make a fibreglass mould. The result is a negative mould – a shell that has every detail of the clay sculpture recorded on its inner surface. If this shell were filled with liquid foam latex, the result would be a solid foam copy of the clay sculpture. Animatronic creatures are not made from solid foam, however. They need to be filled with electronics, mechanical devices and sometimes performers, so the negative mould of the sculpture must be used to produce a hollow skin.

If the character will be a rubber suit brought to life by a human performer, a positive life cast of the performer is placed inside the negative fibreglass mould. The gap between the negative mould of the sculpture and the positive life cast is then filled with foam latex to produce a skin. 'We often shave the life cast of the performer down a little bit,' explains Gillis. 'By making the life cast slightly smaller – especially around the joints where costumes tend to wrinkle a bit – we ensure that the resulting rubber suit will be a really tight fit on the performer's body.'

If a character is to have an entirely mechanical interior, a thin skin of clay is built up inside the negative fibreglass mould of the original sculpture of the creature. This layer of clay will later be

STAN WINSTON

After studying painting and sculpture at the University of Virginia, Stan Winston (1946–) headed straight for Hollywood in 1968 with hopes of becoming an actor. While waiting for stardom, Winston was selected for an apprenticeship in make-up at the Walt Disney Studios, where he discovered that make-up was his true calling.

Winston won an Emmy for his creations for the television movie *Gargoyles* (1972). He next aged actress Cicely Tyson to 110 years of age for the TV movie *The Autobiography of Miss Jane Pittman* (1974), for which he collected another Emmy alongside fellow newcomer Rick Baker (232>).

Winston contributed to several low-budget horror films before creating the make-up that transformed Rod Steiger into W. C. Fields for *W. C. Fields and Me* (1976), and the fantasy characters of *The Wiz* (1978), for which he began to experiment with mechanically articulated faces.

Following a recommendation from make-up guru Dick Smith (<218), Winston was awarded the job of creating facial prosthetics (<215) and full-scale robotics (<221) for James Cameron's modestly budgeted *The Terminator* (1984). The scale of the work required for *The Terminator* led to the establishment of Stan Winston Studio, now one of Hollywood's leading facilities. The studio has created animatronic creatures for films such as *Aliens* (1986), *Predator* (1987), *Jurassic Park* (1993) and *Terminator 2* (1991), and the tiny rod-puppet performers of *Toy Soldiers* (1998). The studio has also created more traditional but no less spectacular make-up effects for films such as *Edward Scissorhands* (1990), *Batman Returns* (1992) and *Interview with a Vampire* (1994).

Winston has directed two films, *Pumpkinhead* (1990) and *The Adventures of a Gnome called Gnorm* (also known as *Upworld*; 1991), and won Oscars for his work for *Aliens*, *Jurassic Park* and *Terminator 2*. With James Cameron and former ILM chief Scott Ross, Winston is also a co-founder of leading Hollywood visual effects company Digital Domain.

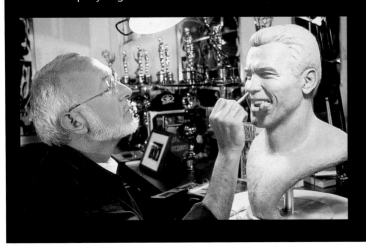

replaced with the character's rubber skin. Various features may be sculpted in it to determine the way that the skin will respond when moved by various animatronic mechanisms. Parts of the anatomy that might later need subtle mechanical manipulation, such as a face, are given a very thin layer of clay, which will ultimately result in a delicate rubber skin. Areas of a character's body that need less subtle movement may be given a much heavier clay lining to produce a thicker, less agile skin.

When the inside of the mould has been lined with clay, another fibreglass mould is made from it. The result is an inner 'core' that fits *inside* the original mould of the sculpture. This core will later be used as part of the internal structure of the finished character. When the clay layer has been stripped from inside the original mould, and the new core is placed within it, there will be a gap between the two moulds where the layer of clay once was. By filling that gap with a material such as foam latex or silicone, a rubber skin is formed.

The result of the sculpting and moulding process is a floppy rubber skin that looks as if some poor creature has had its insides sucked out by a giant mosquito. It is this skin that must be filled with motors and cables to produce a lifelike performing creature.

Inner mechanisms

Planning the internal mechanism of an animatronic creature begins during the design stage – electronics and mechanical mechanisms evolving in tandem with a character's outer appearance. However, most of the physical work on a character's inner mechanisms only begins after the creature has been sculpted in clay to produce a foam latex skin.

'Almost as a by-product of the moulding process that produces the skin, we create a fibreglass inner core, which is exactly the size and shape of the underside of the skin,' comments Jamie Courtier, Creative Director at Jim Henson's Creature Shop. This inner core – a lightweight fibreglass shell – is, in effect, the 'body' of the character. It will have the finished foam latex skin fitted around it, and the internal metal framework of the character will fit within it.

The core is often cut into sections so that the various limbs and joints can move independently. For particularly flexible parts of a character's body, such as the neck, the fibreglass shell of the core may be too rigid to provide the necessary underlying body movement, and may be replaced with a specially created articulated body piece.

Though the fibreglass core presents a perfect ready-made body over which the foam latex skin can be fitted, its rigidity does have limitations. When the fibreglass core is moved mechanically, the skin can move over the top of it quite realistically,' says Courtier. 'However, the pieces of core itself do not actually change shape. In real life, the pieces would change shape as the character moves – tendons would stretch, flesh and muscle would bulge and contract. These days, if a character has to move and behave just like a real animal, we create an inner body that actually replicates those natural movements.'

To achieve this, the internal metal framework of the character is built to resemble the skeleton of the creature in question. The

fibreglass core is then assembled around this skeletal framework. Where muscles need to be seen working beneath the surface of the skin, the fibreglass is replaced with sculpted soft foam muscles. These are encased in an elasticated material such as spandex, which is secured to the skeleton of the creature. A layer of fabric is laid over the foam muscle structure to prevent friction, thus allowing the muscle to move freely below the foam latex outer skin, which is wrapped over the whole framework and generally glued in place at a few key points. Henson's used such anatomically precise techniques to create incredibly realistic animals for both *Babe* (1995) and *101 Dalmatians* (1996).

With the body under construction, attention turns to the actual

Top: *The metal inner mechanisms of an animatronic dinosaur used in* The Flintstones *(1994).* Bottom: *The mechanisms were concealed within the character's fibreglass core. Here, a foam latex skin has been partially fitted prior to painting and artworking.*

mechanisms that will be used to make the character move. With large limbs, movement is generally only required in one or two directions around each joint. Such movement can be achieved by attaching hand-controlled metal

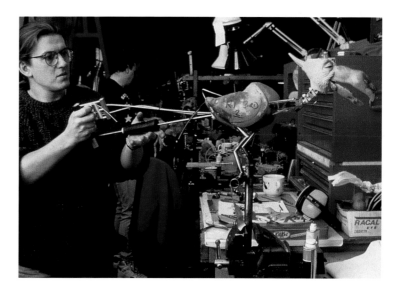

rods directly to the limbs. These rods normally protrude from the body, and end with a control handle that might be a simple one-handed grip or a complex mechanism

A bird built by Jim Henson's Creature Shop for The Flintstones, *controlled by a simple rod and cable-grip mechanism protruding from the back of its body.*

resembling a set of bicycle handlebars. By pulling, pushing and twisting these handles, a puppeteer is able to give a creature its overall body movement.

'We now find that controlling characters with rods is a much more viable option than it was a few years ago,' comments Jamie Courtier. 'We used to spend a lot of time concealing control rods from camera view, which inevitably meant that one part of a creature – usually its rear end – would have to be off-camera. However, it's now relatively fast and inexpensive to digitally remove items like control rods and even puppeteers from a shot after filming. Rod puppetry has two advantages. Firstly, a rod-puppeteered creature is generally easier and cheaper to build than a character that is operated by other, more complicated means. Secondly, having a direct attachment to the creature via a rigid rod means that the puppeteer can create a more fluid, interactive performance, because the puppeteer's own movements are transferred directly to the character.'

For large-scale animatronic creatures, hydraulics may be used to control movement with amazing grace and precision. The 12m (40ft) T-Rex built by Stan Winston Studio for *Jurassic Park* (1993; <172) was mounted on a sophisticated hydraulic motion platform of the type used for flight simulators. To create the dinosaur's movement, the rig could move the huge and potentially dangerous automaton at great speed, bringing it safely to rest within inches of cast and crew.

While hydraulics and rods are suitable for creating big movements, small actions such as facial expressions require more finesse. As many as thirty individual movements may be needed to give an animatronic head the appearance of naturalistic life. These include the eyebrows, cheek muscles, lips, nose and eyes. The movement itself is supplied by a relatively simple interior mechanism that can push, pull or swivel the fibreglass core below the

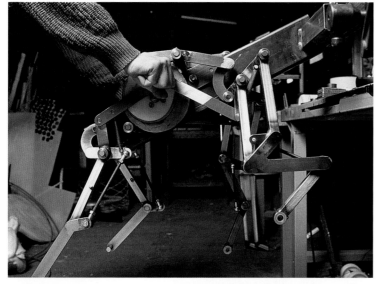

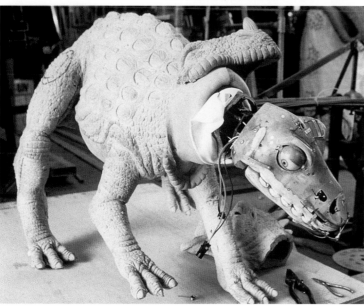

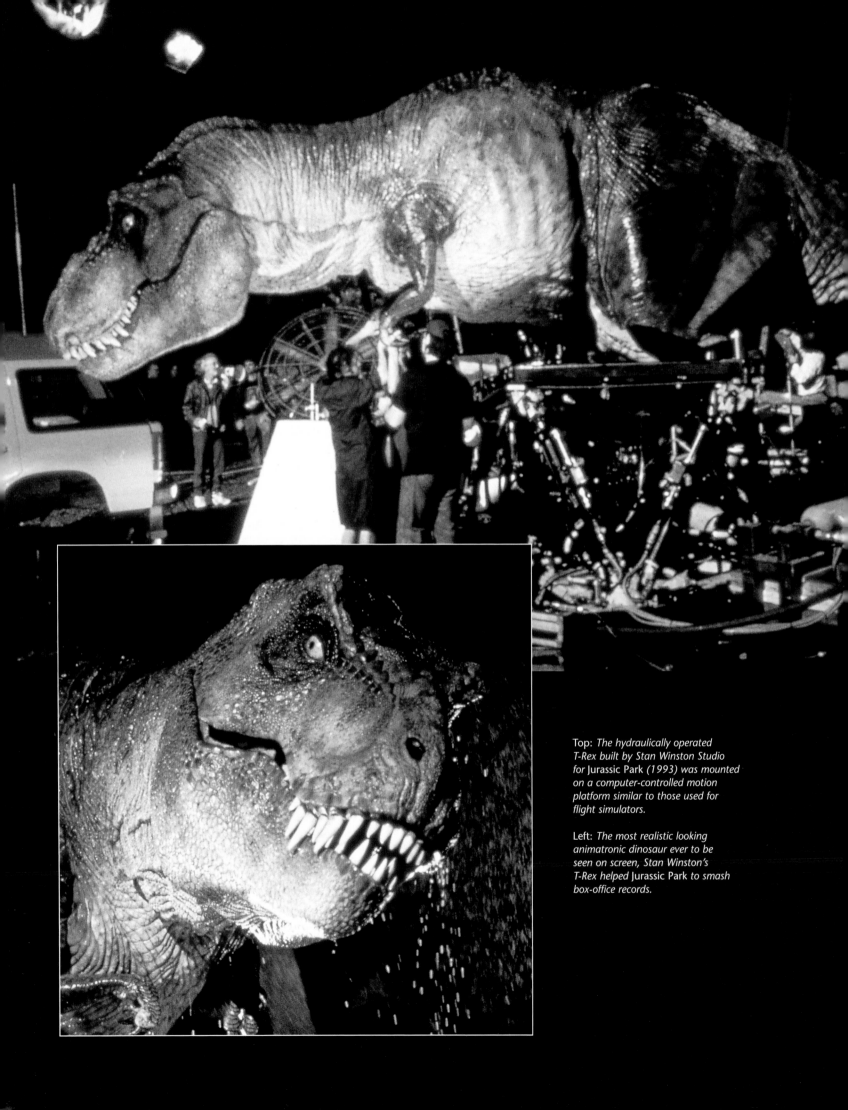

Top: *The hydraulically operated T-Rex built by Stan Winston Studio for Jurassic Park (1993) was mounted on a computer-controlled motion platform similar to those used for flight simulators.*

Left: *The most realistic looking animatronic dinosaur ever to be seen on screen, Stan Winston's T-Rex helped Jurassic Park to smash box-office records.*

manipulated by a puppeteer, who pulls or releases the cable using a handgrip or lever. The other end of the cable is arranged so that it pulls a tab or operates a lever that directly affects the movement of the puppet whenever the puppeteer pulls the handgrip. The cables used for this work – which range from wires as thin as fishing line to heavy duty cables capable of pulling several tons – are kept as short as possible. 'The further a cable has to reach between creature and puppeteer, the more effort is needed to pull it and the harder it is to achieve a subtle performance,' explains Dudman. 'Cable control is really only suitable for characters that can be kept a relatively short distance from the puppeteer.'

Radio-controlled animatronics operate in much the same way as cables, the difference being that a small electric motor within the creature itself is used to push and pull the skin. This motor is controlled by radio waves from a hand-held unit. 'We use the servo motors that are normally used to operate radio-controlled model aircraft,' explains Dudman. 'Instead of having a small spinning drive shaft, these motors operate an axle that twists backwards and forwards. We attach this axle to a rod or cable that in turn moves the latex skin. The only real difference between radio and cable control is that with radio control, there is no physical link between the puppeteer and the character.' Servo motors work under proportionate control, which means that the further and faster the puppeteer moves the joystick of the device, the further and faster the servo motor moves its axle, making puppeteering with servos an intuitive process.

Servos are chosen for their size and power. A small motor, perhaps the size of a box of matches, may fit more easily into the confines of an animatronic head, but it can only produce small, relatively weak movements. Larger motors can produce greater movement but are much harder to conceal – especially when as many as thirty of them are required in the case of an

The external rods and wires used to create the performance of some characters can now easily be digitally removed. Here, Blawp, from Lost in Space *(1998) is puppeteered with an array of rods which will be invisible in the final shot.*

creature's foam latex skin, or, for more subtle movement, can be attached directly to the underside of the skin itself. 'Half the game with getting the movement of a face right is the way in which you actually attach the mechanisms to the costume,' explains Nick Dudman, special effects make-up supervisor on films such as *The Fifth Element* (1997), *The Mummy* (1999) and *Star Wars Episode One: The Phantom Menace* (1999). 'The mechanisms need to be fixed to the foam latex skin so that it will absorb the underlying mechanical qualities of the movement, blurring them to produce an organic feeling at the surface level of the skin.'

Such movement can be supplied either via cable or radio control. 'Cables are usually used when there is no problem with having a large number of unsightly wires coming out of the underside of a creature,' comments Dudman. 'However, if the character needs to be a stand-alone creation, without any wires coming out of it, then its internal mechanisms may have to be operated by radio control.'

Cable-controlled movement works on the same principle as bicycle brakes. A thin cable is threaded inside a slightly thicker tube and lightly lubricated to prevent friction. One end of the cable is

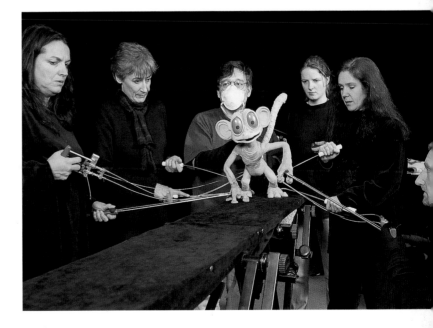

RICK BAKER

Rick Baker's (1950–) fascination with make-up emerged when, as a child, he gave himself hideous fake wounds and dressed up as various monsters. It was then that Baker developed his passion for re-creating apes, a skill for which he has become most celebrated.

Baker began his career building stop-motion puppets, but got his first make-up break on the low-budget monster movie *Octaman* (1971), for which he created an Octopus-like rubber suit. Baker's next assignment, *Schlock* (1971), brought his first opportunity to construct an ape-like creature. The low-budget movie was the debut for writer/director John Landis, who also wore the missing-link ape-man suit created by Baker.

Baker's next opportunity to create an ape was for *The Thing with Two Heads* (1972), the Thing being a two-headed gorilla. Baker thought he would have the chance to create the ultimate gorilla suit for the remake of *King Kong* (1976), but disagreements with the producers led to an unhappy experience and work of which Baker is not particularly proud.

Before his chance to create realistic apes eventually arrived, Baker produced some of the aliens for the cantina scene in *Star Wars* (1977), and collected an Oscar for his incredible transformation make-up in *An American Werewolf in London* (1981).

Greystoke: The Legend of Tarzan, Lord of the Apes (1984) brought Baker the chance to make truly sophisticated simians. Baker built thirty apes with cable-controlled faces. Combined with the performance skills of specially trained actors, the results were the most convincing apes that had ever been created for the movie screen.

Baker won a second Oscar for his amazingly expressive ape-man in *Harry and the Hendersons* (1986), before topping his Greystoke achievements with *Gorillas in the Mist* (1988). His great apes were so convincing that they could be seamlessly intercut with footage of real mountain gorillas. Baker's other work includes *Coming to America* (1987), *Gremlins 2: The New Batch* (1988) and *Mighty Joe Young* (1998).

animatronic head. 'We often find that there just isn't enough room to put all the servos we need into a head, especially if it's part of a costume that has to have room for the performer's head as well,' comments Nick Dudman. 'In such cases, we have to secrete the motors in other places around the body and route their movement through the costume using internal cables.'

Dudman created sophisticated animatronic heads for the law-enforcement characters known as Mangalores in *The Fifth Element*. 'The Mangalores were performers dressed in rubber suits,' notes Dudman. 'The suits themselves were relatively simple, then they were topped off with a silicone animatronic head that went over the performer's own head. The mask was fixed to the body suit with poppers that kept the skin taut. Normally with heads, there may be two places where the performer below is actually visible – around the mouth and also the eyes. In this case, the eyes of the performer were fitted with contact lenses and we made little silicone eyebags – like slugs – that were glued under the performer's eyes to blend them with the mask. I wanted to see right into the mouth of the Mangalores, so the mask was built with a rubber throat that had several rows of teeth. The rubber throat actually rolled down *inside* the throat of the performer, who also wore a rubber tongue. If the Mangalores opened their mouths, you could see right down into their gullets, which really gave the impression of living, three-dimensional creatures. However, because the masks were so close to the faces of the performers, there was no room to hide the servo motors that controlled the facial movement, so we built a special back pack that hung the sixteen facial servos and their batteries down the spine of each performer. The radio-controlled movement of the motors was then transferred via cables that went up through the costume and into the head.'

Eyes

The eyes, it is said, are the windows to the soul. Lon Chaney was one of the first to recognize the importance of a character's eyes. To play a blind man for *The Road to Mandalay* (1926), Chaney peeled the translucent white skin from inside an eggshell, cut it into circles and pressed it over his eyeballs. This gave his eyes the cloudy look of cataracts, but like many of Chaney's efforts, caused the actor considerable pain.

Contact lenses are the safer and generally more comfortable method now used to change the appearance of an actor's eyes. For many years, make-up artists used 'scleral lenses'. These were produced by taking a mould from the performer's eyeball – a difficult and unpleasant task – which was then used to create a tightly fitting, rigid plastic lens that covered the whole of the front of the eye. These lenses were uncomfortable to wear and had to be removed regularly to allow oxygen to reach the surface of the eye. Today, 'corneal lenses' – which cover only the iris and corneal area of the eye – are the more comfortable alternative. These are the same type as the soft lenses that are used for normal

sight correction, and once applied, can be worn all day. Corneal contact lenses can now be made with any colour or pattern desired. Once a design has been created, artwork is sent to a specialist optometrist who transfers the pattern on to lenses ready for use.

Contact lenses are a relatively cheap and simple way to create a striking eye design, such as the eerie mirrored eyes of Yul Brynner in *Westworld* (1973), or the threatening, brightly coloured eyes of Darth Maul in *Star Wars Episode One: The Phantom Menace* (1999). They can also be used to enhance old-age make-up. During extreme old age, the eyes often develop a feature called arcus senilis – a fatty deposit around the edge of the iris that makes the eye look grey and soft. Lenses with

The threatening eyes of Darth Maul (Ray Parks) from Star Wars Episode One: The Phantom Menace *(1999), were created by fitting the actor with special contact lenses.*

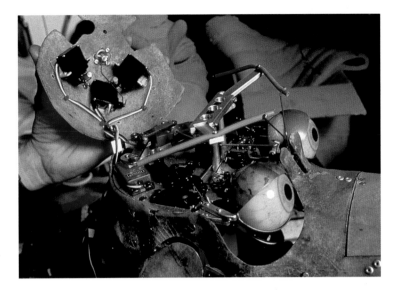

The complex inner workings of a character's eye mechanism. In this case, the character has traditional brass hard-shell eyelids, to which the skin will later be glued.

pale blue-grey rims can be used to mimic this condition in young, healthy eyes, and were effectively used for the old-age make-up created by Dick Smith for *Little Big Man* (1970) and *Amadeus* (1984).

For animatronic creatures, entirely artificial eyes must be created. 'Eyes are one of the most important focal points that bring any character to life,' says Jamie Courtier. 'It really is worth spending a disproportionate amount of time and money on getting a creature's eyes to look good. Dull, lifeless eyes can immediately give a creation away as artificial.'

As with contact lenses, artificial eyes start life as conceptual artwork. 'For models of real animals, we design an eye that is identical to the genuine thing,' explains Courtier. 'For fantasy-type creatures, however, we design original eyes that are in keeping with the character. For the Bark Troll from *NeverEnding Story III* [1994], for example, we designed an iris that was based on the cross-section of a tree trunk.' There are other aspects to the eye that help an audience to judge a character's personality. 'A key part of eye design is deciding the size of the pupil,' says Courtier. 'If a character has large pupils, it will tend to look cute and friendly. Smaller pupils create a more beady-eyed, evil look.'

Eyeballs are made from spheres of plastic resin, ranging from tiny bead-sized globes for mice and birds, to football-sized ones for dragons and dinosaurs. The spheres, which are normally ivory-coloured to mimic the whites of the eyes, have one curvature ground off, leaving a flat surface on to which the painted eye artwork is laid. This flat-sided sphere is then placed in a mould which is filled with clear resin. When set, this gives the whole eyeball a thin transparent skin, and fills out its flattened side to a normal curve. The clear dome of set resin over the eye artwork also acts like a magnifying glass, making the flat design look three-dimensional, especially after the eye has been polished.

Resin eyeballs can be startlingly realistic, but they cannot physically react in the way that a

real eye does. In bright conditions, a real iris contracts to limit the amount of light that enters the eye; while in the dark, the iris expands. This phenomenon was cleverly replicated in *Jurassic Park* (1993), for which Stan Winston Studio built a tyrannosaurus with motorized diaphragms that dilated its pupils. In one of the film's most chilling moments, the huge creature peers into a jeep containing two children. When a torch is shone into its eye, the beast's iris dilates dramatically, giving a true sense of an animal on the prowl.

Jim Henson's Creature Shop found an ingeniously simple way to control the size of eye pupils for the piglet star of *Babe* (1995). A small rubber ball was fixed to the end of a rod and placed inside a hollow eyeball filled with silicone oil. When pressure was applied to the rod, the rubber ball squashed against the inside surface of the eyeball, resulting in a large iris. When the pressure was released, the rubber ball moved away from the inside of the eye and the iris appeared smaller.

Once completed, eyeballs are mounted in a radio- or cable-controlled mechanism that enables them to be rotated in any direction. Remote-controlled hard-shell eyelids made from plastic or metal are mounted just in front of the eyes and pivoted so that they roll over the eyeball when a blink is required. When the eye mechanism is placed in the skull of the creature under construction, the character's skin is glued to these eyelids so that the flesh around the eyes moves as the eyelids open and close.

The hard-shell blink mechanism used in most animatronic creatures is effective when seen from a distance, but in close-up there is something rather artificial about the technique. 'As we've progressed into producing ever more realistic creatures, the eyelid has been one of those things that we have had to finesse,' says Jamie Courtier.

For the film *Buddy* (1997), Henson's aimed to create the most realistic-looking animatronic gorilla ever made for a film. 'Animatronic gorillas had got pretty good over the years,' explains Courtier, 'but something that had never been addressed properly was the eyeball and the eyelid. If you watch a person sleep, you will notice the eyeballs moving around beneath their closed eyelids. This is because eyeballs are not perfectly smooth-sided spheres; they actually have quite a pronounced bulge on the surface over the cornea. It is this corneal bulge that you can see moving under a sleeper's eyelid, and which also moves the skin of an eyelid as it slides over the eyeball during a blink. Such a bulge could never occur with a traditional animatronic blink, because the eyelid is a hard shell mounted just above the surface of the eyeball.'

For *Buddy*, Henson's designed a new type of artificial eyeball that had a realistic corneal bulge. Although the bulge itself is barely noticeable, the quality of reflection produced by the shape of the new eyeball brought an additional spark of life to the character. While normal animatronic blink mechanisms swing a solid, semi-circular lid over the surface of the eyeball without actually touching it, Henson's designed a new type of flexible eyelid that actually touched the eyeball and changed shape as it was dragged over the corneal bulge.

Finally, Buddy's eyes featured an electronic detail that made the life of the puppeteer a little easier. 'When we look at something while our body is moving around, our eyes automatically adjust so that they continue looking at the same object even though the position of our head may have changed radically,' notes Courtier. 'To replicate this trait during a performance, a puppeteer must physically alter the position of the eyes so that they still look in the same direction, however much the head moves. To solve this, Buddy's eye mechanism included a gyroscopic feature that actually sensed the movement of the head and applied a counter movement to the eyes. Once the eyes were locked into looking at something, Buddy could move freely while his eyes continued to look at the right spot.'

'As with a lot of the improvements that we make in animatronics, no one in the audience will actually notice such changes,' remarks Courtier, 'but we keep making lots of little breakthroughs that altogether help us to create more convincing characters.'

Fur

Once the body of a creature has been designed, sculpted and cast, some thought must be given to the finished look of its exterior. Leathery creatures, such as lizards and dinosaurs, are sculpted with every exterior scale and wrinkle already in place. The rubber skin therefore only needs to be painted before looking complete. Creatures that are covered with fur or feathers, on the other hand, are sculpted bald and must have an appropriate exterior attached to their smooth rubber skin.

There are various ways to give a creature a coat of fur,' explains Tom Woodruff of special effects make-up company Amalgamated Dynamics Incorporated (ADI). 'One way is to buy ready-made fake fur that can be cut up and fitted to the creature in question. This fur is normally either entirely synthetic, or is sometimes made from yak hair, which is humanely shaved from the belly of yaks and dyed various colours. We generally find that this off-the-shelf fur is not quite near enough in colour and texture to what we need, and so our specialist manufacturer will actually make fur according to our specifications. Using samples that are sent to us, we blend different grades and colours to create the type that we want. We then ask the manufacturer to produce a fur that has ten per cent of one variety of fur, forty per cent of another and so on.'

An alternative to using ready-made fur is to create it from scratch. 'For really good hair, we find that we normally have to make our own,' explains Woodruff. One way to do this is to hand-tie every single hair into a piece of elasticated material such as spandex. The finished fur, which can take weeks or even months to produce, is then cut into the appropriate shapes and attached to the body of the creature, or stretched over the limbs and body parts like a tightly fitting sock.

Instead of producing a hand-tied body sock, hairs can be hand-punched directly into the foam latex or silicone skin of the creature, a painstaking and laborious process. Using a tool made from an ordinary sewing needle with the top of the eye cut off to create a prong,

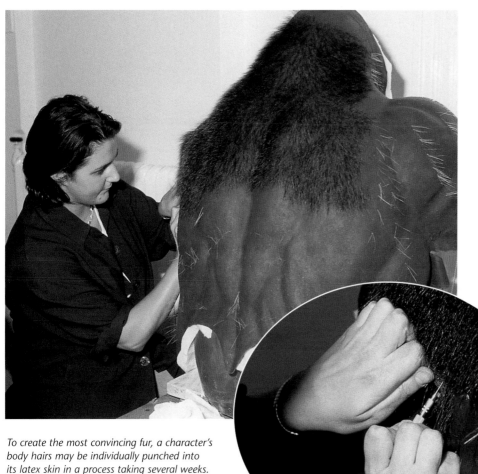

To create the most convincing fur, a character's body hairs may be individually punched into its latex skin in a process taking several weeks. Here, 'Buddy' the gorilla is given a fur coating at Jim Henson's Creature Shop.

the artist selects a single hair and punches it into the skin. The hair does not need to be glued because the natural grip of the rubber skin holds it in place. Blending and mixing grades and colours of hair is an art in itself, as is punching the hair into the skin so that it stands at the correct angle. This is perhaps the most effective, if labour-intensive, method of creating realistic fur – the coat shifts and bristles naturally as the rubber beneath creases and bulges during a performance. The method is particularly effective when used with silicone, because the translucent material leaves the roots of the hair just visible below the skin.

To produce a covering of very fine short hairs, hand-punching would be impractical. In this case, the body of the creature can be 'flocked' – finely chopped fur is sprayed directly on to the body of a creature that has been covered in glue. During the spraying process, the body is given a negative electrostatic charge, while the chopped hairs are given a positive electrostatic charge. These opposing charges cause the hairs to stand upright in the glue. Before the glue dries, an electrostatic wand can be waved over the standing hairs to encourage them to point in various directions and resemble the way that real fur grows on animals.

Despite the incredible range of fake furs that are available, it is sometimes impossible to re-create nature realistically. 'On principle, I, like most people, will always use fake fur if possible,' says

special effects make-up designer Nick Dudman. 'Unfortunately, it occasionally proves impossible to create a fake version of an unusual variety of fur, and the real thing will have to be used. We always use legitimate suppliers who only supply fur from recognized sources, and we certainly never use anything that comes from any sort of threatened species.'

To prepare real animal fur, a strong, water-soluble glue is combed through the pelt. When the glue has set, the leather backing is scraped from the fur using a razor blade. The back of the fur is then painted with liquid latex, which replaces the leather and holds the roots of the fur in the correct position. When the latex has set, the water-soluble glue is washed away to leave a perfect coat on a flexible, hygienic rubber backing.

Using real fur and hair is becoming increasingly unacceptable by most people's standards, and new ways of creating substitutes are constantly being sought. When faced with finding realistic-looking dog fur for *101 Dalmatians* (1996), Jim Henson's Creature Shop developed a method of treating sheep's wool to produce the type needed. Many other types of humanely gathered fur types are used to create alternatives to the real thing.

No matter how good the hair on a creature may appear, however, the success of an artificial hairdo can ultimately depend on the way in which it is filmed. Flattering lighting and some well-chosen filters can make all the difference.

Performance systems

When one imagines the work of a puppeteer, visions of a sole performer hunched over a dangling marionette or crouched under a table with their hands buried inside a glove puppet come to mind. However, the sophisticated animatronic creatures now built for feature films need to have more than a few simplistic body movements in their repertoire. To be adequately expressive, a character's face alone may have as many as thirty separate control functions. Bringing such creations to life can require some high-tech solutions.

Although Jim Henson's Creature Shop is known for the craftsmanship of its animatronic creations, the organization is most proud of its commitment to character performance. 'Our company sprang from Jim Henson's desire to create amazing characters,' comments Jamie Courtier, Henson's creative director. 'The technology behind a character was not important to Jim; it was the final performance that counted. Some of his greatest characters were, after all, only simple glove puppets. However, as our feature film work has developed, the devices that we use to bring life to our characters have become more and more complicated.'

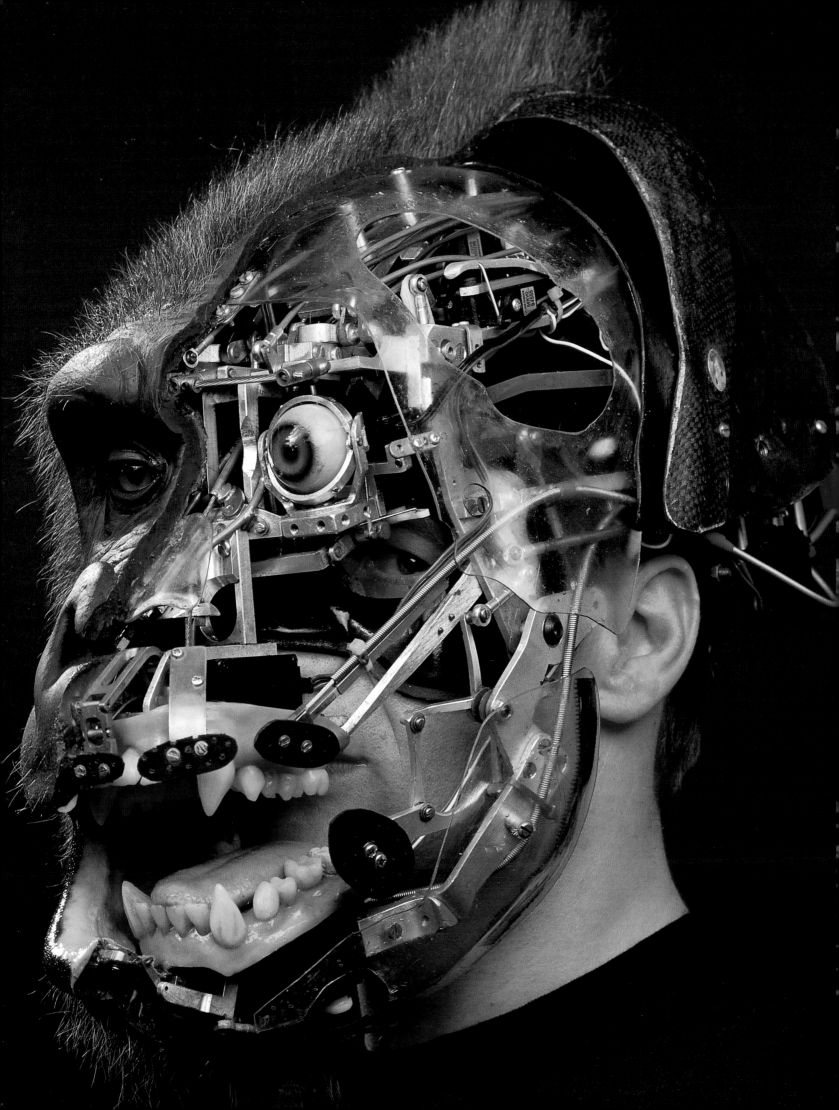

'Imagine a radio-controlled face with thirty motors in it,' continues Courtier. 'It would be impossible for a single person to operate so many channels of movement effectively. We might need four or five puppeteers, each operating half a dozen of a character's expressions. Simply coaxing a smile from a character could require a considerable team effort. To reduce the number of performers, we came up with our Performance Control System.'

The system works on the premise that any character's facial performance is made up of a limited repertoire of expressions – sadness, smiling, confusion and so on. The manner and degree to which these emotions are expressed is what differentiates the personality of each character. If a puppet with a sophisticated animatronic face were brought to life by a team of puppeteers, each member would need to work in perfect harmony. A simple smile might involve one performer creating a grin, another the flaring of the nostrils and yet another a slight widening of the eyes. By linking an animatronic creature to a computer, however, a puppeteer is able to program the key expressions of a character into the computer's memory. The computer then knows that when a character smiles, each of the motors controlling the face should move in a particular way. 'The system allows puppeteers to work with pre-set expressions – you simply ask for a smile and get one,' explains Courtier. 'The puppeteer can create an amazing performance simply by asking the computer for a little more sadness or a little more anger. The computer will automatically mix and match those expressions to create something that is unique, but within the pre-set parameters for that character.'

To operate the system, the puppeteer uses both hands to manipulate a set of controls. The right hand slips into a mechanical glove that measures every twist, turn and clench of the puppeteer's hand. These movements directly affect the puppet – by twisting his or her hand, the puppeteer can turn its head; opening and closing the hand will cause the character's mouth to open and close.

The left hand grips a joystick that can swivel in all directions. Each finger rests on a control dial, while the thumb slots into a cup that acts as an independent miniature joystick. It is this set of controls that is normally used to navigate between the pre-set expressions. 'The whole system is totally flexible,' says Courtier. 'If a puppeteer wants to control a frown with the forefinger, we can set it up that way. If the puppeteer would rather use the thumb, then we will change things accordingly.'

To create the farmyard characters for *Babe* (1995), Henson's refined the system to include speech controls. Henson's had already used a system of puppeteering lip movements for *Teenage Mutant Ninja Turtles* (1990), in which performers wore a facial device that used infra-red to measure their mouth position a hundred times a

This cutaway head of the gorilla from Buddy *(1997) shows the intricate array of servos and control mechanisms fitted into the space between the mask and the performer's head.*

second and transfer those moves to the turtles' lips. The system worked but the results were crude. 'For *Babe*, we needed to create refined lip movements that synchronized

with pre-recorded character dialogue,' says Courtier. 'So we created the Henson Performance Recording System.'

The computer system uses the pre-recorded dialogue from a scene and analyzes the sounds to form the lip movements of the character. The facial performance is displayed as a graphic wave on a computer monitor, and the puppeteer can use a graphics pen to alter it manually in order to refine the performance. 'The beauty of this system is that it is only the speech that is pre-recorded,' states Courtier. 'The puppeteer will perform the creature as usual and the computer will only take control during the time that the character has to perform a line – it's a perfect combination of new technology and old-fashioned puppeteering.'

New technology has made many of the great creature performances of recent years possible. While Henson's used computers to help create the movement of the tiny star of *Babe*, Stan Winston has used digital technology to control work of a very different scale.

'Although many of the dinosaurs of *Jurassic Park* [1993] were computer-generated, we could never have got our live-action dinosaurs to look so good without computers,' states Winston. 'Our 12m [40ft] T-Rex was mounted on an enormous motion platform and we controlled its movements via a computer.' Winston's team built a 1:4 scale 'waldo' – a model of the animal with encoders at each of its joints. When this puppet was moved by hand, the encoders measured the movement of its joints and sent the signals to a computer. The computer then scaled up the moves and relayed them to the hydraulic joints of the full-scale dinosaur. The waldo could transfer real-time puppeteering directly to the dinosaur, or could be used to program each of the 57 joints (also known as 'channels of movement') individually to create a performance that could easily be repeated.

'Our other great innovation with the T-Rex was the elimination of what we call "wagga-wagga",' explains Winston. 'When a big but flexible device like the T-Rex comes to a halt after a fast move, the whole thing wobbles – an instant giveaway that the creature is fake. We used the computer to detect all potential wobbles and apply a counteractive movement to another part of the character. This effectively cancelled out the wobble. It worked beautifully.'

Costume performers

No matter how fine the design and engineering of an animatronic character, without a good puppeteer on the outside – or an able performer on the inside – the creation will remain nothing more than a lifeless collection of metal, rubber and fur.

One of the world's most experienced costume performers is Peter Elliot, whose speciality is re-creating the lifelike movements and expressions of apes for films such as *Greystoke: The Legend of Tarzan, Lord of the Apes* (1984), *Buddy* (1997) and *Instinct* (1999).

'I approach an ape performance as a form of method acting,' explains Elliot. 'The only way to behave like an ape is to "become" an ape – to understand how an ape thinks, why they do the things that they do.'

was asked to spend two years researching ape behaviour. In that time he became an accepted member of a family of chimpanzees, and learned to communicate and interact freely with them. 'One of the greatest personality traits of an ape is that it lives in the now, whereas we humans are continually living in the past or the future,' he comments. 'If an ape has a problem, it comes to a conclusion there and then. Apes also have a very short attention span. It's a survival mechanism. If you sit and think about anything for too long in the jungle, something will leap on your back and eat you.'

To demonstrate the way an ape thinks, Elliot sits on the floor with a collection of household items. Within seconds, he transforms himself into a chimpanzee, speaking its thoughts aloud as it plays with the items – smelling them, tasting them, throwing away those it does not like. To add to the performance, Elliot uses the five basic chimp sounds: hoots, grunts, barks, growls and screams. The resemblance to a chimp is uncanny.

'Many people think that one ape is just like another, but chimps are vastly different to gorillas, which move and react in their own unique way,' emphasizes Elliot. 'Gorillas have a particular social structure that makes their reactions very different. They also move in a very different way because they are

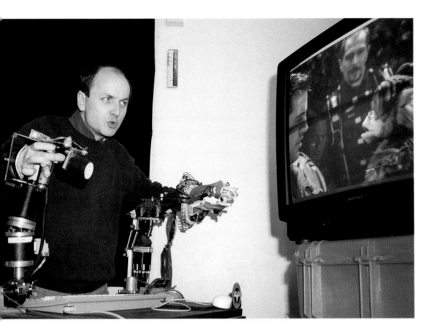

The Henson Performance Control System allows puppeteers to engineer the actions of their characters by remote control. The performer places their hands in a pair of mechanical gloves; a video camera and monitor are used to view the puppet's actions when it is some distance away.

After working as a professional acrobat and diver, Elliot trained as an actor before landing the part of an ape in *Greystoke*. Although production of the film was postponed, Elliot

This early mock-up of the gorilla created by Stan Winston Studio for Instinct *(1999) shows the unique new arm extension design that was suggested by performer Peter Elliot.*

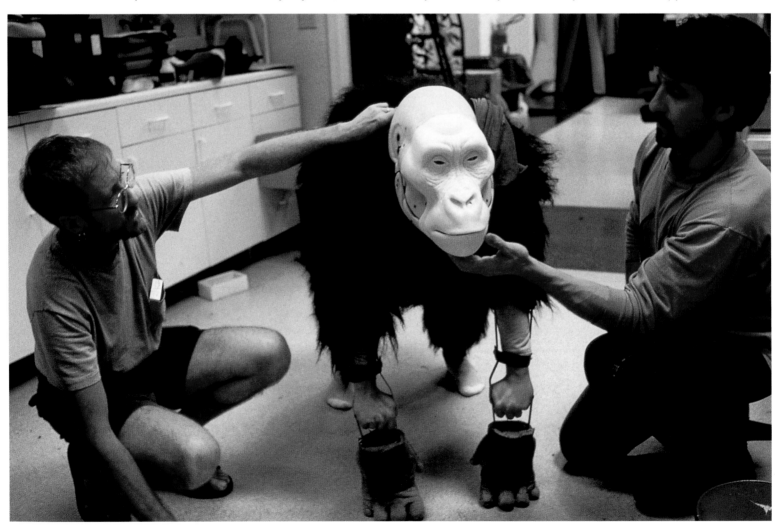

In early 1954, Japanese producer Tomoyuki Tanaka found himself desperately looking for a 'blockbuster' film subject after the collapse of a major production that he had been planning. At the time, science fiction was the rage in Hollywood, and films such as *Monster from the Ocean Floor* (1954) and *Them*! (1954) featured plots that capitalized on the widespread fears of nuclear radiation. Tanaka concluded that while Americans had a fear of radiation, only the Japanese had direct experience of the horrors of nuclear war and therefore a film based on this subject could prove popular. The result was one of the most famous monster films of all time: *Gojira* (1954), known in the West as *Godzilla*.

Gojira was made by Japan's Toho Studios, a production company as famous for the films of celebrated Japanese director Akira Kurosawa (*The Seven Samurai* (1954), *Throne Of Blood* (1957)) as it is for its long-running series of *kaiju eiga* (literally meaning 'monster movies'). The plot of the film centres around a 120m (400ft) amphibious creature that is awakened by an A-bomb explosion. The beast wreaks havoc on various Japanese cities, conventional weapons being unable to stop it. Eventually, Japanese scientists invent a device that removes all the oxygen from the sea, suffocating the creature in its natural habitat. The monster was called Gojira after an overweight studio technician, whose nickname was a combination of the words 'gorilla' and kujira (Japanese for whale).

The head of Toho's special effects department was Eiji Tsuburaya (1901–1970). Tsuburaya had produced the effects for Japanese propaganda films during the war, and had learned how to re-create convincing battle scenes using models (<111). His simulated attack on Pearl Harbor was so convincing that American occupying forces who later saw the footage thought that they were watching film of the actual battle. Tsuburaya supervised the construction of beautifully intricate model cities for Gojira to trample. Tsuburaya's 1:25 scale model buildings had detailed interiors and delicate small-scale brickwork so that they would collapse convincingly. Model vehicles were cast in iron so that they looked appropriately heavy when kicked or crushed by giant feet.

Gojira himself underwent several design phases, starting life as a mutated octopus-like creature before evolving into a giant dinosaur-style lizard. The monster was created by dressing performers in suits made of foam latex and reinforced with bamboo and urethane. The suits were painted dark grey, not green as is often assumed. Gojira's mouth was operated by the performer inside the costume, while its tail was manipulated by wires from the outside. Toho called his suit method 'suit-mation'.

The monster's scenes were filmed at high speed to make the creature and the buildings it destroyed look far larger than life. The high-speed photography required extremely bright lights, and the performers who played Gojira (Katsumi Tezuka and Haruo Nakajima, who would play the role until 1972) had to endure the extreme heat inside the unventilated suit, losing 300ml (½ pint) of sweat during some scenes and frequently fainting.

In addition to the full Gojira suit, a bottom-half suit worn with suspenders was used for foot and leg shots, and a hand puppet of the beast's face was used for expressive close-ups.

Gojira and its twenty-one sequels (to date) are often mocked in the West as the ultimate in poorly made monster movies. This misinformed view is the result of the badly doctored versions that are usually shown outside Japan. The dialogue of the original film is frequently dubbed into foreign languages, often leading to

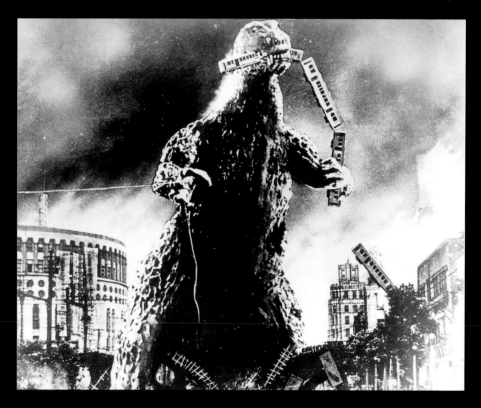

inappropriate changes in meaning and plot. Dubbing has also led to criticism of the acting. In fact, some of Japan's greatest actors have starred in Gojira films. In addition, inferior footage has sometimes been added to the Western versions, and the original musical soundtrack, often by the highly respected classical composer Akira Ifukube, replaced by a different score altogether.

Although some of the later Gojira films did suffer from inferior production values, the early films of the series are vibrant and well made, and need to be seen in their original versions if they are to be fully appreciated.

so massive and so strong. Playing a gorilla largely comes down to getting the breathing right. They have this amazing presence, a heavy but graceful way of moving, and that stems from the way they breathe.' As Elliot talks, his facial expression begins to resemble that of a gorilla, with a down-turned mouth and heavy brow. A deep growling comes from within his chest and his nostrils flare with each breath. 'When you get the breathing right, everything else falls into place – the sense of weight and natural rhythms of movement seem to follow.'

Acting like an ape in normal circumstances is one thing, but translating that into a convincing practical performance when sealed inside a heavy rubber suit is something else altogether. 'We might spend quite a while getting the movement and presence of an ape correct during rehearsal,' says Elliot, 'but when the costume is finished and we start to wear it, it can be very demoralizing. When you put on a 7kg [15lb] gorilla head that protrudes 15cm [6in], the size of the head multiplies your own head movement. As a result, we have to pare back our internal performance to produce an accurate external performance.'

Working inside a suit offers other impediments. 'A real gorilla may weigh 180kg [400lb]. It would be impossible to perform inside a costume that actually weighed that much, so the weight has to be

Ape impersonator Peter Elliot dressed in his costume for Buddy *(1997).*

suggested by the way I move, and that comes down to the breathing. However, ninety per cent of a gorilla's expressions are done with the mouth shut, so I will be trapped in an artificial head, with no fresh air, breathing my own carbon dioxide. You need to do this slow, heavy breathing to get the performance right, but you're actually near to suffocation. The heavy breathing and growling also tends to upset the sound recordist. If the scene has dialogue, they will want as much silence as possible so they can get a clean recording of the actors' voices. However, I need to growl and grunt to perform properly – not to mention the noise that comes from the thirty or so motors that are operating the face mask.'

Working inside a suit can be an exhausting and uncomfortable experience. 'It can be so hot in a suit that I will sweat off 3kg [7lb] a day. Then there is the itching. If you have an itch or blisters – which often result from wearing the costume – you can't scratch because it's under a layer of rubber and fur. I've developed a form of self-hypnosis so that things like that don't drive me mad.'

A large part of a gorilla performance comes from the facial expressions of the creature, operated not by Elliot but by a puppeteer working with radio control. 'I work very closely with the puppeteer during rehearsals,' explains Elliot. 'I will act all the facial expressions as I move and they will learn how those expressions match my actions. It has to become a symbiotic relationship. It's no good if they create a facial expression after I've done a movement – it should be simultaneous. When performing, I try to give subtle indicators of the movement I'm about to make, and those guide the puppeteer.' The external puppeteer also has a role to play in guiding Elliot's own performance. 'The only way I can see when I'm in a suit is through a tiny gap in the nostrils, so when I'm walking on all fours, all I can see is the floor below me. The puppeteer normally uses a microphone linked to my ear-piece to guide me around the set.'

Elliot's understanding of apes also enables him to guide those who make the costumes. 'I can make suggestions that will help the engineers and artists produce a better costume. For *Instinct* [1999], I asked the Stan Winston Studio to construct a new form of arm extension [a gorilla's arms are disproportionately long, and costumes include crutch-like arm extensions]. For the first time ever, I had wrists that flexed just like a real gorilla's. Before then, it was the one thing that was never quite right. I think that we can really do gorillas justice now.'

Digital make-up

While computers can now produce spectacular creatures that perform in ways that animatronic creations simply never could, for instance the reptilian star of *Godzilla* or the marauding insects of *Starship Troopers*, the silicon chip has also started to encroach on some of the more traditional areas of special effects make-up – it is now being used to apply what would once have

Top left: *To produce a head-turning shot for* Death Becomes Her *(1992), ILM filmed Meryl Streep with a blue hood over her head and a prosthetic twisted neck to create a background plate.*
Left: *Streep's blue hood was digitally removed using background information from a clean plate.*
Above: *Streep performing the actions for her backwards-facing head in front of a blue-screen, so that it could be isolated and placed into the background plate. In order to control the placement of Meryl Streep's hair in the final composite, a ponytail was filmed in front of a blue-screen and used to replace her own hair. A digital twisted-neck element was created to replace the prosthetic neck used when filming the original plate.*
Below: *Final composite in which Streep's backwards-facing head has been added to her body along with a digital twisted-neck element. A reflection of the head has been placed in the mirror on the piano for added realism.*

Imhotep's digital make-up seen in gruesome close-up.

carefully composited on to the footage of the actor, so that the prosthetic make-up was subtly blended with its gruesome computer-generated enhancements.

Although computer-generated make-up and creature effects have become increasingly sophisticated and convincing in recent years, Dudman does not believe that the days of the traditional make-up artist are numbered. 'Digital methods will never be as fast or economical as practical make-up. Computers have the potential to do some amazing make-up effects, but one person with a few bits of rubber can do in a few hours what it will take a team of highly paid computer experts weeks or months to achieve. I'm sure that will never change significantly.'

Ultimately, Dudman believes that practical make-up will remain a popular option because of the life that a flesh-and-bone actor can bring to a character. 'I think that our work will continue to be used

as long as audiences want to see actors and not cyber-performers,' says Dudman. 'People definitely enjoy seeing computer-generated performers, and CG films like *Toy Story* [1995] are very entertaining. At the end of the day, however, I think most viewers want to see real actors. Even if a film character is a hideous beast, that character can be given so much more life, and so many more emotions, if there is a good actor beneath the make-up. And there are other reasons why practical make-up and animatronics will continue to be used. Many actors and directors prefer working with practical make-up creations on set. The director can see exactly what they are dealing with, and actors can interact with something that is very tangible, instead of being asked to hold a conversation with a cardboard head on a stick where a computer-generated character will eventually be.'

Stan Winston is in broad agreement with Nick Dudman about the way that computers will affect his art in the future. 'I was absolutely

thrilled when I first saw the computer-generated dinosaurs in *Jurassic Park*,' comments Winston. 'Many people panicked and started predicting the end of traditional make-up and practical creature effects, but CG will never replace live effects, never. From a film maker's point of view, you can almost guarantee that if an effect can be done live, it will be done live. It normally looks better, it's cheaper to produce and it allows you to achieve a performance on set with actors and technicians interacting with it. However, CG allows us to do things that we just can't do practically, and often now it's a case of mixing CG with practical effects on a shot-by-shot basis. Take *The Lost World* [1997]. In that film, there are shots of animatronic dinosaurs, and the audience might work out that it's a mechanical creature, but then you suddenly get a shot where the dinosaur leaps into the air and the audience will think "Oh, that can't be real, it must be done another way." Then we go back and forth, between different methods, depending on what the needs of the shot are. Ultimately, if the story is well told, we can have a mix of practical effects and computer effects and people won't have the time, or the inclination, to sit and think about how any of it is done – they will just enjoy the story.'

For Winston, digital effects are just another way of allowing film makers to realize their visions more fully. 'Even now people argue about which is better – practical effects or computer effects? For me, it has nothing to do with technology; it's all about creating convincing characters for film. Whatever the method used, the end result is the important thing. There is a place for totally CG movies, but they won't replace movies with live actors. People often ask if we will ever reach the stage where we can do completely convincing computer-generated actors. Of course we will; it's only a matter of time. But does that mean that we will be able to replace Al Pacino? I don't think so. Pacino, or any live performer, brings something to the mix that no animator ever will. And where animatronics is concerned, it thrills people to know that what they are looking at is real, that something is a genuine, full-blown, mechanical creation that can be touched. People want us to do more, to keep pushing the limits of live effects. As long as an audience wants to see this kind of thing, it will be done.'

For Winston, computer-generated effects are just a different tool in the box, another method that can be utilized in conjunction with others to help give audiences a better filmgoing experience. '*Toy Story* is a wonderful CG movie, *The Phantom Menace* has some great CG characters, and in the future there will be even more realistic CG movies that people will flock to see,' says Winston. 'However, these are just different ways of telling a story. As audiences, we like things to be presented to us in different ways. We still go to the theatre, we still like traditional cell animation, we still like to see Muppet movies where the characters are really nothing more than crude sock puppets. These are all different ways of telling stories, of presenting characters – none is more valid than any other. CG won't replace other things, it will exist alongside them, and one will complement the other.'

KEN RALSTON

Growing up in Los Angeles, Ken Ralston (1953–) developed an early passion for film making and spent much of his childhood creating 8mm home movies full of models, animation and other effects.

As a result of his early film-making experiments, Ralston found work at Cascade Pictures, one of Hollywood's leading visual effects houses. There he built sets, sculpted models, animated puppets and created numerous optical effects for hundreds of television commercials.

In 1976 Ralston was invited to join a group of young effects artists to create the effects for *Star Wars* (1977). Having started at ILM as a special effects camera assistant, Ralston graduated to camera operator for *The Empire Strikes Back* (1980) before helping to design and animate the Go-Motion dragon for *Dragonslayer* (1981). The following year he earned his first credit as special effects supervisor for *Star Trek II: The Wrath of Khan* (1982) a job he shared with Jim Veilleux. Ralston won his first Academy Award for co-supervising the landmark effects in *Return of the Jedi* (1983) for which his achievements included the amazingly complex space battle sequences. As a supervisor at ILM, Ralston was responsible for the creation of astounding effects in a string of landmark films. Perhaps his most memorable work has been produced in collaboration with director Robert Zemeckis, for whom he has supervised effects such as flying time-travelling cars for the *Back to The Future* trilogy (1985, 1989, 1990), the interaction of humans and cartoons in *Who Framed Roger Rabbit* (1988), performers with holes through their bodies in *Death Becomes Her* (1992), the removal of an actor's legs in *Forrest Gump* (1994) and an incredible trip through the universe in *Contact* (1997).

After more than twenty years at ILM, Ralston left in 1995 to become President of Sony Pictures Imageworks where he continues to oversee the creation of groundbreaking visual effects. He has won Academy Awards for his work in *Return of the Jedi*, *Cocoon* (1985), *Who Framed Roger Rabbit*, *Death Becomes Her* and *Forrest Gump*.

PHYSICAL EFFECTS

DURING THE PRODUCTION OF A MOVIE, TECHNIQUES AS DIVERSE AS ANIMATION, MINIATURES, TRAVELLING MATTES, ANIMATRONICS AND PYROTECHNICS ARE GENERALLY GROUPED UNDER THE BROAD HEADING OF 'SPECIAL EFFECTS'. HOWEVER, THE EFFECTS TECHNIQUES EMPLOYED IN ANY SINGLE FILM ARE OFTEN PRODUCED BY ISOLATED TEAMS OF PEOPLE, SOMETIMES WORKING ON OPPOSITE SIDES OF THE WORLD AND AT DIFFERENT TIMES IN THE PRODUCTION SCHEDULE. VARIOUS ATTEMPTS TO DISTINGUISH BETWEEN THESE DIFFEENT EFFECTS IN THE CREDITS OF A FILM HAVE SOMETIMES CREATED CONFUSION. IN THE PAST, TERMS SUCH AS 'SPECIAL EFFECTS', 'SPECIAL PHOTOGRAPHIC EFFECTS', 'MECHANICAL EFFECTS', 'OPTICAL EFFECTS' AND 'VISUAL EFFECTS' – TO NAME JUST A FEW – COULD BE ENCOUNTERED IN CREDITS AND USED TO REFER TO DIFFERENT EFFECTS TECHNIQUES FROM ONE FILM TO ANOTHER.

The outrageous gags performed by Mack Sennett's Keystone Kops involved highly complicated physical effects.

Today, there is broad agreement about how different techniques should be defined. The credits of a modern film are likely to group effects into several distinct categories. 'Visual effects' describes any process that takes place separate to, and usually after, the shooting of the main live action of a film. This includes computer animation and optical or digital compositing. 'Special effects make-up' (sometimes described as 'special make-up effects') describes any form of three-dimensional make-up process, including prosthetics and animatronics. The catch-all title 'special effects' is generally reserved to describe any form of effect that is performed 'live' in front of the camera during principal photography, such as explosions, bullet hits, collapsing buildings, rain, wind and so on. What the credits of most films now refer to as 'special effects' may also sometimes be called 'mechanical effects', or, as in the case of this book, 'physical effects'.

In the early years of the burgeoning film industry, many effects that can now be achieved more safely and conveniently using sophisticated optical or digital techniques could only be achieved by staging them as live events. Many of the early slapstick comedies featured relatively sophisticated physical effects. The madcap antics of Mack Sennett's Keystone Kops (<17) entailed incredibly complex preparations so that telephone poles collapsed, trams collided, cars drove through houses and people flew through the air on cue. Simple sixty-second sequences took teams of 'gag men' days to prepare. For effect more than safety, these 'Sennett stunts' were often performed in slow motion and filmed with an under-cranked camera to make the final sequence appear madly frenetic when the film was projected at the normal speed.

Perhaps the most consummate early physical effects artist was silent comedian Buster Keaton (1895–1966). The young Keaton

In Steamboat Bill Jnr *(1928), Buster Keaton avoided injury by standing exactly where the open window fell.*

had planned to become a civil engineer, but when he began working in films, his engineering skills were employed in devising complicated mechanical stunts and solving technical problems during film making. Keaton always worked in collaboration with Fred Gabourie, who helped him to design, build and operate the gags for all of his films. Gabourie later became head of the prop department at MGM. One of Keaton's best mechanical effects was the hurricane sequence in *Steamboat Bill Jnr* (1928), in which entire houses collapse on cue or are blown into the air. In the most spectacular stunt in the sequence, the front of a house falls forwards, and Keaton only manages to avoid being crushed by standing where an open window falls over him. Meticulous planning and engineering by Gabourie ensured that the wooden house frontage cleared Keaton's head by just a few inches.

Despite changes in technology and safety regulations, the physical effects work of Keaton and the Keystone Kops remains typical of what physical effects must achieve today. Modern physical effects supervisors may find themselves planning anything from violent storms to enormous explosions, from sinking ships to crashing cars. Physical effects is therefore one of the most diverse and consistently challenging areas of special effects work.

ATMOSPHERIC EFFECTS

Though not particularly glamorous or exciting, a large proportion of physical effects work involves providing what are known as 'atmospheric effects' – meaning wind, rain, snow, fog and smoke. Such effects are required to some degree in almost every film, whether big-budget extravaganza or modest period drama.

Rain

Rain can make location filming impossibly uncomfortable and often causes long delays. When it is actually needed on screen, the real thing can rarely be relied upon to arrive at the right moment, and it is almost impossible to film effectively when it does. The best policy, therefore, is to hope for a dry location and create the perfect rain when it is called for.

Rain, of course, is nothing more than water that falls from the sky. Making fake rain simply involves getting water up above a scene so that it can fall back down again in a controlled manner. When filming in a studio, rain is produced either by pumping water into an overhead system of pipes that are filled with holes, or by employing rain stands – tall pipes topped with a nozzle to spray water in the desired direction. Different types of nozzle can create anything from a fine mist to heavy droplets. The amount of water sprayed during each take of a rain scene can be surprisingly large, and a waterproof wall may be built around the edge of a set so that the water can be drained away or pumped back into the system. If a studio set needs to have rain falling outside its windows, a rain bar may be fitted just above each window to sprinkle a curtain of water outside. This falling rain is collected in a small trough underneath the window, where it is pumped back up to the rain bar and recycled (fig. 1).

Creating rain on location can be more complicated. Water is easy to find in towns and cities. With a permit from the necessary authorities, fresh water

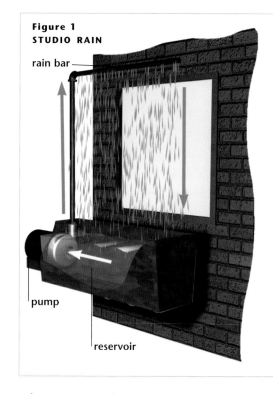

Figure 1
STUDIO RAIN

rain bar

pump

reservoir

can be drawn directly from the mains supply using the hydrants intended for use by the fire services. However, films are often shot in exotic or inaccessible locations where a supply of fresh water is not readily available. In such places, large tanker trucks that hold thousands of gallons of water may be used to pump water to rain stands. If rain is needed for a prolonged period, a small fleet of tankers may be kept busy providing a constant supply of fresh water. If performers do not have to be soaked by the water, it may be collected from local rivers – providing the water has been tested for safety. Sterilizing chemicals are almost always added to the water used for rain, and in cold conditions it is heated to keep performers comfortable.

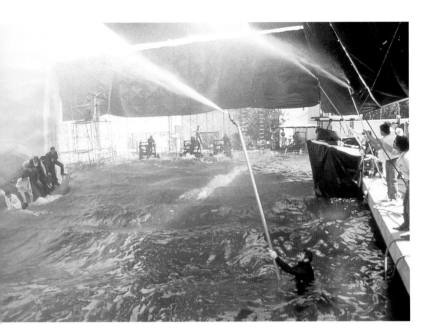

Rain stands shower the crew of the Enterprise *as they perform in a studio tank for a scene in* Star Trek IV: The Voyage Home *(1986).*

framing a shot so that areas of smooth ground are not visible, the impression of deep rain can be created by producing patches only where it will be noticed most – such as just in front of the camera and on the roofs of distant cars and houses. Soft ground surfaces such as grass do not reveal whether rain is falling on them or not, so as long as there is a blanket of rain across the screen, an effective rainstorm can be created without having to spray rain on to every square inch of ground.

Finally, effective rain only results from the appropriate photography. To be seen properly, rain must be lit from behind or from the side at an angle. This way, light refracts through the water rather than reflecting off it. Even a downfall of biblical proportions will look pathetic on film if it is lit from the front. Some technicians add milk or paint to the water to help make it more visible, but without suitable lighting, even this will not make rain obvious.

Location rain often has to fall over far larger areas than studio rain. To cover a wide area, heavy-duty valves of the type used as fire sprinklers on oil tankers can be adapted and hung from an overhead crane. These can spray water over a distance of several hundred feet, though large pumps may be needed to provide the necessary pressure. The noise of these pumps and the deluge that results normally means that any dialogue recorded during a scene will need to be replaced (285>).

Since creating consistent artificial rain over a large area is practically impossible, the 'downpours' are often only staged immediately in front of the camera in the foreground of a shot. However, background surfaces that are hard or smooth, such as roads, rivers and lakes, will plainly reveal that the rain is not falling on them. By

Film makers have always enjoyed re-creating destruction wrought by the might of water. For *The Ten Commandments* (1923), director Cecil B. De Mille used thousands of gallons of water to film the parting of the Red Sea. On four occasions, De Mille released massive waves of stored water, and the resulting floods washed from Paramount Studios to downtown Hollywood, resulting in arrests each time. For the flood scenes in *Noah's Ark* (1929), director Michael Curtiz released fifteen thousand gallons of water on to crowds of extras from tanks positioned immediately above the set. The extras were smashed to the ground, resulting in serious injuries.

For scenes that actually take place in water, rough sea conditions are re-created in the safety of the studio tank. A system of mechanical wedge-shaped paddles that plunge in and out of the water can produce quite large waves, but massive walls of water are created using tip-tanks – large metal containers filled with hundreds or thousands of gallons of water (fig. 2). When a wave is required, the tank is either tipped over or a valve at its base is opened. The released water gushes down an adjustable chute with an upturned

The creation of a storm for The Mosquito Coast *(1986). Rain stands supply a deluge of rain while motorboat engines churn the water and huge fans whip up storm-force winds.*

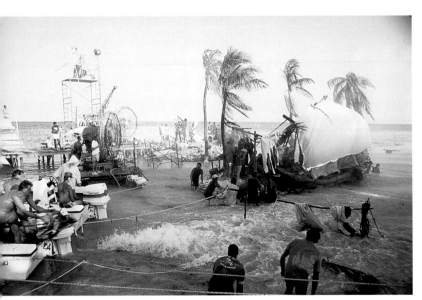

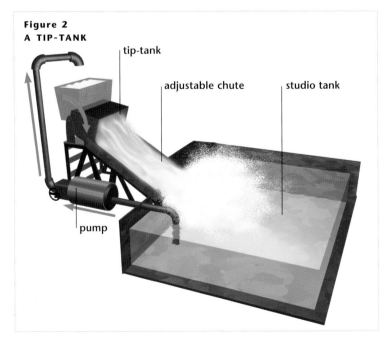

Figure 2
A TIP-TANK

tip-tank

adjustable chute studio tank

pump

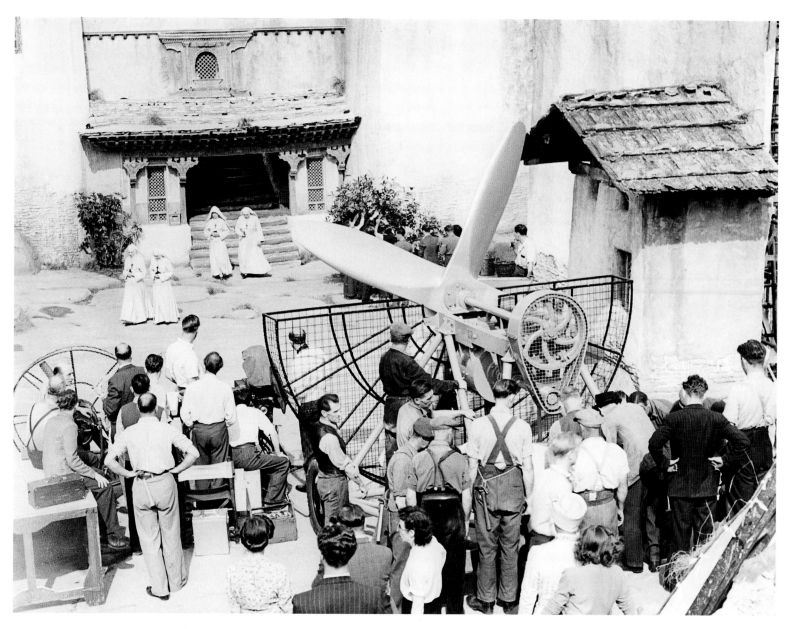

*Enormous fans were used
to create violent winds for
the storm sequence in
Black Narcissus (1947).*

lip at its bottom. As the water leaves
the chute, it sprays into the air
and atomizes. This atomized water
looks like a dense wall of water as it
travels across the screen, but if properly controlled it can engulf a
performer without any danger. Large pumps are used to quickly
refill the tip-tanks between takes.

Wind

To create wind for films, fans that vary in power – from hair-dryers
to jet engines – are used. The most commonly used wind machines
employ a converted automobile or aircraft engine to drive a set of
propellers that are from three to six feet in diameter. The blades are
mounted within a protective wire cage and the whole unit is
mounted on a turntable. These fans can create enough wind to
move large trees at a distance of several hundred feet. For *Twister*,
the jet engine from a Boeing 707 was used to create the film's
tornado-blasted scenes.

An alternative method is to employ a device called a 'wind
mover', which operates on the Venturi principle. A metal funnel
pointing in the direction of the desired breeze has compressed air
pumped into it. As the air rushes from the front of the tube, it cre-
ates a vacuum behind it that sucks in and then propels even greater
quantities of air in the same direction.

Because wind itself cannot be seen, lightweight and harmless
materials such as dust and leaves are usually thrown into its path to
indicate its speed and strength. It is possible to create the impres-
sion of powerful wind by using smaller sized fans to ruffle the hair of
actors in the foreground, while objects such as distant trees are agi-
tated using ropes pulled by hidden technicians.

Perhaps the most famous wind effect in film history is the twister
from *The Wizard of Oz* (1939). This effect did not actually involve
any wind at all, though it was a major mechanical achievement.
Special effects supervisor Arnold Gillespie (<112) built a thirty-foot
funnel of muslin that was motorized to spin at high speed. The fun-
nel was suspended from a gantry in the roof of a stage, while the

base of the contraption was connected to a winding track that followed a different path to the top of the tornado. The base of the funnel sat in a pan that blew fullers earth (a very fine powdered clay) into the air around it. As the spinning funnel moved across the studio, the differing paths of its top and bottom gave it the realistic twisting look of a tornado.

Smoke

It is said that there is no smoke without fire. But starting a fire whenever smoke is needed for a scene would be impractical, unpredictable and potentially dangerous. Instead, a number of

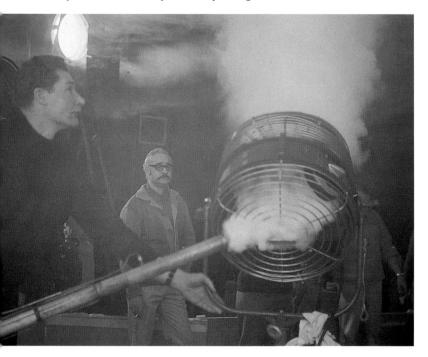

Smoke from heated oil is fed into a fan to create clouds for an aerial scene in Memphis Belle (1990).

methods are used to create the effect of smoke without having to set fire to anything.

To quickly create a large volume of billowing smoke, smoke 'bombs' can be used. These are simply canisters that can produce huge quantities of smoke when activated. The smoke is the same type used by aeronautical display teams. It comes in a range of colours and can be purchased in canisters that last for varying periods of time. This smoke is produced chemically and is quite noxious, making it unsuitable for extensive use around performers.

The most commonly used method of creating smoke is to use a specially built machine that can make the exact quality and quantity of smoke required. These machines all work on the principle that oil produces smoke when it is heated. A typical smoke machine consists of a heating element – similar to that found in a kettle – that is used to heat oil. The vapour from the boiling oil is sprayed from a nozzle whereupon it condenses to create plumes of white smoke. The machines used to create this type of smoke range from small hand-held devices to enormous vehicle-based machines that are capable of smoking up large areas of a landscape.

In windless conditions, this smoke will hang in the air long enough for most scenes to be filmed. Wafting the smoke with a paddle as it sprays from the machine will cause it to form a consistent, misty haze. This type of smoke is commonly used to create an atmosphere in outdoor scenes such as woodlands, where sunshine streaming through the branches of trees will form dramatic shafts of light in the smoke.

Over the years, various types of oil have been used for the creation of smoke, some of which have been outlawed due to their detri-

A hand-held smoke machine fills a studio with fine mist.

mental effect on the health of film workers. The substances now commonly used are a type of mineral oil which has no serious effects on health, and an oil alternative called ethyl glycol.

An alternative method, which does not involve heating oil to produce smoke, uses a liquid called 'cracked oil'. This substance has pressurized air passed through it until it slowly begins to emit a very fine white mist. Unlike the heated oil method that creates smoke at the touch of a button, this technique takes some time to produce a large volume of smoke. The method is most commonly used when shooting miniatures in a sealed studio (<94). The smoke machine can be connected to a device that measures the density of the atmosphere, and will regulate the output of smoke to ensure a consistent density. This is particularly

A dry-ice machine billows heavy fog into woodlands where it will hug the ground to eerie effect.

important if a model is being filmed with a motion-control camera over a period of many hours. The consistent density of cracked oil smoke makes it suitable for emulating underwater conditions. The underwater model sequences for movies such as *The Hunt for Red October* (1990) were filmed in a studio full of smoke in a technique that is known as 'dry for wet'.

An effect sometimes seen in horror films, music videos and stage shows is the distinctive ground-hugging mist created by dry ice. Dry ice is crystalized carbon dioxide, created by reducing the pressure and temperature of carbon dioxide gas to produce a 'snow' that is pressed into blocks of solid ice.

When dry ice is warmed, it 'melts' from a solid to a gas, creating clouds of fog-like smoke. This fog is heavier than air, so it sinks to produce a dense white carpet that will roll down walls and creep across floors.

To create a fog, pieces of dry ice are dropped into warm water, either in a simple bucket or a specially made dry ice machine. The warmer the water, the more fog will be produced. The impressive dense clouds created by dropping dry ice into boiling water will dissipate quite quickly, while the less impressive quantities created by cooler water will hang in the air longer. The pressure of the fog created using this method is usually enough to pump it some distance through pipes to the point where it is to emerge.

Because dry-ice fog is heavy, it will collect on the floor, building in depth according to the quantity produced. To create a layer of a specific depth, a wall the correct height will be built around the stage. When the fog reaches the top of this wall it will overflow and escape to other areas of a room.

When solid, dry ice remains at a constant temperature of –79°C. Handling the ice without protection can cause severe skin burns. Despite this, however, dry ice wrapped in insulation material and placed in actor's mouths to vaporize breath has been used to give the impression of a very cold atmosphere when filming in a warm environment.

Cobwebs

No spooky house or jungle cave would be complete without a thick veil of cobwebs across every corridor and doorway. The device used to make an artificial spider's web is a type of hand-held fan that has a small pot of special cobweb cement fitted to the shaft that spins the fan blades. As the fan spins, a small hole in the cement pot emits a thin stream of liquid cobweb that is blown out to land and set on nearby props. The method is similar to the one used to spin cotton candy in fairgrounds.

The threads produced by a cobweb spinner are relatively short and weak, so large curtains of cobweb are prepared with a network of supporting monofilament fishing line before being sprayed with web. A handful of fine dust is then thrown over the web for the finishing touch. The cement traditionally used for cobwebs was a type of rubber that was noxious when sprayed, would disintegrate after a few days, and would ignite if in contact with a naked

When activated, a cobweb spinner emits a string of silky material from the container at the centre of its rotating blades.

flame. Modern cobweb cement is made from a much more practical formula.

Electrical effects

Lightning and electrical effects have charged the air of many horror films. Lightning and the bright dancing tendrils of electrical charge are usually hand-animated and added to a scene after filming, but many electrical effects have been filmed 'live'.

Probably the most famous electrical effects were those created by Universal Studios electrician Kenneth Strickfaden for *Frankenstein* (1931). Strickfaden created a range of fabulous-looking electrical contraptions for Frankenstein's laboratory – giving them exotic names such as 'bariton generator' and 'nucleus analyzer'. These devices encouraged massive electrical discharges to leap from one antenna to another, filling the air with electricity. Thousands of volts surged through equipment just feet from the main players. As Boris Karloff lay half naked on the operating table, technicians above him operated white hot carbons to send showers of sparks down on him. Strickfaden's devices turned up in many Universal films over the years, and were eventually discovered in storage by director Mel Brooks, who plugged them back in for use in his Gothic parody *Young Frankenstein* (1974).

Snow and ice

Snow is perhaps the hardest of all the natural elements to reproduce artificially on film. However, fake snow is infinitely preferable to the real thing. Although genuine snowy locations allow immense creative freedom in terms of camera movement and shot expanse, natural snow may look less than pristine after a film crew has arrived, set up equipment, built sets and conducted rehearsals. Once disturbed, real snow can be extremely hard to rearrange, allowing shots to be repeated just once or twice before a fresh location has to be used. Natural falling snow is also highly unpredictable. It arrives when it is not wanted and refuses to fall when it is required. The majority of movie snow is therefore fake.

Historically, the most commonly used snow substitute is salt. Salt looks good on film, has the frosted appearance of snow, can be arranged into crests and drifts and can be watered down to produce a convincing slush. However, salt can kill plant life, contaminate watercourses and, when used in large quantities, pollute land for years. A popular recipe for Hollywood snow in the 1930s was a mixture of gypsum, salt and bleached cornflakes. It took forty-six tonnes of this mixture to cover a street in snow for *Elmer the Great* (1933). Another early popular snow substitute was asbestos dust.

Before it was recognized as a health hazard, truckloads of the powdered material were delivered to studios and spread across every surface. It was even arranged on actors' hair and clothing, and shovelled into wind machines to create picturesque but toxic blizzards.

Much of David Lean's epic *Doctor Zhivago* (1965) was filmed not in frozen Russia but in the sweltering heat of a Spanish summer. For the scene in which the Red Army charges across a frozen lake, a Spanish field was levelled and covered with sheets of iron on top of which thousands of tonnes of marble dust were spread. This was then steamrollered flat so that the charging horses would slip and slide as if on a real frozen lake. To complete the illusion, 'lakeside' trees were frosted with a spray of whitewash and a rowing boat was positioned as if trapped in the ice.

The Red Army charges across a frozen lake – actually a Spanish plain covered with fake snow – in Dr Zhivago *(1965).*

Today, creating snow for the movies is big business, involving considerable investment and research into methods and materials. One of the world's leading snow-men is David Crownshaw, who can supply snow for every occasion. 'We actually have more types of snow than the Eskimos have words for!' says Crownshaw, whose company, Snow Business, has branches in the United States, Germany and the UK. 'We have over a hundred types of snow, each of which is used to create a different look or to perform in a different way. Our snow is made from all sorts of materials, including plastics, foams and even potato starch, but about eighty per cent of the snow that we supply is made from paper.'

Paper has been used to make snow for some time, but the snow that Crownshaw pioneered is fundamentally different from its forerunners. 'Most paper snows were small flakes that had been cut or punched out of larger sheets. This gave them straight edges that made them fall rather unrealistically and blow away as soon as there was any wind,' he explains. 'However, we make our snow differently. Instead of

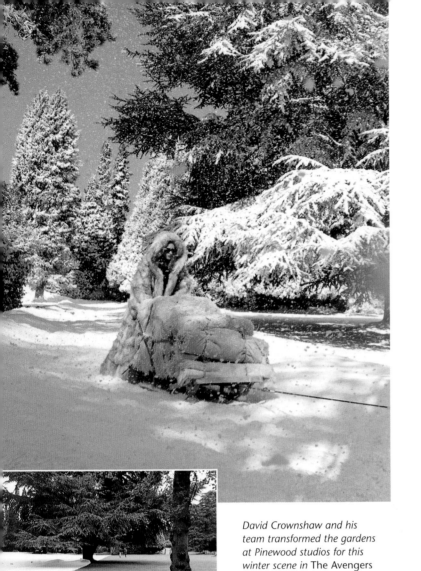

David Crownshaw and his team transformed the gardens at Pinewood studios for this winter scene in The Avengers *(1998). Lawns were carpeted with rolls of white fibre before being covered with paper snow. Trees and foliage were sprayed with a combination of C-90 and paper snow.*

being cut, our paper snow is ripped so that it has very fluffy edges. When ripped paper snow falls, it meanders and tumbles like real snow. When it's on the ground, it clumps together like real snow. When the wind is really strong, it doesn't blow away, but forms drifts just as real snow does.'

Although paper snow is the product that Crownshaw uses most often, he usually employs a variety of fake snows, according to the needs of a scene. 'We might use six or seven different types of snow in any one scene,' explains Crownshaw. 'In fact, if you look at real snow on the ground, you will see lots of different textures and sizes, so although we use different materials for speed, economy or performance, the more types we use in one shot, the better it seems to look.'

The majority of snow-work does not involve the simulation of actual snowfalls but rather the dressing of sets and locations with a layer of already settled snow. To cover wide areas of distant landscape quickly, large volumes of water-based foam can be pumped from a large-diameter hose. For one shot in Kenneth Branagh's *Hamlet* (1997), Crownshaw's team covered thirty-five hectares (eighty-six acres) in snow, much of it foam. Although this method is fast and cheap, foam degrades quickly and will only last for a few

hours before breaking down, so it is best when used for single shots. For areas in the middle distance, large-sized paper snow can be used; the size of the flakes helps to give some texture to the covered area. In the foreground, much finer grades of paper snow are used. Rather than smothering delicate features such as grass and twigs, finer paper snows cling to them and give definition, much as real snow would.

Altering the water content of paper snow controls its characteristics. The snow is held in large hoppers from which it is blown along pipes up to 500m (1640ft) in length. As the snow is sprayed from the pipe, the paper is mixed with the desired quantity of water using adjustable nozzles. A dry, fluffy snow can be kicked up as people run through it; wetter snow forms distinct tracks when vehicles drive through it and, when sprayed, it will stick on to vertical walls and even ceilings.

Rather than covering everything with snow, Crownshaw often creates a convincing winter scene by coating an area with fake frost. 'If deep snow is not absolutely necessary to the plot, an equally effective impression can be given using a product called C-90. It's actually a pure cellulose powder that is used by the food industry, so it's completely environmentally friendly,' he states. 'To apply C-90, we first spray water on to the areas we want to coat. Then we blow thick clouds of the white dust into the air, and it sticks to anything that is wet. This material only gives a thin coating but creates a really convincing heavy frost that is every bit as effective as a thick blanket of snow. As soon as filming is finished, we spray the area with water again and the C-90 is washed away.'

Other set-dressing materials include types of clear silicone rubber that can be melted and spread over areas to form glistening ice, and liquid paraffin wax that sets when tipped into bodies of water to form a floating sheet of ice. Painting glass with a solution of bitter and Epsom salts creates the illusion of frosted windows.

To create falling snow, a number of different methods can be used. Inside studios, hoppers or pipes can be set up in the roof to release

Clouds of C-90 are sprayed on to trees to create a convincing winter snow scene.

A winter valley created by a number of different techniques. A wooden platform was built over a real stream and sheets of white ice-like perspex were laid on it. Paper snow and C-90 were used to cover the trees and foliage.

resist sending at least one person, vehicle or object flying through a plate-glass window.

For stunts where injury seems avoidable – such as vehicles smashing through windows – real glass is likely to be used. Stunt performers will also sometimes jump through panes of real glass. In such cases, a sheet of tempered glass is normally fitted with a glass breaker – a small spring-loaded arm tipped with a sharp metal point. Glass breakers fitted to the bottom of a window are triggered at the exact moment that a stunt performer is about to jump through it. If the timing is correct, the window will shatter just as the performer hits it, giving the impression that it is the performer's body that is doing the breaking. If the glass breaker fails to work, the stunt performer is more likely to bounce dramatically off the glass than plunge through it.

When the risk of serious injury is too great to use real glass, a safer alternative is employed. Fake glass, as well as other objects that are to be safely broken or smashed during filming, are called 'breakaway effects'.

The earliest breakaway effects were achieved using a variety of simple materials. Objects such as plates and vases were hand-made from bread or pie dough, which was baked hard and then painted. Such items were solid enough to withstand rough handling and would break when required. A popular alternative to dough was ordinary casting plaster. This material, mixed with sand or sawdust to make it brittle, is still sometimes used for items such as vases and pots.

Breakaway glass was first made by dissolving large amounts of white sugar in a small quantity of boiling water. When cooled, this solution would crystallize into a glass-like material that would shatter without any sharp edges. Bottles were produced by pouring the sugar solution into plaster moulds, and

paper or plastic snow. On location, small hand-held machines can be used to spray foam into the air; when handled correctly, they can provide quite a convincing snowstorm. The great advantage of foam in such cases is that it appears to melt when it lands on an actor's skin. A quick and easy way of creating a blizzard is to use snow candles – hand-held incendiary devices that emit plumes of white paper ash into the air for several minutes. Several candles waved randomly in the air will cover a large area with remarkably realistic snow. 'Although paper ash doesn't melt realistically in the way that foam does, snow candles generally produce a better quality of falling snow,' says Crownshaw. 'However, from a vanity point of view, it can be quite pleasing when you create a really convincing blizzard and a paper snowflake lands on someone and doesn't melt. That way some observant viewers will realize that it's not a real storm, but a really good imitation.'

When asked if digital techniques have diminished the need for artificial snow, Crownshaw reveals that modern methods have actually had the reverse effect. 'Producers used to delete really big snow scenes from their scripts because they knew what it could involve. Today, snow isn't a problem. The CGI guys can do a great job of painting vast distant landscapes white, and we can concentrate on doing better quality work that performers can interact with in the smaller foreground areas. We now do more snow than ever before, so we actually like the CGI people!'

BREAKAWAY EFFECTS

In the movies, no bar brawl would be complete without beer bottles being smashed over heads, and few action-adventure films can

Making breakaway glass.
Far left: Pieces of solid resin are melted over a stove.
Below: The liquid resin is poured into rubber, plastic or fibreglass moulds.
Right: As the resin sets, its surface is warmed to prevent bubbles and ripples.
Far right: The set resin is carefully removed from its mould, ready for use. This shape is one quarter of a lighthouse lens for the film The Lighthouse (2000).

Using standard moulding processes, breakaway glass objects can be produced in almost any shape and colour.

uncoloured clear glass is usually made with a tiny amount of green dye to give it the greenish tint glass normally has. Once in liquid form, this resin is poured into plaster moulds to create glass objects of almost any shape and size. Provided they are handled carefully, the glasses and bottles that result from this process are strong enough to be filled with liquids and will shatter quite realistically when smashed. Sheets of glass up to 2m (6ft) square can be produced by pouring the liquid resin on to a smooth metal or marble tabletop on which lengths of angle-iron have been laid to produce a mould of the correct size. The tabletop is often heated slightly to avoid the flow lines that can occur when the resin sets too quickly. Once the resin is poured, its surface may be warmed with a hot-air gun to prevent small bubbles and other inconsistencies from setting into the surface of the glass. Once cooled, resin glass can be set into any window frame, just like the real thing.

slabs of glass were made by pouring it on to a flat surface. Sugar glass was never a perfect alternative to real glass, however. Objects made from the material were only semi-transparent and were full of rough crystals and flow lines. The addition of a little cream of tartar helped to make sugar glass look slightly more realistic, but real glass objects were normally used in establishing shots, and the sugar glass substituted at the last moment for shots of the actual breakage. A better-looking fake glass was made from stearic acid (an extract of animal and vegetable fats). Although stearic acid produced a much more convincing glass substitute, it was subject to 'cold flow' – once cast, an object would gradually 'melt', slowly sagging like a wax object under high heat. For this reason, stearic acid breakaway objects had to be made shortly before use.

Today, breakaway glass is made from a pre-prepared plastic resin that can be purchased in thick slabs. This resin is melted down in a saucepan over a stove to produce a clear liquid. Dyes can be added to this liquid to produce glass of any colour. Glass made with undyed liquid resin tends to be slightly yellow, so

A stuntman playing James Bond plunges through a breakaway window in GoldenEye (1995).

Some movie scenes require glass that has already been shattered. Many sets need to be strewn with broken glass after an action sequence, for example, and in scenes where a stunt performer has performed the dangerous act of diving through a window, the real star has to be seen landing on the ground in a shower of glass splinters. To make ready-shattered glass, a special silicone-based plastic is cast into sheets and then broken into thousands of tiny pieces that look exactly like the bright, sharp fragments that result when real glass is shattered

Ripley (Sigourney Weaver) brandishes a customized weapon that combines a Thompson sub-machine gun with a pump-action shotgun in Aliens (1986).

fired, it propels a cloud of super-heated gases hot enough to set fire to nearby materials.' To demonstrate this point, Clarke fires a single round from a revolver into a polystyrene tailor's dummy from a distance of around 1m (3ft). A large hole filled with many black flecks is melted into the polystyrene. 'The black bits are grains of unburned gunpowder,' points out Clarke. 'If you were fired at with a blank, these bits of powder could embed themselves in your skin and scar you permanently, just like a tattoo. As well as the powder, there is sometimes a small piece of cardboard wadding used to pack the gunpowder in the shell that effectively becomes a cardboard bullet that can penetrate flesh at close range.' There is also the danger of brass shards. Blanks are made of brass – like normal shells – and because there is no bullet to hold in the powder, the end of the shell is crimped shut. When fired, this crimp is blasted open and small pieces of hot brass will travel some distance from the weapon, which could result in injuries. 'Blank guns should never be fired at anyone. They are always pointed to one side of a target person, and the camera angle hides the fact that the aim is off.'

Once a performer is aware of the danger posed by the weapon, the armourer teaches him or her how to use the device. 'We feel that the better a performer knows the weapon, the better they will look and feel when using it,' explains Clarke. 'If you watch Bruce Willis in Die Hard [1988], you'll notice how well he uses a weapon. That's because he fully understands how guns work and is able to load them, strip them down and clear any stoppages himself. He doesn't need to think about how he uses his gun and, as a result, gives a convincing performance and is able to do little bits of interesting action – like reloading his weapon – without thinking about it. We try to ensure that all performers whose characters are meant to be experienced with guns reach that standard. Another reason for intensive training is to calm a performer's nerves. Many people are understandably nervous about using a gun, and nerves can easily lead to accidents.'

As well as training the performer to use a weapon, an armourer has a good knowledge of

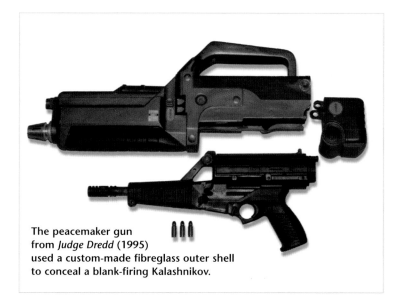

The peacemaker gun from *Judge Dredd* (1995) used a custom-made fibreglass outer shell to conceal a blank-firing Kalashnikov.

how any character is likely to use a gun. 'Throughout the ages, the way people have handled weapons has changed,' notes Clarke. 'The way an eighteenth-century person held and used a pistol was quite different to the way we do now. It's part of our job to know these details and pass them on to the performer.'

During filming, armourers work with the director, fight co-ordinator and special effects supervisor to plan each shot. 'We have to help the director achieve the shot they are thinking of, but at the same time we can sometimes tell them that what they are planning is dangerous. Very often we will come up with more exciting alternatives that a director didn't know were possible. We then rehearse performers, and get them used to the rhythm of the shot – they walk it through saying "bang, bang, bang" whenever they are going to fire their gun. This is very important because in the turmoil of an action sequence, it's easy for a performer to get confused and shoot at the wrong time and place. This rehearsal is also useful for the special effects crew, who use it to practise when they are going to operate their bullet-hit effects [see below], which is a totally different part of the equation.'

Finally, when the scene is fully rehearsed, the armourer loads all weapons and hands them to the performers. 'Once we have stepped away, it is over to the performers and, if we've done our job, there won't be any problems,' states Clarke. 'We still need to keep an eye on all the weapons, though, to make sure there are no stoppages or other mechanical problems. When the director shouts cut, nobody relaxes. This is potentially the most dangerous time because people lower their guard. We go in and take the weapons from the performers and make them safe. Only when we give the all-clear can the crew relax.'

BULLET HITS

When a gun has been fired, the audience naturally expects to see its effect – a person or object struck by a bullet. When film was a young medium, the only way to achieve this effect was to fire *real* bullets. A hired sharpshooter or a fixed-position rifle would actually fire

bullets into the scenery surrounding an actor. Providing the target was relatively soft, the performer would not be harmed by flying debris or a ricocheting bullet. In the classic gangster movie *G Men* (1935), actor Edward G. Robinson appears in several shots in which his surroundings are strafed by real bullets. In the late 1930s, the Screen Actor's Guild put a halt to this traumatic and dangerous practice. Bullet hits were then achieved as a split-screen effect (<44), the performer on one side of the screen being filmed in one take, and the bullet hits on the other side of the screen in another. A safer alternative was to fire small chalk pellets from a slingshot to create a puff of white dust where they hit an object. These pellets would not harm an actor, but they didn't create the dramatic burst of destruction that a real bullet would.

One early method of producing the explosive effect of a real bullet hitting scenery involved carving a small crater in the target object and plumbing it with a pipe connected to a source of compressed air (fig. 3). The pipe was fed through the back of the object, while the crater on its front was filled with an appropriate material such as loose plaster or sawdust. A burst of compressed air would blow this material out of the hole on cue. A sequence valve could be used to create the staggered blowing of holes to simulate machine-gun fire. This method is still occasionally used.

Today, the effect of a bullet hit can be produced

A gun using compressed air to fire capsules containing blood, silver paint or zirconium can be used to create a number of bullet-hit effects.

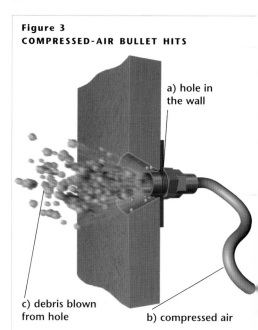

Figure 3
COMPRESSED-AIR BULLET HITS

a) hole in the wall

c) debris blown from hole

b) compressed air

either pyrotechnically or non-pyrotechnically. Non-pyrotechnic methods involve firing small capsules from a specially designed air gun. The capsules, which are made of a thin gelatine, can be filled with any substance and, when fired at a solid object, burst to release their contents. If firing at a wall, these capsules are filled with powder of the appropriate colour to produce a puff of dust for each bullet hit. If strafing the side of a car, capsules can be filled with a thick silver paint that splatters to produce what looks like metallic holes in the paintwork. To produce the effect of sparks when a bullet ricochets off metal, capsules are filled with a metallic element called zirconium, which produces sparks when it hits a hard surface.

Pyrotechnic bullet hits use a small explosive device called a 'squib'. A squib resembles an ordinary domestic fuse with a wire protruding from one end. The wire is connected to a source of electrical power, and when the power is switched on, the squib will explode. 'Squibs come in all sorts of shapes and sizes,' explains Chris Corbould, who, having worked on nine James Bond films – three as special effects supervisor – has probably simulated as many gun hits as anyone in the business. 'Squibs are basically an off-the-shelf item that we use for any number of purposes, not just for bullet hits. Some squibs just produce a smokeless blast, some create smoke and a flash, and some create a shower of sparks like a bullet hitting metal. We use different types of squib for different types of job. They're quite a useful little device.'

Pyrotechnic bullet hits have to be set up long before any weapon is fired (fig. 4). Each required bullet hole is carefully dug into a surface, primed with a squib and then camouflaged. For example, a target such as a plaster wall is pre-prepared by having a cone-shaped hole dug out and the squib placed at the bottom. The thin electrical wire of the squib is threaded through a small hole at the base of the crater and out the back of the wall, where it is connected to a power source. The back of the wall immediately behind the squib may have a type of putty or a metal plate fitted over it to ensure that the blast of the squib is directed forwards. The cavity is then filled with plaster (sometimes mixed with materials such as sawdust to make it brittle) and painted. When an electric current is applied to the squib, the pre-prepared hole is blasted out. Objects made of wood will have a bullet

Figure 4
PYROTECHNIC BULLET HITS

- prepared hole
- metal backing plate
- debris
- squib in prepared hole
- splinters and plaster to hide hole
- electrical wire

hole gouged out and, after the squib has been positioned, the wood splinters will be lightly glued back into position. In fact, the types of holes created by movie bullets are rarely true to life. A real bullet hitting an object such as a plaster wall would make a relatively small hole on impact and would only create a large crater on the reverse of the wall where it exits.

Part of the art of using squibs is in hiding their presence before they are detonated. 'Fixing squibs into scenery in a studio is relatively easy,' explains Corbould. 'It's just a case of drilling a hole through the plywood or plasterboard walls, and then threading the squib through from behind. It's also usually pretty easy outdoors because it's just a case of burying the wires in the ground – for The Mummy [1999], we just buried the wires in the desert sand. It's a lot more difficult if you're working on location in some historical building. People obviously don't want you making holes through their walls, so you have to find ways of attaching squibs and hiding wires without drilling into anything. Sometimes it's a case of fabricating fake walls or door frames that can be destroyed. Hiding the wires from squibs can be fairly easy if a scene is only being filmed with one camera. If we know where the camera is, we can tape wires behind objects like the legs of furniture and then run them under carpets. However, these days action scenes are often filmed with multiple cameras and even moving hand-held cameras. Not knowing what parts of a location are going to be seen by the camera can make hiding wires very difficult and involve a lot of work.'

The cables that come from a squib are wired into a device that allows each one to be detonated on cue. Sophisticated firing mechanisms called 'clinker boxes' can be programmed to detonate each squib at exactly the right moment in a sequence. Once the firing sequence is triggered, each detonation will be accurate to within hundredths of a second. 'Although we use some hi-tech ways to trigger the detonation of bullet hits, we often prefer the old-fashioned nailboard method,' explains Corbould. A nailboard is simply a board on which a number of 'nails' are fixed in a row. Each nail is connected to a terminal into which a single squib is wired. A special effects technician holds an isolated metal rod that is connected to a source of low-voltage power. As each nail is touched with the live part of the hand-held rod, an electrical current travels to the squib and detonates it. Rapid machine-gun fire can be simulated by dragging the rod over the nails at the desired speed. 'We find nailboards useful because a competent technician can perfectly match the firing of bullet hits to whatever live action is going on in a scene. The firing can be slowed down or speeded up depending on the movements of characters, ensuring that no one is near a bullet when it goes off,' says Corbould.

Keeping track of bullet hits can be a logistical headache if a scene requires a large number of hits. 'One of the biggest shots we have done in terms of the sheer quantity of hits going off was for the Russian archive sequence in GoldenEye [1995],' notes Corbould. 'We initially prepared the shot with just a few hundred bullet hits, but the director, Martin Campbell, filmed the shot once and then

decided he wanted a lot more bullets. Every qualified pyrotechnician we could find was brought in, and we wired and prepared 1800 squibs overnight – a shot like that would normally take at least a couple of days to set up. Every single wire in the spaghetti-like mass was numbered so we knew exactly which bullet would go off and when. During filming, a number of technicians each had their own area to watch and detonate. The 1800 squibs all went off in about ten seconds – it was pretty impressive. Keeping track of every bullet hit was vital because, even though most of what was being destroyed in the scene was books and paper, a piece of flying card could be quite painful. When you will be working with actors for nine months on a project, it's important to retain their confidence in you.'

When bullets are required to hit a performer, there are pyrotechnic and non-pyrotechnic options. Non-pyrotechnic methods include firing blood-filled gelatine capsules that burst when they hit the performer. Alternatively, a small piece of blood-soaked cotton wool can be fired at the actor using a blowpipe. Another option is to prepare a realistic bullet wound and conceal it with a piece of foam rubber made to look like normal skin. A thread attached to this fake skin can then be pulled, causing the skin to fly off and reveal the wound.

The pyrotechnic method of simulating body hits again involves the use of squibs (fig. 5). A metal plate backed with a layer of leather is strapped to the body of the performer under his or her clothes. A low-powered squib is taped against an indentation or channel in the metal plate. The wire from the squib normally runs down the trouser leg and out to the detonating device, although performers who are to be shot on the run may wear a self-contained battery-operated squib that they can detonate themselves during the action. If the gunshot wound needs to include blood, a small bag of fake blood is placed next to the squib to produce a trickle, or directly over the squib to create a dramatic spurt. For an even bloodier effect, pieces of meat can be added to the blood mixture. For a scene in which a criminal accidentally shoots his own foot in *Straw Dogs* (1971), effects supervisor John Richardson filled a leather boot with fake blood, steak and squibs. When detonated, blood and flesh burst through the shoe leather. 'For family films like the Bond movies, we rarely use any blood when characters are shot,' explains Corbould. 'It's usually enough to see the burst of dust and fabric caused when a squib goes off under some clothing. Often we don't use body hits at all. If a run of machine-gun bullets hit a wall behind a character, the audience will assume the person has been hit as well, and they can fall to the floor without any visible wounds. This is especially true if the person being hit is a stunt performer, because they always like to jump in the air when hit!'

Although the squibs used for body hits are low-powered, they can still be dangerous. 'When anybody is near a squib, you have to be careful,' emphasizes Corbould. 'The devices are detonated electrically, so you have to make sure you don't give anyone a shock. Actors have to be trained to move without letting their hands pass in front of the squib, as it could burn a hand. Even the shredded clothing that flies out when a squib is detonated can be dangerous.'

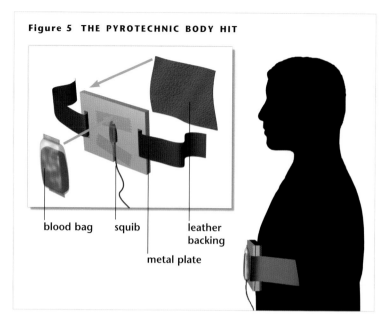

Figure 5 THE PYROTECHNIC BODY HIT

blood bag squib leather backing

metal plate

PYROTECHNICS

Pyrotechnics – the art and science of creating fire and explosions – can produce some of the most visually stunning special effects. Although explosions for the movies are designed to look spectacularly devastating without presenting any

When detonated, a black-powder bomb throws smoke and debris high into the air.

danger to those involved, the potential threat to life and limb is still very real. Explosions are created using powerful and dangerous materials, and must only be attempted by professionals with years of training and experience, and for whom safety comes above any other consideration.

The laws governing the use of explosives and explosive materials vary in different countries and states. Those wishing to buy and work with such materials must demonstrate that they have expert knowledge of the safe storage, preparation and use of explosives before they will be awarded a licence to do so. Such explosives licences are normally divided into a range of different grades, and as pyrotechnicians gain more knowledge and experience of their craft, they become eligible for licences that bestow greater responsibility on them.

At the heart of many pyrotechnic effects is a highly inflammable material called 'black powder'. Composed of a number of basic ingredients, including charcoal and potassium nitrate, black powder comes in various grades, from a fine dust to small chunks like pieces of gravel. Although a few grammes or ounces of this powder will do little more than burn furiously when lit with a match, the same quantity is capable of reacting violently when used under certain conditions. 'The key to using black powder for explosions is the way in which you prepare the powder for the job,' explains John Richardson, who has supervised the special effects for films such as *The Omen* (1976), *Superman* (1978), *Aliens* (1986) – for which he won an Academy Award – *Starship Troopers* (1997) and every James Bond film since *Moonraker* (1979). 'A

A huge fireball of burning petrol and diesel engulfs an aircraft in The Battle of Britain *(1969).*

Compressed propane gas is expelled and ignited by a gas mortar.

small quantity of black powder in a heap will do little more than go off with a flash if you ignite it,' continues Richardson. 'However, if you take the same amount of powder and try to restrict its combustion by packing it into a container, the powder will be unable to burn slowly, and the only way it can release its energy is to explode with great force. Like most aspects of pyrotechnics, it's not what you use, it's how you use it.'

To create explosions, black powder is packaged in plastic or cardboard containers to create 'bombs'. An electrically controlled detonator, similar to the squibs used to make bullet hits (<259), is planted in the powder before the container is sealed and wrapped with tape. The tighter the powder is packaged, and the thicker the wrapping of tape, the more violent the resulting explosion.

When detonated, black-powder bombs create a powerful blast with a bright flash and a quantity of white smoke. Various materials can be mixed with the black powder to create a more interesting flash – copper filings make the flash green; zinc makes it blue; strontium nitrate, red; and iron filings produce a shower of sparks. However, this blast is rarely visual enough to fulfil the needs of film makers. 'Black-powder bombs are normally just the basis for creating much more visually impressive explosions,' explains Richardson. 'We use the blast to lift various materials into the air using mortars.' Mortars are simply variously shaped heavy-gauge steel tubes or pans that are used to hold black-powder bombs and the material that the bombs will be blasting into the air. A simple round tube will blast its contents straight up into the air in a relatively thin column. A wide, shallow mortar with sloping sides will create a lower blast that spreads material out over a wide distance.

'Mortars are normally buried in the ground or placed out of sight wherever an explosion has to occur,' says Richardson. 'A black-powder bomb is placed in the base of the mortar, and over that goes the material that we want to throw into the air. Only very soft materials are used, such as peat, cement powder or chunks of foam – basically, anything that won't do serious damage if it hits someone at great speed. We have to be extremely careful that no small stones find their way into the mortar. Anything like that effectively turns into a bullet when blasted and could potentially kill someone.'

As well as flying debris, movie explosions often require huge clouds of billowing fire. 'We create fireballs using a variety of liquid fuels,' explains Richardson. 'The most commonly used fuel is ordinary gasoline, which creates a brilliant orange ball of fire. Sometimes we use diesel, which produces a redder flame that is tinged with oily black smoke at the edges. We often use naphthalene, which creates explosions that look a bit like a cross between petrol and diesel, or isopropanol (pure alcohol), which is useful for indoor explosions because it has a relatively cool flame that is safer when performers are involved.' Naphthalene and isopropanol are useful because both fuels have very little 'residue'. When used in an explosion, petrol or diesel continues to burn after the initial ignition, and any fuel that does not burn in the air rains to the ground or sticks to scenery, where it burns until depleted. Naphthalene and isopropanol, on the other hand, both burn immediately and are depleted in one very fast explosion, creating potentially safer balls of fire.

To create fireball effects, plastic bags full of the chosen liquid are placed on top of a black-powder bomb in a mortar [fig. 6]. 'We usually use two bombs when creating a fireball explosion,' explains Richardson. 'The force of the bomb that vaporizes the fuel can actually be enough to extinguish any fire, with the result that gallons of vaporized fuel just float off into the sky. A second bomb placed on the edge of a mortar will ensure that the vaporized fuel is ignited properly as it rises into the air.' The alternative method of creating fireball explosions is to use a gas mortar – a metal funnel that releases and ignites a cloud of compressed propane gas.

In addition to fireballs, a number of other distinct types of explosion are frequently used in the movies. 'One of the most popular effects is for great plumes of sparks to rocket out of an explosion,' notes Richardson. 'These can be created using an off-the-shelf pyrotechnic item called a "directional spark charge". These charges come in various different sizes to simulate anything from a sparking

Figure 6 FIREBALL MORTAR

second black-powder bomb or 'igniter'

mortar buried in ground

bag of fuel

black-powder bomb

John Richardson gave added drama to this fireball explosion in Blue Thunder *(1983) by adding directional spark charges to create plumes of sparks.*

electricity socket to a 90m [300ft] high fountain of sparks.'

Each movie explosion is a carefully controlled balance of various charges and materials. 'We actually choreograph explosions to get something that has the right combination of different shapes, colours and types of fire and debris,' says Richardson. 'On *A Bridge Too Far* [1977], there was an explosion when a character accidentally turned a flamethrower on an ammunition dump. That explosion involved fifty-six detonations in a period of just five seconds, each one carefully designed and timed to complement the others.'

Explosions are almost always filmed at high frame rates in order to make them last longer on the screen (<104), and, as a result, the choreography of pyrotechnics can involve time delays that are calculated in tenths or even hundredths of seconds. 'What looks like a gap of one second between different parts of an explosion on film can actually be a difference of a quarter or an eighth of a second during filming. We therefore have to have a pretty good sense of exactly how each detonation will interact with the others.' Whenever more than one charge is to be detonated, care has to be taken with the wires. 'An explosion can go wrong because the first bang either burns or cuts the wires to the other charges,' says Richardson. As a result, all wires are carefully arranged and often channelled inside protective metal tubing.

Directors often like to show people being thrown through the air as a result of impressive explosions. If filled with soft materials, mortar explosions should not present too much danger to stunt performers at a safe distance from the blast. Performers can be made to look as if they are closer to the explosion than they are if a scene is filmed with a long lens, which has the effect of reducing the apparent distance between objects (<40). The dramatic force of an explosion can be suggested by using a pneumatic springboard called a 'kicker plate' to throw stunt performers a considerable distance into the air. Kicker plates are basically hinged metal plates that, when activated, spring open with great force. As an explosion is detonated, stunt performers jump on to kicker plates, depressing a trigger which causes them to be fired dramatically into the air. The violent force of a kicker plate is more likely to cause injury than the explosion itself.

Explosions using black powder are designed to look visually impressive but, though potentially extremely dangerous, are not usually powerful enough to do serious damage to property. 'We can rig impressive-looking explosions inside real buildings, and after the fireball has died down, the place is perfectly intact and unharmed,' says Richardson. 'Sometimes, however, we are required to physically destroy buildings or sets. Such explosions are made up of two distinct parts. There is the "cosmetic", colourful-looking bit that is achieved using black powder and gasoline devices, and then there is a totally separate process designed to inflict the actual damage to the property.'

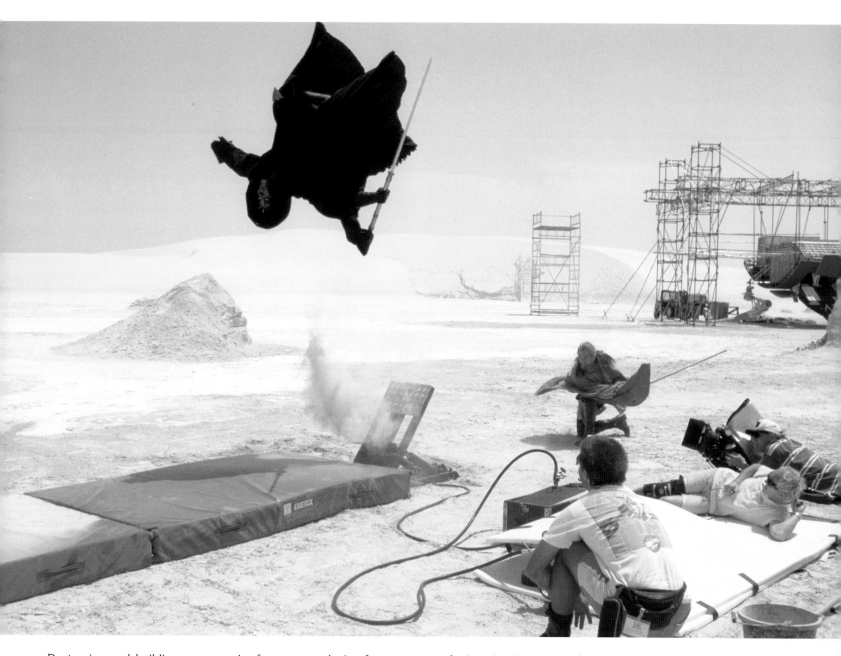

Destroying real buildings can require far more explosive force than is safe in most film making situations. 'We always search for a way of using the minimum amount of explosive,' Richardson explains. 'We first weaken any structure so that it is barely standing and it wouldn't take much more than a high wind to make it come to pieces. Then we place explosives in strategic positions, such as the last remaining support posts. Once these points are blown, the building will collapse, and it will look like it was the work of the cosmetic explosion we have arranged to go off at the same time.' The best material for cutting objects such as support posts is a high-explosive cord known variously as Cordtex, Det-Cord or Prima-Cord. 'Cordtex is a sharp, violent explosive that is rather like a plastic clothes-line that can be wrapped or taped around any object. By putting a piece around a tree trunk, you could blow a tree in half. It's a very useful material, and we use a lot of it.'

As well as creating explosions on land, effects supervisors are also asked to create them in the water. 'We often have to produce explosions in rivers or in the sea, especially for James Bond movies where boat chases are almost one of the staple ingredients,' states Richardson, who has executed impressive water explosions in films such as *Moonraker* (1979) and *Deep Blue Sea* (1999). 'We need a great deal of force to get water up in the air, but black powder-based explosions are rarely strong enough. Instead, we usually use industrial high explosives. These need to be very securely anchored to the river or seabed, with no chance of their being moved by tides or current. The explosive itself has a float attached to it so that it will remain at the correct depth under the surface of the water.'

The depth at which the charge goes off is vital and has to be correct to within a few inches. If it is too deep, it will not lift the water high enough; if it is too shallow, it will lift an unimpressive quantity of water a very long way. 'Due to the difference the depth of water

Stunt performer Ray Parks is propelled into the air by a pneumatic kicker plate during the filming of Star Wars Episode One: The Phantom Menace *(1999).*

265

Top: *Black powder mixed with soap flakes creates a plume of white smoke.*
Middle: *Black-powder bombs and gasoline can blow oil drums high into the air.*
Bottom: *Pyrotechnics and bullet hits are detonated electrically using a firing box or 'clunker box'. Each explosive is wired into a separate terminal and can be programmed to go off sequentially or operated manually by a pyrotechnician.*

makes to an explosion, we have to be very knowledgeable about local tidal patterns and be able to judge the depth of waves – a wave going over a charge can add another couple of feet to the depth of the water.'

Unlike land-based explosions whose position can be clearly marked, underwater explosives are not easily visible to either stunt performers or pyrotechnicians. 'With any form of explosive, it is absolutely imperative that the area of the explosion is always in full view of the person who will be detonating the charge. If a scene involves a number of explosions, there may be a team of people in different positions to keep an eye on each charge,' explains Richardson. 'It is also important that performers know exactly where an explosion will occur, so that they can avoid them. With water, this can be difficult because the explosive is hidden below the surface. We normally arrange small cork floats that bob on the surface immediately above the explosive, and anyone driving a boat keeps a lookout for them. However, when driving a speedboat at 50mph, spotting and avoiding a tiny float can be quite tricky. The technician overseeing each charge has to decide if a boat is at a safe distance before detonating an explosion – a few feet can make the difference between a safe stunt and blowing the boat up.'

An important consideration when detonating explosives in water is the power of the resulting shock waves. 'Shock waves travel through water with a far greater force than through air,' explains Richardson. 'If a person is in the water near an explosion, they can suffer physical harm. The shock wave could result in internal injuries to organs like the kidneys, and if somebody's head is under the water, the shock wave could rupture their eardrums. I have been standing in water when dynamite has been detonated some distance away, and the shock wave felt like a very strong slap against my legs.' Shock waves are not only harmful for

humans. 'Underwater explosions can kill all the aquatic life in the immediate area,' says Richardson. 'We therefore tend to detonate a few small explosions before the bigger explosion to frighten the fish away.' During the filming of the high-speed boat chase sequence in *The World Is Not Enough* (1999), special effects supervisor Chris Corbould used ultrasonic equipment to scare the fish of the River Thames away from the enormous explosions that he had devised. 'The equipment was the type used by power stations to discourage fish from swimming up their water outlet pipes,' he explains.

Corbould's impressive river chase sequence from *The World Is Not Enough* was a particularly complicated operation. 'We were filming on the River Thames near famous landmarks like the Houses of Parliament as well as the actual headquarters of the British secret service, MI5, and many waterfront residential properties. Some of our explosions involved sending up to five tonnes of water into the air, so we had to be extremely careful that we did not cause any alarm or damage. In the event, our explosions merely set off a few car alarms.'

As well as ensuring that the film's pyrotechnics did not interfere with the city and citizens of London, Corbould had to consider the effect that filming in a major city could have on his own plans. 'Explosions are almost always detonated electrically,' explains Corbould, 'and because of this, mobile telephones and radios are strictly banned on the set – it is possible that such equipment could induce an electric current in a wire and cause an accidental explosion. However, in a city like London, there is no way to control the signals that are flying around. So, instead of using electrical detonators, we wired our high explosives with a system that detonated them by shock. The cable we used was lined with explosive, and when we detonated that cable from the land, it sent an instantaneous shock to the high explosives tethered in the water.'

High explosives are sometimes just too dangerous to be used when filming water sequences. This is particularly true if actors need to be anywhere near an explosion, or if the explosion is taking place within the confines of a shallow studio tank. 'Within a tank, we would normally use an air mortar to create a water explosion,' says John Richardson. 'This involves using an underwater reservoir of compressed air and an underwater valve. When the valve is opened,

Chris Corbould safely created the huge water explosions in the heart of London for The World Is Not Enough *(1999).*

CLIFF RICHARDSON

Pioneering British effects supervisor Cliff Richardson (1905–1985) began work in

Cliff Richardson and his son John, using an early snow machine.

London's film industry as a prop boy in 1921. Richardson's fascination with the technical aspects of the job, especially his interest in guns and gunpowder, gained him a reputation as the person to tackle any unusual request.

Richardson worked his way up to special effects supervisor at a number of Britain's leading studios, including British International Pictures, where the young Hitchcock made his early films; Ealing Studios, home of the famous Ealing comedies; and Denham Studios, where classics such as *The Thief of Bagdad* (1940) were produced.

As supervisor, Richardson became best known for planning scenes of mass destruction. He created the impressive train derailment in *Lawrence of Arabia* (1962) and the destruction of a real aircraft hangar for *The Battle of Britain* (1969), as well as the many pyrotechnic stunts for *The Dirty Dozen* (1967). However, Richardson enjoyed the small challenges that he was asked to solve just as much as the larger ones. For the swamp scene in *The African Queen* (1951), real leeches refused to perform as required, so Richardson made rubber leeches with internal blood sacs that bled when Humphrey Bogart pulled them from his skin. For the same film, Richardson created a swarm of mosquitoes by floating tea leaves in a tank of water (<113).

Richardson invented many devices that became widely used in the film industry. These included an oil-vapour smoke machine, a gas-powered machine gun, a nozzle for spraying foam snow and the 'Danté' – a contraption used to safely create enormous blankets of fire. Richardson used the Danté in what he considered to be one of his most successful shots, the burning of a huge warehouse for *The Battle of Britain*.

Before his retirement Cliff Richardson often worked in partnership with his son John Richardson (1940–), who has himself become a leading special effects supervisor, working on several James Bond films.

Atlanta on fire in Gone with the Wind *(1939) – the burning buildings were old studio sets built for other films, including* King Kong *(1933).*

burning over these appliances. Flame bars come in various shapes and sizes to produce different qualities of flame. They are positioned at a safe distance behind objects that need to appear to be on fire, and immediately in front of the camera to create foreground fire.

As well as using flame bars, fire specialists may smear a highly inflammable gel on to objects that need to be seen burning. This burns for a limited period, so only enough to last the duration of the shot will be applied to fireproofed objects before each take. Film sets that are to be set on fire during the making of a film are largely built with fireproof materials, and only the parts that need to burn are covered with gel and set alight.

One of the most famous fires in the history of the movies is the burning of Atlanta in *Gone with the Wind* (1939). This sequence was filmed on 10 December 1938 at the RKO-Pathé studio in Culver City, California. The fuel for the fire was the Skull Island set from *King Kong* (1933), which itself had been adapted from exterior sets

Cliff Richardson created this dramatic scene for The Battle of Britain *(1969) without actually damaging any of the buildings that appear to be on fire.*

originally built for Cecil B. De Mille's *King of Kings* (1927). This set was dressed to resemble nineteenth-century Atlanta and plumbed with a network of pipes through which a thousand gallons of fuel per minute were pumped to produce an enormous conflagration. The 60m (200ft) flames demolished the site in just six minutes. The resulting footage was used both in *Gone with the Wind* and later for the burning of the mansion in Hitchcock's *Rebecca* (1940).

SPECIAL PROJECTS

Whenever a script calls for anything beyond the ordinary, the physical effects supervisor gets the job of providing the action. For this reason, physical effects supervisors need a thorough understanding of an incredibly wide range of subjects.

'When you get a script, you go through it and identify all the scenes that might require some sort of effects input,' says George Gibbs, whose ingenious effects for *Indiana Jones and the Temple of Doom* (1984) and *Who Framed Roger Rabbit* (1988) have won him Academy Awards. 'Sometimes it's a simple case of making a note to use breakaway glass bottles in scenes where there may be the possibility of a breakage. Other times the effect is something massive that will require months of planning – those are the type of projects that I tend to specialize in. My job is to think about the requirements of a shot and apply my knowledge of subjects as diverse as electrical and mechanical engineering, pneumatics, hydraulics, explosives, carpentry, plumbing, metalwork and chemistry. Of course, no supervisor can be expert in all these things, but we should know enough to have a good idea of how an effect might be achieved. Then it's up to us to do the research in that area, and find the people who are the real experts.'

One of Gibbs's biggest assignments was to build a 75m (250ft) rope bridge for *Indiana Jones and the Temple of Doom*. 'Of course, an Indiana Jones film is full of effects challenges,' notes Gibbs, 'but most films have one really big or difficult job that takes up a disproportionate amount of time and energy. On *Temple of Doom*, it was the rope bridge.'

To build the rope bridge, which was far longer than any that exists in real life, Gibbs enlisted the help of a British engineering company that was constructing a dam near the Sri Lankan location chosen for the sequence. 'To get the bridge in place, we had to dynamite 60cm [2ft] of solid rock from a cliff top on one side of the gorge, to make it the height we needed. We then drilled 1.5m [5ft] down into the rock so that we could secure the steel I-beams that the bridge would be suspended from. The bridge itself was made from flexible 2.5cm [1in] crane cable – this had been calculated to be the correct specification by several world-class engineering companies. We strung four cables across the gorge – two for the handles and two for the bottom part of the bridge. The bottom two cables had wooden slats fixed between them to make the walkway. We then had to wrap real rope around the steel cables to

271

Opposite: *George Gibbs supervised the major engineering project needed to build and then safely destroy the huge rope bridge in* Indiana Jones and the Temple of Doom *(1984).*

make them look like rope, and connect rope banisters between the top and bottom cables.'

After ensuring that he had built the safest, strongest bridge possible, Gibbs had to find a way to destroy it. 'In the film, Indiana Jones cuts through the bridge with a knife. In reality, the steel cable had a combined breaking strain of hundreds of tonnes,' says Gibbs. 'The only way to break it was to use explosives. After lots of experiments and research, we had some explosive cutting devices made for us by a French company that produces the explosive bolts used for escape hatches in spacecraft. They were about the size of a polystyrene teacup and had a groove into which the bridge cable slotted. When detonated, the cutters blasted a kind of chisel right through the cable.'

In the film, the bridge breaks and falls with a full complement of passengers. 'We built dummies that had a compressed air mechanism inside them to make their arms and legs flail around during the fall. These dummies were very basic and were made at the last minute, but they really made the million dollars spent on the sequence worthwhile.'

Sometimes special effects supervisors come across problems to which no one knows the answer, and which only experimentation can solve. 'For *A Fish called Wanda* [1988], I was asked to crush an actor into wet cement with a steamroller,' remarks Gibbs. 'The set-up was relatively simple. We dug a 1m [3ft] wide, 75cm [30in] deep trench in the runway at London's Heathrow Airport. This allowed a wide steamroller to drive over a stunt performer in the trench. To establish the fact that it was a genuinely heavy machine that was going to go over our stunt man, the steamroller first drove over some wheelbarrows that we made from zinc – a very soft metal that crushes nicely. Obviously, we couldn't fill the trench with real cement because the stunt performer had to be submersed in the stuff. Also, the scene would take several days to film and we didn't want the cement to set. We discovered that porridge mixed with a little black paint looks just like cement and was quite safe to use, so we made hundreds of gallons of porridge in cement mixers. However, the real problem was that the porridge went mouldy very quickly. We tried all sorts of preservatives without success, but eventually we discovered that the best thing to keep the porridge fresh was to mix it with Camp coffee [a type of liquid coffee concentrate]. No one in the world could have told us that we needed to use coffee; it's just one example of the strange problems that we can often only solve through experimentation and imagination.'

Physical effects are potentially dangerous to everyone involved. 'Effects can often present an actual risk to those working and performing around them. Of course, everything we do is designed with safety as the number one priority, but some stunts are just inherently risky.' Gibbs considers one of his most potentially dangerous assignments to be the giant ship propeller that he built for *Indiana Jones and the Last Crusade* (1989). In the film, Indiana Jones fights

an opponent while his speedboat is dragged into a rapidly rotating ship propeller. 'We built a giant propeller with a huge hydraulic engine to turn it at great speed,' remembers Gibbs. 'Harrison Ford had to perform on the speedboat as it was being physically chopped up by the propeller. When you've got a star like Harrison Ford actually doing his own stunts and a three-and-a-half tonne propeller revolving just three metres [10ft] away, your calculations have to be spot on. If we had miscalculated how quickly we could stop the propellor or the way the boat broke up, then Harrison could have been minced. The danger was very real.'

Physical effects can also present danger to those who design and operate them. In his years as an effects supervisor on the James Bond films, John Richardson has gained a reputation as someone who becomes more than usually involved with his effects. 'Our work with physical effects often crosses boundaries with the work of the stunt team,' claims Richardson. 'Much of our work is designed and planned in tandem with the stunt guys because they are often the ones who will end up performing with the effects on screen. However, sometimes our own work can be physically strenuous. As well as the risks involved when working with dangerous chemicals and high explosives on a day-to-day basis, there are all kinds of perilous situations involved with rigging effects at great heights, underwater or even hanging out of aeroplanes.'

One of Richardson's most dangerous tasks came during the filming of *Moonraker* (1979). 'We wanted a shot of a speedboat going over the ninety-metre [300ft] Iguazu waterfalls in Brazil,' recalls Richardson, 'so we put the boat in the river about half a mile upstream from the falls. However, because the water was quite shallow, five of us had to get into the water and manhandle the boat around rocks until

Supervisor John Richardson performs a stunt worthy of James Bond himself as he attempts to move a boat stuck on rocks during the filming of Moonraker *(1979).*

we got it in the right position. We then released it and it floated towards the edge of the falls. Then, right at the very edge of the drop, it got impaled on a rock and we couldn't move it. After much discussion, and in a moment of madness, I offered to hang from the underside of a helicopter and try to push it off, so we flew up to the boat with me clinging to the end of a rope. After dropping me in the water and then in the trees, the pilot eventually got me on to a rock and I tried pushing the boat but it wouldn't budge. So I decided to grab the boat and signal the helicopter to move away. The idea was that the helicopter would drag the boat free and I would be the human link. As I held on to the boat and the helicopter moved away, I could feel my arms getting longer, but by this time, I was determined to shift the boat. Then I heard this ping, ping, ping noise. It was the stitching of my harness breaking. I realized then that I should probably let go, and we flew back to land with me hanging on to the skid of the helicopter just as James Bond would. Later that night it rained somewhere upstream and the extra water flushed the boat over the falls when we weren't there to film it.'

Animals, particularly horses, have always played an important part in the movies, often resulting in accusations of cruelty. The most controversial technique used for equine stunts was called the

John Fulton engineered the simple but effective illusion of an unseen person walking through snow for The Invisible Man *(1933).*

'running W', a method that involved wiring a horse's front legs with a W-shaped arrangement of cables that ran up to the underside of the horse's belly and from there to a stake secured to the ground. When a running horse reached the end of the cable, its front legs would be pulled from underneath, causing it to turn head over heels. If done properly, the trick was said to cause the horse no pain, but there is no doubt that many horses have been injured by this and other stunts over the years.

'Today stunts like the running W are outlawed,' comments Nick Allder, whose physical effects have appeared in films such as *Alien* (1979), *Leon* (1994) and *The Fifth Element* (1997). 'We now try to find ways that allow animals to appear in films without any form of cruelty. For *Braveheart* [1995], Mel Gibson wanted to see horses doing somersaults and all kinds of stunts that we can no longer expect real animals to perform. To provide such shots we built a pneumatic sling that would fire an artificial horse and a stunt performer 6m [20ft] along a track in one and a half seconds before the launching them into a jump or a fall. We used the device for shots where horses run into wooden stakes during a battle and for a shot where Mel Gibson appears to jump his horse from a castle into a lake. The results were so convincing that we decided to video the process because we thought we might receive complaints, and sure enough the animal rights people were on to us as soon as the movie was released.'

Physical effects supervisors are often asked to suggest the presence of an invisible character or force on screen. For *The Invisible Man* (1933), John Fulton (<47) used clever mechanical gags and wire work to make doors open, chairs move and items float around as if the unseen hero of the film was actually interacting with them.

© Touchstone Pictures and Amblin Entertainment, Inc.

MICHAEL LANTIERI

For Who Framed Roger Rabbit *(1988), George Gibbs created hundreds of scenes in which objects reacted to characters to be added later by animation. For this shot, a coat was made to bulge as if it contained a wriggling rabbit (1988).*

In one scene, the presence of the invisible man is indicated by the appearance of his footprints in fresh snow. To achieve the effect, Fulton created a wooden floor with foot-shaped holes in it. These holes were stopped up from below and artificial snow laid over the top. During filming, the foot-shaped holes were opened sequentially, causing the layer of snow to collapse down-wards as if being compressed by invisible feet.

The use of wires and other hidden mechanical methods to move objects during filming was resurrected by George Gibbs during the making of *Who Framed Roger Rabbit* (1988; <140). Although the stars of the film were largely animated cartoons, many of the props and environments with which they interacted were real. 'We devised dozens of mechanical methods of creating the impression that the animated characters were actually present during filming,' explains Gibbs. One of the most complicated sequences in the film involved a bar-tending octopus whose eight arms each performed a different task. 'The octopus, which was animated and added into the scene later, used its cartoon tentacles to move real items – it took a glass from a shelf, made a Martini, poured a beer, wiped down the counter, lit a cigarette and took money from a customer. Each of the real items was carefully puppeteered using rods or wires concealed below or above the stage. We also built robotic arms controlled by tiny motors that could move objects like real cigars up to the mouths of cartoon characters. Such rigs were eventually hidden behind the cartoon characters, which were later added over the top. Other props included a computer-programmed piano whose keys worked automatically so that Donald Duck and Daffy Duck looked as if they were playing a real piano.'

While Gibbs created the physical effects for the scenes shot in England, those filmed in the United States were supervised by Michael Lantieri (<275). 'Although we didn't know it at the time,

Michael Lantieri was born and raised in Burbank, the heart of Hollywood film production, so it is hardly surprising that he wanted to become involved in film making from an early age.

After leaving school, Lantieri started work at ABC television for a year before finding employment in the special effects department at Universal Studios, where he created effects for television series such as *The Six Million Dollar Man*. Lantieri ended up spending eight years at Universal learning all the basic special effects crafts, until he was offered the opportunity to supervise the effects for *Flashdance* (1983). After several similarly small effects films, Lantieri began to create major-league physical effects for films such as *Poltergeist II* (1986) and *Star Trek IV: The Voyage Home* (1986).

After supervising the ingenious mechanical effects for the American shoot of *Who Framed Roger Rabbit* (1988), Lantieri provided increasingly sophisticated effects for a string of films produced or directed by Steven Spielberg, including the two *Back to the Future* sequels (1989 and 1990), *Hook* (1991) and *Jurassic Park* (1993) for which he won an Academy Award.

Lantieri has gained a reputation for creating large-scale physical effects that seamlessly integrate with computer-generated animation to give the illusion of fantastic characters interacting realistically with live-action environments. In films such as *The Flintstones* (1994), *Congo* (1995), *Casper* (1995), *The Indian in the Cupboard* (1995), *Mars Attacks!* (1996), *The Lost World* (1997), *Deep Impact* (1999) and *Wild, Wild West* (1999), Lantieri has continually pushed the limits of physically achievable effects, leaving only the most impossible feats to the computer. Lantieri made his debut as a director with the film *Komodo* (1999).

Roger Rabbit was actually a practice run,' states Lantieri, whose responsibilities included staging the film's opening sequence in which cartoon character movie stars are seen working in a real film studio. 'What we didn't realize back then was that making objects and environments respond to characters not present during filming would one day turn out to be a very significant aspect of physical effects work. In 1988, the age of digital visual effects was still a distant dream, but when it did eventually arrive, this was just the kind of work that we would need to produce time and time again.'

After *Roger Rabbit*, Lantieri worked on several films that were among the first to explore the computer's potential to manipulate images of props and environments. 'When we made *Back to the Future Part II* [1989], we had characters flying around on hoverboards, which were like skateboards that hovered instead of using wheels,' recalls Lantieri. 'To get the boards and the people to fly, we hung them in a very traditional way using thin piano wires that were almost invisible on screen. We went to great lengths to build sets that had a lot of vertical lines in them so that the vertical wires would blend into the background and be less noticeable. On the few occasions that the wires were very visible, ILM used old-fashioned rotoscoping techniques to hand-trace the wires and remove them optically [<54].

For scenes like this from The Lost World *(1997), Michael Lantieri created the illusion of the presence of dinosaurs, even though the creatures themselves were animated and composited into the scene much later.*

However, just two years later when we did *Hook* [1991], digital technology had advanced to the point where cables could easily be removed from a shot using a computer. For the flying scenes in that film, we hung Robin Williams from cables that were ten times stronger and very much thicker than those used in *Back to the Future*. Today, wires are so easy to remove from a shot that we actually paint them to make sure the computer guys can see them clearly!'

Just two years after *Hook*, Lantieri provided the physical effects for *Jurassic Park* (1993), perhaps the most important and influential digital effects film ever made. '*Jurassic Park* was really the first film in which major physical effects had to be designed to complement digital characters that would be added much later in the production process,' says Lantieri. 'In a way, it was very similar to what we had done for *Roger Rabbit* – we had to create the impression that invisible characters were interacting with a real environment. Probably the most complex sequence in which we had to fake the presence of a dinosaur was the scene in which the T-Rex chases a jeep. The dinosaur had to emerge from some trees, smash through a fallen log and ram a moving vehicle. To accomplish this scene, we rigged full-sized trees so that they would fall out of the way as if an invisible dinosaur were pushing through them. A full-size tree trunk that lay across the road was rigged to blow apart and be knocked to one side as if a dinosaur had smashed through it. The jeep was rigged so that its windshield was smashed off by the flying log, and then jumped into the air as hydraulic rams imploded the side of the vehicle as if it had been hit and damaged by the dinosaur.'

Lantieri takes the creation of such sequences very seriously and pre-plans every effect in minute detail. 'We really have to know a lot about the digital character that we are supposed to be representing

on the set,' explains Lantieri. 'I sit with the people who are going to create the computer-generated creature for days on end, discussing its characteristics. We need to know how fast a character can move when running at full speed, how far apart its tail and head might be at full stretch, how heavy it should appear to be – all the details of a character's physique that will allow us to create live effects that digital animators can match their characters to.'

Lantieri himself makes considerable use of computers during the creation of his physical effects. 'We use CAD [computer-aided design] programmes to design our effects rigs and all kinds of specialized software to work out the complex engineering problems that we encounter. We even design whole sequences by creating animated storyboards called "animatics". These allow us to determine exactly how and when all of our effects will work and to try out various alternatives. We also use computers to control our equipment during filming. We can programme events to happen so that an effect occurs when a camera or actor is in exactly the right position.'

Although many of the physical effects that Lantieri creates live can now be produced in the computer, he believes that physical effects will continue to be used for a long time to come. 'Physical effects are generally much cheaper than digital effects. However, the cost of digital effects is coming down all the time, so eventually that will be less of a consideration,' reasons Lantieri. 'I think physical effects will still continue to be used for several reasons. Firstly, they enable actors to feel as if they are interacting with a character; pretending that you are appearing with some creature is actually very hard. The actor that I've seen doing this best is Bob Hoskins in *Roger Rabbit*. Secondly, most directors like to get as much accomplished during the shoot as possible. This means that they can have maximum control over what happens on the set, and they end up with an image that they can use when editing rather than having to wait months while computer effects are added. This is why we go to incredible lengths to create even the most difficult shots live, and we leave only the impossible things for the computer guys to achieve. Finally, unless it's a completely computer-generated film, there always has to be a point at which live effects meet computer-generated effects – wherever that line is drawn is where our physical effects will occur. The more CGI characters that appear in the movies, the more there will be for us to do.'

Effects supervisor Michael Lantieri created all the physical signs of a dinosaur on the rampage for this scene in The Lost World *(1997).*

Sound effects mixing

The sound effects mixer is responsible for combining and manipulating recordings to create new sounds. Sound effects and dialogue were traditionally edited on magnetic tape. Edits were achieved by cutting the tape and splicing it back together with adhesive tape, in the same way that film was traditionally edited. Mixes were achieved by simultaneously running a number of tapes on separate machines and re-recording the resulting combination of sounds on a new tape.

Today, sound editing and manipulation is achieved digitally. All sounds are played into the memory of a computer, where they can be endlessly altered and mixed. A soundtrack can be built up by laying sounds into an almost limitless number of tracks (fig. 1), which can be individually accessed and altered at any point during the editing process. While sound effects editors once went to enormous lengths to create new sounds by mixing, layering, distorting, speeding up or slowing down their tape recordings, individual sounds can now be digitally sampled and placed in the memory of an electronic keyboard called a Synclavier. This keyboard can then be played just like a piano, each key producing a variation of the original sound. The basic sound effects for a suit of armour might be sampled and, as the image of a sword-fighting knight is viewed, the sound effects mixer can 'play' the appropriate sound effects, move by move, like music on the keyboard. Any sounds that do not perform in the required way can be displayed on a monitor as a wave form – a visual representation of the characteristics of the soundwave. This wave can then be altered by directly manipulating its frequency range and amplitudes to affect the noise produced.

The sound of many real objects is often not dramatic enough when recorded and used in a film, so many 'real' sounds have to be re-created artificially. One of the most commonly used sounds in any action film, the gunshot, is a good example of this. When real gunfire is recorded, the sound is normally rather disappointing, often sounding rather tinny and high pitched, and rarely as loud or dangerous as most audiences would expect. The gunfire used for soundtracks is normally manufactured from as many as a dozen different noises, which might include a thunderclap, a dog barking, a door slamming and the sound of several real guns. Each of these constituent sounds will be slowed down, speeded up, changed in pitch or given a little reverberation before being mixed together to produce a violent boom worthy of James Bond's Walther PPK or Dirty Harry's Magnum.

Often, many of the sounds that need to be created are for everyday objects or locations whose natural sounds the director feels are not dramatic or emotive enough. For *Body of Evidence* (1993), Sandy Genler, a sound effects mixer at Sony Pictures Studios, was asked to make a room sound 'sexy'. 'This is typical of the kind of strange request that we get from directors,' explains Genler. 'How do you make a room – which in itself doesn't make a distinct noise – sound sexy? In this case, there was a fan rotating on the ceiling, so we mixed the sound of the fan with the husky breathing of a woman. The breathing was barely audible, but it worked on a subliminal level to give the room the sultry feeling that the director had requested.' Using unusual sounds to exaggerate the noise made by everyday objects is known as 'sweetening', and is commonly employed to add a touch of melodrama to a scene. For the truck chase sequence in *Raiders of the Lost Ark* (1981), the roar of a lion was used each time the vehicle changed gear, making the sequence feel far more sensational than it would have been without it.

With the rise in popularity of films that are set in extraordinary locations, or that feature fantastic events or characters, there is a rapidly increasing need for unusual sound effects. No longer just technicians who are commissioned to create a few unusual noises towards the end of a film's production, sound effects mixers are increasingly being asked to create entire 'soundscapes' that are as much a part of a film's fabric as the set design, costumes and visual effects. The artists who work to create this all-encompassing sound illusion are known as 'sound designers'.

Ben Burtt (1948–; 283>) was one of the first artists to use the term sound designer to describe his work. 'Sound design is a term that has only been around for a couple of decades, and has never been fully accepted by some

Figure 1 DIGITAL EDITING COMPUTER
Modern soundtracks are digitally edited with a computer. The editor can use software to manipulate and mix sounds in almost limitless ways.

people in the industry,' notes Burtt. 'Traditionally, the sound on a film has been broken down into a number of distinct processes that were performed by different people who often never even communicated with one another – they simply did their job and passed their material on to the next person in the chain. However, I, along with an increasing number of other people, believe that sound is as important in the telling of a story as the images. Sound design is not simply about creating a few clever sound effects; it's about how music, dialogue, sound effects and images interact with one another in the telling of a story.'

Burtt was first given the chance to put his theories to the test when he was hired to create the sound effects for *Star Wars* (1977). 'Like the visual effects for *Star Wars*, George Lucas wanted the sound effects for his film to be unlike anything that audiences had experienced before. He didn't want to use sounds that had been pulled from some sound effects library. He wanted exciting and dynamic new sounds, and this gave me the opportunity to create unique effects for spaceships, creatures, weapons and alien environments.'

Burtt approaches the creation of sound effects in two ways. 'When I read a script, the type of sound needed for an effect might instantly come to mind. Sometimes I have a very clear idea of how that sound can be created, but other times I have to experiment with

all kinds of things before I can get the sound I'm thinking of. My other method is to put together tapes of assorted sounds that are interesting to me – I've been collecting sounds for over twenty years, so I have thousands and thousands of them.

For a sequence such as this truck chase from Raiders of the Lost Ark *(1981) every sound would be separately created, recorded and mixed after filming. In this case, truck noises, a horse galloping, punching sounds and numerous other different sound effects were created.*

Then, when I'm looking for a new sound but I'm not sure what is needed, I listen to my tapes until I hear something that hits a chord, and I may develop that sound further through mixing and editing. Suitable sounds come from the most unexpected places. I once went to a missile testing range to record the sound of rockets to use for spaceships, but it was the throbbing noise of the malfunctioning air-conditioning unit in my motel room that ended up being the basis for many of the spaceship sounds in the *Star Wars* movies.'

Burtt's experience with *Star Wars* and its sequels offered unparalleled opportunities. '*Star Wars* was so unique – everything in that film could have sounded almost any way we wanted it to. There was no right or wrong, but I did have some basic rules to help create the sounds I used. The story is essentially about good and evil, so I designed sounds that reflected that. Imperial ships and weapons tended to be shrieking and howling, frightening and

A typical modern sound-mixing suite. Digitized sounds are mixed in a computer and can even be played like music on a keyboard. There is a library of compact discs to hand, containing a huge range of pre-recorded sound effects.

Burtt further manipulated the recording to create 'whooshing' sounds. 'Whenever an object moves towards you and then away from you, the pitch of its sound changes,' explains Burtt. 'This happens when police vehicles pass you by – you hear a strange change in the tone of the sirens as they pass. This is called the "Doppler effect". To re-create this phenomenon, I set up a loudspeaker and played back the basic light sabre noises. I used another tape recorder to re-record this noise through a microphone that I held in my hand and moved back and forth past the loudspeaker at different speeds. The result was these amazing whooshing sounds, just as if the swords were being moved through the air. I used the same process to make all the spaceships sound as if they were moving past the camera.'

Burtt has spent much of his time creating the language of alien characters. 'Developing voices is always the most time-consuming task,' claims Burtt. 'Voices are always judged very critically, and audiences are pretty adept at recognizing and reading languages. It is important that a language does not sound as if it is derived from any that exists on Earth, but at the same time, it needs to possess the same emotional range as real language so that an audience can tell what is being expressed. I have used real languages as a basis, though – for the Ewoks in *Return of the Jedi* (1983), and the Huttese language, first used in *Star Wars* and expanded for *Jedi*, was based on an Inca language called Catua.'

Burtt also uses animal sounds as the basis for many alien voices. 'Chewbacca's voice is basically the noise of various bears with a few bits of walrus, lion and dog added in for extra texture,' explains Burtt. 'I went out and recorded the sound of animals at various zoos and parks and then divided up the recordings into individual sounds that were like the phonemes of speech. I then catalogued these bits according to the way I thought they sounded, so that I had angry sounds, cute sounds, a bunch that sounded like information, others that sounded questioning and so on. When I had this library, I then constructed sentences by editing sounds together according to what Chewbacca was supposed to be saying in each scene. I also had to make sure that these sounds synchronized with his moving lips, which made things quite difficult. I used the same method for the chirps and whistles of the robot R2D2.'

ominous. Rebel spaceships, locations and weapons, on the other hand, sounded less threatening, less sleek and more organic.'

For the shrieking roar of the imperial Tie-Fighters, Burtt mixed a number of original sounds. 'For the basic roar, I used a very old recording of an elephant trumpeting. I slowed that sound right down and lengthened it. To that I added the sound of a car going past on a wet highway – the sort of swish made by tires on a waterlogged surface. Then I added a kind of rasping roar from a military rocket. In fact, I originally created this sound for the laser beam that comes from the Death Star, but it was so popular that it ended up being used for the Tie-Fighters.'

Perhaps Burtt's most famous sound is the crackling electrical hum of the glowing laser swords used by the Jedi knights. 'The light sabres were the very first sounds that I made for the film,' says Burtt. 'After seeing some early concept paintings, I immediately knew the noise that I wanted to create. At the time I had a part-time job as a projectionist. One of the projectors I used was very old and its motor made a wonderful electrical humming noise. This noise alone did not sound threatening enough for a weapon, and I knew it needed something else. A few weeks later, I was using my tape recorder at home and I had a faulty microphone cable. As I carried the microphone past my television, it picked up a humming noise from the picture tube. When I combined this with the projector noise, I had the sound of the light sabres. I actually produced two different versions of this sound: one for Darth Vader's sword, which was pitched in a minor key to sound threatening, and one for Ben Kenobi's sword, which was more of a C-major chord. Together, the two noises clashed and created a disharmony that was symbolic of the struggle between good and evil.'

Since the light sabre sound effects were supposed to emanate from swords as they moved through the air during fight sequences,

Fifteen years after last creating sounds for the *Star Wars* universe, Burtt began working on the design of sounds for *The Phantom Menace* (1999). 'I was very conscious of creating exciting new sounds that remained consistent with the style of the original films,' claims Burtt. 'One of the major changes has been the type of equipment available. Many of the sounds for the original films were created using physical tricks that had essentially been used for decades – like dragging tape through a tape player by hand to affect the sound it made. However, we now work with computers that can do almost anything. The Doppler effect that I created for the light sabres by physically swinging a microphone past a speaker can now be created by a standard piece of software at the touch of a button. I wouldn't say that we can produce better sound effects now, but we can certainly work much faster and we have far more control.'

BEN BURTT

Ben Burtt's (1948–) fascination with sound began when, bed-ridden for a few weeks at the age of six, his father brought home a tape recorder as a form of entertainment. The machine sparked an interest that would become a career.

After gaining a degree in physics, Burtt's short film *Yankee Squadron* (1970) was awarded first prize in the National Student Film Festival, winning him a scholarship to the University of Southern California Film School, where he specialized in sound.

After leaving USC, Burtt found work as a sound recordist and editor on low-budget films before being asked to create the sound effects for a new science-fiction film called *Star Wars* (1977). *Star Wars* gave Burtt the unique opportunity to design sound for entire worlds and their inhabitants. His work for the film changed the way we think about film sound and won him an Academy Award.

Burtt has since become closely associated with the films of George Lucas (1944; <34) and Steven Spielberg (1946–; <34), designing the sound for all subsequent *Star Wars* films, the Indiana Jones trilogy, *Willow* (1988) and *E.T. – the Extraterrestrial* (1982), among others.

The soundscapes designed by Burtt are so inventive and rich that they not only provide a backdrop to the action of a film, but are also an integral part of a film's fabric, adding humour, drama and spectacle in their own right. Burtt's work has inspired a new generation of sound professionals.

As well as working in the field of sound effects, Burtt has directed episodes of the groundbreaking *Young Indiana Jones* television series and several IMAX movies including *Special Effects: Anything Can Happen* (1996), a documentary about the history of special effects.

Burtt has received Oscars for his work on *Star Wars*, *Raiders of the Lost Ark* (1981), *E.T. – the Extraterrestrial* and *Indiana Jones and the Last Crusade* (1989).

Foleying

When pre-recorded sound effects have been selected from a library, and specialized original sound effects have been created, the remaining sounds that are required for a film are created in a process known as 'Foleying'.

The process is named after Jack Foley, a sound editor employed for many years at Universal Studios. Working on a film called *Smuggler's Island* (1951), Foley found himself editing pre-recorded sounds of splashing water to match the actions of an actor paddling a small boat in the ocean. Cutting a sound to match each movement was a laborious process, so Foley decided to get some water and 'act' the scene while watching the film. The resulting recording of splashing water synchronized perfectly with the picture, and the whole process took a fraction of the time that it would have taken to edit pre-recorded splashes manually. Sound effects artists had in fact been doing this kind of thing for years, but Jack Foley probably did more than anyone to refine the technique and make it popular.

Today, the Foley process is responsible for creating a large proportion of the sounds that we hear in any film. If the dialogue and music were removed from the soundtrack of any typical movie, the noises we would hear might include the footsteps of people walking on various surfaces, light switches being turned on and off, objects being picked up and set down – all the creaks and bumps that occur when people and objects move. These sounds may seem natural when heard in a film, but they are almost entirely artificial creations, and are the last to be recorded and added to a soundtrack.

The Foley process begins when the sound editor and a Foley artist carefully study each scene of a film and make a list of every possible

The Foley stage at Shepperton Studios, where a Foley artist is at work creating sounds to match the images on screen. There is a range of props, including a selection of doors, locks and latches, on the far wall.

Foley artist Gary Hecker smashes a large watermelon with a baseball bat to create the sound of exploding bugs for Starship Troopers (1997).

sound that is likely to occur as a result of the action that they see. With a complete list of required sounds, the Foley artist decides exactly how each noise is to be created. Most recording studios have a room piled with a range of props that a Foley artist hits, squeezes, rubs, twists, shakes and rips to create sounds. These props will have been accumulated over the years and are valued not for what they are, but for the sounds they can create. 'The objects that we use to make sounds often bear no relationship whatsoever to the objects whose sound we are trying to re-create,' admits Gary Hecker, a Foley artist at Sony Pictures Studios, who was voted among the top hundred most creative talents in Hollywood in a 1999 survey by the movie industry magazine *Entertainment*. 'This is because when you record the sound of the actual object that you are trying to represent, the recording process can alter the quality of that sound somewhat. So, paradoxically, the sound made by a completely different object is often more real sounding than the sound of the real thing!' Most Foley artists have favourite props that they use time and again. 'One of my best props is a creaky old chair,' states Hecker. 'By treating this chair in different ways, I can make the sound of creaking floorboards, a ship at sea, doors opening and closing – all kinds of noises.'

When all the necessary props have been selected and tested, the Foley artist begins work on a Foley stage, where the sounds for each sequence are created and recorded. 'The first sounds that we record for each scene are the footsteps,' explains Hecker. 'This

means getting two surface sounds correct. One is the type of shoe that an actor in a scene is wearing, the other is the type of ground or floor on which he or she is walking. We have hundreds of pairs of shoes in my size. Each one produces a different sound when used. We also have a large variety of walking surfaces – small square areas of sand, gravel, wooden flooring, carpet, concrete and so on. Sometimes we have to create mud or other special surfaces to walk on. For *The Empire Strikes Back* (1980), we wanted a squishy sound for the scene when Han Solo and Princess Leia walk on the floor of a cave that is actually the inside of a monster's mouth. For that we got large pieces of steak and cracked eggs on to them to produce a really gooey noise when they were stepped on.'

While watching the action – which is repeatedly displayed on a screen – the Foley artist must mimic the movement of each performer, reproducing the exact pace of walk, run or shuffle. If the scene involves dancing, the Foley artist may even have to learn the dance routine in order to re-create the sound of the footsteps. 'Creating footsteps really is a form of performance in its own right, because you have to *become* the actor that you are watching on the screen,' comments Hecker. 'There is quite a knack to walking in a way that will make you sound like a particular performer. In the case of Arnold Schwarzenegger, I wear very heavy shoes that give the appropriate beefy sound, but he also has a very particular stride that is quite hard to replicate when you can't actually walk up and down – we have to do all our walking "on the spot" as we stand on our small areas of surface.'

When the footsteps of each character in a scene have been recorded, the additional sound effects are created. 'You would be amazed by the hundreds of tiny little sounds that there are in each scene,' says Hecker. 'Every time actors move there is the rustle of their clothes, the squeak of their shoe leather, the jangle of the keys in their pocket. We go through each scene and record every one of those sounds. Creating these sounds is an art. Depending on how you handle it, the same prop could be used to create sounds with many different qualities. If we are breaking some glass, I can produce a

Footsteps are one of the most common sound effects. Here the sound of someone walking on sand is being recorded for The Beach (2000). A selection of other walking surfaces can be seen in the background.

crack, a break, a smash or a shatter – it all depends what I do to the glass and how near we place the microphone.'

While Foleying has traditionally only been used to create the mundane sounds in a scene, advances in technology have meant that the process is now being used to produce increasingly complex sound effects. 'Once, the only way to create some sound effects was for a sound designer painstakingly to mix and layer various pre-recorded sounds,' states Hecker. 'However, with the use of modern sound-processing equipment, a lot of complex sounds are now being created "live" during Foley. A good example is the sound of an explosion. This would once have been created by layering many different pre-recorded sounds, including real explosions. However, recently we have created a lot of explosion sounds right here on the Foley stage. To create a big bang, I might use a large hollow vinyl-shelled suitcase. This would be laid on its side and covered in dirt and gravel, and then I would hit it really hard with a baseball bat. This nice, hollow noise would be recorded through a special six-thousand-dollar microphone that can record noises as loud as 150 decibels. Then the sound would be processed through some hard-ware to make it sound deep and full of bass. The result sounds like the most enormous explosion that you've ever heard in your life!'

Hecker is increasingly being asked to adapt the Foley process for the creation of vocal performances for screen creatures. 'Creature sounds have traditionally been made by mixing lots of sounds, including those of real animals,' states Hecker. 'This is an incredibly laborious process in which you are largely dependent on the quality of the available animal noises to create any form of per-formance or emotion. If the sounds are not really well mixed, the result can end up sounding just like something that has been derived from real animals. For films such as *Godzilla* (1998), *Lost in Space* (1998) and *Mighty Joe Young* (1998), I actually made the noise of the animal characters by coming up with a vocal perfor-mance that, when processed through various software and hard-ware, became the voice of each character. The great advantage of doing this is that the director of a film can direct me as a performer and tell me that the character needs to be a little sadder or crosser or happier. It takes me a matter of seconds to make a "sad" noise, whereas a sound designer might spend hours on remixing to get the same result. Sometimes additional noises – in the case of *Godzilla*, the odd animal growl or the sound of screeching metal – are later layered on top of my performance to get the final effect, but the emotive performance comes from my voice.'

Automated dialogue replacement

During the editing of a film, images are cut together using the original production recording as a soundtrack. As a result of conditions during filming, however, much of the dialogue in these recordings is often obscured by the sound of buzzing lights, background chatter, overhead aeroplanes and the hum of production generators. This disrupted dialogue therefore has to be replaced before a film can be completed. 'The original recording of dialogue

as spoken by actors on set is often completely unintelligible,' remarks Max Hoskins of London-based sound company ReelSound. 'This is often simply due to unsympathetic conditions during filming. The common perception among production crews is that sound recording is not very important because sound can always be fixed at a later stage. While it is true that we can do almost anything with sound, if producers and directors spoke to us for five minutes before filming began, it could later save us weeks of time and save them an awful lot of money.'

'Once the picture element of a film has been edited, we go through and listen to the dialogue of each actor,' explains Hoskins. 'Ideally, we need the words of each character to be heard perfectly clearly, with no extraneous background noise. Sometimes a small background noise will drown out a single word spoken by an actor and that word will have to be replaced; other times, there is so much noise in the background that the whole scene has to be re-recorded.' The process of deciding which words are to be replaced and noting where they occur in a scene is called 'spotting'.

Once a film has been 'spotted', the actors are called back for automated dialogue replacement sessions. 'ADR often takes place when actors are already working on their next project, and they may have to take time off to fly across the world and re-record dialogue that they originally spoke many months before. Sometimes, though, we have to go to wherever they are,' says Hoskins. 'Performers appearing in the same scene can't usually be got back together at the same time, so actors usually have to speak their lines to no one. As a result, re-recorded dialogue is generally considered inferior, in performance terms, to original production sound. For this reason, we try to replace as little dialogue as possible, but some films – especially action films – may have as much as seventy per cent of their dialogue re-recorded and replaced.' Some directors, however, enjoy the freedom and flexibility that this process allows them, and some films, such as *Once Upon a Time in America* (1984), have had every single piece of original dialogue replaced.

During an ADR session, performers are shown a scene repeat-edly while listening to the original sound on headphones, so that they can learn to say their lines in exact synchronization with the image. Before videotape made things simpler, scenes were repeated by editing film into a loop that went round and round in a projector. For this reason, ADR is still sometimes called 'looping'.

'When a performer is learning to repeat his or her lines parrot-fashion, it is the last chance for a director to make alterations to the performance,' explains Hoskins. 'Sometimes directors ask the actors to alter the emphasis or intonation of the dialogue slightly. Sometimes they even ask the actors to say a completely new word or line, and they have to find a way to synchronize it with the sen-tence that is being spoken on the screen. We also find alternatives to swear words so that we can produce a toned-down version of the film for use on television or aircraft.' If part of a script has been rewritten since filming, it is likely that the new words will not fit the movement of the mouths already filmed. In such cases, the new dialogue must

be recorded so that it fits the movements of the back of an actor's head in the reverse-angle shots used in most dialogue scenes.

When an actor is ready to repeat dialogue so that it perfectly matches the lip movement on screen, they watch the image once more while their voice is recorded. 'The synchronization of performers' words with the image of their lips has to be exact,' notes Hoskins, 'though these days we can edit words digitally to stretch them or shrink them fractionally to ensure that every word fits absolutely perfectly. When the film is finished, no one in an audience should ever be aware that much of what they hear is actually recorded long after the images were filmed.'

Re-recording

When each sound effect and piece of dialogue has been recorded and edited, every element is brought together and assembled to create a completed soundtrack in a process called the 're-recording mix'.

'The re-recording mix is where we produce the final soundtrack for a film, and it is generally the last creative process in the production of a feature film,' explains Graham Hartstone, head of post-production at London's Pinewood Studios. Each of the individual edited sounds – some lasting only a second or two – is held on what adds up to dozens, or sometimes even hundreds, of separate tracks. These have to be gradually combined and reduced down to the six or eight tracks that will be added to the final version of the film.

As the many tracks of sound are combined, they are manipulated and balanced to sound the way that the director wants them to be heard by the audience. One of the main tasks at this stage is dividing each sound between the various loudspeakers used in film theatres (fig.2). 'Most film theatres now have a minimum of six channels of

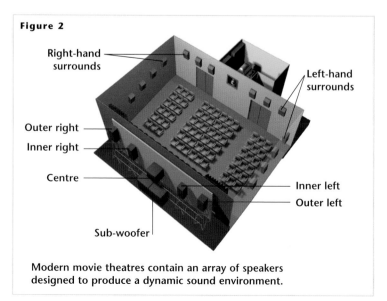

Figure 2

Right-hand surrounds

Left-hand surrounds

Outer right

Inner right

Centre

Inner left

Outer left

Sub-woofer

Modern movie theatres contain an array of speakers designed to produce a dynamic sound environment.

sound,' explains Hartstone. 'Behind each movie screen there are typically four loudspeakers: a centre speaker, a left-hand speaker and a right-hand speaker, which give the impression that sounds are coming from the correct place on the screen, and a sub-woofer speaker, which emits low-frequency, non-directional sounds – the type that make your chair vibrate when a spaceship goes past or a gun goes off. Then in the auditorium itself there are speakers down the walls – these are the left-hand and right-hand surround channels that give the impression that the environment in the film actually extends out beyond the screen. As well as these standard arrangements, some other sound systems use additional speakers. The Sony system uses five speakers behind a screen – a sub-woofer and then outer and inner left- and right-hand speakers – so that it can locate sound even more accurately on the screen. The latest Dolby system uses a third surround channel to send sound to speakers on the back wall of the auditorium.'

The re-recording stage at Pinewood Studios. The room is designed to replicate conditions in a movie theatre so that the re-recording mixer can create the best balance of music, dialogue and sound effects.

During the mixing process, the supervising sound editor and the director will decide which of these speakers each sound should come from. As a sound is being copied on to the new mix, a device rather like a joystick can be used to determine where that sound should come from, and it is then recorded on to the appropriate tracks. A sound that needs to come from the far right of the screen might therefore be divided equally between the right-hand speaker behind the screen and the right-hand surround channel. The source of each sound can also be moved throughout the duration of a shot so that, for example, an aeroplane sounds as if it is coming from behind the audience before appearing on the screen.

The re-recording process takes place in several stages. The hundreds of individual tracks of sound are first reduced to a number of

The final stage of sound production. An operator at Pinewood Studios converts the final soundtrack mix into an optical or digital signal, so that it can be printed on to film and added to release prints.

tracks called pre-mixes. Each pre-mix contains the mix for a particular category of sound. Before the proliferation of digital technology in the late 1980s, all sound was stored and played on reels of magnetic tape. Each reel contained several tracks of sound, so pre-mixing meant running dozens of reels of sound simultaneously and re-recording the hundreds of sounds that they output on to a single reel of tape. Today, the various audio tracks are stored as digital information on hard disks, tapes or CDs, and re-recording is a case of selectively combining various digital files.

'The first thing we do is make the dialogue pre-mix,' explains Graham Hartstone. 'Each character's dialogue may be split up on several tracks, because some of it will be original production sound that was recorded on location, and some will be from ADR sessions (<285). These separate pieces are combined to create one complete track. At the same time as assembling these bits of dialogue, we may make various acoustic alterations to the quality of the sound, so that dialogue spoken in an ADR studio will sound as if it were recorded in the same location as the original dialogue. Next we do pre-mixes for the sound effects. These fall into several categories. We do a mix of what we call "spot effects". These are individual sounds that relate directly to actions on the screen – sounds like doors closing, cars starting, guns firing and so on. Again, these sounds will be held on a large number of tracks, so we re-record them and mix them on to one new track. During this mix, we will compare the sounds to the dialogue pre-mix that we have already done and adjust their volume levels so that none of the noises will drown out important dialogue.

The next stage is to do an atmosphere pre-mix in which sounds such as distant traffic, wind, birdsong and so on are mixed together. 'Generally speaking, we use the director's choice of lens as our cue for how to treat atmospheric effects,' states Hartstone. 'For a big, wide-angled establishing shot, we would probably use the surround speakers to give the audience the impression of actually being in that environment, but for an intimate shot between two characters, we probably wouldn't want the audience to be too aware of the general world around them, so the atmospheric sound may only go to the speakers behind the screen. Our next pre-mix is footsteps and movements. If people are just moving about within the confines of the screen, then their body movements and footsteps will be kept on the centre channels. However, if they move off screen, or run on to it, we may pan the sound accordingly. The final pre-mix is for the film's musical score. This is usually the last element to arrive, and we do the music pre-mix while taking care that it does not swamp the dialogue, or that the music is not spoilt by intrusive sound effects. Music is a very individual thing, and while it is often easy for us to create a satisfactory balance of dialogue and sound effects without the director present, the director is the only one who knows how he or she wants the music to play against the other sounds.'

'When we have done our pre-mixes, everyone important who is involved with a film and its soundtrack will assemble for the final mix,' continues Hartstone. 'This can often be a tense time, because it is literally the last chance to make any creative alterations to a film. When we have done the final mix, we have three "stems". These are the dialogue stem, the music stem and the effects stem. It is important to keep dialogue separate from music and effects because foreign versions of a film will replace the English language dialogue with their own language.' When the soundtrack for a theatrical release version of a film is completed, it is optically printed on to a 35mm negative, the sounds being represented either by a variable width black area at the side of the picture, or by a matrix of black and clear dots that contain the information for digital sound reproduction. There are a number of sound reproduction systems in use today, so each copy of a film may have as many as four separate soundtracks printed on to it so that its sound can be reproduced in any movie theatre (fig. 3). When the negative of the soundtrack has been created, it is sent to a laboratory, where it is married with the negative of the fully edited picture. Hundreds of copies of the film are then made and distributed to cinemas.

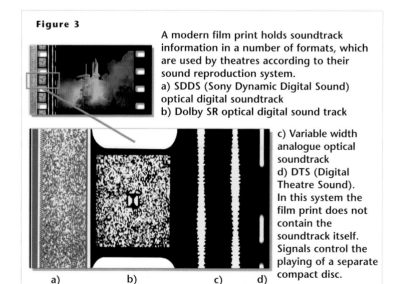

Figure 3

A modern film print holds soundtrack information in a number of formats, which are used by theatres according to their sound reproduction system.
a) SDDS (Sony Dynamic Digital Sound) optical digital soundtrack
b) Dolby SR optical digital sound track
c) Variable width analogue optical soundtrack
d) DTS (Digital Theatre Sound). In this system the film print does not contain the soundtrack itself. Signals control the playing of a separate compact disc.

a) b) c) d)

287

THE CINEMA OF THE FUTURE

OVER THE LAST ONE HUNDRED YEARS, THE ART AND TECHNOLOGY OF SPECIAL EFFECTS HAS BEEN TIRELESSLY IMPROVED UNTIL, AS THE CINEMA ENTERS ITS SECOND CENTURY, FEW CREATIVE BARRIERS REMAIN TO BE BROKEN. WITH THE EXTRAORDINARY ADVANCEMENTS THAT HAVE BEEN MADE IN COMPUTER-GENERATED IMAGERY, IT IS NOW POSSIBLE TO PRODUCE, ARTIFICIALLY, ANY IMAGE THAT THE HUMAN MIND CAN CONCEIVE. MOST FUTURE DEVELOPMENTS IN SPECIAL EFFECTS PRODUCTION ARE LIKELY ONLY TO BE REFINEMENTS OF CURRENT TECHNOLOGY — ALLOWING IMAGERY TO BE CREATED MORE EFFICIENTLY AND CHEAPLY.

Future technological developments will therefore concentrate less on the *type* of images that we create, and more on the way in which we *consume* them. Now, as in the past, we pay to sit in rows and watch an oblong image displayed on a flat screen. But an array of alternative methods of consuming filmed images are now being developed. Some concentrate on the quality of the image itself – making it bigger, sharper, or even extending its apparent depth using 3-D. Other methods attempt to stimulate senses other than sight by physically controlling the environment in which we sit while viewing – such systems introduce movement, aroma, and even changes in temperature.

The cinema stands on the threshold of one of the most revolutionary eras since its invention. Some of the technology now being explored, with its emphasis on increased interaction between image and viewer, looks set to revolutionize the way we perceive visual entertainment for generations to come.

3-D

Since the invention of moving pictures, there have been many experiments in film presentation technology. Few ideas got any further than the drawing board since, during the first half of the century, cinema was the dominant entertainment medium of the world – and Hollywood saw no reason to tinker with a formula that worked. However, the idea of finding new ways to present films was taken more seriously in the 1950s, when television began to steal huge audiences from the cinema. Desperate to halt the decline in moviegoing, the Hollywood studios showed themselves willing to try anything that might distinguish cinema from television and tempt audiences away from their living rooms. Some ideas – such as widening the shape of a cinema screen – were both practical and popular, and remain in use to this day. Other ideas were more harebrained, often seeing the light in only a few movies before fading into obscurity.

The most influential of all 1950s presentation experiments was 3-D, a technique that makes the normally flat images of a cinema screen appear to reach out towards the audience. Though there had been a number of earlier experiments, 3-D cinema only became widely popular with the release of

After the surprise success of Bwana Devil *(1952), Hollywood plunged into the production of 3-D movies.* House of Wax *(1953) was the first 3-D production by a major studio.*

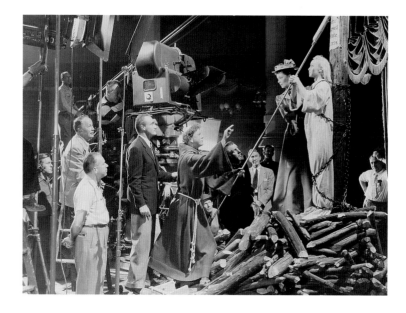

the independently produced *Bwana Devil* in 1952. In fact, the 3-D effects in *Bwana Devil* were actually quite poor – spears waved towards the camera hardly threatened to poke the audience's eyes out, and the occasional encounters with skinny ex-circus lions were barely as thrilling as the 'lion in your lap' promised by the film's promotion. Despite this, and some appalling reviews, *Bwana Devil* was a box-office hit.

Thinking it had found a way to revive its ailing fortunes, Hollywood plunged into the production of 'stereoscopic' films. The trade began to think and talk in terms of 'depthies' and 'flatties' in much the way that 'silents' and 'talkies' had been distinguished on the arrival of sound. But all too often, 3-D was used as a substitute for other production values and some truly terrible films were produced, including *Robot Monster* (1953), a popular candidate for worst movie ever made. There were some more worthy attempts to use the method creatively, however, as in Hitchcock's *Dial M for Murder* (1953) – perhaps the subtlest expression of the technique. But eighteen months after the release of *Bwana Devil*, and with the public already bored of the process, the production of stereoscopic movies dried up. The studios transferred their hopes to other technical innovations such as the widescreen process CinemaScope (<25).

Perhaps the greatest limitation of the 50s 3-D films was the varying quality of their stereoscopic effects. Images rarely 'leapt' from the screen as promised by the publicity, and viewers had to wear uncomfortable red and green spectacles that resulted in a murky-looking image and, in many cases, gave people a headache. Today, however, new technology allows 3-D films to be produced far more effectively than ever before. Anyone viewing a modern stereoscopic production will see images that appear to extend from the screen so realistically that many people cannot resist the urge to reach out and 'touch' them. However, despite their sophistication, the new 3-D techniques still work on the same basic principles that were utilized in the 50s and before.

At the heart of all 3-D processes is the principle of binocular vision. The

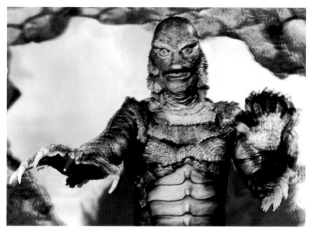

Gill Man from The Creature from the Black Lagoon *(1954) was one of the most popular 1950s creatures to lunge at the audience in 3-D.*

Greek mathematician Euclid, who was the first to notice the phenomenon over two thousand years ago, demonstrated that because our eyes are about two and a half inches apart, each one sees a slightly different perspective of the same scene. By merging these two differing perspectives, our brains create the perception of depth. The phenomenon is easily demonstrated by holding one finger up at arms length. Looking at it alternately with one eye and then the other, the finger will appear to shift in position because it is being viewed from two slightly different angles. Only by looking at the finger with both eyes at once will a real sense of three-dimensional depth be achieved. In order to replicate the way that our eyes work, all 3-D film techniques require a scene to be photographed in stereo – using two cameras to film a scene from slightly different angles. Each of these perspectives must then be presented to just one of our two eyes in order to simulate the impression of binocular vision and three-dimensional depth.

Historically, there have been three basic ways of ensuring that each of our eyes receives just one of the two perspectives necessary to create the 3-D experience. One, the anaglyphic process, uses coloured

1950s cinemagoers wearing anaglyphic glasses enjoy the thrills of a 3-D movie.

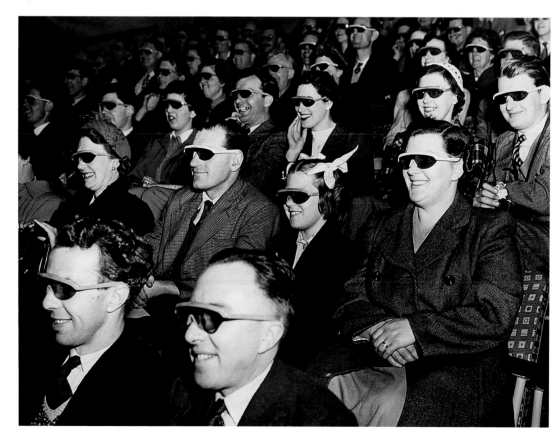

lenses either to transmit or block images of a certain colour. The polarized process, on the other hand, uses the principles of polarized light to separate each image, while the frame sequential process mechanically blocks the view from each eye intermittently. Today's 3-D systems apply new technology to maximize the potential of these processes.

The anaglyphic process was first used for the projection of 3-D images in 1856 when J. C. d'Almeida gave a demonstration at the Académie des Sciences in Paris. Using a magic lantern, he alternately projected two images that had been photographed by two cameras whose lenses were the same distance apart as two eyes. The two images, one coloured red and one coloured green, were viewed by an audience wearing glasses which themselves held one red and one green lens. Each lens effectively obscured the image that was shown in its own colour and highlighted the image shown in the opposite colour. The result was that each eye received only the correct image, producing the illusion of a three-dimensional picture (fig 1). The anaglyphic system, with its familiar red and green glasses, is the most widely known way of creating 3-D films, and it was the method widely used during the 50s. The images themselves can be projected from a single film that either has both the left and right, red and green images superimposed on each frame, or has the red and green images printed on alternate frames. Alternatively, two separate films can be shown simultaneously using two projectors. The anaglyphic system can achieve good 3-D images but it certainly has its drawbacks. Audiences tend to tire of peering through the coloured spectacles for the duration of a whole film. The reliance

Figure 1 THE ANAGLYPHIC PROCESS

The anaglyphic process works by using a red lens to block green (or blue or cyan) light from one eye, and a green lens to block red light from the other eye.

on coloured pictures and spectacles also means that the anaglyphic system cannot be successfully used in full colour.

The polarized light process was discovered in the 1890s and applied experimentally to moving pictures as early as 1896. In the late 1930s the innovations of Dr Edwin H. Land (1909–91), inventor of the Polaroid camera, made the use of polarized light a truly practical method of producing 3-D images.

Polarizing filters work rather like a grid that is made up of microscopic angled slots and bars. Only light that travels at exactly the right angle will pass between the bars while that travelling at any other angle will hit them and bounce off again. The polarization of light cannot be recorded on film during photography, so polarizing filters are placed over lenses during projection. Using two separate projectors, one image of a scene is projected through a polarizing filter with horizontally angled slots, and the other image through a filter with vertically angled slots. A viewer wearing glasses with one vertically slotted lens and one horizontally slotted lens will therefore see a separate image with each eye (fig 2). Polarizing filters in themselves are neutrally coloured, and since colour is not used as a way

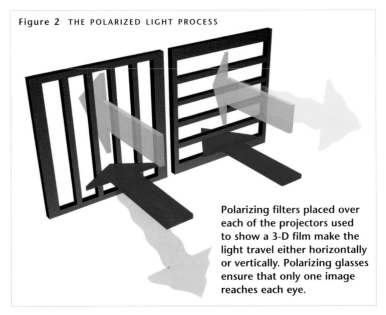

Figure 2 THE POLARIZED LIGHT PROCESS

Polarizing filters placed over each of the projectors used to show a 3-D film make the light travel either horizontally or vertically. Polarizing glasses ensure that only one image reaches each eye.

to separate left and right images, the polarizing method can be successfully used to show 3-D films in natural looking hues.

The 'Teleview' process that was installed in New York's Selwyn Theatre in 1922 was the first to use the frame sequential method of creating 3-D images by using a mechanical means of presenting separate images to each eye. Each viewer looked through a device that contained left and right shutters, which were mechanically opened and closed in synchronization with left and right images that were alternately thrown from a single projector. Looking through a cumbersome contraption attached to the seat in front of them, viewers would be shown one image through the right eyepiece and then one through the left, in rapid succession, to create the impression of depth.

Stephen Hines, one of a number of people who specialize in the increasingly popular field of modern stereography, says that while the basic methods of viewing 3-D films haven't changed, modern equipment does allow far more control over the actual production of spectacular three-dimensional images. 'Today there are several ways of capturing images for a 3-D film,' explains Hines. 'Some systems use a single camera with a special double lens that records two slightly different views next to each other on the same piece of film. But the best way is to use two separate cameras on a platform that allows the cameras to be moved independently to produce different

effects. Once you have those images on two separate reels of film, you can print them and filter them in any way you want depending on how they are going to be shown.'

Hines has invented a camera system that gives film makers total control over the way their 3-D images will look. 'There are several factors that affect the quality of a 3-D image,' he explains. 'Our eyes are about two and a half inches apart. Reproducing this gap, known as inter-ocular distance, will produce images that match our normal perception of images. However, if the distance between the two camera lenses is increased or decreased, it has startling visual implications.' By moving the two lenses farther apart, the final 3-D image looks very small. This phenomenon, called perceptual miniaturization, can often be seen in the popular View-Master 3-D binocular toys. 'View-Master-type pictures are often photographed by using two standard 35mm still cameras that have been bolted side by side,' says Hines. 'Frequently, the result is that the lenses used to take the pictures are twice as far apart as the eyes that we use to view them. As a result, everything looks like it is somehow miniaturized. The reverse happens if the lenses are too close.'

The other major factor that affects 3-D images is the convergence distance of the two lenses. 'Imagine a line that comes from the centre of each of the two lenses being used for 3-D filming. If the lenses are angled very slightly inwards, these lines will eventually intersect. This is the known as the convergence point,' explains Hines. 'When a 3-D film is projected, any object that was beyond the convergence point during filming will appear to be *behind* the plane of the theatre screen, objects that are at the convergence point will appear to be *on* the screen, and objects that are in front of the point will appear to be sticking out towards the audience.'

The rig that Hines has built, called the 'StereoCam', is a platform that can hold two standard 35mm or 65mm motion picture cameras or HDTV (High Definition Television) video cameras. One camera is mounted vertically aiming downwards, while the other is horizontal. Both cameras point at a 45° beam-splitting mirror, which makes it possible for each to film exactly the same scene (fig. 3). However, during operation, the horizontal camera can be moved so that it records a slightly different image to the vertical camera. Moving the horizontal camera can affect both the inter-ocular distance between the two lenses, and their point of convergence, in order to make objects in different parts of a scene appear to leap off the screen. Small video cameras attached to the rig transmit images to a special viewing device which enables the director and camera operator to see a 3-D video image of the scene being filmed.

Figure 3 THE HINESLAB STEREOCAM

A beam-splitting mirror allows a vertically mounted camera and a horizontally mounted camera to film identical images. The horizontal camera can be moved to change the type of 3-D image achieved.

Once the two separate films have been developed, they can be treated according to the method by which they are to be presented. 'Some films are still shown using the red-blue/green anaglyphic process,' explains Hines. 'I've managed to find an optimum balance of coloured filters so that the effect of muddy colours and fringing is minimal. But there is always some fringing when using the anaglyph technique – objects that are in front of the convergence point will have red fringing to their right and objects beyond it will have their fringe to the left. Polarization remains the most practical method of separating the images,' says Hines. 'Polarizing filters are put on each of the two projectors and audiences wear polarized glasses, which present each eye with the correct picture and which have no adverse affect on the quality of the images being projected.' Another system, similar in principle to the Teleview system of the 1920s, uses Liquid Crystal glasses that react to a beam of infra-red light from the projector that causes them to flicker at around 50 hertz and give each eye alternate views of the synchronized pictures on the screen. This system is used by IMAX (see below), which projects its large format 3-D films at twice the regular speed so that each eye can see a different image in turn.

Using up-to-date filming and projection techniques, modern 3-D is hugely superior to the gimmicky process that once produced murky images of varying quality. Creating the convincing illusion that objects and environments on the screen do actually exist in three dimensions, modern 3-D is now a powerful entertainment medium with considerable potential.

Special-venue films

There are a number of other systems that use unusual filming and projection techniques to achieve a spectacular result. So-called 'special-venue films', in which the film itself is the star, are sometimes found in theme parks, but are more often located in major museums and science parks, or as stand-alone sites in city centres.

Special-venue films normally use an unusual film format to produce a particularly high-quality image. The most commonly used system is 'IMAX', which runs 65mm film horizontally through the camera (the 65mm equivalent of VistaVision) at twenty-four frames per second to create the biggest film negative available. IMAX films are projected on to enormous screens that completely fill the viewer's field of vision. The huge size of the screen, combined with the extremely high-quality image, helps to give the viewers the impression that they are actually *at* the location being shown on screen. IMAX films tend to be documentaries set in

impressive landscapes such as the Rocky Mountains or the Arctic. IMAX cameras have even been used by NASA to film breathtaking views of the Earth from space. Though IMAX has been available since the 1960s, it has only recently become widely popular, and there are now hundreds of special IMAX theatres around the world. This has resulted in an explosion of production using the format, including, for the first time, fictional films such as the dramatic forty-minute feature *T-Rex – Back to the Cretaceous* (1998) – a spectacular 3-D movie that stars computer-generated dinosaurs.

A number of hybrid special-venue attractions that combine a range of techniques have also emerged. Among the most impressive of these is Universal Studio's

The enormous size of an IMAX screen fills the viewer's field of vision, making it the most spectacular way of viewing filmed images.

Terminator 2: Battle Across Time (1999), in which audiences view one of the most expensive productions ever filmed. The attraction features 3-D scenes of Arnold Schwarzenegger and other stars of the original film (filmed using Stephen Hines' Stereocam), and some stunning stereoscopic computer-generated animation that appears to leap from the screen and into the auditorium with alarming realism. Excellent stereoscopic 3-D images can be created with the computer since the virtual camera that is used to 'film' within the digital environment is easily doubled to produce the two slightly different perspectives of the same shot that are needed. The inter-ocular distance and convergence point of the two virtual cameras can be controlled so precisely that incredibly effective stereoscopic images result. In the case of *Terminator 2: Battle Across Time*, additional impact is achieved by

Computer-generated characters leap from the screen in this publicity still for Terminator 2: Battle Across Time *(1999).*

Ridefilms

At present, the ultimate in immersive filmed entertainment is the 'ridefilm' – multi-media presentations that combine the experience of travelling on a ride with that of watching a film. Normally the viewer is seated on a motion-base – a hydraulically operated computer-controlled platform that is programmed to move in synchronization with images on a screen. As well as sight, sound and movement, ridefilms sometimes stimulate our other senses by incorporating changes in temperature or using various aromas. Such attractions give viewers the very real impression that they are physically involved with the action that they see on screen.

The most sophisticated ridefilms are based on hit movies, such as the *Back to the Future* ride at the Universal Studios Tour in Florida and California, and can take several years and tens of millions of dollars to create. Because of their expense, such attractions are solely the preserve of the very large theme parks operated by corporations such as Disney, Universal and Warner Brothers. Less extravagant ridefilms are more often installed in smaller parks and entertainment venues where they show films of some exhilarating activity such as motor racing or surfing.

The idea of immersing an audience 'within' a film in the way that a ridefilm does is not a modern one. Pioneering English film maker and inventor Robert W. Paul (<14) came up with the basic prototype of the ridefilm when moving pictures themselves were still a novelty. Working with author H. G. Wells, Paul designed a contraption based on the novel *The Time Machine*. The device was a small room in which an audience would sit to watch the projection of moving pictures that depicted various historical times – as if looking through the window of a time machine. As the images moved from one period of history to another, the walls of the room would shake while air vents blew a breeze over the audience to give the illusion of movement. Paul and Wells applied for a patent on their device in 1895, but neither had the money to develop the project any further.

The 50s threat of television that had film makers scrambling to use 3-D also led many film promoters to look to even more elaborate methods of involving the audience. Some of the most inventive and outrageous concepts of this era were conceived by Hollywood director and producer William Castle (1914–1977). Castle's most famous attempt to physically involve an audience emerged for screenings of his film, *The Tingler* (1959). At a particularly tense moment in the film, projectionists would activate special vibrating motors attached to the underside of a handful of seats in each theatre. Feeling the sudden vibrating 'tingle' in their spine, the more nervous members of the

combining it with a stage show that includes smoke, lasers, and looka-like actors who perform on stage before 'entering' the film by jumping through concealed doorways in the cinema screen.

In most special venues it is the way in which a film is presented that is the most impressive element of the experience. Such presentations tend to use the latest developments in audio-visual technology and are therefore one-off productions so expensive to create that they must play to audiences for many years before becoming profitable. For this reason, special-venue films will continue being created for use in theme parks and major entertainment venues, but will not greatly affect our future cinema-going habits.

audience were supposed to scream in horror, setting off mass hysteria throughout the theatre. Castle called his gimmick 'Percepto' and it helped make a moderate success of his film.

Though the use of vibration to involve an audience lay dormant after *The Tingler*, the idea was reawakened in the 70s when Universal used a system called 'Sensurround' for the release of its disaster epic *Earthquake* (1974). Using a number of special loud-speakers throughout a theatre, Sensurround emitted low-frequency sounds that actually caused the entire venue – including the chairs in which the audience were seated – to vibrate. These vibrations were so powerful that they actually caused physical damage to some of the buildings in which they were used. One Los Angeles theatre had to install a net to catch lumps of plaster as they fell from the ceiling. After its debut, Sensurround was used to enhance screenings of *Midway* (1976), *Rollercoaster* (1977) and the theatrical version of the television series *Battlestar: Galactica* (1979), but the system proved impractical for widespread use.

The 50s assault on our senses even included a number of attempts to make the movies smell more appealing. Among them was a system dubbed 'AromaRama', which was used to add odours to screenings of the travelogue film *The Great Wall of China* (1959). Appropriate smells – guaranteed by the film's publicity not to be objectionable – were wafted into the auditorium through the air conditioning system. A more sophisticated system was used for the film *Scent of Mystery* (1960). 'Smell-O-Vision' released odours that corresponded to images on the film via tubing that ran to each seat in the theatre. The smells – some thirty different varieties – were contained in vials on a rotating drum and were automatically released by 'smell track' signals recorded on the film itself. However, the large cost of converting a theatre to Smell-O-Vision made the system highly impractical, and it was only used for one film in a few venues. Since then, smells have been used to enhance a number of other films including John Waters' *Polyester* (1981) for which viewers were issued scratch-and-sniff-cards – a system advertised as 'Odorama'.

The 1950s also saw experiments into the shape and size of cinema screens. Among these was 'Cinerama', a process that used three projectors to horizontally align three separate images and produce one super-wide picture on the screen. The first film made using the process, *This Is Cinerama* (1952), featured scenes filmed from the front car of a rollercoaster with the aim of making audiences feel that they were themselves sitting on the ride (though the audience experienced no actual motion). Few cinemas equipped themselves for Cinerama, and the ability to create wide images was later more practically achieved with Cinemascope (<25).

Though a number of 'immersive' presentation techniques have been historically available, it wasn't until the 1980s that some of these methods were finally combined to create the first ridefilms. Today's ridefilm experiences are individually designed attractions which use any number of different processes, old and new, to achieve their goal of an immersive entertainment experience.

The father of modern-day ridefilms is visual effects supervisor and cinematic innovator Douglas Trumbull (295>). While working on the visual effects for *2001: A Space Odyssey* (1968), Trumbull helped to create the film's famous Stargate sequence for director Stanley Kubrick. 'The sequence was an extraordinary part of the film both because of the way that it looked [rushing streaks of multi-coloured light that moved towards the camera; <72], but also because it was used in a very unusual way,' says Trumbull. 'The Stargate was seen almost entirely from the point of view of the character played by actor Keir Dullea, and for seventeen minutes the audience saw almost nothing else. The audience was therefore given a first-person experience of this phenomenon – as if they were actually seeing it with their own eyes and going on the journey themselves. That's when I became fascinated with the idea of cinema as an immersive first-person experience rather than the standard melodramatic third-person experience that it had been ever since the medium was invented.'

Trumbull began to investigate ways of making audiences feel more directly involved with the action of a film. 'One of the first things we needed was the ability to create the highest quality images possible,' explains Trumbull. 'Normal 35mm film is sufficient for creating reasonable-looking moving images, but those images are nowhere near the quality required to fool an audience into believing that they are actually seeing "real life" rather than filmed pictures. After a great deal of experimenting, we came up with an optimal balance of film size and frame rate.' The process Trumbull created used 65mm film that ran vertically through a camera and was filmed and projected at a speed of sixty frames per second. This combination of large negative size and fast frame rate produced images that were brighter and sharper than those of any other film process. Projected images were so good that some viewers felt they were actually seeing events first-hand with their own eyes. Trumbull called the process 'Showscan'.

Trumbull next set about providing the other stimulus that he considered necessary for an audience to feel totally immersed in the action of a film: motion. 'I knew that sophisticated hydraulic motion-simulator platforms were being used to make trainee pilots feel as if they were flying a real aircraft while looking at a computer-generated image out of the window. So I reasoned that an audience sitting on a motion platform that had been programmed to move in synchronization with high-quality filmed images would feel as if they too were directly experiencing the events seen on the screen.'

Trumbull's first Showscan ridefilm was installed in Toronto's CN Tower in 1984. 'The ride was called *Tour of the Universe*,' recalls Trumbull. 'Visitors first went through several pre-show procedures in which they were given mock medical examinations and decontaminated – this was all designed to get them into the mood for a trip into space. Finally, the passengers entered a capsule that was mounted on a motion platform. The inside of the capsule was designed to look like the interior of a space shuttle – with a screen at one end where the view from the window could be shown. As the

four-minute film was projected on to the screen in front of the seated audience, the motion platform moved in response to everything seen on screen – blasting into space, reaching Jupiter, hitting an asteroid and coming back to Earth.' The attraction proved very popular with visitors, but the process did not become any more widespread as a result. 'The owners of cinema chains are traditionally very slow to react to any new technology and I think they just didn't know how the attraction might fit into the established cinema-going routine,' remarks Trumbull.

Though *Tour of the Universe* did not take off in the way Trumbull had hoped, the potential of the idea was grasped by Disney, which opened its own ridefilm at Disneyland, California, in 1987. Based on the *Star Wars* films, 'Star Tours' took passengers on a thrilling spacecraft ride through the *Star Wars* universe using four simultaneously running forty-seat motion platforms. Each simulator showed an action-packed film created by Industrial Light and Magic using 65mm film that ran vertically through the camera at thirty frames per second. 'What Disney did was really a great idea,' claims Trumbull. 'They found a way to combine the type of ride that I had developed with a very popular film – therefore making a favourite movie physically accessible to the public.'

The success of Star Tours led to the proliferation of ridefilms at theme parks around the world. In 1989 Douglas Trumbull was given the chance to produce the ultimate in feature film-related ridefilms when he was asked to create an attraction based on the popular *Back to the Future* movie trilogy (1985, 1989, 1990). 'By 1990 the basic motion-platform ridefilm format was well established and I wanted to take the process a step further,' says Trumbull. 'Rather than an audience looking at an image on a flat screen in front of them, I wanted to penetrate the proscenium arch and make people feel as if they were actually sitting *within* the film. I wanted them to see the action not only in front of

A scene from Douglas Trumbull's Back to the Future – The Ride, *in which the audience's DeLorean car is swallowed by a ravenous dinosaur.*

DOUGLAS TRUMBULL

Despite early ambitions to become an architect, Douglas Trumbull (1942–) found that he was more interested in graphic art but, after a year at college, left to work as an illustrator for a small advertising agency. A year later he joined the Los Angeles-based company Graphic Films Corporation, working as a background artist and animator on a number of promotional films for NASA and the US Air Force. Among these was *To the Moon and Beyond*, a Cinerama 360 film that depicted space travel for the 1964 World's Fair.

After seeing *To the Moon and Beyond*, director Stanley Kubrick hired Graphic Films to provide conceptual designs for *2001: A Space Odyssey* (1968). Though the company ceased work on the project when the production moved to England, Trumbull had become so fascinated that he asked Kubrick if he could remain involved. Trumbull eventually became one of the film's four visual effects supervisors, and was responsible for several technical innovations including the creation of the slit scan process used to create the memorable 'Stargate' sequence (<72).

Having proved his ability to create stunning images, Trumbull was then asked to provide the visual effects for a number of big budget science-fiction movies including *The Andromeda Strain* (1971), *Close Encounters of the Third Kind* (1977), *Star Trek: The Motion Picture* (1979) and *Blade Runner* (1982). He directed two effects-heavy feature films: *Silent Running* (1971) and *Brainstorm* (1983).

Trumbull is one of modern cinema's great technical innovators, actively developing and promoting the technology needed to create his visual wonders. He was one of the first to realize the potential of ridefilms, inventing the Showscan process and creating spectacular attractions such as those at the Luxor Pyramid hotel in Las Vegas and the Back to the Future ride at Universal Studios. His company, Entertainment Design Workshop, is now developing new forms of visual entertainment and many innovative 'virtual studio' film making techniques.

them, but also above and to the sides.' Trumbull's ride, which opened at the Florida Universal Studios Tour in spring 1991, used a variation of the IMAX large film format. During filming, a very wide-angle 'fisheye' lens was used to capture the scene both in front, and to the sides, of the camera. A similar lens then projected the resultant images on to a huge 180° hemispherical screen inside a dome. The effect to audiences is of total immersion in the film.

'We created a film in which the audience follows a stolen time-travelling Delorean car through various periods in history,' recalls Trumbull. 'Audience members sit in their own eight-person Delorean car, which is mounted on a motion platform so that it moves in synch with the images on the surrounding screen. The dome actually contains a total of twelve Delorean cars, each on their own motion platform and each carefully arranged so that the passengers cannot see any of the other cars in the dome.' The *Back to the Future* ride offers audiences the amazing feeling of being at the centre of the action – of actually participating in a feature film – and it has become the ridefilm by which all others are judged.

Ridefilms are beginning to become popular at locations other than theme parks. Here Douglas Trumbull stands among the motion platform seats of a ride he has created for the Luxor Pyramid Hotel, Las Vegas.

Due to their expense, major ridefilm attractions based on films such as *Back to the Future, Star Trek* and *Indiana Jones* are only viable in the largest theme parks. Simpler, cheaper attractions are, however, now beginning to proliferate outside the exclusive world of the theme park. The Showscan Corporation, which continues to use the high-quality film process developed by Douglas Trumbull but which now has no other connection with him, is one of a number of companies that install ridefilm attractions in venues around the world as well as creating the films that they show. 'We can create ridefilm attractions to suit any type of venue,' explains Ernest M. Bakenie, Vice President of Sales and Marketing at Showscan. 'We can use either film or high-definition video to project the images on to a screen, and can have any number of seats mounted on motion platforms of various sizes. Unlike the major ridefilms that you find at theme parks, however, our attractions are not built around one film. They can show any film that has been designed as a ridefilm, so what an attraction shows can change every month, every week, or even every day – just like normal cinemas do.'

Showscan and other ridefilm producers experienced a major increase in their business during the late 1990s. 'We have seen a considerable growth in demand for more immersive forms of filmed entertainment,' says Bakenie. 'The public wants to experience different forms of filmed entertainment without having to visit major theme

Sitting on a motion platform that moves in synchronization with projected images, an audience enjoys a ridefilm in a Showscan theatre.

parks. Ridefilm venues can be small and economic enough to exist outside theme parks and can easily be located in multiplex cinemas or family entertainment centres.' Douglas Trumbull expands on the potential of the ridefilm: 'The way that we consume our entertainment will change radically in the future,' he states. 'What we now call the multiplex will probably evolve into a much more sophisticated entertainment media centre. An evening's leisure may still be based around viewing a good "old-fashioned" feature film, but will probably also include dining, gaming and participating in experiences such as ridefilms and various forms of virtual reality. The ridefilm industry may well evolve to work in conjunction with the feature film industry, so that after seeing the standard version of a new movie, you can go next door and experience the ridefilm version, in which a particularly exciting scene from the movie has been adapted and combined with a thrilling motion platform ride.'

Bakenie is in broad agreement with this view. 'Eventually it could reach the point where even normal movie theatres will install motion platform seats. People will then watch a feature film as normal until an exciting action sequence comes along, and then they will experience motion that synchronizes with the film being shown on the screen. Instead of just watching the *Titanic* sink, you will be able to feel your own seat listing over.'

Digital developments and virtual realms

While the reproduction of sound has evolved significantly in the digital age, the projection of images that are recorded and stored on 35mm film has remained essentially unchanged for decades. However, digital projectors that store picture information in a large hard disc memory are now able to project film-quality images on to large screens using millions of microscopic mirrors. Digital projection is attractive to studios and film distributors because it will reduce the huge costs currently involved in manufacturing, transporting and, ultimately, destroying thousands of prints of each new film. Using digital projection, cinemas will receive films on discs, download them through cable links, or have them relayed by satellite. Such methods will help to cut the risk of piracy from stolen film prints and make it easier and quicker for a theatre to adjust the number of screens that are showing a film according to its popularity. Currently, film prints become progressively dusty and degraded with each showing; digital projection, however, will mean that a film will look as good for its hundredth screening as it does at its first. The first digitally projected public screenings of a major movie were of *Star Wars Episode One: The Phantom Menace* (1999), for which four US theatres were equipped with the new projectors. In late 1999 *Toy Story 2* became the first feature film to be entirely created, mastered and exhibited digitally, with selected theatres projecting copies of the movie that had come directly from the

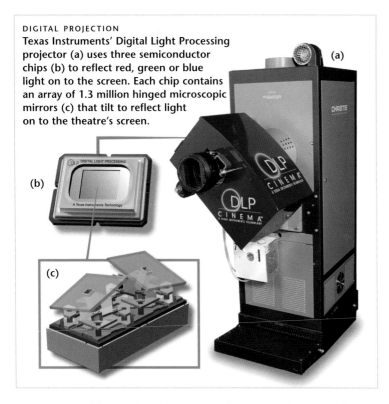

DIGITAL PROJECTION
Texas Instruments' Digital Light Processing projector (a) uses three semiconductor chips (b) to reflect red, green or blue light on to the screen. Each chip contains an array of 1.3 million hinged microscopic mirrors (c) that tilt to reflect light on to the theatre's screen.

(b)

(c)

(a)

computers at Pixar Animation Studios. The future, for major theatre chains at least, will be the exhibition of movies without film.

The continued use of a large screen to communally view films is by no means a certainty. A new technology that dispenses with any form of screen by actually projecting images directly on to the retina of the eye is already available. The system, called Virtual Retinal Display (VRD), was originally developed for military and medical applications – but its potential for entertainment purposes is being explored. The system requires the user to wear a headset which rapidly scans high-resolution images through the pupil and directly on to the retina. To the viewer, these images seem just like ordinary vision – exactly as if they are being seen directly through the eyes and without the black boundaries that we see around the edge of a cinema screen. By linking such a headset to a powerful computer, the head and eye movements of the viewers can be tracked so that as the head is turned, they are able to 'look around' within the environment that they are viewing. In the future it is conceivable that, rather than being rendered out as a 2-D final product, computer-generated films may be 'released' – perhaps via the Internet – in an unrendered 3-D state. A viewer wearing a VRD headset would then act as his or her own virtual camera – as he or she moves their head to see another area of the action, the movement will be measured and used to render, in real-time, their own individual view of the pre-planned on-screen action. Furthermore, because the system is binocular, it can send a slightly different view of a scene to each eye – making it ideal for viewing 3-D films.

In the future, technologies such as Virtual Retinal Display will undoubtedly see widespread use in gaming applications – giving participants a highly interactive relationship with the game they are playing. However, the impact of such 'virtual reality' technology on cinemagoing is more open to speculation. 'In the future, there will undoubtedly be many more ways to receive visual entertainment,' believes Douglas Trumbull. 'The scope for our increased interaction with such entertainment is huge – individuals will be able to choose what they see and even make decisions about how on-screen characters behave. But how that will affect the cinema is hard to tell. I believe that some new form of entertainment that uses computer-generated characters and environments will evolve. This will probably be a highly interactive mixture of the computer game and the cinema as we know it. People may go to the future equivalent of the multiplex to participate in this type of entertainment or, more likely, plug in through the Internet. Ultimately such entertainment may even plug directly into our brain, supplying images and sound and even stimulating certain nerves to control our feelings and emotions. However, despite the increased opportunity for direct interaction with our entertainment, we shouldn't forget the power of the traditional cinema. People do actually enjoy sitting with hundreds of other people in a theatre – where they can laugh and scream in response to a piece of filmed entertainment over which they have no control. Whatever additional new forms of entertainment we create, they will probably exist alongside the old method. There are many entertainment marvels ahead, but the cinema as we know it will be hard to beat, and will still be around for some time to come.'

•

It will take some time before the techniques now being developed for the display and consumption of moving images settle into established new forms of mass entertainment. However, the incredible advances of the last two decades mean that the actual images that these technologies will display are not likely to change vastly; any image imaginable can already be created. But the methods of producing such images are likely to undergo many changes.

Since its invention, the superiority of film as a medium for capturing images has never been challenged. However, high-definition cameras can now record film-quality digital images on tape or disc. This means that footage to be manipulated in the computer will not have to be filmed and then scanned in order to convert it into digital information; it will go straight from camera to computer, cutting out one of the most expensive parts of the digital visual effects process. With this cost removed, digital effects will become affordable to many more productions. When digital projection becomes the standard, movies will be recorded, manipulated, edited and exhibited digitally without a single frame of celluloid having been involved in the process. Digital image acquisition for feature films is already starting to happen. Some scenes in *Star Wars Episode One: The Phantom Menace* (1999) were filmed digitally, and it is expected that the film's sequel will be almost entirely produced in a digital format. Although making movies without film will be convenient, practical and economical, it is likely to be some time before most directors and cinematographers actually come to embrace the concept.

The very structure of the visual effects industry is undergoing many changes which will affect the way movies are produced. The

large long-established effects companies, whose ability to create superior effects was once unquestioned, will find themselves increasingly challenged by a new breed of small rivals able to buy powerful computers and off-the-shelf software at ever lower cost. In order to render their CG images, the big effects facilities have, until now, invested heavily in powerful hardware. However, smaller facilities can now avoid such crippling costs by using the Internet to farm their rendering work out to other companies whose computers are underused or dormant at night. Such 'network rendering' allows any number of remote machines to help create images at a fraction of the traditional cost and time.

This new breed of small effects facilities has emerged, and thrives, partly in response to changes in film production practice. While many months and sometimes even years were once spent planning and producing the visual effects for a major film, today's schedules allow little time for preparation and often require a movie to be ready for release scant months after the completion of filming. Because of this, effects work now tends to be shared between a number of companies, each of which creates just a few of the effects shots in a film.

With digital technology becoming ever more accessible, visual effects – once used to create only the most spectacular story-telling shots in a film – can now be used simply as a money-saving production tool. Where a crew once arrived at a location a week before filming in order to paint buildings, remove television aerials and replace various objects, it is now possible to make many such changes more quickly, and economically, during post-production. Once footage is in a computer, unwanted details may be erased, skies made more dramatic, autumn leaves turned green, crowds of extras multiplied and one actor's best performance combined with another's from a different take. Such 'invisible' effects will undoubtedly become a standard production tool for every film, whether high-octane blockbuster or art-house drama.

While digital effects will increasingly be used to supplement location filming, they also have the potential to replace it altogether. Computers are becoming better at creating photorealistic digital scenery – not just man-made environments such as cities or the interior of spacecraft but also the environments of nature – grass, trees, rivers and oceans. In the future, interior and exterior scenery for films may be created entirely within the computer, making it unnecessary for large crews to travel the world and ensuring that locations match the requirements of a script exactly. Once created digitally, these environments would be composited around performers filmed interacting with a few physical props in a green-screen studio. Studio camera and lighting data will be relayed to a computer which will use the information to render the corresponding digital background scenery. Such 'virtual studios' have already been successfully used for television production and are now being developed for use in the feature film industry.

Given enough time and money, any image imaginable can now be conjured with the computer. For some, however, there remains

one goal; the creation of 'virtual performers' – digital actors indistinguishable from the real thing. Amazingly lifelike interactive digital characters currently appear in many films, but these are often non-human characters such as aliens and dinosaurs whose unfamiliarity helps to disguise their artificial origins. Computer-generated humans tend to be used only very briefly, or in long-shot, so that detailed scrutiny is impossible. There is no doubt that a totally convincing computer-generated actor can and will be created, but in the near future, perfect virtual actors will be so time-consuming and expensive to produce that, other than the publicity gained by the film that features the first virtual cast, the advantages of creating artificial performers are debatable.

The most frequently cited attraction of so-called 'synthespians' is the possibility of making new films with the stars of the past. Humphrey Bogart and Marilyn Monroe are the personalities most frequently tipped for a comeback. There seems to be no doubt that convincing-looking Bogart and Monroe replicas will be possible in the future, but aside from an appropriately hard-boiled face or accurately rendered curves, whether any animator will actually be able to re-create their glamour, or indefinable on-screen presence, remains to be seen. Nevertheless, some enterprising companies have already negotiated for the rights to resurrect certain deceased icons in future movie productions.

The other major use of virtual actors could be for the creation of a generation of entirely new digital film stars. Such characters would be the wholly owned property of entertainment companies and would never have to be paid salaries or royalties, nor would they need an expensive entourage of assistants, drivers and make-up artists. Such performers would become cross-media stars, appearing both in films and computer games. One day a completely convincing, yet wholly artificial, Lara Croft may star in her own series of feature films.

Hollywood has always sought to provide ever-more spectacular images in order to keep audiences coming back for more. But the advent of digital effects has started to challenge the old rules. In 1993, cinemagoers queued round the block to see the computer-generated wonders of *Jurassic Park*. Just a few years later such images were almost commonplace. In the future, film makers will find it increasingly difficult to impress audiences with outstanding images and will instead have to work even harder to create entertainment in which audiences are genuinely swept up by the drama and intrigued by well-observed characters.

A century ago, Georges Méliès was the first film maker to discover that sheer spectacle was not enough to keep audiences coming back, and when he failed to offer audiences anything more than tricks, his films began to lose their popular appeal. Special effects artists will continue to perfect the creation of whatever wonders are asked of them. But in a new century, where films can be made without film, and where dramas may not need actors, the challenge for film makers will be to find new ways of using moving pictures to awe, inspire and entertain us.

SPECIAL EFFECTS LANDMARKS

This section details forty of the most significant special effects films ever made. In compiling this list, hundreds of key effects films from the first hundred years of the cinema have suggested themselves; however, it is beyond the scope of this book to fully cover such a range. While this list is necessarily restricted, it aims to cover the most important and interesting effects movies that have emerged over the decades. Selection is based on the standard and importance of a film's effects at the time of production, and is not intended as a guide to the overall quality of the movies themselves since, sadly, the two do not always equate.

Special effects credits are included for each film, an area not without complications. Early films tended to give screen credits to departmental heads only and not necessarily to those responsible for creating the work. Nevertheless, every attempt has been made to correctly identify those involved in the production of effects in each case. The creation of modern effects films can involve so many people (hundreds of digital artists in the case of a major film) that only departmental heads or supervisors have been listed.

THE ABYSS (1989)

DIRECTOR: *James Cameron*. VISUAL EFFECTS SUPERVISOR: *John Bruno*. VISUAL EFFECTS SUPERVISORS: *Walt Conti (Walt Conti Productions), Robert Skotak (4Ward Productions), Dennis Muren (ILM), Gene Warren Jnr (Fantasy II Film Effects), Hoyt Yeatman (Dreamquest Images)*. SPECIAL EFFECTS CO-ORDINATORS: *Joe Unsinn, Joe Viskocil*. ALIEN CREATURE EFFECTS: *Steve Johnson (Steve Johnson's XFX)*. 145 mins (special edition: 172 mins). *Twentieth Century-Fox*.
The crew of a deep-sea oil rig become involved in a rescue mission to a sunken nuclear submarine where they encounter a strange life form.

A milestone in the evolution of computer-generated effects, *The Abyss* contained ILM's first major computer-generated organic 'character' – a snakelike entity formed of seawater called the Pseudo-pod. With the surrounding environments reflected and refracted in its surface, the character genuinely looks as if it is made of water. At one point, its tip even mimics the faces of the leading characters. Though digitally created, the Pseudopod was still optically composited. Traditional effects included the combination of live action and models – such as a split-screen shot in which a model mini-submarine being dropped into the water was combined with a life-size ship deck with actors on it. Filming of underwater sequences took place in the largest freshwater tank ever built for film use – inside a decommissioned nuclear power station. *Academy Award for Best Visual Effects.*

ALIENS (1986)

DIRECTOR: *James Cameron*. VISUAL EFFECTS SUPERVISORS: *Robert Skotak, Dennis Skotak*. POST-PRODUCTION VISUAL EFFECTS SUPERVISOR: *Brian Johnson*. SPECIAL EFFECTS SUPERVISOR: *John Richardson*. MINIATURES TECHNICAL SUPERVISOR: *Pat McClung*. ALIEN EFFECTS: *Stan Winston*. 137 mins (director's cut: 154 mins). *Twentieth Century-Fox*.
After fifty-seven years in hibernation, Officer Ripley (Sigourney Weaver) – the sole survivor of Alien *– returns to the home planet of the monstrous life form that caused so many problems in the first film. With a crew of Combat Patrol Marines, she attempts to destroy the alien threat.*

Aliens features some of the finest multi-element in-camera visual effects ever produced. For many shots, beam-splitters were used to combine models, live action, matte paintings and other elements. An early shot of the Gateway space station was an in-camera composite produced using a photographic blow-up of a painting of the earth, a glass painting of sections of the space station, a model of sections of the space station, a sun element and model spacecraft flying on wires. Beam-splitters were also used to introduce smoke and fire elements to small models to help with the perception of scale. Other model shots were combined with live action using front and rear projection. Shots of the alien nest were created by combining a partially built full-scale set with a hanging miniature. A variety of aliens ranging from full-sized people-in-a-suit versions to miniature puppets were built. Perhaps the most ingenious alien creation was a small 'face-hugger' which ran along a wire that controlled the scuttling movement of its legs. Major physical effects achievements included a 'powerlifter' – a servo-controlled walking forklift. *Academy Awards for Best Visual Effects and Sound Effects Editing.*

AN AMERICAN WEREWOLF IN LONDON (1981)

DIRECTOR: *John Landis*. SPECIAL MAKE-UP EFFECTS: *Rick Baker*. SPECIAL MAKE-UP EFFECTS ASSISTANT: *Steve Johnson*. SPECIAL EFFECTS: *Martin Gutteridge, Garth Inns*. 97mins. *Polygram*.
Bitten by an English werewolf, an American tourist creates havoc in the streets of London.

American Werewolf achieved some of the most remarkable human-into-wolf transformations ever seen on screen. The basis for this was the 'change-o-head' technique conceived by Rick Baker for this film but which, due to delays, was first used for the transformations created by Rob Bottin for *The Howling* (1980) – on which Baker was a consultant. 'Change-o-head' involved using life-masks of actors and manipulating and distorting them from behind with rods or inflatable bladders to look as if major changes were happening under the skin. For *Werewolf*, Baker used the technique for the whole body so that the character's face, legs, feet, arms, hands and back are all seen stretching and rippling as if the bones below are reorganizing themselves. Fur growing on the body of the wolf was achieved by pulling hair *into* the latex skin and running the film backwards. Other make-up included a fully changed wolf puppet and the lacerated faces of werewolf victims. *Academy Award for Best Make-up.*

THE BIRDS (1963)

DIRECTOR: *Alfred Hitchcock*. PROCESS CINEMATOGRAPHY: *Ub Iwerks*. OPTICAL CINEMATOGRAPHY: *Roswell A. Hoffman*. MATTE ARTIST: *Albert J. Whitlock*. ADDITIONAL VISUAL EFFECTS: *L. B. Abbot, Linwood G. Dunn, Robert R. Hoag*. ANIMATION: *David Fleischer*. MECHANICAL EFFECTS SUPERVISOR: *Lawrence W. Hampton*. MECHANICAL EFFECTS TECHNICIAN: *Marcel Delgado*. 120 mins. *Universal*.
The residents of a quiet Californian town are unaccountably besieged by flocks of angry birds.

Hitchcock's greatest effects achievement, *The Birds* used sodium vapour, blue-screen and hand-drawn travelling mattes to combine real birds filmed flying in a studio with location scenes. Shots in which thousands of birds gathered were created by optically combining up to thirty separate elements. For the final attack sequence, Tippi Hedren spent a week having real birds thrown at her and tied on to her clothes with string. Mechanical birds that flapped and pecked were also used on location. Locations filmed in the Californian town of Bodega Bay were expanded with superbly atmospheric matte paintings. (<55)

BLADE RUNNER (1982)

DIRECTOR: *Ridley Scott.* SPECIAL PHOTOGRAPHIC EFFECTS: *Entertainment Effects Group.* SPECIAL PHOTOGRAPHIC EFFECTS SUPERVISORS: *Douglas Trumbull, Richard Yuricich, David Dryer.* SPECIAL PHOTOGRAPHIC EFFECTS DIRECTOR OF PHOTOGRAPHY: *Dave Stewart.* OPTICAL PHOTOGRAPHY SUPERVISOR: *Robert Hall.* MATTE ARTISTS: *Matthew Yuricich, Rocco Gioffre, Michelle Moen.* ANIMATION & GRAPHICS: *John Wash.* CHIEF MODELMAKER: *Mark Stetson.* MECHANICAL EFFECTS SUPERVISOR: *Terry Frazee.* VISUAL DISPLAYS: *Dream Quest Inc.* VISUAL FUTURIST: *Syd Mead.* 114 mins (director's cut: 117 mins). *Warner Bros.*

In the Los Angeles of 2019, an ex-cop (Harrison Ford) is hired to track down and eliminate a group of dangerously intelligent 'replicants'.

Most of *Blade Runner*'s sumptuous effects are used to portray the LA of the future. Large forced-perspective models of the city were filmed in thick smoke to create long-shots of the heavily polluted environment. Many shots were extended with brilliant matte paintings. A shot looking up at a passing airship through the glass roof of the Bradbury building was created by sticking a photo cut-out of the roof on to glass. This photo, and the camera used to film it, were moved past a stationary model blimp that had advertising images projected on to its silk sides. The 'Spinner' aircraft were created in a range of sizes from eighteen-inch models to full-size mock-ups. Rear projection was used to create the passing backgrounds for shots inside the Spinner cockpit, while front projection provided the backgrounds in the Tyrell Corporation Headquarters.

CITIZEN KANE (1941)

DIRECTOR: *Orson Welles.* SPECIAL EFFECTS: *Vernon L. Walker.* OPTICAL EFFECTS: *Linwood Dunn.* MATTE ARTIST: *Mario Larrinaga.* EFFECTS CAMERA: *Russel Cully.* SOUND EFFECTS: *Harry Essmanti.* SPECIAL MAKE-UP EFFECTS: *Maurice Seiderman.* 119 mins. *RKO Radio Pictures.*

After the death of newspaper tycoon Charles Foster Kane (Orson Welles), a journalist interviews the man's acquaintances in an attempt to discover the meaning of his last word: 'Rosebud…'

Hundreds of subtle effects shots made the modestly budgeted *Citizen Kane* look like a lavish epic. Matte paintings enlarged the interiors of Kane's mansion 'Xanadu' and the exterior of the Kane newspaper offices. Clever optical printing multiplied the crowds at a political rally and combined live action and models to exaggerate the size of an opera house. Hanging miniatures were used to add ceilings to sets, and stop-motion animation created the movement of vehicles on the Xanadu building site. Convincing make-up effects made Welles look both younger and considerably older than his real age (<62).

CLOSE ENCOUNTERS OF THE THIRD KIND (1977)

DIRECTOR: *Steven Spielberg.* SPECIAL PHOTOGRAPHIC EFFECTS: *Douglas Trumbull.* DIRECTOR OF EFFECTS PHOTOGRAPHY: *Richard Yuricich.* MECHANICAL EFFECTS: *Roy Arbogast, George Polkinghorne.* MATTE ARTISTS: *Matthew Yuricich, Rocco Gioffre.* CHIEF MODELMAKER: *Greg Jein.* MOTHERSHIP CINEMATOGRAPHER: *Dennis Muren.* EXTRATERRESTRIAL REALIZATION: *Carlo Rambaldi, Isidoro Raponi.* 135 mins (1980 Special Edition: 132 mins, 1998 Collector's Edition: 137 mins). *Columbia Pictures.*

Though kept secret by the government, mankind's first contact with alien life cannot be hidden from a number of ordinary people who find themselves mysteriously drawn to the chosen landing site.

Spielberg's first major visual effects film used a combination of traditional techniques and cutting-edge technology to create some of the most awe-inspiring effects ever achieved. Shots of the Indiana landscape were produced using forced-perspective models with miniature houses as small as one inch in height. These models were photographed and used as front-projection backgrounds for full-scale

sets used during live-action scenes. Front projection was also used to create the shimmering light patterns on the belly of the alien mothership. The mothership itself was a six-foot model with thousands of tiny lights created using individual internal bulbs, fibre optics and neon-filled aluminium tubes drilled with minute holes. Using a pioneering motion-control system, spacecraft models were filmed in a smoke-filled environment to give them a magical glowing effect. Physical effects included turning a car and a camera upside down simultaneously to create a shot in which the contents of the car float upwards as a spaceship moves overhead.

DARBY O'GILL AND THE LITTLE PEOPLE (1959)

DIRECTOR: *Robert Stevenson.* SPECIAL EFFECTS: *Peter Ellenshaw.* OPTICAL PROCESSES: *Eustace Lycett.* ANIMATION EFFECTS: *Joshua Meador.* 90 mins. *Walt Disney Productions.*

An Irish caretaker (Albert Sharpe) falls down a well and into the kingdom of the leprechauns.

One of the best effects films of its day, *Darby O'Gill* used a range of techniques including deep-focus photography and sodium-vapour travelling mattes, to create shots of full-sized people interacting with leprechauns. Normal-sized sets were combined with oversized replicas using split-screen techniques. Leprechauns interacted with huge models of human limbs while actors playing humans sometimes appeared with small puppets. There are excellent animation effects such as the addition of an animated mouth to a real horse, and some beautiful matte paintings create the rural Irish locations.

DESTINATION MOON (1950)

DIRECTOR: *Irving Pichel.* VISUAL EFFECTS TECHNICAL SUPERVISOR: *John S. Abbott.* MECHANICAL EFFECTS SUPERVISOR: *Lee Zavitz.* EFFECTS PHOTOGRAPHY: *Lionel Lindon.* MATTE PAINTINGS AND BACKDROPS: *Chesley Bonestell.* ANIMATOR: *Fred Madison.* MAKE-UP: *Webster Phillips.* 91 mins. *United Artists.*

After governmental budget cuts, an inventor persuades private investors to pay for his rocket so that the USA can reach the moon before the Russians.

The first great sci-fi movie of the 50s, *Destination Moon* was designed to be as scientifically accurate as possible. The surface of the moon was built on a sound stage where forced-perspective landscaping combined with small people dressed as astronauts helped to give a huge sense of scale. Two thousand car headlamps were used to create the stars in the sky. A full-size 150-foot-high rocket set was built in the Mojave desert, but a model was substituted for the take-off scenes. Stop-motion was used for the landing of the ship and scenes in which astronauts walk along its hull. Full-scale spacewalk scenes were created by hanging actors from wires and manipulating them like puppets. Rubber membranes fitted to actors' faces and operated by hidden levers stretched their skin to produce the effects of G-forces when taking off. *Academy Award for Best Special Effects.*

EARTHQUAKE (1974)

DIRECTOR: *Mark Robson.* SPECIAL EFFECTS CINEMATOGRAPHER: *Clifford Stine.* SPECIAL PHOTOGRAPHIC EFFECTS/MATTE PAINTINGS: *Albert J. Whitlock.* MINIATURES SUPERVISOR: *Glen E. Robinson.* MECHANICAL EFFECTS: *Frank Brendell, Jack McMasters, Lou Ami.* 122 mins. *Universal.*

When Los Angeles is rocked by a huge earthquake, its citizens are affected in different ways.

Much of *Earthquake*'s full-scale destruction was real – pre-weakened full-scale sets were built on enormous shaker platforms, and six-tonne blocks of concrete were dropped just feet from leading actors. Perfect miniature re-creations of landmark buildings were designed to shake apart, and the footage of miniature destruction carefully combined with

that of real locations. The Hollywood dam was re-created as a 56-foot-long miniature – though the problems of miniaturizing water marred some shots of its actual destruction. Over forty exquisite matte paintings expanded the damage done to the city. The film won an Oscar for Special Achievements in Visual Effects and a Scientific and Technical Academy Award for the invention of a camera-shaking device.

THE EXORCIST (1973)

DIRECTOR: *William Friedkin*. SPECIAL MAKE-UP EFFECTS: *Dick Smith*. OPTICAL EFFECTS: *Marv Ystrom*. SPECIAL EFFECTS SUPERVISOR: *Marcel Vercoutere*. SPECIAL SOUND EFFECTS: *Ron Nagle, Doc Siegel, Gonzalo Gavira, Bob Fine*. 122 mins. *Warner Bros.*

A young girl (Linda Blair) becomes possessed by the devil.

For one of the most notorious horror films ever made, Dick Smith turned actress Linda Blair into a child possessed by the devil. In one shot, the words 'help me' appear on the child's stomach. This was achieved by painting the phrase in a chemical that made the skin on a foam rubber stomach swell. The fake stomach was then filmed as heat guns evaporated the chemical, returning the skin to normal. When the resulting film was projected backwards, the words seemed to appear in the flesh. To make the child spew green vomit, hidden pipes were run along the cheeks and into the mouth of stunt-double Eileen Dietz. A nozzle in the mouth then sprayed pea soup on cue. The film marked the first use of 'bladder effects' – for a shot in which the girl's neck puffs up, a balloon was concealed under disguised false skin and inflated with air. Smith's subtlest achievement was to transform 44-year-old actor Max Von Sydow into a 70-year-old. So that performers' breath would be visible in some scenes, the child's bedroom was built within a giant refrigerator. *Academy Award for Best Sound.*

FANTASTIC VOYAGE (1966)

DIRECTOR: *Richard Fleischer*. VISUAL EFFECTS: *L. B. Abbott*. OPTICAL CINEMATOGRAPHY: *Art Cruickshank*. MATTE ARTIST: *Emil Kosa*. MINIATURE SUPERVISOR: *Howard Lydecker*. MINIATURISTS: *Marcel Delgado, Roy Arbogast*. WIRE FLOATING/FLYING EFFECTS: *Peter Foy*. 100 mins. *Twentieth Century-Fox.*

An assassination attempt is made on an important scientist who is defecting to the West. A team of doctors and a submarine are shrunk to microscopic size and injected into the scientist's bloodstream in the hope of repairing the damage to his brain.

Fantasic Voyage re-created the inside of the human body as a series of huge, accurately detailed sets. The brain set was 100 feet long and 35 feet wide while the heart set was 130 feet long and 30 feet high complete with working valves and muscles. A full-sized submarine 42 feet in length and weighing 4 tonnes was built for use in these scenes. Transparent arteries were made to look as if they had blood cells moving within them by using a colour wheel that projected violet and pink discs on to their walls. Shots of actual cells moving through the bloodstream were created by filming blobs of heated vaseline and mineral oil, which floated in water. Scenes in which the explorers swim through the body were created by suspending performers on wires and filming at three times normal speed. *Academy Award for Best Visual Effects.*

FORBIDDEN PLANET (1956)

DIRECTOR: *Fred McLeod Wilcox*. SPECIAL EFFECTS SUPERVISOR: *A. Arnold Gillespie*. MATTE ARTISTS: *Warren Newcombe, Howard Fisher, Henri Hillinick*. MINIATURES SUPERVISOR: *Maximillian Fabian*. ANIMATION SUPERVISOR: *Joshua Meador*. ANIMATORS: *Joe Alves, Dwight Carlisle, Ronn Cobb*. OPTICAL PHOTOGRAPHY: *Irving G. Reis*. 98 mins. *MGM.*

A team of astronauts lands on the planet of Altair-IV to search for survivors from a previous mission. Only two people and their robot are found, but a strange creature begins to attack the newly arrived visitors. A sci-fi update of Shakespeare's The Tempest.

One of the best effects films of the 50s, *Forbidden Planet* still looks good when seen today. The United Planets Cruiser spaceship was a combination of models flown on wires and filmed at high speed; a full-scale studio mock-up of the bottom half of the craft was also built – the top section was matted-in for long-shots. Simple but effective techniques included the use of split screens to make a leaping tiger vanish when shot by the Captain (Leslie Nielsen), and a hand-drawn animated Monster of the Id. Impressive sets included the surface of the planet Altair-IV and the spacecraft cockpit – its flashing lights and control panels required twenty-seven miles of electrical wiring. For many people the film's most memorable character is Robby the Robot – a bulbous two-legged droid with a transparent domed head and concertina arms. Robby's flashing lights, spinning antennae and other moving parts required 2,500 feet of electrical wiring which emerged from one heel and ran to a nearby control panel. Robby was so popular (and expensive) that MGM re-used him in *The Invisible Boy* (1957) the following year.

FORREST GUMP (1994)

DIRECTOR: *Robert Zemeckis*. SPECIAL VISUAL EFFECTS: *Industrial Light and Magic*. VISUAL EFFECTS SUPERVISOR: *Ken Ralston*. OPTICAL SUPERVISOR: *Bruce Vecchitto*. CG SUPERVISORS: *George Murphy, Stephen Rosenbaum*. SPECIAL EFFECTS SUPERVISOR: *Allen Hall*. SOUND DESIGN: *Randy Thom*. 142 mins. *Paramount.*

A slow-witted man (Tom Hanks) drifts through life and experiences a number of extraordinary historic situations along the way.

Robert Zemeckis has always made use of visual effects for story-telling purposes rather than simply for show, and *Gump* is typical of the way in which he employs effects to enhance realism rather than create the unbelievable. The opening sequence of a feather drifting through the sky was created by digitally blending together dozens of blue-screen shots of a real feather. Scenes set in Vietnam involved digital matte painting, and actor Gary Sinise had his legs digitally removed for his portrayal of a Vietnam veteran. Other highlights included the digital manipulation of stock footage to show Hanks interacting with historical figures such as Richard Nixon, John F. Kennedy and John Lennon. Crowd replication was used to create huge numbers of people in a stadium and a political rally. *Academy Award for Best Visual Effects.*

JASON AND THE ARGONAUTS (1963)

DIRECTOR: *Don Chaffey*. SPECIAL VISUAL EFFECTS: *Ray Harryhausen*. 104 mins. *Columbia.*

The fabled Jason (Todd Armstrong) travels on board his ship, the Argo, in search of the Golden Fleece, encountering a host of mythical gods and beasts along the way.

Considered by many (including the animator himself) to be Harryhausen's best work, *Jason* contains some of the most memorable stop-motion sequences ever to have been committed to film. Highlights include Talos, an enormous bronze statue who comes to life when the treasure he guards is threatened. With his startlingly impassive face, the character creaks and grinds as he moves – a deliberate attempt to indicate the rusting of joints rather than the bad animation claimed by some critics. Other characters include a seven-headed Hydra and a pair of devilish half-bird, half-human Harpies. The film is most remembered for the amazing sequence in which three men fight seven sword-wielding skeletons. The extraordinary interaction between actors and puppets makes this perhaps the most complex and thrilling stop-motion scene ever achieved.

JURASSIC PARK (1993)

DIRECTOR: *Steven Spielberg.* SPECIAL VISUAL EFFECTS: *Industrial Light and Magic.* FULL-MOTION DINOSAURS: *Dennis Muren.* LIVE-ACTION DINOSAURS: *Stan Winston.* DINOSAUR SUPERVISOR: *Phil Tippett.* SPECIAL DINOSAUR EFFECTS: *Michael Lantieri.* SOUND DESIGN: *Gary Rydstrom.* 126 mins. *Universal.*
Using fossilized DNA, scientists genetically re-create living dinosaurs for display in an island theme park. Based on the novel by Michael Crichton.

Jurassic Park was the film that finally convinced the world that the computer was the effects tool of the future. ILM's computer-generated dinosaurs had a life never before captured in an artificially created performance. Highlights include a T-Rex attack at night, in which a digital dinosaur snatches a real actor from a toilet – the actor being replaced by a digital performer at the last moment – and a stampeding herd of Gallimimus. Computer animation was complemented with animatronic creations that ranged from a forty-foot T-Rex to a tiny hatchling, as well as a number of close-up feet, arms and heads which intercut seamlessly with the CG work. Dinosaurs were made all the more convincing by brilliant sound design which created their growls and roars by mixing a number of real animal calls. As well as creating the interaction of digital dinosaurs with real environments, physical effects included a number of impressive set pieces, such as an artificial tree with breakaway branches to enable a full-sized jeep to be dropped through it (<170). *Academy Awards for Best Visual Effects, Sound and Sound Effects Editing.*

KING KONG (1933)

DIRECTOR: *Merian C. Cooper, Ernest B. Schoedsack.* SPECIAL EFFECTS SUPERVISOR: *Willis O'Brien.* ANIMATION PUPPETS: *Marcel Delgado.* SPECIAL EFFECTS TECHNICIANS: *E. B. Gibson, Orville Goldner, Fred Reefe, Carroll Shepphird.* ARTISTS: *Mario Larrinaga, Bryon L. Crabbe.* OPTICAL EFFECTS: *Linwood Dunn, William Ulm.* REAR PROJECTION: *Sydney Saunders.* DUNNING PROCESS SUPERVISORS: *Carroll H. Dunning, C. Dodge Dunning.* WILLIAMS PROCESS SUPERVISION: *Frank Williams.* 103 mins. *RKO Radio Pictures.*
A film producer discovers an island populated by dinosaurs and a gigantic ape. The ape is captured and taken to New York in chains where it escapes and causes havoc.

The greatest effects film of its day, *Kong* used every technique available at the time. A full-size bust, arm and leg were built for close-ups, but most shots of Kong were created using an eighteen-inch stop-motion puppet. Stop-motion animation was also used for the Skull Island dinosaurs, various shots of human characters, and the attacking aircraft and elevated train sequences. Traditional 2-D animation created a flock of seagulls on the approach to Skull Island. Composite shots were created using Williams Process and Dunning Process travelling mattes, double-exposure split screens and both miniature and full-sized rear projection. Glass shots were used to portray many locations including the establishing shots of Skull Island and the New York skyline. The front of the Skull Island wall was a full-size set but the reverse of the wall was created by combining a miniature wall and foreground with footage of extras on the roof of a studio building (<152).

THE LAST STARFIGHTER (1984)

DIRECTOR: *Nick Castle.* DIGITAL SCENE SIMULATION: *John Whitney Jnr, Gary Demos (Digital Productions).* SPECIAL EFFECTS SUPERVISOR: *Kevin Pike.* SPECIAL EFFECTS: *James Dale Camomile, Michael Lantieri, Darrell D. Pritchett, Joseph C. Sasgen.* 101 mins. *Universal/Lorimar.*
When he achieves a high score on his favourite video game, a teenage boy (Lance Guest) discovers that the game is actually a recruitment device used by a race of aliens.

An important landmark in the development of computer-generated images (or 'Digital Scene Simulation', as it was then commonly called), *The Last Starfighter* created all of its spaceship shots digitally. The new technology was still lacking many of the subtleties that make today's animation so convincing – most surfaces look too 'perfect' and there is no motion blur in shots of fast-moving spaceships. However, this film made the potential of the technique obvious. The building and animation of computer models took two and a half years using a $15 million Cray Supercomputer – one of the most powerful computers in the world at that time. Gary Demos and John Whitney Jnr received a Scientific and Technical Academy Award for 'the practical simulation of motion picture photography by means of computer-generated images'.

THE LOST WORLD (1925)

DIRECTOR: *Harry Hoyt.* RESEARCH AND TECHNICAL DIRECTION (STOP-MOTION ANIMATION): *Willis O'Brien.* CHIEF TECHNICIAN: *Fred W. Jackman.* TECHNICAL STAFF: *Marcel Delgado* (ANIMATION PUPPETS), *Homer Scott, J. Devereaux Jennings, Vernon L. Walker.* ART TECHNICIAN: *Ralph Hammeras.* 108 mins. *First National Pictures.*
After claiming to have discovered the existence of dinosaurs, Professor Challenger (Wallace Beery) persuades a national newspaper to finance a scientific expedition to a remote jungle plateau. Based on the novel by Sir Arthur Conan Doyle.

The first great creature movie, *The Lost World* is a silent masterpiece that still makes remarkable viewing. Puppet dinosaurs animated by Willis O'Brien were built by Marcel Delgado using wood and wire skeletons covered with foam rubber – a great improvement over the clay puppets which, until then, had been the norm. Animation highlights include a stampede of some fifteen dinosaurs on the run from an erupting volcano and morning-after shots in which herds of dinosaurs browse on vegetation and the carcass of a dead creature. The dinosaurs were not the film's only animated elements; an Apatosaur in a swamp was surrounded by pliable gelatin which was re-moulded between shots to look like mud. Animation and live action were effectively combined with clever split-screens. The brontosaur which rampages around London had both its tail and head built full-size. The film was originally around 108 minutes in length (depending on the speed of projection) but was later re-edited to half this length. Much of the original footage has been lost over the years but a campaign to find and restore the lost scenes is gradually returning the film to its full glory. (<149)

THE MATRIX (1999)

DIRECTORS: *Larry & Andy Wachowski.* VISUAL EFFECTS SUPERVISOR: *John Gaeta.* ASSOCIATE VISUAL EFFECTS SUPERVISOR: *Janek Sirrs.* DIGITAL EFFECTS SUPERVISOR: *Rodney Iwashina (Manex Visual Effects).* PROSTHETICS: *Bob McCarron.* ANIMATRONICS: *Paul Katte, Nick Nicolaou (Make-up Effects Group).* BULLET-TIME TECHNICAL DIRECTOR: *Kent Estep (Manex Visual Effects).* SPECIAL EFFECTS SUPERVISORS: *Brian Cox, Steve Courtley.* MODELS AND MINIATURES SUPERVISOR: *Tom Davies.* 136 mins. *Warner Bros.*
A computer programmer (Keanu Reeves) is recruited to help fight a form of artificial intelligence which, having defeated mankind in a global war, now keeps most of humanity plugged into an artificial reality.

One of the most visually innovative movies of its decade, *The Matrix* used groundbreaking digital techniques to produce some stunning action sequences. The film is best remembered for its 'bullet-time' shots in which performers supported on wires were photographed with hundreds of still cameras to create a single shot that moved around an extreme slow-motion performance. Interesting 'invisible' effects included the construction of 'virtual backgrounds': still photographs of real environments were taken from carefully measured positions.

THE THIEF OF BAGDAD (1940)

DIRECTORS: *Ludwig Berger, Michael Powell, Tim Whelan.* TRAVELLING MATTES: *Tom Howard, Stanley Sayer.* MATTE ARTISTS: *W. Percy Day, Wally Veevers.* MINIATURES: *Johnny Mills.* MECHANICAL EFFECTS: *Lawrence W. Butler.* SPECIAL SOUND EFFECTS: *Jack Whitney.* 106 mins. **United Artists.**
After an evil grand vizier (Conrad Veidt) deposes a good caliph (Miles Malleson), a young boy (Sabu) – the eponymous thief – helps to restore the throne to its rightful owner.

Thief was the first film to use Technicolor blue-screen travelling mattes for scenes such as a mechanical horse riding through the sky, the appearance of a giant djinn and shots of a flying carpet. Other effects included glass shots, matte paintings, and forced-perspective sets for the re-creation of the exotic city of Bagdad (filmed in a London suburb), model ships and giant mechanical props such as an over-sized djinn's foot and a spider. *Academy Award for Best Special Effects.*

THINGS TO COME (1936)

DIRECTOR: *William Cameron Menzies.* SPECIAL EFFECTS DIRECTOR: *Ned Mann.* SPECIAL EFFECTS ASSISTANTS: *Lawrence W. Butler, Wally Veevers.* SPECIAL EFFECTS PHOTOGRAPHY: *Edward Cohen ASC, Harry Zech.* MINIATURE DESIGNS: *Ross Jacklin.* MATTE PAINTINGS: *W. Percy Day.* ASSISTANT MATTE ARTIST: *Peter Ellenshaw.* 92 mins. **London Films.**
After a catastrophic world war, the citizens of Earth form a futuristic new society. Based on the book The Shape of Things to Come *by H. G. Wells.*

Though the production of *Things to Come* did not involve the development of any new techniques, the sheer number and quality of effects ensure its status as a landmark film. Superb matte paintings established the city 'Everytown', its destruction and eventual rebuilding. Thirty years of war were depicted by a series of scenes in which futuristic model tanks rumble across battlefields and aircraft swarm overhead. Live-action footage of real cities was carefully combined with scenes of miniature destruction using split-screen work. Optical printing effects superimposed text to show the passing of the years as well as legions of soldiers on the march. The film is best remembered for its scenes of a utopian technological future. Society reconstructs itself in an exciting montage of excellent effects work in which models, matte paintings and live action are combined using split screens, optical printing and rear projection. The vast city of the future was created by combining full-scale sets and models (complete with working lifts and monorails) using foreground miniatures and the Shuftan process.

TITANIC (1997)

DIRECTOR: *James Cameron.* SPECIAL VISUAL EFFECTS: *Digital Domain.* VISUAL EFFECTS SUPERVISOR: *Rob Legato.* DIGITAL EFFECTS SUPERVISOR: *Mark Lasoff.* 2D DIGITAL EFFECTS SUPERVISOR: *Michael Kanfer.* ADDITIONAL VISUAL EFFECTS: **Banned from the Ranch, Cinesite, CIS Hollywood, Digiscope, 4ward Productions, Hammerhead Productions Inc, Industrial Light and Magic, Light Matters Inc, Matte World Digital, Pacific Title Digital, Perceptual Motion Pictures, Pop Film.** SPECIAL EFFECTS SUPERVISOR: *Thomas L. Fisher.* SPECIAL MAKE-UP EFFECTS: *Greg Cannom.* SOUND DESIGN: *Christopher Boyes.* 194 mins. **Paramount/Twentieth Century-Fox.**
The romance between two young people of differing social backgrounds is played out against the doomed maiden voyage of the Titanic.

An effects film on an epic scale, *Titanic* combined cutting-edge effects technology and old-fashioned tricks to create some stunning sequences. Long-shots of the ship were created by filming a 44-foot 'miniature' with motion-control and combining it with CG water, smoke, passengers and other elements. Larger scale sections of the ship were built and sunk in a specially created tank and a full-scale ship was constructed in Mexico.

Some interiors, such as the first-class lounge and the engine room, were miniatures with actors composited into them. Beautifully executed morph sequences acted as transitions between the present day and the past and even as a link to footage of the genuine *Titanic* wreck. Motion-captured performances allowed digital actors to perform many stunts, and digital face replacements put the faces of leading actors on to the bodies of stunt performers. Major physical effects included flooding full-scale sets with thousands of gallons of water. The soundtrack contained more sound elements than any other film in history. *Academy Awards for Best Visual Effects, Sound and Sound Effects Editing.*

TOY STORY

DIRECTOR: *John Lasseter.* ART DIRECTOR: *Ralph Eggleston.* SUPERVISING ANIMATOR: *Pete Docter.* DIRECTING ANIMATORS: *Rich Quade, Ash Brannon.* 80 mins. **Disney/Pixar.**
A young boy's collection of toys comes to life when nobody is looking. However, the harmony of the group is threatened with the arrival of a new high-tech spaceman, 'Buzz Lightyear'.

The world's first computer-generated feature film, *Toy Story* thrilled children and adults alike with its mix of action and comedy. Director John Lasseter proved that computer-generated performances could be as good as anything in an ordinary animated film. Lasseter received a special Oscar for the production of this landmark film. (<173)

TRON (1982)

DIRECTOR: *Steven Lisberger.* VISUAL EFFECTS SUPERVISORS: *Harrison Ellenshaw, Richard W. Taylor.* COMPUTER ANIMATION: *Digital Effects Inc, Triple-I, MAGI, Robert Abel & Associates.* 96 mins. **Walt Disney Productions.**
A computer games designer (Jeff Bridges) finds himself inside the world of his computer where he is forced to fight for his life in an all-too-real video game competition.

TRON was an early showcase for computer animation, using the technology to create the action and environments within a computer. The film's non-computer-generated scenes were also a major effects task, requiring actors to be filmed in black-and-white so that glowing neon costumes and backgrounds could be added optically. (<126)

20,000 LEAGUES UNDER THE SEA (1954)

DIRECTOR: *Richard Fleischer.* VISUAL EFFECTS CINEMATOGRAPHER: *Ralph Hammeras.* PROCESS CINEMATOGRAPHER: *Ub Iwerks.* OPTICAL CINEMATOGRAPHY: *Art Cruickshank, Eustace Lycett.* ART DIRECTOR: *Harper Goff.* ANIMATION EFFECTS: *Joshua Meador, John Hench.* MATTE ARTIST: *Peter Ellenshaw.* MECHANICAL EFFECTS SUPERVISOR: *Robert A. Mattey.* MINIATURE CONSULTANTS: *Howard and Theodore Lydecker.* GIANT SQUID MODELLER: *Chris Mueller.* GIANT SQUID TECHNICIAN: *Marcel Delgado.* 127 mins. **Walt Disney Productions.**
After a strange beast has been terrorizing sailors, an armed frigate sets out to discover the truth. The ship is attacked by the 'beast', and its survivors rescued by Captain Nemo (James Mason) in his futuristic submarine. Based on the novel by Jules Verne.

The effects highlight of *20,000 Leagues Under the Sea* is a sequence in which the submarine, Nautilus, is attacked by a giant squid. Weighing two tonnes and with eight forty-foot long tentacles, the mechanical beast was operated by a combination of electronics, hydraulics, pneumatics and old-fashioned puppeteering – each tentacle was controlled by some twelve hand-operated wires. The Nautilus was built as a two-hundred-foot mock-up that actually floated in the sea, and as half a dozen miniatures ranging from eighteen inches to twenty-two feet in length. Due to the difficulty of filming miniatures with early

Cinemascope lenses, some models were built in artificially compressed proportions. These 'squeezed' models were filmed with normal camera lenses and then un-squeezed to the correct proportions when the resultant images were projected with an anamorphic lens. Glass shots by Peter Ellenshaw include a crater around the surfaced submarine and the landscape of Vulcania island. *Academy Awards for Best Special Effects and Art Direction.*

2001: A SPACE ODYSSEY (1968)

DIRECTOR: *Stanley Kubrick.* SPECIAL EFFECTS SUPERVISORS: *Wally Gentleman, Tom Howard, Con Pederson, Douglas Trumbull, Wally Veevers.* ADDITIONAL SPECIAL EFFECTS SUPERVISORS: *Les Bowie, Charles Staffell.* MATTE ARTISTS: *Roy Naisbitt, John Rose.* ADDITIONAL MATTE CINEMATOGRAPHY: *Richard Yuricich.* MAKE-UP: *Stuart Freeborn.* 161 mins. *MGM.*
After the discovery of a mysterious black obelisk on the surface of the moon, mankind is forced to search for answers about his place in the universe. Based on the short story 'The Sentinel' by Arthur C. Clarke.

One of the greatest effects films ever made, *2001: A Space Odyssey* used a range of innovative techniques to portray space flight as accurately as possible. The film made the first major use of front projection for the opening 'Dawn of Man' scenes, a shot in which Earth is seen from a window during a phone call, and for projecting live action into the windows of model spacecraft. Huge model spaceships, up to fifty-four feet in length, were filmed using an early type of motion control. Optically produced travelling mattes were avoided by using multiple pass exposures on the original negative, and hand-drawn mattes. The famous 'Stargate' sequence was created using the innovative slit-scan animation technique. Convincing scenes of weightlessness were created with ingenious wire work. Physical effects achievements included a massive 38-foot vertical barrel that rotated at three miles per hour. This set represented the centrifuge of the Jupiter Mission spacecraft and was used to create shots of crew members walking around the walls of their ship. *Academy Award for Best Special Effects.* (<72)

WAR OF THE WORLDS (1953)

DIRECTOR: *Byron Haskin.* VISUAL EFFECTS SUPERVISOR: *Gordon Jennings.* VISUAL EFFECTS CINEMATOGRAPHER: *W. Wallace Kelley.* MATTE CINEMATOGRAPHY: *Irmin Roberts.* OPTICAL CINEMATOGRAPHY: *Paul K. Lerpae.* PROCESS CINEMATOGRAPHY: *Farciot Edouart.* MATTE ARTISTS: *Jan Domela, Chesley Bonestell.* MINIATURE SUPERVISOR: *Ivyl Burks.* MECHANICAL EFFECTS SUPERVISOR: *Walter Hoffman.* MARTIAN MAKE-UP: *Charles Gemora.* 85 mins. *Paramount.*
The Earth is invaded by a race of Martians against whom even the most powerful weapons are useless. Adapted from the novel by H. G. Wells.

Hugely expensive to make, and a smash hit at the box office, *War of the Worlds* is the film that effects producer George Pal is perhaps best remembered for. Three Martian ships, each forty-two inches in diameter, were built from copper and translucent plastic – allowing them to glow ominously from internal lights. The ships glided through the sky suspended on wires that were connected to an overhead gantry. The Martian craft's famous death-rays were created by burning a piece of welding wire with a blowtorch to create a stream of sparks. This was filmed against black and superimposed on to shots of the models. People and objects vaporized by the Martians were made to glow and disappear with effects animation. Large areas of Los Angeles and various Californian landscapes were built and destroyed in miniature. A Martian, complete with flapping gills and pulsating veins, was created from papier-mâché, wire and sheet rubber – though it is most remembered for its spindly three-fingered hand. *Academy Award for Best Special Effects.*

WHO FRAMED ROGER RABBIT (1988)

DIRECTOR: *Robert Zemeckis.* SPECIAL VISUAL EFFECTS: *Industrial Light and Magic.* VISUAL EFFECTS SUPERVISOR: *Ken Ralston.* MECHANICAL EFFECTS SUPERVISORS: *George Gibbs (UK), Michael Lantieri (US).* DIRECTOR OF ANIMATION: *Richard Williams.* OPTICAL PHOTOGRAPHY SUPERVISOR: *Edward Jones.* VISUAL EFFECTS CAMERA OPERATOR: *Scott Farrar.* 103 mins. *Warner Bros./Touchstone/Amblin.*
In a world where cartoon characters interact with humans, a private detective (Bob Hoskins) is on a murder case in which the chief suspect is animated film star Roger Rabbit.

Roger Rabbit combined human performers with new and classic cartoon characters ('Toons') in the most spectacular film of its type ever made. During filming, physical props were manipulated on wires as if being used by invisible characters – bicycles rode on their own and pianos were played with invisible fingers. Cartoon characters were then hand-drawn and animated to match these physical effects before being optically composited into the live action. Animated characters genuinely look as if they are within the real environments; in the Ink and Paint club scenes, where actors and Toons mingle, the Toons move in and out of pools of light in a smoky atmosphere with the same subtle changes of tone and colour as the human characters. *Academy Awards for Best Visual Effects and Sound Effects Editing.* (<140)

WILLOW (1988)

DIRECTOR: *Ron Howard.* SPECIAL VISUAL EFFECTS: *Industrial Light and Magic.* VISUAL EFFECTS SUPERVISORS: *Dennis Muren, Phil Tippet, Michael McAlister.* SPECIAL EFFECTS SUPERVISOR: *John Richardson.* STOP-MOTION ANIMATOR: *Tom St. Amand.* MAKE-UP SPECIAL EFFECTS: *Nick Dudman.* OPTICAL SUPERVISORS: *John Ellis, Bruce Nicholson, Kenneth Smith.* MATTE PAINTING SUPERVISOR: *Chris Evans.* MATTE ARTISTS: *Caroleen Green, Paul Swendsen.* CG SUPERVISORS: *Douglas Scott, George Joblove.* MORPHING SOFTWARE: *Doug Smythe.* 125 mins. *Lucasfilm/MGM.*
In a land of magic, a midget (Warwick Davis) tries to protect a baby boy from an evil queen who, according to prophecy, he will one day destroy.

Important as the first film to use 2-D digital morphing (for a sequence in which a number of creatures change into one another), *Willow* is an effects treat. A pair of tiny pixies were created through a combination of travelling mattes and oversized props. Stop-motion brought to life a two-headed dragon, an enchanted brazier and the wings of a fairy queen. Effects animation created lightning and sparks. Animated smoke effects seen during the destruction of the evil queen were created using a complex form of slit scan. Special creature effects included dogs dressed as hell-hounds and an animatronic possum. Includes some beautiful matte paintings.

YOUNG SHERLOCK HOLMES (1985)

DIRECTOR: *Barry Levinson.* SPECIAL VISUAL EFFECTS: *Industrial Light and Magic.* VISUAL EFFECTS SUPERVISOR: *Dennis Muren.* MOTION SUPERVISOR: *David Allen.* EFFECTS CAMERAMEN: *Scott Farrar, Michael Owens.* GO-MOTION ANIMATION: *Harry Walton.* OPTICAL SUPERVISOR: *John Ellis.* MATTE PAINTING SUPERVISOR: *Chris Evans.* PHOTOGRAPHY SUPERVISOR: *Craig Barron.* COMPUTER ANIMATOR: *John Lasseter.* 109 mins. *Paramount.*
Sherlock Holmes and Watson meet while at school and have their first adventure when they investigate a number of mysterious deaths.

Young Sherlock contained some beautiful matte paintings of Victorian London and some excellent animated sequences of small cakes that come to life as part of a drug-induced hallucination. The movie is most important for having the first computer-generated character to appear in a feature film – a stained-glass knight who leaps from a church window.

GLOSSARY

Additive Process A method of creating colour pictures by combining two or three images, each of which contain one of the three primary colours (red, green and blue). Red, green and blue light will produce white light when mixed equally and can be combined in different quantities to produce any other colour in the spectrum.

Algorithm A set of instructions written in a computer language that instruct the computer to perform a specific task.

Aliasing A phenomenon present in digital images when the number or size of pixels used to describe an image are insufficient to create enough subtlety or detail, with the result that edges can appear jagged. Anti-aliasing algorithms used during rendering help to identify and reduce the effect of aliasing.

Analogue Used to describe any method of recording or transmitting sounds, images or data by creating and storing modulations such as size, width or density that are directly analogous to the subject in question.

Anamorphic Lens A specially engineered lens that horizontally squeezes images during filming so that a disproportionately wide picture can be recorded on the almost square frame of standard 35mm film. During projection, a second anamorphic lens is used to 'unsqueeze' the image to its normal proportions.

Animatic A rough version of any complex action or special effects scene. Animatics are created during pre-production by using video footage, simple animation, images filmed from a storyboard, and rough sound effects, music and dialogue. Animatics allow directors to plan their scenes in detail before shooting begins.

Animation The process of photographing models, puppets, pictures or artwork one frame at a time. Between each frame, some aspect or aspects of the subject are altered so that when the film is projected at the normal speed of twenty-four frames per second (for normal 35mm film), the subject appears to move independently.

Animation Camera Camera capable of photographing a single frame at a time, which points down at a flat table where artwork is arranged. Hand-drawn cartoon or special effects animation is photographed with an animation camera. The camera is fixed to a rostrum which allows it to be moved nearer or further from the artwork. Also called: animation stand, rostrum camera or down-shooter.

Animatronic Any remotely controlled system that uses pneumatics, hydraulics, cables, rods, or motors to produce life-like performances from puppets or models.

Aperture An opening through which light passes on its way to or from the film. In a camera, the aperture regulates how much light passes through the lens and is controlled by an adjustable hole called a 'diaphragm' or 'iris'. The amount of light is measured in 'f-stops' or 't-stops'. In a projector, the aperture is a changeable mask that determines the aspect ratio of the image being projected.

Armature The underlying framework or skeleton of a model or puppet. Armatures are usually very light but are extremely tough and carefully engineered to withstand the rigours of filming.

Aspect Ratio The relative width and height of an image when viewed on a cinema screen or television. Aspect ratios

are measured in terms of width against height. Therefore, an image that is two and a half times as wide as its height is said to have an aspect ratio of 2.5:1. A standard frame of 35mm film has an aspect ratio of 1.33:1, which is known as 'Academy Ratio' and is also the same dimension as a traditional television screen. 35mm cinema images are typically projected in one of two standard ratios; 1.85:1 ratio is usually produced by masking off the top and bottom of a normal 1.33:1 image during printing or projection. 2.35:1 is a much wider image that is the result of using anamorphic lenses to 'squeeze' a wide image on to a standard sized piece of film and then decompressing it during projection. 70mm films are normally projected with an aspect ratio of 2:2.1.

Atmospheric Effects Physically produced effects that alter the quality of the atmosphere in a studio or on location. These include smoke, rain and snow.

Automatic Dialogue Replacement (ADR) The replacement of dialogue originally spoken and recorded during filming with new dialogue recorded at a later date. Also called 'dubbing' or 'looping'.

Bald Cap A rubber cap stretched over a performer's head to create the illusion of baldness, or ensure that a wig fits snugly.

Ball-and-socket Joints Small joints used in the construction of the metal (or sometimes wood) armatures used as skeletons for animation puppets. A ball on the end of one limb is fitted into a precisely fitting socket on the adjoining limb. The joint is loose enough to allow the easy manipulation of a puppet but tight enough to ensure that the puppet keeps its shape when posed.

Beam-splitter An optical device such as a prism or two-way, half-silvered mirror that divides and re-directs the light that hits it. A single image projected into a beam-splitter will be equally divided and exit as two identical images of the same scene. The device can work in reverse so that two separate images entering the beam-splitter exit as a single beam of light.

'Beauty Pass' see Pass

Bi-pack Some special effects shots require two separate films to be run through a camera simultaneously. Each reel of film is held in a separate magazine, but the two strips are sandwiched together or 'bi-packed' when they run through the gate where they are exposed to light. Commonly, bi-packing is used to expose an image or matte from one piece of film on to another.

Bit The basic unit of computer information, which can be represented as either 0 or 1. The number of bits used to describe each colour in an image is called 'bit-depth'.

Black Powder A fast-burning material that comes in grades ranging from a fine powder to small chunks and is the basis of most pyrotechnic explosions and fireworks.

Blue-screen A screen of a carefully balanced blue colour which is placed behind performers or objects during filming to allow the optical or digital creation of travelling mattes. Some screens used for the optical generation of mattes use a translucent blue material backlit with fluorescent tubes to produce an intense colour. Today's digital matting processes can produce a matte from a surface painted blue, green or any other consistent colour.

Blue-screen Process An optical process by which subjects filmed in front of a blue-screen are combined with a separately filmed background. There are two basic systems, the blue-screen colour separation process and the superior blue-screen colour difference process. Most special effects houses used their own variations of these techniques to produce their travelling mattes. Such optical processes have now largely been replaced by digital alternatives.

Blue Spill Any blue light that is reflected on to the subject, and hence into the camera, during the filming of blue-screen footage. If not corrected, these areas become transparent during compositing.

Boolean Operations A method of creating a 3-D digital model by performing an addition, subtraction, union or intersection between two or more 3-D objects.

Breakaway Effects Props Props designed to break easily and safely during the filming of action sequences. These include chairs made from lightweight balsa wood, which can be smashed over heads, and windows for stunt men to jump through.

Cable Control The remote-controlled operation of puppets or models via cables that are pushed and pulled either by hand or by small motors.

CAD (Computer Aided Design) Specialized engineering or design software used in the planning and construction of models, props, sets, lighting set-ups and complex special effects equipment.

Cannon Car A specially modified vehicle which uses a pyrotechnic or pneumatic cannon to fire a projectile from its base in order either to propel it or turn it over.

Cartesian Co-ordinates Named after the French mathematician and philosopher René Descartes, the co-ordinates that locate any point in space relative to at least two perpendicular axes. A point in 2-D space is defined by its X and Y co-ordinates, while a point in 3-D space also has a Z co-ordinate.

Cathode-ray Tube (CRT) The part of a television or computer monitor that enables an image to be displayed on its screen. Streams of electrons emitted by a cathode inside a vacuum bombard a phosphorous screen causing it to glow. Electro-magnets are used to deflect the electrons so that they hit the correct part of the screen in order to form an image.

CCD (Charge Coupled Device) An electronic chip used in video cameras and film scanners to convert images into digital or analogue signals. Small light-sensitive cels on the surface of the chip convert the light that hits them into an electrical charge proportional to the quality of the light. This electrical signal is recorded either as an analogue signal, or is converted and stored as a digital signal in the form of a series of binary digits.

Cel Animation The traditional method of creating hand-drawn 2-D 'cartoon' animation. Each changing frame of movement is drawn and painted on a clear cel (made from cellulose acetate). This cel is placed on top of a painted background before being photographed. Twenty-four cels are needed per second of action and there are some 130,000 in a typical animated feature.

CGI; Computer-generated Imagery (or Computer Graphic Images) Any 2-D or 3-D images created entirely within a computer. Often shortened to 'CG'.

Cinematographer The person with overall responsibility for the photography of a feature film. The Cinematographer 'designs' the overall look of a film by choosing the type of camera, film, lenses, lighting, filters, and other equipment used during filming. He or she must be in constant contact with other departmental heads to ensure consistency of style, and work closely with the Visual Effects Supervisor to ensure that effects will conform to the overall style. Also called Director of Photography (DOP or DP) or Lighting Cameraman.

Cloud Tank A glass tank filled with saline solutions of various densities and used to film billowing cloud formations.

Colour Separations By copying a colour image on to black-and-white film through red, green and blue filters, it can be broken down into three black-and-white positive records of the red, green and blue content of the scene. These black-and-white records (called colour separation masters) can be successively printed back on to normal colour film stock through the same colour filters to produce another colour image. Colour separations are used in the creation of optical travelling mattes, to control colour balance during optical compositing, and as a method of storing important films in a black-and-white format so that their colour detail will not fade over time.

Composite Any image that is made up from a combination of two or more elements filmed at different times or places. Compositing, the actual process of combining these various images, can be done in-camera, in an optical printer, or now more frequently using a computer.

Contact Printing The copying of images from one exposed and developed piece of film on to raw stock by sandwiching the two together and shining light through them.

Cyberscan A method of transcribing a real object into a digital model by accurately measuring its features with a laser.

Dailies The previous day's filming that has been developed and printed overnight. At the beginning of each working day, director and key crew members assemble to watch the 'dailies' or 'rushes'.

Dental Alginate A quick-setting plaster made from seaweed extracts used to make life casts of faces and body parts for make-up purposes.

Depth of Field The distance in front of the camera over which objects appear to be acceptably in focus. When objects both near and far from the camera are in sharp focus, a shot is said to have a 'deep' depth of field. When objects near the camera are in focus but those just a few feet behind them are out of focus, a shot is said to have a 'short' (or 'narrow' or 'shallow') depth of field. Depth of field is affected by the focal length and aperture of the lens on the camera, the amount of light in a scene, the shutter speed of the camera, and the speed rating of film being used.

Depth Perception When filming models, depth perception is created by filling the set with a fine smoke, stretching large sheets of fine cloth or bridal veil between planes, or painting distant objects in dull colours.

Developing The laboratory process during which chemicals are used to make visible the latent image on an exposed piece of film. Also called Processing.

Difference Matte A digital method of creating a matte by comparing two almost identical images. Changes detected in the second image, such as the movement of an object, can be used to create a matte to remove the object from the scene.

Digital Used to describe methods of recording, storing and transmitting images, sounds and data through the conversion of analogue information into binary numbers (combinations of ones and zeros). Digital information can be copied and transmitted repeatedly with no loss of detail, making it ideal for special effects production where images need to be copied and combined many times.

Digital Backlot 3-D computer models used to replace or extend real film sets. Building locations in the computer reduces the time and money involved in constructing major sets.

Digital Matte Painting The extension, manipulation and improvement of filmed images using 2-D digital paint methods to create buildings and locations that do not exist.

Digital Paint The digital equivalent of paint and brushes. Digital paint may be used to touch up individual frames of film, create texture maps for digital models, or paint entire scenes for digital matte paintings. As well as painting with colours, artists can paint with 'textures' that have been sampled from real photographs or paintings. The most commonly used digital paint software is Adobe Photoshop.

Digitize To convert the characteristics of any object, sound or image into digital information so that it can be used or manipulated by a computer.

Displacement Animation A method of animation in which parts of a model are physically moved between photography of each frame. This differs from replacement animation in which the model is substituted with a new one in a different pose.

Dissolve Scene-changing technique in which one image slowly fades out as the new image fades in. Traditionally created on an optical printer, dissolves are normally used to indicate the passing of time between scenes.

Dolly The moving platform on which camera and camera crew are pushed around to create a moving camera or 'dolly' shot. The platform is usually mounted on tracks that are laid on the ground to ensure smooth movement.

Double Exposure Two overlaid images on a piece of film caused by running the film through a camera twice. The technique can be used to create in-camera dissolves or the appearance of transparent ghosts.

Dubbing The process of laying down new dialogue and sound effects on to filmed images. The term is also commonly used to describe the copying of sound and images from one video tape to another.

Dunning–Pomeroy Process The first method to use the principles of coloured light to create travelling mattes on black-and-white film. The technique bi-packed an orange-dyed positive of the required background image on top of raw stock inside the camera. In the studio, an actor lit with orange light performed in front of a blue-screen. The image of the actor passed through the orange-dyed background image film in the camera to be recorded on the new film, while the blue light had the effect of printing the orange background image into the areas around the actor.

Dynamation The name given by Ray Harryhausen and producer Charles Schneer to their split-screen method of combining stop-motion animation with rear-projected live-action in *The 7th Voyage of Sinbad* (1958). For later Harryhausen films the same basic technique was variously renamed as 'Superdynamation' and 'Dynarama', while non-Harryhausen animated films hailed similar effects as 'Regiscope', 'Fantamation', and 'Fantascope' among others.

Edge Detection Traditionally, complex objects that moved in a 3-D fashion in animated feature films had to be painstakingly drawn, frame by frame, by artists skilled at portraying changing perspective. Today, complex objects are first created as 3-D computer models and then animated to produce the desired movement. Edge detection software then analyzes the image in each frame and produces a series of 2-D black-and-white outline cels as if drawn by hand. These are then coloured and integrated into the traditionally animated elements. The method was first used to create images of turning cogs and machinery in Disney's *The Great Mouse Detective* (1986).

Effects Animation In 2-D animated feature films, the animation of any form of complex moving object or substance other than the main characters. Includes moving water, falling leaves, fire, smoke, clouds and shadows. In live-action feature films, effects animation is hand-drawn, painted, photographed and composited optically or digitally, to create lightning, the muzzle flash on guns, sparks and smoke.

Emulsion The layer of photochemically sensitive gelatin mixture that coats a strip of clear flexible material to create photographic film. Colour film has three layers of emulsion, each being sensitive to one of the three primary colours.

Establishing Shot The first image in a sequence which is used to establish a location, time and mood before cutting to close-ups of the main action. Matte paintings are commonly used to create establishing shots of fictitious locations.

Exposure The act of directing light on to a piece of undeveloped film in order to record an image. When film receives too much light it is said to be 'over-exposed'. When too little light makes an image too dark it is 'under-exposed'.

Extrusion A digital modelling method by which a 2-D template of an object's cross-section is first drawn in terms of height and width before being extended to the desired depth to produce a 3-D model.

Fade A film technique in which an image gradually changes from a normally exposed picture into a solid colour – normally black – as a scene transition. A fade-out is where the picture turns black, while a fade-in is where the picture emerges from the black.

Film Format Type of film used for a project either in terms of the physical width of the film as measured either in millimetres (i.e. 35mm or 70mm) or by trade name (i.e. IMAX or VistaVision).

Film format is also known as film 'gauge'. The term is sometimes used to describe the shape of the projected image in terms of width and height; also known as 'aspect ratio'.

Film Recorder A device used to record digital images from a computer on to the analogue medium of film. CRT film recorders use a camera to film the images from a high-quality computer monitor, while laser recorders shine a beam of coloured light directly on to a piece of film.

Film Scanner A device that converts the analogue information held on film into digital information for manipulation within a computer. Light is shone through a frame of exposed and developed film and on to a CCD chip, converting the image into electrical signals which are recorded as digital information.

Film Speed The 'speed' of photographic film refers to the sensitivity of its emulsion to light. 'Fast' film needs little light to record a correctly exposed image while 'slow' films need much more. Film speed is measured in terms of an exposure-index, which is stated by film manufactures and measured by a number of international standards.

Filter Any substance such as glass or gauze that affects the quality of light passed through it. Filters can be attached to camera lenses, over lights, or within optical printers. In the digital world, filters are algorithms that are applied to digital images in order to affect the characteristics of groups of pixels, for instance by making them blurred or warped.

Fluid Dynamics The study of the way that fluids and other small particles flow under different circumstances. Such characteristics can be reduced to a number of complex mathematical rules that may be used to create realistic computer-generated water and smoke.

Foley The recording of synchronized sound effects to match silent images. Most noises heard in a film are created during a Foley session rather than being recorded during original filming. The process is sometimes called 'Foley walking' or 'footsteps' since a large part of the job involves reproducing the sound of walking.

Forced Perspective A false illusion of depth or size created during the construction of models or sets by artificially shortening the distance over which objects would naturally appear to change in size. This means that exceptionally large looking sets can be built in much smaller spaces and for less money than would otherwise be the case. Sets with dramatic forced perspective are sometimes peopled with tall actors in the foreground and small people in the distance, as in the case of the engine room set of the *Enterprise* in *Star Trek: The Motion Picture* (1979).

Frame Rate The number of frames of film that are exposed per second during filming. Normal 35mm motion picture photography is filmed and projected at twenty-four frames per second (fps).

Front Projection A method of simultaneously filming performers in a studio and pre-filmed background images which are projected on to a highly reflective backdrop from in front. The projector and camera are positioned at 90° to one another yet are able to share the same optical path due to the positioning of a beam-splitting mirror at an angle of 45° between them. The method can also be used to combine live action and matte paintings.

f-stop The amount of light that travels through the lens of a camera is controlled by opening and closing a diaphragm or iris. Each successive opening of a diaphragm lets in twice as much light as the last and is called an f-stop or just 'stop'. f-stop numbers range from f1, which allows all the light entering a lens to reach the film to f32, where almost all the light entering the lens is blocked from the film. T-stop numbers, sometimes confused with f-stops, are an electronic calculation of the actual amount of light that reaches the film plane.

Gate The place behind the lens of a camera where a frame of film stops momentarily to be exposed to light or, in the case of a projector, to be projected on to a screen.

Generation Each time a filmed image is copied it is one generation on from the original negative. Since image quality is lost with each subsequent generation, film makers try to ensure that images seen in the cinema are of a generation as close to the original negative as possible. Digital processes have removed the problems of generational loss since each copy of a digitized image contains all the original information.

Glass Shot A method of integrating a painted image with live action by painting the desired additions to a scene directly on to a sheet of glass positioned in front of the camera. The camera films a combination of the image *on* the glass and the background scenery seen *through* the glass.

Go-motion A sophisticated variation of stop-motion animation in which the puppet is pre-programmed to perform each incremental move while the shutter of the camera is open. The result is an animated character that moves with lifelike motion blur.

Grain The emulsion on photographic film is made of tiny grains of silver halide suspended in gelatin. The larger the size of these grains, the more sensitive the film is to light, but the more 'grainy' the image appears when projected. Grain can clump together in the emulsion of a film, becoming quite visible on a cinema screen. Grain becomes more noticeable the further away each generation is from the original negative.

Graphics Tablet A sensitive desktop device which can be used by computer operators to draw using a special pen. Anything drawn on the tablet will simultaneously appear on the computer monitor. The graphics pen can also be used like a paintbrush – the amount of digital paint applied varies with the pressure applied by the pen. A graphics tablet can also be used like a 'mouse' to give instructions to a computer.

Hardware The basic machinery of computers which includes monitors, hard disk drives and microchips.

Hierarchy A chain of interdependent elements in any jointed digital model – typically a limb of a computer-generated character's body. The position of an object in a hierarchical chain affects the way that it reacts when the objects to which it is linked are moved during animation, and how those other objects react when *it* is moved.

High-contrast Film A variety of black-and-white film that only records extreme contrasts of tone – converting most tones and colours into either black *or* white. Used in the production of mattes and titles.

High-contrast Mattes A method of producing optical mattes that relies on the subject being separated from its background by extreme differences of contrast. Typically, a model spacecraft might be filmed by a motion-control camera in two passes. In the first pass, the model is lit perfectly (the 'beauty pass') but no light is allowed to fall on the backdrop, which remains dark. In the second pass, no light is allowed to fall on the model but the backdrop is lit brightly – making it a stark white. The model becomes a black silhouette against the white backdrop and, when filmed with high contrast black-and-white film, is used to produce male and female mattes.

High-speed Photography Filming at higher than normal frame rates will result in 'slow motion' images when such film is projected at the normal rate of twenty-four frames per second. High-speed photography is often used to create a sense of scale when filming 'miniature' effects such as models, smoke or water. While most miniature photography is achieved at two to four times normal speed, some shots involve filming several thousand frames per second using highly engineered cameras made by the Photosonics corporation.

IMAX A large-format film process which uses 65mm film horizontally, resulting in a frame that is three times larger than that in normal 65mm photography and ten times the size of the frame in standard 35mm photography. As a result, the image quality is superb and can be projected on to an enormous screen.

In-betweeners During the drawing of traditional 2-D animation, a lead animator draws only the key poses of a character in each scene – perhaps two or three key frames for every second of action. In-betweeners draw the stages of action between these frames.

In-camera Effects Any visual effect that can be achieved during original filming without having to use an optical printer or other process at a later stage. In-camera effects include fast and slow motion, fades, dissolves, split-screen effects and tricks with mirrors and filters. Though they can give superior results because they are achieved on the original negative, such effects are generally avoided since they risk damaging the original negative image.

Introvision A complicated variation of front projection which effectively enables the 2-D projected background image to be split into various planes. Performers can be made to appear as if they are actually acting 'within' the environment of the projected image.

Inverse Kinematics A method of digital character animation by which only the end joints or limbs in a hierarchical skeleton are moved to the desired position. The way that the rest of the body moves in response is calculated automatically by the computer according to pre-set rules.

Key-frame In traditional 2-D animation, the most important images are drawn by lead animators to indicate the major changes in character movement. (Less experienced animators complete the in-between frames.) In computer animation key-frames are still used, with the animator setting the position of any object every few frames, and the computer calculating the transitions in between (interpolating). Key-frames are also used to control lights, cameras and other aspects of the virtual environment throughout a sequence.

Keying The digital process of selectively laying one image on top of another involves producing a matte or 'key' that is derived from some quality of the image to be overlaid. A 'key' can be 'pulled' from a number of attributes in an image including its luminance (luma-keying), and its chrominance (chroma-keying).

Kicker Plate A pneumatically operated springboard used to fling stunt performers or objects into the air when filming action sequences.

Latent Image The invisible image that lies dormant on a piece of film after it has been exposed to light but before it has been developed. Some visual effects processes involve keeping an exposed but undeveloped piece of film in the camera, or in storage, before re-exposing it to other elements, for instance a matte painting, at a later stage. Such methods are called 'latent image' or 'held take' processes.

Latex Rubber Liquid produced from the sap of the rubber tree. When combined with fungicides and other chemicals, it is used to create various densities of solid rubber including the foam rubber for prosthetic make-up and animatronics.

Lathing A digital modelling method by which a basic 2-D shape is rotated about an axis to create a 3-D object with the same profile.

Life Cast A mould bearing the exact features of a performer, used for the creation of prosthetic make-up and costumes to ensure a perfect fit. The process usually involves covering the performer's body and face in quick-drying plaster to produce a negative mould from which a positive cast can be taken. Instead of the traditional method of producing a life cast, which can be unnerving for the subject, a cyberscan can now be used to create an accurate replica of a performer's features in a computerized milling process.

Locked-off Camera A camera which has been tightly secured to ensure that it will not move during the filming of a shot.

Lofting A digital modelling technique in which a number of 2-D shapes are arranged along a path (a spline) horizontally and then linked together to create an object with a changing profile.

Lydecker Technique A method of suspending and flying models from tensioned wires. Perfected by Howard and Theodore Lydecker in the 1930s.

Magazine The detachable light-proof compartment which holds the film for a movie camera. Magazines generally have two chambers, one containing a reel of unexposed film, the other a take-up chamber which receives the film after it has been exposed in the camera.

Match-moving When computer-generated elements need to be placed into a live-action scene that has been filmed with a moving camera, the CG elements must be 'filmed' with an identical camera move so that they will merge realistically with the live action. Match-moving is the process of matching the movements of the computer's virtual camera to those of the live-action camera. Also known as 3-D camera tracking.

Matte Box A slotted frame that is attached to the front of a camera in which metal or cardboard mattes can be inserted to prevent the film's exposure to parts of an image.

Matte Line The place in a composite image where two separately created elements meet. When the combination of elements is not entirely successful, a discernible black line may be visible between or around them. With optical printing, matte lines were virtually impossible to avoid completely but the precision of digital compositing techniques means that matte lines need no longer be a problem.

Matte Painting A painting, usually of a location, which is combined with live-action footage, animation, or models to produce a realistic composite image. Paintings were traditionally done on large sheets of glass and combined with other images through a variety of optical processes, such as rear or front projection. Matte paintings are now usually painted directly within a computer before being digitally combined with live-action elements.

Mattes Any form of mask that prevents light from reaching and exposing areas of film. The area of film left unexposed is usually filled with an image from another source at a later stage. Mattes are sometimes simply black masks made of sheet metal or cardboard that are positioned in front of a camera during filming. Alternatively, they may be produced through a number of optical methods and held on a piece of film. Mattes always exist in two complementary parts; one matte allows exposure on one part of the film and prevents it in another, while a counter-matte covers the already exposed area and allows the rest of the frame to receive a different image. A matte and its counter-matte are often referred to as a male and female matte. Today, mattes are usually produced digitally using a number of processes.

Mesh The vertices, segments and polygons which collectively create the structure of a digital model.

Miniature Any object or location that is reproduced at a smaller scale for filming purposes.

Model Any object or location that has been reproduced for filming purposes. Models are not necessarily smaller than the real thing – they may be the same size or, when people need to look small by comparison, even larger than the real object. Though models are usually perfect re-creations of the exterior of an object, they often lack interior detail such as motors or mechanisms.

Model Mover A device used to support and move models – such as spaceships – during filming. Usually operated by motion-control to ensure consistently repeatable movements.

Morphing The process by which one image appears to transform, seamlessly, into another. Computer morphing can merge one 2-D image into another, or change one 3-D model into another. Morph sequences often involve a series of objects that will be transformed into one another over a set period of time. Each object in the sequence is called a 'Morph target'.

Mortar A pipe, funnel or dish used to control the characteristics of pyrotechnic explosions.

Motion Blur The blurring that occurs if an object moves while it is being photographed or filmed. Though it is actually a technical shortcoming, motion blur helps moving images to look more natural to the human eye by preventing the strobing that would occur if objects moved from frame to frame without blur. Because stop-motion puppets are motionless when photographed, go-motion was invented to create realistic motion blur. Computer-generated animation usually has motion blur artificially added during rendering, since the virtual camera has no shutter.

Motion Capture Methods of capturing the natural movement of bodies or faces so that it can be used for the animation of computer-generated characters.

Motion Control A method of recording or programming the movements of a film camera so that a shot can be achieved exactly as required, and repeated whenever necessary. Particularly useful for filming a number of different elements in separate takes or 'passes' so that they can be effectively combined at a later date.

Multiplane Effects Naturalistic changes in focus and perspective in 2-D animation achieved by arranging artwork in a number of layers or 'planes' in front of the camera. Such effects were first successfully used after the construction of Disney's multiplane camera in 1937, and are now achieved by arranging layers of scanned artwork in a computer.

Negative When an image has been photographed and the film from the camera developed, the result is normally a negative image – in the case of black-and-white photography the dark and light areas are reversed, while in colour photography dark and light are reversed and the colours are complementary to the original. When copied or 'printed' on to print film, the negative image is reversed into a normal positive image.

Nodal Head A special tripod head that tilts or pans a camera around the nodal point of a lens so that the view of a scene changes but the perspective from which it is seen does not.

NURBS Non-Uniform-Rational-B-Spline A sophisticated digital modelling technique which generates model surfaces as a number of separate patches, each of which is influenced by a set of continuous curves (or splines).

Optical Effects Visual effects that are created with an optical printer. Strictly speaking, only effects created using an optical printer are 'opticals', but the phrase is widely used to distinguish any process that involves using the properties of light, film and lenses (such as front and rear projection) from physical effects that are achieved on the set, or digital effects that are produced in the computer.

Optical Printer A device used to create optical visual effects by manipulating photographic images while copying (printing) them from one film on to another. At its simplest, the optical printer is simply a projector and a camera facing one another; the projector shines its image through a lens and on to the new film held in the camera. Effects achieved using an optical printer include the compositing of travelling matte

photography, split-screen effects, dissolves, fades and wipes. Optical printers have largely been replaced by digital alternatives.

Optical Sound A system of reproducing film sound which involves converting electrical sound signals into an analogue pattern that is printed as a continuous strip alongside the images on a piece of film. This signal is converted back into sound during projection.

Original Negative Matte Painting A method of combining paintings and live action by exposing both on to the same original negative film without any additional processes. Also known as 'latent image matte painting'.

Over-cranking Running a film through a camera at faster than the normal speed of twenty-four frames per second. When the developed film is projected at the normal speed, the action appears in slow motion. Running a camera slower than the normal speed to create speeded-up images is called 'under-cranking'.

Particle System A digital method of generating and animating the random movement of a large number of particles for the creation of swarms, clouds, tornados, fireworks and so on. Particle systems control various parameters such as the number of particles in a shot, where they come from, how they move in relationship to one another, their velocity and drop-off. Changing any one aspect will change the entire pattern of movement. The particle flow in a shot is normally determined using basic particles before they are replaced with the objects required for the scene – which may in themselves be animated, such as flying birds.

Pass During the photography of models or miniatures, an image is often filmed in several 'passes'. Each one captures a specific aspect of the image, usually on a separate piece of film. In the case of a model spaceship, separate passes might be used to film the model's internal lighting, the glow from its engines, a smoky atmosphere, and a silhouette for the production of a travelling matte. In a 'beauty pass' the model in question is lit to look its best externally. The best aspects of different passes are combined optically or digitally. The result is a shot in which all elements of an image are balanced to produce an image difficult or impossible to achieve in a single take. When a shot involves a moving camera, motion control is essential for ensuring that the camera movement is identical for each pass.

Physical Effects Any effects that are physically achieved on set during filming. Includes the use of pyrotechnics, atmospherics and large-scale mechanical props. Also known as 'mechanical effects'.

Pilot Pins Pin Registration Most optical visual effects processes require every image in a sequence to be positioned in exactly the same place on each subsequent frame of film. This allows elements held on separate films to be precisely combined, ensuring production of a successful composite image. To ensure perfect 'pin registration', cameras and projectors used in visual effects use special pilot pins which fit snugly into the perforations in a piece of film, holding it absolutely steady in the aperture during photography or projection.

Pixels An abbreviation of 'picture element'. Pixels are the tiny squares of colour which make up a digital image. Each image consists of many thousands of pixels – the more used to describe a picture, the higher its resolution.

Plate Any still or moving image used as a background for front or rear projection, optical travelling matte processes, or in a digital composite shot. To ensure that backgrounds will be suitable for use later in production, plate photography is often overseen by visual effects supervisors who travel to locations with the film's main crew. Lighting and camera movement in a plate are carefully planned so that effects elements can be effectively matched to them. The word 'plate' originates from the early days of still photography when negatives were made of sheets of glass (plates) with photographic emulsion on their surface.

Polygon Simple two-dimensional geometric shapes which are the building blocks of 3-D digital models.

Prima-Cord A high-explosive 'rope' that can be wrapped or taped around objects in order to destroy them on detonation. Also known as Det-Cord.

Primitives Basic 3-D geometric objects that are often used as a basis for the construction of more complicated digital models within the computer. Primitives such as spheres, cubes and pyramids may be squashed, squeezed, distorted or intersected to create other more interesting forms.

Procedural Modelling/Procedural Animation Time-saving digital modelling and animation techniques by which the shape or movement of objects is calculated by the computer according to pre-programmed mathematical formulas.

Process Camera/Process Projector A camera or projector which uses pin registration to ensure that each frame of film is held absolutely steady during the photography or projection of special effects elements.

Process Shot Usually describes composite shots achieved using rear projection. The term is sometimes also used to describe a shot achieved using optical travelling matte processes.

Production/Pre-production/Post-production The process of creating a film is divided into three distinct phases. Pre-production refers to the parts of the film making process that occur before filming begins. This includes scriptwriting, the design and construction of props and sets, casting of actors, financing and scheduling. Production is the actual phase of shooting a film in a studio or on location, and is usually the shortest part of the film making process. Post-production refers to the processes that occur after shooting. This includes editing, the creation of special effects, dubbing and sound effects, recording the musical score. The actual timing of these phases may overlap somewhat – editing usually begins during the production phase, for example.

Prosthetics False limbs, noses, or other appendages which are seamlessly fixed on to the face or body of a performer.

Pyrotechnics The creation of explosions and bullet hits by using real explosives and other highly flammable materials. Non-pyrotechnic alternatives are available

– using compressed air to blow debris into the air, for example.

Radiosity A method of creating extremely realistic lighting for 3-D digital images. The computer calculates the interaction of light emanating from every surface in a scene. Radiosity produces the most convincing digital images but is extremely time-consuming and machine-intensive.

Raw Stock Unexposed and undeveloped film.

Ray Tracing A method of calculating physically accurate lighting in 3-D digital scenes by tracing the path of light beams as they bounce around an environment.

Rear Projection A method of combining live-action foregrounds with pre-filmed background scenery. Actors perform in front of a translucent screen which has still or moving images projected on to it from behind. A camera films the composite image. Animation, models and matte paintings can also be combined with background footage in this way. Also called rear-screen projection, back projection or process photography.

Registration Pins Metal pins that precisely fit into the sprocket holes in a piece of film in order to position each frame exactly and hold it absolutely steady during exposure in a camera or projector.

Release Print The final version of a film, produced in large quantities for distribution to cinemas.

Rendering The final process in the production of computer-generated images. During rendering, every instructional aspect of a 3-D scene (lighting, camera, geometry, texture maps, animation, etc.) is studied by rendering software in order to calculate the final 2-D image.

Replacement Animation A method of stop-motion model animation in which puppets to be animated have all or part of their body replaced between photography of each frame, rather than being physically moved and re-positioned by hand, as in displacement animation.

Re-recording The process of copying and mixing various pre-recorded sound effects and dialogue to create the final soundtrack for a film.

Resolution The quality of a digital image expressed in terms of pixels or pixels per unit area.

Reverse Blue-screen An unusual method of creating blue-screen travelling mattes used in the early 1980s. Rather than using a blue background screen to create a matte of a foreground object, the object was painted with a special translucent ultraviolet paint. The model was first filmed with normal lighting in front of a black screen. Using separate film, another identical pass was made. This time the model was lit with ultraviolet light which turned the model blue, resulting in an image of a blue model against a black background. This film was used to create the travelling mattes. The reverse blue-screen process was first used for shots of a model fighter aircraft in *Firefox* (1982).

Rotoscope A combined camera and projector that is mounted on a rostrum and points down at a table. Images from a film can be projected downwards and traced on to paper or cels, which can then be used to create artwork for

lightning, ghosts, or other hand-animated effects. The artwork is then re-photographed and optically combined with the original footage. The digital version of rotoscoping is mainly used for dividing each frame of a sequence into areas that will become either background or foreground when an element such as a dinosaur is composited into the scene.

Scale The comparative size of a model compared to the real object on which it is based. A one-foot model of a twelve-foot car has a scale of 1:12. Solid objects can be effectively re-created at smaller scales while certain natural elements such as fire and water are difficult to miniaturize convincingly.

Scotchlite Trade name for a highly reflective material manufactured by the 3M company. With 250,000 tiny glass beads on each square inch of its surface, Scotchlite is 'retro-reflective' – the majority of light hitting it is reflected directly back to its source. Generally used for reflective road signs and safety clothing, Scotchlite is also much employed in the effects industry for front-projection processes.

Segment A basic piece of geometry that links vertices during the construction of a digital model.

Shader A specially written algorithm used by computers during rendering to calculate the way that light interacts with the surface of a digital model. Shaders determine the final look of an object.

Shape Interpolation A method of creating movement by instructing the computer to interpolate, or 'morph', between a number of fixed shapes. It is commonly used to create facial performances by interpolating between a number of pre-made facial expression models.

Showscan A high-quality film format that moves 65mm film vertically through the camera and projector at a speed of 60 fps. Showscan is also the name of a corporation that uses the process to create ridefilm attractions.

Shuftan Process A traditional method of using mirrors to combine full-scale live action and miniatures in-camera.

Shutter The device inside a camera that intermittently allows light to enter and expose the film within. Shutters are normally rotating discs with openings that let light reach the film held motionless in the gate for exposure, and block light while the film is being advanced to the next frame. The shutter on a film projector prevents light from reaching the screen while each frame is being pulled into place.

Slit Scan A type of animation that produces images of streaking light. Produced by exposing a single frame of film, over a long period, to artwork that is seen through a slit in a screen. The camera, artwork and even the slit may be in motion.

Slow Motion An effect that makes action appear unnaturally slow, achieved by running film through the camera at speeds faster than the twenty-four frames per second normally used for filming and then projecting the film at the normal speed. A scene filmed at forty-eight frames per second and projected at twenty-four will move at half its original speed. Some special effects shots may be filmed at speeds as high as five hundred frames per second, making a one-second event stretch to over twenty seconds on-screen. Also called 'over-cranking'.

Sodium Vapour Process A travelling matte process using two films mounted in a single camera simultaneously to produce both the foreground element of a shot and its complementary travelling matte during original filming. The matte was created by placing the foreground element (i.e. an actor) in front of a yellow backdrop lit by sodium vapour lamps. A beam-splitting prism inside the camera sent the light from the yellow backdrop to one film to produce the matte, and all other light to another film to record the image of the foreground element.

Spline A path created within the computer by interpolating between a number of points in 3-D space. A spline could control the movement of a virtual camera by manually defining various key camera positions in a sequence and allowing the computer to calculate the path that links them. Spline-based modelling defines the surface of a digital model by using a relatively small number of control points, which are linked to produce a shape.

Split Screen Any process that exposes two or more different areas of the frame of film in subsequent exposures. Typically used to allow the same actor to appear twice in the same frame. One side of the screen is matted off during exposure before the film is rewound. The matte is reversed, the film re-exposed, and the actor now appears on the opposite side of the frame. Some split-screen effects try to hide the fact that the image is produced by more than one exposure, others use them for dramatic effect – for instance to show two people in different locations speaking on the telephone. Split screens need not be stationary – the line dividing the two exposures can be moved from frame to frame.

Sprocket Holes Small perforations along the edges of a film strip that are engaged by the teeth of sprocket wheels to move film through a camera or projector.

Squib A small pyrotechnic device used to simulate bullet hits. Squibs come in various sizes and are detonated electrically – either directly through a wire or occasionally by radio control.

Stop-motion A method of animating models by physically altering their position in between the photography of each frame. When the resulting images are projected at the normal speed, there is the illusion of autonomous movement. Also called 'stop-action'.

Subtractive Process A method of creating colour pictures by combining three images, each of which contains just one of the three primary 'complementary' colours of cyan, magenta and yellow. Individually, these colours work to filter out the other colours in the spectrum that make up white light; when the separations are projected they therefore produce a resulting image that is the desired colour. This method is used in all modern colour film processes.

Superimposition The layering of two or more images so that they are transparently visible at the same time. Also called double or multiple exposure.

Supervisor The senior effects technician responsible for overseeing the production of effects for a film. Most major films have two types of effects supervisor; the Special

Effects Supervisor works on the physical and mechanical effects in a film, while the Visual Effects Supervisor oversees the production of visual effects such as matte painting, animation, travelling mattes and miniature photography. Supervisors begin working on a film during pre-production when they study the script and plan how each effect can be best achieved using the allocated budget. This is followed by a period of research and development during which techniques are tried, materials tested, and specialized equipment or software created. During production, supervisors oversee the safe and efficient filming of scenes in which physical effects are used, or the shooting of plates to which visual effects will be added during post-production. The Special Effects Supervisor's job normally ends when shooting finishes, while the bulk of the Visual Effects Supervisor's work takes place during post-production when the live action has been filmed and is ready for additional changes.

Take Each time the camera is started and then stopped to film a shot. Several takes of each shot are normally filmed and the best is selected and used during editing. After the first take, each subsequent version of a shot is called a retake.

Tank A large area of water in a film studio that is used for the filming of scenes involving boats and water. Tanks normally have a large painted backdrop and contain underwater tracks and pulleys for the manoeuvring and sinking of boats.

Texture Mapping A method of adding colour or surface detail to digital models. To create texture maps, photographs or artwork of surfaces and patterns can be scanned into the computer, or created using digital paint software. Texture maps are then applied to the model using mapping co-ordinates to ensure that they fit correctly. As well as adding 2-D detail to a model, certain texture maps can change the appearance of a model's shape. *Bump maps* are greyscale maps that can make a flat surface look bumpy by the way that light and shadow interact. Alternatively, *displacement maps* can be applied to a model surface to physically alter its shape. *Opacity maps* can be applied to a 'solid' model to make areas of its surface appear see-through.

Three-dimensional/3-D Most images that we see have the two-dimensional aspects of height and width. Images produced using stereoscopic photography (two cameras) are capable of creating images that, when combined, appear to have the third dimension of depth. Traditional cartoon animation is 2-D since characters and backgrounds are flat pieces of artwork that can only be viewed and filmed from one angle. Model animation is 3-D because the camera and the models are able to move in all dimensions during animation. However, unless filmed stereographically, the resulting filmed images are two-dimensional. Computer-generated animation is often called 3-D animation because the models and environments are constructed in three-dimensional space within the computer – allowing the computer's virtual camera to roam around and 'film' them from any angle. Like normal motion picture

photography the result is, however, a 2-D image of a 3-D scene.

Time Lapse Photography A method of filming an event over a long period of time to produce a sequence in which it appears to occur far more quickly. Once a camera is set up it can be programmed to photograph one frame every second, every hour or even every week. Time lapse is often used to create speeded-up images of naturally slow processes such as the growth of plants or the movement of clouds.

Time Slice Photography An effect produced by editing together images of the same subject that have been photographed simultaneously from different perspectives. The effect is of a motion picture camera moving through a moment that has been 'frozen in time'.

Tip Tank A large tank of water which can be tipped or emptied to create waves during the filming of floods and storms. Also called 'tipper tank' or 'dump tank'.

Tracking Shot A shot in which the camera moves in a linear fashion either towards, away from, or past the subject. The camera is normally mounted on a crane, track or wheels to allow smooth movement. Also called 'dolly shot', 'trucking shot' or 'travelling shot'.

Travelling Matte When a foreground object such as a building needs to be placed in front of a separately filmed background, an opaque matte that is exactly the same shape and size as the building must be created. The background element is then re-photographed with the matte to produce a shot of the background that contains an unexposed area that is the shape of the foreground object. This element is then exposed to the foreground element using a counter-matte to cover the already exposed background area of the frame. When the film is developed, the result is a composite of the two images. Travelling mattes are used to combine two separately filmed elements when the foreground element (e.g. a person) changes shape or position from frame to frame – necessitating a new matte for each frame. Many methods of producing travelling mattes have been used - most rely on the foreground object being filmed in front of a coloured background. Traditional techniques such as the sodium vapour process and the blue-screen colour difference process created mattes optically. Today, most travelling matte shots are created digitally.

Vertex A single point in two or three-dimensional digital space. By linking three or more vertices basic shapes called polygons can be created and used to construct complex digital models.

Virtual Camera The hypothetical camera used to film animation and environments created within the computer. The virtual camera is not actually a camera but rather the 'device' used to describe the viewpoint that the computer will use when deriving information about the digital world during the process of rendering. Virtual cameras have been designed to replicate the abilities of real cameras and can be programmed to use different types of lenses and animated to move like real cameras.

Virtual Reality Images of computer-generated environments and characters that are displayed to a single viewer using a form of headset or projected directly on to the retina of the eye (virtual retinal display) to give the viewer the impression that he or she is immersed within a scene. VR systems react to the movements and actions of the viewer, allowing him or her to directly influence events. Used for military, medical and gaming purposes, they are likely to develop into a sophisticated new form of interactive entertainment.

Virtual Sets/Virtual Studio Photorealistic computer-generated environments that replace the need for large film sets or location filming. Actors perform within an empty studio using minimal sets and props. During filming, cameras that move freely around actors relay their exact movements to a computer, changing the way that the virtual camera reacts accordingly. Filmed live action and computer-generated backgrounds are then composited.

VistaVision 35mm film that is run horizontally through the camera to create a negative that is eight perforations wide – twice the size of a normal 35mm image. First developed in the fifties, VistaVision produces images that are sharper and less grainy than those in normal 35mm photography, making them ideal for optical visual effects processes that require the repeated copying and therefore degradation of an image.

Wedge A strip of identical images, each of which has been photographed at different exposure levels. It is used to find the best exposure or balance.

Williams Process Early travelling matte process that filmed foreground images against a black or white backdrop and used high-contrast film to produce a matte.

Wipe The replacement of one image with another through some form of decorative transition rather than by a straight cut. The second image normally replaces the first by appearing to 'wipe' across the screen.

Wire-frame Model The most basic visual form of a computer-generated model before it has had any textures applied to it.

Wire Removal The removal of wires used to hang or support characters or objects during filming, as well as other unwanted elements from a scene. A painstaking task when attempted optically, it is now achieved digitally with relative ease.

Zoom The process of altering a shot during photography so that the camera appears to get closer to or further from its subject. In fact, a camera does not actually move during a zoom in or out, it is only the focal length of the zoom lens that is altered.

Zoptics A variation of front projection in which the zoom lens on a camera is linked with the zoom lens on a projector. By simultaneously increasing the size of the projected image and the field of view of the camera, the projected image will appear to remain the same size when re-photographed while any foreground object will appear to shrink. First used to make Superman fly towards or away from the camera in *Superman* (1978).

SELECTED BIBLIOGRAPHY

Abbott, LB., ASC. *Special Effects, Wire, Tape and Rubber Band Style.* California: The ASC Press, 1984.

Bacon, Matt. *No Strings Attached – The Inside Story of Jim Henson's Creature Shop.* London: Virgin Publishing, 1997.

Bizony, Piers. *2001: Filming the Future.* London: Aurum Press, 1994.

Boorman, John and Donohoe, Walter (editors). *Projections 5: Film-makers on Film-making.* London: Faber and Faber, 1996.

Bouzereau, Laurent and Duncan, Jody. *Star Wars: The Making of The Phantom Menace.* London: Ebury Press, 1999.

Brosnan, John. *Movie Magic.* London: Macdonald and Jane's, 1974.

Brownlow, Kevin. *The Parade's Gone By...* London: Columbus Books, 1989.

Clark, Frank P., *Special Effects in Motion Pictures.* New York: Society of Motion Picture and Television Engineers, Inc., 1966.

Coe, Brian. *The History of Movie Photography.* Westfield, N.J., 1981.

Dunn, Linwood G., ASC, and Turner, George E., *The ASC Treasury of Visual Effects.* California: The ASC Press, 1983.

Fielding, Raymond. *The Technique of Special Effects Cinematography (Fourth Edition).* London: Focal Press, 1985.

Finch, Christopher. *Special Effects: Creating Movie Magic.* New York: Abbeville Press, 1984.

Fry, Ron and Fourzon, Pamela. *The Saga of Special Effects.* Englewood Cliffs, N.J., Prentice Hall, Inc., 1977.

Goldner, Orville and Turner, George E., *The Making of King Kong.* New York: A.S. Barnes & Co., Inc., 1975.

Hayward, Philip and Wollen, Tana (editors). *Future Visions: New Technologies of the Screen.* London: BFI Publishing, 1993.

Hutchinson, David. *Film Magic: The Art and Science of Special Effects.* London: Simon and Schuster, 1986.

Hutchinson, David. *Fantastic 3-D.* New York: Starlog Press, 1982.

Imes, Jack Jr. *Special Visual Effects.* New York: Van Nostrand Reinhold Company, Inc., 1984.

Johnson, John. *Cheap Tricks and Class Acts.* Jefferson, North Carolina: McFarland & Company Inc, 1996.

Katz, Ephraim. *The Macmillan International Film Encyclopedia.* London: Macmillan, 1994.

Langford, M.J. *Advanced Photography.* London: The Focal Press, 1974.

LoBrutto, Vincent. *Sound on Film: Interviews with Creators of Film Sound.* Wesport CT: Praeger, 1994.

Monaco, James. *How To Read A Film (Revised Edition).* Oxford: Oxford University Press, 1981.

Noake, Roger. *Animation: A Guide to Animated Film Techniques.* London: MacDonald and Co, 1988.

Pank, Bob. *The Digital Fact Book.* Newbury, England: Quantel Limited, 1988.

Ryan, Rod (Editor). *American Cinematographer Manual (Seventh Edition).* California: The ASC Press, 1993.

Salt, Barry. *Film Style & Technology: History & Analysis (Second Edition).* London: Starword, 1992

Salisbury, Mark and Hedgecock, Alan. *Behind the Mask: The Secrets of Hollywood's Monster Makers.* London: Titan Books, 1994.

Shay, Don and Duncan, Jody. *The Making of Jurassic Park.* London: Boxtree, 1993.

Sklar, Robert. *Film: An International History of the Medium.* London: Thames and Hudson, 1993.

Smith, Thomas G., *Industrial Light and Magic: The Art of Special Effects.* New York: Ballantine, 1986.

Taylor, Al and Roy, Sue. *Making A Monster.* New York: Crown Publishers, Inc. 1980.

Thompson, David. *George Méliès, Father of Film Fantasy.* London: Collins, 1992.

Timpone, Anthony. *Men, Makeup, and Monsters.* New York: St. Martin's Griffin, 1996.

Vaz, Mark Cotta and Duignan, Patricia Rose. *Industrial Light and Magic: Into The Digital Realm.* New York: Ballantine, 1996.

Walker, John (editor). *Halliwell's Film Guide (Eighth Edition).* London: Harper Collins, 1992.

Wilkie, Bernard. *Creating Special Effects for TV and Films.* London: Focal Press, 1977.

Wilson, Steven, S., *Puppets and People.* San Diego: A.S. Barnes & Company, Inc., 1980.

MAGAZINES

American Cinematographer (monthly), P.O. Box 2230, Hollywood, CA 90078, USA. www. Cinematographer.com

Cinefantastique (monthly), 7240 West Roosevelt Road, Forest Park, IL 60130. USA.

Cinefex (quarterly), PO Box 20027, Riverside, CA 92516, USA. www. cinefex.com

Fangoria (eight issues a year), O'Quinn Studios, 475 Park Avenue South, New York, NY 10016, USA.

SFX (fourteen issues a year), Future Publishing, 30 Monmouth Street, Bath, BA1 2BW, UK.

Starburst (monthly), P.O. Box 371, London, SW14 8JL.

Starlog (monthly), 475, Park Avenue South, New York, NY 10016, USA.

INDEX

Page numbers in italics refer to illustrations

PICTURE CREDITS

2-3: 20th Century Fox (image courtesy of Digital Domain, Inc.); 8 SM; 9 SM; 10t MoMA; 10b BFI; 11t&bl BFI; 11c Kobal; 11br SM; 12 BFI; 13 Kobal; 14 BFI; 15t Kobal; 15b BFI; 16b Kobal; 16t RGA; 17t Kobal; 17b Kobal; 18t BFI; 18b 20th Century Fox (courtesy Kobal); 19 Kobal; 20t BFI; 20b Kobal; 22t Still reproduced courtesy of Carlton International Media Limited (courtesy JFC); 22b Kobal; 23t Kobal; 23b Still from *Ships with Wings* appears courtesy of Canal+ DA (courtesy RGA); 24t Corbis/Bettmann; 24b 20th Century Fox (courtesy Kobal); 25t Courtesy of Paramount Pictures. © 2000 by Paramount Pictures. All Rights Reserved (courtesy BFI); 25b © 1953 Warner Bros. Pictures, Inc. All Rights Reserved (courtesy Kobal); 26 BFI; 27t © 1962 Eon Productions, Ltd. All Rights Reserved (courtesy RGA); 27b 20th Century Fox (courtesy Kobal); 28 Kobal; 28/29 © 1966 Turner Entertainment Co. All Rights Reserved (courtesy BFI); 29 © 1968 Turner Entertainment Co. All Rights Reserved (courtesy BFI); 30 Kobal; 31 BFI; 32 © 1982 The Blade Runner Partnership. All Rights Reserved (courtesy BFI); 33 Copyright © 2000 by Universal City Studios Inc. Courtesy of Universal Studios Publishing Rights. All Rights Reserved (courtesy BFI); 34 BFI; 35 Still from *Terminator 2: Judgement Day* appears courtesy of Canal+ DA (courtesy RGA); 36 BFI; 36/3 Copyright © 2000 by Universal City Studios Inc. Courtesy of Universal Studios Publishing Rights. All Rights Reserved (courtesy RGA): 38 Courtesy of Panavision UK; 40 Copyright © 2000 by Universal City Studios Inc. Courtesy of Universal Studios Publishing Rights. All Rights Reserved (courtesy Kobal); 45 Copyright © 2000 by Universal City Studios Inc. Courtesy of Universal Studios Publishing Rights. All Rights Reserved (courtesy BFI); 46 Courtesy of Barry Salt; 49t Still reproduced courtesy of Carlton International Media Limited (courtesy Kobal); 50t Courtesy of Paramount Pictures. © 2000 by Paramount Pictures. All Rights Reserved; 50b © Disney Enterprises, Inc. (courtesy RGA); 53t BFI; 53b © 1978 Film Export A.G. All Rights Reserved (courtesy BFI); 55 Courtesy Lucasfilm Ltd. *Return of the Jedi* © 1983 Lucasfilm Ltd. & TM. All Rights Reserved. Used under authorization. Unauthorized duplication is a violation of applicable law (courtesy RGA); 56l Copyright © 2000 by Universal City Studios Inc. Courtesy of Universal Studios Publishing Rights. All Rights Reserved; 57b © 1933 RKO Pictures Inc. All Rights Reserved (courtesy BFI and Kobal); 58t © 1966 Turner Entertainment Co. All Rights Reserved (courtesy JFC); 58b Richard Rickitt; 60t Stills reproduced courtesy of Carlton International Media Limited (courtesy JFC); 60-61 Courtesy of Richard Edlund Films (photo Virgil Mirano); 62 © 1941 RKO Pictures Inc. All Rights Reserved (courtesy BFI); 63t Courtesy Lucasfilm Ltd. *Return of the Jedi* © 1983 Lucasfilm Ltd. & TM. All Rights Reserved. Used under authorization. Unauthorized duplication is a violation of applicable law (courtesy RGA); 64 Still from *Terminator 2: Judgement Day* appears courtesy of Canal+ DA (courtesy RGA); 65 Courtesy of Richard Edlund Films; 67t Courtesy Hammer Film Production Ltd (courtesy BFI); 67b Copyright © 2000 by Universal City Studios Inc. Courtesy of Universal Studios Publishing Rights. All Rights Reserved (courtesy RGA); 68t Courtesy of Pinewood Studios; 68b Courtesy of Paramount Pictures © 2000 by Paramount Pictures. All Rights Reserved (courtesy Kobal); 70b © 1978 Film Export A.G. All Rights Reserved (courtesy RGA); 71c © 1993 Warner Bros., a division of Time Warner Entertainment Company, L.P. All Rights Reserved (courtesy RGA); 72 © 1968 Turner Entertainment Co. All Rights Reserved (courtesy BFI); 73-74 © Quantel; 77tr Richard Rickitt; 78b Richard Rickitt; 78t & 79 Courtesy of Richard Edlund Films; 80t © Quantel; 80b Richard Rickitt; 81 *Lost In Space* Copyright 1998, New Line Productions, Inc. All Rights Reserved. Photo appears courtesy of New Line Productions, Inc. (courtesy The Magic Camera Company); 82 © Quantel; 84t Courtesy of CFC; 84b Courtesy of Paramount Pictures © 2000 by Paramount Pictures. All Rights Reserved (courtesy of CFC); 85 Courtesy of Men In White Coats; 86 Courtesy of Paramount Pictures © 2000 by Paramount Pictures. All Rights Reserved (courtesy BFI); 87b Photographic still from *The English Patient* provided courtesy of Miramax Films. All Rights Reserved (courtesy of CFC); 88/89 Courtesy of Men In White Coats; 90 Courtesy of Richard Edlund Films; 91b 20th Century Fox (courtesy of 4 Ward Productions); 92 © Disney Enterprises, Inc. (courtesy RGA); 93 RGA; 94 Courtesy of Kevin Brownlow; 96 © 1987 Danjaq LLC and United Artists Corporation. All Rights Reserved (courtesy of John Richardson); 97t&bl Courtesy of Richard Edlund Films (photo Virgil Mirano); 97br & 98 Courtesy of Hunter Gratzner Industries; 99b Courtesy of The Magic Camera Company; 99t Photo by Nigel Stone; 100 © 2000 by Universal City Studios, Inc. Courtesy of Universal Studios Publishing Rights. All Rights Reserved. (courtesy BFI); 101 © Fridrich-Wilhelm-Murnau-Stiftung, distribution Transit Films GmBH (courtesy RGA); 102-104 Courtesy of Joe Viskocil; 104br © 1984 Orion Pictures Corporation. All Rights Reserved. (courtesy of Joe Viskocil); 105 Courtesy of Joe Viskocil; 107 20th Century Fox (courtesy of 4 Ward Productions); 108 Courtesy of 4 Ward Productions; 109t RGA; 109b Effects Associates; 110t 20th Century Fox (courtesy Kobal); 110b Effects Associates; 110/11 20th Century Fox (image courtesy of Digital Domain, Inc.); 111t Still from *Cutthroat Island* appears courtesy of Canal+ DA (courtesy of Effects Associates); 112/13t 20th Century Fox (courtesy Kobal); 112b Courtesy of Academy of Motion Picture Arts and Sciences; 113b BFI; 114 Courtesy of Lucasfilm Ltd. *The Empire Strikes Back* © 1980 Lucasfilm Ltd. & TM. All Rights Reserved. Used under authorization. Unauthorized duplication is a violation of applicable law. (courtesy Kobal); 115t Courtesy of 4 Ward Productions; 115b Courtesy of Joe Viskocil; 116tl BFI; 116tr Courtesy of 4 Ward Productions; 116/17 © 1987 Warner Bros. Inc. All Rights Reserved. (courtesy Kobal); 117br Courtesy of Paramount Pictures. © 2000 by Paramount Pictures. All Rights Reserved. (courtesy RGA); 118 Courtesy of Paramount Pictures. © 2000 by Paramount Pictures. All Rights Reserved. (courtesy BFI); 119t © 1968 Turner Entertainment Co. All Rights Reserved. (courtesy BFI); 119b Courtesy of Academy of Motion Picture Arts and Sciences; 120t © Disney Enterprises, Inc. (courtesy RGA); 120b Courtesy of Lucasfilm Ltd. *Star Wars* © 1977 Lucasfilm Ltd. & TM. All Rights Reserved. Used under authorization. Unauthorized duplication is a violation of applicable law. (courtesy RGA); 121b Courtesy of Sony Pictures Imageworks; 122 Courtesy of John Dykstra; 123 Courtesy of Lucasfilm Ltd. *Star Wars* © 1977 Lucasfilm Ltd. & TM. All Rights Reserved. Used under authorization. Unauthorized duplication is a violation of applicable law. (courtesy of Industrial Light & Magic); 124 Courtesy of Evans and Sutherland; 126 © Disney Enterprises, Inc. (courtesy Kobal); 132 Photograph from the motion picture *Antz* TM & © 1998 DreamWorks L.L.C., reprinted with permission by DreamWorks Animation (courtesy of Pacific Data Images); 133 Copyright © 2000 by Universal City Studios, Inc. Courtesy of Universal Studios Publishing Rights. All Rights Reserved. (courtesy RGA); 134-135 Courtesy of The Magic Camera Company; 137 RGA; 138 BFI; 139t © Disney Enterprises, Inc. (courtesy BFI); 139b Courtesy of Jon Brook; 140t BFI; 140b © Disney Enterprises, Inc. (courtesy BFI); 142 © Touchstone Pictures and Amblin Entertainment, Inc. (courtesy Kobal); 143t Richard Rickitt; 143b Courtesy of Paramount Pictures. © 2000 by Paramount Pictures. All Rights Reserved. (image courtesy of Industrial Light & Magic); 144 Courtesy of Lucasfilm Ltd. *The Empire Strikes Back* © 1980 Lucasfilm Ltd. & TM. All Rights Reserved. Used under authorization. Unauthorized duplication is a violation of applicable law (courtesy BFI); 145t © 1968 Turner Entertainment Co. All Rights Reserved. (courtesy BFI); 146 20th Century Fox (courtesy RGA); 147-149 Photographs from the motion picture *Prince of Egypt* TM & © 1998 DreamWorks L.L.C., reprinted with permission by DreamWorks Animation; 150b US Department of the Interior National Park Service, Edison Historical Site; 151 BFI; 152/53 Kobal; 154 © 1933 RKO Pictures, Inc. All Rights Reserved.

(courtesy RGA); 155t © 1933 RKO Pictures, Inc. All Rights Reserved. (courtesy RGA); 156t BFI; 156/57 © 1969 Warner Bros./Seven Arts, Inc. All Rights Reserved. (courtesy BFI); 158t Kobal; 158b © 1981 Turner Entertainment Co. All Rights Reserved. (courtesy BFI); 159t BFI; 159b © Touchstone Pictures. All Rights Reserved. (courtesy BFI); 160 Courtesy of Paramount Pictures. © 2000 by Paramount Pictures. All Rights Reserved. (image courtesy of Industrial Light & Magic); 161 Courtesy of Tippett Studio; 162-163 Richard Rickitt; 164t Courtesy of CFC; 164b Courtesy of Paramount Pictures. © 2000 by Paramount Pictures. All Rights Reserved. (courtesy of CFC); 165 *Lost In Space* Copyright 1998, New Line Productions, Inc. All Rights Reserved. Photo appears courtesy of New Line Productions, Inc. (courtesy of Jim Henson Company); 167 Photograph from the motion picture *Antz* TM & © 1998 DreamWorks L.L.C., reprinted with permission by DreamWorks Animation; 168t Courtesy of Pacific Data Images; 168/69 20th Century Fox (courtesy RGA); 169t Copyright © 2000 by Universal City Studios, Inc. Courtesy of Universal Studios Publishing Rights. All Rights Reserved. /c. 1996 Warner Bros., a division of Time Warner Entertainment Co., L.P. and Universal City Studios, Inc. All Rights Reserved. (courtesy RGA); 170 Courtesy of Pixar Animation Studios; 171t RGA; 172 Copyright © 2000 by Universal City Studios, Inc. Courtesy of Universal Studios Publishing Rights. All Rights Reserved. (courtesy RGA); 173t Courtesy of House of Moves; 173b 20th Century Fox (image courtesy of Digital Domain, Inc.); 175 © Disney Enterprises, Inc. (courtesy BFI); 176t Courtesy of CFC; 176b Copyright © 2000 by Universal City Studios, Inc. Courtesy of Universal Studios Publishing Rights. All Rights Reserved. (courtesy of CFC); 177 Courtesy of Arete Image Software; 178 Photographs from the motion picture *Antz* TM & © 1998 DreamWorks L.L.C., reprinted with permission by DreamWorks Animation. (courtesy of Pacific Data Images); 179 Photograph from the motion picture *Antz* TM & © 1998 DreamWorks L.L.C., reprinted with permission by DreamWorks Animation; 181/82 Copyright © 2000 by Universal City Studios, Inc. Courtesy of Universal Studios Publishing Rights. All Rights Reserved. (courtesy Kobal); 183 © 1984 Lorimar/Universal A Joint Venture. All Rights Reserved. (courtesy Kobal); 185 © Lucas Digital Ltd., photographer David Peters (image courtesy of Industrial Light & Magic); 186 Manex Visual Effects; 187 Courtesy of Lucasfilm Ltd. *Star Wars Episode One – The Phantom Menace* © 1999 Lucasfilm Ltd. & TM. All Rights Reserved. Used under authorization. Unauthorized duplication is a violation of applicable law. (image courtesy of Industrial Light & Magic); 188 Stills reproduced courtesy of Carlton International Media Limited (courtesy JFC); 189-190 BFI; 192 Courtesy of Kevin Brownlow; 193t Copyright © 2000 by Universal City Studios, Inc. Courtesy of Universal Studios Publishing Rights. All Rights Reserved. (courtesy BFI); 194bl BFI; 195 Courtesy of Richard Edlund Films; 196-198 BFI; 199-201 Courtesy of Harrison Ellenshaw; 201b © Touchstone Pictures. All Rights Reserved. (courtesy of Harrison Ellenshaw); 202/203 Courtesy of Lucasfilm Ltd. *Raiders of the Lost Ark* © 1981 Lucasfilm Ltd. & TM. All Rights Reserved. Used under authorization. Unauthorized duplication is a violation of applicable law. (courtesy BFI); 203-205 Courtesy of Paramount Pictures. © 2000 by Paramount Pictures. All Rights Reserved. (images courtesy of Industrial Light & Magic); 206 Courtesy of Matte World Digital; 207 Courtesy of Paramount Pictures. © 2000 by Paramount Pictures. All Rights Reserved (courtesy of Matte World Digital); 208t Copyright © 2000 by Universal City Studios, Inc. Courtesy of Universal Studios Publishing Rights. All Rights Reserved. (courtesy of Matte World Digital); 208b Courtesy of Matte World Digital; 209 20th Century Fox (courtesy of Matte World Digital); 210 Copyright © 2000 by Universal City Studios, Inc. Courtesy of Universal Studios Publishing Rights. All Rights Reserved. (courtesy BFI); 211t BFI; 211b RGA; 212tl Kobal; 212tr © 1973 Warner Bros., Inc. All Rights Reserved. (courtesy RGA); 214 Richard Rickitt; 216-217 Courtesy of Jim Henson Company; 219 & 220b Courtesy of Paramount Pictures. © 2000 by Paramount Pictures. All Rights Reserved. (courtesy BFI); 220t BFI; 221 © 1984 The Saul Zaentz Company. All Rights Reserved. (courtesy Kobal); 222bl © Fridrich-Wilhelm-Murnau-Stiftung, distribution Transit Films (courtesy RGA) 222/23 RGA; 224t Courtesy of Lucasfilm Ltd. Star Wars © 1977 Lucasfilm Ltd. & TM. All Rights Reserved. Used under authorization. Unauthorized duplication is a violation of applicable law. (courtesy Kobal); 224b Courtesy of Stan Winston Studio; 225 Copyright © 2000 by Universal City Studios, Inc. Courtesy of Universal Studios Publishing Rights. All Rights Reserved. (courtesy of Stan Winston Studio); 226-228 Courtesy of Stan Winston Studio; 229 Courtesy of Jim Henson Company; 230-231 Courtesy of Stan Winston Studio; 230bl Copyright © 2000 by Universal City Studios, Inc. Courtesy of Universal Studios Publishing Rights. All Rights Reserved. (courtesy of Stan Winston Studio); 231br Courtesy of Jim Henson Company; 232 Courtesy of Cinovaton; 233b Courtesy of Lucasfilm Ltd. *Star Wars Episode One – The Phantom Menace* © 1999 Lucasfilm Ltd. & TM. All Rights Reserved. Used under authorization. Unauthorized duplication is a violation of applicable law. (image courtesy of Industrial Light & Magic); 233-235 Courtesy of Jim Henson Company; 236 Courtesy of Stan Winston Studio; 238 Courtesy of Jim Henson Company; 239 Toho Co. (courtesy BFI); 240 Courtesy of Jim Henson Company; 241-244 Copyright © 2000 by Universal City Studios, Inc. Courtesy of Universal Studios Publishing Rights. All Rights Reserved. (images courtesy of Industrial Light & Magic); 245 Courtesy of Ken Ralston; 246-248 BFI; 248bl RGA; 249 BFI; 250tr Richard Rickitt; 250 BFI; 251 Courtesy of Artem Visual Effects; 252 © 1965 Turner Entertainment Co. All Rights Reserved. (courtesy RGA); 253-254 Courtesy of Snow Business International Ltd; 254b Richard Rickitt; 255 © 1995 Danjaq, LLC and United Artists Corporation. All Rights Reserved; 256-257 Richard Rickitt; 258 20th Century Fox (courtesy RGA); 259tl Courtesy of Artem Visual Effects; 259tr Richard Rickitt; 261b Courtesy of Artem Visual Effects; 262 © 1969 Metro Goldwyn-Mayer Inc. All Rights Reserved. (courtesy BFI); 263-264 Courtesy of Artem Visual Effects; 265 Courtesy of Lucasfilm Ltd. *Star Wars Episode One - The Phantom Menace* © 1999 Lucasfilm Ltd. & TM. All Rights Reserved. Used under authorization. Unauthorized duplication is a violation of applicable law. (image courtesy of Industrial Light & Magic); 266-267 Courtesy of Eon Productions; 269t Courtesy of Lucasfilm Ltd. *Raiders of the Lost Ark* © 1981 Lucasfilm Ltd. & TM. All Rights Reserved. Used under authorization. Unauthorized duplication is a violation of applicable law. (courtesy BFI); 269b Courtesy of Artem Visual Effects; 270tl Courtesy of John Richardson; 270/71t © 1939 Turner Entertainment Co. All Rights Reserved. (courtesy RGA); 271b © 1969 Metro Goldwyn-Mayer Inc. All Rights Reserved. (courtesy BFI); 272 Courtesy of Lucasfilm Ltd. *Indiana Jones and the Temple of Doom* © 1984 Lucasfilm Ltd. & TM. All Rights Reserved. Used under authorization. Unauthorized duplication is a violation of applicable law. (courtesy BFI); 273 Courtesy of John Richardson; 274 Copyright © 2000 by Universal City Studios, Inc. Courtesy of Universal Studios Publishing Rights. All Rights Reserved. (courtesy Kobal); 275tl © Touchstone Pictures and Amblin Entertainment, Inc. (courtesy RGA); 275tr Courtesy of Michael Lantieri; 276 Copyright © 2000 by Universal City Studios, Inc. Courtesy of Universal Studios Publishing Rights. All Rights Reserved. (courtesy RGA); 277 Copyright © 2000 by Universal City Studios, Inc. Courtesy of Universal Studios Publishing Rights. All Rights Reserved. (image courtesy of Industrial Light & Magic); 281 Courtesy of Lucasfilm Ltd. *Raiders of the Lost Ark* © 1981 Lucasfilm Ltd. & TM. All Rights Reserved. Used under authorization. Unauthorized duplication is a violation of applicable law. (courtesy BFI); 282 Richard Rickitt; 283t © Skywalker Sound, photographer Steve Jennings (image courtesy of Industrial Light & Magic); 283b Photo by Hugh Gilbert; 284t Courtesy of Gary Hecker; 284b Richard Rickitt; 286c Courtesy of Pinewood Studios; 287t Richard Rickitt; 288 BFI; 289t Copyright © 2000 by Universal City Studios, Inc. Courtesy of Universal Studios Publishing Rights. All Rights Reserved. (courtesy BFI); 289b RGA; 292bl Courtesy of Imax Corporation; 292/93 Courtesy of Universal Studios, Inc.; 295br Photo by Douglas Kirkland (courtesy of Douglas Trumbull); 295bl © 2000 Entertainment Design Workshop (courtesy of Douglas Trumbull); 296 © 2000 Entertainment Design Workshop (courtesy of Douglas Trumbull); 297 Courtesy of Showscan Corporation.

First published in 2000 by Virgin Books
An imprint of
Virgin Publishing Ltd
Thames Wharf Studios
Rainville Road
London
W6 9HA

Copyright © Richard Rickitt 2000

The right of Richard Rickitt to be identified as the Author of this Work
has been asserted by him in accordance with the Copyright Designs
and Patents Act 1988

First published in the United States in 2000 by Billboard Books
An imprint of Watson-Guptill Publications
A division of BPI Communications, Inc.
770 Broadway, New York, NY 10003
www.watsonguptill.com

Library of Congress Cataloging-in-Publication Data for this title can
be obtained from the Library of Congress

Library of Congress Card Number: 00-102955

ISBN 0 8230 7733 0

Printed and bound in Great Britain by Butler and Tanner Ltd, Frome
and London

Set in Korinna and Stone Sans

First printing 2000

1 2 3 4 5 6 7 8 9 / 08 07 06 05 04 03 02 01 00

AUTHOR'S ACKNOWLEDGMENTS

Firstly I would like to thank my parents, Martin and Barbara;
I hope this book serves as some compensation for the explosions,
fires, crashes, floods and enormous electricity bills that I inflicted
upon them during my teenage filmmaking experiments. I would
also like to thank my other family members and friends who saw
so little of me during the writing of this book – and who tolerated
my complaints about the agonies of writing when they did.

I would like to thank Carolyn Thorne and James Bennett at
Virgin Publishing for their faith in the project and for their tireless
efforts to coax text from me. Many thanks also to Jon Haynes, who
had the unenviable task of learning about the darkest mysteries of
special effects in order to edit my text; to Sue Michniewicz, who
must have redesigned the book a dozen times; to Liz Heasman,
who spent many hours tracking down images which matched my
vague descriptions; and to Alan Jones, for casting a critical and
scholarly eye over the final text.

Special thanks are due to Robert and Diana Phipps, and Craig Barron
and Krystyna Demokowicz for their generous hospitality whilst
researching in America.

Very great thanks are also extended to my old friend Simon
Winstanley, who not only ran our business almost single-handedly
whilst I worked on this book, but whose own intimate knowledge
of the subject enabled him to create the graphic illustrations with
his usual flair and attention to detail.

I would also like to thank my dear friend Mark Bennett, a passionate
movie buff and fine creative writer, who propped me up on the
occasions that I ran out of inspiration.

Finally, and above all, I thank my wife Varsha, who patiently and
graciously endured seemingly endless days and nights alone as
I struggled to complete the task. I dedicate this book to her with
my deepest love and respect.

PUBLISHER'S ACKNOWLEDGMENTS

Editorial Director: Carolyn Thorne
Editors: James Bennett, Jon Haynes, Michelle Pickering
Design: Sue Michniewicz
Graphic Illustrations: Simon Winstanley, Clockwork Digital.com
Picture Research: Liz Heasman

Thanks also to Linda Wood and Chris Turner.